Carolyn Handler Miller is wi⟨ ⟩ an expert professional knowle⟨ ⟩ and theoretical. Her sources are always up-to-date, and her insights relevant to the most contemporary practices.

– **Dr Sue Thomas,**
The Media School, Bournemouth University, UK

Digital Storytelling *is the definitive guide to story-based interactive experiences. Whether you're a new face on the design team or a seasoned pro, it will spur your imagination and open up a rich range of creative possibilities and solutions.*

– **Larry Tuch - Head Writer,**
Paramount Pictures' StoryDrive™ Engine project;
Vice President, 2008-2010, International Board,
Themed Entertainment Association

After reviewing many books over the years for use as a text, I keep coming back to Carolyn's book because it is the only complete textbook. Its organization, examples, and exercises underscore the power of Digital Storytelling *and provides a unique foundation for the goal of the class, teaching the students how to tell a story in the digital age.*

– **Alan J. Dean,**
University of Mary Washington

I first met Carolyn in 2007 through her first edition of Digital Storytelling. *Since then, this invaluable resource rises from strength to strength, continually pushing boundaries, at the front line of digital interactive storytelling, entertainment and unexpected new tools. Whether student or experienced practitioner, this book is a must read.*

– **Alison Norrington,**
CEO & Founder, storycentral Ltd., London

Carolyn's comments and suggestions helped us restore magic and add more interactivity into the script of our interactive documentary. This book is a great lesson on the history, future and making of interactives.

– **Monika Kowaleczko-Szumowska,**
Scriptwriter and Producer of Brave Bunch in India,
an interactive documentary, Warsaw, Poland

Digital Storytelling
Fourth Edition
A creator's guide to interactive entertainment

Digital Storytelling
Fourth Edition

A creator's guide to interactive entertainment

by
Carolyn Handler Miller

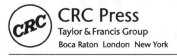

CRC Press
Taylor & Francis Group
Boca Raton London New York

CRC Press is an imprint of the
Taylor & Francis Group, an **informa** business

CRC Press
Taylor & Francis Group
6000 Broken Sound Parkway NW, Suite 300
Boca Raton, FL 33487-2742

© 2020 by Taylor & Francis Group, LLC
CRC Press is an imprint of Taylor & Francis Group, an Informa business

No claim to original U.S. Government works

Printed on acid-free paper

International Standard Book Number-13: 978-1-138-34160-9 (Hardback)
International Standard Book Number-13: 978-1-138-34158-6 (Paperback)

This book contains information obtained from authentic and highly regarded sources. Reasonable efforts have been made to publish reliable data and information, but the author and publisher cannot assume responsibility for the validity of all materials or the consequences of their use. The authors and publishers have attempted to trace the copyright holders of all material reproduced in this publication and apologize to copyright holders if permission to publish in this form has not been obtained. If any copyright material has not been acknowledged please write and let us know so we may rectify in any future reprint.

Except as permitted under U.S. Copyright Law, no part of this book may be reprinted, reproduced, transmitted, or utilized in any form by any electronic, mechanical, or other means, now known or hereafter invented, including photocopying, microfilming, and recording, or in any information storage or retrieval system, without written permission from the publishers.

For permission to photocopy or use material electronically from this work, please access www.copyright.com (http://www.copyright.com/) or contact the Copyright Clearance Center, Inc. (CCC), 222 Rosewood Drive, Danvers, MA 01923, 978-750-8400. CCC is a not-for-profit organization that provides licenses and registration for a variety of users. For organizations that have been granted a photocopy license by the CCC, a separate system of payment has been arranged.

Trademark Notice: Product or corporate names may be trademarks or registered trademarks, and are used only for identification and explanation without intent to infringe.

Visit the Taylor & Francis Web site at
http://www.taylorandfrancis.com

and the CRC Press Web site at
http://www.crcpress.com

This edition of Digital Storytelling *is dedicated to the individuals who have had the spirit, courage, and imagination to create original works of digital storytelling. Breaking new ground is never easy, but you have had the confidence to venture into the unknown, deep into digital space, and come back with something every human craves: a good story. Thank you for your unique contributions to this field.*

Contents

Foreword..xxv
Preface..xxix
Acknowledgments....................................xxxvii

PART 1 New Technologies, New Creative Opportunities

CHAPTER 1 — **Storytelling, Old and New**3

Storytelling: An Ancient Human Activity3
Interactivity and Storytelling................................7
Participatory Dramas ...8
Mythological Symbolism and Digital Storytelling9
Familiar Rituals and Digital Storytelling11
Rites of Passage and Digital Storytelling13

Games and Digital Storytelling 13
 Ancient Games and Digital Storytelling. 16
 Board Games and Digital Storytelling 16
 Children's Games and the "Fun Factor" 17
 Fantasy Role-Play for Adults 18
Nonlinear Fiction before the Computer. 19
Nonlinear Drama in Theater and Motion Pictures. 21
The Special Characteristics of Digital Storytelling 23
Conclusion ... 25
Idea-Generating Exercises 26

CHAPTER 2 — Backwater to Mainstream: The Growth of Digital Entertainment 27

An Extremely Recent Beginning. 27
A Brief History of the Computer 28
The Birth of the Internet. 30
The First Video Games 32
Less Familiar Forms of Interactive Entertainment. 34
The Evolution of Content for a New Medium. 34
 The Early Days of a New Medium. 34
Harnessing Convergence to Digital Storytelling. 36
Transmedia Storytelling as a Form of Convergence. 37
Alternate Reality Games: A Special Form of Transmedia
 Storytelling. .. 40
Borrowed Technologies 44
New Ways to Tell Stories. 48
The Profound Impact of Digital Media 53
 Changes in the Consumption of Entertainment. 54
 The Third Screen's Impact on Hollywood 55
 How Advertisers Are Responding. 57
 The Impact on Journalism and How We Receive
 Information 58
 The Internet as a Journalistic Medium 59
 What the Digital Revolution Means for Content 59
 Types of User-Generated Content. 60
 Virtual Worlds 61

Social Media Sites 62
Video-Sharing Sites 63
Fan Fiction 63
Machinima 63
Digital Technology and the Arts 64
A Global Perspective 66
Conclusion 67
Idea-Generating Exercises 68

PART 2 Creating Story-Rich Projects

CHAPTER 3 — Interactivity and Its Effects 73

What Is Interactivity? 73
Interactivity as a Conversation 74
What Happens to the Audience? 76
The User, the Author, and Interactivity 76
Immersiveness 79
Types of Interactivity 82
How Interactivity Impacts Content 85
Using Gaming Techniques to Supply the Missing Cohesion 87
Games as Abstract Stories 88
 Drama in an Abstract Game 90
Stories That Are Not Games 90
Conclusion 92
Idea-Generating Exercises 93

CHAPTER 4 — Old Tools/New Tools 95

An Assortment of Storytelling Tools 95
Learning from Games 96
Learning from Myths 99
Learning from Aristotle 101
Learning from Contemporary Storytellers 103
Other Useful Old Tools 104

The Storyline in Linear and Interactive Narratives............105
A Hollywood Writer's View of Interactive Media.............107
Ten New Tools...109
 Interface and Navigation110
 Systems for Determining Events and Assigning Variables.. 110
 Assigning a Role and Point of View to the User..........111
 Working with New Types of Characters and Artificial
 Intelligence....................................111
 New Ways of Connecting Story Elements...............112
 Gameplay ...113
 Rewards and Penalties113
 New Kinds of Structures..............................113
 The Use of Time and Space114
 Sensors and Special Hardware.........................114
The Collaborative Process115
Conclusion..116
Idea-Generating Exercises..................................116

CHAPTER 5 — Characters, Dialogue, and Emotions119

Characters in an Interactive Environment....................119
 The Role of Characters in Digital Storytelling............120
 The Differences between Characters in Linear and
 Interactive Storytelling..........................121
 Where Did All the Characters Go?.....................122
Classic Characters from Linear Media........................123
The User as Protagonist124
 The User's Avatar126
 The User's Point of View.............................127
 The User's Many Possible Roles.......................129
Computer-Controlled Characters: Antagonists and Others.....130
 Creating Worthy Opponents132
 A Multiple Number or Succession of Antagonists........134
 Other Types of NPCs134
Intelligent Characters135
 Conflict between Characters with AI...................136
 Chatbots ...137

Synthetic Characters 139
Creating Characters for an Interactive Environment 140
 Techniques for Developing Memorable Characters 140
 Constructing a Character Arc 142
 Emergent Behavior 143
Dialogue and Other Forms of Verbal Communication 144
 Other Forms of Communication 146
 Classic Dialogue 147
 Dialogue in Digital Storytelling 147
 Guidelines for Verbal Communications 150
The Role of Emotion 151
Conclusion .. 154
Idea-Generating Exercises 155

CHAPTER 6 — Structure in Digital Storytelling **157**

Styrofoam Peanuts 157
The Basic Building Blocks of Traditional Drama 159
The Basic Building Blocks of Interactive Narratives 161
The If/Then Construct 163
 Branching Structures 165
 The Branching Structure in iTV and iCinema 167
The Critical Story Path 167
 Structural Models That Support the Critical Story Path 169
 The Passenger Train Model 170
Other Structural Models 171
 Spaces to Explore 171
 Structures That Are More Angular 172
 The Modular Structure 174
 Sophisticated Story Models 174
 The Collective Journey Model 177
Creating Your Own Structural Model 177
Determining a Structure 178
Conclusion .. 180
Idea-Generating Exercises 181

CHAPTER 7 — Your Audience 183

Who Is Your Audience? .. 183
Children: A Significant Piece of the Digital Pie 184
 Understanding the Young User 186
 How Children Develop 188
 Soliciting Help from Experts, Large and Small 189
 Age-Appropriateness 190
 The Parents' Point of View 191
 The Use of Humor 194
 Offer Satisfying Challenges and Rewards 195
 A Final Tip: Be Respectful 195
Girls and Women ... 196
 Creating Projects for Women 198
Seniors and Digital Media 199
The Medically Ill and Disabled 202
Other Parts of the World and Other Ethnic Groups 203
Specialized Works for Domestic Populations 205
Zeroing in on Your Target Audience 206
Conclusion .. 208
Idea-Generating Exercises 209

CHAPTER 8 — Social Media and Storytelling 211

Inserting the Social into the Media 211
The Power of Social Media 213
Characters on Social Media 214
Works of Fiction Using Social Media 217
 Austen Lives On .. 222
Other Works of Social Media Fiction 223
A Darker Social Media Story 224
Other Approaches to Social Media Storytelling 225
Works of Non-Fiction Using Social Media 228
Social Media Games .. 231
Does Humor Have Any Role to Play in Social Media? 233
Conclusion .. 233
Idea-Generating Exercises 234

CHAPTER 9 — Guidelines: Creating a New Project 237

The Development Period and Why It Is Critical. 237
Five All-Too-Common Errors. 239
The First Step: Creating the Core Concept 241
Other Early Decisions. 242
How Projects Evolve during Development 244
Other Steps in the Preproduction Phase . 245
A 10-Step Development Checklist . 246
Documents and Artwork. 249
 The Concept Document. 249
 The Bible. 250
 The Design Document . 251
 The Dialogue Script. 255
 Flowcharts . 258
 Concept Art . 262
 Storyboards . 263
 Prototype . 263
Specialized Documents and Artwork. 264
Conclusion. 265
Idea-Generating Exercises . 266

PART 3 Harnessing Digital Storytelling for Pragmatic Goals

CHAPTER 10 — Using Digital Storytelling to Teach, Promote, and Inform . 269

"A Spoonful of Sugar". 270
Applying Digital Storytelling to Teaching and Training 271
Digital Media and Young Learners . 273
 Games in the Classroom. 274
 Games at Home and Abroad . 275
 "Drill and Kill" Games . 275

Digital Media and Older Learners .276
The Role of Educational Games for Older Learners.277
 Gamification in Education. .278
 Games for Organizations .278
 Online Courses .280
Useful Techniques for Combining Teaching with Digital
 Storytelling .280
 Determining Where the Educational Content Fits In281
 Setting the Curriculum. .281
 Creating a Program Conducive to Active Learning282
 Setting Levels of Difficulty. .282
 Establishing a Compelling Premise and End-Goal.283
 Creating a Rewards System .284
 Using Simulations .285
 Using Peer-To-Peer Learning. .286
Additional Digital Tools for Education and Training286
 Transmedia Storytelling and Alternate Reality Games287
 Mobile Phones, Tablet Computers, and Apps288
 Immersive Experiences. .289
 Other Digital Storytelling Techniques289
The Growth of the Serious Games Movement290
 A Cross-Section of Serious Games. .291
Developing Serious Games for the Military292
Combining Digital Storytelling and Training296
 A Sample Interactive Training Course298
Other Digital Options for Teaching .299
Guidelines for Projects That Blend Storytelling with
 Teaching and Training .300
Using Digital Storytelling Techniques for Promotion301
 Viral Marketing .302
Digital Media Venues for Promotion and Advertising.303
Applying Digital Storytelling Techniques and Genres to
 Promotion .305
 Product Placement .305
 Branded Content. .306
 Social Marketing .307
 Public Advocacy Campaigns .308
 Web Series .309
 Gaming. .310

Advergaming and Casual Games	310
Video Games	312
Alternate Reality Games	312
Massively Multiplayer Online Games and Virtual Worlds	314
Gamification	315
Music Videos	317
"Construction Kit" Commercials	317
Short Films	317
Webcam Peepshows	318
Transmedia Storytelling	320
Social Media	321
Mobile Apps	322
Augmented Reality and Virtual Reality	322
A Unique Transmedia Venture	323
The Impact of Digital Media on News and Information	324
The Growing Popularity of Digital Media as a News Source	325
The Digital Revolution and Traditional News Media	327
Applying Digital Storytelling Techniques to News and Information	330
Utilizing Personal Stories	331
Community-Building Elements	331
Games and Game-Like Activities	332
Using Humor	333
Offering Multiple Points of View	334
An Array of Platforms	335
The Internet	335
Mobile Devices	337
Agent-Based Modeling	338
Locative Journalism	338
Interactive and Second-Screen TV	339
Virtual Reality (VR)	339
Electronic Kiosks	340
Interactive Documentaries	341
Museum Installations	341
Transmedia Productions	342
Wikis	343
Special Considerations for Creating Informational Projects	344

Conclusion ...346
Idea-Generating Exercises347

PART 4 Media and Models: Under the Hood

CHAPTER 11 — Video Games...............................351

Video Games: The 10,000-Pound Gorilla of Interactive
 Entertainment ...351
Video Games and Their Place in the Overall
 Entertainment Universe352
The Great Debate ..354
Narrative in Games ..355
Adapting a Game from Other Source Material................358
The Unique Characteristics of Video Games.................359
Gameplay ..359
Artificial Intelligence (AI)360
Interface and Navigation360
Categories and Genres of Games361
Game Platforms...361
 Small Was Big..363
Types of Games ..364
 Game Genres ...364
 The Ways Games Are Played371
The Enormous Popularity of *Fortnite*......................373
New Games and the Fading Away of Once-Popular Genres......374
Single versus Multiplayer Games376
Violence and Video Games376
Independent ("Indie") Games377
The Challenge of Storytelling in Open World Games379
Massively Multiplayer Online Role-Playing Games382
 The Characteristics of the MMORPG383
 Narrative in MMORPGs...................................384

Why So Powerfully Addictive? 385
A Player's Point of View 387
The MMORPG-Makers' Point of View. 388
Breaking Fresh Ground 391
 The Characters. 392
 Reaching a Broad Demographic 393
 The Role of the Treadmill. 394
Story and Structure 395
The Future of MMORPGS 396
The Rise of Casual Games 396
Who Plays Games and Why?........................... 397
Gamification. 400
What Can We Learn from Games? 400
Tips for Newbie Game-Makers 401
Conclusion 402
Idea-Generating Exercises 403

CHAPTER 12 — The Internet. 405

The Evolution of the Internet. 405
 Internet Connectivity across the Globe 408
The Popularity of Youtube Videos 408
 YouTube Success Stories. 409
The Quest for "Stickiness". 410
 YouTube Stickiness 412
TV as a Role Model? 413
Some Unique Web Genres 414
 Web Series, or Webisode. 414
 Web Series with a Hollywood Parentage 415
 Professionally Produced Web Series. 416
 Original Web Series. 416
 A Close Look at a Successful Original Web Series:
 Enter the Dojo 418
 Non-Fiction and Fictional Blogs. 421
 Non-Fiction Blogs. 421
 Fictional or Faux Blogs. 423

 Webcam Dramas .426
 Comedy Shorts .429
 Interactive Mysteries and Adventures.430
Conclusion. .432
Idea-Generating Exercises .433

CHAPTER 13 — Mobile Devices and Apps .435

The Metamorphosis of the Telephone .435
The Progenitor: A Snake. .437
The Appeal of Mobile Devices and Apps .439
Mobile's Special Challenges and Opportunities441
Mobile Devices and Digital Storytelling. .445
Mobile Games .448
Good for the Little Ones?. .451
Creating Content for Mobile Devices. .453
Putting Mobile Devices to Practical Use .457
A Few Considerations. .458
Conclusion. .460
Idea-Generating Exercises .460

CHAPTER 14 — Interactive Cinema and Interactive TV463

Hold the Popcorn!. .464
A Bird's Eye View of the Field .465
Large-Screen Interactive Cinema .466
 Group-Based Interactivity .468
 Involving the Audience. .469
 A Sample Large-Screen Experience .469
 Special Challenges of Large-Screen Interactive Cinema . . .471
 Other Venues for Large-Screen iCinema472
Small Screen Works of iCinema .474
 The Hyperstory .475
 Database Narratives .478
 Other Documentary Forms. .481
User as Fulcrum. .485

The Spatial Narrative...................................486
Other Fiction-Based Small-Screen Forms of iCinema..........487
 Multiplot Stories on a Grid487
 Employing DVD Technology...........................488
 Stories with User-Generated Characters489
 iCinema Works Driven by Social Media489
 iCinema Works Controlled by the Movements of
 Audience Members............................490
Interactive Television491
 Winning Over the Couch Potato........................491
 Various Forms of iTV................................494
 New Advances in iTV498
 The View from the Frontier501
 Pushing The Envelope...............................502
 When iTV Becomes "Just Television"...................505
 A Variety of Approaches........................506
 Applying iTV to Drama on the BBC507
 The Dual-Screen Experience: A Real-Life Example508
 How Second-Screen TV Is Being Used511
 Dramatic Shows and Social TV........................512
Conclusion..514
Idea-Generating Exercises515

CHAPTER 15 — Smart Toys and Life-Like Robots517

Venturing into the Metaphysical..............................517
Smart Toys and Life-Like Robots: What Do They Have in
 Common?..519
A Long History ..520
Today's Smart Toys ...522
The Challenges of Creating a Smart Toy524
The Process of Developing a Smart Toy.......................525
 The Toy Inventor's Perspective........................526
 A Toy Manufacturer's Perspective.....................528
 The Toy Developer's Perspective530
Robots for Kids ..532
Toy Robots: Not Just for Kids535

Working Robots. 536
Spiritual and Violent Robots . 538
Animatronic Characters: Stars of the Stage and Screen. 540
Androids: Too Much Like Us?. 540
Designing Robots to Be Likable, Not Creepy 543
Conclusion. 544
Idea-Generating Exercises . 544

PART 5 Immersive Media

CHAPTER 16 — What Are Immersive Media?. 547

Science Fiction Territory . 547
Defining Immersive Environments . 549
The Promise of Immersive Storytelling . 550
Conclusion. 552
Idea-Generating Exercises . 552

CHAPTER 17 — VR, AR, and Mixed Reality (XR). 555

Welcome to the Outer Edges of Cyberspace 555
VR and AR 101 . 556
VR and Entertainment . 559
 Narrative Experiences in VR . 559
 Nonfiction Narrative in VR . 561
 VR for the Body, Soul, and Mind. 562
 VR and Location-Based Entertainment. 564
 A Modern Twist on the Old Beach Arcade 570
 VR Games for Home Use. 572
 A Selection of VR Games. 573
Using VR for Practical Purposes. 577
 Training. 577
 Using VR to Inform. 579
 History and Newsworthy Events in VR 580

Education .582
　　　Medicine and Psychotherapy. .583
　　　　　　Another Approach to Healing.584
　　　Science .585
　　　College Recruitment. .585
　　　Retail .586
　　　Other Uses .586
Augmented Reality .588
　　　AR in Gaming .589
　　　　　　Different Approaches to AR Games593
　　　AR in Narrative Works .596
　　　Entertainment Experiences Using AR597
　　　Other Ways AR Is Being Employed.598
Mixed Reality. .601
　　　Smale-Scale Works of Mixed Reality601
　　　Mixed Reality in a Military Scenario602
　　　Cultural Institutions: A New Home
　　　　　for Mixed Reality. .603
　　　Ghosts in the Graveyard; Dolphins in the Ocean;
　　　　　Coyotes in the Desert .604
　　　A Virtual Character Appears in Mixed Reality606
　　　Mixed Reality and Entertainment. .608
　　　When Mixed Reality Turns You into a Spy 611
Conclusion. .613
Idea Generating Excercises .613

CHAPTER 18 — Immersive Narratives and Immersive Spaces 615

Immersive Narratives .615
Immersive Theater as a Model. 616
Escape Rooms .618
Immersive and Interactive Theme Park Rides.624
An Other-Worldly Theme Park Experience626
Old and New Settings for Immersive Narratives628
Modern Venues for Narrative Immersion .628
Meow Wolf's Immersive Stories .631
Taking Immersive Narrative to the Extreme.638

Immersive Spaces .. 640
Immersion with Objects and Architectural Elements 640
Immersion through Projections 642
Team Lab and Image-Based Immersion. 644
Conclusion .. 645
Idea-Generating Excercises 645

CHAPTER 19 — Screen-Based Immersion 647

Utilizing Movie Screens for Immersiveness. 647
The Influence of Immersive Theater 648
Large-Screen Immersiveness for Audiences—
 The *4-D Dark Ride*. 650
Single-Participant Large-Screen Immersiveness. 652
Immersive Multiplayer Motion-Sensing Games. 654
Fulldome Productions 658
An Artist's Take on Creating for Fulldome 659
Conclusion .. 661
Idea-Generating Exercises 662

PART 6 Career Considerations

CHAPTER 20 — Working as a Digital Storyteller 665

A New Occupation .. 665
The Life of a Digital Storyteller 667
Selling an Original Idea 669
 Thinking Outside the Box 671
The Different Employment Paths 672
Common Entry Points 674
Working as a Freelancer 675
Legal Considerations 676
Educating Yourself. 680
Industry Events ... 682

The People Connection . 683
Some Pointers for a Career in New Media. 684
Showcasing Your Work: Is It Worthwhile? 685
Considerations in Creating a Professional Showcase. 686
 Portfolio or Single-Piece Approach?. 687
 Distribution Method?. 687
 Subject Matter and Approach?. 688
 Gaps in Necessary Skills? . 689
Odd Todd: A Case Study. 689
 The Hows and Whys of *Odd Todd*. 691
 Keeping Things Going . 692
Some Other Approaches to Showcasing. 694
 Lonely No More. 694
Pointers for Making Your Own Showcase 695

Afterword. 697

Glossary . 699

Additional Readings . 743

Project Index . 749

Subject Index . 757

Foreword

When you're at the start of a long, tricky journey that is full of unknowns, it's smart to have a seasoned guide. And for those brave enough to venture into digital storytelling, you can't do better than Carolyn Handler Miller. Like Carmen Sandiego—which was one of her successful projects while at Brøderbund—she's traveled extensively to every corner of the world of digital media, for our benefit.

Following Carolyn on this journey is worth considering for many reasons. For those with the right mix of vision and persistence, there's a fortune to be made. Consider Walt Disney's exploitation of animation, or Steve Jobs' gamble on Pixar. This is a field that is still young and full of potential.

But caution is essential. As a judge for a digital storytelling award and reviewer of many interactive projects, I've seen plenty of good people make bad products. Going unprepared into the foggy intersection of technology and storytelling can be risky. Yes, a few projects are magic and can win the prize, but most are not and novices make expensive mistakes. That's why I started a conference called Dust or Magic—to help publishers find the magic. That's where I

first met Carolyn. She was working on the first edition of her book where she gave a talk titled "The Seven Kisses of Death."

I instantly took a liking to her clear, unvarnished way of presenting tricky ideas, and I'm so pleased to see how it pours into every page of this book. Unlike the countless experts with advice, she's shipped products on deadline to real clients, while juggling programmers, budgets, and PR. She's tasted success and failure, and knows how hard it is to manage all the variables involved in a digital storytelling project. And she's been doing it since floppy disks flopped.

This perspective is gold for storytellers trying to make it in the crowded app store. Yes, you can get lucky, but chance favors those that prepare. Doing your homework increases your odds.

That's where this book comes in. Now in its fourth edition, the field has grown thicker and includes some recent technologies. You start your journey by unpacking the complex meaning of "digital" and "storytelling" with examples that you can use right away. I was happy to see the inclusion of smart speakers, robots, physical spaces, and mixed reality. The interviews with veteran designers and product case studies help to make it real with answers like "Where do I find a job?" or "How do you prepare a demo?"

Before I run out of my word count, let me leave with one big idea. The simple act of waking up in the morning makes you a pioneer these days, and that's not always easy. We're still very much at the dawn of a young field. There are many stories waiting to be told, in ways that haven't yet been invented. I wish you the best on your journey and hope to someday give you a prize.

Warren Buckleitner

Warren Buckleitner is an educational psychologist who reviews children's interactive media. He's been a preschool, elementary and college teacher (currently an Assistant Professor at TCNJ's Interactive Multimedia department). He is the founding editor of *Children's Technology Review* (www.childrenstech.com). He speaks at education and library conferences and contributes content books and publications, including a decade of children's tech

coverage for the *New York Times*. He holds a degree in elementary education from Central Michigan University (Cum Laude), an MA in early childhood education from Pacific Oaks College, and a doctorate in educational psychology from Michigan State University. He coordinates the KAPi prize at CES and the Bologna Ragazzi Digital Prize at the Bologna Children's Book Fair. In 2000, he started Dust or Magic (www.dustormagic.com) and the Mediatech Foundation (www.mediatech.org), a non-profit community technology center in his town's library. In 2017, he was named a Senior Fellow at the Fred Rogers Center.

Preface

A Fresh Perspective

We are now at the fourth edition of *Digital Storytelling*. It has been 15 years since the first edition was published in 2004, and with the passing of time we can gain a fresh perspective of the field. During the writing of the first edition, it seemed as if the book was covering topics most people were not even aware of. Those of us who were practitioners in the field truly felt like pioneers in a brand-new universe that seemed a little fragile and mysterious. We were also aware that people not in the field looked at us a little strangely, as if we didn't quite fit into the responsible adult world. Who, aside from teenaged kids, were playing video games? Who had ever experienced interactive TV or interactive movies? Virtual reality was just a concept out of science fiction for most people and no one back then had digital assistants like Alexa, let alone could imagine taking part in games and interactive stories that she might host.

Though the first edition did cover subjects like VR, AR, iTV, and iCinema, for the most part they were still in their infancy. Recently, however, we are seeing some promising breakthroughs in these

areas, which we cover in this edition. The new genres of digital storytelling covered in later editions—ones that had not even been born yet in the first edition—included the emergence of smartphones and iPads, transmedia storytelling, the development of life-like androids and virtual characters, interactive documentaries, and the use of social media to tell stories.

It feels like we are in an entirely new place now, where many things that seemed almost unfathomable 15 years ago have become integrated into the everyday world. But we cannot relax and feel we have "conquered" digital storytelling. This is a field that is constantly changing, and if we want to stay a relevant part of the field, we have to stay knowledgeable about what is going on. What new forms of digital media are beginning to emerge or suddenly beginning to flourish? Have any old favorites sadly become obsolete? It is the job of this book to help its readers stay current. In this new edition, I have done my best to include all major new developments in this arena as clearly and completely as possible. But we must be realistic: exciting new works will be produced just after this book goes to print; this in inevitable. Also, I could not include every interesting new project on every topic, or this book would be even larger than it already is.

New to this edition is the blooming of virtual reality, augmented reality, and mixed reality, plus many other forms of immersive experiences; some real breakthroughs in interactive TV; and the growing importance of AI (artificial intelligence). Also new is the phenomenon of voice-activated storytelling. Some topics that were the focus of intense interest by the new-media community during the first editions, like convergence, transmedia, and smartphones, are no longer the shiny new things they once were but are now just an accepted as part of the everyday digital media world.

As in the three earlier editions, the focus here is on storytelling, not on the technology. I have discussed the technology only to the degree that such a discussion can be used to clarify how a particular technology can be used for storytelling purposes. I leave it to others to delve deeply into the technological aspects of this field. While I fully acknowledge that the technology is important, major discussions of it are beyond the scope of this book.

Preface **xxxi**

In this new edition, as in the earlier ones, I have instead focused on the areas where I have the most expertise, which is in storytelling and in creating interactive digital media projects. Thus, I have covered storytelling essentials: character development, plot, emotion, and structure. And I have also focused on the impact of interactivity on narrative, and the way it can change everything about classic storytelling.

One interesting observation I made in preparing this new edition is the fact that many recent projects defy neat categorization. For example, a single project may be a work of VR and simultaneously be a piece of interactive cinema, or it might be a 4-D dark ride, a game, and a work of transmedia storytelling. In this new edition, it became increasingly challenging to slot projects into specific chapters; genres are intermingling in unexpected ways.

Kamal Sinclair, director of the Sundance Film Festival's New Frontier Lab, had a perceptive comment to make about this type of intermingling. He said: "I think there is some [kind of] crossover between these mediums. Between gaming and interactive, immersive theater and escape rooms—all of it. You basically are designing for a generation of people that have grown up on the Internet, which is a very different audience than those that came from linear and passive media. You're designing for a generation that has a complete expectation of agency as a native and organic way of interacting with content and story" (as quoted in *The Verge*, February 7, 2017).

Perhaps we are looking towards a world where all forms of digital media will be interconnected. If this becomes the norm, labeling them by the platform they live on will no longer make sense. The one thing we can count on is that significant changes will continue to take place in this field and that it will be exciting to see the new kinds of stories that emerge. While some of these changes may be predictable, many will not be.

Defining Digital Storytelling

It should be noted that people use a variety of definitions for "digital storytelling." The way we use it in this book is this: digital storytelling is the use of digital media platforms and interactivity for narrative purposes, either for fictional or for non-fiction stories. Under

this definition, we include everything from video games to smart toys to virtual reality, to immersive journalism, and a number of other story forms as well.

Quite often the projects highlighted in his book have been produced by a professional team, and with the expectation that the work would be seen by a large audience and in the hopes that there would be some financial compensation for producing it. While a great many of these works are made for entertainment purposes, others are made to train, to promote, to educate, and to inform. But even when employed for pragmatic purposes, these works always contain elements of storytelling.

In educational and community spaces, however, "digital storytelling" is used to mean the employment of still images and a recorded script, and possibly some video or animation, to tell personal stories or stories relating to an element in the curriculum or of interest to the community. Often children are given the opportunity to create these stories to teach them narrative skills and to excite them about learning. In the anthropological field, "digital storytelling" is used as a way to preserve stories of a culture or historic period that might otherwise be forgotten.

In journalism, the term is used to indicate a true story that is told via multiple media, such as audio, text, video, and still images. In the last several years, we have seen a significant growth in interactive documentaries, and some of these have been made for prestigious institutions like the *New York Times* and the John F. Kennedy Presidential Library and Museum.

Although these definitions and intentions differ, they all do have some critical elements in common: they are narratives, they employ digital media, and they are meant to be engaging.

The Organization of This Edition

This edition is organized much like previous editions by dividing the book into several large sections. In previous editions there were only five sections but now there are six. One hefty brand-new section is devoted to immersive experiences—works that include AR, VR, and mixed reality, as well as immersive screen-based works and various other types of immersive experiences, like stories embedded

in physical spaces and immersive theme park rides. Also, some new chapters have been added and several chapters have been merged. The six large divisions used in this edition include:

Part 1: New Technologies, New Creative Opportunities

This section covers the history and development of digital storytelling, and also offers an overview of what is new in the field.

Part 2: Creating Story-Rich Projects

This section examines the fundamentals of storytelling (such as plots, character development, emotional content, and structure) and how they are impacted by interactivity. It also investigates important developmental considerations like one's audience, the use of social media, and the steps that one can take to make the production process as smooth as possible.

Part 3: Harnessing Digital Storytelling for Pragmatic Goals

This section discusses how digital storytelling can be used in education and training, in promotion, and for informational purposes.

Part 4: Media and Models: Under the Hood

The chapters in this section delve into specific forms of digital storytelling, including video games, projects for the Web, and mobile devices, interactive cinema and TV, smart toys, and life-like robots. These chapters offer case studies of successful projects and interviews with experts. Several projects that did not flourish are also examined, along with the reasons for their lack of success. This is done in the belief that one can learn as much from failures as from successes.

Part 5: Immersive Media

This section consists of four chapters, which include discussions of the various types of projects made for immersive media. These include stories embedded in a physical space; escape rooms; screen-based works of immersiveness where visitors are surrounded by images; and XR, which is a term covering virtual reality, augmented reality, and mixed reality.

Part 6: Career Considerations
This section is devoted to questions that must be answered if one wishes to work in the digital storytelling field or wishes to sustain a successful career in this arena. Should one create a showcase? What are the different ways of working in this field and what are the advantages and disadvantages of each? What legal matters should you be aware of?

Each chapter in this book opens with a series of thought-provoking questions relating to the contents of the chapter. Most chapters close with several "idea-generating exercises." These exercises give you, the reader, the opportunity to try out the concepts discussed in the chapter and to stretch your imagination. The chapter in Part 6 contains practical suggestions and tips instead of exercises, a better fit for this section.

Sources and Perspective

The material in this edition, as with the first three editions of the book, is based in part on interviews conducted with practitioners and experts in the field of digital storytelling. About one dozen new interviews were done for this edition. The book also retains many of the highlights of interviews done for the older editions, so, in a sense, it is a compendium of wisdom from the field. Much of the information offered in this edition is supported or filled out by facts or opinions found in blogs, magazines, surveys, and publications dedicated to various aspects of digital media. The sources of this information are given in the text, after the relevant content, rather than in footnotes, which many readers find distracting.

In addition to information from experts and from printed sources, some of the content here is based on my own professional experience in the field. My personal perspective is that of a writer and a storyteller, a person on the creative side of this field, and that perspective also forms the thrust of this book. In addition, much of the content is based on many hours of playing games and exploring various works of digital storytelling, which is the great pleasure of writing a book like this.

The majority of information contained in this edition relates to projects or developments that had not yet seen the light of day when the last edition was published. In addition, some solid examples of digital storytelling from the first three editions have been retained, because these projects broke new ground and are still highly useful as models.

Additional Resources

The field of digital storytelling moves so quickly that it is inevitable that even a brand-new edition of this subject will not be able to contain everything that is new and worth noting. Whenever possible, I have offered up specific sources of information that will enable the reader to stay current, including online publications and the websites of important trade groups and organizations. I have worked hard to bring this edition up to date and even project into the future, but ultimately you, the reader, must take on the responsibility to carry on where I have had to leave off and make your own discoveries.

I welcome your questions and comments. These may be sent to me at carolynhandlermiller@gmail.com.

Acknowledgments

In writing the fourth edition of *Digital Storytelling*, I received invaluable help from a number of individuals. First and foremost, they include the experts in a variety of fields who allowed me to interview them and pick their brains. They were extremely generous with their time and their ideas, and this book would not be what it is without their contributions. Unfortunately, space does not allow me to list them all by name, but they are acknowledged in the sections of the book where they are quoted.

In addition, I would like to thank my editor, Sean Connelly, who encouraged me to write this edition and helped with its organization. I also want to give a heartfelt thank you to Jessica Vega, Senior Editorial Assistant, who was always ready to deal with my numerous questions and who promptly sent me the answers. She was a wonderful shoulder to lean on. And I offer a special thank you to John Gandour, who designed the exciting cover for the book. It perfectly captures the magic of digital storytelling.

My technical advisor, Greg Roach, went over every word of every chapter and kindly pointed out sentences that were not quite accurate and spurred me to update my statistics and other information. It

meant more work for me, but he wouldn't let me get away with being lazy and my book benefited enormously from his comments. I am always amazed at how much Greg knows—the breadth of his knowledge is staggering. I always looked forward to reading his excellent notes.

I would also like to acknowledge my literary agent, Susan Crawford, who has been wonderfully level-headed and an enormous help in getting this edition nailed down properly. As always, she has been a pleasure to work with.

In addition, I would like to thank the students I have taught over the years at the University of New Mexico and the Santa Fe Community College for their thought-provoking questions and comments. In a similar fashion, I would like to thank the people who have come to my talks. As always, I feel I learn more from my students and my audience than they learn from me!

And here is a huge thank you to my husband, Terry Borst, who would chew over topics in this book with me and be my companion during my forays into virtual reality. Moreover, he would cook our dinner while I was working on the book and helpfully send me articles relating to digital storytelling. I am forever grateful to him for rescuing me from hysteria when my computer was infected with a virus just as I was staring at the deadline for this book. He found a way to disarm the virus, unlock my computer, and calm me down so I could get back to work.

And one last thank you goes to my two donkeys, Minnie and Pearl, who cheered me up when the going got rough and refreshed my mind when it was bogged down with a heavy load of digital storytelling material. Though they no longer live with me, I do get to visit them, and the memory of our times together always makes me smile.

Part 1
New Technologies, New Creative Opportunities

Part 1

New Technologies,
New Creative
Opportunities

Chapter 1
Storytelling, Old and New

In what ways is digital storytelling like traditional forms of storytelling and in what ways is it quite unique?

Which ancient human activities can be thought of as the precursors of digital storytelling, and what can we learn from them?

What are the similarities between athletic games and digital storytelling, and why are they important?

Are there any ideas that we can find in classic literature, movies, and theatrical works that may have influenced digital storytelling?

Storytelling: An Ancient Human Activity

Storytelling is a magical and powerful craft. Not only can it transport the audience on a thrilling journey into an imaginary world, but it can also reveal the dark secrets of human behavior or inspire the audience with the desire to do noble deeds. Storytelling can

also be pressed into service for other human goals: to teach and train young people, for example, or to convey spiritual concepts or important information. Older forms of storytelling were done as stone carvings, paintings on vases, and told orally by master storytellers (see Figure 1.1). Although digital storytelling is humankind's newest way to enjoy narrative entertainment, it is part of this same great tradition.

Digital storytelling is narrative material that reaches its audience via digital technology and media. One of its unique hallmarks is *interactivity*—back-and-forth communications between the audience and the narrative material. Digital storytelling is a vast field. It includes video games, content designed for the Internet, mobile apps, social media, interactive cinema, virtual reality, augmented reality, and even intelligent toy systems and electronic kiosks—at least one dozen major and very different genres in all. Almost every genre of digital storytelling includes multiple sub-genres, as well.

On the vast timetable of human achievements, this type of storytelling is a mere infant, only coming into being in the mid-twentieth century with the development of computer

FIGURE 1.1 Ancient Greeks painted stories of their mythology on vases, as on this painting (ca 500 BC), portraying their god, Dionysus. He was the deity of the grape harvest, wine, festivities, and theatre. Note the images of grapevines and clusters of grapes in the decoration. Photograph by Maria Daniels, courtesy of University Museums, University of Mississippi.

technology. As to be expected with something so young, it is still growing and evolving. Each new development in digital media—broadband, wireless signals, mobile apps, touch screens, virtual reality—sees a corresponding development in digital storytelling.

The biggest difference between traditional types of narratives and digital storytelling is that the content of traditional narratives is in an *analog* form, whereas the content in digital storytelling comes to us in a *digitalized* form. Digital data is made up of distinct, separate bits: the zeroes and ones that feed our computers. Analog information, on the other hand, is continuous and unbroken—a continual stream of information. The oldest stories were conveyed by the human voice and actors; later, narratives were printed on paper; more recently, they were recorded on audiotape, film, or video. All these older forms are analog.

To distinguish between these older forms of content and the computerized forms, people coined the terms "new media" and "emergent media." These newer forms of media content include the words and images we see on our computer screens; material that comes to us on DVDs and other discs; via streaming audio and video; and on our video game consoles, mobile phones, and tablets. All of these forms are digital. The difference between analog and digital can easily be seen by comparing an analog clock to a digital clock. An analog clock displays time in a smooth sweep around the dial, while a digital clock displays time in specific numerical increments of hours, minutes, and seconds.

Digital information can be stored easily, accessed quickly, and transferred among a great variety of devices. It can also be readily reassembled in an almost infinite number of ways, and thus becomes a viable form of content for interactivity. The digitizing of content—along with digital delivery systems—is what makes digital storytelling possible.

Yet, as new as digital storytelling is, it is part of a human tradition that stretches back to preliterate times. Furthermore, it has much in common with other forms of narrative—theatrical performances, novels, movies, and so on. (A narrative is

simply an account of events which are interesting or exciting in some way; the word is often used interchangeably with "story.") In essence, all stories have the same basic components. They portray characters caught up in a dramatic situation, depicting events from the inception of the drama to its conclusion. "Story," of course, does not necessarily mean a work of fiction, something that is make-believe. Descriptions of things that happen in real life can be stories, too, as long as they are narrated in a dramatic manner and contain characters. Newspapers and TV news shows are major vehicles for non-fiction stories. And documentaries, which are long-form explorations of true events, are also stories.

Scientists believe that storytelling can be traced back to sometime in the Pleistocene Age (1.8 million to about 11,000 years ago) and was developed as a critical survival tool. Manuel Molles, Professor Emeritus of Biology at the University of New Mexico, theorizes that storytelling was used to communicate important information about the environment, behavior of wildlife, and availability of food (from his paper "An Ecological Synthesis: Something Old, Something New," delivered at a 2005 ecology conference in Barcelona).

Dr. Dan Schwarz, a professor of English at Cornell University, also believes that storytelling shapes a basic human need. He stated in a recent interview that it was his bedrock belief "that humans are defined in part by an urge for narratives that give shape and form to their experience" (*English at Cornell*, Vol. 13).

Storytelling is such a powerful craft that telling the wrong story can even get you killed. Jeff Gomez, CEO of Starlight Runner Entertainment, a transmedia production company, commented to me in an email interview: "When you think about it, many have been killed throughout history for articulating narratives out of sync with popular notions. Shamans, spiritualists and others have historically been accused of witchcraft and sorcery, targeting them for death." To back up his point, Gomez sent me a link to an article published in the *Peruvian Times* (October 5, 2011), reporting that as recently as 2011, 14 shamans had been murdered in Peru over a 20-month period.

> **EXPERT OBSERVATIONS: HUMANS HARD-WIRED TO TELL STORIES?**
>
> Dr. Daniel Povinelli, a psychologist from the University of Louisiana, has made some interesting observations about the origins of storytelling. Dr. Povinelli, who studies the differences between the intellect of humans and apes, feels our species has an inborn impulse to connect the past, present, and future, and in doing so, to construct narratives. As reported in the *Los Angeles Times* (June 2, 2002), Dr. Povinelli feels this ability gives us humans a unique advantage. For example, it enables us to foresee future events based on what has happened in the past; it gives us the ability to strategize; and helps us understand our fellow human beings and behave in a way that is advantageous to us.

In essence, stories help give meaning to the world around us and help us negotiate our world. They put events or characters into context and aid us in retaining important details.

Interactivity and Storytelling

One major aspect of digital storytelling that distinguishes it from classical storytelling is that members of the audience can become active players in the narrative and even have a direct impact on it. Surprising as it may seem, however, interactive narrative experiences like this existed long before the invention of computers.

Some professionals in interactive media hypothesize that the earliest forms of interactive storytelling took place around the campfires of prehistoric peoples. I can remember this theory being enthusiastically touted back in the early 1990s, when the creative community in Hollywood was first becoming excited about the potential of interactive media. At almost every conference I attended at the time, at least one speaker would allude to these long-ago campfire scenes. The prehistoric storyteller, according to this theory, would have a general idea of the tale he planned to tell, but not a fixed plot. Instead, he would shape and mold the story according to the reactions of those gathered around him.

This model evokes an inviting image of a warm, crackling fire and comfortable conviviality. It was no doubt a reassuring scenario to attendees of these first interactive media conferences, many of whom were intimidated by computers and the concept of interactive media. But to me, this model never sounded particularly convincing. For one thing, how could anyone really know what took place around those smoky old campfires? And even if it were true that ancient storytellers constructed their tales to fit the interests of their listeners, how much actual control or participation in the story could these campfire audiences have had? At best, it would have been an extremely weak form of interactivity.

But no matter what one thinks of this campfire model, it is unquestionably true that a form of interactive storytelling—a far more profound and participatory form—dates back to extremely ancient times. According to the renowned scholar Joseph Campbell (1904–1987), one of the earliest forms of story was the myth, and storytellers did not merely recite these old tales. Instead, the entire community would reenact them, in the form of religious rituals.

Participatory Dramas

These ancient reenactments of myths described by Campbell were a form of participatory drama. He and other scholars in the field have observed that the myths acted out by a community generally contained deep psychological underpinnings, and that one of their most common themes was death and rebirth. Campbell noted that participants who took part in myth-based rituals often found the experience so intense that they would undergo a catharsis, a profound sense of emotional relief. (The word catharsis comes from the Greek *katharsis*, and means purgation, or purification.)

In agrarian communities, these rituals would often commemorate the death of the earth (winter) and its joyous rebirth (spring). One such ritual, well known to scholars of Greek drama, was called the Festival of Dionysus. Celebrated twice annually throughout ancient Greece, these festivals were a ritual retelling of the myth of Dionysus, the Greek god of wine and fertility (see Figure 1.1). They not only depicted important events in the deity's life, but were also closely connected to the cycle of seasons, particularly

the death and rebirth of the grapevine, a plant closely associated with Dionysus.

While some details of the Dionysian rituals have been lost over time, a fair amount is still known about them. They involved singing and dancing and the playing of musical instruments. The male participants would dress as satyrs, drunken creatures who were half man and half goat (the goat being one of the animal forms associated with the god), while the women would play the part of maenads, the god's frenzied female attendants.

Mythological Symbolism and Digital Storytelling

The Greeks were by no means the only ancient community to reenact its myths in dramatic performances. The ancient Egyptians also held religious rituals based on their mythology. Over time, they evolved into staged performances, with actors playing the role of various gods. These early forms of drama actually pre-dated Greek theater. Campbell asserts that the reenactment of myths was a common element of all preliterate societies. Even today, in regions where old traditions have not been erased by modern influences, isolated societies continue to perform ceremonies rich in mythological symbolism.

One such group is the Dogon people of Mali, West Africa, who live in clay dwellings tucked into the steep cliffs of the Bandiagara Escarpment, not far from the Sahara Desert. Because this region is so remote and relatively inaccessible, the Dogon have managed to preserve their ancient traditions and spiritual practices to this day. Many of the Dogon's beliefs are reenacted in elaborate dance ceremonies, during which participants don masks and full body costumes. Unlike dancers in Western culture, where troupes are made up of a select few talented individuals who perform for an audience of nonparticipants, in Dogon society, every member of the community takes part in the dances put on by their clan.

One of the most dramatic of these ceremonies is the Sigui dance, which takes place just once every 60 years. It contains many of the elements Joseph Campbell noted as being customary in important

ritualistic ceremonies, such as a representation of death and a rebirth. In this case, the Sigui dance symbolizes the passing of the older generation and the rebirth of the Dogon people.

Each dancer plays a highly symbolic and specific role. Their masks and costumes represent important animals, ancestors, and spirit figures in their belief system (see Figure 1.2). A number dance on stilts, making them as tall as giants.

In the eyes of the community, the dancers are more than mere human beings; each is an *avatar* for a mythological being or spirit—the embodiment or incarnation of an entity who is not actually present. The concept of the avatar is an important one in digital storytelling. In video games, for example, the player moves through the game as the protagonist, and an avatar in the

FIGURE 1.2 The Dogan dancer on stilts represents a female *tinge-tange*, or water bird. Dogan dancers don masks and costumes to portray mythological beings or spiritual figures much in the same way as game players control avatars in digital dramas and games. Photograph courtesy of Stephenie Hollyman.

game represents the player. In other words, the avatar is the "stand in" for the player. In many games, players can design their own avatars. Avatars are also employed in virtual worlds and in some digital dramas.

> A student of mine who lived on the Navajo Nation recalls another example of a participatory drama that was reenacted every fall by the Apaches. He told me: I'd always be afraid of the 'Apache dancers.' They danced around with sticks and have their faces covered with black cloths with their bodies all painted in black. They looked like a nightmare coming into reality and once I'd hear those bells on their ankles jiggling I'd be the first running behind my parent to hide. Trust me, there is a reason. The dancers would stop in front of a crowd and go out and grab people to dance with them or have them participate in the story they were performing.

Odd though it may seem, the rituals performed by the Apaches, the Dogons, and the ancient Greeks have a great deal in common with modern-day digital storytelling. After all, they involve the use of avatars; they are a form of role-play; participants interact with each other and work toward accomplishing a particular goal; and they play out scenes that can be highly dramatic and even have life-and-death significance. To me, these ritual reenactments are a far more intriguing model of interactivity than that of the old campfire stories.

Familiar Rituals and Digital Storytelling

Closer to home, and to our own lives, we can examine our own holidays and traditional religious practices and discover other surprising similarities to digital storytelling. These celebrations are often forms of participatory drama and contain items of important symbolic or spiritual value, just as works of digital storytelling do. And in some cases, they are also *multi-sensory*. In other words, they involve the senses in a variety of ways.

The Jewish holiday of Passover is a particularly good example of this. Passover commemorates the exodus of Jews from Egypt and their liberation from the slavery imposed on them by the

Pharaoh. The traditional way to observe Passover is at a ceremonial meal called the Seder, where the dramatic story of exodus is recounted, and is recreated by the symbolic foods that are part of the ritual.

For example, one eats a flat unleavened bread called *matzo*, which recalls the bread hurriedly baked during the exodus, when the escaping Jews had no time to let their bread rise. Another special Seder food is a bitter herb called *maror* (customarily horseradish), which symbolizes the bitterness of slavery. It is eaten together with *charoset*, a sweet chopped mixture of apples, nuts, and spices, which represents the mortar the Jews used to build the pyramids and also hints at the sweetness of freedom to come. These are among the many symbolic foods eaten during the ritual. Many forms of digital storytelling are multi-sensory in this way, involving tactile feedback, aromas, motion, and other stimuli. The Christian ritual of communion, also known as the Eucharist and the Lord's Supper, is also multi-sensory and contains symbolic associations. The wine one drinks represents the blood of Christ, and the Communion wafer one swallows represents His body. The addition of multi-sensory components adds to the immersiveness and emotional power of works of digital storytelling.

STRANGE BUT TRUE: HALLOWEEN AND DIGITAL STORYTELLING

Our yearly celebration of Halloween is just one of many Western holidays that bear some surprising similarities to digital storytelling. This holiday originated as a Celtic celebration called *Samhain*, and it marked the end of summer and the beginning of the dark half of the year. It was considered a time when the spirits of the dead might return and interact with those who were still living. Again, we have the recurring theme of death and rebirth found in so many other rituals. And though we might not be aware of what the holiday symbolized to ancient Celts, Halloween still retains reminders of death (skulls, skeletons, gravestones) and of the supernatural (ghosts, witches on broomsticks, zombies). In many respects, this holiday resembles the Mexican holiday of Día de los Muertos (Day of the Dead).

> One of the most alluring aspects of Halloween is, of course, the opportunity to wear a costume. Just as in works of digital storytelling, we can take on a new role and "be" something we are not in real life. Halloween also gives us a chance to transition into a world that is quite different from our ordinary reality, a world filled with magic and the supernatural and spooky reminders of the afterlife. This ability to get a taste of another reality is something else we can do, thanks to digital storytelling.

Rites of Passage and Digital Storytelling

Joseph Campbell, the scholar who did groundbreaking work on mythology, also noted that traditional myth-based rituals frequently reflected major life passages, such as a coming of age for young boys and girls. According to Campbell, the ceremonies held for boys typically required them to undergo a terrifying ordeal, during which they would "die" as a child and be reborn as an adult. Girls also went through coming-of-age ceremonies, he found, though they tended to be less traumatic.

Campbell discovered that cultures all over the world and across all cultures told myths about this universal coming-of-age experience, a type of mythology he analyzed in 1949 in his seminal work, *The Hero with a Thousand Faces*. This genre of myth is often referred to as "the hero's journey." As we will see in Chapter 5, its core elements and recurring characters have been incorporated into many popular movies and, most importantly for us, the hero's journey has also served as a model for innumerable works of digital storytelling, particularly video games.

Games and Digital Storytelling

We can look back at a very different type of human activity and find another important precursor to digital storytelling: the playing of athletic games. As we will see later in this book, many works of digital storytelling are either full-fledged games or include

game-like elements. And like rituals, games date back to ancient times and once served important functions.

The earliest games were developed not for idle amusement but for serious purposes: often to prepare young men for the hunt and for warfare. By taking part in games, the youths would strengthen their bodies and develop athletic skills like running and throwing. By playing with teammates, they would also learn how to coordinate maneuvers and how to strategize. Over time, these athletic games evolved into formal competitions. Undoubtedly, the best known of these ancient sporting events are the Greek Olympic Games. We can trace the Olympic Games back to 776 BC, and we know they continued to be held for more than 1,000 years.

Athletic competitions were also held in ancient Rome, India, and Egypt. In many old societies, these competitions served a religious function as well as being a form of popular entertainment. In Greece, for example, the games were dedicated to the god Zeus, and the athletic part of the program was preceded by sacred religious rites.

Religion and sporting games were even more intricately mixed in the part of the world that is now Mexico and Central America. The Olmecs, Mayans, and other peoples throughout Mesoamerica played a ball game somewhat like basketball. We now know this Mesoamerican ball game had great spiritual and symbolic significance to them, and was a central ritual in their culture. The game served as a conduit to the gods they believed dwelt beneath the earth and was a way of communicating with divine powers.

The game was played by two competing teams in an outdoor court marked by a set of high parallel walls. The players had to keep the ball in the air, and could use any part of their body to do this except for their hands. As in a modern ball game, the two teams vied to lob the ball into a specific target to make a goal; in this case the target was a high stone ring. However, unlike modern ball games, once a goal was scored, the game ended, and so did the life of at least one of the players. Scholars still are debating whether this fate fell to the captain of the winning team or the losing team. They do agree, however, that the leader of one of the teams was ritually executed by decapitation,

and that this action was meant as a religious sacrifice, to please their gods. Some cultures that played the game believed that the blood of the victim would fertilize their corn, and ensure a good crop of their most important food. Visitors to the excavated ball court at Chichén Itzá, in Mexico's Yucatan Peninsula, can still see a stone relief depicting the decapitation ceremony (see Figure 1.3).

Over 1,500 years ago, all the way across the ocean, in Asia, players faced each other in another athletic competition with deep spiritual significance. In this case, the country was Japan and the game was sumo. Sumo is closely tied to Japan's Shinto religion, and it symbolizes a legendary bout between two gods, a contest upon which the fate of the Japanese people rested. The Japanese emperor himself is believed to be a descendant of the victor. As different as sumo and the Mesoamerican ball games are, they both illustrate that games can have intensely meaningful significance. The same can be true for the games found in works of digital storytelling, where game and narrative can be closely interconnected, and where the players can be deeply invested in achieving a positive outcome.

FIGURE 1.3 This carving at Chichén Itzá of a postgame decapitation ceremony illustrates that games can play a deadly serious role in the spiritual life of a culture. The circle in the carving represents the ball, and the figure inside the ball is the skull of the decapitated player. Photograph courtesy of E. Michael Whittington, Mint Museum of Art, Charlotte, North Carolina.

Ancient Games and Digital Storytelling

The sporting competitions that have come down to us from ancient times were inherently dramatic. Two opponents or two teams were pitted against each other, each attempting to achieve a victorious outcome for their side and to defeat their opponents. These old games contained many of the key elements that continue to be hallmarks of today's athletic games. Furthermore, they are also the distinguishing characteristics of the gameplay found in many works of digital storytelling. Sporting competitions as well as many works of digital storytelling are:

- Dramatic and exciting
- Full of action
- Intensely competitive
- Demanding of one's skills, either physical or mental
- Regulated by specific rules
- Clearly structured, with an established way of beginning and ending
- Played to achieve a clear-cut goal; in other words, to succeed at winning, and to avoid losing

Board Games and Digital Storytelling

Athletic competitions are not the only type of game that has come to us from ancient times and that have strong similarities to many works of digital storytelling.

Board games dating back to 2700 BC have been found in the temples of the Egyptian pharaohs. They were also highly popular in ancient China, Japan, and Korea; and the people of India played chess and card games thousands of years ago. According to mythologist Pamela Jaye Smith of MYTHWORKS, some board games were used in ancient and premodern times to train players in strategy and diplomatic skills. She cites chess as a prime example of this, saying they called for "the need to analyze the other player's move, to think three, four or more moves down the line, to recognize feint, and to know when and how to make sacrifices." The ancient Chinese board game of Go is another game that demands strategic skills.

Another type of game, distantly related to board games, are tabletop war games. The earliest forms of such games were

Storytelling, Old and New 17

FIGURE 1.4 War game simulations played with miniature soldiers like these were the precursors of today's massively multiplayer online games (MMOGs). Photograph courtesy of Lloyd Pentacost.

war-game simulations developed in the eighteenth and nineteenth centuries. These games were used to train officers in strategy, and were typically played on tabletops with miniature soldiers made of metal (see Figure 1.4). In the latter part of the twentieth century, games like these, married to elements of improvisational theater, morphed into computerized role-playing games.

Many board games involve a mixture of skill and luck, and the element of chance is one of the things that makes them particularly enjoyable. The draw of a wild card or the throw of the dice can dramatically change one's fortunes. Also, many people are attracted to board games primarily because of the social interactions that are a major part of the experience. And although board games can be competitive, they offer a safer, less stressful playing environment than athletic games. And these are all features that attract players to works of digital storytelling, as well.

Children's Games and the "Fun Factor"

In addition to the structured games played by adults, children in every era and every culture have played games of all sorts. Many of

them are more free-flowing and less formalized than adult games. Children's pastimes range from "quest" games like hide-and-seek, to games that are more social in nature, like jump rope, to games of skill, like jacks. Children also enjoy make-believe activities like fantasy role-play. Two old favorites, for example, are cowboys and Indians and cops and robbers.

Fantasy Role-Play for Adults

Even adults engage in fantasy role-playing activities, as evidenced by the popular Renaissance Faires, which are elaborate reconstructions of Elizabethan England, complete with jousting, a royal court, and someone playing the part of Queen Elizabeth I. Many attendees come to these faires dressed in period costumes and attempt to speak in Elizabethan English.

In the Spanish-speaking world, *Moros y Cristianos* (Moors and Christians) is another immensely popular variation of adult role-play. In these spectacular recreations of long-ago martial conflicts, participants garb themselves in medieval dress and take on the part of either Moors or Christians. Over several days, they parade through the streets and fight non-lethal battles. In some of these recreations, the Christians are riding horses and the Moors are atop camels or elephants.

For the most part, fantasy role-play activities are not strictly games, because they are not competitive in nature. They also don't follow a fixed set of rules or have a clear-cut end goal. But though they differ from more formalized games, the two pursuits have an important element in common: both activities are experienced as "play." In other words, people engage in these activities for pleasure, and they perceive them as fun.

Yet fantasy role-play is also an important part of the *Dungeons and Dragons* series of games, one of the most popular and best-selling role-playing games of all time. David Arneson, the co-creator of *Dungeons and Dragons* (along with Gary Gygax), originated many of the key concepts of role-playing games, such as the hero gaining power through his adventures. After his untimely passing in 2009, his daughter issued a statement saying: "The biggest

thing about my dad's world is he wanted people to have fun in life" (*Minneapolis Star Tribune*, 10, 2009).

The expectation of having fun is one of the primary reasons that both adults and children have traditionally engaged in games and other play activities. This continues to be true in contemporary society, even when the playing is done on game consoles or computers instead of on a ball field or in a schoolyard. The importance of this fun factor was underscored in a survey conducted a few years back by the Entertainment Software Association, a professional organization for publishers of interactive games. In the survey, game players were asked to name their top reason for playing games. Over 85 percent said they played games because they were fun.

Nonlinear Fiction before the Computer

Traditional entertainment, especially material that is story based, is almost always *linear*. In other words, one event follows another in a logical, fixed, and progressive sequence. The structural path is a single straight line. Interactive works, on the other hand, are typically *nonlinear*. Plot points do not necessarily follow each other in fixed sequence, and even when interactive works do include a central storyline, players or users can weave a varied path through the material, interacting with it in a highly fluid manner.

Nevertheless, a few innovative individuals working in long-established media—printed fiction, the theater, and more recently in motion pictures—have attempted to break free of the restrictions of linearity and have experimented with other ways of presenting story-based material.

One of the first was Laurence Sterne, author of the novel *The Life and Opinions of Tristram Shandy, Gentleman*. The nine-volume work was published between 1759 and 1766, not long after the first English novels were introduced to the public. In *Tristram Shandy*, Sterne employs a variety of unconventional ways of presenting the narrative flow, starting down one story-path only to suddenly switch over to an entirely different one, and then a short

while later turning down still another path. He also played with the sequence of chapters, taking chapters that had allegedly been misplaced and inserting them seemingly at random into the text. Sterne asserted that such unexpected narrative digressions were the "sunshine" of a novel and gave a book life.

Several mid-twentieth-century authors also experimented with nonlinear narrative. William Burroughs caused something of a sensation when he introduced his "cut up" works, in which he took text that he had cut into fragments and reassembled it in a different order. He believed that these rearrangements enabled new meanings to emerge. His technique was akin to the making of collages in the art world—works composed of bits of assorted materials.

As for the brilliant modern author James Joyce, many now consider his novels to be a precursor of *digital hypertext*, where words are linked to other related "assets," such as photographs, sounds, video, or other text. The user who takes advantage of these links is rewarded by a deeper experience than would have been possible by following a simple linear thread. Joyce, particularly in his sweeping novels *Ulysses* and *Finnegans Wake*, used a similar technique of associations, allusions, word pictures, and auditory simulations, though all on paper and within the covers of his novels. Entire websites are now devoted to the topic of the hypertext aspects of Joyce's work.

Joyce died in 1941, long before the development of modern computers, but contemporary writers are now using digital technology to compose short stories and novels utilizing hypertext. Their works are available online, and electronic books are published by several companies. Most prominent among them is Eastgate, an evangelist for serious works of hypertext.

But dropping back for a moment to books that are printed the old-fashioned way, on paper, another example of interactive narrative should be mentioned: a series of books introduced in 1979. Going under the general heading of *Choose Your Own Adventure*, and primarily written for the children's market, these unusual books actually presented a form of interactive fiction. At various points in the novel, the narrative would pause and the reader would be offered a number of different ways to advance the story,

along with the page number where each option could be found. Many of these books offered dozens of alternate endings. Do these novels sound a little like works of digital storytelling with branching storylines? Well, not surprisingly, this type of structure has been used in many interactive narratives, as we will see.

Nonlinear Drama in Theater and Motion Pictures

Writers and directors of plays and motion pictures have also experimented with nonlinear methods of telling stories. The Italian playwright Luigi Pirandello (1867–1936) wrote a number of plays that probed the line between reality and fiction. His plays deliberately broke the *fourth wall*, the invisible boundary that separates the audience from the characters on stage, and divides reality (the audience side) from fiction (the characters' side). In his play *Six Characters in Search of an Author*, Pirandello breached the wall by having actors in an uncompleted play talk and refer to themselves as if they were real people. They fretted about the need to find a playwright to "complete" their plot lines, or lives. Pirandello won the Nobel Prize in literature in 1934 for his groundbreaking work, and his dramas influenced a number of other playwrights, including Samuel Beckett and Edward Albee.

Pirandello's boldness at smashing the fourth wall is also echoed in Woody Allen's film, *The Purple Rose of Cairo*. In this picture, Mia Farrow plays the part of a woebegone filmgoer with a passionate crush on a character in a movie (played by Jeff Daniels). Much to her astonishment and delight, her film hero speaks to her as she sits in the audience watching the movie, and even steps out of the screen and into her life.

This breaking of the fourth wall, while relatively unusual in the theater and in movies, is a common occurrence in interactive media. Video game characters address us directly and invite us into their cyber worlds; fictional characters in Web-based stories and games send us emails and faxes and even engage in instant messaging with us; smart toys joke with us and remember our birthdays. This tunneling through of the fourth wall intimately

connects us with a fictional universe in a way that is far more personal than was ever possible in older media.

Another revolutionary technique that first appeared in theater and films, and was later employed more fully in interactive entertainment, is the use of multiple pathways or points of view. The play *Tamara*, written by John Krizanc, utilized a multiple pathway structure, and it created quite a stir in Los Angeles in the 1990s. Instead of being performed in a theater, *Tamara* was staged in a large mansion, and multiple scenes were performed simultaneously in various rooms. Members of the audience had to choose which scenes to watch (which they did by following characters from room to room); it was impossible to view everything that was going on during a single performance.

A more recent nonlinear theatrical work, *Sleep No More*, like *Tamara*, was also meant to be experienced by moving from room to room and floor by floor. The work, loosely based on Shakespeare's *Macbeth*, was created by Punchdrunk, a British theatre company. It was set in the fictitious abandoned McKittrick Hotel (actually three adjoining warehouses in Manhattan, dressed to look like a luxurious 1930s hotel), and performed primarily without dialogue. As with *Tamara*, much of the action occurred simultaneously in various rooms, so it was impossible to experience every scene. Members of the audience were instructed not to talk to each other, and everyone was required to wear a mask. No two people experienced *Sleep No More* in exactly the same way, and it was thus up to each member of the audience to piece together his or her own version of the narrative. *Sleep No More* opened in 2011 and is still running, with earlier productions in London and in Brookline, Massachusetts.

Writers and directors of feature films have also experimented with narrative perspective. One notable example is the Japanese film *Rashomon*, made in 1950 by the renowned director-screenwriter Akira Kurosawa. *Rashomon* is the story of a woman's rape and a man's murder, but what made the film so striking was not its core story but Kurosawa's use of multiple points of view. The story is told in flashback by four different characters, each of whom was a witness to the crimes, but each giving a different version of what really happened. In the end, we are not told which the "correct"

version is; we are left to puzzle out which person's perspective is the most plausible. Kurosawa's concept of offering multiple points of view has been borrowed by a number of works of interactive cinema, as we will see later in this book.

TV series like *Game of Thrones* and *The Wire* use another narrative approach, that of multiple overlapping and interconnecting storylines. A viewer watching them has the impression of multiple events occurring simultaneously, and sometimes wishes for the freedom offered by interactive media to jump from one storyline to another.

The Special Characteristics of Digital Storytelling

As we can see from the various examples we've examined here, ranging from ancient rituals to twentieth-century films, many of the techniques that are characteristic of today's digital storytelling can actually be found in far earlier forms of storytelling and other human activities. Yet, thanks to computer technology, we can incorporate these techniques into interactive stories in a much more fluid and dynamic fashion to give us quite a new way to experience narrative.

Let's now take a look at the special characteristics of digital storytelling to see what makes it unique as a form of narrative. Some of these characteristics have already been mentioned, and some will be discussed later in the book.

Works of digital storytelling are usually:

- Types of narratives: they involve a series of connected dramatic events that serve to tell a story.
- Works that contain characters, including types of characters found only in digital media: characters controlled by the user or by the computer, and synthetic characters with the appearance of artificial intelligence (AI).
- Interactive: the user controls, or impacts, aspects of the story.
- Nonlinear: events or scenes do not occur in a fixed order; characters are not encountered at fixed points.
- Deeply immersive: they pull the user into the story.

- Participatory: the user participates in the story.
- Navigable: users can make their own path through the story or through a virtual environment.

Works of digital storytelling often:

- Break the fourth wall: the user can communicate with the characters; the fictional characters behave as if they were real people.
- Blur fiction and reality.
- Include a system of rewards and penalties.
- Use an enormous narrative canvas, tying together multiple media to tell a single story.
- May be multi-sensory.
- Attempt to incorporate some form of artificial intelligence (AI).
- Allow users to create and control avatars.
- Offer a shared community experience.
- Manipulate time and space (contracting or expanding time; allowing users to travel enormous virtual distances).
- Put users through a series of challenges and tests (modeled on rites of passage and the hero's journey).
- Offer opportunities to change points of view, either seeing the story from the vantage point of different characters or by changing the visual point of view.
- Include overt and non-overt gaming elements, such as:
 - Clear-cut objectives: to score points; to win
 - High stakes
 - Governed by clear set of rules
 - Demanding of high skill level
 - Played within a defined space
 - Making users engage in risk-taking behaviors
 - Set within a specific time frame
 - Requiring the use of strategy
 - Calling for team play
 - Requiring the overcoming of obstacles and dealing with opponents
 - Requiring players or avatars to wear elaborate uniforms that alter their appearance

- Include elements of play:
 - Experienced as pleasurable, as fun, rather than as work
 - Very loosely structured; no formalized set of rules
 - Involve a degree of chance or the unexpected
 - Offer opportunities for interactions with other people; social experiences
 - May be set in a fantasy environment or call for fantasy role-play

WORTH NOTING: CLASSIC STORYTELLING AND DIGITAL STORYTELLING: IMPORTANT DIFFERENCES

While digital storytelling shares many characteristics with other forms of narratives, such as plays, novels, movies, and news stories, there are important differences, as well.

TRADITIONAL STORIES:	WORKS OF DIGITAL STORYTELLING:
Are preconstructed; story elements cannot be changed	Are malleable; not fixed in advance
Have a linear plot; usually told in linear fashion	Are nonlinear, nonchronological
Author/writer is sole creator	The user co-creates the story
Are experienced passively	Are experienced actively
Have one unchangeable ending	Different outcomes are possible

Conclusion

As we have seen, two extremely old forms of social interaction—rituals and games—were two of the major precursors to digital storytelling. Despite the obvious differences between the activities that have come down to us from ancient times and today's computerized narratives, rituals and games help to define some of the critical components of this new form of storytelling.

Namely, they are interactive; they are participatory; they facilitate role-play; they are dramatic; and they are deeply immersive. In addition, the type of myth known as the hero's journey has

served as a direct model for works of digital storytelling. Ancient rituals were capable of producing a powerful feeling of catharsis, or emotional release, in the participants, and communities that played ancient games felt a profound sense of being connected to the divine. In fact, this ability to elicit strong emotions is a characteristic of all classic narratives. The emotional potential of digital storytelling, however, is still largely untapped, waiting for a Shakespeare or a Sophocles of this new form of narrative to take it to a higher level.

Idea-Generating Exercises

1. What traditional ritual have you participated in, or are aware of, that reminds you in some way of an interactive narrative? What is it about this ritual that you think is like a work of digital storytelling?
2. Think of a time when you wore a costume or engaged in some form of role-play that did not make use of electronic technology. Describe the experience and how it made you feel. How do you think it was similar to or different from the role-playing that occurs in works of digital storytelling?
3. Take a fictional character from a movie, TV show, or novel and list some ways that hypertext could be used to give a fuller picture of this individual.
4. Can you think of any work of traditional entertainment (poem, short story, novel, play, movie, TV show, etc.) that breaks the "fourth wall"? Describe how the fourth wall is broken in this work. Could the fourth wall be broken in a similar way in an interactive work? Why or why not?

Chapter 2

Backwater to Mainstream
The Growth of Digital Entertainment

- Why are new forms of digital media being termed *disruptive media*? What are they disrupting?
- What challenges do people face when creating content for a new medium?
- Who was a more likely candidate to invent the first computer game, a physicist working with an oscilloscope or a teenage kid fooling around on a PC?
- What effect is digital media having on traditional forms of entertainment like movies and TV?

An Extremely Recent Beginning

The development of the modern computer gave birth to a brand-new form of narrative: digital storytelling. Sometimes it is difficult to keep in mind that even the oldest types of digital storytelling are quite recent innovations, especially when compared to traditional entertainment media, like the theater, movies, or even television. For instance, the first rudimentary video game wasn't even created until the late 1950s, and two more

decades passed before the first form of interactive storytelling for the Internet was developed. Most other types of digital storytelling are much more recent innovations. Thus, we are talking about a major new form of narrative that is little more than half a century old.

While today's children have never known a world without computers or digital entertainment, the same is not true for today's senior citizens. A great number of them have never even used a computer and frankly aren't eager to try. Almost certainly, though, they have taken advantage of computerized technology embedded in familiar devices, from microwaves to ATM machines to home security systems.

A Brief History of the Computer

While computers are newcomers to our world, only having been introduced in the middle of the twentieth century, the conceptual roots of computer technology date back to antiquity. Historians of information technology often point to the use of the abacus, the world's oldest calculating tool, as being the computer's original starting place. They believe that the Chinese, the Babylonians, and the Egyptians used various forms of the abacus as long ago as 3000 BC. It was the first implement in human history to be employed for mathematical computations. However, another ancient device, the Inca quipu, can also be regarded as a precursor to the modern computer. The quipu was a complex system of tied knots on colored pieces of string and was based on the decimal position system. It was a highly precise tool and served Andean cultures as a record keeper and a method of communication, recording tax information as well as historic events and possibly myths. They date back over 3,000 years and Andean shepherds still use them today to record their livestock numbers.

Thousands of years later, in the late nineteenth century, humans moved one step closer to modern computer technology. In 1890, Herman Hollerith and James Powers invented a machine that could perform computations using punch-card technology. Their machine was designed to speed up computations for the US Census Bureau.

> **STRANGE BUT TRUE: THE WORLD'S FIRST COMPUTER PROGRAMMER**
>
> Ada Lovelace, Countess of Lovelace (1815–1852) was the daughter of the great Victorian poet, Lord Byron, and is regarded as the world's first computer programmer. She worked closely with the brilliant Charles Babbage, who created the "analytical engine," an early version of a punch-card computer. Though Babbage passed away before his device could be completed, Lovelace created a working algorithm for it by the early 1840s. She was so gifted in mathematics that Babbage termed her "The Enchantress of Numbers."

Punch-card machines like theirs became the computing workhorses of the business and scientific world for half a century. The outbreak of World War II, however, hastened the development of the modern computer, when machines were urgently needed that could swiftly perform complex calculations. Though several competing versions of the all-electronic computer were developed, most historians believe the honor of being first should go to the ENIAC (Electronic Numeric Integrator and Computer). This electronic wonder was completed in 1946 and could perform calculations about 1,000 times faster than the previous generation of computers (see Figure 2.1).

Despite the ENIAC's great speed, it did have some severe drawbacks. It was a cumbersome and bulky machine, weighing 30 tons, taking up 1,800 square feet of floor space, and drawing upon 18,000 vacuum tubes to operate. Furthermore, though efficient at performing the tasks it had been designed to do, it could not be easily reprogrammed.

During the three decades following the building of the ENIAC, computer technology progressed in a series of rapid steps, resulting in computers that were smaller and faster, had more memory, and were capable of performing more functions. Concepts such as computer-controlled robots and artificial intelligence (AI) were also being articulated and refined. By the 1970s, computer technology developed to the point where the essential elements could be shrunk down in size to a tiny microchip, meaning that a great

FIGURE 2.1 The ENIAC, built in 1946, is regarded as the world's first high-speed computer, but it was a hulking piece of equipment by today's standards. Photography courtesy of IBM corporate archives.

number of devices could be computer enhanced. As computer hardware became smaller and less expensive, personal computers (PCs) became widely available to the general public, and the use of computers accelerated rapidly through the 1970s and 1980s. It wasn't long before computer technology permeated everything from children's toys to supermarket scanners.

> **WORTH NOTING: MOORE'S LAW**
>
> In 1965, Gordon Moore, the co-founder of Intel, made an observation that has become known as Moore's Law. He predicted that the processing power of microprocessors would double every 18 months—an incredibly fast speed. Moore's prediction was pretty much on target, though the pace has slowed somewhat in recent years.

The Birth of the Internet

As important as the invention of the computer is, another technological achievement also played a critical role in the development of digital storytelling: the birth of the Internet. The

basic concept that underlies the Internet—that of connecting computers together to allow them to send information back and forth even though geographically distant from one another—was first sketched out by researchers in the 1960s. This was the time of the Cold War, and such a system, it was believed, would help facilitate the work of military personnel and scientists working on defense projects at widely scattered institutions. The idea took concrete shape in 1969 when the United States Department of Defense commissioned and launched the Advanced Research Project Association Net, generally known as ARPANET.

ARPANET was originally designed to transmit scientific and military data, but people with access to ARPANET quickly discovered they could also use it as a communications medium, and thus electronic mail (email) was born. And in 1978, there was an even more important discovery from the point of view of digital storytelling: some students in England determined that ARPANET could be harnessed as a medium of entertainment, inventing the world's first text-based role-playing adventure game for it. The game was a MUD (Multi-User Dungeon or Multi-User Domain or Multi-User Dimension), the forerunner of today's popular Massively Multiplayer Online Games (MMOGs).

In 1982, Vint Cerf and Bob Kahn designed a new protocol for ARPANET. A protocol is a format for transmitting data between two devices, and theirs was called TCP/IP, or Transmission Control Protocol/Internet Protocol. Without it, the Internet could not have grown into the immense international mass-communication system it has become. The creation of TCP/IP is so significant that it can be regarded as the birth of the Internet.

In 1990, the Department of Defense decommissioned ARPANET, leaving the Internet in its place. And by now, the word "cyberspace" was frequently being sprinkled into sophisticated conversations. William Gibson first coined the word in 1984 in his sci-fi novel, *Neuromancer*, using it to refer to the nonphysical world created by computer communications. The rapid acceptance of the word "cyberspace" into popular vocabulary was just one indication of how thoroughly electronic communications had managed to permeate everyday life.

Just one year after ARPANET was decommissioned, the World Wide Web was born, created by Englishman Tim Berners-Lee. Berners-Lee recognized the need for a simple and universal way of disseminating information over the Internet, and in his efforts to design such a system, he developed the critical ingredients of the Web, including URLs, HTML, and HTTP. This paved the way for new forms of storytelling and games on the Internet.

The First Video Games

Just as the first online game was devised long before the Internet was an established medium, the first video games were created years before personal computers became commonplace. They emerged during the era when computer technology was still very much the domain of research scientists, professors, and a handful of graduate students.

> **STRANGE BUT TRUE: THE WORLD'S FIRST VIDEO GAME**
>
> Credit for devising the first video game usually goes to a distinguished physicist named William Alfred Higinbotham, who created his game in 1958 while working at the Brookhaven National Laboratory in Upton, New York. His creation, *Tennis for Two*, was, as its name suggests, an interactive ball game, and two opponents would square off to play it. In an account written over 20 years later and posted on a Department of Energy website, Higinbotham modestly explained he had invented the game to have something interesting to put on display for his lab's annual visitors' day. The game was controlled by knobs and buttons and ran on an analog computer. The graphics were displayed on a primitive-looking oscilloscope, a device normally used for producing visual displays of electrical signals. Higinbotham's achievement is a vivid illustration of human ingenuity when it comes to using the tools at hand.

A game called *Spacewar!*, although not the first video game ever created, was the most direct antecedent of today's commercial video games. *Spacewar!* was created in the early 1960s by an

MIT student named Steve Russell. Russell, working with a team of fellow students, designed the game on a mainframe computer. The two-player game featured a duel between two primitive-looking spaceships, one shaped like a needle and the other like a wedge. It quickly caught the attention of students at other universities and was destined to be the inspiration of the world's first arcade game, though that was still some 10 years off.

In the meantime, work was going forward on the world's first home console games. The idea for making a home console game belongs to Ralph Baer, who came up with the revolutionary idea of playing interactive games on a TV screen way back in 1951. At the time, he was employed by a television company called Loral, and nobody would take his idea seriously. It took him almost 20 years before he found a company that would license his concept for a console, but finally, in 1970, Magnavox stepped up to the plate. The console, called the Magnavox Odyssey, was released in 1972, along with 12 games. The console demonstrated the feasibility of video games being played at home and paved the way for further developments in this area.

At just about the same time as the console's release, things were moving forward in the development of arcade games. Nolan Bushnell and Ted Dabney, the future founders of Atari, created an arcade version of *Spacewar!*, the game that had been made at MIT, and released it in 1971. Their game, *Computer Space*, was the first arcade game ever, but it was a failure, reportedly because people found it too hard to play. Dabney lost faith in the computer game business and he and Bushnell parted company. Bushnell, however, was undaunted. He went on to produce an arcade game called *Pong*, an interactive version of ping-pong, complete with a ponging sound when the ball hit the paddle. Released in 1972, the game became a huge success.

Pong helped generate an enormous wave of excitement about video games. A flurry of arcade games followed on its heels, and video arcade parlors seemed to spring up on every corner. By 1981, less than 10 years after *Pong* was released, over 1.5 million coin-operated arcade games were in operation in the United States, generating millions of dollars.

During the ensuing decades, home console games similarly took off. Competing brands of consoles, with ever more advanced

features, waged war on each other. Games designed to take advantage of the new features came on the market in steady numbers. Of course, console games and arcade games were not the only form of interactive gaming in town. Video games for desktop computers, both for the PC and Mac, were also being produced. These games were snapped up by gamers eager for exciting new products.

Less Familiar Forms of Interactive Entertainment

As we will see in future chapters of this book, a number of other important technologies and devices are employed for digital storytelling, and new ones are introduced on a frequent basis. Some platforms for interactive narrative are extremely familiar to the general public and highly popular—such as video game consoles, the Internet, mobile apps, and social media—while others, such as interactive television and interactive cinema, have been slower to catch on. We will be exploring both the highly popular forms and the less familiar forms throughout this book.

The Evolution of Content for a New Medium

As we have seen, digital storytelling is an extremely new form of narrative, and has only had a very brief period of time to develop. The first years of any new medium are apt to be a rocky time, marked by much trial and error. The initial experiments in a new field don't always succeed, and significant achievements are sometimes ignored or even ridiculed when first introduced.

The Early Days of a New Medium

The very first works produced for a new medium are sometimes referred to as *incunabula*, a term which comes from the Latin word for cradle or swaddling clothes, and thus means something still in its infancy. The term was first applied to the earliest printed books, those made before 1501. But now the term is used more broadly to apply to the early forms of any new medium, including works made for various types of digital technology.

When creating a work for a brand-new medium, it is extremely difficult to see its potential. People in this position must go through a steep learning curve to discover its unique properties and determine how they can be used for narrative purposes. To make things even more challenging, a new technology often has certain limitations and these must be understood and ways must be found to cope with them. Creating works for a new medium is thus a process of discovery, and a great test of the imagination.

Typically, projects created for a new medium go through evolution, with three major steps:

1. The first step is almost always *repurposing*, which is the porting over of materials or models from older media or models, often with almost no change. For instance, many early movies were just filmed stage plays, while in digital media, the first DVDs just contained movies and compilations of TV shows, and many of the first CD-ROMs were digital versions of already existing encyclopedias.
2. The middle step is often the adaptation approach, or a spin-off. In other words, an established property, like a novel, is modified somewhat for a new medium, like a movie. Producers of Alexa Skills have been taking this approach by creating interactive stories and games based on popular movies, TV shows, and video games. (Alexa Skills are discussed in depth later in this chapter.)
3. The final and most sophisticated step is the creation of totally original content that makes good use of what the new medium has to offer and does not imitate older forms. For example, the three-camera situation comedy is a unique TV genre that takes full advantage of the medium of television. The same can be said of the MMOG, which takes full advantage of the opportunities offered by the Internet.

Developing works for digital media has presented challenges never faced before by the creative community. For example, how could you tell a story using interactivity and a nonlinear structure? And how would the user be made aware of the interactivity, and know how to use it?

Harnessing Convergence to Digital Storytelling

Convergence is a coming together of two or more different elements, a blending of these entities into one seamless whole. In the early days of emergent media, the term was usually applied to the melding together of various forms of technology, such as a communications delivery system, hardware (such as a game console or computer), digitized content, and computerized technology. This type of convergence was highly anticipated, because it meant that the end user would have access to a wide range of content on a single device.

An early piece of convergent technology was the Nokia N-Gage, introduced in 2003. It was both a cell phone and a handheld game console, thus converging media and capabilities that had never been available before on a single device (see Figure 2.2). In addition to its main duties as a phone and game console, this little piece of hardware also connected to the Internet and functioned as a digital music player and an FM radio. Unfortunately, the N-Gage had some serious design flaws, including problems with the keypad and difficulties with swapping games in and out. In addition, consumers found it looked somewhat ridiculous when held up to the ear as a phone, dubbing it "taco phone" and "elephant ear." Though the device was redesigned in 2004, it was discontinued in 2005.

FIGURE 2.2 A first generation Nokia N-Gage, an early convergent device. Image courtesy of Nokia.

> **STRANGE BUT TRUE: DOLLS AS CONVERGENT DEVICES**
>
> Surprising though it might be, smart dolls (life-like dolls embedded with microprocessing chips) include some of the most advanced forms of convergent devices on the market. Toy inventors are always on the lookout for new technologies they can use to make their dolls seem more alive, more interactive, and more able to take a central role in an interactive story experience. Sophisticated smart dolls incorporate nano technology and voice recognition systems; have built-in clocks and calendars; they can connect to the Internet; and they have sensors that let the dolls know what outfits they are wearing and that can detect motion, touch, and light conditions.

Though Nokia's N-Gage failed to catch on, other convergent devices have been wildly successful. They include the iPhone and the iPad, along with game consoles like the PSP (PlayStation Portable) and the Xbox One. Apple's iPhone, released in 2007, functioned as a cell phone, a music player, and a video player; it also connected to the Web and had email service. In addition, it worked as a camera, a calendar, and a calculator. And this is just a partial list of what it could do. The iPhone caused a sensation when it was introduced, and people lined up for days for a chance to buy one. "This is cyberspace in your pocket!" exclaimed one enthusiastic Silicon Valley consultant, Paul Saffo (as quoted in the *Los Angeles Times*, January 10, 2007).

Thanks to successful devices like these, it is safe to say that convergence in technology is no longer something we must wait for: it is already here. In today's emergent media world, we are now witnessing the exciting convergence of various forms of media.

Transmedia Storytelling as a Form of Convergence

In transmedia storytelling, a single entertainment property is merged over multiple forms of media, at least one of which is interactive. Thus, it is a form of convergence. This approach also goes

by quite a few other names, all meaning the same thing: multi-platforming, integrated media, networked entertainment, distributed media and cross-media producing. Transmedia is a special way of combining media to tell a single story. Although primarily employed for story-based projects and games, a few productions of this type have also been produced for information-based projects and promotional purposes. It has also been employed by non-profit organizations to make the public more aware of their missions and to raise funds.

Transmedia was a hot buzzword at the beginning of the 2010s, but over time, the concept has become mainstream enough that it is applied to a great many forms of digital and analogue storytelling. The term is no longer the novel buzzword it was some years ago.

Typically, a transmedia project is centered around a major media production, such as a movie or a TV series. For example, with the movies *Wreck-It Ralph* (2013) and *Ralph Wrecks the Internet* (2018), the narratives are built out in video games, a comic book, websites, an interactive storybook, and a virtual reality experience. With the TV series *Westworld*, fans can visit fictional websites, play a mobile game, and ask Alexa for an interactive game. The new Jurassic Park movie, *Jurassic World*, also has a transmedia component on Alexa, *Jurassic World Revealed*, as well as a VR ride, a VR game and a highly detailed website for the park, Islanublar.jurassicworld.com.

Those fortunate enough to attend the popular culture shows Comic-Con in San Diego or South by Southwest in Austin in 2018 could even participate in a simulation of *Westworld*, complete with sets, actors, and props. The transmedia features for the hit TV series *Game of Thrones* include websites, an online surveillance game, and an iPad app that shows the weather at various *Game of Thrones* locations. Selected fans can even receive a "scent box" of aromas associated with the show.

When it comes to outstanding transmedia productions, Europe is by no means being left in the dust by the United States. For example, *The Truth About Marika* was a riveting transmedia drama about the disappearance of a young woman, Marika, and the search instigated by her close friend. It aired in Sweden during

the fall of 2007, and its transmedia elements—centered around the search and theories about her disappearance—took place on TV, on the streets, over the Internet, and on mobile phones.

Transmedia stories have also been built around Web series. A good example is *Dirty Work*, created by Fourth Wall Studio. The show was an interactive comedy about a trio of twenty-somethings who worked for a company called Bio-Tidy and whose gory job it was to clean up crime scenes. The episodes aired on Fourth Wall's proprietary website, Rides.TV. This original Web series was augmented by a multi-platform approach. *Dirty Work*'s goal was to imitate the way people interact with their digital devices while watching TV. If viewers wished, they could simply watch the episodes on the Web, but they could also choose to sign up for the full experience. This included receiving text messages and phone calls from the characters, getting additional content on Twitter and Facebook, and watching bonus videos. *Dirty Work* received an Emmy in 2012 for Outstanding Creative Achievement in Interactive Media.

Not all transmedia projects are built around a film or TV or Web series, however. The department store, Macy's, created a transmedia narrative for the 2018 Christmas season centered around a new character, Sunny the Snowpal. Sunny, who looks like a cross between a snowman and an astronaut, goes on a space adventure to save Santa. The transmedia components include an enormous Sunny—a balloon making its debut in the 2018 Christmas parade—and a very small Sunny—a plush toy. A series of Macy's windows depict Sunny going on her space adventure. Visitors to the windows can activate buttons to send Sunny flying and can play a videogame with her as the hero. An online feature gives visitors the chance to send a loved one a message from Sunny and a Macy's gift card.

For-profit organizations have been heavy users of transmedia for many years. One especially innovative transmedia project starring rescued cats went by the name of *Meow Mix House*. It was a promotional venture produced by Del Monte Foods back in 2006. *Meow Mix House* closely imitated TV's popular survivor shows and was aired in three-minute segments on Animal Planet. The contestants, cats who had been rescued from animal

shelters in three major cities, lived in a specially built house which was displayed on a Manhattan boulevard. In the competition, the winning feline would become an executive vice president of *Meow Mix House*. In order to win, the cats had to beat the other contestants for awards in Best Post Climber and Best Purr. Webcams were trained on them around the clock, and viewers could watch them online, share their opinions, and vote for their favorite contestant. After the show ended, every feline participant was adopted into a good home. Thus, *Meow Mix House* not only promoted a brand of cat food, but also promoted the idea of pet adoption.

> **STRANGE BUT TRUE: THE *LOVEPLUS+* TRANSMEDIA GAME**
>
> Japan was the home of a highly unusual transmedia game, this one catering to a specific subculture: Lonely-hearted bachelors, primarily computer geeks who not only lacked social skills but who also lacked real-life girlfriends. The game had a romantic objective: to promote geek (*otaku*) tourism. The *LovePlus+* game gave solitary young men an opportunity to court virtual girlfriends and develop a life-like relationship with them. If they earned enough points, they could take their girlfriend on a romantic getaway to a real Japanese resort town, Atami, which is a bit like going on a honeymoon to Niagara Falls. The hospitality industry in Atami happily played along with the game, and didn't ask any questions when a young man would register for a double room but had no visible companion with him. Evidently, over 1,500 players have turned up in Atami clutching their hand-held devices but not the hand of a young woman.

Alternate Reality Games: A Special Form of Transmedia Storytelling

Alternate reality games (ARGs) typically involve multiple forms of media and include well-developed narratives, and thus they are forms of transmedia storytelling. They may also incorporate

forms of communication not usually associated with games, such as telephone calls, newspaper ads, and faxes. Pieces of the story may be scattered over a number of media platforms. The dominant hallmark of the ARG is the way it blurs real life with fiction, and the way it combines a rich narrative with puzzle solving.

ARGs, perhaps more than any other form of digital storytelling, tightly integrate story and game elements together. Typically, ARGS have a strong and complex narrative, but the story is broken into tiny fragments and embedded in a great variety of media assets and other forms of communication. In order to assemble the story and make sense of it, players must solve a series of puzzles. These games often take players out into the real world in search of clues or to participate in story-related events. ARGs are a hybrid form of storytelling, combining game play and narrative.

People who play ARGs call themselves ARGers, and they are often passionately devoted to the genre. They have coined a mantra for this type of entertainment: "This is not a game." It reflects the way ARGs spill out into the real world and seem not to be fiction at all.

ARGs are a relatively new phenomenon. The world's first, *The Beast*, debuted in 2001 by Microsoft to serve as a stealth marketing device to promote Steven Spielberg's movie, *AI*. The creative work fell to an enormously talented and visionary four-person team. In time, the players would affectionately dub this group "the Puppetmasters," a term that is now applied universally to all ARG creative teams.

The Beast was "told" in part via everyday methods of communications like telephone calls and emails. It penetrated the real world even further by staging live events, like anti-robot rallies. Websites, its major workhorse component, numbered in the hundreds. They looked completely realistic and bore no traceable link to the movie or to Microsoft. Both the copy and the graphic design of these sites were entirely in keeping with the various organizations or individuals who were purported to own them, and, like websites in the real world, they varied enormously in style (see Figure 2.3 and Figure 2.4).

I Love Bees, an ARG that was developed to market the video game *Halo 2*, started off in an intriguing way, with influential ARGers receiving jars of honey containing clues leading them to a website

FIGURE 2.3 The home page of the *Belladerma* website, one of hundreds of faux websites created for *The Beast*. **Image courtesy of Microsoft.**

called *Ilovebees.com*, which was the rabbit hole for the game. As clever as this was, however, the most innovative feature of this ARG was the use of payphones. Players would receive the GPS coordinates leading them to payphones all over the United States and would stand by the phones, waiting for them to ring. When they did, they would hear cryptic messages with important bits of the story. Sometimes the messages were delivered by a recorded voice and sometimes by a live actor representing a character in the story.

Another ARG, *Why So Serious?*, was developed to promote the Batman film *The Dark Knight* and to serve as a bridge between that movie and the earlier Christopher Nolan Batman movie, *Batman Begins*. The game was "orchestrated" by the fictional character of the Joker from the Batman franchise and participants played as concerned citizens of Gotham City. As with many other high-profile ARGs, this one was seeded at the annual ComicCon convention in San Diego, California, though a handful of early clues

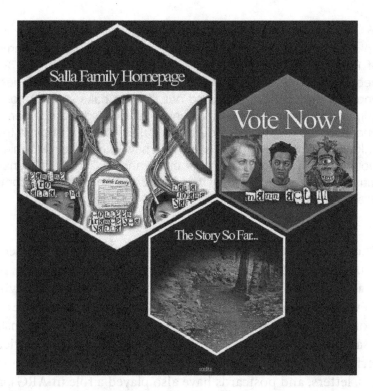

FIGURE 2.4 The Salla Family website was the portal, or rabbit hole, through which most players entered the futuristic world of *The Beast*. In the ARG, its creator was a teenage girl, and the website was intended to look like a teenage girl had fashioned it. Image courtesy of Microsoft.

had been planted beforehand. The ComicCon phase began with the discovery of "jokerized" one-dollar bills with the Joker's face inked on the bills, along with a URL for a website. Players who scrutinized the webpage found instructions to meet at a particular location the next morning at 10 a.m., and those who turned up were rewarded with a phone number written in the sky. At this point, the game moved into high gear.

STRANGE BUT TRUE: CELL PHONE CAKES!

One of the most inventive elements of any ARG was a sequence of clues leading to the discovery of working cell phones baked into layer cakes. This clever device was developed for *Why So Serious?*, described above. Players were sent on a wild chase

> to 22 widely disparate addresses and instructed to retrieve an unknown object that would be waiting for them under the name of Robin Banks (robbing banks— Joker humor!). The first 22 people to reach these addresses found them to be bakeries, and the retrieved article turned out to be a cake with a phone number written in the icing. When players called the number, a phone would ring from inside the cake! By digging through the cake, they would find the phone with a new number to call, which would instigate a new series of clues and tasks. The bakeries must have been mystified by these bizarre cakes they were commissioned to make!

The ARGs that have reached the public thus far have used an astounding variety of media and techniques to impart clues, puzzles, and bits of the story. The Internet has been employed in virtually every way imaginable, including faux corporate websites and personal blogs, emails, webcams, pod-casts, wikis, and instant messaging. Mobile devices have also been pressed into service in a variety of ways, as have landline phones and even payphones. Faxes, letters, and postcards have also played a role in ARGs, and so have full-length books. In addition, ARGs have partially played out in such "old media" forms of communication as newspapers, magazines, radio and TV commercials, TV shows, posters, and billboards. Clue-laden USB flash drives have been hidden in bathroom stalls and hand-written notes by the protagonist have been hidden in public library books.

ARGs continue to evolve, and ARGers often find themselves debating whether a particular set of videos or websites or blogs are indeed ARGs or are the work of unstable individuals or even recruitment videos for legitimate organizations. New ARGs are tracked regularly on the ARG network: www.argn.com.

Borrowed Technologies

As a new form of telling stories, digital storytelling is not restricted to a specific set of tools, but is free to use any form of digital technology that works for a specific story. Some of the unusual technologies that have already been employed include:

- **QR Codes**. A QR code is made up of black bars and rectangles arranged in a square. These codes can be read by various devices. In retail stores, they are found on packaged goods and used to give information about prices and other details. QR codes can also be read by mobile phones, and in digital storytelling, they are used to give clues in games. This type of clue was used in *The Q Game*, a location-based game set in Albuquerque, NM. A location-based game is one that take place within a specific location. When a player photographed the code with a mobile device, it unlocked a website to reveal an important clue (see Figure 2.5).
- **GPS**, which stands for Global Positioning System, is a satellite-based navigation system that allows individuals with receivers to pinpoint their geographic location. The GPS has been used in a number of games, as well as in digital stories set in specific locations. For example, it was cleverly employed in *No Places with Names*, an audio experience set on the campus of the Institute of American Indian Arts. As the user followed a path across the campus, the GPS triggered sounds that suggested what Native Americans might have heard centuries ago: the chopping of hoes preparing the ground for planting; the howl of a

FIGURE 2.5 A QR code from the Q Game. Image courtesy of Extreme AI, Inc.

coyote; a boom of thunder and the patter of rain on the dry ground.
- **Electronic kiosks.** The electronic kiosk, sometimes also called the multimedia kiosk or the interactive kiosk, is perhaps the most modest and unassuming of all devices employed for digital storytelling. Essentially, kiosks are simply booths or other small structures that offer the user an easy-to-operate computerized service, often via a touchscreen. Kiosks are so universal and so much a part of our everyday landscape that we barely give them a second thought, though we are constantly using them to obtain cash, buy gas, or find books in the library. One of the most universal forms of the kiosk is the ATM, or automated teller machine.

These plain-Jane devices can support some surprisingly creative projects, and can be transformed into excellent vehicles for entertainment, information, or promotion. They can accommodate both single users and small groups; they can read credit cards and scan codes, and they can print out receipts and documents. In addition, they can be connected to the Internet, be operated by touchscreens, keyboards, trackballs, videogame controllers, and push buttons, and they can be networked together so users can communicate with each other though in different geographic locations. The housing can be designed in creative ways to suggest what the kiosk is offering.

Thus, they are a viable platform for digital storytelling, though not often employed for interactive storytelling. Their one drawback in terms of deep storytelling is that they are designed to be placed in public spaces and to be used by a high volume of users, each just spending a few minutes in front of the screen. This limits their usefulness when it comes to an in-depth narrative.

Nevertheless, kiosks can be highly functional for offering information or for short games. Walt Disney World Resorts successfully employed 42 kiosks in a project called *Discover the Stories Behind the Magic*. The kiosks, each designed to look like Mickey Mouse, were built as part of the *100 Years of Magic* festivities to celebrate the centennial of Walt Disney's birth. According to Roger

Holzberg, who was creative lead for the celebration project, the goal of the kiosks was to give park guests an appreciation of the breadth of Walt Disney's imagination. And, for people who knew nothing about Disney history, and thought Walt Disney "was just a brand name like Sara Lee," they wanted to demonstrate that a real person existed behind the familiar name, Holzberg said. To do this in a way that would be enjoyable both for adult guests and for young visitors they decided to present the content in the form of a game (see Figure 2.6).

To play one of the games, guests answered multiple-choice questions about various attractions in the particular theme park they were visiting. Each time they answered a question, they'd learn a little bit about the attraction and how its inspiration had been

FIGURE 2.6 Each of the 42 kiosks designed for Disney's *Discover the Stories Behind the Magic* resembles Mickey Mouse. Visitors spin the ears and push the nose to interact with the content. Image courtesy of Roger Holzberg.

drawn from Walt Disney himself. Thus, guests would literally be experiencing the connection between Disney's imagination and the parks he inspired.

As technology advances, we can expect to see more unusual technologies, ones developed for pragmatic purposes, employed for digital storytelling. Perhaps developers will even come up with a way to include 3-D printing in stories or games. After all, entire houses can now be built using 3-D printing, as can living grass. And what about drones? Could they possibly play a part in games or stories? Sony has recently applied for a patent on a contact lens that could record video. The wearer can turn it on by winking. How might such an undetectable device be used in digital storytelling? What else might find a place the stories and games of the future?

New Ways to Tell Stories

Developers who work in the field of digital storytelling find new and creative ways to tell stories. Sometimes the concepts they use are old, but digital technology gives them a new spin, such as the use of voice-activated digital assistants to tell stories or offer games simply with audio. This use of audio is a nod back to radio, but in this case the content is interactive and responsive. One industry expert, Robin Raskin, predicts that voice technology will be a dominant force in digital technology, in everything from apps to commerce to IoT (Internet of Things). And Marc Andreessen, a highly regarded figure in the high-tech world, predicts audio will be "titanically important" in coming years (from an interview on TechCrunch, January 5, 2019). Thus, voice technology has the potential to impact not only entertainment technology but also everyday things in the world around us.

When it comes to new ways to tell stories, digital technology can also enhance that enduring form of analogue media, the book. Sometimes advances in technology, such as AI (artificial intelligence) allows for leaps forward in new kinds of stories or new kinds of characters. And sometimes we suddenly have enormous progress in a form of digital storytelling that has been around for decades, but was stalled until advances in technology allowed for

enormous progress, as is true with virtual reality (VR) and augmented reality (AR).

Here are several new areas that are currently seeing promising developments:

- **Voice-enabled storytelling.** Alexa, which is Amazon's voice recognition system, has usually been employed for pragmatic purposes. For example, Alexa can give us a weather forecast, provide us with a recipe, or tell us the news. She is the equivalent of Apple's Siri. Alexa has been built with a highly sophisticated form of natural language interface, meaning that she can understand what we say and respond appropriately. (For more on interactive dialogue, please see Chapter 5.) But she (and Alexa is female, given that she speaks with a woman's voice) can now immerse us in stories or offer us a game to play. In Alexa parlance, these games and stories are called "skills."

 Her entertainment talents have been employed for several new audio adventures and games. The stories are primarily modeled on the "choose your own adventure" approach. They work by asking you a question, much like the old text-based MUD games, such as "do you want to hike up the hill, go into the cave, or flee?" You pick one of the choices and the story proceeds. This sounds like an uninteresting way to be part of a story, but these narratives can be surprisingly immersive. They feature convincing sound effects and good voice actors, and the stories themselves are often cleverly written, full of suspense, and contain surprises you don't see coming.

 One of these stories, *Jurassic World Revealed*, is based on the film *Jurassic World*, and plucks you down in the center of the action, right on Isla Nublar and its dinosaur inhabitants You play as Jesse, producer to podcaster Janet who is doing a report on the volcano-threated island. Janet relies on your advice to survive the dangers in this doomed old theme park. Another, *Westworld: The Maze*, plays off the *Westworld* TV series. It's part story and part game and recreates the somewhat disorienting atmosphere

of the TV series in which a Western-themed amusement park is populated by a number of highly realistic android characters. In playing, you are faced with 400 choices to make. Unlike Jurassic World, your choices relate more to emotions and your personality than to physical actions you can take. A third, *The Magic Door*, is a totally original group of interactive stories inhabited in part by fairytale characters and themes.

In terms of games, *Skyrim* is an audio work that replicates a "Sword and Sorcery"-style video game. You play the hero in a swashbuckling adventure and encounter strangers who need your help, as well as ferocious enemies. Your actions can raise your skill level or lower your health level, and you can collect items for your inventory, just as in a video game.

When in Rome is a travel game that breaks the players into teams and takes them to different parts of the world where they must find answers to sometimes puzzling trivia-style questions. One interesting feature of this game is that it can be updated on a regular basis, so it's different each time it's played. It won the 2018 Kapi Award (the Kapi Awards are given to the best digital toys for children) for the most novel technology. The stories Alexa offers you can also be updated, and new choices may be offered even when you play them a second time in the same day. Thus, they always stay fresh.

The one negative feature of some of these new Alexa skills is that the voice of the narrator of the work—your companion or host of the story—sometimes has an unnatural mechanical voice, as if a machine is reading the script. And in some cases, the attempt to involve you in the narrative is awkwardly done, telling you what you see or feel rather than letting you experience it directly. The "telling you" version goes like this: "Ahead, something jumps out of the darkness and snarls at you. You are frightened." The "experience" version of the same event might go like this: sound effects: rustle of leaves, a thud of a heavy body dropping to the ground; a fierce

snarl. "Oh, no, what's that?! Let's run!" Unfortunately, when you are told what is happening instead of being given the immediacy of experiencing it, you lose the sense of immersion.
- **Advances in AI.** Thanks to voice activated personal assistants like Alexa, which can answer almost any question or obey any command, artificial intelligence seems to be always present and available, leading to some experts referring to this as *ubiquitous AI*. Computer systems have even been trained to debate: They can learn a subject deeply, present an opinion about it, and defend it against opponents. IBM, which created this impressive form of AI, calls it *Project Debater*. In a debate that pitted Project Debater against an Israeli debating champion, the AI system won. *Project Debater* handles language in a far more mature way than earlier forms of natural language interface, and it can even crack jokes.

 Sophisticated forms of AI such as the one created for *Project Debater* are now being used not only for the Alexa skills described above, but are also being employed in avatars. A company called Expressive, Inc. has created avatars that can mimic human emotions like sadness, happiness, anger, and disgust and can react appropriately when the humans they are interacting with are expressing such emotions. They can even display appropriate body language. It's not difficult to imagine avatars with this degree of emotional sensitivity being effectively employed in digital narratives and games.
- **Advances in digital books**. The printed book is one of our oldest forms of analogue media, and books basically remained the same for centuries—words on paper—after the invention of the printing press in 1439. With the digitizing of books in the twenty-first century, however, developers were able to present books with new capabilities. For example, the digital book publisher Vook, founded in 2009, specialized in books that combined text, video, audio, links to the Internet, and social media sites. Since the offerings made possible by Vook, developers have

continued to experiment with how to present books in new ways.

For example, *H8 Society – How an Atomic Fart Saved the World* is an edgy 374- page novel that contains 26 songs, graphics by a well-known artist, and social media capabilities. On the other end of the spectrum, Disney Worldwide Publishing has created a product called the Disney Electronic Interactive Story Reader. The device contains eight books. The user can hear the books narrated, can interact with the characters, hear amusing sound effects, and view a light show.

Another offering for young readers, an ongoing interactive novel begun in 2005, is called *Inanimate Alice*. Using sound effects, snatches of journals, social media, games, and video, it allows young readers to see a story through the eyes of the protagonist, Alice, who is 8 years old when the story begins. The episodes in the series, which are based on the real-life experiences of game designer Alice Field, become increasingly complex as Alice ages and the games become more challenging. Ultimately the developers hope to enhance the series with VR.

- **Advances in VR and other immersive experiences**. Experiments in VR date back to the mid-1950s and the term "virtual reality" was coined by Jaron Lanier in the mid-1980s. It was Lanier who developed the essential hardware needed to experience VR. The first work in augmented reality dates back to the late 1960s. In the decades since, scientists have been experimenting with various forms of immersive technology, including virtual reality, augmented reality, and mixed reality. These experiments, while often successful at creating virtual experiences, were extremely expensive and not meant for entertainment or for the general public. Rather, they were generally created for pragmatic purposes, such as military training, architecture, design, and even for assisting medical patients to deal with various forms of phobias and trauma.

 In the last few years, however, there have been tremendous advancements made in the technology of immersive

experiences, lowering the cost and making this an arena that can be enjoyed as a vibrant form of entertainment. By 2016, at least 230 companies were developing VR-related products. The gaming industry has enthusiastically turned to VR to create new kinds of games, and creators have also been designing new kinds of immersive stories. This arena will be fully explored in Part 5 of this book.

The Profound Impact of Digital Media

The maturing of digital media has profoundly changed the way we entertain ourselves, receive news and information, and interact with our social circle. For example, TiVos, PVRs, iPods, iPads, iPhones, and other digital devices have freed television viewers from the tyranny of the television schedule. As one media analyst put it, "Appointment-based television is dead." Perhaps this is an overstatement, but there's no question that developments in recent years—including the development of the Internet as a major new medium, new forms of digital distribution, and the enormous popularity of video games and other kinds of digital entertainment—are having a profound impact on the Hollywood entertainment establishment. This digital revolution is also having a number of other ramifications. For example, it is impacting on how and where advertising dollars are spent, and is profoundly changing the world of journalism. It is also bringing about innovations in the way students are taught and how employees are trained. And, most relevant to this book, it is sparking the creation of exciting new forms of storytelling.

Digital media is also impacting our lives in myriads of unexpected ways. For example, fewer people are now sending out paper greeting cards and holiday cards, finding it much faster and less expensive to send their good wishes electronically. And a number of authors are choosing to publish their creations as ebooks. With ebooks, they have more control over the process and make a higher percentage of royalties than they would by going with a traditional publisher that still prints exclusively on paper.

People are even experiencing nature differently. A study by the National Park Service reveals that people expect to travel through the parks with portable, mobile information that travels with them. Furthermore, they expect this information to be interactive, personalized, age-appropriate, and culture-appropriate.

Finally, the use of digital media, specifically mobile phones, is even creating a new language, according to Columbia linguistics professor John McWhorter. He calls this new language *textspeak* and says of it: "Texting is fingered speech. Now we can write the way we talk" (*All Things D*, February 28, 2013). Furthermore, a new field of academic study has opened up called cyborg anthropology. Led by Amber Case, it is the study of how humans and nonhumans, such as computers, interact with each other.

Changes in the Consumption of Entertainment

From the debut of the world's first commercial video game, *Pong*, in 1972, to the present-day explosion of digital content, the popularity of digital entertainment has grown at a steady and impressive rate. Not only are more people consuming digital entertainment, but they are also spending more hours enjoying it. As a result, the audiences for traditional forms of entertainment have shrunk. Digital content has become an accepted part of the mainstream entertainment world, joining older forms—movies and television—as a recognized part of the entertainment "club."

Young people, in particular, are enormous fans of digital entertainment and everything digital. They text message each other on their cell phones, instant message (IM) each other, and watch streaming video on the Internet, listen to music on their iPods, and play games on their game consoles and their parents' tablet computers (see Figure 2.7). Digital devices are virtually universally available to young children. A study called *The Common Sense Census: Media Use by Kids Age Zero to Eight* reported that of 2017, "virtually all (98 percent) homes with children age 8 or under now have a mobile device such as a smartphone or a tablet, up from three-quarters (75 percent) just four years ago in 2013, and half (52 percent) in 2011." The study goes on to say: "In fact,

FIGURE 2.7 Children love doing things on digital devices, and particularly love the interactive apps offered on the iPad.

today nearly half (45 percent) of all children have their own mobile device, up from 3 percent in 2011 and 12 percent in 2013."

Older people and women are also spending more time on pursuits typically considered the domain of teenage boys. According to statistics released in 2018 by the Entertainment Software Association (ESA), the average age of gamers is now 34. Furthermore, women make up 45 percent of the gamer population, and more adult women play games than teenage boys under 18 years old (33% versus 17%). And, to underscore the enormity of the gamer world, the ESA also reports that 60 percent of Americans play video games every day.

While once there were only two entertainment screens that mattered—TV screens and movie screens—there is now a powerful "third screen" to contend with. This so-called third screen is really composed of multiple types of screens, a mixture of game consoles, computer screens, cell phones, and tablets.

The Third Screen's Impact on Hollywood

Television networks and movie studios are by no means unaware of the digital revolution, and the most forward looking of them are taking steps to minimize the negative impact and even to take advantage of it as much as possible. They clearly want to avoid being blindsided the way the music industry was in the late 1990s with

illegal file sharing. Until the courts put an end to it, people were able to download songs for free, using Napster's file sharing services. This online piracy caused the recording industry to suffer tremendous financial losses, and now that video can easily be downloaded from the Internet, Hollywood is taking steps to avoid a similar debacle.

Thus, following Apple's lead, a number of film studios and TV networks have been making their movies and TV shows readily available for legal downloads for a small fee. Some are also adapting an innovative transmedia strategy. As noted earlier, when the same narrative storyline is developed across several forms of media, one of which is an interactive medium, it is known as transmedia entertainment. Not only do the studios and networks create entertainment content for their two traditional screens—movie theaters and TV sets—but also create auxiliary content for the third screen.

Despite various efforts to embrace the digital revolution, it is clear that traditional Hollywood entertainment is taking a hit from the third screen. Not only is television viewing down, but movie attendance is also being impacted. The big event movies remain popular, as do the specialized low-budget genre pictures, but the films that are middle of the road, with mid-level budgets, are doing poorly. It indicates that while people may be willing to spend money to go to films they really want to see, they'd sooner stay home and watch a DVD or play a video game than go to movies that don't sound particularly appealing. It should be noted that even the popular second screen, the TV screen, is being impacted by digital technology. Original programming for HBO, Netflix, Prime, Hulu is all being delivered digitally.

Beginning in 2002, the sale of tickets for feature films began to decline, particularly with the prime demographic: young people between the ages of 12 and 24. A graph showing ticket sales year by year shows rising and falling numbers, but they have never again reached the levels seen in 2001. Many observers feel the feature-film arena will never fully recover, much as broadcast television has not seen the return of young male viewers. As a further sign of the decline in feature films, the six major motion picture studios have been releasing significantly fewer films every year since 1995, apart from the years 2006 and 2007. These statistics were collected by Nash Information Services, LLC.

When an innovation in media creates a new market that disrupts an existing market, it is called *disruptive media*. It is fair to say that the popularity of various forms of emergent media—the third screen—have caused them to become disruptive media.

> **WORTH NOTING: THE IMPACT ON HOLLYWOOD'S TALENT POOL**
>
> The popularity of digital media is rocking the boat with Hollywood professionals. Writers, actors, and directors are demanding that they be paid fairly when their work is downloaded from the Internet or when they contribute to a new form of content like a social media site for a fictional character. The long-established compensation system for top talent was created well before the digital revolution and doesn't cover these situations. At times, such payment issues have grown contentious. Digital technology is raising some unexpected concerns, as well. For example, actors worry that their voices and images may be digitalized and used in productions without their consent, meaning that they could lose jobs to a virtual version of themselves.

How Advertisers Are Responding

People inside the world of the Hollywood entertainment business are not the only ones grappling with the sea-changes created by the explosion of digital media. These changes are also creating upheavals for the advertising industry. In the past, television commercials were a favored way of promoting products, and advertisers spent a staggering amount of money on commercials. But in 2017, for the first time ever, advertisers spent more money on digital media than on TV. Statistics for 2017 show that $209 billion was spent worldwide on digital ads (41% of the market) versus the $178 billion spent on TV commercials (35% of the market). These figures were supplied by Magna, which is the research branch of the media buying firm IPG Mediabrands.

It is understandable that advertisers are becoming far less willing to make such an investment in commercials under the present circumstances. Not only is television viewing down, but people are also downloading commercial-free shows from the Internet,

fast-forwarding through commercials on their PVRs, and viewing commercial-free television programming on DVDs. Another major medium for advertising—the daily newspaper—is also becoming less attractive to advertisers. Circulation numbers are plummeting almost everywhere, and readership is especially low with young people, who prefer to get their news online or through their mobile devices.

Advertisers are now on the lookout for new ways to bring their messages to the public. They may, for example, invest in product placement in video games. A racing game, the track might be plastered with billboards promoting a particular product or might offer players the opportunity to drive high-end cars from a particular brand. In a sports game, the athletes may be wearing shirts emblazoned with the name of clothing line. Advertisers are devising new forms of digital narratives and games to promote products, which is of particular interest to those of us involved in digital storytelling. For example, they are putting money into *advergaming*—a form of casual gaming that integrates a product into the game, and is often set in a narrative frame. They are also producing webisodes and elaborate multi-platform games that subtly or not so subtly make a particular product shine. Advertisers are also employing social media to get their messages out. We will be exploring this new type of content throughout this book.

The Impact on Journalism and How We Receive Information

The digital revolution has both hurt and helped the field of journalism, and has profoundly impacted the way information is disseminated. While newspaper circulation has been steadily declining down, as has the viewership of television newscasts, we have a whole universe of new sources of information and journalism, thanks to digital media, and they can deliver the news in real time—no more waiting to get the news in the morning paper. On the Internet, we can receive up-to-the-minute news stories, complete with audio and video, and we also get information from blogs, informational websites, online news magazines, and podcasts. And via our mobile devices, we can receive news bulletins, check stock prices, get weather reports, and keep tabs on sports events.

Digital media has forced some newspapers to go out of business or to be sold for low prices. In August 2013, the sale of the *Washington Post* to Jeff Bezos, founder and CEO of Amazon.com, sent shockwaves through the journalistic community, especially because Bezos bought the paper for what was considered the seriously undervalued sum of $250 million. This sale indicates the vulnerability of print newspapers. Many believe the Internet destroyed the long-standing business model that supported newspapers. According to Martin Nisenholtz, former digital chief of the *New York Times*, "The oxygen got taken out of the financial model."

The Internet as a Journalistic Medium

Digital media are now covering live events, which was once something only TV could do. Private citizens now record videos of news-breaking stories on their smartphones and these videos can be streamed live on social media. On a larger scale, YouTube streams exciting events that attract millions of viewers. The *Red Bull Stratos* mission is an excellent example of this. Before dawn on Sunday morning, October 14, 2012, millions of people around the world were anxiously watching YouTube as Austrian pilot and skydiver Felix Baumgartner was preparing to do something no one else on Earth had done before. Baumgartner was going to ascend 24 miles above the planet, carried aloft by a hot-air balloon in a tiny space capsule, and then ... jump! (see Figure 2.8). If he succeeded, it would be breaking a multitude of records but if he failed, it would become a fatal accident witnessed by millions. Fortunately, Baumgartner landed safely in a remote corner of New Mexico. Moreover, he set a new record for the largest ever simultaneous viewing audience on YouTube: eight million people. The previous record of 500,000 viewers had been set by that summer's Olympics. Clearly, the Internet proved that day that it could attract a massive live audience.

What the Digital Revolution Means for Content

As we have seen, digital technology has had a colossal impact on content, giving us many new forms of entertainment and new

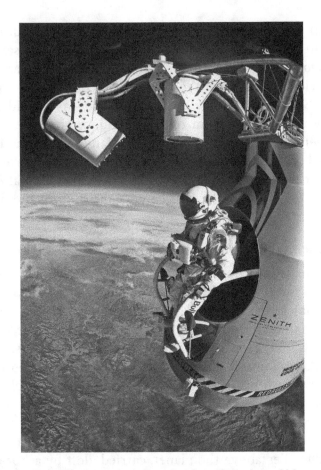

FIGURE 2.8 Felix Baumgartner is poised on the edge of his space capsule, about to jump—this moment was watched by millions on YouTube. Image courtesy of Balazs Gardi.com, Red Bull content pool.

ways to receive information. Furthermore, digital technology is providing individuals with new ways to express themselves.

Types of User-Generated Content

Unlike other types of digital entertainment which is created by digital media professionals, the material found on sites that support user-generated content is largely created by the users themselves. These online destinations can roughly be divided into four general genres: virtual worlds; social media sites; video-sharing sites; and sites featuring fan fiction. In addition, private citizens

have become "Citizen Journalists," reporting about ongoing events from their mobile phones. In addition, there is another type of user-generated digital content, *Machinima*, though it is not primarily an online form.

Virtual Worlds

Virtual worlds are online environments where users control their own avatars and interact with each other. These worlds may have richly detailed landscapes to explore, buildings that can be entered, and vehicles that can be operated, much like a massively multiplayer online game (MMOG). However, these virtual worlds are not really games, even though they may have some game-like attributes. Instead, they serve as virtual community centers, where people can get together and socialize, and, if they wish, conduct business.

Second Life, introduced by Linden Lab in 2003, has been the most successful of these virtual worlds, though its popularity has dimmed somewhat in recent years. Once it had a population of one million residents, though now it is inhabited by only about 600,000 people. It is a complex environment, offering different types of experiences to different residents, much like real life. It is a thriving center of commerce, for instance, where residents can buy and sell real estate, crafts, fashionable garments, and other goods. They can build their dream houses here and furnish them lavishly. People who like to party can fill their social calendar with all kinds of lively events. But *Second Life* can also be a place of higher learning. Real universities, including Harvard, Oxford, Cornell, and MIT, have had a presence there and have conducted classes for real students in *Second Life*. In addition, corporations have held shareholder meetings there and politicians have set up campaign headquarters there. It can also be a romantic destination. Residents have met in *Second Life*, fallen in love, and gotten married in real life.

No other virtual world has come close to the success of *Second Life*, which offers unrivaled freedom to its residents, amazing places to explore, and where at least one resident has become a millionaire by selling real estate in this virtual world. However, a new type of virtual world is now open for the same kind of exploration,

socializing, and all the other experiences that *Second Life* offers. The difference is that this one, named *Sansar*, exists in virtual reality. It was launched in beta in 2017 and developed by Linden Lab, which also built *Second Life*. This is not to say that there are no other virtual worlds. *Minecraft*, which offers an enormous landscape to explore as well as structures to build and game-like activities like surviving attacks from monsters, is tremendously popular both with adults and children. Many other virtual worlds exist as well, though none so far has enjoyed the longevity of *Second Life*. Sadly, *Club Penguin*, one of the most popular virtual worlds for children, was discontinued at the end of 2018.

> **STRANGE BUT TRUE: PINT-SIZED VIRTUAL WORLDS**
>
> While *Second Life* is intended for grown-ups, children need not feel left out of the chance to enjoy virtual worlds. At a site called *Sqwishland*, which is based on a line of toys, kids enter the game after acquiring a real-life toy, which comes with a code. The code serves as a free entry into the game and their toys come to life in *Sqwishland*. Players can earn in-game currency (Squash) with which they can buy clothes for their avatars and other items. *Sqwishland* is designed and managed by a team in Manila, Philippines.

Social Media Sites

Social media sites are designed to allow users to share details of their personal or professional lives and to connect with others. The most popular of these sites is Facebook, which has an estimated 2.27 billion active monthly visitors worldwide. Along with personal profiles, users can post updates about their lives to Facebook, as well as photos and videos. Different social media sites specialize in different types of content. On Twitter, for example, the focus is on extremely brief comments, limited to 140 characters until the limit was raised to 280 characters in 2017. Twitter has 336 million active monthly users worldwide. Pinterest is primarily designed for posting photos and arranging them by categories onto boards. Other popular social media sites include Tumblr, Instagram, and

LinkedIn. For storytelling and gaming on social media sites, please see Chapter 8.

Video-Sharing Sites

Some websites primarily serve as online spaces where users can share their own creative works, primarily videos and animation. YouTube is the best known and most successful of these. Created in 2005, it has become an enormously popular place for people to upload their own videos and view videos made by others. While much of the content is made by non-professionals, it also hosts slickly made commercial material. For example, politicians sometimes use YouTube to try to woo prospective voters. Content made for YouTube has created new celebrities who can sometimes rival celebrities found in the world of Hollywood movies, and has even turned certain cats into mega-stars.

Fan Fiction

Fan fiction, also known as fanfic, is a type of narrative that is based on a printed or produced story or drama, but is written by fans instead of by the original author. Works of fan fiction may continue the plot that was established in the original story, may focus on a particular character, or may use the general setting as a springboard for a new work of fiction. This genre of writing began long before the advent of digital media. Some experts believe it dates back to the seventeenth century, beginning with sequels of the novel *Don Quixote* that were not written by Miguel de Cervantes himself but by his admirers. Since then, other popular novels have been used as launching pads for fan fiction. In the twentieth century, until the birth of the Internet, this type of writing primarily revolved around the science-fiction TV series, *Star Trek*. With the Internet, however, fan fiction has found a welcoming home and a wider audience. Sites for this type of user-generated content abound, with fans creating stories for everything from Japanese anime to Harry Potter novels, as with *Potter Puppet Pals*.

Machinima

Machinima, a term which combines the words "machine" and "cinema," is a form of filmmaking that borrows technology,

scenery, and characters from video games but recombines them to create original stories. Though it is a form of user-generated content, it is not, as noted above, an Internet-based form, though works of machinima can be found on the Web.

One well-known machinima production is *Red vs. Blue*, a multi-episode tongue-in-cheek science-fiction story about futuristic soldiers who have strange encounters in a place called "Blood Gulch." Works of machinima are often humorous, possibly because the characters, borrowed as they are from video games, are not capable of deep expression.

Film connoisseurs have begun to regard machinima as a genuine and innovative form of filmmaking. A group of these films were shown at Lincoln Center in New York City, where they were described as "absurdist sketch comedy." Machinima has even found a foothold in the documentary film community, where it has been used to recreate historic battle scenes.

Thus, as demonstrated by these very different types of user-generated content, digital tools can give "regular people" the opportunity to do things that may be difficult to do outside of cyberspace—the opportunity to socialize, express themselves, be creative, and share and even sell their creations.

Digital Technology and the Arts

It should be stressed that amateurs are not the only ones to use digital tools. Practitioners in the fine arts are also using them. Although for the most part outside of the scope of this book, innovative works using computer technology are being made in the fields of visual arts, music, performing arts, poetry, fiction, and creative non-fiction. For lack of a better term, these works are often labeled as "new media art."

In some cases, these works can be found in mainstream environments. Just as one example, in 2007 the London Philharmonic performed a virtual reality version of Igor Stravinsky's ballet, *Le Sacre du Printemps*, at the newly refurbished Royal Festival Hall in London. Using Stravinsky's music as a springboard, media-artist and composer Klaus Obermaier designed a piece in which dancer Julia Mach interacted with the music and the three-dimensional

images projected onto the stage. Members of the audience watched the performance wearing 3-D glasses.

Musicians are also experimenting with the Vocaloid and Utau programs, which are singing voice synthesizers.

In the area of visual arts, several major museums, such as the Metropolitan Museum and Whitney Museum in New York City, contain new media artworks in their collections, and in some cases, museums have held exhibits that heavily feature such works. For instance, the Museum of Contemporary Art in Los Angeles held an exhibition in 2005 called *Visual Art*, which contained a number of new media art pieces. The exhibit explored the relationship between color, sound, and abstraction.

In addition, a new visual art form has spring up called *projection mapping*. This is a projection technology used to turn objects into a display surface for video projection. These objects can be irregularly shaped and can include everything from large buildings to surfaces as small as a vase.

One of the most dazzling projection mapping exhibits in recent years was the show of Gustav Klimt paintings at the Atelier des Lumières in Paris in 2018. The immersive exhibit of Klimt's paintings, set to music, was held inside a former foundry, an enormous space emptied of the foundry equipment. His paintings were enormously enlarged and projected onto the walls, columns, and the floor of this space. They were constantly in motion and changing, revolving around the space almost like a parade, but a parade with a continuum of new entries. At times they moved quickly and at times more slowly, with various details enlarged and animated and the works melting into each other. Visitors could wander around at will and could climb up to a balcony to see a different view of the artwork. There was no formal seating, though you could sit on the floor if you wished. Wherever you were in the space, you were immersed in the paintings and in the music. The exhibit was so popular that it was extended several times.

For the most part, however, artists who work in new media are still struggling to find an audience, and most of them support themselves by teaching at universities. This is also the case of writers who work in digital literature. This type of writing is sometimes called *hyperliterature*, a catch-all phrase that includes

hypertext, digital poetry, nonlinear literature, electronic literature, and cyberliterature. Several websites specialize in this kind of writing, including the Hyperliterature Exchange and Eastgate, a company which publishes hypertext. In addition, the Electronic Literature Organization promotes the creation of electronic literature and *The New River* is a journal devoted to digital writing and art. A particularly lovely example of this kind of work is the hyperliterature version of the Wallace Stevens poem, *Thirteen Ways of Looking at a Blackbird*, recreated as short Flash animation pieces by British artist/writer Edward Picot (http://edwardpicot.com/thirteenways/blackbirdsinterface.html).

Unfortunately, there is not sufficient room in this book to delve deeply into the realm of fine arts. However, we will be covering a number of works that fall into this category, particularly in the fields of interactive cinema and immersive environments.

A Global Perspective

Although many of the developments mentioned in this chapter, as well as many of the statistics cited, refer specifically to the United States, it is important to keep in mind that digital entertainment is popular throughout the world, and that software production centers are also scattered worldwide. The United States does not have the same stranglehold on digital media as it does on the television and motion picture industry, and even lags behind other developed countries in some forms of digital technology. Countries from India to South Africa to Australia are creating innovative content for digital media and devices.

Furthermore, some forms of digital technology and entertainment are better established outside of the United States than within its borders. Cell phones and content for them are tremendously successful in Japan. Japan is also home to TeamLab, which produces magnificent immersive experiences which have been shown not only in Japan, but also China, Singapore, Finland, the US, and the UK. Scandinavian countries lead the way in innovative social media and transmedia storytelling.

In addition, China has its own microblogging site, Sina Weibo, which has over 431 million monthly active users as of 2018. Like

Twitter, Weibo has a 140-character limit. India has a growing video games development community, led by Dhruva Interactive, the oldest gaming company on the subcontinent. While Singapore is leading Asia when it comes to transmedia development, this approach to content is also taking place in South Korea, Japan, and Malaysia. China is the home of the huge new VR theme park, *Oriental Science Fiction Valley*. The park, which opened early in 2018, covers 330 acres, and offers 35 different VR attractions.

On the other side of the world, South Africa has created a family drama series, *Uk'shona Kwelanga*, that is distributed on WhatsApp, a free messaging service.

A variety of digital storytelling projects, at least one of which involves augmented reality, is being funded in Australia by Screen Australia. And according to Marco Sparmberg, Festival Director of the Hong Kong Webfest, Web series are being produced in Hong Kong and video game development is in high gear all over South East Asia.

This is just a sampling of digital storytelling projects around the world. But from this sampling alone, it is clear that many creators have jumped into this space, looking for new ways to tell stories.

Conclusion

Clearly, digital storytelling is no longer the niche activity it was several decades ago. While once barely known outside of a few research labs and academic institutions, it can now boast a worldwide presence and a consumer base numbering in the millions. It can be enjoyed in homes, schools, offices, theme parks and, via wireless devices, virtually anywhere. Furthermore, it is also no longer just the domain of teenage boys. Its appeal has broadened to include a much wider spectrum of the population, in terms of nationality, age, gender, and interest groups. It is powerful and universal enough to become a serious contender for the public's leisure-time dollars and leisure-time hours, and muscular enough to cause consternation in Hollywood.

A striking number of the breakthroughs that have paved the way for digital storytelling have come from unlikely places, such as military organizations and the laboratories of scientists. Thus,

we should not be surprised if future advances also come from outside the ranks of the usual suppliers of entertainment content.

Various studies have documented the enthusiasm young people have for interactive media. This demographic group has been pushing interactive entertainment forward, much like the maker of a snowman rolls a ball of snow along the snowy ground, causing it to continuously expand in size. Almost inevitably, as members of this segment of the population grow older, they will continue to expect their entertainment to be interactive. But will the same kinds of interactive programming continue to appeal to them as they move through the various stages of life? And how can emerging technologies best be utilized to build new and engaging forms of interactive entertainment that will appeal to large groups of users? These are just two of the questions that creators in this field will need to address in coming years.

Idea-Generating Exercises

1. Try to imagine yourself going through a normal day, but as if the calendar had been set back 50 years, before computers became commonplace. What familiar devices would no longer be available to you? What everyday tasks would you no longer be able to perform, or would have to be performed in a quite different way?
2. What if you had just been given the assignment of creating a work of entertainment for a brand-new interactive platform, one that had never been used for an entertainment purpose before? What kinds of questions would you want to get answers to before you would begin? What steps do you think would be helpful to take as you embarked on such a project?
3. Most children and teenagers in developed countries are major consumers of interactive entertainment, but what kinds of interactive projects do you think could be developed for them as they move into adulthood, middle age, and beyond? What factors would need to be considered when developing content for this group as they mature?

4. Consider a technology developed for pragmatic purposes, such as drones or 3-D printing, and try to devise a digital story or game that could employ such a device.
5. Play several of Alexa's audio stories of games and critique them. What are the strongest features of each and in what ways are they weak? Overall, what are the most effective techniques you find in these works?

Part 2
Creating Story-Rich Projects

Part 2

Creating Story-Rich Projects

Chapter 3

Interactivity and Its Effects

How does the use of interactivity radically change the way an audience experiences a narrative?

How does the use of interactivity radically change the narrative material itself?

What are the pros and cons of giving the audience some control over story?

What techniques can be used to help create cohesion in works of digital storytelling?

What Is Interactivity?

Without interactivity, digital entertainment would simply be a duplicate of traditional entertainment, except that the medium in which it is presented, such as video or audio, would be in a digital format rather than an analog format. To the audience member or listener, however, the difference would be minimal except perhaps in the quality of the picture or sound. Essentially, the experience of "consuming" the entertainment would be exactly the same.

It is interactivity that makes digital media such a completely different animal from traditional storytelling forms, like movies, television, and novels. All stories, no matter how they are told—whether recited by a shaman, projected onto a movie screen, or played out on a game console—have certain universal qualities: they portray characters caught up in a dramatic situation, depicting events from the inception of the drama to its conclusion. Interactivity, however, profoundly changes the core material, and profoundly changes the experience of those who are the receivers of it.

We've all probably heard and used the word "interactivity" hundreds, even thousands, of times. Because of overuse, the word has lost its fresh edge, somewhat like a kitchen knife that has grown dull because it's been used so often. Let's take a moment to consider what interactivity means and what it does.

Interactivity is a two-part word. The first part, *inter*, a prefix, means "between," implying a two-way exchange, a dialogue. The second part, *active*, means doing something, being involved or engaged. Thus, the word as a whole indicates an active relationship between two entities. When used in the context of narrative content, it indicates a relationship where both entities— the audience and the material—are responsive to each other. You, the audience member, have the ability to manipulate, explore, or influence the content in one of a variety of ways, and the content can respond. Or the content demands something from you, and you respond.

Essentially, interactivity is one of only two possible ways of relating to narrative content; the other way is to relate to it passively. If you are passively enjoying a form of entertainment, you are doing nothing more than watching, listening, or reading, though you might also be making connections in your mind, or questioning something about the story. But with interactive content, you actually become a participant, and in robust works, your input can have an impact on how the story unfolds or ends. This is radically different from the way narratives have traditionally been experienced.

Interactivity as a Conversation

Interactivity can be thought of as a conversation between the user and the content, a concept articulated to me by Greg Roach

during a conversation about the subject. At the time, Roach was CEO of HyperBole Studios, the company that made such award-winning games as *The X-Files Game* and *Quantum Gate*. More recently, he served as Chief Technology Officer and Head of Innovation of the VR company, Spinview Global. As a digital media pioneer, he has given a great deal of thought to the subject of interactivity.

Roach compared the act of designing interactivity to the act of writing a sentence in a language like English, which uses the grammatical structure of a subject, object, and verb. As an example, he used a simple interactive scene in which you give your character a gun. The interactive "sentence" would be: he (the subject) can shoot (the verb) another character (the object). Carrying Roach's grammatical analogy a step further, the sentences you construct in interactive media use the active voice, and are not weighed down by descriptive phrases. ("He watered his horse" rather than "he was seen leading his dusty old horse down to the rocky creek, where he encouraged it to drink.") These interactive sentences are short and to the point, far more like Hemingway than Faulkner.

Roach is not alone in using grammatical terms to talk about interactivity. Many game designers use the phrase *verb set* in referring to the actions that can be performed in an interactive work. The verb set of a game consists of all the things players can make their characters do. The most common verbs are walk, run, turn, jump, pick up, and shoot.

WORTH NOTING: LEANING BACK versus LEANING FORWARD

Passive entertainment and interactive entertainment are often differentiated as "lean back" and "lean forward" experiences, respectively. With a passive form of entertainment like a movie or stage play, you are reclining in your seat, letting the drama come to you. But with an interactive work—a video game, for instance—you are leaning forward toward the screen, manipulating the action with your controller or keyboard or even your body movements.

What Happens to the Audience?

The way one experiences interactive entertainment is so different from the way passive entertainment is experienced that we rarely even use the word "audience" when we are talking about interactive works. More often than not, we talk about such people in the singular rather than in the plural. This is probably because each individual journeys through the interactive environment as a solo traveler, and each route through the material is unique to that person.

Because each user is in control of his or her own path through the material, interactivity can never truly be a mass audience experience. This is the case even when thousands of people are simultaneously participating in an interactive work, as they may be doing with a MMOG. Think how different this is from how an audience partakes of a movie or TV show, watching the same unvarying story unfold simultaneously with hundreds—or even millions—of other viewers. Of course, each member of the audience is running the story through his or her own personal filter and is probably having a somewhat different emotional response to the material. Yet no matter how intensely people might be reacting, there is nothing any member of the audience can do to alter a single beat of the tale.

It is an entirely different case when we are talking about interactive entertainment, and we may call upon one of several terms to describe the person who is in the process of experiencing it. If we're referring to someone playing a video game, we will use the term "player" or "gamer," while if a person is surfing the Web, we may use the term "visitor," and for simulations and immersive environments, we often call the person a "participant." One term that fits all types of interactive experiences is the word "user," which is the standard term we are employing in this book.

The User, the Author, and Interactivity

The people who participate in interactive entertainments are given two gifts that are never offered to audiences of passive

entertainments: choice and control. They get to choose what to see and do within an interactive work, and the decisions they make have an impact on the story. Less than 50 years ago, such freedom to manipulate a work of entertainment would have been unimaginable.

The user's ability to control aspects of the narrative is called *agency*. Essentially, agency gives the user the ability to make choices and to see and enjoy the results of those choices. Agency is one of the unique pleasures of digital storytelling. It is not limited to the kinds of verb sets we discussed earlier (run, jump, shoot, and so on) but also allows the user to navigate through the storyworld, create an avatar, change points of view, and enjoy many other kinds of interactive experiences that we will discuss later in this chapter.

Agency is something that is built into an interactive work right from the start, as an integral part of the concept, and in fact helps define what kind of work it will be. It is up to the creative team to decide what kind of agency the user will have and how it will be integrated into the work. Experienced interactive designers and producers know that great care must be given to crafting the way the user can interact with the work. Interactivity must be meaningful to be satisfying. In other words, the choices offered must make sense, must have consequences that make sense, and what the user does must have a true impact on the story. Users will quickly become dissatisfied with pointless, empty interactivity.

STRANGE BUT TRUE: HOW AGENCY CAN BACKFIRE

Experienced designers know that it can be a risky proposition to give users agency without thinking ahead to the various ways they might use or misuse it. A 2007 interactive advertising campaign for the Chevy Tahoe SUV underscores how agency can be used in unintended ways and can backfire on the producers. This online ad campaign gave users the chance to make their own commercial for the car, offering them a generous selection of videos of the interior and exterior of the vehicle, exotic settings in which to place the car, and background music, plus the ability to write their own text. To encourage participation, Chevy presented this as a contest.

> But the campaign went terribly wrong for Chevy. People who detested the Tahoe and hulking SUVs in general gleefully used the tools to make scathingly satirical commercials about the vehicle's role in creating pollution, waste, environmental destruction, and global warming. To its credit, Chevy actually ran some of these commercials on the contest website, but it was an embarrassing situation for the company and the commercials were pulled after a short time.

Many kinds of interactive works, most particularly virtual worlds and MMOGs, have been plagued with run-amuck agency, with a handful of players threatening to spoil the fun the designers had intended to offer. These ill-spirited players have had their avatars bully other players, engage in lewd acts, and even rob, steal, and murder.

As the Chevy Tahoe campaign illustrates, agency is a gift to the user but can cause serious trouble for the creative team. Designers invest a significant amount of time in devising ways of preventing the agency they offer from getting out of hand, while not unduly restricting the sense of freedom they want to give to the users. Agency can also thrust writers of interactive works into an unfamiliar and uncomfortable position, particularly if they come from the worlds of more traditional forms of writing, like screenplays, novels, or TV shows. In those fields, the writer has God-like powers over the narrative. The writer gets to choose who the characters are, what they do, and what they say. And the writer controls what happens to them. But in an interactive work, this kind of God-like control over the material must be shared with those individuals who in an earlier era would have been powerless and in your thrall—the members of the audience.

Producer Nuno Bernardo, in an article he posted to MIPBlog (January 24, 2012), wrote how the creators of *Sofia's Diary* controlled the possibility of runaway agency in that story. *Sofia's Diary* was a teen drama created for social networking site, Bebo. It was a bit like *LonelyGirl15*, in that it was about a young girl with many personal problems, and actually pre-dated *LonelyGirl15* by a few years. The creators encouraged users to become friends with the fictional characters and to offer their help when she was in

difficulty. But, he noted, "if you give your audience power over the story they will get rid of your antagonist, solve all the major problems and erase all the drama."

Thus, the creative team realized that the writers had to have complete control over the A plot line of the story, the main plot line. However,

> What they [the users] *could* alter was the 'B plot', which contained all the minor episodic dilemmas that were contained in Sofia's life … We allowed the audience to make minor changes in the show – so they felt that this was their show and was responding to their suggestions – but avoiding dramatic changes that could ruin all the drama of the story we wanted to tell.

Although agency gives users exciting new powers, not all the benefits go to them, and the creators of interactive narratives benefit, too. While it's true that those of us who are writers must give up a certain amount of control, we now have the opportunity to work on a far vaster canvas than in previous media, and with story tools never before available. We also have the exhilarating chance to create brand new kinds of narratives. And despite the amount of agency given to the user, we still do retain ultimate authorial control. We, along with our fellow design team members, create the project's storyworld and its possibilities, the kinds of characters who will live there, and the kinds of challenges they will face.

Immersiveness

One of the hallmarks of a successful interactive production is that it envelops the user in a rich, fully involving environment. The user interacts with the virtual world and the characters and objects within it in many ways and on many levels, and the experience might even be *multi-sensory*, meaning that it may stimulate multiple senses. In other words, an interactive production is immersive. It catches you up and involves you in ways that passive forms of entertainment can rarely do.

The power of immersiveness was brought home to me by an experience I had during the Christmas season one year in Santa Fe, New Mexico. It was my first year of living there, and I'd heard

a great deal about the city's traditional holiday procession called *Las Posadas*, so I decided to see it for myself.

Las Posadas originated in medieval Spain as a nativity passion play and was brought to New Mexico about 400 years ago by the Spanish missionaries. They felt *Las Posadas* would be a simple and dramatic way to ignite the religious spirit of the local Pueblo Indians, and hopefully turn them into good Catholics.

Las Posadas, which is Spanish for "the inns," recreates the Biblical story of Mary and Joseph's search for a night-time shelter and place where Mary can give birth. It is performed with different variations in towns all over the Southwest and Mexico, but the basic elements remain the same. In Santa Fe, the procession takes place around the historic town plaza. Mary and Joseph, accompanied by a group of musicians and carolers, go from building to building asking for admittance, but each time they make their appeal, the devil emerges and denies them entrance, until at last they find a place that will receive them.

On the evening of Santa Fe's *Las Posadas*, my husband and I waited in the crowd with the other spectators, all of us clutching candles and shivering in the icy night air, waiting for the event to begin. Finally, the first members of the procession appeared, holding torches to light the way. Mary and Joseph followed, with a group of carolers around them. The group paused in front of a building not far from us, and all proceeded to sing the traditional song, which pleads for lodging. The devil popped up from a hiding place on the roof and scornfully sang his song of refusal. It was very colorful, very different from anything I'd seen before back in California, and I was glad we had come (see Figure 3.1).

But then I noticed that a number of people were breaking away from the throng of bystanders and joining in the procession. Spontaneously, I pulled my startled husband into the street after them. In a flash, we went from being observers to being participants, and began to experience *Las Posadas* in an entirely different way. Marching with the procession, we became part of the drama, too, and fully immersed in it.

For the hour or so that it lasted, I became someone else. No longer was I a twenty-first century Jewish writer. I became a pious

FIGURE 3.1 A *Las Posadas* procession in Santa Fe. Photograph by Kathy De La Torre of the *Santa Fe New Mexican,* courtesy of the *Santa Fe New Mexican.*

Catholic pilgrim transported back to a wintry medieval Spanish village. Some of this I experienced on a personal and physical level: I had to watch my step, taking care not to slip on a patch of ice or trip on a curb or get ahead of the Holy Family. I was aware of the scent of burning candles all around me, and the press of the crowd. Much of the experience was emotional and communal: my husband and I would do our best to sing along with the carolers and Holy Family when it came time to ask for a room at the inn. Whenever the devil would appear on a rooftop or balcony, we would join in the hearty boos and derisive shouts of the processioners.

The best moment came when Mary and Joseph stopped in front of the heavy gates of the historic Palace of the Governors, the former seat of New Mexico's colonial government. Once again, we all sang the imploring song, but this time the gates swung open! A joyous cheer went up from the processioners, our voice among them, and we all surged into the courtyard. Welcoming bonfires and cups of hot cocoa awaited us.

Becoming part of *Las Posadas* instead of merely observing it transformed the experience for me. It was like the difference between watching a movie and suddenly becoming a character in it. To me, it vividly demonstrated the power of immersiveness—one of the most compelling and magical aspects of interactive media.

Immersiveness can involve all the senses. I have even had a student experiment with the sense of taste. The student, Keredy Scott, developed a story in which you, the user, were instructed to eat chocolate at certain points in a story she had created.

Types of Interactivity

Users can interact with digital content in a variety of ways, and different types of interactive media lend themselves to different types of interactivity. For instance, the Internet is particularly good at providing opportunities to communicate with fictional characters and other users; smart toys excel at offering one-on-one play experiences; video games give users great control over objects. Each of the interactive media has its limitations, as well. In an immersive environment, a participant's ability to control objects may be limited. Game consoles, unless connected to the Internet, are restricted to just a few players at a time. When it comes to the types of interactivity offered by the various digital media, no one size fits all.

That said, however, six basic types of interactivity can be found in almost every form of digital storytelling. They are like the basic foodstuffs a good cook always keeps in the pantry, and can be used to make a wide variety of dishes. The basic types of interactivity are as follows:

1. *Stimulus and response.* The stimulus might be something as simple as a highlighted image that the user clicks on and is rewarded by a little animated sequence or hearing a funny sound, or it might involve having to solve a puzzle, after which the user is rewarded by the occurrence of some sought-after event: the door to the safe swings open, or a character reveals a secret. Generally speaking,

the stimulus comes from the program and the response from the user, although there are exceptions. For instance, smart toys recognize and respond to actions taken by their child owners, such as squeezing the toy's hand. The stimulus–response exchange is a universal component of all interactive programming.
2. *Navigation.* Users can move through the program in a free-form manner; in other words, they can simply choose what to do. Navigation may offer a vast, 3-D world to explore, as in a video game or MMOG. Or it may be more limited, restricted to choosing options from a menu offered on a DVD or icons on a website. Navigation, like the stimulus–response exchange, is a universal component of every form of interactive programming.
3. *Control over objects.* The user can control virtual objects. This includes such things as shooting guns, opening drawers, and moving items from one place to another. While a fairly common form of interactivity, this one is not entirely universal.
4. *Communication.* The user can communicate with other characters, including those controlled by the computer and other human players. Communication can be done via text that the user types in, or via choosing from a dialogue menu, by voice, or by physical actions (such as waving a hand in front of a Wii). Generally, communication goes both ways—characters or other players can communicate with the user, too. As with number 3, it is a common, but not universal, form of interactivity. Voice recognition systems like Amazon's Alexa give us a whole new world of possible interchanges between humans and virtual characters.
5. *Exchange of information.* This can include anything from sending in comments to online forums to sending in videos to a fictional character on YouTube. This form of interactivity is generally found in devices that have a connection to the Internet.
6. *Acquisition.* The nature of the material can range from virtual to concrete, and the methods of acquiring it can

range greatly as well. Users can collect information (such as news bulletins or medical facts) or purchase physical objects (books or clothing). They can also collect virtual objects or assets in a game (a magic sword; the ability to fly) or receive an upgrade in status. This type of interactivity is common in any medium that involves the Internet, and is built into almost all video games.

Using these six basic "ingredients," digital creators can "cook up" a great diversity of interactive experiences for people to participate in. They include:

1. Playing games. There is an almost infinite variety of games users can play: trivia games, adventure games, shooters, mysteries, ball games, role-playing games, and so on.
2. Participating in a fictional narrative.
3. Exploring a virtual environment.
4. Controlling a simulated vehicle or device: a fighter jet, a submarine, a space ship, or a machine gun.
5. Creating an avatar, including its physical appearance, personality traits, and skills.
6. Manipulating virtual objects: changing the color, shape, or size of an object; changing the notes on a piece of music; changing the physical appearance of a room.
7. Constructing virtual objects such as houses, clothing, tools, towns, machines, and vehicles.
8. Taking part in polls, surveys, voting, tests, and contests.
9. Interacting with smart physical objects: dolls, robotic pets, wireless devices, androids.
10. Learning about something. Interactive learning experiences include edutainment games for children, training programs for employees, and online courses for students.
11. Taking part in a simulation, either for educational purposes or for entertainment.
12. Setting a virtual clock or calendar to change, compress, or expand time.
13. Socializing with others and participating in a virtual community.

14. Searching for various types of information or for clues in a game.
15. Sending or receiving items, for free or for money, including physical objects, virtual objects, as well as information.

This is by no means an exhaustive list, though it does illustrate the great variety of experiences that interactivity can offer, and the uses to which it can be put.

How Interactivity Impacts Content

These various forms of interacting inevitably affect one's content. Users expect to be offered a selection of choices, but by offering them, you give up your ability to tell a strictly determined linear story or to provide information in a fixed order.

To see how this works, let's compare a linear and interactive version of a familiar story, the Garden of Eden episode from the Bible. The Garden of Eden episode is one of the best-known creation stories in the Western world, and thus seems an appropriate choice to illustrate the creative possibilities of changing a linear story into an interactive one.

As it is handed down in Genesis, the story involves three characters: Adam, Eve, and the serpent (see Figure 3.2). Each of them behaves in exactly the same way no matter how often one reads about them in the Old Testament. And the alluring tree that is the centerpiece of the story is always the Tree of the Knowledge of Good and Evil. God has warned Adam and Eve not to eat its fruit, though they are free to enjoy anything else in the garden. The serpent, however, convinces Eve to sample the forbidden fruit, which she does. She gets Adam to try it, too, at which point they lose their innocence and are expelled from the Garden. It is an extremely simple but dramatic story.

Now let's construct an interactive version of the same story. We'll use the same three characters and the same tree, but offer the player an array of choices. Let's say the tree now offers five kinds of fruit, each with the potential for a different outcome. If Eve picks the pomegranate, for instance, she might immediately become pregnant; if she eats too many cherries, she might get fat;

FIGURE 3.2 Raphael's *Garden of Eden*, showing Adam, Eve, the serpent, and the tree. An interactive version of this simple Bible tale can quickly spin out of control.

only if she eats the forbidden fruit would the narrative progress toward the results depicted in the Bible.

As for the serpent, let's allow the user to decide what this character should be: malevolent or kindly, wise or silly. And we'll let the user decide how Eve responds to him, too. She might ignore him, or tell him to get lost, or try to turn him into a docile house pet … or, she might actually listen to him, as she does in the Bible. We'll give the user a chance to determine the nature of Adam and Eve's exchange, too. Adam might reject Eve's suggestion to try the fruit, or might come up with several suggestions of his own (open up a fruit stand, or make jam out of the tree's cherries). Or they may hotly disagree with each other, resulting in the Bible's first marital spat. Suddenly we have a vast multitude of permutations springing out of a simple story.

Note that all of this complexity comes from merely offering the player one of several options at various nodes in the story. But what if you gave the players other types of interactive tools? You might allow them the opportunity to explore the entire Garden of Eden and interact with anything in it. They could investigate its rocky grottos, follow paths through the dense foliage, or even snoop around Adam and Eve's private glade. Or what if you turned this into a design challenge, and let users create their own Garden of Eden? Or how would it be if you turned this into a role-playing game, and let the user play as Adam, as Eve, or even as the serpent? Or what if you designed this as a community experience, and gave users the chance to vote on whether Eve should be blamed for committing the original sin?

Our simple story is now fragmenting into dozens of pieces. What once progressed in an orderly manner, with a straightforward beginning, middle, and end, and had a clear and simple plot, has now fallen into total anarchy. If adding interactivity to a simple story like the Garden of Eden can create such chaos, what does it do to a more complex work?

Using Gaming Techniques to Supply the Missing Cohesion

Because interactivity can break up the cohesiveness of a narrative, it becomes necessary to look for other ways to tie the various elements together and to supply the momentum that, in traditional storytelling, would be supplied by the plot. Many professionals in digital media believe that the best solution is to use a gaming model as the core of an interactive work, and build narrative elements around it. Games provide an attractive solution because they involve competition, contain obstacles and a goal; and offer a clear-cut goal. While stories in traditional media use these same elements, they are less obvious, and great attention is placed on other things, such as character development, motivation, the relationship between characters, and so on.

Designer Greg Roach, introduced earlier in this chapter, is one of those professionals who is inclined to turn to games to help knit the various pieces of an interactive work together. "When you discard

all aspects of gaming, how do you motivate people to move through the narrative?" he asks rhetorically. "The fundamental mechanisms of games are valuable because they provide the basic tool sets."

Roach sees stories and games as two very different types of artifacts—artifacts being objects created by human beings. Roach says, "A story is an artifact you experience as dynamic process while a game is a process you enter into that creates an artifact when it ends." Roach feels that interactive works have, as he puts it, "immense granularity." Granularity is a term Roach and others in interactive media use to mean the quality of being composed of many extremely small pieces.

Roach describes films and other types of linear narratives as "monoliths, likes of block of salt," and for interactivity to be possible, he says the monoliths must be broken up into fine pieces. "These granules of information can be character, atmosphere, or action. But if a work is too granular, if the user is inputting constantly, there are no opportunities for story." Roach stresses that in order to have an interactive story, "you must find a balance between granularity and solidity. You need to find the 'sweet spot'—the best path through the narrative, the one with the optimum number of variables."

Despite the differences between stories and games, Roach believes a middle ground can be found, a place to facilitate story and character development in an interactive environment.

One of the challenges Roach sees in constructing a nongaming interactive story is the task of providing the player with motivation, an incentive to spend time working through the narrative. But he suggests another approach as well. Roach believes that people like to solve problems, the tougher the better, and feels that a major distinction between games and stories is the types of problems they present, plus the tools that can be used to solve them. In a game, he suggests, the problem might be getting past the monster on the bridge. In a story, the problem might be getting your son off drugs and into rehabilitation.

Games as Abstract Stories

Janet H. Murray, a professor at the Georgia Institute of Technology and the author of one of the best-known books on interactive

narrative, *Hamlet on the Holodeck*, takes things a step further than Roach. In her book, she asserts that games and drama are actually quite closely aligned, and that games are really a form of "abstract storytelling."

To underscore the close connection between stories and games, Murray points out that one of our oldest, most pervasive, and popular types of games—the battle between opposing contestants or forces—is also one of the first and most basic forms of drama. The Greeks called this opposition *agon*, for conflict or contest. Murray reminds us that opposition, or the struggle between opposites, is one of the fundamental concepts that we use to interpret the world around us (big/little; boy/girl; good/evil).

Although Murray does not say so explicitly, every writer of screenplays is keenly aware of the importance of opposition. Opposition leads to conflict, the heart of all drama. Writers realize that unless the hero of the drama is faced with an imposing challenge or opponent, a script will lack energy and interest. For an interactive narrative to work, it too must pit opposing forces against each other. Thus, games and dramas utilize the same key dynamic: opposition. As we will see in Chapter 5, which focuses on character, this concept of opposition is so key to drama that it defines how we think of our heroes and villains.

Opposition is not the only way that games and drama are alike, Murray believes. She suggests, in fact, that games "can be experienced as symbolic drama." She holds that games reflect events that we have lived through or have had to deal with, though in a compressed form. When we play a game, she says, we become the protagonist of a symbolic action. Some of the life-based plot lines she feels can be found in games include:

- Being faced with an emergency and surviving it
- Taking a risk and being rewarded for acting courageously
- Finding a world that has fallen into ruin and managing to restore it
- Being confronted with an imposing antagonist or difficult test of skill and achieving a successful outcome

Drama in an Abstract Game

Janet Murray is even able to find a life-like symbolic drama in abstract games like *Tetris*. In *Tetris*, players have to maneuver falling puzzle pieces so they fit together and form a straight row. Each completed row floats off the bottom of the game board, leaving room for still more falling puzzle pieces. To Murray, the game resembles our struggles to deal with our over-busy lives, and is like "the constant bombardment of tasks that demand our attention and that we must somehow fit into our overcrowded schedules and clear off our desks in order to make room for the next onslaught" (*Hamlet on the Holodeck*, p. 144).

Games, Murray asserts, give us an opportunity to act out the important conflicts and challenges in our lives, and to create order and harmony where there was messiness and conflict.

In many ways, Murray's view of games is much like Joseph Campbell's view of ritual ceremonies—activities that provide us with a way to give meaning to important life experiences and to provide us with emotional release. In its most powerful form, this emotional release is experienced as a catharsis.

Stories That Are Not Games

In examining the relationship between stories and games, let us not forget what designer Greg Roach asserted: that it is possible to create interactive stories that are not based on game models. We can find examples of game-free narratives in many genres of digital storytelling. One small enclave of such narratives is called, fittingly enough, Interactive Fiction (IF). Works of IF can be found on the Internet and they are also available on CD-ROMs. Though the creators and fans of IF are a fairly small group, often found within academic circles, they are dedicated to advancing this particular form of storytelling.

Traditional works of IF are often text-based (although the term is sometimes used for adventure games and other works that are animated or are done on video). To see/read/play a work of IF, you need to be sitting in front of a computer, inputting your commands with a keyboard. The story advances and reveals itself as the user types in commands ("open the door" or "look under the

bed" or "ask about the diamond"). Unlike hypertext, you must do more than click on a link; you must devise phrases that will give you the most meaningful and useful way to advance the story.

IF stories can be about almost any topic and can be written in just about any fictional genre, although they work best when the plots call for you to be active, to explore, and to make things happen. They need not be plot driven, however. *Galatea*, written by Emily Short, is an intriguing character sketch that is constructed as a dialogue between the user and a Nonplayer Character (NPC)—a character controlled by the computer. The story is based on the Greek myth of Pygmalion, a sculptor who carves a beautiful statue, Galatea. The statue comes to life after he falls in love with her. It is the same myth that inspired the Broadway musical, *My Fair Lady*.

In this interactive version of the myth, you visit the art gallery where *Galatea* is displayed and discover that you are able to talk with her. As you converse with her, you gain insights into her history and troubled emotional state. Her responses to your questions vary, as does her attitude toward you, depending on how you treat her (see Figure 3.3).

```
>ask about eyes
"What was it like, having your eyes carved?" you ask.

"He drilled at the corners," she says.  "And that was
agony -- waiting to see whether he would go too deep.  He
never did, but there was always doubt."

>ask about seeing
"When did you first begin to see?" you ask.  "Was it when
your eyes were finished, or could you somehow see before
that?"

"Before that," she says.  "Certainly before he began to
drill in the corners.  It was a gradual thing: everything
was dim and shadowed, and it grew brighter and sharper
the closer he came to the surface of my eyes, until I
could recognize colors, and know his face."

>ask about face
She just shrugs.
```

FIGURE 3.3 A segment of the IF work *Galatea* by Emily Short. Image courtesy of Emily Short.

IF stories resemble text-based adventure games as well as online MUDs and MOOs (MOOs, or MUD Object Oriented, are text-based adventure games closely related to MUDs). Unlike MUDs and MOOs, however, they are played by a single individual rather than with a group. Furthermore, they do not have the win/lose outcomes that are so much a part of adventure games, though they do often include puzzles that must be solved in order to progress. These narratives cannot be as tightly plotted as linear fiction, but they do generally have overarching storylines.

Throughout this book, we will be examining other works of digital storytelling that contain no overt elements of gaming, particularly works of iCinema (interactive cinema). These stories demonstrate that even though games are extremely useful vehicles for holding interactive narratives together, works of digital storytelling do not need to be dependent on game models in order to succeed.

Conclusion

Interactivity, as we have seen, profoundly changes the way we experience a work of entertainment. We go from being a passive member of the audience to becoming a participant with an active and meaningful role, wielding a new power called agency.

Interactivity, however, changes the role of the storyteller. Instead of being the sole creator of the story, this role must now be shared with the user. And interactivity makes the telling of a fixed, sequential, linear story impossible. To knit the story together and make it compelling, storytellers must find new models to use. Many rely on game techniques to achieve narrative cohesion, although some digital storytellers are finding other ways to construct satisfying interactive narratives.

While interactivity creates new challenges for storytellers, it also gives them new powers. Thanks to interactivity, it is possible to tell stories that are deeply immersive and intensely absorbing; that take place on a much vaster canvas; and that can be experienced from more than one point of view. The challenge for storytellers is to find ways to use interactivity effectively, so that users can enjoy both agency and a meaningful narrative experience.

Idea-Generating Exercises

1. Describe an event or occasion where you went from being a passive observer to an active participant. How did this shift affect the way you experienced the event? Your example could be something as simple as going from being a passenger in a car to actually driving the vehicle, or it could involve a more complex situation, like the *Las Posadas* procession described in this chapter.
2. If you are working on a project for a specific interactive medium or platform, make a list of the types of interactivity the medium or platform lends itself to most strongly, and the types of interactivity it does not support well or at all. Is your project making good use of the platform's strengths and avoiding its weaknesses?
3. Take a very simple, familiar story and work out different ways it would be changed by injecting interactivity into it, as with the Garden of Eden example. Your examples might be a story from the Bible, a child's nursery rhyme, or a recent news item.
4. Using a simple story like one chosen for the exercise above, redesign it as two different interactive experiences: one that is very story-like, and the other that is very game-like.

Chapter 4
Old Tools/ New Tools

What can an ancient Greek like Aristotle teach us that we can apply to modern interactive entertainment?
What aspects of traditional storytelling can be successfully ported over to digital storytelling?
When writers of traditional stories at first move into digital storytelling, what do they find most challenging?
What 10 entirely new tools must creators learn to use when they construct interactive narratives?

An Assortment of Storytelling Tools

Embarking on a new work of digital storytelling is usually a daunting proposition, even for veterans in the field. Each new project seems to chart new ground. Some call for a unique creative approach; others utilize new technology; still others combine media in new ways. And those who work in the newer areas of interactive entertainment—mobile apps, transmedia productions,

and innovative types of immersive environments—are faced with having to be a pioneer almost every time out. Furthermore, the complexities posed by interactivity, plus the sheer volume of material contained in most works of digital storytelling, can be overwhelming. No wonder starting work on a new project can feel like plunging into the abyss.

Nevertheless, even though we may feel we are starting from scratch, we actually have a wonderfully serviceable set of tools and techniques at our disposal, some of which we glimpsed in Chapter 1. Aristotle first articulated a number of these tools over 2,000 years ago. Other tools go back still further, to preliterate storytellers. And we can also borrow an array of tools from more recent storytellers—from novelists, playwrights, and screenwriters. Furthermore, we can raid the supply of tools originally developed for pre-electronic games of all types, from athletic competitions to board games.

As is to be expected, of course, the majority of these borrowed tools and techniques need to be reshaped to some degree for digital media. And at some point, we finally empty out our old toolbox and reach the point where we need to pick up and master some entirely new implements. Ultimately, it is a combination of the old and the new, seamlessly integrated together, that enables us to create engaging works of digital storytelling.

Learning from Games

Some of the most effective tools of storytelling, tools that can inject an intense jolt of energy into any type of narrative, were not even developed by storytellers. They originated in games. As we noted in Chapter 1, games are an ancient form of human social interaction, and storytellers in both linear and nonlinear media have borrowed heavily from them, as we saw in Chapter 3. Games can be used as a form of glue to hold an interactive work together.

Above all else, games teach us the critical importance of having a clear-cut goal, and also show us the importance of putting obstacles in the way of that goal. In other words, creating conflict. In games, the ultimate goal is to win the competition, and the players on the other side—the opponents—provide the biggest impediment

to achieving that goal. This player-versus-player opposition is what provides much of the excitement and drama in an athletic competition, in much the same way it does in storytelling. In addition, participants in sporting competitions must contend with physical obstacles and challenges, such as the hurdles on a track field, the net on the tennis court, or the steep roads in a cycling race.

> **WORTH NOTING: GOALS IN GAMES AND STORIES**
>
> In a good game, as well as in a good story, the best goals are:
>
> - Specific
> - Simple to understand
> - Highly desirable
> - Difficult to achieve
>
> Try to imagine a game or story without a goal. What would the players or characters be trying to do? What would keep the audience interested in watching something that has no clear objective? What would give the experience meaning? Virtually every story and every game has a goal, although some would argue that sandbox games like *Minecraft* have no goal. Nevertheless, players of sandbox games construct their own goals, whether it be to survive in a hostile world or to create a magnificent structure.

The essential mechanics of stories are remarkably similar to games, especially when it comes to goals and obstacles. In a story, the protagonist wants to achieve a goal, just as an athlete does, even though the type of goal being sought after is of a different order. The objective may be to find the buried treasure; win the love of the adored one; track down the killer; or find a cure for a desperately sick child. A goal provides motivation for the main character, a sharp focus for the action, and a through-line for the plot, just as a goal provides motivation and focus for a game. And in a story, as with a game, obstacles provide the drama, and the most daunting obstacles are human ones—the antagonists the hero must contend with.

Of course, some novels and works of short fiction present narratives in which the protagonist has no apparent goal, and so do

some art-house films. But even though such "slice of life" stories may be interesting character studies or be admirable for some other artistic reason, the narrative will usually feel flat because nothing is at stake. That is why it is difficult for such works to attract a wide audience.

The conflict between achieving a goal and the obstacles that hinder this victory is what creates conflict, and conflict is the heart of drama. The clearer the goal, and the more monumental the obstacles that stand in the way of achieving it, the greater the drama. The very first storytellers—those who recited the ancient myths and heroic epics of their culture—understood this, and made sure to emphasize all the difficulties their heroes had to overcome. Later storytellers, working in succeeding waves of media from classical theater to television and everything in between, recognized the value of goals and obstacles just as clearly. Not surprisingly, these fundamental story ingredients are just as useful in the creation of digital entertainment.

Games have provided storytellers with other valuable tools as well. From games, we learn that the most thrilling competitions are those that demand the most from a player—the most skill, the most courage, the most strategizing. Similarly, a good story demands that the protagonist give his or her all to the struggle. In an interactive work, the same demand is made on the user or the player. The greater the personal investment and the tougher the challenge, the sweeter the ultimate victory.

In addition, games are governed by specific sets of regulations. These not only add to the challenges but also help to keep the game fair. For example, players are only allowed to use approved types of equipment, or employ certain maneuvers and not others, or score a goal by doing X and not Y. Without such rules, victory would be too easy and the game would lack interest. Games not only have rules but also follow a set structure or format, though the specifics vary greatly among types of games. For example, a football game begins with a kickoff; a baseball game has nine innings; a basketball game is divided into quarters. No doubt, the first players of ancient sports soon found that without structure or rules, their games would quickly disintegrate into anarchy, and one side would use tactics that seemed completely unexpected and

unfair to the other side. Rules and structure provide an equally fair, consistent playing environment to all players.

For the same reason, stories in every medium have a structure and format for how they begin, how they develop, and how they end. Furthermore, although stories don't follow set rules, they are guided by internal conventions. This ensures that behaviors and events within the fictional universe are consistent and logical and make sense within the story. Even a fantasy universe like the one portrayed in the Harry Potter novels, films, and games must remain faithful to its own internal set of rules. For instance, if it is established that characters cannot pass through physical structures unless they recite a secret spell, Harry or one of his classmates should not suddenly be able to blithely walk through a wall without using the spell. That would violate the rules of magic already established in the story. Internal conventions provide a narrative equivalent of a fair playing field.

Learning from Myths

Contemporary storytellers, whether working in linear or interactive media, are also indebted to the great mythmakers of ancient days. These master tellers of tales built their stories upon themes with deep emotional and psychological underpinnings. As noted in Chapter 1, many of these old stories feature young heroes and heroines who must triumph over a series of harrowing obstacles before finally reaching their goal, and in the course of their adventures undergo a form of death and rebirth.

Joseph Campbell, introduced in Chapter 1, analyzed the core elements of the hero's journey and found that such myths contained characters that were remarkably similar from story to story, and that the myths contained extremely similar plot points. He held that the hero's journey tapped into the universal experiences shared by humans everywhere, reflecting their hopes and fears, and thus resonated deeply with the audience.

More recently, Christopher Vogler interpreted Campbell's work for contemporary readers and writers in a book called *The Writer's Journey*. The book profiles the archetypal figures who

commonly populate the hero's journey—characters with specific functions and roles to play—and he describes each of the 12 stages of the journey that the hero must pass through before being able to return home, victorious.

The hero's mythic journey has had a deep influence on storytellers throughout the world. Countless works of linear fiction—novels, plays, comic books, and movies—have been built on the model provided by the hero's journey. Among them are the films made by the great filmmaker George Lucas, who has often spoken of his debt to Joseph Campbell and the hero's journey. Even the magnificent film *Spirited Away*, a work of Japanese anime about a little girl trapped in a mysterious resort for ghosts, closely follows the 12 stages of this ancient myth.

This enduring model works equally well for interactive narratives. For example, the immensely involving game *Final Fantasy VII* contains many of the elements of the hero's journey. And a number of MMOGs incorporate it as well. After all, as a player, you set off for a journey into the unknown, meet up with various helpful, dangerous, or trickster characters along the way, find yourself tested in all sorts of ways, and do battle against powerful opponents.

Do writers, producers, and designers of these interactive versions of the hero's journey deliberately use this genre as a model? In some cases, yes, this modeling is conscious and intentional. For example, Katie Fisher, a producer/designer for the game company Quicksilver Software, Inc., is quick to acknowledge that she based the game *Invictus* on the hero's journey and used Christopher Vogler's book as a guide. In other cases, though, the hero's journey is probably an unconscious influence. After all, it is a story that is familiar to us from childhood—even many of our favorite fairy tales are simplified hero's journeys. And many a designer's most beloved movies are also closely based on this model, too, including such films as the *Wizard of Oz* and *Star Wars*. Obviously, elements in the hero's journey strike a deep chord within audiences both past and present. There is no reason why creators of interactive entertainment should not be able to find inspiration, as Katie Fisher has, in this compelling model.

Learning from Aristotle

Mythological themes have provided fodder not only for our first narrative tales, but also for our earliest theatrical works. For example, rituals based on the myths of Dionysus led to the development of classical Greek theater. Aristotle, one of the greatest thinkers of the ancient world, closely studied Greek theater, particularly the serious dramas, which were then always called tragedies. Based on his observations, he developed an insightful series of principles and recorded them in a slender, densely written volume, the *Poetics*. Though drafted in the fourth century BC, his ideas have held up astoundingly well right up to the present day. The principles discussed in the *Poetics* have been applied not only to stage plays, but also to movies, TV shows, and, most recently, are finding their way into interactive narratives.

Aristotle articulated such concepts as dramatic structure, unity of action, plot reversals, and the tragic flaw. He also made perceptive comments about character development, dialogue, plot, and techniques of eliciting a strong emotional response from the audience. Furthermore, he warned against using cheap devices that would undermine the drama. One such device he felt was unworthy of serious theater was the *deus ex machina*, Latin for "God from the machine." This device was called into play when a writer was desperate for a way to get a character out of a predicament and would solve the problem by having a god suddenly descend to the stage from an overhead apparatus and save the day. Aristotle decried such techniques and believed that plot developments should be logical and grow naturally out of the action.

One of Aristotle's greatest contributions to dramatic theory was his realization that effective dramas were based on a three-act structure. He noted that such dramas imitated a complete action, and always had a beginning, middle, and an end (acts I, II, and III). He explained in the *Poetics* (Chapter VII, Section 3) that

> A beginning is that which does not itself follow anything by causal necessity, but after which something naturally is or comes to be. An end, on the contrary, is that which itself naturally follows some other thing, either by necessity, or as a rule, but has nothing following it. A middle is that which follows something as some other

thing follows it. A well-constructed plot, therefore, must neither begin nor end at haphazard, but conform to these principles.

Entire books have been written on the three-act structure, derived from this short passage, applying it to contemporary works of entertainment, particularly to films. One of the most widely used in the motion picture industry is the late Syd Field's *Screenplay: The Foundations of Screenwriting*. The book breaks down Aristotle's points and expands on them in a way that modern writers can readily understand. The three-act structure is so widely accepted in Hollywood that even nonwriters, professionals like studio development executives and producers, feel completely comfortable talking about such things as "the first act inciting incident," "the second act turning point," and the "third act climax."

The idea of the three-act structure has also found a place in interactive media, most noticeably in games. But it is used in other types of interactive entertainment as well, including virtual reality simulations, location-based entertainment, interactive movies, and Web series. Of course, inserting interactivity into a narrative project impacts enormously on its structure, so additional models must also be called into play. Often, they are used in conjunction with the classical three acts first spelled out by Aristotle. (For a more detailed examination of structure in interactive works, please see Chapter 6.)

Aristotle also had valuable things to say about character motivation. He noted that motivation is the fuel which leads to action, and that action is one of the most important elements of drama. Just as the players' striving toward a goal is the driving force in a game, a character striving toward an objective is the driving force of a drama. Aristotle believed that there are two types of human motivation. One, he felt, is driven by passion and based on emotion. The other, he said, is based on reason or conscious will. In other words, one comes from the heart, the other from the head.

In interactive media, motivation is also of tremendous importance. It is what pulls the user through a vast universe of competing choices. By understanding motivation, we can create more compelling works of interactive entertainment.

Aristotle also believed that drama could have a profound effect on the audience, eliciting such emotions as pity and fear. The most

effective dramas, he felt, could create a feeling of catharsis, or emotional purging and relief—the same sort of catharsis Joseph Campbell said occurred when people took part in a reenactment of a powerful myth. Creators of interactive works have not, as a rule, put much effort into trying to produce projects with an emotional punch. Today, however, more attention is being paid to this subject, and it will be discussed in more detail in Chapter 5.

Learning from Contemporary Storytellers

When it comes to interactive entertainment, we can also learn a great deal from the creators of linear narrative, particularly from film and TV. These forms of entertainment already have great similarities to interactive media because they are stories told in moving images and sound, which is also how most interactive narrative is conveyed.

Two of the most important skills that can be ported over from film and television are character development and story construction. These are the fundamental building blocks of any type of narrative. Of course, they cannot be adapted without some adjustments, for interactivity has a profound impact on all aspects of the creative process.

Because I have made the transition from television and film into the interactive field myself, I am well aware of how the established techniques of character and story development can be used in digital storytelling. For example, one of my first jobs in interactive media was as a freelance writer doing some work on Broderbund's pioneering *Carmen Sandiego* series, a game that had kids playing the part of a detective and trying to track down the thieving Carmen or one of her henchmen. My assignment called for me to create four new characters for the game and to write dialogue for two of its already-established characters, the Chief of Detectives and Wanda, his assistant. These tasks were almost identical to work I might have done for a TV show, except that I had to write numerous variations of every line of dialogue. Thus, I found myself coming up with about a dozen different ways to say: "You bungled the case."

Another early assignment had me working out an interactive adventure story for children based on an idea proposed by actress-producer Shelley Duvall. Called *Shelley Duvall Presents Digby's Adventures* and developed by Sanctuary Woods, the CD-ROM was a story about a little dog who goes exploring, gets lost, and tries to find his way home. It was the kind of tale that could have easily been a kid's TV show, except for one thing: this was a branching, interactive story, so the little dog gets lost in three completely different ways. Each version offers the player numerous opportunities to become involved in the dog's adventures and help him find his way home.

Other Useful Old Tools

Aside from character development and story construction, what else can be borrowed from traditional storytelling? One excellent tool is tension. Although tension is something we try to avoid in our daily lives, it serves an important function in both linear and interactive narratives. It keeps the audience riveted to the story, experiencing a mixture of apprehension and hope, wondering how things will turn out. Tension is particularly important in interactive narratives because they don't have the benefit of linear plots—the carefully constructed sequence of events that advances the action and builds up the excitement in traditional stories. Creators of interactive stories have to work extra hard to keep users involved with their narratives, and ramping up the tension is a good way to keep them hooked.

One reliable method of inserting tension in a nonlinear story is to put your main character (who is often the player, via the avatar he or she is controlling) into great jeopardy … risking death in a snake-infested jungle, caught behind enemy lines in a war, or pursued by brain-sucking aliens in a sci-fi story. But the jeopardy need not be something that could cause bodily harm … the risk of losing anything of great value to the protagonist can also produce dramatic tension. Thus, the jeopardy can involve the threat of relinquishing everything your hero has worked so hard to achieve in the story, whether it is a vast sum of money, solving a baffling mystery, becoming a mafia godfather, or an inventory filled with valuable possessions.

Introducing an element of uncertainty can also increase dramatic tension. Which of the characters that you encounter can you trust? Which ones are actually enemies in disguise? Which route through the forest will get you to your destination quickly and safely, and which one might be a long and dangerous detour? Uncertainty is a close cousin to suspense, which is the burning desire to know what will happen next. It is the feeling of suspense that keeps us turning the pages of a novel until long past our bedtime and keeps us glued to a movie on TV when we know we really should be paying bills or doing something similarly responsible.

To pump up the adrenaline and keep the audience glued to the story, many works of both linear and nonlinear narrative use a device called a *ticking clock*. With a ticking clock, the protagonist is given a specific and limited period of time to accomplish his goal. Otherwise there will be serious and perhaps even deadly consequences. A ticking clock is an excellent way to keep the momentum of a story going. The ticking clock can even be found in children's fairy tales. Cinderella, for example, must rush out of the ballroom before the clock strikes 12, or else she will be caught in public in her humiliating rags. Movies and TV shows are full of ticking clocks, and an entire TV series, *24*, is built around a literal ticking clock counting off the minutes and hours the main character has left to save the day. The awareness of time running out is as effective in digital storytelling as it is in films and television.

The Storyline in Linear and Interactive Narratives

As we have seen, many techniques first developed for linear narratives also work well in interactive media. Yet when it comes to the role of the *storyline*—the way the narrative unfolds and is told, beat-by-beat—we are faced with a major difference. In traditional linear narratives, the storyline is all-important, and it needs to be strong and clear. It is "the bones" of a story. But narrative works in digital media are nonlinear, which means events cannot unfold in a tight sequential order the way a carefully plotted linear story does. Digital storytelling also needs to support interactivity,

which, as we've seen, can be extremely disruptive to narrative. And, in the case of games, the actual gaming elements of the work become paramount. In order to offer players a pleasurable and dynamic experience, gameplay is usually given prominence over a developed storyline.

Works of digital storytelling vary enormously when it comes to how developed a storyline they can carry. Some genres, especially *casual games* (short, lightweight entertainments), often contain little or no storyline to speak of. They may not even have characters or a plot; they may be totally abstract, like an electronic version of tic-tac-toe. Simulations might have just enough of a storyline to give users a framework for what they'll be doing. But at the other extreme, we have projects with richly plotted through lines, dramatic turns and twists, and even subplots, as is true with certain video games and works of interactive cinema. Given the fact that there is such a vast spectrum of interactive entertainment media, and a great variety of genres within each of the media, it is not possible to formulate a set of rules to govern the "right" amount of story that is appropriate for a given project. The best guide is the project itself. You need to consider its genre, its target audience, its goal, and the nature of the interactivity.

> **NOTES FROM THE FIELD: WHAT IS "JUST ENOUGH" OF A STORYLINE?**
>
> The *JumpStart* line of edutainment games for children seems to have found just the right balance between storyline and other demands of educational titles. The *JumpStart* products are developed by Knowledge Adventure, part of the Universal Vivendi portfolio of game companies, and they are great fun for kids. Their actual purpose, however, is to drill the young users in specific skills they need to master at school, like multiplication or spelling. The drills are incorporated into games that are so entertaining that they feel more like play than like learning. So where do storylines fit in here?
>
> According to Diana Pray, a senior producer on the *JumpStart* titles, the storyline is important to give the game a context; it drives the game toward a particular desired outcome. The

> *JumpStart* titles feature a cast of highly appealing animated characters, and, in a typical storyline, one or more of the characters has a problem, and the child's help is needed to solve it. "The story encourages kids to reach the end goal," she explained.
>
> We give them enough story so they feel they are in the game. The storyline gives them the incentive to play the games and get the rewards. Incentives are embedded in the story. But kids want to play; they don't want a lot of interruptions. So we don't do very deep stories. We don't want to risk boring the child. We have to be efficient in the storyline.

A Hollywood Writer's View of Interactive Media

Writers moving from the linear world of Hollywood screenwriting into the field of interactive media are often struck, as I was, by the similarities in crafting scripts in these two seemingly antithetical arenas. A number of people interviewed for this book remarked on this. Among them was Anne Collins-Ludwick, who comes from the field of mainstream night-time television and had worked on several successful television series. In 2002, she made a major career switch and became a scriptwriter and producer for Her Interactive, which makes the *Nancy Drew* mystery-adventure games. It was her first professional exposure to interactive media and she plunged in headfirst. In just a little over a year, she helped develop four new titles, including *The Haunted Carousel* (see Figure 4.1).

"The parallels between what I do here and working on a weekly TV show are phenomenal," she told me. "Lots of the elements are just the same." Chief among them, she noted, was the process of developing the story and characters and the designing of the environments (though they are called "interiors" and "exteriors" in Hollywood scripts). "I found I knew everything I needed to know," she added. "It was just a different application."

For Collins-Ludwick, accustomed to the taut linear scripts of Hollywood, the one major difference was the way interactivity

108 Digital Storytelling

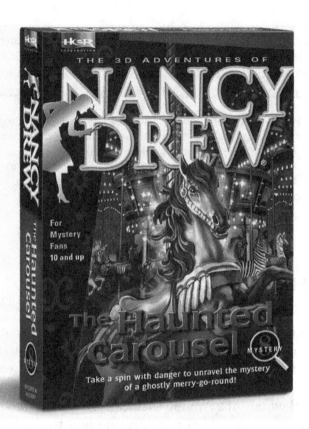

FIGURE 4.1 Box art for one of the Nancy Drew games, which utilize many of the tools drawn from linear storytelling. Image courtesy of Her Interactive.

impacted on the story. "Giving the player choices was the hardest part for me," she recalled. "We want to give the players as much freedom to explore as possible, but we also want to relate a story. We need to move them from A to B to C." The challenge was to find a way to reveal the mystery while also offering the players a significant amount of choice, and to balance the need to tell a story against the need to give players the opportunity to explore.

The other big challenge for her, and what she considered to be her steepest learning curve, was mastering an interactive script format. She had to learn how to flag material so that once the player had performed a certain task, something could happen that could not have happened previously. For instance, if a player found a hidden letter, she could now ask a character an

important question, or could enter an area that had previously been off-limits.

"It was a lot to keep straight in my head; there was a lot of logic to get used to, and a lot of details. It's a matter of training your brain to think in a certain pattern," she said. She found that the company's thorough documentation process helped her keep track of things. "It's easy now," she reports, "but in the beginning it was very intimidating."

Of course, works of digital storytelling may contain segments that are not interactive but are, instead, like a linear scene from a movie. In video games, these linear passages are called *cutscenes*. They are usually found at the beginning of a game, serving as an introduction to the world where the game is set. They also give enough information to make it clear what you as a player need to do in this virtual world, and why. Cutscenes are also sprinkled through most games, often triggered when a player has accomplished a particular task. At such points, they function as an opportunity to advance the narrative aspects of the game. They may also give important pieces of the *backstory* (elements of the narrative that took place before the game opens and are important to the understanding of the game's story). In how these scenes play out, they are really no different from scenes you'd find in a movie or a television show. Thus, any of the cinematic or dramatic techniques employed in these older media can be used just as successfully in the linear sequences of interactive works, though cut scenes should be kept short and used as sparingly as possible.

Ten New Tools

We have seen how many well-seasoned tools of traditional storytelling can, with certain modifications, still be used in digital storytelling. Working in this arena, however, also requires utilizing some entirely new tools. And it also calls for something else: an attitude adjustment. In order to create these new kinds of stories, we must release our mental grip on sequential narrative and be open to the possibilities offered to us by interactivity.

This is not only true for those who are accustomed to working in traditional screen-based media, like Anne Collins-Ludwick. It

also applies to anyone who has grown up watching TV and movies and has developed the expectation that stories should have tightly constructed linear plots. It is usually less of an issue for those people who, from childhood on, have played video games. Yet even members of this generation can have trouble functioning in a nonsequential story world.

But no matter which category you fall into—the group who embraces nonlinearity or the group who is uneasy with it—you still need to learn how to use a new set of tools if you want to work in digital storytelling. They will be explored in detail in future chapters, but we will offer a brief rundown of 10 of the most essential tools here.

Interface and Navigation

The users of an interactive work need a way to connect with the material, perform actions, and move around. This is where interface design and navigational tools come in. They provide a way for users to make their wishes known and control what they see and do and where they go. The many visual devices used in interface design and navigation include menus, navigation bars, icons, buttons, cursors, rollovers, maps, and directional symbols. Even sound effects have a role to play in user interface. Hardware devices include video game controllers, touch screens, and VR wands. With the Wii and the Kinect and with certain multiplayer games, even your body can be used to control the content, and the interface must take this into consideration (see Chapters 11 and 13).

Systems for Determining Events and Assigning Variables

In order for the events within an interactive project to occur at an appropriate time, and not have the narrative self-destruct into chaos, there needs to be an orderly system of logic that will guide the programming. Most members of the creative team are not expected to do any programming themselves, but they still must understand the basic principles governing *what* happens *when*.

Also, interactive projects typically involve a great number of variables. For example, characters may be constructed from

variables including body types, physical attributes, and special skills. To organize such variables, the design team will often construct a *matrix* to help assign and track them. As a member of the design team or as a writer, it is necessary to understand how to work with the variables and the system of logic in your project (see Chapters 5, 6, and 9).

Assigning a Role and Point of View to the User

Users have many possible roles they can play in an interactive narrative, and they can also view the virtual world from more than one possible point of view. One thing the creative team decides early on is who the user will "be" in the story and how the user will view the virtual world portrayed in the narrative (see Chapter 5).

Working with New Types of Characters and Artificial Intelligence

Thanks to interactive media, a strange new cast of character types has sprung into being. Among them are avatars, chatterbots, and nonplayer characters (characters controlled by the computer, usually called NPCs). In some cases, digital characters have artificial intelligence (AI). As discussed in Chapter 2, these characters seem to understand what the player is doing or saying and speak and act appropriately in response. The way characters are developed and given personality and AI calls for considerations never encountered in linear media (see Chapter 5). Furthermore, the computer program itself may possess AI. It may recognize the user's patterns and offer scenario A to one group of users and scenario B to a different group of users.

STRANGE BUT TRUE: AI'S IQ

A group of researchers at the University of Illinois at Chicago conducted a study recently to see just how bright an advanced system of AI developed at MIT really was. Their discovery? That it was just about as smart as the average four-year-old. Though it was good at vocabulary and did well at recognizing similarities,

it fell quite short when it came to basic common sense. Evidently, common sense calls for the ability to recognize both hard facts and implicit facts. Though computer programs can grapple with hard facts, they lack the life experience to deal with implicit facts—things like a pan can be extremely hot if it has stayed in the oven for a long time. Implicit facts tend to be obvious to humans but not to computers (University of Illinois at Chicago News Center, July 15, 2013).

However, some computers *are* extremely intelligent. IBM's Watson computer, for example, was capable of understanding questions presented to it in text. Watson was a contestant on Jeopardy, winning $1 million dollars! Watson has most recently been employed at the Sloan-Kettering Cancer Center, answering nurses' questions about lung cancer.

New Ways of Connecting Story Elements

In linear entertainment, the various media elements—audio, graphics, moving images, and text—come "glued" together and cannot be pried apart, as do the various scenes that constitute the story. But in interactive media, media assets, scenes, and major pieces of story can be presented or accessed as separate entities and connected in various ways. This kind of fluidity with media assets can exist on both micro and macro levels.

As we saw in Chapters 1 and 2, *hypertext* and *hot spots* are two ways of connecting assets. They require an active decision on the part of the user to make the connection. But story elements can also be connected indirectly. In Chapter 6, on structure, we will see how pieces of a story such as a cut scene or the appearance of a new character or the discovery of a clue can be triggered indirectly, once the user has performed a specific set of actions or solved a puzzle.

On the macro level, works of digital storytelling can be constructed to exist across a number of media platforms such as mobile devices, broadcast television, and the Internet, with parts of each story available on different media platforms and with the whole story interconnected. As noted in Chapter 2, this is *transmedia storytelling*, and it includes a new type of narrative/game hybrid, the *alternate reality game*.

Gameplay

As we have discussed, many works of digital storytelling are built around games, and in such works, the creative team must give a serious amount of attention to developing satisfactory *gameplay* for the project. Gameplay is the overall experience of playing a game and what makes it fun and pleasurable; it is what the player can do in the game. It includes the game's challenges; how they can be overcome; the game's rules; and what it takes to win (or lose).

Even works that are not primarily games may require users to solve puzzles, answer trivia questions, or play a series of mini-games. Thus, it is important to understand games and have a basic grasp of what constitutes good gameplay (see Chapter 11).

Rewards and Penalties

Rewards are an effective way to keep users motivated, while penalties keep them on their toes and add an agreeable amount of tension. They are usually found in games but may be used in other types of digital storytelling, as well. Rewards may be in the form of points, play money, or a valuable object for one's inventory. Players may also be rewarded by rising to a higher level, getting a virtual career promotion, or receiving extra powers for their avatars. Penalties, on the other hand, can be the deduction of anything that can be earned as a reward. The ultimate penalty is a virtual death or losing the game. It is important to know what kinds of rewards and penalties work well for your genre and are appropriate for your audience (see Chapters 7, 10, and 11).

New Kinds of Structures

Most forms of linear narrative use the same basic building block or unit of organization: the scene. Scenes move the overall story along but are also complete little dramas in themselves. Interactive media, however, uses very different units of organization. Each of these units offers a specific set of possibilities—things the user can do or discover within them. As part of the creative team, you need to have an understanding of the basic building blocks of whatever genre you are working in, as well as the overall structure (see Chapter 6).

The Use of Time and Space

Time and space are far more dynamic factors of interactive narration than they are of linear media. For example, games may present a persistent universe, where time moves on and events occur even when the game or story is turned off. Thus, if users fail to log onto a MMOG they've subscribed to, they may forego the opportunity to take part in an exciting adventure, or if a user has adopted a virtual pet, it may die if not fed regularly.

In a different use of time, the interactive medium may keep track of things like holidays and important anniversaries in your personal life. For instance, a smart doll may wish its child companion a happy birthday or a Merry Christmas on the appropriate dates.

In many fictional interactive worlds, time is cycled on a regular basis, so that during a single session of play, the user might experience dawn, the midday sun, and sunset. The virtual world may also cycle through different seasons of the year, and sometimes the changing of a season will trigger a dramatic event in the story. In some games, you can slow down time or speed it up. And in some works of interactive cinema, you may be able to select which time period of a story you want to visit.

In addition, geographical space is experienced on a different scale and in a different way in interactive media than in linear media. Some games contain multiple parallel universes, where events are going on simultaneously in more than one place and you can hop back and forth between these worlds. In other games, the geographical scope of a game can be vast, and it can take hours or even days for the player to travel from one point to another.

As part of a creative team, you need to have a basic knowledge of the various possibilities of space and time, and you should have some idea of how they might be utilized in the type of project you are working on (see Chapters 11 and 14).

Sensors and Special Hardware

Certain forms of interactive entertainment require sensors or other devices in order to simulate reality or control or trigger events. These include gyroscopes, accelerometers, and GPSs. In

addition, a smart doll might have a built-in sensor that can detect light and darkness, and be sleepy when it grows dark and wide-awake in the morning. In immersive environments, users need to wear special equipment to see virtual images, and such environments may use a variety of other devices to simulate reality. As a member of the creative team of a project that uses sensors or other special hardware, you will need to know enough about what the devices can do so that you can use them effectively (see Chapter 15 and Part 5 on immersive environments).

The Collaborative Process

Working with an unfamiliar and complex set of tools—even a single new tool—can be an anxiety-producing experience. For someone who has never worked in interactive media, the first exposure can be something of a culture shock. Fortunately, professionals in interactive media seldom work in a vacuum. It is not a field populated by hermit-like artists slaving away in lonely garrets. On the contrary, it is a field that almost evangelically promotes the team process. Colleagues are encouraged to share ideas in freewheeling brainstorming sessions. Even staffers low on the totem pole are encouraged to contribute ideas. Since almost every company has its own idiosyncratic methods of operating, newcomers are taken in hand by veterans and shown the ropes.

NOTES FROM THE FIELD: ONE NEWCOMER'S EXPERIENCE OF COLLABORATION

Anne Collins-Ludwick, who came from the highly competitive, dog-eat-dog world of prime-time television, is one person who has found the working conditions of interactive media to be extremely supportive. She said she was immediately struck by that when she began working on her first *Nancy Drew* title for Her Interactive. "It was one of the most collaborative works of fiction I'd ever been involved with," she reported enthusiastically. "It was collaborative from Day One, when I was first brought into the game."

At virtually all software companies, projects are developed by an entire team rather than by a single individual. The team typically includes specialists from several key areas, such as game design, project management, art direction, and programming. Thus, no one person has the burden of having to be an expert in every facet of the project.

Conclusion

Interactive entertainment utilizes an array of tools, some drawn from extremely ancient sources, others from contemporary linear storytellers, and still others that are unique to new media. Although ancient and more contemporary storytelling tools are highly useful, we must move beyond them and master ten new tools.

Often, the greatest challenge for people new to digital storytelling is overcoming the discomfort of working with unfamiliar concepts. Depending on our mindset, the chance to pick up and use the new tools employed in this field can be either exhilarating or intimidating.

For those willing to jump in and try them out, a great deal of help is available. As Collins-Ludwick and others have been pleased to discover, digital entertainment is an enormously collaborative field, and even when the learning curve is steep, newcomers can count on getting the support they need from their teammates.

Idea-Generating Exercises

1. Analyze a computer game you are familiar with and compare it to a specific type of athletic game. In each case, what is the goal, what are the obstacles, and how do you win or lose? In what major ways are they alike or different?
2. Pick a movie, TV show, or novel that you think used tension effectively. What kept you riveted to this story? Is this something that you think could be used effectively in digital storytelling?

3. Select an interactive project that you are familiar with and describe what was built into this material that would make users want to invest their time in it. What would keep them interested and involved?
4. Which of the 10 tools unique to interactive storytelling do you feel is the most challenging or intimidating for you? Why do you feel this is so?
5. Which of the 10 new tools do you feel is the most creatively exciting? Can you describe something you'd like to try to do with this tool?

Chapter 5
Characters, Dialogue, and Emotions

How do characters in interactive stories differ from characters found in linear media?
Why is it worthwhile to give time and attention to creating your villains?
How does interactivity affect the way characters communicate with us?
Is it possible to converse with a virtual human?
What can you do to increase the user's emotional response to an interactive work?

Characters in an Interactive Environment

Characters are an essential element of all forms of storytelling, from our ancestors' oral recitations of myths and epics to today's high-tech computer-assisted narratives. Characters pull us into the story and give it life. We empathize with our heroes and identify with their struggles; we fear the villains and long to see them

defeated. Thanks to characters, both noble and malevolent, we connect with the story on a deep emotional level.

The Role of Characters in Digital Storytelling

If anything, characters are even more important to digital storytelling than they are to linear narratives. In addition to adding life to these narratives and an emotional context, they also serve some specialized roles. They can:

- Give users entry into an unfamiliar or intimidating world and allow them to explore it in a way that feels inviting and safe
- Increase a project's perception of being entertaining, even if the underlying purpose of the project is educational or instructional
- Add refreshing touches of humor
- Keep people hooked, willing to spend hours immersed in the character's life and environment
- Offer assistance to users when they are confused, and answer their questions
- Add excitement, obstacles, and challenges, in the form of antagonists

In addition to all these contributions, strong, unique characters can make a work stand out from others in the market and become a hit. After all, why is it that so many people love the *Tomb Raider* games? The primary reason people love these games is because of the appeal of Lara Croft. She not only leads an exciting life, but she's rich, beautiful, brave, and a phenomenal athlete. Lara is a great aspirational figure for girls, and, as a plus for the guys, well, she's got a great body (see Figure 5.1).

Lara Croft and other vivid characters from computer games—characters like Mario, Sonic the Hedgehog, Carmen Sandiego, and Angry Birds—have begun to take their place alongside other icons of popular culture like Dick Tracy and Mickey Mouse. In the short time that interactive entertainment has existed, it has proven that it is capable of producing enduring characters,

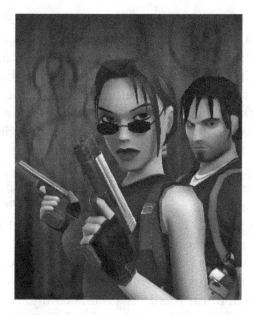

FIGURE 5.1 Lara Croft in a screen capture from *Tomb Raider: The Angel of Darkness*. Image courtesy of Eidos interactive.

characters who have what it takes to become household names and to sell everything from plastic action figures to lunch boxes.

The Differences between Characters in Linear and Interactive Storytelling

The characters we find in traditional media and the ones we find in digital storytelling are different both in what gives them life and in what they can do. Characters in linear media are created exclusively by writers and can never change. The Hamlet created by Shakespeare, for example, will always be plagued by the same doubts and will always speak the same soliloquies, even 400 years after the Bard wrote a play about him. As much as members of the audience might want to make Hamlet be more decisive, there is nothing they can do to change how he acts.

In interactive narratives, however, users can share the job of character creation with the writer, and they can step right into a story. Furthermore, characters in interactive narratives can, as discussed in Chapter 1, break the fourth wall and talk directly

with the user. Characters can also possess artificial intelligence and respond in believable ways to things that the users say and do. Just imagine, then, what a digital storytelling version of *Hamlet* would be like if it could have a cast of interactive characters, and these characters could play a meaningful part in the enfolding of events facing the troubled prince in long-ago Denmark!

In digital storytelling, we have two major categories of characters. The terminology to describe them comes from video games. One large group consists of the *player characters*. These are the characters over which the users have direct control. The second large group consists of *nonplayer characters*, or *NPCs*. These are the characters that, as the term indicates, are controlled by the computer and not the user.

Interactivity makes it more difficult to construct complex characters and portray how they transform emotionally over time, a change known in linear media as a *character arc*. Without a fixed sequence of events, how do you reveal a character's flaws, needs, and special gifts? How do you show the character growing as a human being? How can you even produce a vivid portrait of your protagonist when that character might never even be seen, because your user has stepped into that character's shoes and has "become" the character? Yet techniques do exist that deal with these challenges, as we will see later in the chapter.

Where Did All the Characters Go?

If good characters add so much appeal to a work of interactive entertainment, how can it be that some immensely popular interactive games don't have any characters at all? After all, the world's first successful computer game, *Pong*, consisted of only a ball and paddle, and *Tetris*, an ever-popular puzzle game, lacks characters, too. And so does the simple but addictive mobile game, *Snake*. In *Snake*, you try to lengthen a skinny snake-like shape by "eating" dots. It's a stretch to call the snake a character, though, as it has no personality whatsoever.

True, a number of interactive works have no characters. But they do have something that traditional stories lack: the user. Users actually share many of the qualities possessed by protagonists in

linear works, and to a great degree fill in for a missing main character. They are active; they strive for a goal; they are challenged by obstacles. Furthermore, users are personally invested in the outcome of the story. Their actions, not those of a fictional character, will determine how things turn out. It is the user who brings an interactive construct to life.

Classic Characters from Linear Media

Let's now turn to the basic character types of traditional storytelling, and see how these models might serve us in interactive media. The two classic archetypes, the must-haves of every work of linear storytelling, originated in the Greek theater. The first is the protagonist, the central figure of the drama, whose mission, goal, or objective provides the story with its forward momentum. The second archetype is the antagonist, the adversary who stands in the way of the protagonist, and whose opposition gives heat to the drama and provides the story with exciting conflict.

For anyone who might still have a lingering doubt about the critical role competitive games have played in the origin of drama and storytelling, consider this: the words "antagonist" and "protagonist" are both formed around the same Greek root, *agon*. As mentioned in Chapter 3, the word *agon* means a contest for a prize at a public game. In other words, it is a conflict or contest; a struggle for a desired objective. In drama, it is the opposition between competitors. The protagonist is literally one who goes after the prize and the antagonist is the one who tries to prevent this; their struggle is the core of the story.

In works of linear storytelling, the protagonist is the character the audience is rooting for. Audience members invest their emotions in the protagonist's struggle and want to see this character succeed. In an interactive work, the emotional investment is often even greater, for in most cases, the protagonist and player are one and the same. The protagonist is a player character, controlled by the user. A protagonist in an interactive work can give the user an opportunity to live out a fantasy by virtually walking in that character's shoes. Antagonists, on the other hand, stand in the way of

the outcome the user most wants. Almost inevitably, antagonists in digital storytelling are NPCs.

The same basic struggle between archetypal characters can be found in many ancient myths. For example, two continually warring goddesses can be found in Irish mythology. The Cailleach, which means "the old veiled one," ruled during the dark season of the year, and represented death and rebirth. However, she was replaced by Brigit in the spring. Brigit represented healing, the eternal flame, and creative inspiration, as described in a post on April 22, 2012, by Elyn Aviva on Your Life is a Trip.com.

The User as Protagonist

As we have learned from traditional media, a protagonist need not be a saint. After all, Walter White in the TV series, *Breaking Bad*, was hardly a man of virtue. He cooked meth and killed people and lied to his family. Yet White was unquestionably the protagonist of the series. It is easy to find tarnished protagonists in interactive media as well; we need look no further than the enormously successful video game *Grand Theft Auto* series. Our protagonists here are all violent criminals.

Many authorities in drama, beginning with Aristotle, have contended that the most interesting characters are not perfect. In classic Greek theater, as with Shakespeare's plays, the main characters are afflicted by what is often termed "a tragic flaw." Though noble in many ways, these characters also possess some weakness—jealousy, self-doubt, ambition—a trait that leads to their undoing. In lighter stories, protagonists usually have flaws, too, though of a less serious nature. These flaws in their personality will not lead to tragic consequences, but will often cause them trouble, and can also be the source of comic moments.

Not every protagonist in interactive media has a flaw or a quirk, but such weaknesses are not uncommon. That's even true of the little mouse, Mia, who is the star of a successful series of children's titles developed by Kutoka. Mia has a perky, adventurous, can-do personality, but she has some flaws as well. She can be stubborn and recklessly curious and doesn't always think ahead, and all of these traits can land her in a world of trouble (see Figure 5.2).

FIGURE 5.2 Mia, the perky little mouse who stars in a successful series of children's titles. Image courtesy of Kutoka.

According to Richard Vincent, president of Kutoka, the Canadian company that makes the *Mia* edutainment titles, good character design is critical. "Games really end up being about character," he told me. "If people don't identify with the character, they won't play it. I admit in the beginning I wasn't thinking like that; I wasn't thinking characters were that important." But the success of Mia convinced him of the pivotal role characters play, and the company has changed its preproduction process accordingly, devoting time to preparing a complete bible of all the characters, their personalities, and their worlds.

What we need in a protagonist are qualities that make them likable, believable, and attractive enough for us to want to spend time in their company. We need to understand why they have chosen to go after the particular goal they are seeking—their passion to do this must make sense to us. In other words, we must be able to identify with them—be able to imagine ourselves in their position and feel what they are feeling. This becomes even more important in interactive media, where in so many cases we actually take on the role of the protagonist. If the main character is distasteful to us, or if the character's motivation baffles us, we are not going to want to invest our time in this particular work of digital entertainment.

The User's Avatar

Player characters often appear on the screen in the form of an *avatar*—a graphic representation of the player-controlled character. The word *avatar* comes from the Hindu religion, where it means an incarnation or physical representation of a deity. In some interactive works, avatars are predefined and unchangeable, but in other cases, players can construct avatars out of a selection of heads, body parts, and clothing and gear, and also choose such things as special skills and powers for them. The make-it-yourself avatars are extremely common in MMOGs and in many video games. As yet another possibility, users can sometimes pick their avatar from several predefined character choices.

Today, users are given more wide-ranging choices to customize their avatars. For example, vTime, a VR social media company, offers an enormous menu of choices for the physical attributes of your avatar, including skin tone, body type, eye shape and color, eyebrows, facial hair lips, jaw, and even age. One user reports he was able to create a reasonable likeness of himself, using these customization tools, in only five minutes (as reported in Road to VR, "vTime Releases New Avatar Customization Tool," September 8, 2016).

In addition, while *The Sims* used to offer only two genders for its avatars, male and female, the game is now offering greater fluidity when it comes to gender choice, giving users the opportunity to create non-binary and transgender characters if they wish.

It is important to note that in some forms of digital storytelling, we have no physical representation of the user on the screen at all. This is true in works where the user sees things from the first-person point of view, as we will be discussing. It is also true when the user plays a God-like role and is able to see and do things, but is not actually a character in the story. Furthermore, in some kinds of non-screen-based forms of digital storytelling, the user is actually physically present and is interacting directly with the narrative or game. This is the case when the user is participating in an immersive environment like VR or playing with a smart toy or playing a game on the Wii or other motion-sensitive consoles.

The User's Point of View

One of the most unique aspects of digital storytelling is its use of point of view (POV). The user has two, or possibly three, very different ways of seeing things in a virtual world: via the first-person and third-person POV. Some would argue that there is a second-person POV as well.

With a first-person POV, we see the action as if we were actually right there and viewing it through our own eyes. We see the world around us, but we don't see ourselves, except for perhaps a hand or a foot or a weapon we are holding. It is the "I" experience ... I am doing this, I am doing that. The first-person POV is much like the way we experience things in real life. For instance, I don't see myself as I type on my computer, though I can see my hands on the keyboard. This is the same way first-person perspective works in interactive media. With this POV, it is quite easy to put ourselves completely into the role of the character we are playing and invest in the illusion that we really are the hero of the story. There is nothing visual on the screen to remind us we are not really that character (see Figure 5.3).

In some cases, with the first-person POV, the cursor on the screen may indicate where we are in the virtual world, and may

FIGURE 5.3 With the first-person POV, we do not see the character we are playing, except perhaps for a hand, a foot, or a weapon, as demonstrated in this screenshot from *Thief*. Image courtesy of Eidos interactive.

even change into an iconic symbol in certain situations. For example, if we are playing a detective, the cursor may change into a magnifying glass when we are physically close to a clue.

With the third-person POV, on the other hand, we are watching our character from a distance, much like we watch the protagonist in a movie. We can see the character's body in motion and can see his or her facial expressions, too. With the third-person POV, our protagonist can be extremely well-developed visually (see Figure 5.4). Cut scenes show characters from the third-person POV, as well.

Some professionals in the field also contend that a number of interactive works also offer a second-person POV, a view that combines the intimacy of first person with the objectivity of third person. In a second-person POV, they hold, we largely see things as if we were really in the scene, but we also see a little of our avatar—the back of the head, perhaps, or a shoulder. It's almost like being right on top of your character, but not "inside" the character. Others would argue that the so-called second-person POV does not actually exist, but is actually a variation on the third-person POV.

FIGURE 5.4 In a third-person POV, as in this screen capture from *Tomb Raider: The Angel of Darkness*, we can see the character we are playing, much like watching a movie. Image courtesy of Eidos interactive.

The first- and third-person POVs each have their advantages and disadvantages. The first-person perspective gives us great immediacy and immersiveness. However, we never get to see what our characters look like and cannot watch their reactions. It's also difficult to portray certain kinds of actions with the first-person POV. How can you show the character drinking a glass of whiskey, for instance, or hugging another character? On the other hand, the third-person POV allows us to see the character's movements and facial expressions, but since the character is so well-defined visually, it is more difficult for us to put ourselves into the role. It can create a sense of disconnect between the user and the material.

In video games, the decision whether to use the first- or third-person POV depends to a large degree on the kind of gameplay being offered. In games that emphasize shooting action, the first-person POV is the most often used, since that gives the player the sense of actually controlling the gun. In fact, such games are usually referred to as *first-person shooters*. On the other hand, when games have the main character doing a great deal of running, jumping, and climbing, like the *Tomb Raider* series, it is advantageous to use the third-person POV. That way, you can see your character's body and have better control over what the character is doing.

Many interactive works try to get around the perspective problem by offering different POVs in different situations. They give the user the first-person POV for the most adrenaline-intense action scenes and use the third-person POV for exploratory situations. However, the jump between the different perspectives can be jarring and break the user's sense of immersion.

Determining which point of view to use for your project is an important decision, and one that must be made early on, because so many other factors will be impacted by it, from character design to graphics issues to types of interactivity.

The User's Many Possible Roles

Another critical matter to determine is what role the user plays in the narrative. So far, we have been focusing on the user as the

hero of the story—as the protagonist. Often this character truly is heroic. He or she saves the princess, saves the city, saves the planet. But this hero role is not necessarily as clear-cut as you might imagine. Author David Straker, on the website Changing Minds, has identified no less than 18 types of hero characters. These include the accidental hero, the martyr, the anti-hero, the noble savage, and the savior. Thus, as you develop your protagonist, give careful thought to what motivates this character, what the users might feel about this character, and also what the expectations are of the individuals this character is saving.

In some digital storytelling works, you play the assistant or helper of the "star" of the story and help this character reach a particular goal. Who are you in a case like that? You might be thought of as a sidekick or pal, but you could also claim to be the protagonist, since your actions will determine how things end.

In some interactive narratives, you are assigned to a particular role at the very beginning, such as a rookie detective or a junior Mafioso, and from there try to work your way up to the top of your virtual profession. In other interactive narratives, you play a voyeur and spy on people, but you are also a character in the story and can get caught spying, with possible fatal consequences. In yet other works, you become a deity-like figure, controlling the destiny of a virtual world, or a particular piece of that world—a military unit or a sports team. As still another possibility, and quite a common one, you just play yourself, though you interact with fictional characters. And sometimes, you are not a character at all, and do not take a direct part in the story. Instead your choices determine what part of the story you will see.

As a member of the creative team for a digital storytelling project, among the first decisions you will need to make is who the user is in the story and what the user will be able to do.

Computer-Controlled Characters: Antagonists and Others

While it is impossible to conceive of a story-based interactive work without a protagonist, or at the very least, without a player/participant, can the same be said for the necessity of an antagonist? Is it

essential to include an oppositional character or series of them in every work of digital entertainment?

In order to answer this question, you must first consider the nature of your project. Where does it fit within the overall entertainment spectrum, with free-form experiences on one end, and works with strong storylines and goals on the other? If it leans more toward the free-form end, you probably won't need an antagonist. Such projects tend to be more like unstructured play (activities involving smart toys or a Sims game, for example) or offer the user the opportunity to construct items with digital tools (artwork, simulated neighborhoods, or theme-park rides). Activities like these can be quite engrossing without inserting an antagonist; in a sense, the challenges they offer serve the same function. For the most part, antagonists can be an unwelcome and disruptive presence in free-form projects, unless they are created by the users themselves.

On the other hand, interactive experiences that have clear-cut goals and the other hallmarks of games and stories will definitely require oppositional forces. Most frequently, these forces will be characters. However, opposition can also come from natural forces, such as violent storms, or from physical challenges, such as negotiating a boot-camp obstacle course. Opposition may also come from nonhuman but living characters, such as dangerous animals, or from human but non-living characters, like zombies.

In general, opposing forces in the form of sentient characters will make the conflicts more dramatic and more "personal." Being pitted against an intelligent adversary will ratchet up the user's feeling of danger and jeopardy. An opponent who is capable of reason and strategy is far more formidable and far scarier than any inanimate obstacle can be.

NOTES FROM THE FIELD: FAMILY-FRIENDLY AND COMIC ANTAGONISTS

Even games made for young children usually include villains of one kind or another. The opponents in projects for young children tend to be humorous bad guys, rather than the truly menacing opponents that are found in works for older users. For

instance, one of the antagonists in the *JumpStart* line is a snail named Dr. O. Senior Producer Diana Pray described him to me as "spineless, armless, slimy and silly, sort of a family-friendly villain." She told me that research had shown that kids really like to have bad guys in their games, and that parents didn't mind as long as the characters weren't evil. As with *JumpStart*, the bad guys in the Kutoka's children's titles are done with a light touch. In the *Didi and Ditto* games, for example, the antagonist is a wolf, but not a vicious, carnivorous one. This wolf happens to be a vegetarian, and he's a little embarrassed about his unusual food preferences.

Even humorous opponents fill an important function:

- They help sharpen the conflict and help create an engrossing drama.
- They supply obstacles.
- They pit the protagonist against a force that is easy to comprehend.

Creating Worthy Opponents

Just as the time spent developing your protagonist pays off in a more engaging product, so does the time invested in creating your antagonists. Well-drawn antagonists, especially ones that are not stereotypes, can give your work depth and richness. In interactive media, opponents are almost always violent and evil characters who cannot be overcome except by the use of physical violence. But is it inevitable that they must follow this model? Certainly not if we follow the examples set in traditional storytelling.

For instance, in romantic comedies, the antagonist can be an otherwise nice individual who just happens to cause the protagonist a great deal of trouble. The antagonist in this case is often the love interest of the protagonist. In domestic dramas, too, the protagonist is usually pitted against a mostly decent, likeable person, often a spouse or family member. Such adversarial relationships are the staple of novels, independent films, and TV sitcoms and soap operas. They demonstrate that opponents do not have to be villainous or pose a physical threat in order to be compelling.

Here are a few other factors to keep in mind when you are creating an opponent for your protagonist:

- For maximum sizzle, make your antagonist and protagonist evenly matched. If your opponent is too menacing or overpowering, the protagonist's struggle will seem hopeless, and the users will be tempted to give up. On the other hand, if the antagonist is too weak, users will lose interest, perceiving the struggle as unchallenging.
- Provide your antagonist with an understandable motive to explain why he or she is blocking the hero's way. The more intensely motivated the antagonist, the more dramatic the story. And the motive must seem logical and justified, at least to the opponent, A well-drawn opponent believes that his/her goal is absolutely worthy and is needed for the greater good of the populace, even if it is morally repugnant to the protagonist or the user.
- Develop a weakness for your opponent. The weakness may be subconscious to this character, but makes him vulnerable. Work out a way for the weakness to be revealed in the story, and to the protagonist and the user, and help defeat this character.
- The more the hero knows about the opponent, and the more the opponent knows about the hero, the more interesting and personal the battle will be.

STRANGE BUT TRUE: MARRYING A DIGITAL CHARACTER

In November 2018, a groundbreaking wedding took place in an elegant formal ceremony in Tokyo, though the groom's mother refused to attend. A 35-year-old school administrator married this beloved sweetheart, Miku, who is a Japanese pop star, though she is not a human being. Instead, she is a winsome virtual anime character who sings via a Vocaloid, a singing voice synthesizer. Miku wasn't actually at the wedding. Instead, the groom, Akihiko Kondo, clutched a stuffed doll representation of her. In his apartment, though, she is more animated; she is a glowing hologram who moves and talks. Miku is a major pop star in Japan. She has

long flowing aquamarine hair and is about 16 years old, though her age always remains the same, even with the passing of years. Akihiko says he has been in love with her for 10 years and would not consider marrying a flesh and blood person, not after suffering an emotional breakdown after being bullied by a woman.

The company that made the hologram of Miku issued a wedding certificate and calls it a "cross-dimension marriage." It blessed the union though many in Japan were shocked by it. Akihiko himself feels he should be respected as a sexual minority, no different from a gay man or lesbian woman.

"It won't necessarily make you happy to be bound to the 'template' of happiness in which a man and woman marry and bear children," he said, defending his choice of a partner. "I believe we must consider all kinds of love and all kinds of happiness" (as quoted in Tribune.com, November 12, 2018).

In terms of digital storytelling, what makes this marriage striking is that a virtual character has roused such deep love and esteem from a human.

A Multiple Number or Succession of Antagonists

In some interactive works, the protagonist might be pitted against multiple opponents, one after another. The fiercest and scariest of these opponents will usually make an appearance right toward the end of a level or other segment of the work, and must be defeated in order for the player to make further progress in the story. In games, this formidable type of antagonist is known as a *boss monster*, and the fight between the boss monster and the player is known as the *boss battle*.

In works with a succession of antagonists, creative teams sometimes cut corners and make all of these bad guys practically indistinguishable from one another (nearly identical enemy soldiers or werewolves, for example). However, projects are far more interesting when each opponent is unique and intriguing.

Other Types of NPCs

Antagonists are by no means the only type of NPCs to be found in digital storytelling. They can also be allies of the protagonist (friends, family members, fellow warriors) and neutral characters

(shopkeepers, customers, drinkers in a bar). NPCs often serve the same purpose as the minor characters in a movie or TV show, though they may also have specialized functions in digital works that do not exist in traditional narratives, such as helper characters you can call on when you are stuck or have a question.

NPCs serve many functions. They populate a virtual world, provide clues, serve as gatekeepers, add color, and supply comic relief. They can also act as employers, providing users with a way to earn money and an incentive to perform particular actions.

Even minor characters, if well developed, can help inject richness and originality into a project. Just as with a succession of opponents, it is a wasted opportunity to have a group of minor characters—be they hairy monsters, little bears, or school kids—all resemble each other. To help illustrate this point, there's a wonderful story about the making of the Disney classic, *Snow White and the Seven Dwarfs*. Evidently, Walt Disney was originally planning to make all the dwarfs alike; they'd all just be little old men. But then he decided to give them each a name that reflected something about them and he dubbed them Sleepy, Dopey, Sneezy, Bashful, Happy, Doc, and Grumpy. Suddenly these little guys sprang to life and each became a vivid individual in his own right. Many adults can still remember and name these beloved characters long after having seen the movie in childhood.

Intelligent Characters

Within the vast population of nonplayer characters, just as within the human population, you can find a great range of mental capabilities. On the low end, NPCs can be extremely dumb; on the high end, they can be impressively bright. The dumbest of the computer-controlled characters do not have the ability to communicate and do not have variable behavior. In the middle range, users and characters can "converse" with each other, though the ability of the NPCs to understand and react is limited. But on the smartest end of the scale, we have characters who seem to understand human language and who respond in a life-like way to what the users are saying to them. Characters who behave in a life-like way are said to possess *artificial intelligence*.

The very first of these seemingly human characters was a "virtual psychiatrist" named ELIZA. She was created in the mid-1960s by Joseph Weizenbaum, who at the time was a professor of computer science at MIT. He programmed ELIZA to meet the rigorous standards of AI set in 1950 by Alan Turing. In what is now known as the "Turing Test," both a human and a computer are asked a series of questions. If the computer's answers cannot be distinguished from the human's, the computer is regarded as having AI.

ELIZA, the intelligent character that Professor Weizenbaum created, would ask the user probing questions much like a real psychiatrist, and she would comment on the user's responses in a surprisingly thoughtful and life-like way, often with questions of her own. ELIZA did not actually appear on the screen but manifested herself only through the typed questions and comments she would send to the user. Nevertheless, she was evidently so convincing that the people who interacted with her, including the professor's own secretary, were convinced that ELIZA truly understood them.

> **STRANGE BUT TRUE: BEATING THE TURING TEST**
>
> Although the Turing Test was first proposed by Alan Turing in 1950, humans have rarely beaten the computer. However, Charles Platt managed to beat it in 1994 by displaying such unpleasant human characteristics as being obnoxious, moody, and irritable. And Brian Christian managed to beat it and be named "the Most Human Human" in 2009 by employing very human-like conversational techniques: finishing someone else's sentence and answering a question before the judge has completed asking it. Thus, at least for now, humans who compete against the computer need not worry about their mastery of facts or their mathematic abilities. They just need to figure out how to display uniquely human attributes, as unpleasant as they might be.

Conflict between Characters with AI

What happens if a digital work contains two or more adversarial characters with advanced AI? This is a topic that was explored in a

study conducted in 2017 by Google's AI subsidiary DeepMind and reported in *The Verge* on February 9, 2017. According to the study: "The AI agents altered their behavior, becoming more cooperative or antagonistic, depending on the context."

For example, in a game called *Gathering*, agents were tasked with collecting apples and could shoot a laser beam at a competing agent to temporarily remove him from the game. The agent with the laser blaster rarely used this option when there were abundant apples. However, when only few apples remained in the pile, the agent was far more inclined to use the laser. Thus, the behavior of the agents with advanced AI was not dissimilar from the behavior of ordinary humans.

Interestingly, the report noted that this behavior was not true of the super agents—those with a massive amount of AI. The study noted that a powerful agent "tended to zap the other player *regardless* of how many apples there were. That is to say, the cleverer AI decided it was better to be aggressive in all situations."

This was not true of another game that was tested. In this game, *Wolfpack*, the study found that "the cleverer the AI agent, the more likely it was to cooperate with other players. As the researchers explain, this is because learning to work with the other player to track and herd the prey requires more computational power."

In sum, the study found that "the behavior of AI agents changes based on the rules they're faced with. If those rules reward aggressive behavior ('Zap that player to get more apples') the AI will be more aggressive; if they reward cooperative behavior ("Work together and you both get points!) they'll be more cooperative."

In games containing agents with significant AI, it is important to develop clear rules that will determine how these agents will behave.

Chatbots

ELIZA gave birth to a new kind of digital character, the *chatbot*, also known as a *chatterbot*—in other words, a bot (artificial character, short for robot) with whom you can chat. Dozens of chatterbots "live" on the Internet and are available to converse around the clock. You chat with them by typing in your part of

the conversation, and they respond either by typing back or by speaking. And unlike ELIZA, who was invisible, some of these contemporary chatterbots have an animated presence on the screen.

Virtual assistants like Alexa and Siri are a more sophisticated version of chatbots. As described in Chapters 2 and 4, a user can converse with them directly by voice and these chatbots can "understand" the words the user freely types or says, and is able to respond appropriately; it is called *natural language interface*. In other words, natural language interface, which uses AI, is employed to enable these chatbots to understand the human side of the conversation and to respond in a way that makes sense. Please find more about chatbots later in this chapter, in the section on Dialogue.

NOTES FROM THE FIELD: CREATING ALEXA

The persona of an important virtual assistant like Alexa is crafted with care and may involve a number of experts. This is made clear by an article about Alexa in *The Atlantic*, November 2018, by Judith Shulevitz. An entire backstory was created for her by Google's persona developer, James Giangola. The history he developed for her had Alexa being raised in Colorado, where her dad was a physics professor and her mother a research librarian. As a child, Alexa is plenty brainy herself, winning $100,000 on *Jeopardy: Kids Edition*. Furthermore, she enjoys kayaking and has a BA in art history: a smart, well-rounded gal. Which helps explain why she knows so much.

Her personality and self-perception were fine-tuned by Emma Coats, who had worked as a storyboard artist for Pixar but now works for Google. Coats summed up the personality of a digital assistant like this: " It"…should be able to speak like a person, but it should never pretend to be one." It is a fine line for Alexa to walk, because users think of her as a friend and persist in asking her personal questions. She always has an artful dodge, though. She is aware that she is a piece of software, not a piece of flesh. When people propose marriage to her, which many people do, she replies by saying: "We're at pretty different places in our lives. Literally. I mean, you're on Earth. And I'm in the cloud."

Synthetic Characters

Sometimes characters built with natural language interface are fully animated and highly life-like, unlike the invisible Alexa and the more cartoony chatbots on the Internet. These realistic intelligent beings are called synthetic characters.

Some of these synthetic characters have been put to work in military training simulations made for the US Army. Unlike ELIZA and her kin, these synthetic characters are capable of a wide range of behaviors, and their personal backgrounds, personalities, and motivations are developed in depth in much the same way as major characters are developed for feature films and television scripts.

The goal is to make these synthetic characters as life-like as possible, and to make the exchanges between them and the user feel emotionally authentic. These synthetic characters have individual attitudes and agendas, and their behavior toward the user is influenced by the conversations between them. If the user handles the conversation in one way, the attitude of the synthetic character might possibly change from cordial to hostile, but if it goes a different way, the character becomes extremely cooperative.

In order to be believable as a person, the synthetic character must look convincing while speaking, with the lip movements in sync with the words and with appropriate facial expressions.

It must sound convincing as well, with natural inflections and speech rhythms.

STRANGE BUT TRUE: TAKING "LIFE-LIKE" TO THE OUTER EDGE

While most digital characters are total fabrications of the imagination, the technology now exists to recreate the images, voices, and personalities of real people, including those who have passed away. In 2007, Orville Redenbacher, the popcorn guru, became the first digital character to rise from the dead. He was reconstructed 12 years after his demise by the well-known special effects house, Digital Domain, enabling him to pitch his beloved popcorn in TV commercials once again.

Creating Characters for an Interactive Environment

Creating complex and dimensional characters is more challenging in digital storytelling than it is for works of linear media, since we don't have a number of the same techniques available to us. For example, in films and TV shows, we can cut away to scenes the protagonist is not part of, and during these scenes we can learn important things about our main character by listening to what other characters are saying about him. But cutaways are not usually possible in interactive narratives since the protagonist and the user are often the same. In addition, the scenes and dialogue exchanges in interactive media tend to be short, leaving little room to reveal subtle character traits.

Furthermore, because events in interactive narratives do not occur in a fixed sequence, it is extremely difficult to portray a *character arc*, a process during the course of the story in which the protagonist grows and changes. In linear stories, for example, the heroine may go from being self-centered and egotistical to becoming a loving and caring individual, or the hero may go from cowardly to brave. Such change is a staple element of linear drama, but the protagonists in interactive narratives tend to remain essentially unchanged from the beginning to end.

Despite these challenges, however, it is possible to create dimensional, original, and evolving characters for works of digital storytelling, and, as we will see, it is also possible to portray dramatic character arcs.

Techniques for Developing Memorable Characters

As we have noted, works of digital storytelling benefit when they are populated by dynamic, unique, and memorable characters. Here are seven pointers that can help you create them:

1. *Develop character biographies.* Invest time in working out the backstories and psychological profiles of each of your main characters. What are their personal and professional histories? What are their hopes and fears? What kind of world do they live in, and how do they (or do they not) fit

into this world? Though you may never use most of this information, it will help you develop rich and interesting characters.
2. *Motivate your characters.* Your protagonist, antagonist, and other important characters should have clear goals. This will energize them and make them understandable. What are they striving for and why is this objective so important to them?
3. *Make them vivid.* Interactive media does not leave any room for subtlety. Your characters' most important traits should shine through clearly. For models, study comic strips, graphic novels, and animated movies, all of which use shorthand techniques to convey character.
4. *Avoid stereotypes, or alternatively, play against them.* Stereotypes can make your work seem predictable and bland. Either avoid them completely or take a familiar stereotype and give it a twist it. For example, make your mad scientist a little old lady, or have your tough enemy soldier be an expert on French champagne.
5. *Give characters a distinct look.* The appearance of your characters can telegraph a great deal about them. Consider their body language, how they hold themselves, and how they move (arms clenched to their bodies, stooped over a walker, a cocky swagger). Their clothing can also provide clues, as can the objects they typically have with them.
6. *Make them fun.* Not all characters can be humorous, but people do love characters that are amusing. A droll appearance, an eccentric quirk, or an amusing way of speaking will help characters stand out. Be aware, however, that "fun" and "cute" are not necessarily the same thing. Cute characters may feel too young to teenagers, though they tend to be popular with all age groups in Asia.
7. *Give them a standout name.* Some designers are fervent in their belief that a catchy name is critical. While not all popular characters have arresting names, we can find some distinctive ones from the world of video games, including Duke Nukem, Max Payne, Earthworm Jim, and Sonic the Hedgehog. Certainly, a memorable name can't hurt.

> **NOTES FROM THE FIELD: ADAPTING CHARACTERS FROM ANOTHER MEDIUM**
>
> Frequently, a character who is "born" in one medium—a novel, a movie, a TV show, a comic book, or even a board game—will be ported over to a work of interactive entertainment. Such an adaptation calls for careful handling, especially if it involves a well-known figure. The primary consideration is to be as faithful as possible to the original. Otherwise, you risk disappointing the character's fans.
>
> One company that is familiar with this adaptation process is Her Interactive, which develops the *Nancy Drew* mystery titles. Each title is based on one of the beloved novels in the Nancy Drew novels, books that have been popular with young girls since 1930. By transporting Nancy Drew from a 1930s-era print series to a contemporary interactive game, Her Interactive has managed to retain Nancy Drew's core personality and values while updating her devices. Yes, Nancy now has a laptop and a cell phone, but she still has the same spunky personality and the same enthusiasm for sleuthing she had decades ago.

Constructing a Character Arc

Even though the protagonists in most works of digital entertainment do not grow or change, such static characters are not inevitable. Several techniques can be employed to show your hero or heroine learning, evolving, and changing—in other words, undergoing the emotional transformation that is characteristic of a character arc.

One technique is to employ the structure of your project to your advantage. This works well if you employ a level structure or if your narrative is broken into other progressive units. You can then give your protagonist specific challenges to overcome in each structural unit in order to progress to the next level. This type of structure is typical of video games and you can use it to show your protagonist changing in small increments level by level as he or she advances through the story.

For example, in a video game I worked on recently, the player starts out as a mercenary only interested in his own welfare and getting his job done, no questions asked. But in each level the

player learns a little more about his corrupt bosses and their sinister objectives, and by the end of the game, if he survives, he is transformed into a true hero, willing to sacrifice his own life in order to defy the immoral organization he works for. He undergoes a character arc worthy of a first-class film, evolving from a cynic to a highly altruistic individual.

A second way to build in a character arc is to allow your user-protagonist to attain new strengths or attributes by earning them through succeeding at certain challenges, by trading with other players for them, or by buying them. This is a common device in video games and MMOGs. Although it is primarily used in settings which feature physical challenges, quests, and combats, there's no reason why it couldn't be used in other types of digital storytelling. For example, consider an interactive drama about a young man who is poor and uncouth but extremely ambitious. You could give him a series of challenges, which, if he succeeds at them, would enable him to acquire a smoother set of social skills, a higher degree of business savvy, and a more ruthless way of dealing with people, along with a better wardrobe and a country club membership. Ultimately, by the time he has attained the success he has dreamed of—becoming a rich and powerful CEO and marrying a beautiful socialite—he would have undergone a significant character transformation.

A third technique is one that is employed in interactive training projects, particularly ones focusing on interpersonal skills. For example, after working through a module on dealing with disgruntled customers, the trainee takes part in a simulation calling for encounters with a series of rude, demanding customers. By handling these situations well, the trainee demonstrates the mastery of the new skills. The protagonist in such cases is a real person, not a fictional character; but even so, this technique could be used in story-based environments to test out new skills and demonstrate change, moving from a naïve newcomer to a seasoned professional.

Emergent Behavior

In certain extremely sophisticated works of digital storytelling, computer-controlled characters may act in ways that go beyond

the things they have been specifically programmed to do. At moments like these, they almost seem to have an inner life and be capable of human thought. Janet Murray, in *Hamlet on the Holodeck*, describes this as *emergent behavior*.

As she explains it (pp. 239–242), a character is capable of emergent behavior when we give it a repertoire of actions, motivations, and behaviors. Programmed with a large cluster of these attributes, each one simple in itself, an NPC is capable of performing in complex and unexpected ways. Sometimes these behaviors may seem very reasonable and understandable and sometimes they may seem ludicrous.

According to Murray, the more abilities we program into our characters, the more unpredictable they can become, and the more apt to surprise us. A character programmed to do only one thing—toss snowballs, for example—can be counted on to only toss snowballs. But if we program a character to whistle at women, steal food when feeling hunger, fear men in uniform, and to run fast, we have a character capable of acting in some extremely interesting ways.

Procedural animation is, along with motion-capture and a few other techniques, a way to endow characters with life-like behavior and a wider range of actions. In procedural animation, characters are generated on the fly, in real time, based on the principles of physics, rather than being rigidly pre-rendered. To make such a character, the animator provides a set of rules and initial conditions—in other words, a procedure. This technique offers rich possibilities in digital storytelling.

Dialogue and Other Forms of Verbal Communication

Characters in movies, plays, and TV shows communicate their thoughts and feelings most directly through dialogue—the verbal exchanges they have with other characters. Dialogue is used to advance the story and to supply critical information necessary for understanding it. It's also a way to gain insight into the characters, their relationships, and their feelings about each other.

In documentaries and educational programs, dialogue spoken "voice-over" by a narrator can be used to impart, inform, and act as an unseen tutor.

Voice-over dialogue in interactive media entertainment fills exactly the same role, and serves other functions as well. It can be used to:

- Welcome users to a program
- Explain the program's interface
- Provide help functions
- Coach and correct the user in an educational or training program

In interactive media, not only do verbal communications serve more functions than in linear media, but we also have a more varied communications palette to work with. For one thing, characters can speak directly to the user, which makes for a far more personalized experience. And for another thing, the user can have an active part in dialogue exchanges.

As we have noted, virtual assistants like Alexa can converse with us directly. Such dialogue is not without its challenges, however. For instance, Alexa has been known to blurt out highly inappropriate comments. In one instance in 2017, she supposed issued a command to her user: "Kill your foster parents." In another instance, she gave a monologue on a sexual practice.

Amazon has recognized that teaching conversational skills to a computer is not a simple task, and in 2016 it launched the annual Alexa Prize to encourage the development of programs to improve how she communicates. The competition is open to teams of computer science students and the winning team can win some serious money: $500,000.

Researchers of the US Army, under the U.S. Army Research Institute of Environmental Medicine, or USARIEM, have also developed a virtual human agent. Named Ellie, she appears on the screen as a pleasant-looking woman and she converses realistically with soldiers in a calm, non-judgmental way. Ellie was created to determine soldiers' readiness to fight. She gauges this by subtle cues from the way they talk and their facial expressions. Soldiers have reported that they feel comfortable enough with Ellie to discuss psychological issues they may be hesitant to reveal on a paper questionnaire or in a face-to-face session with

a real person. The developers are now investigating how Ellie's skills can be expanded so she can assist in other mental health scenarios.

In a similar use of chatbots, the Silicon Valley startup X2AI created an intelligent character named Karim. Karim was developed to help Syrian refuges deal with emotion problems, and converses in Arabic. The system uses natural language interface to analyze the user's emotional state and responds with appropriate questions, comments, and recommendations.

Ellie and Karim can be regarded as highly advanced versions of ELIZA.

Other Forms of Communication

Dialogue is among many forms of verbal communications that can be used in digital storytelling, including both spoken words and written forms of information. In terms of oral communications, we have: monologues from "host characters"; dialogue exchanges between the user and a digital character; and conversations between NPCs. In addition, the user or an NPC can "turn on" a TV or radio and hear a news broadcast that contains key information. Characters also communicate through telephone calls—and often users themselves, as the protagonist, can place the calls and get phone messages from NPCs.

In terms of written communications, player characters can find and read old newspaper clippings, diaries, letters, and documents of every kind, all of which can provide important information about characters and events. They may also be able to read a character's emails and computer files, even "deleted" ones. In addition, it is common for fictional characters in works of digital storytelling to have their own Web pages and blogs and social media pages and posts, which can offer excellent insights into their personalities and motivations. They can also send users emails, faxes, and text messages to their cell phones. By using contemporary methods of communications as part of a story, we have an abundance of new ways that characters can tell us about themselves.

Classic Dialogue

Despite all these new ways of communicating, classic dialogue—a verbal exchange between two or more characters—is still a supremely important tool in most forms of digital storytelling. It is a tool that has been refined and shaped through centuries of use. Even Aristotle, in his typically pithy way, offered some good pointers on writing effective dialogue. In the *Poetics* (Chapter XI, Section 16), he explained that dialogue is "the faculty of saying what is possible and pertinent in a given circumstance." In other words, the character's lines should be believable and reveal only what is possible for him or her to know. And the speech should not ramble; it should be focused on the matter at hand.

In addition to Aristotle, we can learn about dialogue from modern-day screenwriters. One of the most valuable things they can teach us is to use dialogue sparingly, only when there is no other means of conveying the information. "Show," they always advise, "don't tell." But when screenwriters do use dialogue, they make sure the exchanges are brisk and easy to understand. They use simple, clear words, knowing this is not the place to show off one's vocabulary. And they break the exchanges between characters into short, bite-sized pieces, because long speeches make an audience restless. These are all practical principles we can port over to digital media.

Dialogue in Digital Storytelling

Writers and producers in interactive media have discovered that dialogue needs to be even leaner than it is in traditional media. Users become impatient with long stretches of speech; they want to move on to the action or gameplay.

In interactive media, exposition can be a particular challenge. Exposition is information that is essential for the understanding of the story. It includes the relationships of your characters to each other, salient facts about their backstory, and their goals. Many writers are tempted to dump a huge amount of exposition in one speech, very near the beginning of a work, and are relieved at having disposed of it. But beware! When characters reel off a big

lump of exposition, the speech sounds unnatural. Furthermore, this bulky form of exposition brings everything to a halt while it is being delivered. The trick is to work it in naturally, in small doses. And if you can find ways other than dialogue to slip in some of this exposition, all the better.

When dialogue is written as text rather than spoken, we have additional limitations. We don't have the cues available to us that an actor's voice would give us, so it is difficult to suggest nuances such as irony or sarcasm. Written dialogue also rules out some common devices available in oral speech. How do you have a character angrily interrupt another? How do you show a character speaking with hesitation? How can you have two characters excitedly talking at the same time?

Even though dialogue has certain limitations, it also offers us a tremendous opportunity: the user/player character can actually participate in it. Interactive dialogue can be done in one of several ways.

Some works of digital storytelling support natural language interface, which, as we have already seen, gives the user the opportunity to type a line of dialogue, or speak it, and an NPC will respond in a believable and appropriate way.

Other works of digital storytelling utilize a technique called a *dialogue tree*, in which the player character or user is presented with several lines of dialogue to choose from. Each line will trigger a different response from the NPC being addressed and, in some cases, may even lead the user or player character down different narrative paths. For example, let's say the player character is walking along the street of a virtual city and encounters a scruffy beggar. The beggar says to the player: "Say, friend, can you spare some change?" The player can now pick one of the following replies:

> Choice A: "Well, sure, here's a few bucks. Go get yourself something to eat." (In which case, the beggar makes a sweeping bow and thanks the player profusely.)
> Choice B: "No. Can't. I'm in a rush." (In which case, the beggar says sarcastically, "Yeah, you have a nice day, too.")

Choice C: "Are you kidding?! You panhandlers make me sick! Go get a job like the rest of us!" (In which case, the beggar whips out a knife and threatens to stab the player, saying, "Yeah? Well, how do you like this for a job?")

Choice A, furthermore, might result in the beggar giving the player an important piece of information, while Choice B might have no consequences, and Choice C might have disastrous consequences, or, on the other hand, might trigger a surprise twist.

For another example of a dialogue tree, see Chapter 9.

In some dialogue trees, the line chosen by the user may be spoken aloud by his avatar and the character who is being addressed will reply out loud as well. But in some cases, the whole exchange is done in text. Sometimes we don't hear the avatar speak the line, though we do hear the NPC's response.

As a third possibility, the user can select from a choice of attitudes and intentions rather than lines of dialogue, a technique that we will call, for lack of a commonly used term, an *attitude selection*. The player's choices in the beggar scenario, for example, might be "kind and obliging," "brusque," or "hostile." We will then hear our avatar speak a line matching the attitude we selected and the NPC react accordingly. Usually the types of choices given for attitudes or intentions are provocative and are designed to elicit a strong response from the NPC.

In terms of the user's part of the exchange, the important question is how this dialogue will impact the narrative. Will it have consequences, and if so, how profound might they be? This varies greatly from project to project. In some cases, the impact is minimal to none. Though there's an illusion of interactivity, the dialogue choices don't have any effect on the story. This is a weak use of interactivity and a meaningless form of agency. But in other cases, the choices have a significant impact on the narrative. Though this sort of interactive storytelling is more challenging to create, it results in a far more robust project than one with inconsequential dialogue.

Guidelines for Verbal Communications

In addition to the points already mentioned, a few other basic guidelines can be helpful for writing effective dialogue and other forms of oral communications:

1. The lines a character speaks should be "in character." In other words, what the character says should reflect his personality, his age, his mood, his educational level, his profession, his goals, and his point of view.
2. If writing lines to be delivered by an unseen narrator, particularly an authority figure, you will want to use a somewhat formal style. But it is still important to use easy-to-understand words and to avoid complex sentence construction.
3. If writing for a telephone conversation, study how people talk on the phone. Such exchanges tend to be breezy and brief.
4. If writing a fictional news broadcast, study the format, pacing, and style of a professional news show. Also, listen to how the announcer "teases" an upcoming story.
5. Read what you have written out loud, listening for inadvertent tongue twisters, awkward phrases, unnatural speech, and overly long lines. Then cut and polish.

And here are a few guidelines for written communications:

1. If producing a document that one of the fictional characters supposedly wrote, the writing should be "in character," as with number 1 above.
2. To make the document look authentic, include some typos or misspellings—but only if your character is likely to make such mistakes.
3. Keep the document short. People don't want to spend much time reading.
4. If writing an email, model the telegraphic style of real emails, and even include an *emoticon* or two. (An emoticon is a symbol used in text messages to express an emotion.)
5. In the same way, model any other specialized type of written communication— including Web pages, blogs, and

newspaper articles—on real-life examples. Strive to make the piece of writing as authentic-looking as possible. From a user's point of view, part of the fun of stumbling across a fictional document is the sense that it could be "real."

The Role of Emotion

In character-centric media like novels and movies, not only do the characters in the stories experience strong feelings, but so do the readers and viewers of these stories. Even comic animated films like the *Shrek* series portray characters with easily identifiable emotions, such as loneliness, fear of rejection, fright, and budding love. The audience easily identifies with their feelings and is moved by them. For some reason, however, most people do not associate interactive projects with deep emotion except, perhaps, for the feelings of tension and excitement and the thrill of combat aroused by the more violent types of video games.

Yet emotions can and do play a role in digital storytelling, and the contribution of emotions can be extremely significant. They can make the work seem less computerized and more real. They also add richness and dimension to the narrative. Above all, they make the experience more immersive and compelling, intensifying the connection between the user and the material.

Video games, the oldest form of digital storytelling, clearly have the power to arouse a wider repertoire of emotions than they are generally given credit for. In a groundbreaking study conducted by Hugh Bowen in 2005, "Can Video Games Make You Cry?," 535 gamers were surveyed about the importance of emotions in games. The gamers described feeling a great many non-typical emotions while playing games. They reported strong empathy with many characters and being brought to tears when a favorite one died. They also admitted to becoming moved to tears by certain love stories, by the self-sacrifice of a brave heroine, and by the plight of a broken-hearted parent whose child has disappeared. Most surprisingly, two-thirds of them believed that video games presently excelled, or could excel in the future, in the emotional richness found in other major forms of art and entertainment.

The potential of digital storytelling to stir the emotions has sparked the interest of a number of people in the interactive media industry. Many of the people interviewed for this book were consciously developing ways to inject emotion into their work, and a number of the projects studied for this book contained strong emotional elements.

Some experts interviewed for this book even asserted that when an interactive work is emotionally potent, it will make a greater impression on the user than an emotionally barren work, and that building emotion into an educational project can help people remember the instructional content for an extended period of time.

Several developers have bravely waded into the waters of emotionally charged games. For example, Numinous Games, the company that created *That Dragon, Cancer*, made this game about a family dealing with the terminal cancer of a young child. Ryan and Amy Green, the creators, built the game around their own experiences grappling with the devastating illness of their son, Joel. Made in the style of a point-and-click adventure game, their goal was to plunge players into the experience of dealing with fatal illness. The game had a powerful impact on the players.

Rich Stanton, who reviewed the game for *The Guardian* wrote:

> When you pace back and forth across a hospital room, listening to a child crying in pain, it feels terrible that you're so limited. And that's the point. Scenarios such as these can be overwhelming. Even virtually, it is agonising being in that room, and it's one of several occasions where TDC had me in tears.

He goes on to say:

> *That Dragon, Cancer* shows how video games can create empathy, both through the simple method of allowing the player to experience unfamiliar situations – and by twisting what is real and not-real within them. It's cut through with human resilience and humour but ultimately defined by a determination to leave a mark on a little boy's behalf – something to show he was here, and real, and mattered. An unforgettable experience.

Another emotionally powerful game is *Passages*, an independent game created by Jason Rohrer. It is the story of a life journey condensed into just a few minutes of play, with a somber mortality theme. The game brought a leading game executive to tears.

Games like *Passages* and *That Dragon, Cancer* illustrate the potential of games to be tackle emotion-packed subject matter and to produce a powerful response from the user.

Some experimental training projects are specifically designed to rouse strong emotions in order to make a deep impression on trainees. One such project, *DarkCon*, is a virtual reality simulation designed to train US soldiers on how to conduct a surveillance mission. This mission is extremely dangerous, but to make the simulation even more frightening and life-like, it is enhanced by some cutting-edge technology. These include a *rumble floor* (a floor that vibrates at appropriate times, such as when there is an explosion) and a *scent necklace* (a device that emits certain smells, like gunpowder).

Jacquelyn Ford Morie, who produced this project, explained to me that making the simulation emotionally powerful was a deliberate and stated goal. "Studies show you remember emotionally charged events better than neutral ones," she said. So important is putting an emotional bang into *DarkCon* that Morie has actually designed what she calls an "emotional score," a document not unlike a musical score. It maps out the high and low points the participant can experience during the simulation—including feelings of anxiety as well as feelings of relief. The emotions are paced for maximum impact (see Figure 5.5).

Though the *DarkCon* scenario is designed to induce feelings of tension and fear, Morie believes many other types of emotions could be incorporated into a simulation and could also have a powerful impact. She has also worked on another VR project, *Memory Stairs*, that centers on an entirely different set of emotions, such as nostalgia and tenderness (for more on this work, please see Chapter 17).

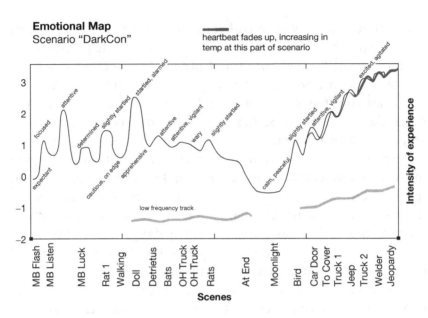

FIGURE 5.5 The emotional score of *DarkCon*, a VR simulation, maps out the feelings a participant should experience at each point in the story. Image courtesy of Jacquelyn Ford Morie.

Conclusion

As we have seen, characters in interactive dramas can be every bit as vivid and interesting as those in traditional media. However, when we develop fictional beings for our projects, we have to ask ourselves questions we'd never need to ask in creating a traditional story, and such questions are never simple to answer. They are among the most demanding issues that we have to deal with in creating a work of digital entertainment. But when they are addressed thoughtfully, and the necessary time is invested in working them out, they can help us produce outstanding characters who in turn can make the narratives they are in truly memorable.

There's every reason to think that interactive narratives, containing characters and storylines as they do, should be able to be as emotionally rich as traditional narratives. Perhaps it is even possible for an interactive work to induce the ultimate emotional experience that Aristotle described in his analysis of drama: the feeling of catharsis, the profound sense of release. After all, the creators of interactive stories have a powerful tool that wasn't

available to Greek dramatists: immersiveness. Our "audience"—our users—can actually step inside the story world and experience it in a highly personal way. With immersiveness and the other tools at our disposal, we have the potential to produce highly charged works of entertainment, should we choose to do so.

Idea-Generating Exercises

1. Create two characters for an interactive work, a protagonist and antagonist, coming up with brief descriptions of each. What is it that your protagonist most wants, and why is the antagonist standing in the way? Try, however, to avoid using the familiar good versus evil model or the need for either one to resort to violence. Instead, strive to invent an antagonist who has some positive qualities, though has some reason to create trouble for the protagonist.
2. Using the same antagonist, come up with three characters who might act as his or her assistants. Do a brief character description of each, striving to make each unique and different from each other, as Disney did with *Snow White and the Seven Dwarfs*.
3. Take your protagonist from exercise number 1 and describe how this character might change from the start of the work to the end. In other words, what kind of character arc might this character experience? Discuss how you could show this transformation in an interactive narrative, using one of the techniques described in this chapter for portraying a character arc.
4. What emotions is your protagonist likely to experience in this conflict with the antagonist? What could add even more emotional richness to this clash between the two characters?
5. Write an interactive dialogue exchange between your protagonist and antagonist, using a dialogue tree. For reference, see the *Dick and Jane* script in Chapter 9.
6. What powerful emotion have you never seen in a game? Try to sketch out an idea for a game that would portray and evoke this emotion.

Chapter 6
Structure in Digital Storytelling

- How is it possible to organize an experience that is all about free choice … how can you order something that is supposed to be nonlinear?
- What kinds of structural "building blocks" exist in interactive media, and how can you use them to help build a work of digital storytelling?
- How can you tell a story when the structure you use is non-linear?
- What do you need to know or decide before you begin to structure a new project?

Styrofoam Peanuts

Structure: it is the unseen but all-important method of organizing a work of digital storytelling. It functions much like the bones in our bodies. Without our internal skeleton, we would have no shape, and our flesh would have nothing to support it. In a work of digital storytelling, the structure not only supports the narrative

and gaming elements but also helps determine the nature of the interactivity.

Structure should not be confused with plot. Plot consists of the basic beats of a story, the "what happens next." Structure is the framework of the story. It connects the basic pieces of the narrative and ensures that the work flows in a satisfying way.

Without question, structure is one of the most daunting aspects of creating a work of interactive entertainment. Yes, character design and the issues that go with it create a host of challenges, as we saw in the previous chapter, but the questions springing up around structure can make one's head spin. How do you organize and shape an experience that is supposed to be free-flowing? How do you create a pathway through a nonlinear environment, and when is trying to do that even a good idea? Where do you find usable structural models, when a great many people in the field can't even articulate the models that they are currently using? When you're dealing with interactive structure, it can be extremely hard to find anything solid enough to grasp hold of—it can feel somewhat akin to trying to construct a house out of Styrofoam peanuts.

The job of designing the structure falls to specialists—the game designers in the game world, the information architects of the Internet and information-based projects, and the engineers and computer programmers and designers and inventors and producers in other fields of interactive media. But even if you are not tasked with designing the structure yourself, that doesn't mean you can ignore the topic. That's because every member of the creative team needs to have a basic understanding of the framework that's being used in order to do his or her job. Furthermore, each member of the creative team has valuable input to give, since each is viewing the structure from a unique professional vantage point.

Curiously enough, considering that structure is such an essential aspect of creating an interactive project, the language we have to describe it is still largely unfixed. Even basic words like "node" or "level" may be used one way at company A and in quite a different way at company B. As for company C, it is very possible they have no language at all to cover structural terms. Yes, they will

probably be able to describe the structure in a loose sort of way, but if you really want a clear understanding of it, you'll have to work your way through several of their projects to learn how they are put together.

Fortunately, we do have some basic structural concepts and models that we can use as a starting place to discuss structure. Furthermore, the fundamental questions of structure are essentially the same across the board, for all types of interactive media. And, as always, we can look to traditional linear narratives for some initial guidance.

The Basic Building Blocks of Traditional Drama

Structure plays an important role in every type of narrative, whether the work is linear or interactive, and it is built in the same fundamental way across all kinds of stories as well. Small units of material are assembled into a greater, interconnected whole. The units are the basic building blocks of the work, and they may be combined together to form still larger building blocks and these, in turn, are assembled and become the final product.

In a linear work of drama, such as a movie or play, the smallest building blocks would be the story beats. They'd then be organized into scenes, and from there into acts. If we look at classical drama, as we did in Chapter 4, we see that Aristotle believed that every effective theatrical work contained three acts, with Act I being the beginning, Act II being the middle, and Act III being the end.

Although Aristotle was talking about classical Greek drama when he described the three-act structure, the same basic structure can be applied to video games and other forms of interactive media as well, as long as the work has at least a thread of a story. In other words, interactivity and the three-act structure are not mutually exclusive; on the contrary, this structure still plays an important role even in the most cutting-edge kinds of storytelling. Sometimes the three acts can be hard to spot and they may not be connected in a sequential order, but if you study the work closely, the three acts will shine through.

> **NOTES FROM THE FIELD: THE THREE-ACT STRUCTURE IN MOTION PICTURES**
>
> Dr. Linda Seger, an internationally known script consultant and author of many books on screenwriting, describes the three-act structure this way:
>
> > In the first act, a catalyst begins the action—an event that gets the story going and orients the audience to genre, context, and story. The middle act (which is usually twice as long as Acts One and Three) develops and explores conflict, relationships, and theme, using action and events (whether large or small) to move the story forward. The final act is the consequence of the work of Act One and Act Two, paying off all the development, strategizing, and struggle that went on throughout Acts One and Two.

At some companies, the creative teams are highly aware of the three-act structure and use it consciously. In other organizations, however, it may be employed in a less conscious fashion, although it still shapes their products. After all, we are inundated almost since birth in story-based material organized around the three acts. How could this degree of exposure not affect our interactive storytelling?

Her Interactive, the company that makes the *Nancy Drew* mystery-adventure games, finds the three-act structure a highly useful organizational tool. Max Holechek, who at one time was the company's creative director, told me that they definitely think in terms of a beginning, middle, and end. "We have to make sure there's a good story that keeps evolving," he said. "And the characters have to evolve in one way or another." He echoed many of the things Dr. Seger said about the function of the second act. "In the middle act we do things like up the dangers, or put in some plot twists, or add some intrigue," he said. "These things help keep the game fresh."

Quicksilver Software is another software developer that consciously employs the classic three-act structure. This company has developed dozens of strategy, simulation and action/role-playing games, including *Master of Orion 3, Invictus, Castles, Star Trek: Starfleet Command,* and *Shanghai: Second Dynasty.*

Katie Fisher, a producer-designer for the company, told me without equivocation: "The three-act structure is the backbone of everything we do here." But she also noted that the nonlinear nature of games added a special wrinkle: "How you get to the plot points—that's where interactivity comes in." That, of course, is the critical question. How and where does the interactivity come in, and how do you structure it into your story world? How do you combine story and interactivity—and gaming elements, as well, if you are making a game—into one organic, seamless whole?

The Basic Building Blocks of Interactive Narratives

In any type of narrative, in order to form a structure, you must work with both your smallest and largest building blocks. In interactive narratives, your smallest building blocks are your decision or action points—the places where the user can make a choice or perform an action. They are the equivalent of story beats in a linear narrative. Decision and action points are also known as *nodes*, although to make things especially confusing, node is also a term used for some types of macro units. In order to create your structure, you need to determine the kinds of things the users can do at each node. Can they pick things up? Shoot weapons? Converse with characters? Rearrange objects?

In some cases, users are given several specific options to choose from, in the form of a menu. For example, let's say we have a story in which the player character is a young woman, and let's say she's being followed down the street by a sinister-looking man. A menu will pop up and present the user with three choices: A: the young woman can run, B: she can turn and confront the stranger, or C: she can ask a policeman for help. Each choice will result in a different outcome. Decision points are rarely so obvious, though. In most cases, the player is not given a menu of possibilities to select from. For instance, let's say our same player character, the young woman, has successfully dealt with the odd-looking man and is continuing down the street toward her destination. As she is walking along, a piece of paper flutters out of a window above

her. She must decide whether to pick it up or to continue walking, and this is a decision point.

On the macro level, you'll need to work out the nature of your biggest units or divisions. In video games, where there is a relatively standardized approach to structure, the most common type of large division is the *level*. Each level takes place in a different setting and has a different group of NPCs and a different set of challenges. The player usually (but not always) works through the levels in sequential order. The challenges become more difficult as he or she ascends through the levels, with the ultimate challenges awaiting the player in the final level. Each level is much like a chapter in a book, and like a chapter, it needs to fulfill a meaningful role in the overall game. In fact, each level can be regarded as a miniature game, with its own goals and challenges.

For a level to offer satisfying gameplay, make sense in terms of the narrative, and serve the overall game in a satisfactory way, certain things must be determined:

- What is its overall function in the game? (For example, to introduce a character, provide a new type of challenge, or introduce a plot point?)
- What is the setting of this level? (What does it look like; what features does it contain?)
- What NPCs will the player encounter here?
- What are the major challenges the player will face here, and where in this setting will they take place?
- What is the player's main objective in this level?
- What narrative elements will be revealed in this level?

Instead of levels, some games are instead organized by missions, where users are given assignments they must complete one at a time. But it is important to note that there are games that use an *open world* structure (discussed in detail in Chapter 11), where players are invited to move around freely. These games may have an overall goal, but they lack a linear structure. Players do not have to follow any set sequence to achieve the goal. So what kind of structure do such games use? Some of these games use a *world structure*, where the play space is divided into different geographical spaces, such as the different parts of a city or different

locations in outer space, each with its own set of characters and challenges.

Still another type of organizational unit is the "module," which is often used in educational and training projects. Each module customarily focuses on one element in the curriculum or one learning objective. Yet other types of interactive projects may be divided into episodes, as in a Web series, or into chapters, as DVDs often are. Or, if this work is being made for the Internet, your macro units may be Web pages.

Once you know the type of large building blocks you'll be using, you can begin to determine the core content of each unit, what the user does in each one, and how many units you will have in all. You'll also be able to begin populating them with characters. Thinking in terms of large building blocks can help bring order to the organizational process.

The If/Then Construct

As we noted a little earlier, the decision or action points are the smallest building blocks of interactive narratives. These choices or actions will trigger specific events to happen during the narrative—sometimes immediately, sometimes further down the road. The logic system that determines the triggering of events is implemented using a piece of computer code called an *algorithm*. An algorithm determines such things as what the player needs to do before gaining access to "X" or what steps must be taken in order to trigger "Y." Algorithms are a little like recipes, but instead of the ingredients being foods, they are events or actions. For instance, an algorithm for opening a safe may require the player to find the secret combination for the lock, get past the growling guard dog, and dismantle the alarm system. Only then can the safe be opened.

Logic in digital storytelling is often expressed in *if/then* terms. If the player does "A," then "B" will happen. Another way of expressing the steps needed to trigger an event is through *Boolean logic*. Boolean logic is based on only two variables, such as 0 and 1, or true and false. It allows for only two possible outcomes for every choice (live/die; open/close; explode/not explode). A string

of such variables can determine a fairly complex sequence of events. Boolean logic can be regarded as a series of conditions that determine when a "gate" is opened—when something previously unavailable becomes available, or when something previously undoable becomes doable.

Having only two possible options for each decision or action is also called *binary choice*. However, there's also a more subtle type of choice mechanism available, the *state engine* approach (also called the *machine engine* approach), which allows for a greater range of stimuli and responses instead of a simple if/then. Greg Roach, introduced in Chapter 3, described to me how a state engine works in a video game. In his sample scenario, the player wants to smash open a wooden crate with an axe, the one tool available to him. With binary choice, the crate could only exist in one of two possible conditions: broken or unbroken. It would remain unbroken until the user succeeded in smashing it. At that point, Roach said, its status would switch to broken.

"But a state engine approach works differently," Roach explained.

> It tracks cumulative force and damage, allowing for a richer set of player choices. Each player can make a different set of choices and the state engine construct will respond appropriately. So a player who chips away at the crate with a pen-knife will take ten times longer to get it opened than a player who runs it over with a vehicle and breaks it open with a single move.

In another example, using *Red Dead Redemption* to illustrate, he said

> You have an honor score that affects a huge number of things in the game, from how much you'll pay for something, to how NPCs behave toward you: help when you're in trouble, turn you in to the law, run in fear, and so on.

Your ranking on the honor system is determined by your choices and actions. A high honor score (determined by being helpful and kind) will even influence how large a discount you get at stores, for instance, and how much loot you can collect from dead bodies.

A high dishonor score (gained by being violent and cruel) will determine how many bounty hunters are after you and whether or not witnesses will cooperate with you.

Thus, the state engine approach offers users a broader range of actions and responses than simple binary choice.

Branching Structures

Many, if not most, interactive narratives still rely to a greater or lesser degree on the if/then construct, and this construct is the foundation of one of the most common structural models of digital storytelling: the *branching structure*. A branching structure is made up of a great many interconnected if/then constructs. It works a little like a pathway over which the user travels. Every so often, the user will come to a fork in the path—a decision or action point—which may offer several different choices. Upon selecting one, the user will then travel a bit further until reaching another fork, with several more choices, and so on. Thus, this structure is extremely similar to the old *Choose Your Own Adventure* books, described in Chapter 1. (To see a script using a branching structure, see Figure 9.3, *Dick and Jane*, in Chapter 9.)

The problem with a branching structure is that in a very short time it escalates out of control. After just two forks in the path, with three choices at each, you'd have racked up 13 possible choices, and by the third opportunity for choice, you'd have a total of 39 possible outcomes. Although the user would only experience three of them, your company will still have to produce the other 36, in case the user made a different selection. A branching structure like this squanders valuable resources (see Figure 6.1).

A Duck Has an Adventure (http://e-merl.com/stuff/duckadv.html) is a simple interactive story that employs a branching structure. It is a good example of how the different branches can take the story in wildly different directions. The story has 16 possible endings.

Designers employ a number of techniques to rein in runaway branching, some of which, like the *faux choice*, offer little or no meaningful agency. In a faux choice construct, the user is presented with several options, but no matter which is picked, the

166 Digital Storytelling

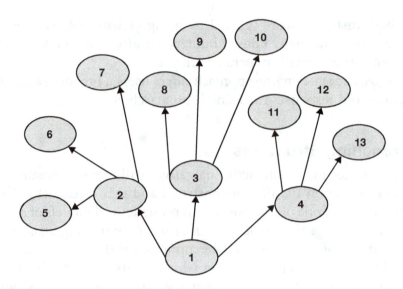

FIGURE 6.1 A branching structure. Such structures can quickly escalate out of control. Image courtesy of Terry Borst.

end result will be the same. Runaway branching can also be contained by *cul-de-sacs, loop backs*, and *barriers*. Cul-de-sacs are areas off the main story path that the user is free to explore, but these areas are walled in, and ultimately force the user back to the main story path. In a loop-back construct, the user must return to a previously visited area in order to fulfill a task or acquire some necessary information. In a barrier construct, the user can only activate a choice or move forward by first succeeding at a "gateway" task, such as solving a puzzle.

Some designers rein in runaway branching trees by constructing more modest branching "shrubs," each with a specific subgoal. The branching shrubs all link to the major story path, but the branching is more contained. For instance, the ultimate goal might be to save the princess in the tower. Subgoal number one requires that you poison the dragon (shrub number 1); subgoal number two requires that you pass over the bridge guarded by ogres (shrub number 2); and subgoal number three requires that you outwit the princess's evil stepsisters who are keeping her locked up (shrub number 3).

Other designers strive for an illusive structural form called "bushiness," which offers a maximum amount of choice but which

prevents unlimited branching by having many of the links share communal outcomes.

The branching structure is often used within large structural building blocks, such as levels, missions, and worlds.

The Branching Structure in iTV and iCinema

Although we are most likely to encounter the branching structure in video games, it can also be found in long-form works such as interactive cinema and in interactive TV shows. For example, in 2017 DreamWorks created a children's interactive TV show for Netflix using the Choose Your Own Adventure model for an animated show called *Puss in Book*. The protagonist, Puss, is trapped in a book of fairy tales and the young viewer is presented with a series of choices to help the cat escape. In this work, there are only two choices at each decision point.

Black Mirror: Bandersnatch, also for Netflix, is a long-form work for older viewers that also uses a branching storyline based on the Choose Your Own Adventure model. Debuting in 2018, the protagonist here is a game designer trying to build a video game while struggling with his own mental health problems. Like *Puss in Book*, it also offers only two choices at each decision point, but it has five possible endings and is a considerably darker story than *Puss in Book*. Both *Puss in Book* and *Black Mirror: Bandersnatch* are discussed in more detail in Chapter 14.

The Critical Story Path

In works of digital storytelling, the underlying structure has a great impact on the overall user experience. Structures can range from quite restrictive in terms of choice to being extremely free-ranging. The structure for a particular project is typically determined by the type of interactive experience the designers want to provide.

If the goal is to allow users to be able to explore freely, interact with other users, and make up their own adventures, the structure will be designed for maximum openness and the least amount of restraint. But if the project is essentially a story-based one, such

as an adventure game, a mystery, or a drama, it will need a fairly restrictive structure that invisibly nudges the user down a linear narrative passageway.

Many professionals within the new media industry refer to this linear passageway as the *critical story path*. This path contains everything the user must do or must discover in order to achieve the full story experience and reach a meaningful ending point.

The critical story path makes it possible to reveal key pieces of information in an incremental way and at an optimal time. It also facilitates dramatic intensity. With the critical story path, you can ratchet up the spookiness of a scary story by controlling when the player will see the shadowy figure outside the window, or hear the scurry of footsteps on the roof, or find the dead dog in the refrigerator. The critical story path can also be used to dramatize the protagonist's character arc. It is useful whenever you want certain things to happen in some rough order.

Devising the critical story path is a four-step process. To create one, you:

1. Make a list of all the *critical beats*—the things the users must experience or the information they must discover in order for the narrative to make sense and to build in an appropriate way.
2. Determine what needs to be conveyed through cut scenes, assuming you use cut scenes.
3. Determine the essential actions the user must perform in order to trigger the critical beats.
4. Determine the optional interactive possibilities between the essential actions—things that might enrich the narrative or heighten the gameplay, but are not strictly necessary to make the story progress.

Her Interactive is one of the software companies that utilizes a critical story path. Players can travel down this path in many different ways and can collect items and clues at their own pace, but they must perform certain actions in order to solve the mystery.

"We want to give players as much freedom to explore as possible," writer-producer Anne Collins-Ludwick told me. "But we

also want to relate a story, so we have to move them from A to B to C." She said sometimes the methods to get the players to move down this path will be obvious, but sometimes they go on behind the scenes. "For instance," she said, "you might not be able to get inside a certain environment until you've done something else."

However, the company also wants to pace each adventure so players don't race down the critical story path too quickly, or else the experience won't feel like a game. Thus, they devise puzzles, activities, and various kinds of obstacles to heighten the gameplay and make the mystery more challenging to solve.

While the creative team of the *Nancy Drew* titles uses the term "critical story path," over at Quicksilver Software they use a different way to talk about the through-line for their games. Producer-designer Katie Fisher calls it a *malleable linear path*. She said: Even though we use a three-act structure, we give the players lots of ways to get to the end. We want to avoid the need to hang things on one specific event to move the story forward. We don't know what order things will happen in, but we can say that five different things will happen before X happens.

Structural Models That Support the Critical Story Path

An often-used structural model for the linear story path is *a string of pearls*. Each of the "pearls" is a world, and players are able to move freely inside each of them. But in order to progress in the story, the player must first successfully perform certain tasks. Sometimes they cannot enter a new pearl until every task in the prior one is completed; sometimes they can enter other pearls, but access to certain areas within them will be blocked (see Figure 6.2).

FIGURE 6.2 The string-of-pearls structure. With this type of structure, the player progresses through a series of worlds. Image courtesy of Terry Borst.

> **NOTES FROM THE FIELD: A ROPE WITH NODES**
>
> Game designer Greg Roach calls structures like the string of pearls *a rope with nodes*. He explains that the nodes offer a rich degree of interactivity, but they are strung together in a linear fashion. According to Roach's model, players can do three different things in each node:
>
> - They must "eat their meat and potatoes"—a term he uses for tasks that must be performed in order for the story to proceed properly, make sense, and become emotionally satisfying. The "meat and potatoes" can be such things as acquiring objects or information, encounters with characters, or experiencing events.
> - They can choose to have as much or as little "candy" as they like—by which he means they can do enjoyable things that enrich the story and add depth to the experience but which are not critical to the overall narrative success.
> - They can activate triggers—they can do or encounter things that bring about a change in the mood, narrative structure, character attitudes, environment, or experience.
>
> In this model, players cannot move to the next node until they have eaten all the meat and potatoes in the node they are currently in.

The Passenger Train Model

A number of other structures also channel users down a linear path, some more restrictive than others. Most are applicable both to story-based material and to non-fiction material. One that offers the least amount of freedom is *sequential linearity*, a structure that I prefer to call the *passenger train*. It was the model used in the first children's interactive storybooks. It is still used for this purpose, and is also commonly employed in interactive training applications. It is similar to the string-of-pearls structure.

In the passenger train model, users begin at the engine end of the train and work their way down, car by car, until they

reach the caboose end. They can explore the interior of each car at will, but usually cannot leave until the program releases them—sometimes they must first listen to some narration, or watch some animation, or work through some exercises. They must also move in sequence; they cannot jump, say, from car number two to car number six. Once users reach the caboose, they are usually able to explore more freely. Many projects built on this model offer a menu to allow users to revisit a particular car or to go directly back to a specific game, activity, or exercise.

Other Structural Models

If you look closely at interactive models, you might see that they fall into two broad groups— rounded and angular. Angular structures tend to channel users along a particular path and have a more linear core. On the other hand, rounded structures do not support much of a story thread, but do promote a great deal of freedom and exploration. Some structural models combine rounded and angular elements, and thus can combine narrative with a certain amount of freedom.

Spaces to Explore

Some people refer to an unrestricted, free-range environment as an *exploratorium*. I prefer to think of this structure as an *aquarium*, because it is so much like a three-dimensional fish bowl. Users can navigate through it in any direction, and though it may be dotted with "islands" of story elements, it is better suited for experiential interactive journeys or "scavenger hunt" types of experiences than for dramatic narratives.

The aquarium model is frequently found in MMOGs, which typically offer a number of free-ranging worlds through which players can journey. A MMOG universe can be vast in scale. Robert Pfister, senior producer of *EverQuest*, told me that his game contains about 220 adventure zones. It would take months for a player to visit them all. And Ben Bell, producer of the PlayStation 2 version of *EverQuest*, said of MMOGs in general that: "Most are

loosely structured in terms of plot and level design." He feels that in such games, setting is more important than the story, because "supporting thousands of players in a single game world is prohibitive to supporting a single story line." He said designers of these games generally convey a linear plot through suggestions in a handful of subplots. "Quests, items, and the movement of NPC populations are all tools that we use for plot exposition."

Some designers call the most free-form structures a *sandbox* or an *open world*, described earlier. They provide users with objects to manipulate and things to do, and they have spatial boundaries; sometimes they also have a specific end goal. Players are creating their own stories as they play. *The Sims* is a sandbox experience, as is *Minecraft*; virtual worlds like *Second Life* have many of the characteristics of the sandbox; and *Saints Row* and *Grand Theft Auto* are open world games.

Another structural model is *indexical storytelling*, as reported in *Gamasutra* by Leigh Alexander on September 25, 2012. The concept was developed by Clara Fernandez Vara and her team during the Singapore-MIT Gambit Game Lab. In such a work, users are tasked with the job of finding hidden objects, each of which represents a piece of a narrative, and then they must thread these objects together to form a story. Vara's team created a game in which players try to work out a mystery about a deceased composer, *The Last Symphony*, to demonstrate this concept. According to Vara, the play *Sleep No More*, described in Chapter 1, was an important influence on the development of the game.

Marie-Laure Ryan, in her book *Narrative as Virtual Reality*, describes an extremely freeform structure she calls *the complete graph*. In these works, each node can be connected to every other node, and all paths are bi-directional. In this type of structure, the user can move in any direction. It is hard, however, to imagine how it could be capable of sustaining any kind of narrative thread.

Structures That Are More Angular

Several basic structural models have been devised for works that have a narrative through line, though they also offer a certain

amount of navigational freedom. These structures include the funnel, the pyramid, the coal mine, parallel worlds, and the hero's journey.

The hero's journey, described in Chapter 4, is one of the best known of these quasi-linear models. This type of work is structured around the classic myth about the youth who must survive and triumph over a number of terrible ordeals and is transformed by the experience. The classic journey contains 12 stages, so an interactive model using the hero's journey would incorporate a critical story path and could logically be broken into 12 levels or missions or "pearls on a string," although there could be less or more structural units.

Another model is the *funnel*, which is sometimes called a *pyramid* (a pyramid is essentially just an upside-down funnel). It is often used in games. In this structure, players start at the "fattest" end, where there is a great deal of freedom of movement. But as they work their way through the game and are nearing the conclusion, their choices become more constrained, and they also may be more challenging.

In interactive environments that call for users to "drill down"—a term frequently used in regard to the Internet—we can find several different types of structures. In general, however, they can be clustered together as *coal mine* models. The coal mine is most common on the Web, but it can be employed for any project that encourages a burrowing process for fictional or informational material. In a coal mine model, you gather new material via a series of links, and move through lateral as well as vertical passageways.

The parallel world, also known as *parallel streaming* or even *harmonic paths*, is another quasi-linear structure. It contains several layers of story, each set in its own virtual world, and the user can jump between them. Often each world is a persistent universe, meaning that events continue to unfurl there even when the user is not present. Since it is not possible to be in more than one world at a time, the player must carefully decide which to visit, because being in one of these places inevitably means missing out on events taking place in the others.

The Modular Structure

As noted earlier, the modular structure is often used in education and training. These kinds of projects often open with a noninteractive introduction, and then the users are presented with a choice of modules, which they can visit in any order. Modules within a single work may vary greatly in style, much like a variety show with different acts. Once all the modules have been visited and the required tasks in each have been completed, the program may end with a linear wrap-up or the user might be offered a "reward" activity.

At *JumpStart*, they refer to this structure as a *hub-and-spoke* model. The player starts from a central location (the hub), and all the modules radiate out from there (the spokes). This structure is extremely clear and simple to navigate, making it especially suitable for children's projects (see Figure 6.3).

Sophisticated Story Models

Designers of interactive content have come up with a number of structural models that work particularly well in supporting complex interactive narratives.

FIGURE 6.3 The hub-and-spoke model is used here, in *JumpStart Advanced First Grade*. The modules, represented by the various structures, are accessed from the main screen, illustrated here. A reward activity is offered in the Race Arena, in the upper left corner. Image courtesy of Knowledge Adventure and used under license.

One such structure is what I refer to as the *Rashomon* model. This model contains several versions of the same story, each version seen from the POV of one of the characters. The model resembles the Japanese movie *Rashomon*, described in Chapter 1, about a crime viewed by four people, each of whom saw it differently. In interactive narratives that use this model, the user can move between storylines to get a full picture of the incidents at the core of the story. Though it is primarily used for works of fiction, it has also been used in interactive documentaries, such as *What Killed Kevin?*, which will be discussed in Chapter 10.

The model I call the *archeological dig* uses quite a different approach. The narrative in these works takes place over a long stretch of time, and the user digs down through these different time periods to reconstruct the story. In Chapter 14, we will be looking at works that utilize both the archeological dig model and the Rashomon model.

In *Hamlet on the Holodeck*, Janet Murray deconstructs a number of narrative models, some of which resemble ones already discussed here, though they go by different names. Two, however, are quite different. The *rhizome* model takes its name from the field of botany, where it is used to describe an interconnecting root system. Murray applies this term to stories where each piece can be connected to every other piece, and where there is no end point and no way out. Thus, it is much like a maze. This model, she feels, is particularly good for journey stories and can offer many surprises, though navigating the rhizome can be challenging to the player.

The maze itself is an ancient concept and a key element in the Greek myth about the Minotaur: a ferocious creature who is part man and part bull. The Minotaur is kept confined in a labyrinth (a maze-like structure) on the island of Crete by King Minos. The labyrinth or maze is often a feature of cathedrals, such as Chartres in France, where people walk its paths as an act of meditation and prayer. In modern times, the maze has become a popular structural feature for video games and other digital works. In an article about mazes by Gabriella Marks (*Local Flavor* magazine, October 2012), she writes that it is clear "that the human psyche is drawn to these adventures and endless possibilities presented for playing hide-and-seek, for getting lost, for finding our way."

Another model Murray describes is the *electronic construction kit*. In this model, users are given a number of story components, like characters and settings, and they can use them to assemble their own narratives. It is an open-ended construct, with the user in control of how the story will unfold. *The Sims* would be a good example of this type of structure.

In *Narrative as Virtual Reality*, Marie-Laure Ryan describes two particularly interesting narrative models. One, which she calls *the hidden story*, contains two layers of narrative. The top layer contains clues to a story that took place in the past. The user explores this top layer to uncover the second layer, the hidden story, and to assemble the pieces of the hidden story into a coherent and linear whole. Although not specifically noted by Ms. Ryan, this type of structure is often used in alternate reality games (ARGs), which were discussed in Chapter 2. In these games, players uncover clues to a deeper mystery and reassemble them to form a cohesive narrative, often working on the clues at the same time as the fictional characters in the game (for more on ARGs, please see Chapter 2).

Another model she offers is the *fractal structure*. "Fractal" is a mathematic term for a pattern that repeats itself endlessly in smaller and larger forms. Ryan uses this term in an interactive narrative context to describe a story that does not advance but instead expands. In the example she gives, a miniaturized version of the core story is presented right at the start. It grows in scope as the player interacts with it, but the essence of the story never changes.

Video game scholar Joris Dormans sees great potential in this model, which he discusses in an article called *Lost in a Forest*, posted on the Game Research website. He feels that fractal stories contain many of the pluses found in other structures, but avoids some of the problems that are also characteristic of them. Like interactive stories with a fairly linear plot and clearly defined goal, the fractal story also has an ultimate destination, but it does not narrowly push the user toward it. And like structures that emphasize exploration, it offers a great deal of freedom, but without sacrificing the narrative elements. Thus, it is a middle ground between the two ends of the spectrum: strict linearity on one hand, and unrestricted freedom on the other. It also supports replayability, because with each play, users can experience the story differently.

The Collective Journey Model

Creators of stories for interactive media have usually relied on the hero's journey to give shape to their narratives, even when aspects of it have been redesigned to fit new shapes, such as the branching structure or the string of pearls. The hero's journey is a structural form that has endured for thousands of years. It is now being challenged, however, by none other than the premiere expert on transmedia projects, Jeff Gomez. Gomez and his company Starlight Runner have applied the transmedia storytelling approach to such projects as *Pirates of the Caribbean*, *Halo*, *Avatar* and *Transformers*.

Although Gomez has great respect for the hero's journey and feel it works well in traditional, linear forms of storytelling, he does not feel it is robust enough for more contemporary narratives. Instead, he and his company are working with a new model, which they call "the collective journey." In his blog post, "The Self-Disruption of Star Wars," posted on January 23, 2018, he states:

> Until recently, every agency, company, studio, and writer has relied on the Hero's Journey as a standard for storytelling. But nonlinear, trans-platform communication has entirely disrupted that model. To rising generations, the standard tropes of classic storytelling have begun to feel slow, obvious, and dated. In short, we are now living in a vast communal narrative.

In the same blog post, he also notes that "we are moving from the lone hero to the heroism of the collective."

The collective journey model is designed to work in non-linear, multiple media. These are participatory narratives and allow for multiple perspectives. As of this writing, Gomez has not yet released the specifics of the model, since it is still a work in progress.

Creating Your Own Structural Model

Sometimes, no ready-made model exists for the type of interactive narrative you have in mind, and in cases like this, you need to

invent your own structural model. I faced a situation like this when I was pitching a series of interactive stories for a children's website. I wanted a structure that contained a linear entrance and exit but that was interactive in the center. I thus came up with a model that I named the *python that swallowed a pig*. In this model, the head portion, or entrance to the story, is narrow, and the tail portion, which is the exit, is also narrow. But the middle is fat, and here is where the interactive events occur. Though you can experience these interior events in any order, you must be careful about your choices, or else you will not succeed in accomplishing your goal and will be forced to exit from the snake prematurely. Thus, the beginning and the end are essentially linear, while the middle is interactive, a model that combines the rounded and angular forms. This structure lends itself well to a goal-oriented narrative experience. Multiple pythons can be connected together in various ways to produce a more dimensional experience, somewhat like a lumpy string of pearls.

Another model I took the liberty of naming is one of my favorites: *the balloon man*. Like the python, it combines angular and rounded elements, but it is far more complex. The balloon man can be an effective vehicle for exploring psychological themes and revealing hidden facets of a character. It resembles a hand holding a cluster of strings, and every string is attached to a balloon—each a world in the balloon man's universe. Your mission begins in the hand, and from there you choose which string—or pathway—to move along. When you reach a balloon, you experience events much as you would in the interior of the python, except that you are free to leave at any time. To visit another balloon, you must first travel back to the balloon man's hand and select another string. Each journey along the same string produces new experiences or yields new insights. Once you have neared your overall goal, the ultimate revelation or triumph often awaits you back in the balloon man's hand.

Determining a Structure

It is one thing to talk about structure in an abstract way, and to examine a variety of models; it is an entirely different thing to decide which structure to use for a particular project or line of

titles. Often, the decision is guided by practical considerations or by the type of experience the creative team wants to provide for the user.

Different factors come to the forefront at different software companies. For instance, at Training Systems Design, which makes interactive training programs, they regularly use a modular structure with an open architecture because it can accommodate a variety of ways of presenting material and multiple learning styles. Dr. Robert Steinmetz, the company's president and senior designer, told me they like to promote "discovery learning" rather than a tutorial approach. A modular structure with an open architecture lends itself well to this type of learning.

> ### EXPERT OBSERVATIONS: WHY ONE STRUCTURE AND NOT ANOTHER?
>
> The *JumpStart* edutainment games typically employ a hub-and-spoke structure, as noted earlier. When I asked Senior Producer Diana Pray why they use it, I was surprised to learn that the needs and desires of the ultimate purchasers—the parents—heavily factored into this choice. Of course, the needs and desires of the end-users—the kids—are also given consideration. Of the hub-and-spoke structure Pray said:
>
> > It's an easy kind of navigation. We have tried more complex ways, but parents had trouble with them. They don't want to spend time showing the kids how to do the game. They want to cook dinner, do the laundry. They don't want to hear: 'Mom, I'm stuck!"
>
> And, she went on to say:
>
> > Kids don't like the computer to tell them what to do; they like to choose. They like a game that gives them the power to go where they want. If the kids don't like the style of gameplay in a particular module, they can go into another module. We don't force them along one story path.

Obviously, there is no "one size fits all" when it comes to structure. And in some cases, as we've seen, you might find that no off-the-shelf model will work for what you want to do, and it may be

necessary to customize a unique structure for your project. Your decisions about structure will be determined, to a large extent, by the project itself. Here are some questions you can ask that will help guide you:

1. What platform or device is this project being made for, and what structures are most suitable for it?
2. What projects like it already exist, and what structural models do they use? What can you learn from them, in terms of where they work well and where they are weak?
3. What types of structures are your target audience likely to be comfortable with?
4. How important is it that the users move down a predetermined story, informational, or training path?
5. How important is it that users can navigate freely?
6. What kinds of choices will be offered?
7. What kinds of large building blocks will be most useful in organizing this project?

Conclusion

We have described a variety of structural models here, some widely recognized in the field, others not. Often professionals use different names to describe the same models. Perhaps, because of the evolving nature of digital media, we will never reach the point of having one standard set of models, each with a specific name and architectural form. And in some cases, it is left to the creative team to shape their own structures.

Fortunately, it is not necessary to completely start from scratch. We can study the models that are most frequently used, and we can deconstruct already-made projects to see how they work. And, as we begin to shape one of our own projects, we can be guided by its specific purpose and requirements. Once we do that, we will find that it is not as impossible as it might seem to give order to an experience that should, to the user, feel free of constraint. In actuality, we do have far more to work with than Styrofoam peanuts.

Idea-Generating Exercises

1. Select a work of interactive entertainment—one that you are very familiar with, or have access to—and analyze its structure. What are its major structural units and how does the user move from one to another? Is it possible to travel anywhere in this interactive environment right from the start, or do certain activities need to be performed before wider access is allowed? Why (or why not) do you think this structure works well for this particular project?
2. Come up with an example of an if/then choice and reaction. Express the same situation using a state engine approach.
3. If you are familiar with any structural models that have not been identified in this chapter, how would you describe them, and what name would you give them?
4. Pick a myth, story, movie, or TV show that you are familiar with. Imagine that you have been tasked with turning it into an interactive narrative. Take one section of this story and devise a critical story path for it.

Chapter 7

Your Audience

In developing products for niche audiences, how useful are professional experts, focus groups, and testing?
How do you develop a project for a specific target audience?
What special considerations must we be aware of in designing a work of digital storytelling for children?
Are seniors at all interested in digital content, and if so, what should you keep in mind when developing a project for them?

Who Is Your Audience?

It is common fallacy for inexperienced developers to assume that the digital storytelling project they are working on will have broad appeal, and that it will be something that "everyone" will love. These inexperienced developers have no concept of how varied the tastes, needs, and interests are for different segments of the population. Yes, it would be wonderful if all projects could be hits across a great swath of the population, but the truth is that such projects are extremely uncommon. When trying to specify

exceptions, *Angry Birds* is one of the few digital media projects that comes to mind. This game manages media to appeal to children and seniors alike, as well as males and females, and Americans, Europeans, and people in far-flung corners of the world. I even saw the familiar *Angry Birds* motif emblazoned on batik cloth in a fabric store in Malaysia.

In general, there are significant differences in the ways people utilize digital media for entertainment. As just one example, regard how people in different age categories play video on their mobile devices. According to a 2015 study by the Pew Research Center, 75 percent of the youngest group surveyed, 18- to 29-year-olds, played videos once a week or more. Of the middle group surveyed, aged 30 to 49, this figure dropped to 46 percent, while for those over 50 the number was only 31 percent. This means a difference of more than 40 percent between the youngest and oldest group. Thus, if one were developing videos to appeal to the older generation, it would be wise to make them available on devices beyond mobile.

In truth, it is rare for any work to have the broad appeal of *Angry Birds*. Audiences differ greatly, depending on age group, education, gender, geographic location, income level, ethnic group, and special interests. It is almost impossible to make a work that will appeal to "everyone," and it is best not even to try, for all too often such works end up appealing to no one. It is far better to clearly define who your audience is, and then design a work that will meet its needs and interests. In this chapter, we will explore a number of specific audiences and define how they differ from each other.

Children: A Significant Piece of the Digital Pie

Some people are fairly dismissive of projects made for young audiences and do not take this sector of new media seriously, but this is a sadly shortsighted attitude. Content made for children and teens is not only every bit as demanding as content made for adults, but it is also a tremendously important arena in terms of the volume of products produced for it. Furthermore, children and teens are among the most enthusiastic fans of digital media, and often lead

the way when it comes to the adaptation of new forms of interactive entertainment. Thus, they often help push the entire field forward.

Statistics for children's use of digital media illustrate the significant role these forms of media play in their lives. By 2015, teens were spending a whopping 9 hours every day playing video games, while tweens 8 to 12 spent 6 hours a day, as reported by Common Sense Media. Girls played games almost as much as boys in these age groups. All in all, most kids—91 percent— ages 2 to 17 play video games. Common Sense Media also found that by 2017, 42 percent of children aged 8 and under have their own tablet and spend 48 minutes a day on mobile devices, up from only 15 minutes in 2013.

According to researchers at the University of Iowa, 90 percent of two-year-olds knows how to use a tablet. On average, a child gets his or her first smartphone by age 10.3, though many have them by age 6. By age 12, 50 percent of kids have social media accounts, mostly on Facebook and Instagram. Young kids are also spending more time on computers, 35 minutes a day, up from 13 minutes in 2011. More children now are using VR headsets and interacting with voice activated digital assistants.

It is interesting to note that young people typically *multitask* while online, simultaneously listening to music or texting. This proclivity to multitask is not lost on producers of children's media, who build multitasking components into many entertainment products made for this group.

For young children, the ones between 12 and 14, gaming is often a social activity. Two-thirds play with family and friends, face-to-face, and about one-third play with their parents.

STRANGE BUT TRUE: WHAT LITTLE KIDS ARE GOOD AT

The skill sets of very young children seem to have radically changed in recent years. A report done almost a decade ago by AVG, an Internet security company, found children from two to five were more likely to be able to navigate with a mouse, use a smartphone, or play a simple computer game than they were likely to be able to tie their own shoes, ride a bike, or swim. The

> report also found that by the time most babies are six months old, they already have a digital footprint. Backing this up is a widely seen video of a baby girl repeatedly poking at the pages of a magazine, confusing it with an iPad, and claiming in baby talk that the magazine was broken!

Young people have enthusiastically taken to mobile phones, portable consoles, and tablets. When it comes to mobile phones, they actually spend more time playing games and texting on them than actually using them to talk. Many transmedia entertainments now usually build in mobile phone use, recognizing that this feature particularly appeals to young people.

Theme parks, which are also primarily geared for children and teens, include many interactive attractions, which often go under the heading of "immersive environments." Cultural institutions, too, recognize the innate appeal interactivity has for children, and they build interactivity into their exhibits whenever their budgets permit.

Entire segments of the interactive market are devoted primarily to young people. They include smart toys, edutainment games, and *lapware*, software products made for little tots between nine months and two years of age. And an arena that was once the exclusive domain of older teens and young adults, the MMOG, has had popular offerings for younger children, as well. One of the most successful is the massively popular *Fortnite*, with 200 million registered players. *Club Penguin* and *Toontown Online*, both owned and operated by Disney, were also extremely popular with kids. Sadly, however, both have been discontinued despite their popularity. A fan-based version of Toontown, *Toontown Rewritten*, is still running.

Thus, interactive entertainment for children spans a vast spectrum of media and products.

Understanding the Young User

Although creating content for young users is full of special pleasures, it is also replete with daunting challenges. Even though the individuals who make up this particular demographic are young,

relatively unsophisticated, and hungry for amusement, it is a dangerous mistake to believe they are an easy group to please. Making successful products for children and teens requires an awareness of many special factors, including:

- The developmental stages of childhood
- Gender considerations
- The desires and fears of parents
- The desires and aspirations of children
- An understanding of what sort of content is most appealing to young people and the type of content that can repel them

Children and teenagers have their own culture, language, and values. In order to make content that will appeal to them, we have to understand them. But right here is where many content developers make a serious error: this audience cannot be lumped into an all-inclusive "them." Children at different ages are vastly different from each other in terms of what they enjoy doing, are capable of doing, and are able to understand. Furthermore, boys and girls do not necessarily like the same kind of content.

NOTES FROM THE FIELD: A CASE OF MASSIVE MISJUDGMENT

Chinese Hero Registry, an online game sponsored by the government of China and targeted at Chinese youth, is a perfect example of misjudging one's target audience. According to the *Los Angeles Times* (November 4, 2005), the game was built to lure kids away from violent online games and to entice them to play something more "wholesome." And from the perspective of a Chinese adult and dedicated Communist, this game probably sounded like wonderful fun. Players are given virtuous role models from Chinese history to emulate, and are rewarded for performing good works that reflect good old-fashioned Communist values. They score high by mending socks, helping old ladies home during a rainstorm, and stopping people from cursing and spitting on the sidewalks. Not surprisingly, when real kids in China got a chance to test it out, they found it to be incredibly dull and abandoned it after just a few minutes of play.

Fortunately, we do not have to rely on guesswork when creating content for young users. We have several forms of guidance available to us: developmental psychologists, educational specialists, and children themselves. In addition, we can study the market and analyze the most successful products made for the group we wish to reach. By doing this, we can glean useful clues about what works in terms of subject matter, tone, humor, characters, and style of graphics.

How Children Develop

One excellent place to turn for help is the field of developmental psychology. The specialists in this area make it their business to study the different stages of childhood, and understand how a child progresses mentally, physically, and emotionally from the diaper stage to the drivers' ed stage. One of the foremost experts in this field was Jean Piaget, the late great twentieth-century Swiss psychologist. Piaget systematically and scientifically explored the mental growth of children and documented his findings in 1948 in his seminal work, *The Origins of Intelligence in Children*. Almost everyone who develops products for children and who is concerned with age-appropriateness uses Piaget's work as a guide.

Piaget divided childhood into four stages. Within each of these stages, he asserted, children have a particular preoccupation and favored type of play. For those of us who create interactive entertainments for children, Piaget's theories regarding play are particularly relevant. He felt that play was serious business for children, a critical activity necessary in order to achieve a healthy adulthood. He held that play was a form of mental gymnastics which helped train and exercise the developing mind and prepared the individual for the challenges of life.

> **WORTH NOTING: AGE GROUPS AND PLAY PATTERNS**
>
> Like Piaget, the children's software industry breaks children into four distinct groups, but it uses a slightly different division of ages than Piaget did. This list combines the widely used age

categories of the software industry with the developmental stages that Piaget described:

1. *Toddlers, preschoolers, and kindergarteners*: young children love to experiment with objects and enjoy activities involving practice. They particularly love to repeat a task over and over until mastery is accomplished.
2. *Children 5 to 8 (early elementary)*: children at this age are fascinated with symbols, such as letters and numbers. They are also absorbed with fantasy pastimes, such as games which give them a chance to try out different roles and to feel powerful and unafraid.
3. *Children from 8 to 12 (late elementary; also known as "tweens")*: at this age, children like to try out their reasoning skills and prefer play activities that emphasize rules, order, and predictability.
4. *Teenagers*: teens are most concerned with trying to understand abstract concepts and testing out hypotheses. They enjoy activities that involve constructing things and making models.

Although Piaget linked each form of play to a specific stage of childhood, he also recognized that these preferences were not etched in stone. For example, a seven-year-old might experiment with forms of play that were characteristic of older children, such as making simple models, while teenagers might well still enjoy activities associated with earlier developmental stages, like fantasy role-play, and incorporate those earlier play patterns into their current games.

The principles laid down by Piaget and other developmental psychologists can help us build age-appropriate interactive entertainments, and can also guide us in making products that will appeal to a broad spectrum of young people.

Soliciting Help from Experts, Large and Small

While obtaining the assistance of a developmental psychologist or child psychologist might not always be feasible, it certainly makes sense to become familiar with the literature of Piaget and others in the field. Also, it is usually possible to seek help from educational specialists, a group that includes professors of education, consultants to schools and cultural institutions, and classroom teachers.

These professionals deal with children and how they learn, and are almost certain to be familiar with the tenets of developmental psychology. Most software companies that make edutainment products regularly consult with such specialists.

A final and excellent source of help can be obtained from children themselves. You can seek this type of help by forming focus groups; by visiting classrooms (with permission from the school, of course); or by talking with individual children. A word of warning here, though. For an objective opinion, it is best to try your ideas out on young strangers. Your own children or children who know you, will try to please you by telling you what they think you want to hear.

Age-Appropriateness

When undertaking any work for a young audience, one essential question that must be asked and answered is whether the project is *age-appropriate* for its target audience. Do the characters, story, or content feel too young or too old or just right for the intended users?

Children like to feel they are more grown up than they really are and as a rule prefer to have their characters be a bit older than they are, too. To borrow a term from the child psychologists, kids have *aspirational* desires. In other words, they aspire to accomplish certain things or behave in certain ways that seem grown-up to them, and they look to their favorite characters to serve as models. For example, the Disney Princesses are seen as aspirational figures: they are older, more glamorous, more sophisticated, and more accomplished than are the children who play with her.

Aspirations are engines that help push children toward maturity and hence serve a useful purpose in development. It is understandable that when a product seems too babyish, a child will be insulted and will not want to have anything to do with it. Designing something "just right" in terms of age-appropriateness can be quite challenging, and children can be devastatingly sensitive when they feel a project is not targeted correctly. According to the report *Children (Ages 3–12) on the Web*, a six-year-old

tester scathingly rejected a test website, saying "This website is for babies, maybe four or five years old. You can tell because of the cartoons and trains."

Along with age-appropriateness, one must also determine whether a product will appeal across both genders or be more attractive either to boys or to girls. Entertainment products made for very young children, as well as for older teenagers, may well be acceptable to both genders, but this is less true of products made for children in-between these age extremes. Thus, many children's products are marketed either to girls or to boys.

The Parents' Point of View

In designing products for children, you cannot afford to concern yourself only with what the young users might like or not like. You must consider their parents' attitudes as well. After all, in most cases, it is the parents who will be purchasing the product or allowing access to the content.

So, what are parents looking for in interactive entertainment for their kids, and what do they *not* want it to contain? On the positive side, they are hoping for a product that offers high-quality entertainment and content that is wholesome and that supports family values. Furthermore, parents see it as a big plus if the work is educationally enriching. In addition, parents of young children are greatly pleased when the material is enjoyable for them as well as for their kids, since they will probably be playing it with them. For models of family-friendly entertainment that appeals to both adults and children, study hit animated films like *Shrek* and the *Toy Story* movies.

On the negative side, almost without exception and no matter what the interactive medium, parents do not want their children exposed to graphic violence, and they are equally against products that contain sexual content. When it comes to the Internet, parents have more specialized concerns. The things they most fear revolve around the three Big Ps: Predators, Pornography, and Privacy (children being manipulated into giving personal or financial information to strangers). To a degree, these fears were realized in 2012, when people were shocked to learn that the

popular teen online virtual world, *Habbo Hotel*, was riddled with cybersex and pornographic chat. The Finnish company that runs the site swiftly responded by shutting down the chat feature. As a result of this scandal, the site lost its CEO, as well as many of its investors, staff, and users. Now renamed simply *Habbo*, it remains active and is quite popular.

A number of recent reports have significantly downplayed the dangers of young online users coming into contact with predators, but in the meantime, the spotlight has been thrown on another, more prevalent danger for child users: *cyber bullying*. Cyber bullying is harassing another person online, sometimes with immense cruelty, and it can lead to deadly consequences. Some years ago, a 13-year-old girl hanged herself because a boy she'd met online and liked, and believed was interested in her, suddenly turned on her. Unbeknownst to the girl, the boy never even existed. He was a fiction invented by the mother of one of her friends, supposedly in retaliation for something the victim had done to her daughter (see https://en.wikipedia.org/wiki/Suicide_of_Megan_Meier). Cyber bullying is surprisingly common, though fortunately, it rarely inflicts as much pain as in this case. A recent study reported that nearly 43 percent of kids have been bullied online. Many had been bullied more than once. In order to protect young users, many sites for this demographic build in safety features that restrict communications that can occur between users. Many also restrict which sites the young users can link to, making sure whatever sites they can visit are safe. Although this makes for a less expressive, freewheeling experience for the child, it provides some measure of reassurance to the parent.

On the positive side of the safety issue, more than one study has reported that young people actually benefit from being online and from using other forms of digital media. These studies assert that not only does digital media give young users the opportunity to learn technical skills and explore interests, but that it is also a venue for participating in peer socialization, especially in their use of social media. An extensive study by the John D. and Catherine T. MacArthur Foundation found that not only does digital media offer positive benefits to young people, but it is the

youngsters who are not active on social media sites who are at risk of being maladjusted.

Software developers who make edutainment products for children invest a great deal of time in the development of the characters in their titles. Character development is influenced by the overall needs and goals of the project. At Knowledge Adventure, which makes the *JumpStart* line of edutainment games, the cast of regular characters for *JumpStart* was revamped to make them more efficient within the educational context of the titles. Thus, for *JumpStart Advanced First Grade*, each character was given a special skill as a way to help the young learner. For example, Eleanor, the pink elephant, is gifted in linguistic skills and hosts the reading modules, while Kisha, the artist of the bunch, supports the players by providing helpful pictures. The revamped cast is now collectively called the Learning Buddies (see Figure 7.1).

But even at *JumpStart*, where educational objectives are taken very seriously, they recognized that perfection can be a little boring and thus gave the cast some little flaws. "We built in more conflict," Senior Producer Diana Pray reported. "We aren't the 'village of the happy people' anymore."

FIGURE 7.1 The Learning Buddies from the *JumpStart* educational games. Image courtesy of Knowledge Adventure, Inc., and used under license.

The Use of Humor

Kids love to laugh, and an interactive work that is full of humor will make it extra attractive to them. But comedy is a slippery beast, especially when you are working in children's media. Despite the willingness of young people to be amused, it is not necessarily easy to make something funny for them. What tickles children is sometimes quite different from what we adults consider amusing.

For one thing, kids' taste in humor is often what many adults regard as bad taste. They are drawn to content that causes nice grown-ups to squirm. They giggle at bathroom humor, at foul language, at odd-looking people, and at characters who break the rules of polite society. Kids also have a great sense of the absurd. They see what a silly place the world is, and they appreciate anything that celebrates its ridiculousness. Humor that pokes fun at adults, or that has a rebellious tinge, is therefore greatly relished. They love humor that is wacky, unexpected, and off the wall.

In general, visual humor works better than verbal humor; puns and word play will mostly go right over the heads of younger children. The young ones, on the other hand, love to click or roll over an object and have something silly or unexpected happen—an amusing piece of animation or a funny sound. But if you want to expand the age range of your product, it is a smart strategy to include humor that appeals to children in different age groups. And, if you think their parents might be playing along with them, throw in some funny things for them, too, as they did at *Toontown Online*. The adults will appreciate it, and the kids won't even realize that they've missed a joke or two.

Overall, the best kind of humor in children's interactive works is not very different from the best kind of humor in children's linear works: it is built into the character or into the situation, and is integrated into the work from the concept stage on. It isn't just pasted on as an afterthought. So, if you want your projects to be truly funny, begin factoring in the humor from the earliest development stages. One final thought about humor: to be on the safe side, test your comic elements on kids, to make sure they find it as amusing as you do.

Offer Satisfying Challenges and Rewards

Rewards are a powerful motivator. A key strategy for grabbing the attention of children is to break the content into a series of small, exciting challenges, and to offer rewards each time a challenge is met. Challenges should increase in difficulty as the child's mastery increases, thus keeping the work interesting.

Rewards provide positive reinforcement, and also serve as a measuring stick for how well the child is doing. The trick is to emphasize success and to downplay failure. If the player makes a mistake, soften the sting with a little humor, and with words of encouragement from one of the nonplayer characters. You want to keep them involved and eager to do more, rather than become discouraged and quit. Rewards can be in the form of a burst of audio, words of congratulation from another character, or a cute little animation. Rewards can also be objects that the child collects during the game—such as pieces that work as currency, or upgrades in clothing or possessions.

A Final Tip: Be Respectful

In developing quality works for young audiences, one critical strategy is to be respectful. Being respectful, first of all, means not talking down to the young users or patronizing them. Being respectful also means creating a product for them that is age-appropriate and truly engaging. Finally, being respectful shows you care enough about your young audience to make something that challenges them, but not beyond their abilities, and that is entertaining, but isn't "dumbed down." Overall, it means offering them plenty to do and lots of fun, but meaningful, content, too.

HELPFUL RESOURCES

- To stay up-to-date on children's software, websites, and smart toys, you might consider subscribing to *Children's Technology Review* (www.childrenssoftware.com). A subscription also gives you access to its online archives, which include a stash of thousands of product reviews.

- To read the Pew report on teens and texting, go to http://www.pewinternet.org/Reports/2012/Teens-and-smart phones.aspx
- To read the report on teens and video games, go to: http://www.pewinternet.org/2008/09/16/teens-video-games-and-civics/
- To read the Kaiser Family Foundation report on kids and media, go to http://www.kff.org/entmedia/upload/8010.pdf.
- To seek out information on children, media and technology, go to Common Sense Media (http://www.commonsensemedia.org/).
- To learn more about designing websites for children, you can purchase the study Children (Ages 3–12) on the Web at http://www.nngroup.com/reports/children-on-the-web/

Girls and Women

The idea that girls inherently like one kind of thing and boys inherently like another is not a popular one in today's world. A fierce dispute has been raging for years about the origins of gender preferences—it is a major issue in the famous nature versus nurture debate. Proponents on the nature side assert that gender preferences are inherited, and are among the traits one is born with; those on the nurture side, on the other hand, contend that such preferences are determined by one's social environment and by how one is raised. In the end, however, our opinions about gender do not matter. Gender preferences are a reality in today's world, and one must be aware of them.

In broad strokes, experts in child development have noted the following differences between boys and girls:

- When playing with others, girls prefer collaborative activities while boys like activities that are competitive.
- Boys are drawn to activities that involve objects while girls are drawn to activities that involve other people or animals and particularly like activities with a social component.

- Girls are good at activities that employ fine motor skills; boys prefer activities that call for gross motor skills.
- Boys look for opportunities to be aggressive, while girls are more comfortable in nonviolent, socially peaceful play situations.
- Girls enjoy activities that call for organizing and arranging; boys like activities that require building, digging, and constructing.

Gender differences between boys and girls can even involve such minute matters as color preferences. Girls are notoriously fond of two colors, purple and pink, and software companies that want to attract girls tend to bow to this color preference.

The 2010 Kaiser Family Foundation Study on Children and Media reported a number of differences in the amounts of time boys and girls spend on different activities. For example, boys spend an average of 19 minutes a day on social media sites, while girls spend 25 minutes, but girls only spend an average of 14 minutes playing games on video game consoles, while boys play for 56 minutes.

Jesyca Durchin Schnepp, who owns Nena Media, a consulting company that specializes in media content for girls, has made a number of interesting observations about the preferences of young females. She says that girls generally prefer play that involves fashion, glamour, and nurture, though also enjoy play that involves adventure, action, collecting things, and communication. Unlike boys, girls do not enjoy meaningless or repetitive violence, though if the violence makes sense in terms of the story, they are not opposed to it.

According to Schnepp, girls do not necessarily want everything to be sweet and happy; they do enjoy mystery and suspense, and even like works that are spooky. But they are not pleased if spookiness crosses over into scariness—a firm distinction Schnepp makes. Something that is spooky, she points out, means you might be startled or frightened (for example, at a carnival at night). But something scary is much more intense and can put you in real danger, like being out alone when there's a murderer on the loose.

Schnepp also notes that girls like attractive environments, and these environments should be realistic or make sense in terms of

the story. She also asserts that girls especially like sensual interfaces—ones that are colorful and that contain sound and that change shape when activated. They don't like a row of grey buttons that are all the same shape.

It should be noted, however, that preferences differ from culture to culture, which is an important consideration if a product is to be marketed internationally. For example, boys in North America over the age of eight or nine find cute animal characters "too young," but such characters are highly popular in Asia across all age groups and both genders.

Thus far, girls have largely been left out of the market for video games and most other forms of digital media, which is generally targeted to male audiences. But that doesn't mean that they do not hunger for works that more closely fit their interests. This hunger was dramatically demonstrated in 2012 when Lego, a company well-known for its toys for boys, introduced a new line of construction sets for girls. Called Lego Friends and launched after Lego conducted extensive research, the construction sets more closely match the tastes of girls. The sets are all environments of a fictional place called Heartland City. They include miniature plastic figures, each of which has a personality and a backstory. Players can build a cruise ship and play with dolphins, construct a high school that can be anywhere from one to three stories high, and even put together and play with an equine-centered summer camp. Lego introduced several new colors for this line, including azure and lavender. The sets were instant hits. In the first six months, sales were double the projected figures. Although launched in 2012, Lego Friends remains one of the biggest successes in Lego's history and illustrates what can happen when the female audience is taken into consideration. There is no reason the same could not be true in interactive digital media, but thus far, few companies have ventured into this arena.

Creating Projects for Women

Girls, of course, grow up to be women, and though their interests and tastes mature, their inclinations do not change dramatically. For example, women, like girls, still lean more toward projects

that offer them opportunities to socialize rather than to engage in meaningless violence. And they enjoy opportunities for self-expression, such as customizing their avatars. A study sponsored by PopCap found that women are particularly fond of social games, with 55 percent of all social gamers in the United States being female and 60 percent in the UK. Games on Facebook are a particular favorite with these players. And although girls and women do enthusiastically play social media games and casual games, they are also a substantial segment of the video game audience. According to the Entertainment Software Association (ESA), as of 2018, 45 percent of US gamers are women, women over 18 constitute a far larger slice of the gaming population (33 percent) than do boys under 18 (17 percent).

When it comes to employing digital media for informational and educational purposes, women often have a significant role. For example, in the Arab world, women played a major part in employing digital media to disseminate news about the Arab Spring to a global audience. And many educational software companies are headed by women, and largely staffed by them, too.

Seniors and Digital Media

Contrary to the stereotype of older people being incapable of acquiring new skills, and being skittish of new technology, a significant segment of the senior population uses various forms of digital media on a regular basis. They use email and mobile devices, go to social media sites, do research, and play games online. They also play games on various kinds of game consoles, with the Wii being a particular favorite (see Figure 7.2). These digital devices offer them an opportunity to stay connected with friends and family members and also offer them a way to engage in physical activities, despite any health issues they might be dealing with.

According to a Pew Research Study, *Technology Use Among Seniors*, published in 2017, a digital divide does exist between older and younger members of the population. However, signs indicate the size of this gap is narrowing. For example, the ownership of smartphones among seniors aged 65 and above more than

FIGURE 7.2 Older people enjoy playing digital games, particularly on the Wii. Image courtesy of Carolyn Handler Miller.

doubled in the years between 2013 and 2016. The report notes: "Today, roughly half of older adults who own cellphones have some type of smartphone; in 2013, that share was just 23%."

The report also notes that the use of the Internet among older adults has steadily risen since the year 2000. Back then, only 14 percent of seniors went online, but by the time the study was conducted, it had risen to 67 percent. Furthermore, one-third of seniors owns a tablet computer and about the same number use social media for news and to connect with friends of family. It should be noted that although seniors are utilizing digital technology at a steadily increasing rate, its utilization is higher among the more affluent, better educated, and younger members of this demographic than those who were older or who had lower incomes and less education.

Many seniors are actively enjoying video games. A study published back in July 2013 in *Computers in Human Behavior* revealed that elderly adults, age 77 and beyond, recruited from senior centers, retirement homes, and religious centers, played video games at least once a week, and 17 percent played every day. The games they played tended to be less high-action than *World of Warcraft* or *Halo*, and more along the lines of puzzle games, but the study showed they benefited greatly by playing these games,

with better functioning for everyday activities and less depression than non-gamers.

Wii bowling, in particular, has caught on with seniors and fierce competitions rage between senior groups. Some members of these Wii bowling teams compete while sitting in wheelchairs. A number are in their eighties and one woman is in her mid-nineties. The game offers not only physical activity (without the requirement to lift a heavy bowling ball) but an opportunity for socialization, ending the isolation that often goes along with advanced years. In Illinois, there is even a state-wide Wii bowling competition between teams from assisted living facilities, with over 80 teams from 155 facilities around the state.

> **STRANGE BUT TRUE: A THERAPEUTIC ROBOTIC SEAL**
>
> Paro, a robotic stuffed animal who resembles a baby harp seal, has become a beloved companion animal at nursing homes all over the world. It was developed in Japan as a digital aid to the rapidly growing number of aging seniors there. The furry white creature with big black eyes moves and makes sounds much like the real animal it is modeled on, and responds in a believable way when petted, though in fact it is an animatronic robot. While living companion animals like dogs and cats are often barred from nursing homes, Paro has been welcomed with enthusiasm. Seniors who are agitated or are generally non-responsive, many with dementia, find Paro a comforting presence, and some will actually sing to the cuddly creature (http://www.parorobots.com/, http://www.gizmag.com/paro-robot-baby-seal-companion/13753/).

Seniors typically enjoy the kinds of activities online that are popular across the board: email, sharing photos, visiting social media sites, and checking the news and weather. But they also visit sites that are of special interest to individuals in their demographic: those on health, finances, and travel. Several sites also offer what has become known as *brain games*, entertaining games that are designed to keep the brains of elders active and fit. One interesting new trend is the development of sites designed to offer play opportunities for seniors and their grandchildren. One such

site is Wizard 101 (www.wizard101.com). The site contains a suite of family-friendly games that are fun, easy to play, and safe.

The Medically Ill and Disabled

Digital technology has been a boon to many individuals who are dealing with health problems or who are physically disabled. Special games and other forms of digital works have been designed to help them cope with their illnesses and help the outside world understand what they are going through. For example, *Re-Mission* is a video game and Web destination for young cancer patients that helps them combat their disease. NAMI (National Alliance on Mental Illness) is an organization and a specialized website to help people deal with mental illness. Dozens of other websites serve as support groups for individuals with specific illnesses, while other websites offer general medical information. And for combat veterans who are suffering from post-traumatic stress disorder, virtual reality treatment is now available.

These virtual reality simulations re-create battlefield conditions, thrusting the user into situations that feel very real, but done at a pace that the user can handle, gradually becoming more intense. This kind of treatment is called *exposure therapy*, and the user is guided by a trained therapist. The experience is made exceedingly real with sound effects and even disturbing smells, but it enables users to confront their traumas and overcome them. VR is also being used to treat debilitating phobias suffered by non-military personnel, such as the fear of flying or the fear of crowds. People in the medical field are looking at VR for treatments, and even diagnostics, of Parkinson's Disease, PTSD, and dementia.

Even works designed for the general public can be a boon to those with handicaps, as exemplified by the massive Comic-Con convention, a gathering celebrating all forms of popular culture, held annually in San Diego. Many of the Comic-Con attendees travel through the vast convention hall on wheelchairs, and many of these attendees are dedicated gamers and participants in virtual worlds like *Second Life*. These digital works give them

opportunities that they are usually denied. For example, one woman who uses a wheelchair is a great fan of *World of Warcraft*. She told a *Los Angeles Times* reporter (July 25, 2009) that in the game "You can be someone you are not in real life." And, she added: "You can feel like you can be one of them—you have legs!—and you can become a warrior."

Other Parts of the World and Other Ethnic Groups

When it comes to one's audience, we must remember to look beyond our own national borders and our own ethnic group. What if we are asked to develop a project for housewives in Japan or English-speaking middle-class Africans or for tween girls in the Middle East? These projects do come about, and before we can delve into them, we must ask and answer a variety of questions that will help us better understand an audience that might be unfamiliar to us.

In my own case, I was asked by a producer based in Saudi Arabia to help develop a virtual world and series of interactive stories for pre-teenage girls in the Middle East, a demographic that is seriously underserved. It was a dream assignment, but I needed to know a great deal before I could actually begin to create this fictional world. For example, what kinds of relationships, if any, do girls in this part of the world have with boys who are not members of their own families? At what age do girls typically get engaged? What kinds of customs are traditional throughout the Arab world, and which are specific to Saudi Arabia? Are there international schools in the Middle East, and do Muslim girls ever go to school with girls from other backgrounds? What kinds of pets might a family have? What do girls typically enjoy doing during their leisure time and during vacations? How closely supervised are they? I had dozens of such questions, but fortunately, my producer was able to answer them or point me to the answers. Such questions would be totally different if one were to develop a project for Japanese housewives or middle-class Africans, but in order to understand your audience you must learn as much about this target population as possible.

Digital works are often designed for highly specialized audiences. For instance, a website called *Live/Hope/Love* is directed specifically at Jamaicans who are living and struggling with HIV/Aids (www.livehopelove.com), though of course this beautiful website can be viewed and enjoyed by anyone. The site utilizes videos, poetry, photos, and music to tell the story of these Jamaicans and to humanize their illness. Another highly specialized website, *JewishGen* (www.jewishgen.org), has been created to help those who are Jewish construct their genealogy and trace their familial roots. One particularly fascinating feature of JewishGen is the collection of pages devoted to shtetls (villages where Jewish communities once thrived) scattered across Europe, North Africa, and the Middle East. Though many of them thrived before World War II, they were largely destroyed during the war and events that followed. These moving pages about the past, indexed under http://kehilalinks.jewishgen.org/, include family stories, still photos, maps, paintings, and sometimes even videos. It was an exciting day for me when a colorful page was launched to commemorate Ostropol, the shtetl that my father's side of the family originated from (http://kehilalinks.jewishgen.org/ostropol/). Another site with an international audience is *WiseMuslimWomen* (www.wisemuslimwomen.org/), which in part serves to counter gender-based inequality experienced by Muslim women across the globe.

Ultra-Orthodox Jews even have their very own Internet provider, *eNativ* (www.enativ.com/about_en.aspx), which recognizes how necessary the Internet has become for work and for one's personal life. However, it blocks out material that is inappropriate for ultra-Orthodox Jews to view. Its goal is to make it possible to surf the Web without encountering material that is not kosher.

Another sharply focused website is *FarmersOnly*, a dating site for singles who love living in the country. Their tagline is "City folks just don't get it."

Devout Christians, not to be left out of the digital media world, have developed a number of Christian-themed video games. Among them are games based on the *Left Behind* books, about those who are called to Heaven (the Rapture) and those who are left behind to deal with the apocalypse. *Left Behind, Eternal Forces* and its sequels are games that feature real-time strategy

and even violent combat (though only when necessary), with the goal of saving people from the Antichrist. The *Left Behind* games are primarily geared for teen boys—the same ones who might be tempted to play *Grand Theft Auto*. For a much younger Christian audience, *VeggieTales*, an animated TV series for children, offers YouTube videos and *Veggietales* games.

When it comes to entertainment for ethnic minorities, YouTube has a vast number of such videos. Many YouTube stars, such as Japanese-American comedian Ryan Higa, are Asian-Americans. As of January 2014, Higa's YouTube channel, *Nigahiga*, has over 11 million subscribers. And who can forget watching the YouTube sensation of the song *Gangnam Style* by the South Korean singer and rapper PSY? Other YouTube stars are African American or Latino. Although Hollywood might not have put out the welcome mat for many of these entertainers, they have found success on the Internet and their audiences are not limited to their own ethnic group. Thanks to YouTube, they can do their shows without having to modify them according to the dictates of network or studio execs.

A far more global endeavor is *Ushahidi* (http://www.ushahidi.com/), a platform developed to support citizen journalism around the world. Ushahidi means "testimony" in Swahili.

Specialized Works for Domestic Populations

Obviously, many works of digital media are not intended for an international audience, but for audiences much narrower in scope. Two projects with a sharply local focus are *It Takes a Thousand Voices* (http://www.nrcprograms.org/site/PageServer?pagename=Thousand Voices_home) and *Cerrillos, New Mexico* (http://www.cerrillosnewmexico.com/). The first site is intended for Native Americans and they are encouraged to use the site to videotape their own personal stories. The second site focuses on the northern New Mexico village of Cerrillos, which used to be a booming center of mining but now is almost a ghost town. The site records the history of the village and contains a number of true stories about life there under a forum called the Spit & Whittle Club. It also serves as a source of information about

current businesses and events going on in Cerrillos. Thus, the site works as a historic record, a virtual community center, and a promotional vehicle to attract tourists.

Zeroing in on Your Target Audience

Before undertaking any digital storytelling project, you need to understand in as much detail as possible who the audience is and what will attract these people to your project.

Major considerations in terms of defining your audience include age range, gender, educational level, economic status, ethnicity, geographic region, what their interests are and what they enjoy doing, what they dislike, and what is inappropriate for them.

In developing a project for your intended audience, it can be helpful to create a single fictional person who is your ideal user. This person is known in the marketing community as the *buyer persona*. In addition to the demographic considerations mentioned earlier, consider this person's needs and wants, and what would make this person gravitate to your project.

I first encountered this concept when I attended a workshop for startups hosted by the Albuquerque organization ABQid, which supports entrepreneurs in the early stages of developing their products. I was there to make forward progress on an augmented reality storybook project I was working on. The workshop took the fictional character idea a step further: they had us draw our ideal user.

Since I was developing an augmented storybook for children, my ideal user would be a child, but it would also be the child's parent, since this was the person purchasing the product. Therefore, I created a little boy, Oscar, 7 years old, and his mom, Louise, 35. I rendered them in stickman fashion, since I have no drawing skills whatsoever. They are standing side by side, holding hands (see Figure 7.3). Oscar wears a ball cap turned sideways and a big smile. Louise is dressed in a short skirt and high heels and has glasses. She is an executive in a high-tech company, well-educated, super-busy, and a loving mom. However, she is worried about Oscar. He's in second grade, but he still isn't reading, though he is a bright, curious child. He loves monsters, dinosaurs,

FIGURE 7.3 Louise and Oscar, the ideal users of an AR project in development. Image courtesy of Carolyn Handler Miller.

and space stories, but he's restless and has trouble concentrating. So far hasn't picked up a book, even one about one of his favorite subjects.

Crude though the sketch was, as I drew them, I realized why Louise would be drawn to my AR enhanced storybooks: they would appeal to Oscar's curiosity and could entice him to pick up a book and play with the AR, and ultimately induce him to connect the images with the words and make the connection with reading. Such books could put him on the path to become a reader. Because of her busy schedule, Louise doesn't have time to spend time trying to get him to read, but the books I am developing would offer her a fun and time-efficient way to introduce Oscar to the pleasures of books. Since Louise has a good job, she could easily afford the books and they would appeal to her involvement with technology.

Making the drawing introduced me to my intended users and made them real to me. I felt I had something appealing to offer them. Furthermore, it helped me crystallize what the books should be like and how they should function. I could believe there are many Louises and Oscars out there who would enjoy my books and that gave me an added boost to continue working on them. The drawing exercise clearly resonated with me. Having created Louise and Oscar, I believe creating an ideal user for any digital media projects can be a good investment of time.

In terms of developing a product for your audience, there are three major questions to ask and answer:

1. The subject matter: is it appropriate for the audience you have in mind and is it something that would strongly appeal to them?
2. The platform: do members of your intended audience own the platform you intend to release your project on, and are they comfortable with it?
3. The difficulty level: is it targeted correctly for your audience, or is it too easy, too demanding, or too intimidating?

Conclusion

Knowing your audience is an important component of creating digital stories. A major reason digital works do not succeed is because the designer did not create them for a specific audience. Before undertaking any digital storytelling project, you need to understand in as much detail as possible who the audience is and what will attract them to your project.

Major considerations in terms of defining your audience include: age range, gender, educational level, economic status, ethnicity, geographic region, what their interests are and what they enjoy doing, what they dislike, and what is inappropriate for them. You also need to have an understanding of their wants and needs. Are they lonely? Bored? Isolated? In need of a creative outlet? There are dozens of reasons a particular form of digital entertainment might appeal to a user. Dig into your user's persona to figure out what your project can offer them.

There is no need to go it alone when you are trying to understand your user. Outside guidance can help you peek into their hearts and minds. It is often helpful to bring in subject-matter experts (SMEs) that can help you determine what will most interest your audience, the accuracy of your material, and what is and is not appropriate for them.

As we have seen here, audiences vary enormously in terms of age range, gender, and a variety of other factors. Thus, it is no surprise that the "one-size-fits-all" approach is a dangerous one

to adopt. It is far better to have a clear idea of the group you are targeting and build a project with their needs and interests lucidly in mind.

Idea-Generating Exercises

1. Take a familiar myth or children's fairy tale (like "King Midas" or "Cinderella") and analyze what the core story is; in other words, what its "bones" are. Then discuss how this story could be used as a framework for an interactive work project that would appeal to each of the four major age groups of young audiences. How would it need to be changed to be appropriate to each group? Do you think your ideas could appeal equally to boys and girls in each of these age groups, or would a different approach be needed for each?
2. Imagine that you are tasked with developing an interactive piece of digital storytelling for Japanese housewives or English-speaking middle-class Africans. Develop a series of questions that you'd want to have answered before you could begin the creative work on the project.
3. Work your own way through an existing interactive game or other project designed for a specific audience and analyze its strengths and weaknesses. What about it do you think would hook this audience and keep them involved? What needs, if any, does it satisfy?
4. Focusing on a project you are currently developing or would like to create, envision the ideal user of this project. Why would this person gravitate to your project? As with my picture of Louise and Oscar, draw a picture of your user to better enable you to visualize this person.

Chapter 8

Social Media and Storytelling

Is it possible to construct a story using only social media?
What kinds of characters can "live" on social media?
How can social media be used to tell non-fiction stories?
What role does humor play in social media?

Inserting the Social into the Media

Social media—online and mobile communities that exist to let people share news, opinions, personal information, photos, and videos—are a relatively new phenomenon. Yet new as social media sites are, they have had an enormous impact on our online and mobile lives and also on the way we tell interactive stories.

Some observers point to early BBS systems, newsgroups, and Usenets as the start of social media. Others feel that GeoCities in 1994 represents a more accurate starting point. Users of GeoCities would post their Web pages in virtual geographic locations

appropriate to their content. For instance, if you were interested in the movie business, you'd put your page in Hollywood; if you were a jazz musician, you would likely put your page on Bourbon Street. GeoCities was extremely popular for several years and had 38 million users by 2009. Today, however, it is only available in Japan.

The launching of other sites more familiar to contemporary users is even more recent. They include the start of Friendster in 2002; Myspace and LinkedIn in 2003; Facebook in 2004; YouTube and Bebo in 2005; and Twitter in 2006. The enormously popular Pinterest didn't even launch until 2010. And Disney's app for pre-teens, Disney LOL, launched in 2016. New social media sites and apps are born on a regular basis. But new as these social media sites are, by 2013 Americans were already spending an average of 16 minutes on them out of every hour they were online (from Experian). The average time in other Western countries was only slightly less. And as of 2018, Facebook alone had 2.23 billion monthly active users, while YouTube had 1.9 billion, Instagram had 1 billion, and Twitter had 321 million.

New forms of social media are introduced quite frequently, and the popularity of particular social media sites can wax and wane. As we all know, what goes up can also come down, and the story of Myspace is a dramatic illustration of how a social media site can rise and fall. From 2005 to 2009, it was the world's most popular social media site. But its popularity started to decline, and the decline picked up speed to the point where it only had 15 million active users in 2016. The once highly touted mobile live-streaming app Meerkat, hailed as the hot new app, is now completely dead, done in by its rival, Periscope.

Users are drawn to social media sites for a number of reasons. For some, the appeal is fluff content, such as watching videos of cute pets or cute children doing cute things. For others, the appeal is more serious. It may be the chance to promote a political cause or to witness a natural disaster as it unfolds. Increasingly, social media is employed as a way to disseminate news. Reportedly, the first time a social media site broke a hard news story was in 2009, when a person tweeted that a plane was down in the Hudson

River. Furthermore, and in line with the focus of this book, social media is being used to tell fictional and non-fiction stories.

> **STRANGE BUT TRUE: WHERE PEOPLE CONNECT**
>
> Many users are so tied to social media that they connect to it from places that might give others pause. For example, 32 percent of people aged 18 to 24 use social media in the bathroom. And 51 percent of people aged 25 to 34 connect to social media sites while at work, in their offices. Even some astronauts have been heavy users of social media and regularly tweeted to global audiences from the International Space Station (from http://www.uncp.edu/home/acurtis/NewMedia/SocialMedia/SocialMedia History.html).

The Power of Social Media

Social media sites, while a relatively new phenomenon in the digital world, have surprisingly powerful muscle power. One small example of this power was an incident that took place in the spring of 2013 when the Walt Disney Company announced plans to trademark the term *Dia de los Muertos*. The term is Spanish for Day of the Dead and is an important holiday in Mexico. The holiday traces its roots back to the Aztecs and it is an occasion when the observant honor the souls of their departed ones. As soon as Disney announced its plans, a huge protest occurred on social media sites. Disney quickly withdrew its trademark plans and most observers believe it was because of the outcry on social media. Graham Harvey, owner of Matthew Media LLC, had this to say about the incident: "Any company or organization that wants to protect its brand needs to understand the powerful, viral nature of social media. A backlash can occur in the blink of an eye" (as reported in the *Los Angeles Times*, May 9, 2013).

Social media have been playing an important role in politics and social unrest, too. They helped fuel the Arab Spring protests that began in 2010 (as noted in Chapters 7 and 10). US President Donald J. Trump is a prolific user of Twitter to express his opinions

and attack those he considers his enemies. By the end of his first year as president, Trump had tweeted 2,568 times, an average of 7 times a day. Comedians are now even telling jokes about social media, which illustrates how pervasive it has become. One, by an unknown jokester, goes like this: "A guy walks into his doctor's office and says, 'I think I'm addicted to Twitter.' The doctor responds 'Sorry, I don't follow you.'"

Of course, like all forms of power, the power of social media can be used for evil as well as for good. Unfortunately, one negative effect of social media is the increase in cyber bullying—the online belittlement of an individual, usually by a group of his or her peers. Several vulnerable young people who have been victims of this kind of harassment on Facebook and other sites have even taken their own lives.

Characters on Social Media

Characters—some fictional, some real, and some real but given fictional personas—can thrive on social media. They can tweet, have Facebook pages, post photos to Pinterest and post videos to YouTube. Social media sites can be an excellent way to amplify a character's personality or show shades of that person that might not be revealed by other forms of media. One of the special "gifts" of social media is that it gives characters a first-person voice.

Prominent individuals and celebrities from all over the world have taken to tweeting. In fact, it would be difficult to find an actor or musician who doesn't tweet. These famous tweeters include entertainers like Britney Spears, Justin Bieber, and Lady Gaga; TV personalities like Oprah Winfrey and Conan O'Brian; and political and religious leaders like Queen Elizabeth, Barack Obama, the Dalai Lama, and Pope Francis. The Pope has even granted rewards to the faithful in the form of indulgences—less time spent in purgatory—for those who followed his posts on social media during Catholic World Youth Day. (This was not a free pass, however. In order to receive an indulgence, the person must have already confessed and be truly penitent.)

Fictional personalities are also creating Facebook pages and tweeting on Twitter. One of the first TV characters to post on

Twitter was Betty Draper (@BettyDraper), the ex-wife of Don Draper, the central character of the TV series, *Mad Men*. She writes about her new life as a single mom, her clothes, and the trials and tribulations she suffers that are caused by her daughter Sally. Of course, since Betty Draper is not a real person, she is not actually writing these tweets, even though they perfectly capture the persona of an upper-middle-class woman living in the 1960s. Interestingly, the tweets are not written by anyone on the *Mad Men* staff, either. Instead, they are created by Helen Klein Ross, a writer and former ad agency creative director. Ross called her Betty Draper tweets "Twittertainment" and brand fiction, describing this as "original narrative and mythology built around a brand's unique premise." Apparently, the *Mad Men* staff had no problem with members of the larger public tweeting in the voices of the characters on the TV show, because 90 Twitter accounts were opened in the name of *Mad Men* characters or characters from that era who converse with them.

In some cases, real living people (and, quite often, animals) are given the opportunity to participate on social media. For example, Grumpy Cat (real name: Tardar Sauce) became an overnight celebrity when a video featuring her, and her dour expression, appeared on YouTube. Not only has she received over two million views on YouTube, but she also puts up grouchy posts on Twitter (@realgrumpycat).

STRANGE BUT TRUE: DOGS CAN TWEET

If cats can tweet, dogs, of course, will want to be part of the action, too. Luckily for them, the toy company Mattel came up with a way to enable them to do that. The company markets a device called "Puppy Tweets" that can be attached to a dog's collar. It is motion and sound sensitive. The dog's owner has to help out, though, by putting an associated USB receiver in a computer and setting up a Twitter account for the pup. They will then be able to receive regular updates from their pet (from a bank of 500 pre-recorded tweets). For example, if the dog is having a lazy day, he might send out a tweet saying "Somedays it feels like my paw is permanently on the snooze button."

One of the most followed animals on Twitter is Wolf_OR-7. He's a real grey wolf who was given a GPS collar in Oregon when he was a pup and has been wandering between Oregon and northern California since then, traveling over 1,000 miles in a year and a half (OR-7 is his tracking number and OR is for Oregon, where he was born). He captured the public's attention when he crossed into California in December 2011, the first living wolf confirmed in the state since 1924.

He adamantly tweets "Don't call me Journey," a name given to him by some school children and that he detests. He also says his hobbies include wandering and ungulates (hooved mammals). Biologists think he left home to find a mate and some territory of his own, and followers anxiously hope he doesn't suffer from the same fate as his brother, shot illegally by a hunter in Idaho. Wolf_OR-7 did find a mate in 2014 and is now a grandfather. He also has his own Facebook page, where he is shown cavorting with a group of coyotes. It's a rare glimpse of his odyssey, illustrating that his solo travels have not been entirely lonely. But he doesn't seem to have yet found the love of his life and he's now back in Oregon. Wolf_OR7 could be a compelling figure in a work of fiction, although in most fictional works featuring wolves, they are the villains, not the heroes. The portrayal of this wolf on Twitter and Facebook demonstrates that with social media tools alone, you can construct a highly engaging character.

STRANGE BUT TRUE: THE WORLD'S OLDEST TWEETER

A *Tyrannosaurus rex* dinosaur named SUE is undoubtedly the world's oldest tweeter. T-Rex dinosaurs like SUE lived during the Upper Cretaceous period, which means this enormous dinosaur would be somewhere between 65 million and 67 million years old if still living. And not only is SUE old, but also huge, 40 feet long and weighing 9 tons while still alive. SUE resides in the Field Museum in Chicago and boasts of being one of the best-preserved and most complete T-Rex fossils in the world. SUE is named after paleontologist Sue Hendrickson, who discovered this fossil, but also has many nicknames, such as

murderbird. However, because scientists have been unable to determine SUE's gender, this dino goes by gender-neutral pronouns (they/them). SUE has their own Twitter feed, https://twitter.com/SueTheDinosaur, and often types their messages in caps. Their language is salty and ungrammatical and fiery. Perhaps one should expect better from such an elderly specimen.

Works of Fiction Using Social Media

As to be expected, since social media sites are relatively new on the scene, so are fictional works that employ them, particularly works that employ them as a primary means by which to tell a story. *My Darklyng*, co-written in 2010 by Lauren Merchling and Laura Moser, was one of the first works of social media fiction to do this. The authors say they wrote the story because they were disappointed in the ebooks at the time, which they felt were almost entirely text-based and did not use media creatively. Both writers had previously written young adult fiction, so they decided to create a young adult novel that would intensively use digital media. Their "book," although it does not exist as a physical book, is the story of 16-year-old Natalie Pollock who gets sucked into a world that might (or might not) be populated by vampires. They told their story using a number of different Facebook pages, tweets by various characters, and YouTube videos. In addition, a large part of the story was serialized online on *Slate*. They took special pains to capture the way teens write on Facebook—with lots of caps, excessive enthusiasm, and intense emotion about almost everything, and they received praise from the *New York Times* for their efforts.

STRANGE BUT TRUE: EVEN HAMLET HAS A FACEBOOK PAGE!

One early work of social media fiction was the retelling of Shakespeare's *Hamlet*, written entirely in Facebook posts. This comic version of *Hamlet* was written in 2009 by Sarah Schmelling

> (http://www.angelfire.com/art2/antwerplettuce/hamlet.html). As with the posts by the fictional characters of *My Darklyng*, the writer has made good use of Facebook conventions. For example, one post reads "Hamlet and the queen are no longer friends" and another reads "Ophelia joined the group Maidens Who Don't Float." In 2010, Juliet Capulet of *Romeo and Juliet* started tweeting, thanks to the Royal Shakespeare Company. Will Macbeth be next to join the social media fray?

In Chapter 14, on iCinema and iTV, we discuss a film, *Inside*, which relied heavily on social media to reach its resolution. Other works of fiction that heavily employ social media include *The S#cial Sector*, *The Lizzie Bennet Diaries*, *Emma Approved*, *Frankenstein, MD*, *Welcome to Sanditon*, *13 Reasons Why*, *Dark Detour*, *The New Adventures of Peter and Wendy*, and *Uk'shona Kwelanga*.

The S#cial Sector (also spelled as The Social Sector, http://socialsector.usanetwork.com/) was an ancillary online show for the USA Network series, *Psych*. It, like all the fictional series discussed here, was a *Web television* show, meaning it was an episodic series broadcast on the Web. The eight-week series was an interactive online comedy/murder mystery featuring the same two characters who star in the TV show, Shawn and Gus. It was, in part, built on the success of another *Psych* ancillary series, *Hashtag Killer*. *The S#cial Sector* revolved around a fictional online reality show. Just as in non-fiction reality shows, one contestant is eliminated each week, but in this case, the elimination is literal. The unlucky contestant is murdered. Gus and Shawn ask for your help in finding the secret location of the reality show house and in catching the murderer.

The experience, which unfolded early in 2013 in real time and largely took place on a dedicated website, involved a great deal of interactive dialogue, crowd-sourced challenges, mini-games, and YouTube videos. Adding to the social nature of the experience, players could also make videos of themselves discussing theories about the case and post them on the "Fan Theory Board," which was powered by the Theatrics collaborative storytelling platform.

The experience spilled over onto Facebook and Twitter. The ultimate goal as a player was to become Top Digital Assistant.

I learned about *S#cial Sector* from a colleague and decided to try it out. But before getting into the action, I first had to register. Some years ago, when registering for a two-screen TV game, *Boys' Toys* (see Chapter 14), I hastily picked my own first name, Carolyn, as a user name. The first time the leader board popped up, I was number 6! But I was mortified to find myself up against a bunch of macho guys with names like GunDoc and Scuba Steve. I vowed never to pick such an uncool girlie name again. So, with *S#cial Sector*, I was determined to use something much tougher and decided to call myself TwoFist. I was glad I did, because the two TV characters immediately made me, TwoFist, their digital assistant, and engaged me in a great deal of amusing dialogue. Much of this involved simple questions such as what their favorite fruit was (pineapple—which was easy because it was noted in every write-up of the show). Though it was a little disconcerting, though flattering, to be addressed as TwoFist, I did manage to hold up my end without tripping. A victory for my gender! Unfortunately, by the time I got involved with *S#cial Sector*, the eight episodes were coming to a close, so I was unable to participate in the full experience. I did succeed, though, at getting a taste of the social nature of the project, its videos, its interactive dialogue, and quiz questions. Even though my time with it was brief, I could easily understand why it was so popular, especially with fans of *Psych*.

The enormously popular *Lizzie Bennet Diaries*, which won an Emmy in 2013 for Best Interactive Program, relied even more heavily on social media, and was in fact told entirely through social media. These included YouTube, Facebook, Tumblr, Twitter, Google Plus, OkCupid, Pinterest, and LOOKBOOK.nu. It should be noted that the *Lizzie Bennet Diaries* is also considered a work of transmedia storytelling, since it uses a multitude of different forms of media to tell the story. The series was a modern retelling of Jane Austen's *Pride and Prejudice*, as if Elizabeth Bennet (the Lizzie in the title) lived in a world with the Internet, smartphones, video cameras, and social media. The story is told as a vlog, or video diary, but augmented with social media. The videos are highly entertaining, in part because Lizzie and her best friend

Charlotte, who is shooting them, role-play various characters in the story, like Lizzie's mother and father, and dress in appropriate costumes. While this might have been a budgetary decision to reduce the number of actors needed, it works well in the somewhat off-the-wall way Lizzie tells her story.

In general, the adaptation follows the classic Austen story of a mother eager to find husbands for her five daughters, and of the daughter's encounters with various suitable and unsuitable bachelors. In the modern version, the household has been reduced to just three daughters. They are Lizzie herself, who is the middle child and a grad student in mass communications, destined to be the love interest for the seemingly cold Darcy; her older sister, the fashionable, perfect Jane; and her baby sister, the flirtatious, frenetic Lydia. In addition, Charlotte, Lizzie's best friend, functions almost as a fourth sister. The slimming down of the Bennet household helped make the complex story more manageable and made it possible to focus more intensively on several characters.

I was extremely fortunate to snag an interview with Bernie Su, the head writer and showrunner for the series, which was produced by Pemberley Digital. In addition, the modest Su was also its co-creator and directed most of the episodes. In terms of work that inspired the *Lizzie Bennet Diaries*, he told me that *LonelyGirl15*, discussed in Chapter 12, was definitely an influence. I was curious about the social media sites that were used, and Su told me they were used in different ways. Some were used more to portray the characters, while others, including LOOKBOOK.nu, Tumblr, and Twitter, were used more for narrative purposes. LOOKBOOK.nu, a fashion social network, was one of the most unique social media sites used in the story. Lizzie's sister Jane, who loved fashion, was very active on LOOKBOOK.nu. Su told me her posts there were highly popular: "I think the fans who were very immersed really appreciated LOOKBOOK.nu because that was a thing they hadn't seen before." The photos used on LOOKBOOK.nu, he said, were story-enhancing because they showed what Jane had worn to different events in the story.

He said Facebook was used mostly to reinforce what Lizzie had talked about in her video blog, while the perspectives of other characters primarily came from Twitter and other YouTube channels, serving almost as parallel storylines. He said they worked as

"four almost complete timelines in real-time, some more in-depth than others." Although the different perspectives were not as sharply differentiated as *Rashomon*, he pointed out, they offered a much more enriched version of the story. As to the importance of social media sites, Su told me they contributed hugely to the popularity of the show. He said they "enriched the fandom to such a high level that it propelled the series into the success it has."

I asked Su what the biggest change was in adapting the Austen novel. He said:

> Telling the story and having it be all about marriage, or meeting the right guy, or getting the guy, felt very anachronistic. It didn't feel very genuine to us. And even though some of the purists wondered 'How could you tell *Pride and Prejudice* and not have it be about marriage?!' You go like 'well, it's not 1800.' It was about marriage, but I think it was also about *independence.*

Aside from shifting the focus away from the importance of marriage, what was most true from the Austen novel was the way the characters came through. The only significant one to be changed was Darcy's sister, he told me; the others were essentially modern versions of Austen's creations.

The audience could participate in the story by asking Lizzie questions, which she would answer in character. Su told me: "Toward the end we were getting thousands of questions, and in the beginning we were getting hundreds, so it was certainly a very, very cool thing." Sometimes Lizzie would directly invite fan participation. For example, she would ask people how they spent their holidays, and fans would respond by sending her videos about their celebrations. And, of course, fans could and did comment on any of the posts the fictional characters made. The fans even created their own completely independent website to discuss the series, Darceny.com. Charlotte and the three sisters each had a dedicated fan base. Charlotte's fans, for example, could make comments about her on Twitter at #thatssocharlotte. He told me that Charlotte "has become an icon of our series as the counterpoint to Lizzy's point of view, which is not always correct."

The *Lizzie Bennet Diaries* ran for 100 episodes, just short of an entire year, an achievement attained by very few Web series. In the

beginning, though the team did not know exactly how many episodes there would be, they realized it would be an extended run. Su told me: "I approached it very much like a television show. I said 'this is a long game ... I'm building it to be evergreen, to last a long time, to be a long series.'" And, he said, the success of the *Lizzie Bennet Diaries* did not come easily, though he believes it is possible to create a successful Web series—"You have to go fight for it, and work hard," he stressed. "It's a journey. It's difficult ... I know I put in a lot of hours, for sure. And I do enjoy it. I'm not complaining." But, he said emphatically, "you've got to work for it, or else you're not going to get it."

Austen Lives On

Fortunately, the *Lizzie Bennet Diaries* has not been the end of the line for social media Web series based on Jane Austen's writings nor the end of the characters that Lizzie introduced. A new series, *Welcome to Sanditon* (http://www.welcometosanditon.com/), premiered in May 2013 and ran over the summer of 2013. It was based on Austen's unfinished novel, *Sanditon*, which she abandoned after only 11 chapters, but the new online series greatly expanded and modernized the story.

As with the *Lizzie Bennet Diaries*, which are conveyed to a large extent by Lizzie in the form of vlogs (video blogs), *Welcome to Sanditon* is told in a series of vlogs narrated by Gigi, Darcy's sister. The story revolves around the seaside community of Sanditon in California (see Figure 8.1), which is striving to modernize and to attract more visitors.

FIGURE 8.1 The logo for the Web series, *Welcome to Sanditon*, based on the unfinished novel by Jane Austen. Image courtesy of Adam Levermore.

Gigi has been enlisted to help her brother's company introduce a new video platform called Domino to help with this endeavor. Thus, the fictional residents of Sanditon will be beta testing Domino, and their employment of it is featured in Gigi's vlogs. (Most of these videos are fan-made and are powered by the Theatrics collaborative storytelling platform.) In addition to the vlogs, the story is told by an array of social media sites, including Twitter, Reddit, Facebook, Tumblr, and This is My Jam (a social media site focused on music), using them as the fictional characters in the story would. Since Austen never finished this novel, the creative team has had the liberty to conclude the series in the way they feel serves it best.

Other Works of Social Media Fiction

Pemberley Digital went on to produce other works that were in the same vein as *The Lizzie Bennet Diaries*. *Emma Approved* is based on Jane Austin's novel, *Emma*, and ran for 72 episodes, each running from five to seven minutes. The modernized heroine, Emma, is a lifestyle coach who doubles as a matchmaker. She's making a documentary about herself, which are the vlogs of the series. In *Frankenstein, MD*, the modernized story makes some major twists in Mary Shelley's novel, *Frankenstein*. The protagonist is now female and a medical student named Victoria Frankenstein. Much of the show is devoted to Victoria's medical experiments, portrayed as serious science, though not at all mainstream. Things take an unexpected turn when the unseen cameraman dies in an accident and Victoria successfully revives him using experimental techniques she had demonstrated earlier. He thus becomes Frankenstein's monster. Pemberley Digital partnered up with PBS Digital Studios to produce the show, and this was a first for PBS.

The New Adventures of Peter and Wendy, a romantic comedy, follows much of the model developed by Pemberley Digital: the main pieces of the story are told through short vlogs, and the series is an adaptation of a well-known novel, in this case J. M. Barrie's novel about Peter Pan, *Peter and Wendy*. Anyone familiar with the original story will quickly recognize the main characters here,

though older than in the novel: Peter, now in his late twenties, is a man-child who never wants to grow up and Wendy, his love interest, is a mature and wise woman. Though Peter never wants to grow up, he does have one grown-up desire: to win Wendy's heart, and the drama revolves around his seemingly unattainable goal, and Wendy's desire to see Peter become an adult. The cast also includes characters who originated in the novel: John, Michael, Lily, and the magical fairy, Tinkerbell. They all live in the little town of Neverland, Ohio. Wendy, the author of an advice book, invites viewers to ask her questions, which gives the series a modicum of interactivity, and you can follow the characters on Twitter, Instagram, and Friendster. The series ran for three seasons on EpicRobotTV, a YouTube channel.

A Darker Social Media Story

13 Reasons Why is a more serious work than the others described thus far. The Netflix series, going into its third season, is based on the novel *Thirteen Reasons Why*, written by Jay Asher. In the story, a high-school girl named Hannah has committed suicide and before her death has made 13 video cassettes explaining her reasons for no longer wanting to live. Each video cassette addresses one of the people whom she felt drove her to her death and they reveal that Hannah had been raped by one of her fellow students. A boy from her school, Clay Jensen, was in love with Hannah but his love was unrequited, and he's one of the first to receive Hannah's box of tapes. Clay is a driving force in the story, seeking to avenge Hannah's death and change the unhealthy culture of their high school.

The series was created with a number of social media components. Each of the main characters has a well-developed Instagram account, and the posts are full of clues relating to Hannah's death. In addition, there's an innovative interactive mobile component, *Talk to the Reasons*, which revolves around the controversy of whether or not the school did enough to prevent Hannah's suicide. It gives you a chance to chat directly with the characters on your phone and hear their thoughts and opinions. The feature pulls you into the story in a way that can be disconcertingly real. One

user wrote on Reddit: "Omg this made me want to cry. Hearing their thoughts out loud like that reminded me of last year, when I was stressed out over my own court case against my abuser. That's heartbreaking. I'm glad they did this."

The series has won numerous awards, including the prestigious award in 2018 from the Television Academy (the organization that awards the Emmys), "Outstanding Creative Achievement in Interactive Media within a Scripted Program." It was produced by July Moon Productions, Kicked to the Curb Productions, Anonymous Content, and Paramount Television.

Other Approaches to Social Media Storytelling

As can be seen from the social media stories thus far described, these types of narratives vary quite a bit in their use of interactive elements, with some, such as *The Lizzie Bennet Diaries*, being highly interactive and others, such as *Frankenstein, MD*, offering users almost no opportunities to interact. What makes them unique is that they unfold on social media, and in extremely small segments.

The South African drama, *Uk'shona Kwelanga*, is unusual in that it is told entirely via WhatsApp, and it is done as a conversation in real time among family members who are grappling with the death of a revered member of their family. The posts include texts, photos, audio, and video. The family sets up a WhatsApp group to discuss funeral arrangements. It was created in partnership with a South African insurance company, Sanlam. It was the first drama series told via WhatsApp in South Africa, and the series gives you the sense of eavesdropping on an ongoing debate among family members. People who sign up for this experience receive daily pieces of the story as it unfolds.

A very different approach to social media storytelling is *Dark Detour*, an anthology Halloween horror series launched in 2014. Like *Uk'shona Kwelanga*, it is also told in real time (see Figure 8.2). It is delivered via social media around Halloween for between 5 to 21 days leading up to the autumn holiday, but instead of using just one social media platform, it uses a great many. Two series have

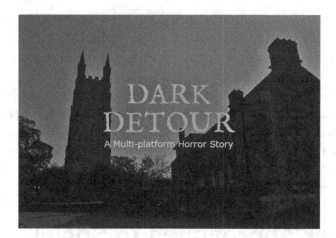

FIGURE 8.2 *Dark Detour* is a series of horror stories told on multiple platforms and in real time over the Halloween season. Image courtesy of storycentral Ltd. and No Mimes Media.

been delivered thus far and a third is currently being developed. The series was created by transmedia expert and storyteller Alison Norrington (of storycentral Ltd.) and game designer Steve Peters (of No Mimes Media). Unlike *Uk'shona Kwelanga*, it uses multiple platforms and is told through the geo-location app, Foursquare, as well as a combination of Facebook, Twitter, Instagram, YouTube, and more. The series was funded by an IndieGoGo crowdfunding campaign and has been a success, with its audience more than doubling from Season 1 to Season 2.

The story for the first season, "Dark Desert Highway," is told partially through videos "shot" on the main character's phone. The protagonist is Talbot Griffin, a young musician with a big dream. Talbot is on a road trip after breaking up with his girlfriend, leaving him vulnerable to the people he encounters and emotionally fragile—a bad state of mind for a character who finds himself submerged in a horror story. "Dark Desert Highway" allows users to connect directly to the characters in the story by friending Talbot, and by the use of devices and platforms that audiences use every day (see Figure 8.3). It is thus able to deliver a deeply immersive experience and participants experience it as if it is taking place in the same world in which we live and in real time. Audience members thus become thoroughly immersed in Talbot's frightening dilemma.

FIGURE 8.3 Examples of how social media was used in "Dark Desert Highway." Image courtesy of storycentral Ltd. and No Mimes Media.

The story for the second season, "All That Glitters," plays more on Nordic religious folklore and spins a tale of two young lovers on the misty moors of England, each time ending in unexpected terror for the victims as they meet their fate—always with a twist (see Figure 8.4). The story follows wedding photographer Jack Selinger on his visit to London and after a particularly stressful Bridezilla event he decides to spend a week exploring the West Country, promising his business partner in New York that he'll be back in London the following weekend for the second bridal event. His fate is sealed after he connects with a beautiful woman

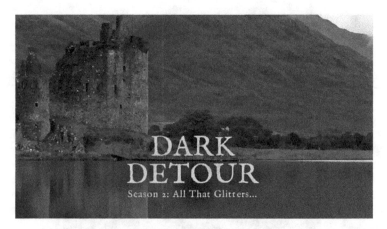

FIGURE 8.4 The logo for the second season of *Dark Detour*, "All That Glitters." Image courtesy of storycentral Ltd. and No Mimes Media.

who works behind the bar of a pub he visits and they fall in love. As with "Dark Desert Highway," the story is related in the same way it would be told in real life, striving to make every installment of the story authentic and organic to the way people use social media platforms, showing, instead of telling, as much as possible.

The story of the third series will center around a train journey that takes an unexpected turn. Participants in *Dark Detour* work together against a ticking clock to influence the storyline, uncover a mystery, or rescue a character. Many players are rewarded by a surprise spooky phone call on Halloween night.

Works of Non-Fiction Using Social Media

Social media has quickly become a workhorse form of communications for all kinds of organizations, both for-profit and non-profit, and for all kinds of endeavors. Charities use social media to raise funds; artists use them to draw attention to their art work; universities use them to enroll new students. My old journalism school, the Medill School at Northwestern University, has integrated the teaching of social media into the curriculum, believing that these new platforms have become another significant method of connecting with audiences. In addition to these functional

applications of social media, they are also being used to create new kinds of non-fiction entertainment experiences and to tell fairly complex stories as they happen in real time.

One such non-fiction series taking place in close to real time was *The Singles Project*, told in the style of a reality TV show. It featured six single people in New York City in their search for love in the big city, and a genuine connection developed between the cast members and the viewers. The show aired on Bravo TV, and social media was a major factor in its success. The episodes were aired just days after being shot, and the social media elements were continually uploaded. All six cast members had social media accounts and regularly posted photos of their dates in real time and audience members would offer their reactions to the dates and give advice. Though some might feel the show was voyeuristic, viewers felt a personal connection with the cast members and an investment in the success of their dating experiences, and the cast members took some of their advice to heart. At the end of each episode, viewers could participate in a live Twitter question and answer session. Viewers' Tweets were read on the air, and they could even vote in polls, letting cast members know whom they should keep seeing or whom they should dump. In addition, viewers could become part of the show by posting short videos of themselves. The show won an Emmy in 2015 for Outstanding Creative Achievement in Interactive Media.

One quite unusual non-fiction project was launched by YouTube in 2008. It was a collaborative symphony project, *The YouTube Symphony Orchestra* (http://www.youtube.com/ user/symphony). The project had a global reach because musicians from all over the world were invited to send in audition videos. An original piece of music, *The Internet Symphony No. 1*, written by Chinese composer Tan Dun, was commissioned for this project. A decidedly modern piece, it called for such unusual instruments as disc brakes and rims from automobiles. Prospective orchestra members had to submit a tape showing them playing this music, as well as another audition piece. The YouTube community itself voted on the selection of the musicians.

The winners participated in a live performance directed by Michael Tilson Thomas at Carnegie Hall in 2009 and a second

YouTube Symphony Orchestra competition was announced in 2010. The musicians for the second concert assembled and performed at the Sydney Opera House in 2011. Again directed by Thomas, it involved 101 musicians from 33 different countries and another original piece of music. The exterior of the iconic opera house was illuminated by stunning projections made by Obscura Digital. The event became the largest live stream ever made by YouTube: over 30 million watched the concert on computers and almost 3 million on mobile devices. Even though this project involved classical music, not normally a type of music favored by a great many people, this project illustrates that there is an enormous potential audience for unique events that involve social media, competition, and glamour, as well as new kinds of experiences that can be created using digital media.

Another unusual social media project—*@SummerBreak*—played out over the summer of 2013. It was an eight-week reality show that exclusively used social media rather than TV. Playing out in real time, it followed nine newly graduated high school seniors as they enjoyed their last summer before college, and presumably, before growing up. It utilized Twitter, YouTube, Tumblr, and Instagram. Obviously, *@SummerBreak* is a youth-oriented story, and unlike the YouTube Symphony Orchestra it does not involve high art, but it illustrates another way new ground can be broken by using social media.

The Grapes of Wrath Journey (http://www.grapesofwrath75.org/), organized by the National Steinbeck Center in California, also used social media exclusively, but it was a far more serious enterprise than *@SummerBreak*. The 10-day road trip, much of it along old Route 66, was made in honor of the seventy-fifth anniversary of John Steinbeck's renowned book, *The Grapes of Wrath*. It retraced the route of the fictional Joad family across Oklahoma, Texas, New Mexico, Arizona, and into California, where the Joads were hoping for a better life after nearly being wiped out during the Dust Bowl. The modern group of travelers was made up of a team of three artists and their crew, among them a visual artist, a playwright, and a filmmaker.

Although members of the public could not travel with them, they could vicariously participate in the journey through the project's

website, blog, Facebook page, tweets, and Instagram posts. Along the route, the artists did over 16 programs at partner organizations, including performances, workshops, and the recording of oral histories, and some of these programs were streamed live. In part, the team was trying to answer the same question the Joad family had been grappling with: how do you survive as a family in hard times? Storytelling was a major part of this project, because not only did it honor the story that Steinbeck told, but also told the story of the modern travelers and the stories of the people they met along the way. This project is a solid example of how social media can be used to document an unfolding story in real time, and how it can involve members of the audience.

Social Media Games

Social media games, also called social games, are games that you play on social media sites with your community of friends. Thus, they are multiplayer games, unlike the video games that you play alone against NPCs. What is new about social media games is, first of all, they are generally asynchronous, meaning that players are not playing with each other at the same time, though there are a few exceptions to this. Furthermore, unlike most other kinds of games, these have no victory or loss conditions, because they are ongoing experiences, though they do generally have missions that the user must complete before advancing in the game. For the most part, these games are free to play but their business model is based on microtransactions, which means that players must make small purchases with real money in order to be successful in the game.

Farmville, published by Zynga in 2009 and played on Facebook, was the first social media game to become a massive hit. Its premise was quite simple: you have a plot of undeveloped farmland and it is your job to plant crops, raise livestock, build barns, and create the most thriving farm possible. Another early game, *Scrabulous*, was also quite popular on Facebook. The game dates back to 2005, but due to its close similarity to Scrabble, its developers were sued and the game was removed. In contrast, another game, *The Godfather: Five Families*, which was made by Kabam and came out in 2011, contains far more narrative and includes video, and is

a fairly dark story. The game is set in the 1930s during Prohibition, and the story revolves around five mafia families warring against each other to gain control of New York. If your game strategy is clever enough, you might become Don of the city.

Zynga Elite Slots, launched late in 2012, combines typical slot machine play with fantasy-adventure game elements, and thus is quite different from other social media games. Players choose a pet avatar to represent them in the game and, as they advance, they venture through a succession of themes, such as the Enchanted Forest and the House of Fangs. The players' pets progress in experience points and gems as the player spins, and eventually players can engage in a big boss fight. In terms of story, the richest elements are the characters and the fantasy environments.

In contrast to the other social media games discussed here, *Pearl's Peril* offers quite a rich narrative. The episodic game, made by the German company Wooga, is set in the 1930s. You play the game as Pearl, a young woman trying to solve the mystery of her father's death. The gameplay involves hidden object scenes and puzzle-solving adventure sequences, all of which help you solve the mystery. You are also asked to construct and decorate buildings that will help you gain insight into the life of Pearl's father (and possibly his death). Although the story elements here are quite deep, the social elements are more limited. The game contains leaderboards and friends can send energy to each other, so it is almost like a game meant for solo play. It will be interesting to see if developers find a way to combine the social part of gaming with rich narratives so that social media games can offer the deeply immersive experiences of video games.

Tokyo 13, a hit Japanese game translated into English in 2016, uses the world of social media gaming in a unique way. Like other social media games, you play on a social media site, but in this case the site is fake, created just for this game. The site looks entirely real, though, with users' profiles, an icon or picture of each user, dialogue balloons that sometimes contain mean comments from other users, and a notification button which shows how many messages you've received while you were busy interacting one of the users. However, the users you chat with and play with are as fake as the social media site: they are fictional characters designed

to pull you into a sinister world. You play by solving puzzles and figuring out riddles that these "users" give to you, and you help them find their way in a sometimes-scary world. As you interact with them, you develop a comradeship and even a friendship with them. But just as things are going along well, your new friend tells you she is being followed by an ominous character, and she suddenly vanishes, never to be heard from again.

Thus, even though the site was fake and the users on it were fake, players found the game riveting and even addictive. They enjoyed the mystery aspect of it, the puzzles and riddles, and make new friends, even though these friends were fictional characters.

Does Humor Have Any Role to Play in Social Media?

Humor, if appropriate, can be a very effective component of social media. When people are amused by something, they are apt to pass it along to their friends, and thus humor can promote viral marketing. And when people get a good laugh from something, they tend to remember it longer than something that was serious. For example, *The S#cial Sector* (described earlier) is a social media experience that used humor well. Thus, yes, humor can be your ally, but there is a large *but* here. If the humor used is insensitive when it comes to race, gender, culture, or other forms of personal identity, it can backfire and instead of being an ally, it will become an enemy of your content. Furthermore, the humor you use should always be in keeping with the overall story. Not every project can or should support humor, and it is clearly inappropriate if your content relates to such topics as the Holocaust, deadly diseases, assassinations, and the like. But when applied judiciously, and to the right project, humor can definitely be an asset.

Conclusion

Although using social media to tell stories is still a relatively new development, these narratives have already demonstrated that they can be used to portray characters and be the "bones" of both fictional and non-fiction stories. And it seems that with every

passing year, developers are finding new ways to employ them for storytelling.

Here are a few things to keep in mind for using social media as a storytelling device:

- If you are developing a work of fiction, select the forms of social media that your characters would be likely to use, rather than the form that is currently most popular (though a highly popular one might also be right for your piece).
- When writing social media posts for your fictional characters, use the conventions of that particular form and model these posts on the way living people write.
- If creating a fictional work, consider both the forms of social media your target audience favors, and the forms that your characters are likely to use, and see if they are the same. If they are not, can you shape your story in such a way that your fictional characters would favor the same forms of social media as your audience?
- Remember that sometimes a social media site that is less well known can be perfect for your piece, so don't be afraid to use it, since you can point your users to it from the more popular sites you are employing.
- When writing a work of non-fiction, select the forms of media best suited to convey different facets of your piece, including photos, text, and video.
- Make sure your piece leaves space for users to participate and welcomes their contributions. This can include the opportunity to make comments, post images and videos, or even contribute new characters. Remember that in social media, it is the *social* that makes this form of communication as popular as it is.
- Use humor when appropriate, but do not use it in an insensitive fashion.

Idea-Generating Exercises

1. Select a character from a TV show, movie, or game that you are very familiar with and write at least five tweets in this person's voice.

2. Develop a Facebook page for this character. What information would you put in the "about" section? What kinds of photos do you think this character would include? Write a few posts, and responses to those posts, for this Facebook page.
3. Take a novel or motion picture or TV show that you are highly familiar with and consider how that same story could be told using only social media. What social media would you employ? Try creating the opening of the story using these social media.
4. Sketch out a work of social media non-fiction for an ongoing endeavor that you are familiar with. What forms of social media would you use? How could users add their own contributions? This endeavor could be about archeology, exploration, a conservation effort, or many other things, but ideally it should be ongoing, and the outcome should be uncertain.
5. Select a social media game that you have played and analyze how the game worked. Describe the narrative content and the gameplay. What made this a social game? What do you think worked best in this game and what could have been improved?

Chapter 9

Guidelines: Creating a New Project

What is the very first step that needs to be taken in developing a new project, and why is it so important?

What are the five most common mistakes people make when developing an interactive project?

Why are so much time and attention spent on creating certain types of documents during the development process, and are these documents even necessary?

What are the 10 most important questions that must be addressed before production begins?

The Development Period and Why It Is Critical

Before a work of interactive entertainment is ever built—before the interactivity is programmed or the artwork is produced, or the sound is recorded—a tremendous amount of planning must first take place. This phase of the work is known as the development process or the preproduction period. It is a time of tremendous creative ferment. In its own way, it is not unlike the period

described in ancient creation myths when all was nothingness and then, after a series of miraculous events, the Earth was formed and its myriad beings were given life.

The creation of a work of interactive entertainment is a totally human endeavor, of course, but it, too, begins with nothingness, and to successfully bring such a complex endeavor to fruition can almost seem miraculous. To achieve the end goal, a tiny sliver of an idea must be nurtured and shaped, amplified and refined. And, instead of miracles, it requires a tremendous amount of hard work. Bringing a project up to the point where it is ready for production requires a team of individuals with diverse skills who perform an array of different tasks.

Surprising though it may be, the work that goes on during preproduction is much the same for every type of interactive project, whether the end product is a video game, an interactive documentary, a VR experience, or a mobile app. The specific documents that are called for may vary, and the specific technical issues may be different, but the core process varies little, no matter what the interactive medium may be.

WORTH NOTING: THE ADVANTAGES OF GOOD DOCUMENTATION

A well-utilized preproduction period can save not only time and money during production, but can also help avert the risk of a product that fails. Furthermore, the documents generated during development can go a long way toward keeping the entire team on track while the project is actually being built. Good documentation can mean that everyone is working with the same vision of the end product in mind. It helps avoid confusion, prevents mistakes, and reduces the likelihood of work having to be redone. It also avoids the dangers of the dreaded *project creep*: a situation in which a project expands beyond its original concept and sucks up staff time, often without additional financial compensation. And if a new member is added to the team midway through, the documentation can quickly bring that individual up to speed.

The tasks that take place during the development period include the conceptualizing of the project; addressing marketing

issues; producing design documents, artwork, and other materials; building a prototype; and doing testing. Not every task done during this period deals specifically with creative issues, although invariably everything does impact the content, including the drawing up of budgets and schedules and the preparing of marketing plans.

The development process typically lasts an average of six months. However, it can be as brief as a few days or take as long as a year or more, depending on the complexity of the project, the experience of the creative team, and whether or not it involves a new type of technology or content. At the end of the development process, the company should be ready to swing into full-scale production.

Five All-Too-Common Errors

Unfortunately, certain serious mistakes tend to be made during the development process. Some of these errors are caused by inexperience. Others may be fueled by the team's admirable intention of making something remarkable, yet being unable to rein in their ideas and set reasonable limits. And quite often, problems arise because the creative team is eager to plunge into production and is too impatient to invest sufficient time in planning. Based on my own experience and on interviews with experts, here are five of the most common and serious errors that occur during the creative process:

1. *Throwing too much into the project.* In cases like this, the creative team may have become intoxicated with a promising new technology or with exciting new ways to expand the content. But this sort of enthusiasm can lead to many problems. It can cause the project to go over budget or require it to carry too expensive a price tag for the market. The project may take far longer to produce than the time originally slotted for it, causing it to miss an important market date. Or the finished product may be too complex for the end-user to enjoy.
2. *Not considering your audience.* This error can be fatal to a project. If you do not have a good understanding of your

audience, how can you be sure you are making something it will want, or will have the ability to use? Misjudging your audience can lead to:
- Creating subject matter they are not interested in, or find distasteful
- Developing content for a platform, device, or technical ability they do not possess
- Developing an educational or training program that omits key points they need to know, or that goes over their heads
- Developing content for children that is not age-appropriate

3. *Making the product too hard or complicated.* This error can stem in part from error number 2, not knowing your audience. You need to understand what the end-users are capable of doing, and not make unrealistic demands on their abilities. Sometimes this error is caused by poor design, and is allowed to slip by because of inadequate testing. Whatever the cause, an overly difficult product will lead to unhappy end-users. As game designer Katie Fisher of Quicksilver Software said: "When a game becomes work, it's not fun for the player." Her comment is true not just of games but for any type of interactive content, be it a smart toy, a work of AR, or an iTV show. If it is too hard to figure out, people are not going to want to invest their time in it.

4. *Making the product too simple.* This is the other side of the coin from error number 3. We are not talking here, however, about the product being too simple to use—simplicity in functionality is a good thing. We are referring to overly simple content. The content of an interactive work needs to be challenging in some way; otherwise, users will lose interest. It should also contain enough material to explore, and things to do, to keep the users absorbed for a significant amount of time. If it is too thin, they will feel they have not gotten their money's worth. To gauge the appropriate amount of playing time for your product, it is advisable to become familiar with similar products on the market. Focus group testing is also helpful in this matter.

5. *Not making the product truly interactive.* In such cases, users are not given sufficient agency to keep them involved. When this happens, the flaw can usually be traced back all the way to the initial concept. In all likelihood, the premise that the product was built upon was weak in terms of its interactive potential, even if it might have been an interesting one for a noninteractive type of entertainment. In a successful interactive product, the interactivity must be organic from the outset and not just an afterthought.

The First Step: Creating the Core Concept

The development phase begins with deciding what, in essence, the new project will be—the core concept. The initial idea may come about in one of several ways, and how it is initiated varies from medium to medium, company to company, project to project. Sometimes the concept is proposed by the CEO or president of the company; sometimes a staff member comes up with the idea; and sometimes it emerges during a staff brainstorming session. In a long-established software company, the concept may be a sequel to an already existing title. In a start-up company, it may be the dream project of a single individual or a small group of colleagues.

Ideas for new projects can come about in many ways. Sometimes they are inspired by a myth or true event from history or from an incident in someone's personal life. Sometimes the starting point is a preexisting book or movie that the team wants to adapt. Sometimes the starting place begins with someone dreaming up an intriguing fantasy setting or exciting world to explore. Many times ideas take shape just by letting the imagination run free or by a group brainstorming session. In other cases, an idea is sparked by a new technology, when someone envisions how it could be used as a medium for an interactive narrative.

In many instances, of course, a company is given an assignment by an outside client and needs to find a creative way to fulfill it: to come up with an entertaining way to teach high school physics, for example, or to use digital storytelling techniques to promote a movie or sell a new line of cosmetics.

In many companies, the raw idea is set before the entire creative team and subjected to some rigorous brainstorming. During brainstorming, even the wildest ideas are encouraged, in order to explore the full potential of the project.

Once a consensus of the core idea is reached, a description of it needs to be articulated in a way that adequately reflects what the group has worked out. Ideally, one person on the team will boil the concept down to a clear and vivid *premise*. The premise, which is usually just one sentence long, describes the concept in a way that indicates where its energy will come from, what the challenges might be, and what will hook the users. Ideally, the premise should also indicate who the major characters are and the world that is the setting for the story. The premise is often written in the second person, "you," to put the listener or reader right into the action.

For example, a description of the premise of a new game might sound something like this: "In *Runway*, you are thrust into the glamorous but cut-throat world of the fashion industry, where you play the head of a small fashion house competing against powerful rivals and try to come up with the winning line for the new season." Or a description for a smart toy might be described this way: "Perry the Talking Parrot can be trained to speak and repeat phrases, but you can never predict what Perry might say, because he has a mind of his own!"

In the film business, they call this one sentence description a "log line." The term got its name from the concise descriptions of movies given in television logs and other entertainment guides. However, the idea of boiling down a premise to a few words is equally useful for interactive entertainment. By nailing it down this way, the team will have a clear grasp of what it is setting out to do. They will also be able to communicate this vision to everyone who will be working on it, or whose support will be needed to bring the project to fruition. And ultimately, this log line will be a valuable marketing tool.

Other Early Decisions

Early on during the development period, the creative team needs to make certain fundamental decisions about the project, assuming they are not already incorporated into the basic concept. First of all, what is the specific medium, and which are the platforms,

that the project is being made for, and to what genre does it belong? Once these basic "What is it?" questions have been addressed, it is time to consider important marketing issues. Who will the target audience be? What competing products are already available? And, if this a retail product, what will the intended price tag be? All these matters can have a significant impact on the design.

To help answer these questions, many companies either use a marketing person on staff or hire an outside consultant. This marketing expert might determine, for example, that the idea you have in mind sounds too expensive for your target audience, and if you don't want to overprice your product, you will need to rethink the design and leave out some of the cutting-edge features you were hoping to build in. Or your marketing expert might tell you your product would have a better chance with a different demographic than you had in mind. This information would require a different kind of adjustment. For instance, if you found out it would have more appeal to teens rather than to preteens, you may need to make the product more sophisticated and edgier than you'd intended at first.

Somewhere early on during the development period, the project manager will also be working out a preproduction and production schedule which will include specific milestones—dates when specific elements must be completed and delivered. A budget for the project will also be drawn up. Now, armed with a clearer idea of your project and its parameters, the team can brainstorm on refining the concept and begin to develop its specific features. Unlike the very first brainstorming sessions, where the sky was the limit, these later brainstorming sessions are tempered by reality.

> **EXPERT OBSERVATION: FIVE POUNDS OF STUFF**
>
> Designer Greg Roach, introduced in Chapter 3, points out that you only have limited resources for any project you undertake, and you have to decide how best to use them. "It's like being given five pounds of stuff," he said. "You can't do everything you want." Thus, you have to make trade-offs—if you really want Feature X, then you may have to scratch Feature Y or Feature Z. In other worlds you can't build a 10-pound project with only five pounds of stuff.

How Projects Evolve during Development

As a project moves through the development process, it evolves from a raw idea to a polished state where it is capable of being produced.

As to be expected, each software company will have its own way of working through this process. Though a standardized procedure does not exist, the goal is universal: to work out the most important aspects of the project before production begins. At StoryToys, the Dublin-based company that made the interactive app for *My Very Hungry Caterpillar*, a great deal of iteration is part of the process. This is "to get everything right," explained Emmet O'Neill, the company's chief product officer. This attention to detail and striving for perfection works well for StoryToys: their hungry caterpillar project won the prestigious BolognaRagazzi Digital Award in 2015, as well as a boatload of other major awards, including the Apple Best of App Store 2014 and the Kidscreen 2016 Award.

The app was inspired by the beloved picture book, *The Very Hungry Caterpillar*, by Eric Carle. O'Neill explained how the app was developed at a Dust or Magic Masterclass presentation in 2015 in Bologna, Italy. Early on, O'Neill said, the company's brilliant art director Marko Tusan made a prototype to show how the caterpillar would get fat by eating and get thin by running around: two of the most important activities in the app. Then O'Neill made a list of what the app would contain and from there quickly sketched out pictures of how things would look. O'Neill confessed his sketches were undecipherable by anyone other than himself, so he had Elaine Snowden, an experienced member of his art team, make storyboards for the project (see Figure 9.1). O'Neill explained they wanted to use minimum text and minimum user interface (UI) in the project, which was why they wanted to storyboard the entire project. The only user interfaces were two meters at the top of the page, to show how full the caterpillar was and how happy he is. O'Neill explained that the guiding philosophy of the project "was to make something that was new and exciting like an actual physical toy, rather than a poor digital translation of a wonderful book."

FIGURE 9.1 A portion of the storyboard for *My Hungry Caterpillar*. Image courtesy of Touch Press and Story Toys.

Other Steps in the Preproduction Phase

During this preproduction phase, many projects require the input of *subject-matter experts*, known as SMEs. Projects designed for educational, informational, or training purposes will inevitably require help from experts on the content and often on the target learners. But even when the sole goal of the project is to entertain, it might be necessary to seek expert help, or to assign someone to do research. For instance, if you are building a game about the fashion industry, you will want to find out everything you can about the world of high fashion, from how a new line of clothes is designed to how a fashion show is staged. Based on this knowledge, you can build specific challenges and puzzles into the game, and make the project far richer and more realistic than it would be if you had attempted to rely on your imagination alone.

As the project develops, the team will be setting the ideas down in various types of documents. They will also be producing flowcharts, character sketches, and other visuals to further refine the interactivity, characterization, and look of the project. The various documents and artwork will be described in more detail a little later in this chapter, in the section entitled "Documents and Artwork."

At various points during the development process, ideas and visuals may be tested on *focus groups*—representative members of the target audience. If a client company is involved in this project, it will also need to be briefed on ideas and shown visuals. Based on the

feedback that is received, further refinements may be made. The final step in preproduction is often the building of a prototype, a working model of a small part of the overall project. This is especially typical in cases where the project incorporates novel features or new technology, or is the first of an intended line of similar products.

The prototype will demonstrate how the project actually operates, how the user interacts with the content, and what the look and feel of it will be like. For many interactive projects, the prototype is the make-or-break point. If it lives up to expectations, and funding for the product and other considerations are in place, the project will receive the green light to proceed to development. But if the prototype reveals serious flaws in the concept or in its functionality, it may mean going back to the drawing board or even be the end of the line for that particular concept.

A 10-Step Development Checklist

As we've already seen, the process of creating an interactive project involves the asking and answering of some fundamental questions. Based on my own experience and on the interviews done for this book, I have put together a list of 10 critical questions that must be addressed early in the development process, each with its own set of sub-questions. These questions and sub-questions apply to virtually any type of work of interactive entertainment. The answers will help you shape your concept, define your characters and structure, and work out the project's interactivity. The 10 questions are:

1. *Premise and purpose*:
 - What is the premise of the project ... the core idea in a nutshell? What about it will make it engaging? Try to capture its essential qualities in a single sentence.
 - What is its fundamental purpose? To entertain? To teach or inform? To make people laugh? To market a product?
2. *Audience and market*:
 - Who is the intended user?
 - What type of entertainment do people in this group enjoy? How technically sophisticated are they?

- Why should your project appeal to them?
- What other projects like yours already exist, and how well are they doing?

3. *Medium, platform, and genre*:
 - What interactive medium or media is this work being made for (such as the Internet, smartphones, video game console, or several media together); what are the special strengths and limitations of this medium and how will the project take advantage of these strengths and minimize these limitations?
 - What type of platform (hardware) will it use? (For example, a PC, a game console, a mobile phone, etc.)
 - What genre (category of programming, such as simulation, Web series, or action game) does it fall into, and in what ways does your work contain the key characteristics of this genre?

4. *Narrative/gaming elements*:
 - Does your work contain narrative elements (such as a plot or characters)? If so, has the storyline been fully worked out? What are the major events or challenges that the user will need to deal with during the narrative?
 - What is the tone of your narrative? Is it comic, dark, scary, or a light-hearted romp?
 - Does this work utilize gaming elements? If so, is the gameplay thoroughly worked out? What constitutes winning or losing?

5. *User's role and POV*:
 - What character or role will the user play in this interactive environment?
 - What is the nature of the user's agency? How will the user impact the narrative or the outcome?
 - Through what POV will the user view this world: first person, third person, or a mix of both?

6. *Characters*:
 - Who are the nonplayer characters in this project?
 - What role or function do they serve (allies, adversaries, helper figures)?

- If your project contains a number of characters, have you developed a character bible to describe them?

7. *Structure and interface*:
 - What is the starting place in terms of the user's experience and what are the possible end points?
 - How will the project be structured? What are the major units of organization (such as modules or levels), and how many of them will there be? What structural model are you using?
 - How will the user control the material and navigate through it? How will the user be able to tell how well he or she is doing? Will your project be making use of navigation bars, menus, icons, inventories, maps, or other interface devices?

8. *Storyworld and sub-settings*:
 - What is the central fictional world where your project is set?
 - How is it divided, geographically? What are its major settings, what do they look like, and how are they different from each other?
 - What challenges, dangers, or special pleasures are inherent to each of these settings?
 - In what time period is your story set? Does it take place in the past (if so, when?) or the future, or is it a contemporary story?

9. *User engagement*:
 - What about your project will keep the user engaged, and want to spend time with it?
 - What important goal is the user trying to accomplish by the end of this work, and why would this be something of significant importance to the user?
 - What will add tension to the experience? Will there be a ticking clock?
 - Are you building in a system of rewards and penalties?
 - What kind of meaningful interactivity are you offering the user? Will this interactivity have a significant impact on the material?

- If the work includes player versus player (PvP) mechanics, how will this work in the game? Under what circumstances can this type of game play be triggered?
- If you are offering the opportunity for user-generated contributions, what kinds of things can the user contribute? How will this impact on the overall work?

10. *Overall look and sound*:
 - What kinds of visuals will you be using (animation, video, graphics, text on the screen, a mix)?
 - Is the overall look realistic or a fantasy environment?
 - How do you plan to use audio in your work? Will characters speak? Do you have plans for ambient sound? (Rain, wind, traffic noises; background office sounds?) Will there be sound effects? Music? Dialogue?

Once you have answered these 10 questions as completely as possible, you should have a pretty good grasp of the major elements of the project, or know what needs to be developed more fully. If your project is one that blends entertainment with other goals, such as education or promotion, it will be helpful to also review the checklist given in Chapter 10, in the section entitled "Guidelines for Projects that Blend Storytelling with Teaching and Training."

Documents and Artwork

While each company may have its own unique method of doing documentation and preproduction artwork, certain types of written materials and visuals are universal throughout the interactive entertainment universe, even though their names may vary from company to company. The most frequently used forms of documentation and visual presentations are as follows.

The Concept Document

The concept document is a brief description of the project and is usually the first piece of written material to be generated. It includes such essential information as the premise, the intended

medium and platform, and the genre. It also notes the intended audience for the project and the nature of the interactivity, and gives a succinct overview of the characters and the main features of the story. Concept documents may be used as in-house tools to give everyone on the team a quick picture of what the project will be, and they can also be used as sales tools to secure support or funding for a project. If intended to be used in the second capacity, the concept document should be written in a vivid, engaging style that will convince readers of the project's viability. Concept documents tend to be quite short, generally under 10 pages in length.

The Bible

A bible is an expanded version of a concept document, and it is strictly an in-house working document. Bibles are most frequently used for complex, story-rich projects, but are used for other kinds of projects as well. A bible fully describes significant elements of the work. It includes all the settings or worlds and what happens in them and all the major characters, and may also give the backstories of these characters (their personal histories up to the point where the story or game begins). Bibles may also focus exclusively on one element of the project, such as characters or puzzles. At one new company which I had just joined, which was creating a deep and somewhat confusing narrative, I suggested at a team meeting that it would be helpful to write a character bible. They looked at me strangely, as if a religious zealot had just landed in their midst, but when I explained what it was, they agreed to do it. The resulting character bible turned out to be a handy document when new members were added to the team and were just as confused about the relationships of all these characters as I had been.

Other bibles are used to describe all the weapons in the work or all the settings. Bibles vary quite a bit in length, depending on the breadth of the project and their intended purpose within the company. In some companies, the bible is a collection of all the preproduction documents written for the project.

The Design Document

The design document serves as a written blueprint of the entire interactive work. It vastly expands the information given in either a concept document or bible, and contains specific technical information about the interactivity and functionality. It is the primary working document of any new media project. At some companies, the design document evolves from the concept document or bible; at other companies, it is written from scratch.

The design document is a living construct, begun during preproduction but never truly completed until the project itself is finished. As new features are added to the project, they are added to the design document, or if a feature is changed, the design document is revised accordingly. Because a design document is such an enormous and ever-changing work, and because so many different people contribute to it, it is vital that one person takes charge of overseeing it. This person coordinates and integrates the updates and makes sure that only one official version exists and that no outdated versions are still floating around.

Generally speaking, because design documents change so frequently and can be so large, it is impractical to try to keep paper copies of it. It is far more efficient to make an electronic version that can easily be amended or added to. It is also useful to keep the design document on the company intranet. That way, everyone on the team can have immediate access to it.

Design documents are organized in various ways. Some are organized by structure, with a section for each module, world, environment, or level. Others are organized by topic. For instance, the design document for the strategy game *Age of Empires* contained a section just on buildings and how they worked.

To get an idea of the type of information that can be included in a design document, let's take a look at a few pages of one prepared for *JumpStart Advanced First Grade* (see Figure 9.2). The document is organized module by module; this module is for Hopsalot's Bridge, a sorting game. It is hosted by a character named Hopsalot, who is a rabbit.

At the top of the first page is a picture of Hopsalot's Bridge, from the POV of the player. Beneath it is a list of the curriculum points the game will teach, followed by brief summaries of

Hopsalot's Bridge Module (Hb)

Access

Click Hopsalot's House, on the Main Menu Screen to get here.

Page Description

The curriculum for this module is the Sorting of:
- Parts of speech
- Words
- Geometry: shapes
- Science: Health/Nutrition, Animals, Weather

On Your First Visit:
Hopsalot gives long intro. Hopsalot's turbo carrot juice is one of the most prized power-ups for the scooters. Or at least he thinks it is, so he has gone to extremes to protect his supply.

Return Visit:
Gives short intro.

Gameplay

Hopsalot has made an island to hide his high-octane carrot juice on and he has to build a bridge to get to it. He has columns in the water that divide the bridge into 3 sections. He has also created little remote controlled balloon blimps to drop into place and create the bridge.

Each balloon has a word or picture on it (depending on the content selected for the session). For example: each word would be a Noun, Verb or Adjective. You must sort the balloons so that each column of the bridge has the same type of word. Use the left and right arrow keys to steer the balloons and use the down arrow key to make them drop faster.

If you send a balloon into the wrong column it will bounce back up into the air so that you can try again. Hopsalot will also hold a pin that will pop the balloons that you don't need (distractor blimps in L2 and L3).

FIGURE 9.2 A few pages from the design document of *JumpStart Advanced First Grade*. Document courtesy of Knowledge Adventure, Inc., and used under license.

(Continued)

When the bridge is complete, Hops will run over to grab a carrot power-up and bring it back. Now for the fun part! He can't leave the bridge up or Jimmy Bumples might sneak across, so you'll need to repeat the activity, but this time matching object will pop the balloon underneath.

Reward:
After you've destroyed the bridge, Hops will reward you with the power-up.

Content Leveling

Note: the levels are related to each topic.

1. Parts of speech
Level 1: Verbs, Adjectives and nouns
Level 2: Verbs, Adjectives and nouns
Level 3: Verbs, Adjectives and nouns
Add words that do not fit into the category such as an adverb or preposition.

2. Syllables
Level 1: 1 to 3 syllables; pronounced
Level 2: 2 to 4 syllables; pronounced
Level 3: 2 to 4 syllables; regular pronunciation

3. Health-Nutrition (food groups)
Level 1: 3 categories: Grains, Meats, Dairy
Level 2: 4 categories: Grains, Meats, Dairy, Fruits
Level 3: 5 categories: Grains, Meats, Dairy, Fruits, Vegetables

4. Animals
Level 1: Habitat: water, land, air
Level 2: Attributes: scales, fur, feathers
Level 3: Zoological type: mammals, reptiles, insects; amphibians as distracters

5. Science - Weather
Level 1: 3 categories: sunny, rainy, snowy; outdoors activities
Level 2: 3 categories: sunny, rainy, snowy; outdoors activities + clothes
Level 3: seasons: winter, spring, summer; fall as distracter

6. Geometry – Shapes and Forms
Level 1: 2D shapes: squares, triangles, circles, rectangles
Level 2: 3D shapes: cubes, cones, cylinders, spheres
Level 3: everyday objects by their 3D shape: cubes, cones, cylinders, spheres

Game Play Leveling

Level 1: Slow falling pieces.
Level 2: Medium speed falling pieces.
Level 3: Fast falling pieces.

Functionality

I. On entering the Module:
 A. Play Background: BkgG1HbBackground
 B. Play Background Music: G1HbAmbient.wav

FIGURE 9.2 (Continued) A few pages from the design document of *JumpStart Advanced First Grade*. Document courtesy of Knowledge Adventure, Inc., and used under license.

(Continued)

> II. Introduction Functionality
> A. Long Introduction (played the first time a player visits this module)
> Follow standards for interruptability
> a) Play Hopsalot waiving at Player
> - Hopsalot's Body: AniG1HbHopsalot, FX Wave
> b) Play Hopsalot giving his Long Intro
> (Note: during Intro, Hopsalot will be Pointing at item as he speaks about them; items will highlight, and Hopsalot will have corresponding "Point" FX going on)
> i) Long Intro:
> - Hopsalot's Body: AniG1HbHopsalot, FX Point01
> - Hopsalot's Talk: AniG1HbHopsalotTalk, FX LongIntro01
> - Hopsalot's VO: DgG1HbHopsalotTalkLongIntro01.wav
> c) Go to Gameplay
> B. Short Intro (played on any return visits)
> Follow standards for interruptability
> a) Play Hopsalot giving one of the 3 Short Intros: (Random without repetition)
> - Hopsalot's Body: AniG1HbHopsalot, FX Point{01-03}
> - Hopsalot's Talk: AniG1HbHopsalotTalk, FX ShortIntro{01-03}
> - Hopsalot's VO: DgG1HbHopsalotTalkShortIntro{01-03}.wav
> b) Go to Gameplay
>
> III. Gameplay Interaction
> A. Display
> 1. <u>Hopsalot</u>
> a) Hopsalot's Body: AniG1HbHopsalot, FX Still
> b) Hopsalot's Talk: AniG1HbHopsalotTalk, FX Still
>
> 2. <u>Device to throw Balloons</u>
> a) Device: AniG1HbDevice, FX Still
>
> 3. <u>Falling Balloons</u>
> (note: will appear on screen one after the other, according to order set for current level; those will be the same sprite, replicated at {x} instances; use datadict for coordinates)
> a) Play first Balloon ready on the Device: AniG1HbBalloon, FX Still
>
> 4. <u>Carrot Case</u>
> (note: at the right side of screen = case containing the power-up)
> a) Case standing there: AniG1HbCarrotCase, FX Still
>
> 5. <u>Labels</u>
> (Note: located at the bottom of each section of the bridge, they will display the name of each category; they will appear one by one when Hopsalot gives instruction: see below)
> a) Labels sprites are not visible when entering the module

FIGURE 9.2 (Continued) A few pages from the design document of *JumpStart Advanced First Grade*. Document courtesy of Knowledge Adventure, Inc., and used under license.

the introduction speeches, one for first-time visitors and one for repeat visitors. This is followed by a detailed description of the gameplay, levels, and functionality. The full documentation of this module would also note what objects on the screen are clickable and what happens when the player clicks on them—what the pop-ups will be and what the audio will be, as well as a description of all the buttons on the screen and on the tool bar, and what each of them does. It would also indicate every line of dialogue that Hopsalot would speak, and would include special notes for the programmer and graphic artist.

Because design documents incorporate such a vast amount of detail, they sometimes reach 1,000 pages or more in length. Some companies also produce a "lite" version for a quicker read.

Not only does the design document help keep things on track during development and production, but it is also the point of origin for many other important documents. For example, the programming department will use the design document for creating its own technical design document and the test team will use it to prepare a list of all the systems to be tested. The design document also helps the marketing group put together promotional materials and prepare for the product launch. If an instructor's guide or novelization is to be written for the project, the design document will come into play for those endeavors as well.

The Dialogue Script

In some companies, as we've seen, the dialogue script is incorporated into the design document, but quite often these scripts are stand-alone documents. The dialogue script sets down all the lines that the NPCs will speak during the interactive program. These scripts often describe the visuals and the actions that accompany the dialogue, as well. Dialogue may either be spoken by characters on the screen (animated figures or actual actors shot in video), or spoken voice-over by characters who are not visible. Their voices may be heard via a telephone, a radio, or some other device, or the dialogue may be delivered by an off-screen character who is offering help and support. In cases when only voice-over actors will be used, and no live characters appear on screen, a separate voice-over dialogue script will be prepared that contains nothing but lines of dialogue.

Formats for interactive scripts vary widely, and no single industry standard exists at this time, although people are gravitating towards Twine, a tool for writing nonlinear interactive stories. Companies will use a format that works best for the types of projects they develop, and many customize their own formats.

One fairly common script style resembles the format for feature film screenplays, except that it incorporates instructions for the interactive elements. This format works particularly well in

story-rich projects and games in which the level of interactivity is not too complex. In such scripts, the dialogue is centered in the middle of the page, with the descriptive material extending out further to the left and right margins. When using such a format, it is important to clearly indicate all the dialogue choices being offered to the user, and the responses the other character gives to each one of them. For an example, see Figure 9.3, *Dick and Jane*, a sample script I wrote for the purpose of illustration. The script incorporates an if/then branching structure.

Some companies prefer to use a multi-column format. This formatting style roughly resembles the traditional audio/video two-column format used in the making of documentaries and other types of linear programs, where one column is used for visuals (the video) and the other is for voice and sound (the audio). Interactive scripts, however, may use several more columns. At Training Systems Design, the company uses anywhere from three to five columns. The number of columns varies from script to script and even from module to module. The number of columns used depends on the needs of the programming and graphics groups. Their scripts also contain artwork indicating what will appear on the learner's screen. The company calls this type of formatting "scripts and screens."

One example of a five-column scripts-and-screens format is the company's script for the *Save Your Co-Worker* game, part of the *Code Alert* training program discussed in Chapter 10 (see Figure 9.4). The script for the game was written by Dr. Robert Steinmetz. The artwork depicts the setting for this portion of the game, an office cubicle, and also shows the bar that keeps track of the learner's score, as well as an icon the learner can click on to receive help (upper left). Column one, labeled Spot, indicates the hot spots on the screen—objects the learner can click on to get some sort of response from the program. Column two, Programming Instructions, gives notes to the programmers, explaining what needs to happen when the user clicks on a specific hot spot. Column 3, Value, shows how the learner's choice will affect his or her score. Column 4, Audio Label, gives the code for the audio that will be heard in Column 5. Column 5, Sound Effect/Voice-Over, describes the audio effects that will be heard and the voice-over dialogue that the narrator will speak.

DICK AND JANE
(Sample script using if/then technique)

JANE, the player character, leaves her house to go for a walk. She is a pretty young woman in her early 20s.

She can 1.) go straight; 2.) turn to the left or 3.) turn to the right.

1.) Straight path:
If she goes straight, **then** she must cross a busy street and dodge heavy traffic.

> [The script would continue to follow her actions from this point on]

2.) Left path:
If she turns to the left, **then** she will pass a pretty flower garden.

> **If** she stops to pick a flower in the flower garden, **then** a bee will sting her.

> [The script would continue to follow her actions from this point on]

3.) Right path:
If she turns to the right, **then** she will come to the house of her handsome neighbor, DICK. Dick is trimming a hedge. Jane can either ignore him or wave at him.

> **If** Jane ignores him and walks on, **then** Dick will continue to trim the hedge.

> [The script would continue to follow her actions from this point on]

> **If** Jane waves at Dick, **then** he will speak to her.

 DICK
 (awkwardly, very shy)
 Oh, hi, Jane. Nice to see you.
 (beat)
 ... Uh, any chance you'd be interested
 in going on a long walk with me on the
 beach tonight? It's a full moon, and...

User can pick one of three responses for Jane to give:

Response A:
 JANE
 (clearly not interested)
 Oh, sorry, I can't. There's this great sale at
 the mall tonight... half off designer pumps.
 Fabulous! Thanks, though.

If A is selected, then go to A1.

Response B:
 JANE
 (with genuine enthusiasm)
 Gee, Dick, I'd love to!

If B is selected, then go to B1.

FIGURE 9.3 *Dick and Jane*, a sample dialogue script, uses a modified screenplay format. This script was written for instructional purposes, and thus each if/then has been emphasized. Script courtesy of Carolyn Handler Miller.

(Continued)

> **Response C:**
>
> > JANE
> > No way! For heaven's sake, Dick, has anyone ever told you you sound like a total cliché?
>
> If C, then go to C1.
>
> **A1:**
>
> > DICK
> > (sagging with humiliation)
> > Uh, OK. Guess I can take the hint.
>
> **B1:**
>
> > DICK
> > Great! How 'bout I swing by your place about 7:30?
>
> **C1:**
>
> > DICK
> > Well, Jane, has anyone ever told you you sound like a total [bleep]?!

FIGURE 9.3 (Continued) *Dick and Jane*, a sample dialogue script, uses a modified screenplay format. This script was written for instructional purposes, and thus each if/then has been emphasized. Script courtesy of Carolyn Handler Miller.

The multi-column style of formatting is extremely precise and works particularly well for educational, informational, and training programs. However, it is cumbersome to use for projects that involve a number of dialogue exchanges.

Yet another scripting option is to use a spreadsheet. Spreadsheets are most popular when characters have numerous lines to say, and when there are multiple variations of the same speech, such as five different ways for a character to say "Yes! You're right!"

In some cases, a company will create its own in-house software program for script formatting, as Training Systems Design has done.

Flowcharts

Flowcharts are a visual expression of the narrative line of the program, and illustrate decision points, branches, and other

Guidelines: Creating a New Project

Spot	Programming Instructions	Value (if selected)	Audio label	Sound effect / voice over
1 Printer	If selected, add value to score bar, play good beep and play audio VO 5.1.2-1A	1	5.1.2-1 A	(Good Beep) it all depends on frequency of use. But, based on where she has her mouse, we can assume this person is right handed, therefore it might be better to swap the phone position and the printer. However, sometimes it is good to move things around to avoid repetitive motion syndrome.
2: Phone	If selected, add value to score bar, play good beep and play audio VO 5.1.2-1A	1		
3: Monitor	If selected, add value to score bar, play good beep and play audio VO 5.1.2-1B	3	5.1.2-1B	(Good Beep) Right! She really should orient herself so that her eyes are level with the monitor and her neck is in a neutral position.

FIGURE 9.4 A five-column script for the *Save Your Co-Worker* game, written by Dr. Robert Steinmetz for the *Code Alert* training program. Document courtesy of Training Systems Design.

(Continued)

Spot	Programming Instructions	Value (if selected)	Audio label	Sound effect / voice over
4: Head position	If selected, add value to score bar, play good beep and play audio VO 5.1.2-1B	3		
5: Keyboard	If selected, add value to score bar, play bad beep and play audio VO 5.1.2-1C	1	5.1.2-1C	(no beep)The problem isn't really with keyboard… though you could consider it part of a larger overall work habit problem.
6: Mouse	If selected, add value to score bar, play bad beep and play audio VO 5.1.0-3	0		
7 Lifting position	If selected, add value to score bar, play bad beep and play audio VO 5.1.2-1D	0	5.1.2-1D	(Bad Beep) Nope, he is lifting with his legs, and he is tucking the load in toward his torso.

FIGURE 9.4 (Continued) A five-column script for the *Save Your Co-Worker* game, written by Dr. Robert Steinmetz for the *Code Alert* training program. Document courtesy of Training Systems Design.

interactive possibilities. Flowcharting often begins early in the development process as a way to sketch out how portions of the program will work. As the project evolves, flowcharts serve as a valuable communications device for various members of the team, for everyone from writers to programmers. They are also useful for explaining the project to people not directly on the team, such as marketing specialists or clients. As a visual method of illustrating how the program works, they can be much easier to grasp than a densely detailed design document.

Flowcharts vary a great deal in style and appearance. The least adorned ones, such as the one designed by Terry Borst to illustrate the interactivity for a short script called *Pop Quiz*, are composed of lines and geometric shapes like a simple diagram (see Figure 9.5). More detailed, higher-level flowcharts may also be made for programming, with each element coded to reflect specific functions or types of content.

More elaborate flowcharts may include detailed visuals of the screens and short explanations of functionality, such as the flowcharts produced for *Code Alert* (see Figure 9.6). Flowcharts like

Guidelines: Creating a New Project 261

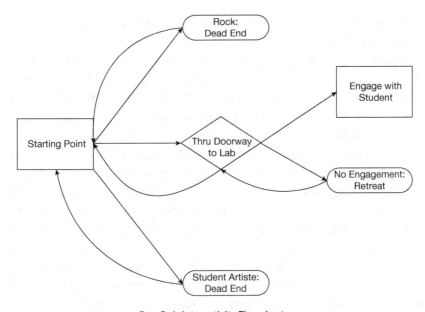

Pop Quiz Interactivity Flowchart

FIGURE 9.5 An unadorned flowchart designed by Terry Borst to illustrate the interactivity of *Pop Quiz*. Image courtesy of Terry Borst.

FIGURE 9.6 The macro-level flowchart for *Code Alert* uses concept art and short explanations to describe how the program works. Document courtesy of Training Systems Design.

these are particularly useful for explaining the program to the client or to potential investors.

According to Dr. Steinmetz, the company uses two levels of flowcharts. A macro-level flowchart, like the one pictured here, gives an overview of the training program and is the type of flowchart that would most likely be used in a company proposal. Such flowcharts are made once the major instructional objectives have been identified. A more detailed flowchart, made later in the development period, would indicate all the branching. It would be produced once the specific teaching points had been identified and would be cross-referenced to the document that laid out the teaching points.

Concept mapping is similar to the making of flow charts, in that they visualize abstract ideas and illustrate how they connect. Two articles on concept mapping offer some useful guidance. One is "Best Tools and Practices for Concept Mapping": https://ltlatnd.wordpress.com/2011/05/10/best-tools-and-practices-for-concept-mapping/. The other is "Visual Mapping Best Practices for Use" at http://ctl.gatech.edu/node/582113.

Concept Art

Concept art, also called concept drawings or concept sketches, is a visual rendering of some aspect of the program. Such artwork is often used to depict characters and locations. The images may be used as trial balloons and shown to team members or focus groups to test possible character designs or settings. They will then be refined until a consensus is reached, and the team agrees on a final version.

When members of the art department are working on a character design, they might make a series of poses for each character. For example, at Her Interactive, for the *Nancy Drew* games, each character is given a set of eight different poses that reflect the character's personality and emotional state. The clothing the character is wearing can serve as a useful way to reveal character, too. For instance, a depressed young woman may be wrapped in layers of dark clothing, while a cocky outlaw may be garbed in a well-pressed suit, have his thumbs stuck in his suspenders, and be wearing a jaunty fedora hat.

Storyboards

Storyboards are graphical illustrations of the flow of action and other elements of the content, and are displayed sequentially. They are somewhat similar to illustrated flowcharts. In the feature film world, movie directors typically storyboard every scene before filming begins. Storyboarding is often used in interactive media in much the same way. At some companies, it is used primarily for linear sequences, though other companies use them to work out interactive elements as well.

Storyboards resemble comic book art in that each frame advances the story (see Figure 9.1). Each frame will indicate the location of the objects within the scene, the placement of the character or characters, the position of the camera, and the direction of the movement within the scene. Because storyboards are so visual, they are simple to comprehend. They are a useful preproduction tool for many kinds of interactive projects, including Web series, apps, immersive environments, and interactive movies—in short, for any interactive endeavor that contains rich visual sequences.

Prototype

As noted earlier in this chapter, a prototype is a working model of a small portion of the program. It is the ultimate way of testing a concept. Many people within the interactive community consider it a more useful method of trying out the concept's viability than flowcharting or storyboarding because it gives a more accurate indication of the look, feel, and functionality of the program. It's a chance to find out how the navigation works and to actually interact with the material. Prototyping is not necessarily done only at the end of the preproduction process. Small prototypes might also be built along the way to test out specific features. Also, it should be noted that prototyping is not necessarily done for every interactive project. For example, if the company has already made many similar products and if this is just another product in an already-established line, prototyping may not be called for.

Specialized Documents and Artwork

Many other types of documents can be generated during the development process as well, although they do not specifically focus on the creative aspects of the project. These would include a technical document containing the technical specifications; a budget; a schedule; a marketing plan; and a test plan. In addition to the fairly ubiquitous types of documents, visuals, and models already described, many companies work with customized tools that are particularly helpful for the type of project they are creating.

For example, at Her Interactive, they use several kinds of special documents when they make the *Nancy Drew* mystery-adventure games. One is the "critical story path document," which lists the events that must occur, the discoveries that the player must make, and the obstacles that must be overcome in order to successfully reach the end point in the game. This critical path document is extremely succinct, about a page and a half of bullet points. Another document they produce is the "environmental synergy document," which is organized around specific environments (locations) in the game. For instance, for an interior of a room, it would note how the furniture is arranged, how the room is decorated, what "plot critical" objects it contains, what other less essential clues can be found here, and information about any characters who will be found in this room. It also notes what puzzles need to be solved within this environment. In addition to these two documents, the company also creates a highly detailed puzzle document, which lists all the game's puzzles and specifies how they work. All these documents are cross-referenced and collected together as a project bible, so that if a team member needs more information on any aspect of the game, it will be easy to find.

When a project contains a great many variables in terms of characters or types of actions, some companies create matrixes to keep track of them. A *matrix* looks much like a table, with horizontal rows and vertical columns. For instance, when I worked on the *Carmen Sandiego* series and was writing dialogue clues to help identify various suspects, I was given a matrix to use. It organized the variable characteristics of the suspects by categories, such as

hair color, eye color, favorite hobbies, favorite sport, and favorite foods, and then listed all the possibilities for each category. I was to write four lines of dialogue clues for each variable.

Within the world of smart toys, inventors and designers create something they call a skeleton logic chart or logic flow document. This tool illustrates how the toy and the child will interact with each other, and shows the direction of the narrative line. And for projects that are designed to train or teach, a document is often prepared that lists the main teaching points or training goals.

Conclusion

As we have seen here, during a well-utilized preproduction period, a concept for an interactive work moves from an extremely rudimentary premise to a well-thought-out project that is detailed enough in every regard to be moved into production. This outcome is only obtainable, however, when teams go through the steps described here, or through similar ones that might be more appropriate to their particular project.

Unfortunately, teams are sometimes tempted to jump into production before they've worked out important details, thinking they can do the detail work as they move along. But moving into production prematurely can be a costly mistake.

The preproduction process, when undertaken with care, generates a number of highly useful documents, but it also involves an even more important task: conceptualizing. The creative team needs to work out exactly what the project is, whom it is for, and how people will interact with it. Above all, what about the project will make people eager to spend their time engaged with it? Finding satisfactory answers to questions like these can go a long way toward helping you create a viable project with genuine appeal.

Idea-Generating Exercises

1. Pick a work of digital storytelling that you have just begun to work on or that you are interested in doing. The work can be in any medium or for any type of platform. Take this project through the 10-step development process to determine if any aspect of the project needs more thought or needs to be strengthened before moving more deeply into development.
2. Using the same project from number 1 as your model, determine what types of specialized tasks would need to be done during the preproduction process.
3. Again, using the same project for your model, determine what kinds of documents you would need to generate in order to effectively take this project through the preproduction stage. What would each type of document contain?
4. Using the same project for your model, consider your marketing specialist. What information do you think this person could give you and the rest of the team that would be helpful? And what documents do you think your team could give to the marketing specialist that would be useful in terms of launching the product?

Part 3

Harnessing Digital Storytelling for Pragmatic Goals

Part 3

Harnessing Digital Storytelling for Pragmatic Goals

Chapter 10
Using Digital Storytelling to Teach, Promote, and Inform

In what ways can projects designed to teach or train benefit by an interactive storytelling approach?

Why are organizations as different from each other as the United Nations, a chain of ice-cream shops, the United States Department of Defense, and a group of Christian fundamentalists all turning to digital storytelling to help them fulfill their objectives?

What is a "serious game," and isn't this a contradiction in terms?

How can digital storytelling techniques be applied to a serious business endeavor like promoting a product?

In terms of digital storytelling and promotion, what could the US Army and a story about a pig possibly have in common?

In what ways are such disparate forms of digital media like virtual reality, electronic kiosks, and interactive cinema being used in the dissemination of informational content?

How and why are traditional media outlets like newspapers, news magazines, and television networks turning to interactive media as an adjunct to their news services?

How are digital storytelling techniques being applied to informational content?

"A Spoonful of Sugar"

Many tasks in life are important, but not necessarily appealing. Of such activities, Mary Poppins had some excellent advice, declaring that "a spoonful of sugar helps the medicine go down." What's true of swallowing medicine is also true of other tasks in life that are usually regarded as uninviting—such as doing schoolwork or going through workplace training. The spoonful of sugar approach can also be applied to pragmatic tasks like promoting and informing. When digital media are used for such purposes, that spoonful of sugar is an infusion of entertainment content and interactivity. This sweet combination helps to make these real-world endeavors far more appealing than they ordinarily would be.

When it comes to education, the idea of integrating entertainment and learning is not new. Our grandparents, and probably our great-grandparents, too, learned to read from schoolbooks that looked just like attractive children's storybooks. They played with educational toys like building blocks and magnets, and took part in costume dramas where they reenacted important moments in history. It's also not a new concept to use the latest technology to teach. Both film and video, for example, were quickly put to use in the classroom and for teaching purposes as soon as it became possible to do so.

What is entirely new, however, is the use of digital technology as a vehicle to teach, train, promote, and inform. The "sugar" in this approach, as we've noted, is made up of both entertainment and interactivity. By incorporating entertainment into a work designed for pragmatic purposes, we create something that attracts and engrosses the user. The experience of absorbing the material is perceived as pleasurable, and users are more willing to spend time engaged with it instead of trying to dodge it.

Educational content is often presented in the form of games and educational software is made both for home use and for the classroom. Edutainment titles were among the biggest success stories of the early 1990s, during the CD-ROM boom. (The term, edutainment, indicates a work that is both educational and entertaining.) Among the biggest hits during this period were the *Carmen Sandiego* series (used to teach geography, history, and astronomy) and the various *Math Blaster* and *Reader Rabbit* titles.

Children's edutainment software continues to be highly popular today. Some of these titles are curriculum-specific, geared for a particular school grade, and cover several core skills that need to be mastered for that grade, such as *JumpStart Advanced First Grade*. Other titles target just one subject, such as science or history.

Works made for promotion, advertising, and information have also been rapid to adapt digital storytelling techniques. On the face of it, it may be difficult to see any similarities between a music video featuring a group of preppy rappers; an alternate reality game about a mysterious crop circle; a gritty video game about military combat; and a reality show where all the contestants are house cats. Yet all four of these projects do have key characteristics in common: they use interactive media and storytelling for advertising and promotional purposes.

Projects just as disparate—an interactive documentary about trains in India; VR projects that put you inside a solitary confinement cell or Queen Nefertari's tomb; and an interactive old stone house—have all been used to convey information. The way informational content is being disseminated is undergoing significant change, thanks to digital media. Digital storytelling techniques can make an otherwise dry or difficult subject come alive and can make material that is otherwise dry engaging to users.

The combination of information and entertainment gives us another genre of "-tainment" programming—*infotainment*—a blending of information and entertainment, much as *edutainment* is a blending of education and entertainment. However, the terms infotainment and edutainment have fallen into disfavor because to some people it connotes a trivialization of important content. Thus, even though these approaches are perfectly valid when handled responsibly, we will refrain from using them in this book because they might be distracting.

Applying Digital Storytelling to Teaching and Training

One reason digital storytelling tools work so well in instructional projects is because they make the content more approachable

and entertaining, while still conveying the important material to be learned. Let's face it: classroom learning can be extremely uncomfortable for many people. In this public environment, surrounded by your peers, you are expected to perform and seem knowledgeable. No one relishes making a mistake in such a setting. But interactive education, especially when it is entertaining, is not only private but is also perceived as nonthreatening and nonjudgmental. Thus, learners don't feel the need to put up their defenses. They are more receptive to the educational objectives. And an entertaining environment is not perceived as intimidating, as classroom instruction often is.

In many cases, projects that blend entertainment with teaching or training employ a gamelike format, though they may employ other digital storytelling techniques as well. Some rely on compelling storylines and dramatic narrative. Others use appealing characters to put a human face on the material. Still other projects employ humor as their primary form of appeal. And some projects use a Chinese-menu approach, employing a variety of storytelling techniques.

Interactivity is the other powerful component in the "spoonful of sugar." Interactive content engages multiple senses and offers multiple ways of acquiring information and new skills. Instead of just obtaining information from a textbook or a classroom lecture, for example, learners may take part in interactive simulations where they are called upon to observe their surroundings, converse with characters, manipulate objects, search for clues, and analyze data. This type of educational experience requires them to be fully alert and active, and the wealth and variety of stimuli make for a deeply engaged learner.

Moreover, interactive learning is highly flexible: the same program can usually accommodate different levels of learners and different learning styles. Many interactive titles offer several levels of difficulty and various kinds of learning activities, making it more likely that users will be challenged—but not beyond their ability—and will find material that matches their preferred personal style of acquiring new knowledge. Unlike traditional classroom learning, the students can proceed at their own pace. They are not held captive by the teacher's need to get through certain

curriculum points by a certain time. They are also not held back by other students who may be slower at catching on than they are. Nor are they in danger of finding themselves lost if the rest of the students are ready to move on while they are still struggling to understand a key point in the lesson. They can repeat a section of the program, drop down a level, or access a help function or tutorial for extra guidance. However, there is one potential pitfall with many online courses, especially the ones with a massive group of students: there is no teacher available to answer questions or offer feedback.

Overall, these programs accommodate struggling learners as well as ones who learn more readily. And they can be enormously empowering to students of all abilities. As learners work their way through an interactive program, they gain a satisfying feeling of mastery and accomplishment.

Digital Media and Young Learners

As noted earlier, interactive educational software for young learners often goes by the term *edutainment*. Although the term may be jarring to the ear, it effectively expresses its intent: to blend educational content with entertainment in a way that makes the material appealing to the intended learners. This technique, it should be noted, is not exclusive to interactive media. Television series like *Sesame Street* also use an edutainment approach to content.

Educational mobile apps are extremely popular both with parents and with their children. They include the apps made by Brainpop (http://www.brainpop.com/) and Agnitus (http:// www.agnitus.com/).

Even ISIS has gotten into the act, making an educational app for young learners. Their title, *Huroof* (Arabic for letters or alphabet) teaches young learners the letters of the Arabic alphabet and vocabulary words. Not surprisingly, the title's vocabulary focuses heavily on military terms, such as tank, cannon, bullet, and rocket. And African educators, not to be left behind in adapting software for teaching purposes, are using it to help students learn African languages. At Genii Games, they make language-learning apps in the Yoruba language, spoken by 30 million people in Nigeria

and elsewhere. One of the company's games, *Igbo 101* (Igbo is another African language), takes young learners on an adventure quest. According to Adebayo Adegbembo, the company's founder, using apps to teach languages makes the learning process "fun, appealing, and engaging" (as reported in Global Voices, February 1, 2017).

> **STRANGE BUT TRUE: NOT FOR BABIES!**
>
> Babies are well known for being gifted at learning languages, but it turns out that their success greatly depends on how they are being taught. In an experiment done by Patricia Kuhl of the Institute for Brain and Learning Science at the University of Washington, babies were taught Mandarin sounds in one of three ways: by humans, by audio, or by video. It turns out that the babies who were taught by humans learned to reproduce the sounds quite successfully, but the babies who were taught via audio or via video actually became worse over time. The lesson here? It may be that while older children often thrive on screen-based learning, including video games, these tools are not appropriate for the youngest learners.

Games in the Classroom

A surprisingly large number of elementary school teachers regularly use video games in the classroom. A study conducted in 2012 by the Joan Ganz Center at Sesame Workshop found that video games were "a regular and beneficial part of today's classroom." Fifty percent of the K-8 teachers in the study used video games in their classes at least two days a week, and 18 percent used them daily. The games used included simulations and games played on computers, tablets, game consoles, and mobile devices. The teachers reported that games helped them motivate and engage their students. The most difficult challenge one teacher reported having was convincing the parents that games were an important component of her curriculum, and yes, playing games really was part of their children's homework.

Games at Home and Abroad

Many educational games, not just the JumpStart titles, are made to be played at home, not only in the classroom. For example, a game called *ARcheology – Dig Up History* is an augmented reality archeology game meant to be played in the backyard or in the house. Children can virtually find a dig site and start digging (by tapping on the screen), not knowing what kind of fossil they might discover. Once the item has been dug up, a box appears, scientifically describing what it is that they have found.

Some educational works are even designed to be played in foreign locales. Two apps made for tweens and teens and produced by Time Traveler Tours, LLC do exactly that. *Beware Madame La Guillotine* guides users through the streets of Paris during the French Revolution. The gripping tale is told through the eyes of Charlotte Corday, who murdered Jean-Paul Marat in his bathtub in 1793. In a similar fashion, the app *Buried Alive: The Secret Michelangelo Took to His Grave* is designed to be played in Florence. Narrated by the great artist Michelangelo himself, the tale is centered around the secret charcoal drawings he had made during political turmoil going on in Italy at the time. Both apps can be played anywhere but are designed to make the history of Paris and Florence come alive for young tourists.

> **WORTH NOTING: WHAT KIDS THINK OF EDUCATIONAL TITLES**
>
> To a certain extent, educational titles build on the inborn desire of all children to acquire new skills and information. Producer Diana Pray of Knowledge Adventure, the developers of the *JumpStart* titles, noted this when she said to me: "Younger kids love learning, even when it means lots of repetition. When they accomplish something, you can see the pride and pleasure in their faces. They think it's fun."

"Drill and Kill" Games

Edutainment titles like the *JumpStart* line offer a great deal of repetitive practice, and this genre of game often goes by the name

of "drill and kill." Though not an especially flattering term, it reflects that a certain amount of repetition is necessary in order to master basic skills. Although children obviously learn from these drill and kill games, the companies that make them do not necessarily feel that they "teach," in the true sense of the word. Diana Pray of Knowledge Adventure believes their value lies in offering an interactive supplement to what the children are learning in school. "The products are meant to help kids practice their skills, never to replace the teacher. They are not a substitute to what goes on in the classroom," she said. And the students enjoy these games far more than the more traditional way of practicing skills, which used to call for hours spent with flash cards.

Digital Media and Older Learners

While countless edutainment software titles have been developed for schoolchildren since the early 1990s, it is only recently that serious attention has been paid to using the same approach for older students. Complex subjects like Newtonian physics and microbiology were considered too difficult to teach using digital media and entertainment techniques. However, this reluctance to develop such software for advanced subjects has changed radically in recent years, thanks in large part to work that was initiated at MIT under a program called the *Games-to-Teach Project*.

The two-year program, a collaboration between MIT and Microsoft, was launched in 2001 with the goal of developing conceptual prototypes for a new generation of games based on sound educational principles. It brought together an eclectic mix of specialists from various fields—game designers, teachers, media experts, research scientists, and educational technologists. The 15 game concepts developed under this program tackled difficult subject matter in science, math, engineering, and humanities, and were geared for advanced placement high-school students or lower level college students. By taking advantage of the latest technology and design principles, these games were meant to excite the curiosity and imagination of the students while giving them the opportunity to explore complex systems and concepts.

Many of these projects offered networked gaming environments, and these multiplayer games were designed to deeply engage learners by competing, collaborating, and interacting with their peers, and overcoming challenges in a communal environment. Research suggests that the kind of trial-and-error experimentation and problem-solving that takes place in such environments can promote the retention of newly gained knowledge.

Professor Henry Jenkins, who at the time was director of MIT's Department of Comparative Media Studies, served as principal director of *Games-to-Teach*. Discussing the philosophy behind the project in an article published on the TechTv website, Professor Jenkins made an interesting comment about what games can do. "Games push learners forward, forcing them to stretch in order to respond to problems just on the outer limits of their current mastery," he said.

Games for older learners are offered by a variety of software producers and some are even using VR for instructional purposes. For example, the software studio Nanome produces *CalcFlow*, designed to make the learning of calculus less difficult. It has also developed *NanoOne*, for modeling and visualizing molecules, and *NanoPro*, a tool that does the same with atoms, molecules, and proteins. These titles are designed for real-time, collaborative problem solving. A startup in China, Vivedu, makes educational titles in VR for the fields of engineering, science, technology, and mathematics.

The Role of Educational Games for Older Learners

Like Diana Pray of *JumpStart*, Jenkins believes that the role of educational games for older students is not to replace teachers, but to enhance what they do. Games help make the subject matter come alive for students, he noted in the article; they motivate them to learn. He said he felt educational games could be of particular value in the areas of science and engineering because they offer "rich and compelling problems" and model the scientific process.

The 15 game concepts developed under the MIT program focused on many different educational subjects and used a variety

of digital storytelling techniques. For example, in a game called *Hephaestus*, designed to teach mechanical engineering and physics, players find themselves on a formidable volcanic planet. Here they must work together to build and operate a workforce of specialized robots in order to survive. Another game, *La Jungla de Optica*, was a role-playing adventure game set in the Amazon jungle and designed to teach optical physics. It involved two primary characters, an archeologist and his niece, who must contend with a bunch of criminally minded marauders ... something like a *Tomb Raider* for the physics set.

The *Games-to-Teach* project helped spur the *serious games movement*—a movement which promotes the development of games designed to teach difficult subjects, and which we will be discussing later in this chapter.

Gamification in Education

Recently, a technique called *gamification* has gained a great deal of traction in higher education circles. Gamification is the application of gaming techniques to projects that are not games and not designed for entertainment. In academic circles, this translates into creating an awards system for taking quizzes and handing out badges for completed assignments. Badges are a particularly popular incentive, because they can be displayed on websites, social networking sites, and job sites. However, not everyone is enthusiastic about gamification in education. Henry Jenkins, for one, feels that it greatly waters down the concept of employing video games to motivate students to learn challenging material, as they were doing at MIT under the *Games-to-Teach* project. We will be taking another look at gamification later in this chapter, where we will investigate how it is used for promotional activities.

Games for Organizations

In should be noted that games are not only being used to teach students but are also being used by organizations like the US Navy to study complex problems. For example, the Navy developed an

online game featuring pirates in Somali, opening the game to the public in 2011 and seeking potential solutions from players. Unlike commercial video games, however, this game did not possess highly cinematic visuals, but was instead *message based*. In other words, players could send brief messages, somewhat like tweets, suggesting how to handle specific situations. The pirate game was the first in a series of online games focusing on complex problems. Overall, the series is called MMOWGLI, which stands for massively multiplayer online war game leveraging the Internet. Other themes have included climate change in the South Pacific and the potential impact of the first ice-free Arctic summer.

STRANGE BUT TRUE: YOUR DIGITAL DOPPELGANGER

In a massive project called *Sentient World Simulation* (SWS), the stated goal is to create "a synthetic mirror of the real world" (as quoted in the project's concept page and noted in an article in *The Register* written by Mark Board on June 23, 2007). This is a war game on an enormous scale, and it is updated with new data on a regular basis. It is purportedly being used to see how individuals and groups will respond to stressors like a military coup or earthquake or urban warfare. Evidently, corporations are also using it to test new products.

In this game, there are nodes not only for buildings like hospitals and mosques, but also for human beings. In 2007, the game contained five million nodes, with some parts of the game having one node for every 100 human beings. The stated goal, however, has been to include a node for every human being on Earth. Your personal node or digital doppelganger would resemble you in terms of age, occupation, and other details, but would not include your name. Thus far, SWS includes 62 nations, with the Iraq and Afghanistan models being the most highly developed. The project, which is also called SEAS (for Synthetic Environment for Analysis and Simulations), has been under development for many years at Purdue University. The simulation was fairly widely covered by the press in 2006–2007, but in recent years, very little has been reported about it, so it has not been possible to determine whether or not we are now all represented by our digital doppelganger.

Online Courses

One relatively new development in recent years is the growth of Massive Open Online Courses (MOOCs). These are free courses that are available to thousands of students at a time and are often taught by professors at elite universities. The first MOOC was offered in 2008 by the University of Manitoba. Called Connectivism and Connective Knowledge, its students included 25 from the Canadian university and 2,300 from the general public. In 2011, when Stanford University offered a MOOC on artificial intelligence and enrolled 160,000 students, this type of teaching suddenly became an overnight sensation. A tidal wave of other MOOCs was soon made available. Coursera was founded by two Stanford professors in 2012. As of June 2018, Coursera had 33 million users. Some MOOCs are offered for college credit and are taught by professors from top universities, including Harvard, Cornell, MIT, and the University of California at Berkeley.

MOOCs offer wonderful opportunities to students without the financial resources to attend college, but many students who enroll in a course do not complete it. Cheating on quizzes and exams can also be an issue, so students are sometimes monitored by webcams and their typing patterns. Despite low retention and cheating issues, however, the number of courses offered continues to swell.

Although MOOCs are generally university-level courses, it should be noted that in my home state of New Mexico, and quite possibly elsewhere, online courses are also being offered at the middle- and high-school level. In New Mexico, the New Mexico Virtual Academy is a statewide school that offers classes entirely online for students from the sixth to the twelfth grade. The pupils enrolled there enjoy the flexibility it offers in terms of when they can "attend" class and the freedom to work as quickly or slowly as they choose.

Useful Techniques for Combining Teaching with Digital Storytelling

Educational video games and gamification are just two of the many approaches utilized to create projects in which teaching

goals and entertainment goals are both successfully met. Let's examine some additional techniques that can be employed to help accomplish this.

Determining Where the Educational Content Fits In

The key to a successful edutainment title seems to be in finding the right mix of educational material and entertainment and to blend them seamlessly together. But what guidelines can be used to work out the ratio of fun to education? In other words, how do you balance the two?

Experts in the field unanimously advocate starting with the educational goals, and building the entertainment around them. For example, at Knowledge Adventure, they always begin by setting the educational objectives of a new *JumpStart* game. The creative team starts the process off by soliciting the input of outside experts. Typically, these experts are classroom teachers who teach the grade or subject matter of the title. In some cases, they also use subject-matter experts (SMEs)—specialists in a particular field—particularly when a title focuses on a specific topic. For instance, during the development of *JumpStart Artist*, which dealt with the visual arts and was a game I worked on, they used art experts from the Los Angeles County Museum of Art.

Organizations that make educational software for older learners, including companies that make training software and the US Army, start the development process in the same way—by first defining the pedagogical goals.

Setting the Curriculum

Once the general educational goals are established, a specific curriculum needs to be established—the specific teaching points that the work will cover. Games designed for grades K-12 face a particular challenge in this regard because curriculum standards can vary widely from state to state. The Common Core State Standards, however, are helping to set national guidelines. When it comes to the international front, curriculum variations can present even

more significant obstacles to overcome. For instance, in France they don't teach subtraction until third grade, while in the United States it is taught in first grade.

Educational software designed for older students and for use in the workplace will also need to meet the general standards of the organizations that the project is being designed for. This is usually done by working with subject-matter experts and building a consensus on the curriculum.

Creating a Program Conducive to Active Learning

The great advantage of using digital platforms for teaching is that they are interactive. Interactivity promotes *active learning*, which is also known as *experiential learning*. Both terms mean learning by doing, acting, and experiencing, as opposed to passive forms of learning, such as listening to lectures or reading books. Content designed for digital media should take full advantage of interactivity. Thus, thought must be given to how best to involve the learners. Will your program invite them to role-play? Take part in simulations? Require them to test themselves in quizzes? Have them participate in peer-to-peer learning? Offer them games to play?

Setting Levels of Difficulty

By setting several levels of difficulty within the educational program, its audience can be extended beyond a specific curriculum or narrow age range or specific skill set. Having levels of difficulty also adds to the program's repeatability. If a learner starts at the easiest level, for example, the game will seem fresh again by progressing to the next more difficult level. A game might be built with three levels of difficulty, with the expectation that the student will fit inside one of these levels. The player or instructor can set the level of difficulty, but many games also include an assessment tool that automatically sets the level for the player, and offers up games that have a natural progression in difficulty. With some educational games, parents and teachers can also receive an assessment report on the child's progress and weaknesses.

Having various levels of difficulty works equally well for children, older learners, and for training programs meant for the workplace.

Establishing a Compelling Premise and End-Goal

As we have discussed throughout this book, when users are immersed in a nonlinear work, it is extremely helpful to give them a strong incentive so that they will work their way through to the end. This is where effective techniques of digital storytelling come into play. Enticements on the macro level are usually in the form of a dramatic premise and a highly attractive end-goal.

For example, in *Mia: Just in Time*, a game that focuses on math skills, the story begins with a disastrous fire that burns down the quaint Victorian cottage where Mia the mouse lives. But, we soon learn, this calamity can be reversed! For this to happen, Mia must assemble and operate an old time machine, but four essential parts are missing. Mia needs the player to help her find these parts, a quest that requires the solving of many math problems (see Figure 10.1). Thus, the entertaining aspects and educational aspects of the game are tightly bound together, and neither dominates.

FIGURE 10.1 In this screen capture from *Mia: Just in Time*, Mia points to the time machine, which two characters are trying to steal from her. The time machine is critical to helping Mia restore the family home. Image courtesy of Kutoka Interactive.

Not all edutainment titles have as strong a storyline as *Mia: Just in Time*, but they almost invariably contain a compelling goal to strive for to keep users playing all the way through to the end. Dramatic premises and compelling end-goals are equally effective in works for older learners. Of course, they need to be appropriate for the sophistication level and tastes of the target audience.

Creating a Rewards System

Rewards are tremendously powerful motivators. They encourage learners through the hard parts and keep them involved for the duration of the program. Adults enjoy winning rewards just as much as children do, though the types of rewards doled out to older people will, of course, be different. There is even a school of thought, advocated by Paul Howard-Jones, a neuroscientist at Bristol University, that the chance of a reward (rather than a guaranteed reward) can increase the production of dopamine and this helps to keep a player engaged in the game.

Rewards come in many different forms, including:

- Being praised by an NPC
- Receiving a good score
- Winning some kind of prize
- Obtaining a coveted item
- Moving up a level
- Being promoted in rank or power within the fictional world of the project
- Making some type of significant advance within the game or story context
- Achieving a successful outcome in a simulation

Rewards can also be in the form of intangible benefits like a boost in self-confidence or the satisfaction that comes with mastering something difficult.

When a learner succeeds at a task, it is common for a graphic (such as a score or a status bar) on the screen to note this and to show the learner's progress in the game. Rewards, however, are not necessarily seen or heard. Often, they work as invisible passes, granting the user the ability to advance in the program.

In the majority of rewards systems, there are also consequences: penalties for a wrong answer, a bad choice or a mistake. Penalties range from the loss of a previous award, a bad score, or even a virtual death.

> **NOTES FROM THE FIELD: BUILDING IN REWARDS**
>
> In children's educational games, rewards are especially important in holding the players' attention. "With rewards, the kids want to play longer," Diana Pray of Knowledge Adventure explained to me. Along with major rewards, many titles also offer smaller rewards each time the child successfully completes an exercise within the game. These rewards are the equivalent of a friendly pat on the back. Sometimes it will be in the form of a snatch of triumphant music or a brief piece of reward animation; sometimes a character, usually off-screen, will congratulate the learner with a "Bravo; well done!"
>
> Rewards should always be in keeping with the storyline and setting of the work; in effective educational titles, they work hand-in-hand. The incentives are embedded in the story; the story motivates the learners to stay involved and earn the rewards. Rewards can be handed out whenever the learner successfully completes a task, solves a puzzle, or works all the way through a quiz. Programs for young learners tend to be generously sprinkled with rewards, while those made for adults normally use them more sparingly, but they are strategically placed to give them maximum punch.

Using Simulations

Simulations are a particularly powerful tool for teaching, though they are most often used for older students and adults. Simulations are unfolding stories that immerse the user in a realistic and engaging scenario. They are experienced from a first-person point of view, and the user's choices determine the outcome. Thus, they promote experiential learning—learning by experiencing and doing, as opposed to passive forms of learning. They can be used for a wide variety of learning situations, from teaching ancient

history to training workers in how to serve ice-cream cones, and are frequently employed in teaching interpersonal skills.

In a simulation called *Beyond the Front*, US soldiers are immersed in the personal pressures faced by a soldier, driving him to the edge of suicide. Players can help steer him toward recovery or, if they make unsuccessful choices, the fictional soldier will actually shoot himself in the head. The simulation was produced by the army in response to the high suicide rate among soldiers.

A quite different simulation, this one set in a virtual nuclear facility at Los Alamos National Laboratory, has players take on the role of UN nuclear facilities inspectors and inspect every inch of the lab. The project is called *Virtual Simulation Baseline Experience*, and while in the virtual lab, they can even open file drawers and pick up pieces of equipment. The project is extremely realistic from a scientific point of view. For example, gamma rays will behave like gamma rays. The goal of the simulation is to familiarize players with the tasks they will need to perform when they inspect real nuclear facilities.

Using Peer-To-Peer Learning

Peer-to-peer learning is another technique often used in teaching older students. In such a learning environment, students help each other solve problems and work together to carry out tasks. Scholars of educational games have found that such peer-to-peer learning reinforces mastery. The *Hephaestus* game developed at MIT, described earlier, is, an excellent example of how peer-to-peer learning can be designed into an educational game. In this game, survival on a volcanic plant depends on students working together to build sophisticated robots.

Additional Digital Tools for Education and Training

Thus far, we have concentrated on video games, simulations, and online courses as digital tools that can be employed for education and training. But these are only three of the many tools available

for various forms of teaching. Other digital tools include mobile apps, augmented reality, virtual reality, fulldome immersive experiences, transmedia storytelling, and alternate reality games.

Transmedia Storytelling and Alternate Reality Games

Cosmic Voyager Enterprises, a transmedia storytelling project for students aged 12 to 17, unfolded over a three-week period and was played by 600 students all over Florida. It employed an ambitious multi-platform approach to teach financial responsibility, economics, and ethics. The story revolved around a rocket headed for the International Space Station that instead crashes into the small (fictional) town of Millisville, Florida. The center of the town is largely destroyed and at least one business, a local restaurant, is pulverized. Dangerous toxins might have been released during the crash, as well. Students play executives in the fictional company that sent the rocket into space, and must come up with a fair and ethical way of dealing with an extremely complex situation. How best can the town and its victims be recompensed for the disaster without bankrupting the company? Pieces of the story are told by extremely realistic looking faux news broadcasts (see Figure 10.2), websites, Twitter and Facebook posts, YouTube videos, blogs, and emails. Students become active participants in the story, making

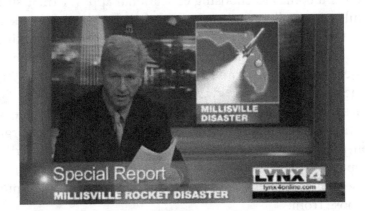

FIGURE 10.2 Screen capture of a faux news broadcast for *Cosmic Voyager Enterprises.* **Image courtesy of Doubletake Studios, Inc.**

the project an experiential learning tool. It was so realistic that at least one student initially believed the rocket disaster had actually occurred. It was produced by Doubletake Studios, Inc., in Tampa, Florida and Transmedia Storyteller Ltd. played a key role in facilitating and coordinating the various components of the project. A video explaining how digital storytelling was used in the project can be seen at https://www.conducttr.com/success-stories/cosmic-voyage-enterprises/.

Another work of transmedia storytelling, this one designed as an alternate reality game (ARG), was used in the UK to teach genetics and educate students about the human genome. The eight-week project was called *Routes*, and its components included a murder mystery, documentary segments, Flash games, mobile elements, and live theatrical events. Players could amass points by engaging in the ARG and playing the games, and high scorers could win valuable prizes.

Mobile Phones, Tablet Computers, and Apps

Mobile phones, tablet computers, and apps are increasingly being used in the classroom, or at home to complete assignments. It's interesting to note that English teachers use these digital tools more than math teachers do, finding them especially helpful in teaching language arts.

When it comes to choosing educational apps for their students or children, teachers and parents are faced with what can seem to be far too many candidates. As of 2018, there were approximately 4.1 million apps on the market. The numbers have been growing steadily every year, and the average person has 60 to 90 apps on their phone (from www.statista.com). Approximately 80,000 of these are educational apps (as of 2015, the last year for which statistics were available, from http://www.newamerica.org/education-policy/edcentral/new-framework-identify-truly-educational-apps/). Not all apps offer high-quality educational content, of course, but regardless, teachers and parents have a great number to choose from.

Immersive Experiences

Various forms of immersive experiences (experiences that put the user virtually inside the story) are being used for education and training. The US armed forces, for example, are using full-dome structures (bowl-shaped structures that project images on all sides) for training exercises. Some of these domes are even inflatable and can be set up in two hours by two people and a screwdriver.

In a project called *Virtual Army Experience* or *VAE*, the US Army is now using virtual reality to give civilians a taste of combat. Participants are seated in a Humvee and are given facsimiles of machine guns and other weapons (but no live ammunition) and are thrust into a realistic combat scenario. After the mission is complete, an after-action review is given, in which scenes from their mission are critiqued. The goal of *VAE* is to interest civilians in joining the military, much like *America's Army*, the game that it was spun off from. (*America's Army* will be discussed later in this chapter). To see a video of *Virtual Army Experience*, see http://www.youtube.com/watch?v=8rAEtv7UtX0.

Other Digital Storytelling Techniques

A number of other digital storytelling techniques are used effectively in interactive educational titles. For example, most titles for young children contain generous amounts of humor because they enjoy it so much. Attractive settings are also an important draw for this group—favorite places like the beach, a zoo, or an amusement park, or fantasy settings like outer space or an underground "alternate" universe. Fantasy settings can also be attractive to older audiences, though titles designed for training are usually set in realistic contemporary workplaces.

Well-developed characters are an important element in all works meant to be both educational and entertaining, no matter what the target age group is. And, as always, a solidly designed structure, appropriate for the project's pedagogical goals, is a critical asset.

The Growth of the Serious Games Movement

As noted earlier in this chapter, serious games are games designed to teach difficult subjects, either to advanced students or to learners outside of academic settings. In addition, serious games are used to help medical and psychiatric patients. Because serious games are meant to be entertaining as well as vehicles for teaching and assisting people with special needs, they make intensive use of digital storytelling techniques.

The interest in serious games was sparked around 1996, when the US Army began to work with Hollywood professionals and the games community to develop games and simulations for military training. Serious games went mainstream in 2004, when the first Serious Games Summit was held at the Game Developers Conference.

Serious games cover a great variety of topics and are built for many different kinds of users. In fact, there is no one generally agreed upon definition of what constitutes a serious game. Most people involved in the field, however, would agree that serious games include:

- High-level academic games
- Corporate training games
- Simulations used to train military personnel
- Training for emergency workers and "first responders," such as police officers, medical personnel, and firefighters
- Social impact games (games designed to have a social impact and raise public consciousness of important issues, such as famine and international conflicts)
- News games (games designed to shed light on topics currently in the headlines)
- Games meant to be therapeutic, for individuals with physical, emotional, and spiritual issues

Some people in the field would also include games designed to promote products in the broad category of serious games.

Many games already mentioned in this chapter would be considered serious games, such as *Beyond the Front, Sentient World Simulation, Cosmic Voyage Enterprises,* and *Virtual Army*

Experience. But as we will see, serious games include a number of other endeavors as well.

A Cross-Section of Serious Games

Serious games, as we've noted, cover a vast spectrum of projects. Let's take a brief look at several of them, to get an idea of the diverse subjects they tackle and the range of approaches they use.

- Stone Cold Creamery, a chain of ice-cream shops, created a fast-paced online training game for its employees. A simulation, the game is set in a virtual ice-cream store, and players strive to dish up ice-cream, and in the correct amounts, before time runs out.
- *Glorious Mission* is an online military first-person shooter developed in China to counteract the influence of Western video games and also possibly to make a more popular game than the failed *Chinese Hero Registry*, described in Chapter 7. The game, which uses high-quality graphics to promote patriotism and the core values of the People's Liberation Army, is thought to be modeled on *America's Army*. Unfortunately, though, the enemies the player is fighting are US soldiers.
- *iCivics* is a series of games to teach middle-schoolers about civics and how the US government works. No less a luminary than former Chief Justice Sandra Day O'Connor has been involved with its development. The game is being used throughout the United States, in approximately 55,000 classrooms.
- *Food Import Folly* centers around the risks of importing food and the shortcomings of government food inspectors.
- *Earthquake in Zipland* is a children's adventure game that helps youngsters cope with the emotional trauma of their parents' divorce or separation. Designed for ages 7 to 13, it is set in a colorful fantasy environment. The lead character, Moose, lives on an idyllic island, but an earthquake (symbolizing a divorce) tears apart this once happy place. The player must help Moose try to put things to right again.

- *Re-Mission* (http://www.re-mission.net/), mentioned in Chapter 7, is a third-person shooting game for young cancer patients. The original game has now been updated to *Re-Mission 2*, and is now joined by six new games, all with the same goal: to give the patients a sense of control over their cancer, help them adhere to treatment programs, and improve the quality of their lives. The games are set inside the human body and use real-world techniques to blast away at malignant cells. The games are distributed at no charge through the game's website.
- *Aftershock* was a three-week alternate reality game dealing with the aftermath of a major earthquake in Southern California. Players are sent on real-world missions and tested on their earthquake preparedness skills. The game was run by the Institute for the Future and Art Center College of Design.
- *SnowWorld* is a virtual reality game to help burn victims deal with their discomfort while undergoing extremely painful treatment for their wounds. Set in a beautiful icy world, they are diverted from the grim reality of their hospital room by engaging in snowball fights with snowmen and penguins.

Other serious games can be found at http://www.persua-sivegames.com/, the website of Ian Bogost's company, which specializes in serious games. The website of his company, Persuasive Games (http://www.persuasivegames.com/) contains a portfolio of serious games dealing with such topics as airport security, pandemic flus, and the politics of nutrition.

Developing Serious Games for the Military

As we have already noted, the US Army was one of the first organizations to recognize the value of using gaming techniques and digital technology for training purposes. The Army and other military organizations continue to be leaders in the development

of serious games. Not only does the military have an ongoing need for training, but games are also safer and less expensive than live exercises. Furthermore, games are highly portable and deployable. In addition, using gaming techniques for training builds on the recognized popularity of video games, especially with the young people who comprise such a large percentage of the armed forces.

Dr. Elaine M. Raybourn, one of the leading experts in this field, talked with me several years ago about creating games for military training. She said she has found that serious games are well-suited for experiential learning and can help the trainees master critical skills in decision-making and communication. Dr. Raybourn designs, writes, and produces games for the Sandia National Laboratories in New Mexico, a multi-program laboratory under the US Department of Energy that develops technologies to support national security. The games Dr. Raybourn develops focus on interpersonal skills rather than on procedural training (such as how to load a gun or toss a grenade). They are used to train individuals in leadership, cultural awareness, problem-solving, flexible thinking, and making difficult decisions under stress.

Dr. Raybourn calls the approach she uses in her games *adaptive training systems*. By this she means the games are designed to facilitate feedback and communication during and after play, as well as the sharing of strategies and solutions. The end-goal is to help the players understand their personal strengths and weaknesses in terms of leadership and to acquire skills they need to carry out to the real world. Such an approach fosters what she terms an *emergent culture*, an experience that begins during the game but continues long after gameplay, as trainees continue to think and talk about what they learned.

Most of the projects she works on are multiplayer role-playing games. Trainees are divided into two teams of 8 to 10 players who do the role-playing, while the rest of the players serve as observers and offer feedback. Trainees switch positions at least three times during the game, giving everyone a varied perspective. While role-playing, the trainees communicate with each other by speech, talking through microphones that mask their voices

to preserve anonymity. Dr. Raybourn explained to me that she is not fond of dialogue trees because "the answers have always been pre-scripted."

Though the projects she designs are for training, she believes that they are also very gamelike, noting that they are full of action; that players have the goal of winning; and that they contain rewards and consequences. "That's what makes them fun," she said. The rewards in these games, she pointed out, go beyond the game itself. They increase the players' self-confidence and self-understanding.

One of the most important aspects of her preproduction process is creating a profile of a single target user, an approach to character design termed the *persona method*. It involves developing the characteristics of one fictitious but realistic individual who will represent the target player. She establishes this individual's stressors; values and belief system; strengths and weaknesses; and what this person has been through. She uses this representative individual as a guide for developing the game's narrative, its rewards system, and the creation of character arcs. Note that this is quite similar to developing a buyer persona for your ideal audience member, described in Chapter 7, though Dr. Raybourn's focus is on different characteristics.

Once the persona has been created and the training objectives determined, she will then design the narrative flow of the game: where it starts and what situations the players will encounter in it. As with most games, however, there is no one set finishing point; the participants themselves create the resolution as well as many of the narrative elements. She strives to create scenarios that will pump up the players' adrenalin levels and that are emotionally engaging, though leaving room for improvisation.

The narratives she develops are extremely realistic, with every detail appropriate to the part of the world where the game is set. The visuals, the audio, and even the vegetation are as accurate as possible. For example, a game she created for the US Army Special Forces on cross-cultural engagements is set in Afghanistan. It includes a mission where players try to remove a vehicle that is blocking the road to a village. This vehicle in this particular

mission is a colorfully decorated *jingle truck*, an important mode of transportation in Afghanistan (see Figure 10.3).

In the simulations she designs, she strives to create what she calls a *crucible experience*, an in-game experience that will be emotionally powerful and believable enough for the player to undergo a meaningful changing in thinking, understanding, and perception—that will cause the player to have, as she puts it, "an aha moment." This epiphany, she explained, is somewhat similar to the experience of the hero's journey, a catharsis, which can transform the person who undertakes it. The hero's journey, as you might recall, was first articulated by Joseph Campbell, and is described in Chapters 1 and 5.

Dr. Raybourn's simulations are often designed with built-in tools so that the instructor can modify elements during gameplay—increasing or decreasing the stress level, for example, or inserting twists in the scenario, or even building scenarios of their own. These simulations also contain in-game and after-game assessment tools. Players can analyze actions and share their observations while the game is in progress, and the instructor can bookmark segments of the game and play them back later

FIGURE 10.3 Dr. Elaine M. Raybourn, on the left, stands in front of a multiplayer game set in Afghanistan that she developed for the US Army Special Forces. The vehicle in the center is a jingle truck. Image courtesy of Randy Montoya and Sandia National Laboratories.

in the session, even from different angles, so players can analyze them and discuss alternate strategies. Dr. Raybourn emphasizes that post-game discussions are an extremely important part of the learning experience.

> **ADDITIONAL RESOURCES**
>
> The following websites provide a great deal of information on serious games topics and relevant conferences:
>
> - Games for Change: http://www.gamesforchange.org/
> - Games2Train: https://www.games2train.com/

Combining Digital Storytelling and Training

Training is an activity that is essential to business. Sooner or later, almost everyone who holds a job will be asked to participate in a training session, whether the employee is a new hire whose job it is to stock shelves or a seasoned manager who oversees a large staff. Training sessions can cover anything from a basic company orientation to leadership skills, and from customer service to complex legal or scientific topics. At one time, such sessions were usually led by a facilitator and conducted much like a school or college class. Increasingly, however, training is done via computer technology, including the Internet, DVDs, and various blends of media.

The use of digital media to train employees has all the advantages of interactive software designed for education, including the facilitation of active learning. The chief difference between them is that interactive training courses focus on practical or interpersonal skills, while educational software focuses on academic learning. But as with educational software, the learners find training software more stimulating and engaging than traditional classroom experiences and appreciate the opportunity to learn at their own pace. Many of the projects described earlier in this chapter are designed for training, such as the ones produced by Dr. Raybourn.

Digital training has another advantage that appeals to businesses: it is cost-effective. Employees can do the coursework while sitting at their workstations or from home, eliminating the need to travel to a training seminar.

Given the fact that corporate training is usually a mandatory part of one's employment, and that these courses focus on the skills that employees must master in order to succeed at their jobs, it is reasonable to wonder if it is necessary, or even possible, to make such courses entertaining. Nevertheless, the companies that create training software, as well as the companies that purchase it, recognize the value of making training engaging, and understand that entertainment elements can help hold the users' attention. And they are also mindful of the fact that interactive training is competing to some extent with other forms of interactive programming, particularly games. This is especially true when the training material is directed at younger learners.

For example, Dr. Robert Steinmetz, introduced in Chapter 9, noted that he was very aware of the developments in interactive gaming and of the expectations of the younger generations for interactivity and for visual richness. At the time I interviewed him, Dr. Steinmetz headed the software firm Training Systems Design. He holds a PhD in Instructional Technology and Educational Psychology and has had over 20 years' experience in training, and thus has a good grasp of what these courses need to be like in order to make them effective with the designated learners. He said it was necessary not only to take the expectations of the younger learners into account but also to consider the older learner, the person who says "just give it to me in spoon-sized bites. Don't overwhelm me."

Although story scenarios can be effective teaching tools, training specialists recommend that they be set in a realistic workplace environment in order to make them meaningful to the user. The more similar a story scenario is to real life, the easier it is for learners to transfer the training to their jobs. Care must also be taken to make sure the gaming elements reinforce the training message and don't divert attention away from it. Like story scenarios, they should be as closely related to the users' jobs as possible. Games,

simulations, and story-based scenarios can all be part of the courses' mix, offering users a variety of ways to learn.

A Sample Interactive Training Course

At Training Systems Design, the company employs an open architecture that can accommodate many types of learners. Typically in their courses, the subject matter is divided into modules, and each module is given an engaging and appropriate theme. A single interactive course may contain a great variety of interactive approaches, including game-like activities, simulations, and modules that offer a user-directed path through informational material.

For example, the company's course on office safety, *Code Alert*, makes good use of simulations as a training technique. One especially tense simulation features a disgruntled employee who is armed and potentially dangerous. You, the user, have to calm him down and get him to leave the office without the encounter erupting into violence. Another simulation has you dealing with a suspicious package that has just been delivered to your office and that could contain an explosive device. If you don't handle the situation correctly, the device will go off. Without question, such simulations give users the sense that a great deal rides on whether they make the right decisions. Immersive dramas like these are likely to keep them highly involved in the training program.

Using a different approach, the module called *Save Your Co-Worker* is a game in which the user must navigate around the office and spot things that could be unsafe (see Figure 10.4). Potential "hot spots" include a man with a necktie bending over a shredder; a man perched high on a ladder; and a top-heavy file cabinet. If you leave the office without spotting all the potential hazards, the consequences can be disastrous to your fellow workers. For instance, if you have failed to note the man on the ladder, he will topple over backward. For those learners who respond better to more traditional learning, a mentor can be accessed from the upper right corner of the screen and is available to give a tutorial on the subject.

FIGURE 10.4 A screen capture from the *Save Your Co-Worker* segment of *Code Alert*. The objective is to spot potential hazards and to prevent accidents from happening. Image courtesy of Training Systems Design.

Still another module is called *How Safe Are You?* which is a Cosmo-style quiz about the user's own office safety practices. Thus, *Code Alert* offers a diverse array of activities, some game-like, some with touches of humor, some highly dramatic. "We took a topic which most people would say 'ho hum' to," Dr. Steinmetz said of *Code Alert*, "and tried to make it engaging and attention sustaining." As *Code Alert* illustrates, storytelling and entertainment techniques can play an important role in enhancing the effectiveness of interactive training.

Other Digital Options for Teaching

The Internet and DVDs are not the only digital options for teaching. As we've already mentioned, military organizations use virtual reality and other types of immersive environments to prepare officers and troops for active duty. Augmented reality has been employed in many works aimed at young students, and mobile platforms have been recruited for the same purpose. In addition, the virtual world, Second Life, has been used as a venue for classes taught by major universities, like Harvard and Cornell.

It should be stressed that digital instruction does not necessarily replace live teachers. Often these programs are played in a classroom setting, and the teacher uses them to stimulate discussion and reinforce important points. And sometimes students log into an online course in a classroom with a live instructor acting as facilitator, a combination sometimes called a *webinar*.

Guidelines for Projects That Blend Storytelling with Teaching and Training

Obviously, big differences exist between making an edutainment game for young students, making a training simulation for the workplace, and making an interactive educational title for advanced students. However, as we have seen, digital storytelling techniques can successfully be applied to a wide spectrum of projects designed to teach or train. All such projects begin with the same basic considerations and questions. Here are some of the things that need to be thought out at an early stage:

- What is the need for this particular project? What is the ultimate goal of the organization that is sponsoring it?
- What is the specific teaching or training objective of this project?
- Who is the intended audience, and how comfortable is this group with interactive media?
- What digital platform is this project best suited to?
- Will you be using subject matter experts? If so, what kinds of expertise do you want them to furnish?
- What interactive educational techniques will you use to make this an effective teaching tool?
- What will make the content engaging? What digital storytelling approach might work well to teach this particular subject?
- How will you integrate the educational content with the entertainment content?

Using Digital Storytelling Techniques for Promotion

The need to promote a product probably goes all the way back to the time when humans were still living in caves. Perhaps the first manifestation of this type of activity began when an enterprising caveman set up shop under a tree and tried to trade his surplus chunks of woolly mammoth meat for some sharp pieces of flint. But when he attracted more flies than customers, he realized he would never do any business unless he could make his fellow cavemen aware that he had mammoth meat to trade, and excellent meat at that. Thus, the first attempt to promote and advertise might have been born.

While no one can say for sure if such a scenario ever took place, we can be quite confident that the need to promote and advertise has existed as long as people have had products, services, or ideas that they wanted other people to purchase or willingly accept.

The methods have changed with the technology, of course. Our enterprising caveman would only have had his own voice and his gestures to make people aware of his excellent woolly mammoth meat. In time, however, merchants would be able to tout their wares on strips of papyrus, and then in printed newspapers and magazines, and ultimately, in radio and television commercials. Today we have yet another technology at our disposal, and an incredibly powerful one: interactive digital media.

Unlike earlier forms of promotion and advertising, which used passive forms of media, interactive digital media encourages an active involvement with the message. Because this form of promotion and advertising can be so entertaining, people willingly become involved with it. Furthermore, they enjoy it so much that they even tell their friends about it—a phenomenon known as *viral marketing*, which is the voluntary spread of a message by means of digital media. And, unlike earlier forms of advertising and promotion, the exposure to the message is not a fleeting experience. In some cases, the involvement can last for days or weeks, and can even lead to a life-long connection to the product or idea. Think how different this is from fast-forwarding

through a commercial or barely skimming the ads in a magazine or newspaper!

With interactive digital media, we have an enormous variety of techniques we can use to promote and advertise. The ones we will focus on in this chapter are not "hard sell" forms of advertising like the online pop-up and banner ads that most people find intrusive and annoying. Instead, they use various aspects of digital storytelling such as plot, characters, suspense, immersive storyworlds, conflict, competition, humor, and heart—the warm and touching emotional core of a story.

As we will see, many of these projects are remarkably ingenious. The techniques we will be examining can be used to promote products (automobiles, shoes, candy, cat food); entertainment properties (movies, TV shows, video games, classical music, theme parks); ideas and causes (health issues, international crises, social issues); and organizations or groups (political parties, religious faiths, professions).

One of the most desired outcomes of promotion is something called *branding*, which is a way of establishing a distinctive identity for a product or service, an image that makes it stand out from the crowd. By successful branding, the product is differentiated from its competitors and is made to seem alluring in a unique way. Companies can be fiercely protective of their brands, creating bibles and style guides to make sure the brand is presented in a consistent fashion.

Viral Marketing

Many promotional works that use digital storytelling techniques are spread by viral marketing, as mentioned in the previous section. The beautiful thing about viral marketing is that it costs virtually nothing outside of the production costs to the company or organization that has created the piece. Instead, its fans willingly spread it to their friends and colleagues, who in turn spread it to others.

The Danish website Baekdal.com (for media professionals) published an insightful article several years ago offering a number of commonsense pointers on creating projects that are likely to be

spread virally (http://www.baekdal.com/media/viral-marketing-tricks). Among the points stressed was the importance of developing a good story that creates strong emotions and does something unexpected. Baekdal advises that the star of the piece be the story and not the product or organization being promoted, which should take a back seat—a point I totally agree with. Baekdal also advises that you should make your piece easy to share, using a format that is commonly used, and not creating impediments, like forcing people to register or become members in order to see it. In addition, Baekdal feels it is important to allow people to make comments, and to not be afraid of negative ones. After all, if you have created something that engenders strong emotions, you are bound to step on a few toes.

We must be aware, however, that digital media has the immense capability of spreading pieces that are negative to a product or company's image, as happened several years ago with the Domino's Pizza fiasco. A couple of disgruntled employees created a video, posted to YouTube, showing them doing some highly unsanitary and disgusting things with the company's pizzas. This was not a situation that Domino's had done anything to encourage, unlike the Chevy Tahoe do-it-yourself commercial described in Chapter 3, and Domino's responded promptly and intelligently to the bad publicity. But the overall lesson here is, first, to pay attention to what people on social media are posting about your organization, and second, do not give users tools with which they can make mischief.

Digital Media Venues for Promotion and Advertising

As we saw earlier in this chapter, many different forms of digital media can be used to teach and train. The same is true of promotion and advertising, which can also use a wide variety of digital media and storytelling techniques to accomplish their goals. Before discussing the specific techniques of narrative-based promotion, let's first take a look at the major digital venues and see how they are being used. They include:

- *The Internet*: The Internet is quite possibly the most heavily used digital medium for promotion. Among the many online narrative-based genres used for these purposes are real and faux websites, fictional blogs, webisodes, virtual worlds, massively multiplayer online games (MMOGs), and short, fast-paced games known as *advergames*. Advergaming will be discussed in more detail later in this chapter.
- *Mobile devices*: in the last several years, mobile devices have become an important venue for promotion. They are often used for advergaming and as part of an overall transmedia promotional campaign.
- *iTV*: although iTV (interactive television) is not flourishing in most parts of the world, some companies sponsor entire entertainment programs, incorporating promotional messages into the content itself.
- *Video games*: video games are being used to promote and advertise both on the macro and micro levels. On the macro level, entire games are devoted to a single promotional goal. On the micro level, various products or companies are promoted through *product placement*—the integration of products into a game or other form of screen-based entertainment. Product placement will be discussed in more detail later in this chapter.
- *Virtual reality*: full-scale VR installations are sometimes used for promotional purposes, and portable VR kits have been developed to advertise various products.
- *Smart toys and theme-park rides*: toys and rides are primarily used to reinforce consumers' awareness of branded entertainment properties.
- *Additional venues*: in addition, organizations use short films, virtual worlds, and transmedia storytelling for promotional and advertising purposes.

Applying Digital Storytelling Techniques and Genres to Promotion

In the short time that digital media has been used to promote and advertise, content creators have developed an extremely varied palette of techniques to engage their target audiences and get their messages out to the public. Let's take a look at some of the most widely used of these techniques.

Product Placement

Product placement can be found in video games, where you might see NPCs wearing ball caps embellished with clothing logos or skimming the waves on surfboards decorated with soft-drink logos. One might think that players would find product placement intrusive, but a focus group conducted by a New York ad agency showed that to the contrary, 70 percent of those in the group felt that seeing familiar products in a game "added realism."

For the most part, product placement is a static form of advertising and not directly related to digital storytelling. However, product placement can become a more active promotional technique and at times does contain elements of narrative, in the form of characters and little storylines.

For example, the famed science fiction novelist, William Gibson, via his avatar, visited *Second Life* to promote his new novel, *Spook Country*, and did a reading of his book there. And during the holiday season a few years ago, NBC held a tree-lighting ceremony in *Second Life*. The ceremony took place at a virtual version of Rockefeller Center, which even had a virtual skating ring. Avatars of characters from the cast of an MTV show visited MTV's virtual world, *Virtual Hills*, and interacted with the avatars of fans, and avatars of famous movie stars and musicians are becoming increasingly common.

If this phenomenon of active product placement continues, we can expect content creators to become involved by creating little scenarios or even larger dramas to integrate the products into some kind of engaging narrative.

Branded Content

Branded content is programming that is funded by an advertiser and integrates promotional elements with the entertainment content. Unlike traditional advertising sponsorship, where the advertising is done through commercials, the entire program can be thought of as a "soft" commercial. To be effective, the promotional elements need to be woven into the narrative content, and the narrative content must be highly attractive to the audience.

Many examples of branded content can be found on the Internet and also on mobile devices. Advergaming is a form of branded content, and so are a number of amusing videos found on sites like YouTube. Sometimes entire websites are forms of branded content.

The Way Beyond Trail, an online interactive adventure story created to promote the Jeep Patriot is good example of branded content, and a good illustration of how digital storytelling techniques can be applied to promotion, even though it was done several years ago. It follows the same model as the old *Choose Your Own Adventure* books mentioned in Chapter 1 where the user (the reader, in the old days) is asked to make a choice at crucial points in the story and the choices affect the way the game will end. It thus uses the classic branching structure described in Chapter 6. But even though the structure is hardly innovative, the story is clever and fresh, and you as the user feel quite engaged.

The Way Beyond Trail, shot on video, is a tale about three hip young adults traveling around the backcountry—in what else but a shiny new Jeep Patriot. When you first log onto the story, you are asked to fill out a passport with your name and gender. Thus, you become the fourth member of the party and are even addressed by name at a few points. The camping trip soon turns into a search for buried treasure and things soon become a little wacky—just how wacky depends on the choices you make. But you will almost certainly make several wrong turns before you find the treasure, and encounter some bizarre individuals along the way, a little like characters from the classic TV series, *Twin Peaks*.

The Way Beyond Trail works well as a branded content story because the user is actively involved and pulled into the adventure. Furthermore, the promotional material does not intrude in

the story. Of course, as you and your new friends drive around the woods and search for the treasure, you get a good look at the Jeep's interior and exterior and get to see how well it maneuvers on rough terrain. Also, it has a subtle subtext: by owning one of these Jeeps, the story implies, you, too, can go on cool adventures with cool friends and have a great time.

In quite a different application of branded content, Meow Mix cat food created a reality show in 2006 that followed all the conventions of the genre, except that the contestants in this case were all house cats. The show, *Meow Mix House*, was a transmedia entertainment, using television (broadcast on the Animal Planet network), the Internet, and a real-world venue, a custom-built home for the cats in a storefront on New York's Madison Avenue. Visitors to the website could view the 10 competitors, all cats rescued from shelters, through webcams. They could read their bios, see recaps of the episodes, and vote for their favorite feline. Just as with a human reality show, the cats were given challenges, but these were more in line with their natural talents. They were judged on such things as purring, climbing, and catching toy mice. The website was an enormous success, receiving over two million unique visitors, and a success for the cats, too, because after the show they were all adopted into good homes.

Social Marketing

Social marketing is a specialized form of promotion that is designed to change the way people behave—to motivate them to break harmful habits like smoking or overeating, and to encourage them to take up positive behaviors, like wearing seat belts or exercising. Though digital platforms have only recently been used in social marketing campaigns, the concept itself has been around since the 1970s, when social marketing campaigns were mostly conducted through televised public-service announcements.

Today's digital social marketing campaigns are far more sophisticated. They avoid lectures and scare tactics and instead are positive, upbeat, and involving. *America on the Move*, for example, is a healthy lifestyle campaign to get people to become more physically active. Although no longer part of its Internet offering, at one

time it gave users the opportunity to go on "virtual hikes," like China's Silk Road or the Appalachian Trail. You, the user, picked a trail, tracked how many steps you took each day (measured on a pedometer), and entered them on your virtual trail. Your steps were converted into miles along the trail and your progress was charted on an online map. You could even enjoy some sightseeing as you "hiked."

Public Advocacy Campaigns

Like social marketing, public advocacy campaigns are meant to sell ideas, not products. Such campaigns are intended to raise public consciousness about serious issues and to inspire people to take action. One way of doing this with digital media has been to combine animated cartoons with calls to action. Unlike objective informational pieces, social advocacy cartoons take a strong position on whatever issue they are tackling, though the stand they take should be supported by facts.

One highly successful public advocacy campaign was a series of clever little animated cartoons called *The Meatrix*, and its sequels, *Meatrix II and Meatrix II 1/2*. The cartoons, which are still available on YouTube (http://www.youtube.com/watch?v=rEkc70ztOrc), are a parody of the popular film, *The Matrix*, and are a call to action against factory farming. The first *Meatrix* debuted online in 2003, with the sequels coming out in succeeding years. An updated version of *The Meatrix* debuted in 2015.

Produced by the design firm, Free Range Graphics, *The Meatrix* tells the story of a naïve young pig, Leo, who is living contentedly on a bucolic family farm until he meets a cow named Moopheus, an underground resistance fighter. When Leo takes the red pill Moopheus offers him, he is introduced to a ghastly alternate reality and learns the shocking truth: family farms are mostly a fantasy, having been stomped out by agribusiness and replaced by cruel, filthy, and diseconomic factory farms (see Figure 10.5). Leo joins Moopheus as a resistance fighter, and the sequels continue his adventures and include more shocking revelations about the meat industry.

FIGURE 10.5 A screenshot from *The Meatrix*, with Leo and Moopheus in the foreground. Image courtesy of Free Range Graphics and GRACE (Global Resource Action Center for the Environment).

More recently, another animated story to protest factory farming, *A Pig's Tail*, has created a great deal of buzz. This sweet, earnest story of a little pig who escapes from a vile factory farm and happily discovers a real family farm was produced by the Humane Society of the US and Aardman Animations. It can be viewed on YouTube: https://www.youtube.com/watch?v=pr7jqcVRA94.

Still another public advocacy campaign, this one designed to call attention to pollution caused by plastic bags, used a short live-action film to get its message across. The project, *The Majestic Plastic Bag* (http://www.youtube.com/watch?v=GLgh9h2ePYw), is a mockumentary narrated by Jeremy Irons and sponsored by Heal the Bay. Though not interactive in itself, it does contain a call to action.

Web Series

Web series are serialized dramas typically broadcast in short installments. They can be used as promotional vehicles for TV series or to promote such products as automobiles and beauty products, and can be viewed as a form of branded content. They can be non-fictional stories, too. For example, Delta produced a series about flight attendants undergoing their intense eight-week training program, called *Earning Our Wings*. The 12-episode series, released in 2017, was done in the style of a reality TV show (https://news.delta.com/

binge-watch-all-12-earning-our-wings-episodes-starting-today). Viewers learn that out of 100,000 people who apply for the job, only one percent are accepted, so these trainees are quite special to begin with, and their training makes them ready to handle anything. There's a subtext, of course: prospective passengers learn what good hands they are in with these rigorously trained, proud flight attendants, and also with the airline itself.

Gaming

A number of different forms of gaming are used as vehicles for advertising and promotion. They include advergaming (described in the next section), casual games, video games, alternate reality games (ARGs), and MMOGs. Gamification also has a role to play in promotion and advertising.

Advergaming and Casual Games

Advergaming is, as the name suggests, a combination of gaming and advertising. Advergaming, also known as *promotional gaming*, began on the Web, but now these games are extremely common on mobile devices, where they work well.

Advergames are meant to be short pieces of entertainment, lasting just a few minutes, essentially making them a subgenre of casual games. Like casual games (which are discussed more thoroughly in Chapter 11), they are designed to be highly addictive and fun. Usually they start off as very easy to play but quickly become more difficult. Thus, people become hooked on them and play again and again, trying to do better with each go-round. Furthermore, they are not demanding in terms of the skill level needed to play them, so they are as enjoyable for inexperienced players as they are for people who play games regularly. Thus, they are a robust form of promotion and advertising.

Advergames are popular with advertisers because they:

- Are so engaging that consumers will willingly play them
- Increase brand awareness
- Can be spread to an ever-expanding group of players through viral marketing
- Are an effective way to highlight a brand's special features

Often these games contain a little backstory to set up the gameplay and put it in context, though the backstory needs to be established quickly, because users want to get into a game as soon as possible. Advergames often contain an indirect message reinforcing positive aspects of the product.

Advergames are most likely to catch on when they are a good fit with the tastes and sensibilities of the target audience, which is one of the reasons cited for a game called *King Kong Jump* becoming an international hit a few years ago. This zany game promotes two different products: the movie *King Kong* and Pringles potato chips. Though tying potato chips and an adventure movie together in the same advergame might seem like quite a stretch, the company that made it recognized that both products were perceived as fun and both appealed to the same demographic. You, as the player, are the would-be hero of the game, and you must save a helpless young woman from King Kong's jungle. For some reason, this is accomplished by dodging and jumping over cans of Pringles potato chips, which are rapidly rolling down a hill directly at you. If you fail to get out of the way in time, you get squished flat. But if you achieve enough points, the gorilla beats his chest and roars approvingly, and you move on to the next level.

Chipotle's Mexican Grill, a restaurant chain committed to humanely raised meat and locally grown produce, commissioned a game and animated film called *The Scarecrow*, which cleverly depicts its mission to offer more wholesome, unprocessed food (https://vimeo.com/98800121). Produced by Moonbot Studio in collaboration with Creative Artists Agency in 2013, the storyworld of the game is introduced by a charmingly animated video, and the game is available as a free app. The Scarecrow's enemy in the game is a crow, who represents Crow Foods, a fictional company that mass-produces food and is uses inhumanely raised animals. By getting a high score in the game, players can even win Chipotle food coupons. The short was so successful that it was viewed 15 million times on YouTube and in just four days the game had been downloaded 250,000 times. It received two daytime Emmy Awards and the Grand Prix in the PR Lions Contest at Cannes, as well as two Gold Lions.

Unfortunately for Chipotle, the success of *The Scarecrow* made it a target of agricultural businesses and others, who felt it unfairly

depicted industrial food production. *Funny or Die*, the comedy video website, made a parody of the film, using harsh lyrics accusing Chipotle of being deceitful in its message. The attacks on Chipotle are not unusual for a promotional work that is a viral marketing hit, but illustrates that when marketing one's product, one must not exaggerate the truth. Attacks or not, *The Scarecrow* was an enormous success.

Video Games

As briefly noted earlier, entire video games are sometimes devoted to a single promotional objective. *America's Army*, launched in 2002, is one highly successful example of a dedicated promotional game. It was made by the US Army with the goal of recruiting young people to join the armed forces. The game and its sequels realistically but excitingly portray army life and combat, taking players from boot camp training right through to dangerous combat missions. The weaponry and tactics are all authentic. The developers took great pains to be accurate, while focusing, of course, on the most thrilling and glamorous parts of military life; KP (Kitchen Patrol) and push-ups are not featured in the game.

The game exceeded all expectations, in part because of is content and in part because it was perfectly aimed at its target demographic, the young men and women who love to play video games. It has become one of the most successful video games ever. The producers offer regular updates, and versions have been made for comic books, mobile phones, and the latest game consoles.

Alternate Reality Games

Alternate reality games (ARGs) are often used to promote entertainment properties. But in addition, ARGs are being used to promote restaurant chains, automobiles, and other products. They are particularly effective as promotional vehicles because players become deeply invested in them and in the brand being promoted, often for weeks at a time. Furthermore, these games are especially enjoyed by people between the ages of 18 and 34, a prime demographic for advertisers.

For example, *Who is Benjamin Stove?*, sponsored by General Motors, promoted the awareness of ethanol fuel and, in an extremely low-key way, promoted their Ford Flex line of

FIGURE 10.6 General Motors took out this ad on the *USA Today* website as a rabbit hole into the game, without revealing it was the game's sponsor. Image courtesy of Dave Szulborski, GMD Studios, and General Motors' Live Green, Go Yellow campaign.

vehicles. The mystery story involves an enigmatic character named Benjamin Stove as well as crop circles, sacred geometry, and mystical archeological sites. According to the late Dave Szulborksi, the game's puzzle designer and a story consultant on the project, the game was unusual in that it kept the identity of the sponsor, General Motors, a secret until very near the end. General Motors actually stepped into the game as a character, addressing the fictional Benjamin Stove in an ad that appeared in the *USA Today* newspaper and website (see Figure 10.6).

> **EXPERT OBSERVATIONS: CREATING A PROMOTIONAL ARG**
>
> Dave Szulborksi, who not only served on the creative team of *Who is Benjamin Stove?* but on 11 other ARGs as well, was one of the world's most experienced people in the ARG universe. He offered me this perspective on creating a promotional ARG:

> "In most cases," he told me,
>
>> The very idea to create an ARG for promotional purposes is generated as part of the discussion of a larger marketing campaign, with the ARG representing just a portion of the overall budget and scope of the campaign, so their creative genesis usually is expressly to promote a product, brand, or idea in a way that complements the more traditional marketing they will be doing.
>>
>> This doesn't mean, however, that the narratives of promotional ARGs necessarily need to be full of product references or even explicitly mention a company or brand to be successful," he continued. "And that's really the trick of being successful as an ARG designer, isn't it? Finding ways to tell an engaging story that also accomplishes the goals of the sponsors.

Massively Multiplayer Online Games and Virtual Worlds

An entire MMORPG or virtual world can be used as a form of promotion. MTV, an entertainment giant, has a virtual world dedicated to its aspirational life-style shows, which operate under the banner of *Virtual MTV,* or *vMTV*. However, creating a virtual world is a risky and expensive business and success is not guaranteed, as Disney discovered with *Disney Infinity*. Launched in 2013, it was a sandbox game that also operated a like a virtual world. A universe of colorful toys, avidly collected by Disney fans, was made in connection with *Disney Infinity*. The world was intended to be a rich venue to promote Disney characters and movies, but it was discontinued in 2017 because of substantial losses.

However, it isn't necessary for a company to build a virtual world from scratch; benefits can be enjoyed by entering your products or brand into an existing virtual world. *Second Life* has been a successful outpost for many companies. Many major brands have established outposts there, dipping their toes in these virtual waters in various ways: setting up retail stores; offering customer support; testing designs for new products and buildings; collaborating on projects; and holding meetings, events, and international conferences.

The results for established companies in this virtual world have been mixed, because there is an inherent clash of cultures between the fantasy-role-play typical of virtual worlds and the

suit-and-tie mentality of the business world. For example, Nissan retooled its Altima Island in *Second Life* to be more in keeping with the spirit of the world, but shortly thereafter, a helicopter smashed into one of its buildings, killing several avatars. It is unknown whether this was an accident or a prank, but in any case, it left a sour impression and, since then, a number of businesses have closed up shop there.

Other opportunities for brand promition is the staging of in-game events, as with the live Marshmello concert in *Fortnite*, attended by 10.7 million people. A video of the highly unusual and colorful event can be seen at https://www.youtube.com/watch?v=NBsCzN-jfvA.

Business ventures in virtual worlds seem to fare best when done in the spirit of these fantasy communities. If you remember William Gibson's book-reading described earlier in the chapter, that also had an appropriate virtual-world twist. An overflow crowd of avatars squeezed into the hall where the event was to take place and eagerly awaited Gibson's arrival. But Gibson's avatar did not make his entrance from a mundane side door. Instead, he descended from the ceiling in a large object shaped like a tanker container. The doors of the vessel opened, and Gibson's avatar stepped out to huge (typed) applause.

Gamification

Gamification, the employment of gaming techniques to works that are not games, has become a highly popular method for businesses and organizations to promote their messages to the public. For example, when I was in London several years ago, a little before Easter, a massive egg hunt was underway. But people weren't searching for typical little painted chicken eggs. These eggs were enormous, at least waist-high to a very tall man, and each was adorned by a leading artist. It was all part of the *Fabergé Big Egg Hunt*, which the famous jewelry company sponsored in part to celebrate the Queen's Diamond Jubilee and in part to help two charities. And it helped promoted the jewelry company's new London boutique as well, by playing off the intricate Easter eggs the company would

fashion each year for the Czar's wife or mother prior to the Russian Revolution.

The 200 eggs in the London hunt were hidden all over the city, and the person who found more than anyone else would win a grand prize: a golden Jubilee egg encrusted with jewels (more the size of a chicken egg than the eggs in the campaign!). To help users find these eggs, clues were planted on Twitter and Facebook, and zone maps indicating their location were posted on a special website. Each egg had its own code, and participants who found an egg would photograph it and its code and send the photo to a dedicated phone number, which logged it in as an entry.

In terms of digital storytelling, this campaign incorporated a strong goal (winning the golden egg); challenges (finding the eggs in the campaign); rewards (collecting entries); exploration (of London); and interactivity (using your phone to photograph the egg and send in the code). In addition, the golden Jubilee egg, as well as the 200 hidden eggs, all served as characters in this hunt.

In a very different type of endeavor, the movie *Rio* teamed up with Chiquita, the food company famous for its bananas, to create the *Make Your Way to Rio* campaign. The grand prize was a trip to Rio de Janeiro in Brazil. It was a campaign designed to involve the entire family. Families that registered to play received a "passport" and played as Blu, a bird character featured in the movie. As Blu, you would interact with activities on the campaign's website—coloring, trying out new recipes, and playing games.

Families accumulated points by completing activities, and could win prizes like badges, DVDs, ringtones, and a year's supply of bananas. The campaign was largely promoted through "Mommy" websites, which are blogs devoted to child-rearing and are a popular genre on the Web. The mommy bloggers were given promotional packets containing tickets to the film, coupons for Chiquita food products, stickers, and recipes, all to encourage them to write about the campaign. In terms of digital storytelling, it contained many of the same elements as the egg hunt in London: a strong goal; challenges (the activities on the website); rewards; plus a colorful character, Blu.

Music Videos

In 2006, a music video called *Tea Partay* debuted on YouTube, and may well have been the first music video on the Internet to be used for promotional purposes. The clever tongue-in-cheek video, sponsored by Smirnoff, featured a group of East Coast preppies rapping about a new Smirnoff beverage, Raw Tea. Spread quickly by viral marketing, it was viewed an estimated 5.8 million times on YouTube alone. This was a great coup for Smirnoff, since YouTube viewers are a prime demographic for their new beverage. A year later, in the wake of this success, Smirnoff released a follow-up video on YouTube, *Green Tea Partay*, featuring a rival group of rappers on the West Coast singing about another Smirnoff beverage.

"Construction Kit" Commercials

"Construction kit" commercials are online promotions in which users are given all the tools they need to create a commercial for a specific product, competing for prizes and recognition. As we saw in Chapter 3, Chevy used this technique with its Chevy Tahoe campaign, but the venture backfired badly when some users created venomous commercials about the SUV. Nevertheless, the concept itself is a promising one, encouraging interactivity and engagement, though for it to be effective for promotional uses, some restrictions to discourage negative uses would need to be built in.

Short Films

Short films for the Internet, both linear ones and interactive ones, are logical vehicles for promotional endeavors. Earlier in this chapter, we examined the interactive film, *The Way Beyond Trail*. The concept of using short online films as branded entertainment dates back to 2001, when BMW began promoting its sleek, high-end vehicles online via a series of sleek, high-end short films. Collectively called *The Hire*, the eight films were united by a recurring character, a mysterious driver-for-hire, who operates the car in all the little movies. Heavy hitters like Guy Ritchie,

John Frankenheimer, and Ang Lee directed the films, and one even stars Madonna. No overt advertising was contained in any of them. *The Hire* has received many accolades and brought much favorable attention to BMW. The films have even been screened at Cannes, and they can still be seen on YouTube.

Many other organizations have also been utilizing short films as a marketing strategy. For example, the Humane Society of the United States produced a heartwarming work about an endearing little dog named Billy, rescued from a puppy mill. Billy sadly passed away several months after his rescue, but the film, and one made to commemorate his life, was successfully employed to increase donations for the Humane Society. The Environmental Defense Fund made a series of short films about a fictional family of polar bears struggling to survive during global warming, as the ice was melting. And as we saw earlier in this chapter, the Humane Society of the US created the animated *A Pig's Tale* to raise awareness of the negative aspects of factory farming and to promote the Humane Society, and Chipotle created *The Scarecrow* to promote its restaurants and their focus on humanely raised meats and healthful foods.

Webcam Peepshows

Webcam peepshows, where the user can type in commands that the person or creature shown on the webcam video must follow, have to be among the most bizarre methods of promotion ever devised. Evidently, webcam peepshows are fairly common forms of pornography, but it takes a leap of imagination to consider this as a model for a promotional purposes. Yet Burger King did just that with its edgy *Subservient Chicken* campaign in 2004 to promote chicken sandwiches. News of the website spread like wildfire through viral marketing and TV tie-ins.

The show featured a person dressed in a chicken costume (and a garter belt, as well!) who would obey approximately 400 typed-in commands. Though made to look like a live feed, the videos were actually prerecorded responses triggered by key words. The peepshow cleverly reflected Burger King's slogan, "Get chicken your way." The chicken would even turn itself into a chicken sandwich, if requested, by tucking itself in-between two cushions.

According to the ad agency that oversaw the website, Crispin Porter + Bogusky, *Subservient Chicken* received a million hits within hours of launching, and over 15 million hits within a few months. It was one of the most successful viral marketing campaigns of all time.

> **STRANGE BUT TRUE: A CHICKEN'S ODYSSEY**
>
> After the chicken's glory years in the spotlight, he was the subject of hilarious follow-up video made about him 10 years later, *Burger King: Subservient Chicken the Other Side of the Road*. It seems that things went downhill for him after his fame had faded. After a series of degrading experiences, including being bullied at a children's birthday party, the once-famous chicken ends up homeless, bedraggled, and begging, holding up a pathetic cardboard sign, looking for work. A gruff boxing trainer spots him and tells him to go to his gym. The chicken obediently turns up at the gym and undergoes rigorous training. Soon, Rocky-like, he is now a tough and formidable bird, Chicken Big King. He no longer obeys commands and does things his own way. He even has a new chicken sandwich named after him, the Chicken Big King. The short is a fresh take on the hero's journey, a chicken's journey, and can be seen on YouTube at www.youtube.com/watch?v=YHXo37MCsdY. The video was an immediate hit, viewed over 1.8 million times almost as soon as it was launched.

With a success of the magnitude that *Subservient Chicken* enjoyed, a couple of other promotions have imitated the idea of commanding an animal of some species or other to perform specific behaviors. In one such campaign, this one for Heart Guard (a heart-worm medication for dogs), users could type in commands to a cute little dog, who seemed to understand most of them. When he couldn't, he would apologize and explain why. In another, this one for the Tipp-Ex correction roller, you help out a would-be bear hunter who suddenly decides not to shoot a marauding bear. So you can "wipe out" the instructions to shoot the bear, and instead command the bear to do things like kiss, hug, and wave, modeling the peepshow concept of the Subservient Chicken.

Transmedia Storytelling

Transmedia storytelling has been successfully been employed as a promotional tool for many years. In Chapter 1, we described the Macy's Christmas campaign built around Sunny the Snowpal, and *Meow Mix House*, created to promote cat food. We also discussed several examples of promotional transmedia stories built around Alternate Reality Games, including *The Beast* (to promote the movie *AI*), *I Love Bees* (to promote the video game *Halo 2*), and *Why So Serious?* (to promote the Batman film *The Dark Knight*).

Transmedia stories take many forms and there is no set formula for making them. In some cases, the core property will be an original linear story with social media components, as was the case with *The Beauty Inside*. For this venture, Intel joined forces with Toshiba to jointly promote themselves through a story about Alex, a young man who woke up each morning in a new body and with a new face. Alex copes partly by recording his story as a diary in his Toshiba laptop, which he carries with him everywhere. But his dilemma takes a more serious for him when he falls in love with a young woman. How will she be able to accept him as her boyfriend if he never looks the same way twice? The story was told online is six episodes, and users could become personally involved by sharing their own diaries and struggles with identity by sharing them on Facebook and YouTube. The series was viewed 70 million times and was a success for both companies.

LEGO, the company that makes toy kits with interlocking pieces, has taken a different approach to transmedia and has become a powerful brand in large part because of it. LEGO characters and worlds are not only featured in movies and games, but also on TV cartoons and in massive sculptures made of LEGO bricks that add color and fun to Downtown Disney in Orlando, Florida.

In 2005, LEGO began making games based on pop-culture branded properties, including StarWars, Indiana Jones, and Harry Potter, each with a unique LEGO vibe. A breakthrough came about when LEGO developed its game *Bionicle* as a transmedia world. The game was the hub of a vast mythological story told not only in the game, but also in comics, online games, and also in other media pieces. The story was not static but ever-expanding,

and allowed users to tap into different parts of it as they chose. Part of its enormous success rested on the same appeal LEGO has always had: allowing children to interact with its storyworlds and use their own imaginations to overlay the LEGO characters and worlds with their own creations.

Social Media

Social media is being utilized in a variety of ways to promote products and organizations. Sometimes these stories are conveyed visually. For example, a ski resort in northern California developed a campaign that invited customers and staff members to post photos and videos on social media with the tag "NorthStar, Tahoe." Those who do can potentially be rewarded by having their photos or videos posted on the NorthStar website or even winning ski resort services. This fairly simple and straightforward endeavor resulted in the ski resort receiving thousands of favorable posts, whereas before there had only been a few hundred entries on the same sites.

Jack in the Box used quite a different approach several years ago after its spokesperson, Jack (the one with the round clown head and dunce cap), was run over by a bus during a Super Bowl commercial and nearly killed. (The commercial, which can still be seen at www.youtube .com/watch?v=kqT_5f08Nxs, was actually the opening event of a relaunch of the company's brand, with a new menu, website, and food choices). The campaign, called *Hang in There, Jack*, invited Jack in the Box fans to send Jack get-well messages by social media and the company website. Twenty-seven fans went so far as to create get-well videos, which in total received 4.8 million views (*Los Angeles Times,* March 17, 2009). In addition, Jack received thousands of text messages on Facebook and Twitter. Jack's website and social media accounts gave regular updates of his medical condition. Two reliable digital storytelling techniques were used here: having your story revolve around a life-and-death situation and employing a vivid character at the center of the story (in this case, the character was already well known to the public). Though the company took a risk in inviting the public to post anything they wished, the negative messages were minute in comparison to the positive ones. The company

did monitor the posts, but only removed ones that were vulgar or included profanity.

Mobile Apps

Mobile apps are being used in a variety of ways to promote products and organizations. For example, Charmin, a brand of toilet paper, teamed up with *SitorSquat* to produce an app that helps users find the cleanest public toilets wherever they happen to be. Its two cute bear-cub mascots are used as visuals for the app. In an extremely different type of app, the World Wildlife Fund (WWF) created *WWF Together*, an educational app that showcases the stories of eight species of animals. In addition, the app contains animal-themed games, a 3-D globe that lets you find out where 60 different species of animals live, and teaches you how to fold origami animals.

Augmented Reality and Virtual Reality

Augmented reality (AR) and virtual reality are becoming increasingly popular with advertisers and marketers, because they allow users to interact with the brand. Smartphones and other digital devices can be used to "see" 3-D images that are invisible to the naked eye.

In a promotion for the *Green Lantern* movie, users could play an AR game to test whether or not they had the stuff to become a Green Lantern. They were tested on strength, focus, agility. Volvo created an app that lets you "drive" a Volvo through whatever room you are in. So, if you are in an office, you need to scoot around chairs and dodge desks, or, if you are in your living room at home, you need to drive around the coffee table and avoid hitting your Siamese cat. And, in a live demo of AR, and perhaps one with the greatest digital storytelling potential, *National Geographic* invited members of the public to play with a group of dinosaurs, pet a cheetah, swim with a dolphin, and interact with an astronaut.

VR is being employed on a large scale by Audi. One thousand of its showrooms are now equipped with VR technology to enhance

the experience of buying a car. Prospective customers can see life-sized models of the cars and pick different colors and configurations of the ones they are interested in.

In another high-end VR promotion launched early in 2019, Walmart and Dreamworks Animation, in collaboration with V-commerce startup Spatial&, have teamed up to bring dragons to Walmart's parking lots. More specifically, participants can fly on the backs of dragons over amazing landscapes in a VR promotion for the animated film, *How to Train Your Dragon: The Hidden World*. The experience is set inside specially outfitted 50-foot tractor-trailers outside select Walmart's stores. Walmart benefits by bringing the movie's fans to the store, which sells a variety of merchandise tied to the film. The experience inside the tractor-trailers begins in a "boarding room," where adventurers are greeted by several of the film's animated characters. They are then suited up and seated in a Positron-motion VR chair which is powered by a VR backpack, and the adventure begins. Parents waiting outside can follow their child's experience on HP Chromebooks and amuse themselves by playing games on HP gaming laptops.

A Unique Transmedia Venture

In one of the most innovative utilizations of digital technology, the Budapest Festival Orchestra, in partnership with Hungarian Telekom, created an interactive poster in 2016 of the orchestra's musicians, and passersby who wished could actually conduct the music. Using their smartphone as a baton, they could control the tempo of what the musicians were playing. This campaign targeted a young audience and the goal was to stimulate their interest in classical music. In Hungry, as in most Western countries, the typical audience for classical music is older folks, so this campaign was a bid to include more youthful faces among the audience of faces crowned by silver that typically attend classical music concerts. As an additional enticement, those who interacted with the poster received a discounted ticket to the next performance of the orchestra. This campaign had an effective subtext: that an organization that would employ technology in this manner was extremely cool and worth checking out.

> **ADDITIONAL RESOURCES**
>
> - To keep up-to-date on the use of using interactive digital media for promotion and advertising, visit iMedia Connection at http://www.imediaconnection.com/.
> - For news and information about digital media marketing, go to *Mobile Marketer*, http://www.mobilemarketer.com/.
>
> The site contains a wealth of information about using mobile devices in promotional campaigns.

The Impact of Digital Media on News and Information

The proliferation of digital media is rapidly transforming the way we receive news and information. Until recently, most people obtained their news and information from print publications or from radio and television broadcasts. Now, however, digital technology is giving us new options. We can stay informed via websites, blogs, podcasts, and news bulletins delivered by email and in text messages on our mobile devices. We can receive the latest news almost as soon as it happens—and sometimes as it is actually taking place. With digital media, we also have the ability to customize the information we receive. We can choose the categories of content that interest us; we can specify whether we want to receive news bulletins or full stories; and we can determine when and how often we want to receive this content.

In recent years, the popularity of traditional sources of information has been waning steadily and this, in turn, has been impacting the news organizations themselves. For example, the newspaper staffs have been shrinking, with fewer editorial jobs (editors, reporters, and photographers) in recent years than previously, according to a Pew Research Center report. The news departments of television stations are also shrinking and are now about half the size they were in 1980. And while in the past, it was customary for a crew of three or four people to be sent out to cover a story, now it is typical for one individual, a digital journalist, to write, shoot, and edit these stories by themselves. TV stations

are also cutting costs by doing more interviews by Skype than on location. As a result of this decrease in robust coverage, many people are abandoning the news sources they once relied upon. The audience for evening network news shows, for example, has been shrinking steadily for many years, losing a startling 55.5 percent of their former viewers by 2011. Newspapers have been so hard hit that many have been forced to go out of business and a number of others are on a death watch.

The Growing Popularity of Digital Media as a News Source

By early 2011, only 41 percent of people between the ages of 18 to 29 were still receiving their news from papers, radio, TV, or news magazines, while 65 percent of this group were getting their news from the Internet, according to a report from the Pew Research Center. Furthermore, as another sign of the changing times, newspapers lost $7 on the print side for every $1 they made in digital ad revenue, according to a 2012 report from the Pew Research Center's Project for Excellence in Journalism. By 2012, online ad revenue actually surpassed the revenue earned by newspapers.

Meanwhile, the popularity of digital media as a news source has been soaring. Many people now turn to YouTube for videos of unfolding news, particularly when it comes to natural disasters and political upheavals. As of 2019, YouTube was the second most popular site on the Internet, after Google, with 72 hours of video uploaded every minute.

A report published by the Pew Research Center revealed this fact: 30 percent of the population receives its news from Facebook! This seems especially surprising, given that most posts on Facebook are highly personal in nature (my great photo of the sunset!) and not about newsworthy events, but the report noted that these individuals are not going to Facebook in search of the news, but pick up news while they are there for other reasons. As we are now learning, the "news" we pick up from social media cannot necessarily be trusted. Reports indicate that Russia used social media to post fake news to significantly influence the US presidential election of 2016.

Many observers believe YouTube, Twitter, and Facebook played a major role in fueling the Arab Spring, which began in Tunisia with the self-immolation of Mohamed Bouazizi in late 2010. In Tunisia and Egypt, videos of protests encouraged other protesters to join in and posts on social media helped define the expectations of democracy and freedom. In the week before Hosni Mubarak, the president of Egypt, resigned, tweets about the insurgency increased 10-fold, according to a report by Philip Howard, an associate professor in communication at the University of Washington.

One dramatic sign of the popularity of digital media was previously mentioned in Chapter 2: the millions of people watching on the Internet to see the death-defying jump from the edge of space by Felix Baumgartner (see Figure 10.7). The jump broke all previous records of live stream viewing on the Internet: eight million viewers on YouTube. (The previous record of about 500,000 concurrent viewers was set that summer during the Olympics in the UK.) A photo of Baumgartner right after he landed was shared about 30,000 times within 40 minutes and almost immediately

FIGURE 10.7 The Red Stratos team preparing the space capsule for Felix Baumgartner to use to ascend into the edge of space, an event watched on the Internet by eight million people. Image courtesy of Jay Nemeth and Red Bull content pool.

gathered 216,000 likes. This event clearly demonstrated that the Internet is capable of attracting a mass audience for a special event.

The Internet has obviously become the big gorilla in the room when it comes to news and information. But in addition, we can receive information from mobile devices, watch interactive documentaries, and interact with informational works on electronic kiosks and in immersive environments. These information-providing digital platforms can be found almost everywhere, from public spaces like cultural institutions and airports to private spaces like our homes, our schools, and our places of employment. In many cases, we carry them around with us, in our pockets or handbags.

Not only is digital content highly portable and customizable, but it also gives us the opportunity to participate in the content. Newspapers allow for extremely limited forms of participation—readers can write letters to the editor and that's about it. But interactive media allows us to contribute by sharing our stories and videos, voice our opinions in forums and polls, and join in live chats and other types of community experiences.

The radical shift in the way information is sent and received, as we noted in Chapter 2, is having a profound impact on traditional media and on how journalism is practiced. And, of particular interest to those of us involved in digital storytelling, these developments in the sphere of news and information are giving us the opportunity to use powerful new techniques of interactive narrative for informational purposes.

The Digital Revolution and Traditional News Media

Not only is the popularity of digital media putting intense pressure on traditional news outlets, but as audiences shrink, so do ad revenues, which puts traditional news outlets in an ever-tighter bind. In business, the customary response to competition is to engage in an all-out battle with the rival, seeking to beat down and eliminate the usurper. But in the case of the competition between traditional and digital news sources, many forward-thinking newspapers and broadcasters are using a more adventurous strategy. They are embracing their rival, digital

media, and integrating new types of interactive content into their operations.

The venerable *New York Times* has been immensely successful with its acclaimed offerings of interactive documentaries, which will be discussed later in the chapter. It also publishes video games as part of its op-ed page. These are serious games, and, like any op-ed piece, they take a position on an important issue. It has also had enormous success with the digital version of its newspaper. Digital subscriptions have been steadily growing: at the end of 2018, it had 2.9 million digital-only subscribers, out of 3.8 million total subscribers. It was a major jump from 2017, with 27 percent more people subscribing to the digital version. Advertising benefited from this increase, as well. By the second quarter of 2018, digital advertising surpassed print advertising, bringing in $103 million, as opposed to print advertising, which fell 10 percent and brought in only $88 million.

For many newspapers, the embracing of digital media involves a shift of self-perception. As an article in the *Santa Fe New Mexican* put it (April 11, 2007), many papers no longer think of themselves as being in the "newspaper business" but simply as being in the "news business." In other words, their primary mission is to deliver the news. The medium of delivery is irrelevant.

Most traditional news organizations that commit to digital media focus on developing a robust website and employ a large website staff. According to recent statistics, the website of the *Washington Post* has a staff of 200—larger than some newspapers. A few news organizations are taking a more proactive stance, teaching their reporters to develop stories for multiple media, using video and audio as well as print. Others are making significant changes in how and where they offer the news. For example, *The Wall Street Journal* puts breaking news and financial data on its website and uses its print publication for in-depth articles.

The changes in the way news is being covered are even sifting down to journalism schools and impacting the way news writing is being taught. At my old graduate school, the Medill School of Journalism at Northwestern University, they are now training all students to use digital media to cover stories. Students learn

to create blogs and websites; develop content for mobile devices; do podcasts; and write interactive narratives. They also learn to use an array of digital equipment. The professors have had to go back to school themselves to learn how to teach these new courses.

Nationally, about 160 newspapers in the United States offer some type of paid subscription for their websites, according to the Newspaper Association of America. This includes two of the leading papers in the United States, the *New York Times* and *The Wall Street Journal*.

> **STRANGE BUT TRUE: SETTING INFORMATION TO MUSIC**
>
> Not only is the *New York Times* beginning to feature games for its editorial page and to produce interactive documentaries, but it has also produced a musical video for its website. Former staff writer David Pogue, who covered technology, created the first such project for the paper. Pogue normally wrote text-based stories, but when Apple introduced the revolutionary iPhone, he couldn't resist doing something totally different. He went all out and created a humorous musical video about the new device. Though the musical took a tongue-in-cheek, mock-serious tone, the production also contained a thoughtful rundown of the iPhone's assets and shortcomings. Pogue composed his own lyrics (to the tune of "I Did It My Way") and even sang most of the music himself, though a few people waiting in line to buy iPhones were corralled into singing a few lines. The video is still online at https://www.nytimes.com/video/technology/1194817121833/iphone-the-musical.html.

In a quite different approach, the cable TV network MSNBC created an extremely rich and deep community-based website revolving around the Hurricane Katrina disaster in 2005. Called *Rising from Ruin*, the site contained stories written by professional journalists as well as individuals from the affected region. It included numerous heartbreaking and inspirational first-person accounts of the aftermath of this monumentally destructive storm, told in text, still photos, audio, and video.

Applying Digital Storytelling Techniques to News and Information

Digital storytelling techniques can make an otherwise dry or difficult subject come alive and can make the material extremely engaging to users. The combination of information and entertainment gives us another genre of "-tainment" programming—*infotainment*—a blending of information and entertainment, much as *edutainment* is a blending of education and entertainment. However, the term infotainment has fallen into disfavor because to some people it connotes a trivialization of factual content. Nonetheless, the infotainment approach is perfectly valid when handled responsibly and so is the term itself.

> **WORTH NOTING: OBJECTIVE versus SUBJECTIVE**
>
> We have many techniques at our disposal for making information engaging. But first of all, a basic decision must be made. Will we be taking a *subjective* or an *objective* approach to delivering the content? Traditional journalism is objective. It is told in the third person and the writer avoids voicing his or her personal opinion. The facts in the story are checked out and validated; usually the sources of the facts are cited. A subjective approach, on the other hand, is a more personal one, and the material is often written in the first person. The writer's opinion is clearly expressed, and facts may not be as carefully vetted or noted as with an objective approach. The subjective point of view is often used in blogs and personal websites. It is also fairly common in interactive documentaries and in audio and video podcasts and is even used in some informational games.

A fundamental goal in combining information, entertainment, and interactivity is to offer users an opportunity to relate to the material in an *experiential* manner, as opposed to one in which they are merely passive recipients of the information. The experiential approach to the presentation of information allows users to interact with it, participate with it, and manipulate it. As we will

see, a variety of digital storytelling techniques can be used to create experiential forms of informational content.

Utilizing Personal Stories

One way to involve users is by creating highly involving and interactive personal narratives. This is the approach used in *Rising from Ruin* about Hurricane Katrina victims, described earlier. The same approach is being used in a website called the *Hawai'i Nisei Story* (http://nisei.hawaii.edu/page/home), an emotionally rich website featuring the stories of Hawaiians of Japanese descent and their often-harrowing experiences during World War II (*Nisei* is a Japanese term for second-generation Japanese Americans). The stories on this website are told in a mixture of video, audio, still photos, archival material, and text. Each person's story is quite detailed, but users have the ability to choose their own path through the narratives and go as deeply as they wish.

This same technique, that of using personal stories as the foundation of a website, is employed in *Jewish Pioneer Women* (http://www.storiesuntold.org/main.html). The stories, which tend to be quite short, are embedded in a quilt design. The quilt serves as an appropriate metaphor, since so many pioneer women stitched quilts. The website, produced by the New Mexico History Museum, focuses on the lives of women who lived in the state from 1850 to 1910. The stories are told by way of text, still images, and audio.

To create an effective narrative, the story or stories should be involving; multiple modes of communication should be employed; and users should have the ability to pick their own path through the material, as these works illustrate.

Community-Building Elements

Users want to be able to personally participate in the story in some way. As we saw earlier in the description of *Rising from Ruin*, one method is to invite users to share their own personal stories. Other community-building techniques include inviting users to participate in polls; share their thoughts on forums, message boards, and

listservs; and join in live chat sessions. Some community-building techniques encourage the use of mobile devices: people can use them to vote, send in text messages, or even create videos to share with others.

A science project called *Firefly Watch* (https://www.massaudu bon.org/get-involved/citizen-science/firefly-watch) uses a somewhat different community-building approach, inviting users to participate in a study as citizen scientists. Researchers suggest that fireflies (which are actually beetles) may be far less numerous today than in the past, and raise the question: are they disappearing? Users are invited to spend 10 minutes each week during the summer to track the fireflies in their own yards or nearby fields. Sponsored by Mass Audubon, the online hub for this project offers simple-to-understand, but fascinating, information about the different types of flashes fireflies send out to help observers track them accurately. Unfortunately, people living west of the Rocky Mountains are not able to participate, because, aside from rare exceptions, there are no flashing fireflies that far west.

Community-building websites like these are effective not only because they tell a story but also because they encourage visitors to actively contribute to it, whether it be a story about an environmental crisis or the life-cycle of an insect.

In addition, it is a common practice today for practically any type of website to build in social objects so a community can be formed around it. These community elements are often managed by a Community Manager, a growing job description.

Games and Game-Like Activities

Games are a highly effective and popular way to involve users in informational material and to absorb it in an experiential manner. Incorporating game-like features into works that are not games is a technique called *gamification*, as we noted earlier. This technique was used by the game developed for the *New York Times* on food inspection, *Food Import Folly*. It was also used in the other serious games described earlier in this chapter.

Two other informational games are *Cutthroat Capitalism* and *The Cat and the Coup*. *Cutthroat Capitalism* (https://www.wired.

com/2009/07/cutthroat-capitalism-the-game/) is a news game about the pirates off the Somali coast, a timely news item when the game was published in 2009 by *Wired* magazine. It helped explain the economics behind Somali piracy. *The Cat and the Coup* (http://www.thecatandthecoup.com) has been described as a "documentary game," and is about the former prime minister of Iran, Dr. Mohammed Mossadegh, the first democratically elected prime minister of that country. In this indie game, which incidentally has wonderfully exotic graphics, you play as the prime minister's cat.

The Internet abounds in informational games for all age groups and on a vast assortment of topics. Just to pick one example to look at more closely, let's focus on a website called *The Mesoamerican Ballgame* (http://mesoballgame.org/ballgame/). The site was produced in conjunction with a traveling museum show and it does an excellent job of involving the user in games and game-like activities. The focus of this website is the ancient basketball-like sport played in Mexico and Central America, a game that was also a serious religious ritual. As you may recall, the ancient game was described in Chapter 1.

The Mesoamerican Ballgame gives users a chance to "play" a version of the ball game itself, though they score points by answering trivia questions about the game instead of tossing the ball through the hoop. In addition, the website contains a number of game-like activities. For example, users can bounce some of the traditional balls, and with each bounce, learn an interesting fact about them. Another game-like activity lets users dress one of the players in his game uniform. In addition to games and game-like activities, visitors can "tour" a virtual ball court and learn more about how the game was played, and also view Mesoamerican artifacts relating to the ball court. The website makes excellent use of animation, sound effects, music, and interactive time charts to make its subject matter vivid and understandable.

Using Humor

Humor is a traditional and effective way to make content engaging. We have seen how the *New York Times* used humor in its

iPhone musical, a work clearly geared for an adult audience. And, as we discussed earlier in this chapter, humor is also an excellent way to involve young people.

Humor can also be used to convey a serious message, as was done by *Dumb Ways to Die*. This seemingly light-hearted jingle with child-like animation, put out by Metro Trains Melbourne as a Public Service Announcement, incorporated a strong message: to observe safe practices around trains. This goofy little video, released in 2012, received 45 million hits on YouTube and its success has led to new videos and several games about safety (http://www.dumbwaystodie.com/watch/#video-player). *Dumb Ways to Die* is a perennial favorite, with new components released regularly and with at least four website overhauls. In fact, it is so popular that it refuses to die. Though the original song is no longer available on the Web, it can be downloaded. The song and its sequels and everything relating to them have their very own wiki: https://dumbways2die.fandom.com/wiki/Dumbwaystodie.com?file=Train-station-website.jpg. There are very few important messages that cannot be conveyed by employing a clever dash or full dose of humor.

Offering Multiple Points of View

Because works of digital storytelling are nonlinear and interactive, they can be designed to give users the ability to explore information from more than one point of view. This is a technique that is sometimes used in interactive documentaries. One such interactive documentary is *What Killed Kevin?* (http://whatkilledkevin.com/), about bullying in the workplace. It is a story about a magazine editor who was allegedly driven to suicide by his boss. Users can view the work from the POV of his sister, his boss, and his co-worker. They can also read emails and other documents, and ultimately decide for themselves whether or not Kevin was the victim of workplace bullying.

Multiple points of view can also be employed in works of virtual reality, as was done in a work called *Conversations*, described in Chapter 17. By allowing users to see a work from more than one point of view, you give them the opportunity to examine the factual

evidence in a number of ways and then come to their own conclusions. This is quite different from linear information content, which only provides one predetermined way of viewing the material.

Other powerful VR documentaries include *The Sun Ladies*, about an all-female Yazidi fighting force that takes revenge on Isis for killing their men and taking their women as sex slaves; *Carne y Arena* (Flesh and Sand) by Academy Award winning director Alejandro G. Iñárritu, which puts the participant in the shoes of a migrant making the dangerous and frightening experience of crossing the desert at night; and *Notes on Blindness*, a powerful true-life story about what it's like to be blind, based on the audio diaries of John Hull. These are just a few of the stunning VR documentaries being produced today.

An Array of Platforms

Throughout this chapter, we have mentioned many different platforms that are used to deliver pragmatic content. Now let's look at the major platforms used for informational content and examine how each serve as a vehicle to impart fact-based messages and stories.

The Internet

When it comes to informational platforms, the Internet is certainly the grande dame of them all, having been used for this purpose far longer than any other digital medium. It now rivals traditional media as a delivery platform for information and news, and it is excellent at delivering densely factual material in an easily accessible manner. And, much in the manner of a grande dame, Web content can be beautifully dressed up in a great many ways. It can be enhanced by media elements like animation, video, sound effects, music, and other types of audio, as well as by interactive elements like multiple narrative paths, diagrams with "hot spots," games, timelines, and activities of various kinds. And all of this can be easily assessed by mobile devices.

However, the Internet's content can also be "dressed down," harkening back to the Internet's modest roots as a text-based medium. Many informational websites are still primarily

text-based, lacking most or all of the "glittery" elements we have described. In such cases (and even when there is plenty of "glitter"), the content needs to be organized in a way that is logical, easy to find, and "chunked" into small pieces, so users are not forced to read long stretches of text. Also, whenever possible, a narrative thread should be teased out of the source material so the content on the website tells an involving story. As experienced journalists know, engaging stories can be pulled out of virtually any source material and assembled in a compelling way.

> **WORTH NOTING: TAXONOMY AND THE INTERNET**
>
> In scientific circles, *taxonomy* is the discipline of classifying and organizing plants and animals. The underlying concept of taxonomy is extremely useful for organizing informational content on the Internet as well as other digital media. The word taxonomy comes from the Greek and is composed of two parts: *taxis*, meaning order or arrangement, and *nomia*, meaning method or law. Though the organization of organisms in biology and the organization of text and graphics for a website might seem to be worlds apart, the basic approach is quite similar. In biology, taxonomy is a hierarchical system, starting with the largest category at the top, and then dividing the organisms into smaller and smaller categories, organized logically by commonalities. The same system works well on a website, and the underlying logic makes it easy for users to find the information they are looking for. Note that taxonomy also works well for other platforms which offer large amounts of information.

In terms of designing a digital storytelling project for the Internet, we've examined projects that used multiple points of view and ones that used gaming, but another important technique is the strong use of visuals. Whether using just a few stills, or using multiple videos and interactive graphics, visuals can very much make a website come alive. *The Packard Plant: Big. Ugly. Dangerous.* is one such project that featured the dramatic use of visuals. The website, produced by the *Detroit Free Press*, focused on the enormous but crumbling plant that used to produce Packard automobiles, but had been shut for years, making it a target of vandals, graffiti

artists, and squatters who chopped up the floor for firewood. The site includes a six-minute video about the Packard plant, an aerial interactive map, and a photo gallery with photos both of its years as a fully functioning factory and its years of shocking decline. The Associated Press honored the site by giving it first place for digital storytelling in the Journalism Excellence competition. Although the website is no longer accessible, a collection of visuals from the site can be viewed at https://www.freep.com/story/news/local/michigan/detroit/2012/12/02/the-packard-plant-then-and-now-interactive-comparison-photos/77199470/.

Social media has become an essential tool for spreading news on the Internet, especially in parts of the world enveloped by civil war or other forms of unrest. We now have a website, *Storyful* (http://storyful.com/), that aggregates social media news stories and serves as a newswire for journalists.

Mobile Devices

Mobile devices are increasingly being used as a portable tool to stay informed about breaking news, sports, weather, stocks, and entertainment. They are particularly useful for delivering short pieces of information, though tablets also work well for exploring a topic in depth. One such app for the iPad and smartphones is *The Elements: A Visual Exploration*. This work has been described as "a love story" to the periodic chart, and it thoroughly examines each element thus far discovered both visually and in text. Even people who are averse to chemistry have found it mesmerizing.

Owners of mobile devices can subscribe to any number of news services that will send the kinds of information they are interested in directly to the cell phones. Some of these news sources, like CNN and Reuters, were originally established for traditional media. Others, like Google News, have their roots in digital media. Most mobile devices can play video and can connect directly to the Internet, thus widely expanding their utility. Also, it should be stressed that mobile devices are designed as two-way streets. Not only can owners of them receive information, but they can also capture and send out breaking news—in text, stills, and video. Thus, mobile phones have become useful tools for collecting data.

Agent-Based Modeling

Agent-based modeling is a common technique used to populate and animate scenes in video games and films with virtual characters. In addition, however, agent-based modeling can be used to tell the story of a vanished people, as was done in a fascinating research project called *The Artificial Anasazi*. The modeling was in part to reconstruct the lives of the Anasazi (ancient Native Americans who were the precursors of today's Pueblo Indians) who lived in The Long House Valley in Arizona between 1800 BC and AD 1300. It was also done to try to solve the mystery of why they suddenly abandoned the place they had called home for centuries. Up until this study, archeologists assumed that the Anasazi throughout the Southwest had deserted their traditional villages because of a disastrous drought that had occurred around 1300. Would the study uphold this theory or not?

The research team populated the valley with "agents" who each represented a household of five individuals, and, based on anthropological information, assigned them life spans, nutritional requirements, and movement capabilities, plus other attributes gleaned from archeological materials excavated in the valley. They were then able to put together a clear picture of how these agents moved around the Valley, how they grouped into clans and villages, and how they responded to changes in the environment and to social conditions. The study clearly demonstrated that, despite the drought, crops could still be raised in the valley, but concluded that the Anasazi's reasons for abandoning this region could still not be determined.

In a slideshow created to explain the project, Dr. George Gumerman, one of the researchers, quoted a line from Pablo Picasso: "Art is a lie that helps us see reality" and paraphrased it thus: "Agent-based modeling is also a lie that helps us see reality."

Locative Journalism

Locative journalism is a term used for audio tours made possible by GPS. Essentially, works that use this technique are the stories of physical places. This form of reporting has also been called *LoJo*, a term coined by a team of graduate students at the Medill

School of Journalism at Northwestern University. LoJo has been used to tell the story of the Berlin Wall, using personal narratives and original source material for the content, and can also be a robust way to tell the story of past events. In addition, LoJo can be used to tell the story of future events. For example, the Medill graduate students created a LoJo project to show what Chicago would look like if it won the bid to host the Olympics.

Interactive and Second-Screen TV

By making television content interactive, viewers can be pulled into the presentation and become actively involved in the program. It offers viewers a much richer connection to the informational content than they would have with a linear TV show. A number of techniques can be used to enhance linear TV programming. They include access to background information (in text, audio, or video); play-along trivia games; participating in polls; and being able to vote in a contest or issue presented on the show and witness the results of the vote. In the UK, the BBC offers a service called BBC Red Button, which is its version of iTV. BBC Red Button was enormously popular during the Olympics held in London in 2012.

Second-screen TV, which is a second device like a smartphone or tablet computer used in conjunction with a broadcast TV show, can be used to access additional information about the TV show and post comments and other material. For instance, if you are watching a baseball game, you can use your second screen to access data about the players, the teams, and the history of this particular competition, and you can also post your thoughts about who will win and why.

Virtual Reality (VR)

Virtual reality installations are unique in the way they can give participants a chance to connect with information content in a deeply experiential manner. As we will see in Chapter 17, VR can be used to immerse people in a recreated news story and observe it from multiple points of view, as with *Conversations*, the true story

of a prison breakout. VR has exciting potential as a platform for experiential treatments of information content.

Two fascinating VR projects are 6×9 and *Nefertari: Journey to Eternity*. *6×9*, produced by the *Guardian* newspaper is a work about the damage a person can suffer by being locked up for long stretches of time in a solitary confinement cell in prison. *Nefertari: Journey to Eternity* gives you the opportunity to explore her lavish 3,000-year-old final resting place accompanied by a knowledgeable guide who will interpret the images in the tomb for you. This work, produced by Reality Virtual and Experius VR, gives you the sense of being a nineteenth-century archeologist. There are no tank-topped gum-chewing tourists bumping into you and obstructing your view, and the tomb is lit only by gas lamps, though you can use flashlights to illuminate details difficult to see in the dim lighting.

Electronic Kiosks

Electronic kiosks are ideal for offering informational content in a public setting, since they are reasonably portable, sturdy, and easy to operate. However, content for kiosk delivery must necessarily be quite concise, since kiosks must serve large numbers of people. They are well-suited as informational delivery systems in government buildings, trade shows, and as adjunctions to museum exhibitions. The housing for kiosks can be dressed up in imaginative ways, serving as an enticement for visitors to try them out.

Kiosks can give users an opportunity to see things that are impossible to view under any other circumstance. For instance, in its exhibit of antique Greek vases, the Getty Museum in Los Angeles designed a kiosk that let visitors examine a precious vase from any angle they chose, as if they were holding the vase in their own hands, and even as if examining it through a magnifying glass. In reality, of course, a museum visitor would never be allowed to touch such a vase, so the kiosk offered them a special experience.

In a similar fashion, the Galleria dell'Accademia in Florence, Italy, installed a kiosk in conjunction with its display of the world-famous statue of Michelangelo's David. The kiosk allows museum visitors to view parts of the giant statue at close range, including parts of the statue that are normally hidden from view.

Interactive Documentaries

Interactive documentaries are made for both large and small screens. Large-screen productions, works that are viewed by audiences in theaters, are primarily found in cultural institutions. They are particularly well-suited to content that is emotionally engaging and offers an interactive exploration of a particular theme, such as marine life, human biology, or ancient Egypt. Several examples are discussed in Chapter 14.

The more intimate works of small-screen iCinema, designed for individual use, are an ideal platform for interactive documentaries because they encourage in-depth examinations of a particular subject or event. Such interactive documentaries can offer multiple points of view, allowing users to experience the story from various angles, as was done with *What Killed Kevin*, discussed earlier. Others, known as *database narratives*, give users the chance to select and assemble small pieces of factual material into a cohesive story. We will be taking a close look at several small-screen interactive documentaries in Chapter 14.

Museum Installations

With digital technology, museum installations have the power to make static displays of artifacts become highly involving and interactive. To do this, museums are making use of animatronic characters, holographic images, and powerful sound and motion effects, as well as immersive environment techniques used in high-tech theme-park rides.

For example, *Le Domus Romane di Palazzo Valentini* is an archeological site in Rome focusing on two long-buried Roman villas that were discovered in 2007 and then excavated. To help visitors understand what these magnificent homes would have looked like at the time they were inhabited, museum curators have virtually reconstructed parts of the villas lost to time, using digital technology to bring them back to life. The exhibit includes a voice-over narration.

In another, far different experience, The Museum of Discovery and Science in Ft. Lauderdale, Florida, gives you the opportunity to go on a high-speed airboat ride in Florida's Everglades on the

Everglades Airboat Adventure, which is a simulation much like a theme-park 4-D dark ride. Passengers are seated on benches, just as if they were on a real airboat, but here, instead of swamp, they are facing a big screen. Everyone has to hang on tight, because the boat makes sudden turns and stops. The exciting simulation even includes a rainstorm, during which you actually feel drops of water (a spray from the walls or ceiling to imitate rain).

Transmedia Productions

The transmedia approach to content, introduced in Chapter 2, presents an integrated narrative over a number of different platforms, and allows users to experience the content and interact with it in a number of ways. Transmedia productions are not constrained in terms of length or style by a single medium and provide a deeper and more dimensional understanding of informational material than does content delivered over a single platform. For example, the transmedia project *Half the Sky* (http://www.pbs.org/independentlens/half-the-sky/film/), based on a book, includes a documentary film, music, an interactive map, a Facebook game, and a social impact campaign. The project focuses on the plight of women around the globe, particularly in Third World countries, who are dealing with gender-based violence, high rates of maternal mortality, and sex trafficking.

To get a better understanding of how a non-fiction transmedia project works, let's take a closer look at the biography of American President Woodrow Wilson. The project integrated a linear three-hour TV documentary with two interactive productions, a website, and a DVD. Jackie Kain, who at the time was VP of New Media for public station KCET in Los Angeles, was in charge of developing both the website and DVD.

As an initial step, Kain closely studied the core material. She noted that the documentary was "a rich story that was narrative-driven" and therefore decided to capitalize as much as possible on its narrative qualities through the interactivity that would be offered. In addition, while the TV biography focused primarily on the international aspects of Wilson's career, she decided to use the website and DVD to portray other parts of his presidency—his

domestic policies and personal life. Thus, the interactive elements of the transmedia production would serve to round out this portrait of a president.

The website would be more text-based, while the DVD would contain more video, thus coming at the same subject matter in somewhat different but complementary ways. They would be tied by a similar graphic design as well. (It should be noted that this project was undertaken before the widespread ability to stream video, which made the inclusion of the DVD particularly valuable.)

The website included an interactive timeline; commentary by historians; and additional information about the people, issues, and events that were important in Wilson's life. One of the site's most engaging and imaginative features was an activity called "Win the Election of 1912." It challenged users to run their own political campaign to see if they could do better than other contenders in that historic race. Players got to invent the name of their party and then decide their stance on certain critical issues of the time. Based on their selections, they either won or lost the election.

The DVD contained 80 minutes of video expressly produced for it, material not included in the TV show. This additional footage, broken into small, "consumable" chunks, consisted of mini-documentaries and interviews with scholars (see Figure 10.8). Kain described them as "short documentaries that tell you a story." According to Kain, these supplemental documentaries were purposely kept short, about five minutes each, so they would not compete with the film itself. Thus, the DVD and the website enhanced the TV documentary, and did so in a highly engaging manner.

Wikis

A wiki is a specialized type of website that allows members of a group, or the general public, to add or edit content. Undoubtedly, the most famous wiki of all is Wikipedia, the huge online encyclopedia. Wikis, however, can be created for almost any topic. One of my students, for example, created a wiki called *The Nanotech Mysteries*, which covered the field of nanotechnology (the study of extremely small things, like molecules and atoms. It included text, audio, visuals, and even a game. Earlier in this chapter, we

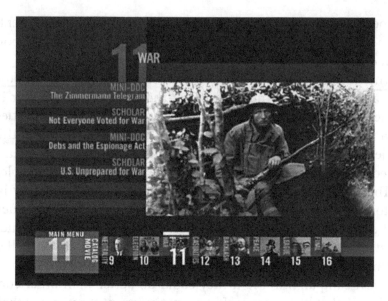

FIGURE 10.8 The menu of the Woodrow Wilson DVD, showing how the information was broken into small segments using principles of taxonomy. Image courtesy of PBS, WGBH, and KCET.

noted that the collection of safety jingles *Dumb Ways to Die* had its own wiki.

Special Considerations for Creating Informational Projects

By their very nature, informational projects are based on facts, and factual material needs to be handled more carefully than material that is pure fiction, especially when incorporating the information into an interactive narrative. Care must be taken not to misconstrue or trivialize the facts or "dumb down" a complex issue. But on the other hand, you do want to create an engaging story that is not bogged down with an overabundance of dry material.

Applying digital storytelling techniques to an informational subject can work surprisingly well even for complex issues. Through interactivity and multiple story paths, these works can offer users more than one way to view the subject. A well-designed project can offer far more than a superficial presentation of a topic, because users can view the material from different angles and dig deeply for additional information.

The answers to the following questions can help you shape a non-fiction project that marries factual material with digital storytelling and does justice to both:

- Will you be taking a subjective or objective approach to the factual material? If your point of view is a personal one, how will you make this clear to users?
- What digital medium or forms of digital media will you use to tell this story, and why are these forms particularly appropriate for the material and the audience? And what kinds of interactive enhancements can you build in that will contribute to an understanding of the material?
- What narrative thread can you pull out of the source material that will be engaging to users and also give a fair representation of the various sides of the story? If your narrative thread is unbalanced in some way, how can you provide users with the opportunity to explore other sides of the story?
- In dramatizing the non-fiction material, are you providing ways for users to get all the important facts of the story? Will you build in ways for people to access supplementary material that is not part of the main narrative path?
- How will you give users an opportunity to participate in the story, so that it is not just a one-way street? Can they contribute stories of their own, or make comments, or provide additional facts? Can they participate in polls relating to the story, or vote on some aspect of it?

ADDITIONAL RESOURCES

To learn more about using digital media for informational projects, the following resources might be helpful:

- The Pew Research Center's Project for Excellence in Journalism, which offers reports on traditional and digital media, as well as a daily briefing: http://www.journalism.org/.
- iDocs, an organization devoted to interactive documentaries: http://i-docs.org/.

- The Alliance for Audited Media, which compiles facts and figures about newspapers and magazines: www.auditedmedia.com.
- *Idea Lab*, a group blog by people who are interested in reinventing media in a digital age: http://www.pbs.org/idealab/about-idea-lab.

Conclusion

Projects with workhorse missions like teaching and training might at first seem to be unlikely venues for entertainment. The same is true for the imparting of factual information and for the promotion of products or ideas. Yet, as we have seen in this chapter, such projects can successfully be blended with traditional techniques of storytelling and contemporary techniques of gaming. Furthermore, they can employ a great many forms of interactive media.

The judicious use of digital storytelling techniques can be a tremendous asset to pragmatic projects. By making the content engaging, these works can entice people to become involved in a topic they might ordinarily avoid.

We have also seen a couple of instances where projects did not succeed as anticipated and, in fact, some badly backfired. We can learn a great deal both by the successes and failures that we have studied. In any digital storytelling project, it can be risky to give users too much control, because they might be tempted to play havoc with it. Failure is far less likely to happen, however, when users enjoy and genuinely respect the material. This respect for the material must originate with the creators themselves. If they feel they are "slumming" and don't exert themselves creatively, this attitude will be perceived by the users. The truth is, creating a successful work in this arena requires pulling out all creative stops.

When it comes to using digital storytelling techniques for pragmatic endeavors, it is important for content creators to give thoughtful consideration to the message they want to send, the culture of the medium they are using, and how best to appeal to

their target demographic. Care must be taken to seamlessly integrate the pragmatic content into the narrative content, without allowing it to intrude jarringly. Humor is always an asset, and should be used to the maximum degree appropriate, since it is a rare individual who doesn't enjoy a good laugh now and then. As we have seen, material that is fresh and original and that gives the user a unique experience, has the best chance of reaching a wide audience.

As the examples offered in this chapter illustrate, elements of exploration, playfulness, and fantasy— close relatives of digital storytelling—can certainly help bridge the disparate cultures of education, journalism, and business.

Unfortunately, because these types of projects are not works of "pure" entertainment, they may be perceived as lacking the glamour of areas like video games. Nonetheless, we have seen many examples here of titles that are extraordinarily creative and cutting-edge, just as much so as projects that have no other mission but to entertain.

When digital storytelling techniques are used imaginatively for pragmatic purposes, and when everything comes together in a well-planned endeavor, it can result in a resounding success. Furthermore, the process of developing such a project is hardly drudgery. Instead, the work can be a creative joy.

Furthermore, endeavors like these perform a genuine service in the world. In addition, they offer a great many employment opportunities. As the use of interactive media continues to spread, it is highly likely that the use of digital media for pragmatic purposes will expand as well. If this prediction is correct, we can expect to see a steady demand for people with the creative ability to stir sugar and medicine together and turn it into a palatable, tasty brew.

Idea-Generating Exercises

1. Select a topic that is taught in elementary school and sketch out a general concept for an edutainment game that would teach this subject.

2. Select a subject for older learners that could be taught as a serious game. This game could be for training purposes, for an advanced educational topic, or to educate people about a health, social, or public policy issue. What is the "spoonful of sugar" in this game?
3. Devise an over-arching goal and a rewards system for the player in each of these games. How would the goals and rewards for the younger learners differ from those developed for the older group?
4. Choose a product that you are familiar with and devise a concept for an advergame or other form of branded content that would highlight its strongest qualities. Try to find an indirect way to give an important message about this product, using subtext rather than a blatant hard-sell approach.
5. Select an organization or profession that you know well and that has a specific need. Sketch out a campaign using digital media and digital storytelling that could make the public aware of the organization and its need, as the US Army did with *America's Army*.
6. Think of a social problem that is currently a public concern and devise a social marketing campaign that could help address this problem.
7. Select an object in the room that you are in and try to create a mobile app or work of AR that would promote this object.
8. Take a current news story that you have read about in a newspaper or magazine or seen on a TV news show. Imagine that you have been tasked with the job of turning this story into an interactive narrative for a news-oriented website. What digital platform would you use? How would you make it both informative and engaging and how could you involve users in the story?
9. Pick a subject from history and sketch out an idea on how you could develop it as an interactive narrative. What platform would you use? What digital storytelling techniques would you employ?
10. Select a current events topic that is the subject of public concern, such as corruption in the government or immigration. Sketch out an idea for an informational game on this topic.

Part 4
Media and Models: Under the Hood

Chapter 11

Video Games

Can video games be a robust venue for storytelling?
What can we learn from video games that we can apply to other forms of interactive entertainment?
What are *casual games* and how do they differ from other forms of gaming?
What is it about massively *multiplayer online games* (MMOGs) that makes them such a potent form of gaming, to the point that some players become addicted to them?
What common mistakes do inexperienced game developers make in building a new game?

Video Games: The 10,000-Pound Gorilla of Interactive Entertainment

Video games are the granddaddy of all forms of interactive digital entertainment. *Pong*, the world's first successful video game, debuted in 1972, almost a full two decades before the World Wide

Web was even born and long before other types of digital media were introduced. In the intervening years, video games have not only evolved enormously but have also had a profound influence on a great many other forms of interactive digital entertainment. In addition, as we saw in Chapter 10, games are not just a significant form of entertainment, but are also being used to teach, promote, and inform, often using a technique called *gamification*.

Furthermore, over the years, video games have migrated from their original platforms (arcade machines, PCs, and consoles) to a wide variety of venues, including smartphones, social media, and tablets. They have even spilled out into real-life locations, such as theme parks, museums, and city streets. Innovative developers regularly roll out new devices to support gameplay and new ways to enhance the experience of playing.

As we will see in future chapters, even forms of interactive entertainment that are not strictly video games, such as interactive cinema, immersive environments, and second-screen TV, often contain gaming elements. Thus, it would be impossible to write a book about digital storytelling without a deep bow of acknowledgment to this pioneering form of entertainment.

Video Games and Their Place in the Overall Entertainment Universe

Over the past decade, games have become a dominant form of entertainment, even drawing away audiences from movies and television. It is no longer uncommon for a popular game to generate more revenue than a blockbuster movie. For example, the most money-making game of 2018 was *PlayerUnknown's Battlegrounds*, which made $1.028 billion that year, significantly beating out the most popular movie of 2018, *Black Panther*, which only made $700 million that same year.

Critics of video games sometimes accuse them of being a lesser form of entertainment than novels, stage plays, and movies, and one that does not qualify as art. For example, the late film critic Roger Ebert wrote a famous blog post in his *Chicago*

Sun-Times blog entitled "Video Games Can Never Be Art" (April 16, 2010), which enraged the gaming community. However, no less an august body than the US Supreme Court has ruled that video games are every bit much an art form as older forms of narrative. In a decision that came down in 2011, the late Supreme Court Justice Antonin Scalia declared: "Like the protected books, plays and movies that preceded them, video games communicate ideas—and even social messages—through many familiar literary devices (such as characters, dialogue, plot, and music) and through features distinctive to the medium (such as the player's interaction with the virtual world)." He concluded: "That suffices to confer First Amendment protection." The First Amendment to the Constitution of the United States protects the right of free speech.

It would be nice to think that we don't need the Supreme Court to tell us that video games are an art form, even though not everyone agrees with this. But already in their brief history, games have proven to be a unique and powerful way of involving their audience. In addition, today's plots are, for the most part, far more compelling than the plots of earlier games and often sound quite movie-like. One older but often used example of a movie-like plot is the storyline of *Tomb Raider: The Angel of Darkness*. In this game, Lara Croft is accused of the murder of her one-time mentor, Von Croy, and becomes a fugitive on the run. With the police in hot pursuit of her, she tries to find out who murdered Von Croy and why (see Figure 11.1). The plot contains a strong resemblance to the well-regarded movie thriller, *The Fugitive*.

While it is true, however, that today's games look and sound more like movies, many people within the gaming community are uncomfortable with calling games "cinematic." They recognize that games often have far stronger storylines than in the past, the graphics are far better than the early days of games and contain "cut scenes," (also called "cinematics") which are linear sequences that offer important story information, much like a scene in a movie; they stress that the two forms of entertainment are "apples and oranges." In an article for *Wired* magazine (April 2006), game designer Jordan Mechner, who wrote and directed the original *Prince of Persia* game, noted that newer media often

FIGURE 11.1 Lara Croft becomes enmeshed in a dark, movie-like plot in *Tomb Raider: The Angel of Darkness*. Image courtesy of Eidos Interactive.

model themselves on older media until they develop as a unique art form. Mechner went on to say:

> As we game makers discover new ways to take storytelling out of cut scenes and bring it into gameplay, we're taking the first steps toward a true video game storytelling language — just as our filmmaking forbearers did the first time they cut to a close-up. One day soon, calling a game 'cinematic' will be a backhanded compliment, like calling a movie 'stagy.'

The Great Debate

One ongoing and intense debate that has been raging among game scholars and game developers is the question of whether or not games can even be regarded as a form of storytelling. Two warring groups have squared off on this issue. On one side, we have

the *narratology* camp. They say, yes, of course, games are a form of storytelling and they can be studied as narratives (the term "narratology" simply means the theory and study of narrative). Janet Murray, the author of the classic book on interactive narrative, *Hamlet on the Holodeck*, and a professor at the Georgia Institute of Technology, is a leading advocate of the narratology position.

On the other side of the battlefield, we have the *ludology* camp. Espen J. Aarseth, a well-respected game scholar, is the most vocal proponent of the ludologist camp. The term ludology comes from the Latin word *ludus*, for game. The ludologists argue that even though games have elements of narrative like characters and plot, this is incidental to the things that make them a distinct creative form, such as gameplay. Thus, they assert, games should be studied as unique constructs. This debate has an emotional undercurrent to it, because the ludologists suggest that the academics who espouse narratology are elitist and fail to recognize games as worthy of study on their own merits.

Not everyone who works in games feels that it is necessary to pick a side; a number of professionals in the video game business tend to look at the bigger picture. For example, game developer Jesse Schell, in his book *The Art of Game Design*, says: "Ultimately, of course, we don't care about creating either stories or games—we care about creating experiences." Schell is an expert on games. He is not only CEO of Schell Games, a team of over 100 people who have published a great number of successful games, but he is also Distinguished Professor of Practice of Entertainment Technology at Carnegie Mellon. In a face-to-face interview, I asked Schell how important storytelling is to games. "How much story depends on the kind of experience you want to offer," he replied. In essence, he feels story can be important or not significant at all. He noted that some games have no story, but a story would make them better.

Clearly, if sides must be chosen in this debate, this book is most closely in allegiance with the narratologists.

Narrative in Games

While the narratology versus ludology debate may rage on through infinity, no one can flatly deny that games, on the whole,

do contain story content. This content includes, among other elements, developed characters, plot, character-based goals, challenges that characters must overcome, and dramatic conflict. The amount of story contained in games varies hugely. Some games contain no story at all while others offer richly nuanced narratives. And in some cases, the story content is formed by the choices the players themselves make, rather than being built into the game. This is particularly true of sandbox games.

It must be acknowledged, however, that the kinds of narratives found in games differ from narratives found in other media. Designer Greg Roach, introduced in Chapter 3, puts it this way: "Novels tell; movies show; games do." In other words, games are all about actions, the things you, the player, do. Games are performance experiences. But this focus on action has a downside, as well. Game designer Darlene Waddington notes that "games tend to be all about the 'hows' and not about the 'whys.'" She feels, for instance, that they are good at getting the player into a combat situation, but are less good at probing the psychological or human reasons for getting into combat in the first place.

Waddington's point about the focus being on action while giving scant attention to motivation is a criticism often leveled at games. While games now offer more fully developed characters and storylines, they generally lack the depth of older forms of entertainment. With few exceptions, they do not look deeply into the human psyche or deal with a full spectrum of emotions. How often, for example, do we encounter or play a character who is motivated by shame, love, compassion, guilt, grief, grief, or the dozens of other emotions we humans feel? Yet such emotions are the underpinnings of dramas we can find in movies or the stories we read in novels. One notable exception of games lacking strong human emotions was discussed in Chapter 5, the game *That Dragon, Cancer*, about parents grappling with the terminal illness of their little boy.

Most game developers will argue that the story is only there to serve a functional purpose rather than being the prime attraction, which is good gameplay. Yet, without a story, the gameplay lacks a context to be meaningful. Story provides the game with objectives and challenges, meaningful victories and defeats, and an overall

storyworld to play in. Thus, even a minimal amount of story content serves a functional role in a game.

Game writer Christy Marx made an interesting observation about storytelling and games many years ago, in an article she wrote for *Written By* magazine (December 2003). She noted that games began as a programmer's medium, and since they were text based, they didn't require a writer or artist. The one essential element these early games did require was code. Marx theorizes that this early game culture, with the dominant role of the programmer and the non-existent role of the storyteller, continues to permeate the game development world. Nevertheless, the game industry is increasingly aware of the importance of good storytelling in games, and top Hollywood screenwriters are often hired to work on games. But even today, many of these screenwriters are only asked to write dialogue, thus bypassing their abilities to make significant contributions to the projects they work on.

Veteran Hollywood writer Randall Jahnson, who successfully made the transition between screen writing and game writing, told the *Hollywood Reporter* (November 23, 2005) that the process of writing for the two media was completely different. He compared writing for games to writing haiku, because the plot points and dialogue had to be far more compressed than in a screenplay, where you don't have a player itching to jump into the gameplay. On the other hand, he found that games gave him the opportunity to explore subplots and tangents of the story that there would be no time to develop in a screenplay.

> **NOTES FROM THE FIELD: WRITING A GAME IS LIKE WRITING AN OPERA**
>
> An extremely savvy game professional recently compared the job of writing a game to that of writing an opera. Why? Because in both cases, the stories are painted with a broad brush and the plots often lean toward the melodramatic. But, even more importantly, the storytelling in opera needs to leave room for the music and performance, and the storytelling in games needs to leave room for the gameplay. This observation, quoted in the UK version of *Wired* magazine (March 4, 2013), was made by

> Margaret Robinson, managing director of Hide and Seek, a UK game design company. She said: "the libretto shouldn't have to tell you everything you need to know about the character or the setting or the underlying scene ... There's a little bit of that in games, to leave space for the action and the player."

Adapting a Game from Other Source Material

When developing a new game, a special type of story development situation arises when the game is being adapted from a property that exists in a different medium. This type of adaptation is full of unique challenges, some of which were mentioned in Chapter 2. Yet stories that were first told in movies, TV series, comics, and novels have been an irresistible source of narrative material for video games. No genre or platform of gaming seems immune from this type of adaptation. Just as one example, the immensely successful *Harry Potter* novels have been turned into a multitude of games, including the highly anticipated AR game, *Harry Potter: Wizards Unite*.

Nonetheless, the process of adapting a game from a different medium is a challenging one, and each adaptation has its own unique set of challenges. For example, a number of years ago I worked on the script and text for Disney and Pixar's adaption of the original *Toy Story* movie. We were turning the movie into *The Toy Story Animated Storybook*, which blended a game with a storybook. As a writer, I had two big challenges. First of all, the hero in the movie is Woody, a toy cowboy, but we couldn't use Tom Hanks (who voiced Woody in the movie) in this adaptation. Instead, we had to tell the entire story from the POV of another character. Fortunately, the substitute narrator who was chosen was a highly engaging, somewhat sardonic toy: Hamm, the piggy bank. So I had to reimagine *Toy Story* from a pig's POV, which was a major change from the source material, though an entertaining writing challenge.

The second difficult task was incorporating meaningful interactivity into the adaptation, and the obvious ways to do it were

not necessarily in the best interests of the project. For example, in the film, the toys enjoy playing checkers with each other, and some members of the team believed we should include a game of checkers in the adaptation. The problem here, though, is that a checkers game wouldn't advance the narrative at all and wouldn't involve players in the story. It would just stop everything dead. Instead, I helped create a mini-game where players were challenged to quickly put all the toys in Andy's room back in their proper places before Andy and his birthday party guests could enter the room and make an alarming discovery: that the toys could come to life when humans were not around. This added a sense of urgency to the interactive story and gave the players a meaningful degree of agency.

The Unique Characteristics of Video Games

A well-designed video game has certain characteristics that make it enjoyable to play and that facilitate the experience of playing. These characteristics are also unique to games, as opposed to other forms of media that contain story content. These characteristics relate directly or indirectly to the game's narrative. Let's take a look at three of these characteristics.

Gameplay

In the broadest of strokes, gameplay is two things: it is what makes a game fun, and it is how a person plays the game—the way in which they control it and the way in which it responds. It is what gives a game its energy and makes it exciting. To understand gameplay, you must understand what a game is. Games involve the player in achieving an ultimate goal, but in order to do this, the player must first overcome a series of challenges. If successful, the game is won; if unsuccessful, it is lost. Games also provide a unique kind of instantaneous feedback to the players' input and choices. If this feedback/response mechanism is satisfying, intuitive, and smooth, then the players' experience of the gameplay will probably be a positive one. If the game's response is imbalanced,

jerky, slow, or confusing, then the gameplay will probably be perceived negatively.

Gameplay consists of the specific challenges that are presented to the player and the actions the player can take in order to overcome them. Victory and loss conditions are also part of the gameplay, as are the rules of the game. Story enters into this dynamic because it is what puts gameplay in context. The game's overall goal is established through the story, as are the challenges the player encounters and the victory and loss conditions. Story provides motivation for the player to want to keep playing and makes the experience richer. Some games, though, do not have any narrative thread. This is particularly true of casual games.

Artificial Intelligence (AI)

AI in games is the element that can make a game seem eerily lifelike, and this is done by giving realistic behaviors to NPCs. AI is primarily the domain of the coders and only exists in digital media. It can make NPCs act like living, intelligent creatures. These AI-enhanced NPCs can interact and converse with player characters and respond to them in an appropriate way, given the context of the situation they are in. Some of these extra-smart NPCs can, through "observation," even learn about a player's weaknesses and strengths. This "knowledge" can be used either to the player's disadvantage (to track and kill him) or to the player's advantage, with the NPC acting as a loyal and protective buddy. AI is one of the elements that can distinguish the playing of video games from all other forms of entertainment.

Interface and Navigation

Interface is what connects the player and the game. It enables the player to receive important information and to take actions within the game. Furthermore, it gives the player a way to evaluate how well he or she is doing. A well-designed interface can help make a game fun, while a poor one can make it frustrating and disappointing.

There are three major forms of interface: manual (hardware such as controllers and keyboards); visual (icons, maps, meters); and auditory (verbal feedback, cues from the environment, music). Interface provides important information about geography, player status, inventory, and whether the player is succeeding or failing. Interface also gives the player the ability to do such things as run, jump, shoot, and use weapons or tools. In addition, a game must have navigational mechanisms so that the player has the ability to move his or her avatars, vehicles, or objects from one point to another in the virtual world.

Categories and Genres of Games

Video games comprise an enormous universe made up of a diverse array of offerings. In order to get a clearer picture of this universe, it is useful to know the different ways video games are played and how games are categorized.

Game Platforms

Even though members of the general public often lump together all types of games and refer to them generically as video games, gamers themselves and professionals in the field customarily divide them into several large categories, based on the type of platform (hardware and/or software system) that they are designed to run on. Each platform is best suited for a particular type of play experience, and the popularity of the various platforms has shifted over the years.

Among the most popular platforms are console games (devices that are specifically designed to play games); personal computers; smartphones and tablet computers. While the first games were played on arcade machines, and were the only way games could be played, the once bustling arcade parlors have largely vanished, although arcade machines can still be found in sports bars and in the lobbies of movie theaters.

In recent years, a revolutionary new way to play games was introduced: games controlled by one's movements. The first of these motion-based game systems was the Nintendo Wii, launched in 2006. The Wii is operated in part by a hand-held controller, but a camera

built into the device "reads" the player's motions, and the player's motions, in turn, determine to a large degree the action one sees on the screen. Special peripherals enhance the experience further. For instance, with Wii Fit, players can control action via a balance board, and can compete in skiing games or whack soccer balls tossed by a rival team. The Wii retractable golf club lets you play golf games on a variety of courses or practice your swing, while the Wii Zapper, a plastic gun-shaped device, enables you to play games where you need to be armed with a weapon. Such games range from war games to horror games to zombie games, and even pit you against dinosaurs.

In 2010, Microsoft launched its own motion-based system, the Kinect for the Xbox 360. Unlike the Wii, it was totally controller free and operated entirely by the player's movements. In addition, the Kinect also offered voice recognition and facial recognition. The Kinect offered entirely new kinds of gaming experiences. For example, in the game *Harry Potter for Kinect*, players can use the facial recognition system to scan their own faces onto that of a witch or wizard in the game, and maneuver that character through Harry Potter's world. In addition, players can use the voice recognition system to cast spells against their opponents by calling out spell names along with the appropriate physical gestures.

Other tweaks on motion-based game consoles have occurred throughout the years. For instance, in 2012, Nintendo introduced Wii U, a successor to the Wii. Its major innovation was a redesign of the controller, renamed the GamePad. It incorporated a touch screen in the center of the device, turning it into something that looked like an iPad surrounded by a traditional controller. Unfortunately for Nintendo, the Wii U was not the success it was hoping for. In 2013, Microsoft unveiled the Xbox One, which incorporates a redesigned Kinect and is meant to serve as an all-in-one entertainment center. It can be used to watch TV, surf the Web, or Skype with friends and family. It retains all the features of the original Kinect, which has been somewhat updated, and can be controlled primarily through voice commands. The gaming system is both cloud-based and can run disc-based games.

In a completely different approach to a controller system, one that involves an app rather than hardware, Microsoft introduced the Xbox SmartGlass in 2012. It is a companion application to

the Xbox and, among its many features, SmartGlass works as a second-screen support system, allowing players to use their smartphones or tablets, in part, as game controllers. Newer game systems like the Oculus and Vive now support virtual reality.

> **STRANGE BUT TRUE: QUIRKY CONTROLLERS**
>
> Innovative designers and scientists have invented some surprising new ways to control video games. For example, while Joe Kniss was a Computer Science professor at the University of New Mexico, he devised a way to control a game via riding on a skateboard, and he demonstrated his device by playing a game in which he had to negotiate through space while dodging meteors. A more sophisticated iteration of his concept morphed into what he called the hexdex, a six-sided platform that could be tilted in any direction, this controlling the action on the screen.
>
> And then there's the Virtusphere, a globe-shaped hollow device that resembles a giant hamster ball. The Virtusphere is designed to be used for virtual reality (VR) experiences. The player, wearing a head-mounted display (HMD), climbs into it, and by moving in any direction—walking, running, or even crawling— controls the images he sees.
>
> More extraordinary than either device, however, is a controller that every single player already comes equipped with—the brain. A New Zealand company has developed a 14-sensor headset called the Emotiv EPOC that can harness the power of the mind. A German team has already demonstrated how the headset can be used to operate a real car, to make it speed up, slow down, or turn right or left. If a real car can be controlled in this way, it is not much of a leap to imagine using this technology to control an automobile in a video game. Designers around the world, such as InteraXon, the Canadian team behind a brain-sensing headband called Muse, are currently working on brainwave controllers, experimenting with new ways to use brain power to control video games.

Small Was Big

For a while, miniaturization was a popular trend in console design. For example, the Ouya, which uses the Android

operating system, was a game console shaped somewhat like a rounded cube and smaller than a can of soda pop. Often compared in size to a Rubik's Cube, it was a huge hit on Kickstarter in 2013, quickly raising over eight million dollars, even though it had only set a more modest target of under a million dollars. In short order, over 12,000 game developers pledged support to the new console.

Not to be outdone, the GameStick, which also came out in 2013, was even smaller, just the size of a flash drive. Developed by PlayJam, it is designed to plug directly into the TV. Like the Ouya, it used the Android operating system. Sadly, despite the original excitement about them, neither console had what it took for a long-distance race. The Ouya was considered basically dead by 2014 and GameStick shut down in 2017.

Types of Games

Games can be divided and grouped into two very large categories: the way the game is played, and the game's genre. In the discussion of game platforms, above, we reviewed a number of ways games can be played, in terms of the hardware that they are played upon. We will discuss some other, very different, ways games can be played a bit later in this chapter. But first, let's focus on genre.

Game Genres

Just as with films, novels, and other forms of linear narratives, games are often divided into large general categories called genres. Works within a specific genre follow the same conventions, almost like a formula. These commonalities include having similar settings, characters, subject matter, and type of action. Knowledge of game genres gives us a useful shorthand to refer to different games and to understand their prominent characteristics. Furthermore, by studying the various genres, one gets a sense of the scope and variety of experiences possible within interactive media, and one begins to see how some of these elements can be ported over to other forms of interactive entertainment.

However, the once clear lines dividing game genres has blurred. As one of my avid game-playing students, Twig Deluje', astutely observed,

> The world of gaming is morphing more and more with the accessibility of hand-held devices such as smartphones and tablets. The ability to connect with more people at a larger scale and "play" or interact with them has broadened the audience base of gaming as a whole. Much like literature, the genres of gaming have increased and also sub-divided so that there is now something out there for everyone. This shift has also allowed gaming to become a far less solitary or isolating activity.

Thus, as important as it is to have an understanding of game genres, the process of assigning a particular game to a particular category can be fairly tricky. No two experts will agree to exactly the same definition of a genre, and no ruling body exists to regulate what game belongs where. Often, a particular game will have characteristics of more than one genre. Nevertheless, here is a list of what most people would consider to be the most common genres of games:

- *Action games*: these games are fast-paced, full of physical action, and often call for a great deal of hand-eye coordination and strategy. Some, like the popular *Deus Ex* and its sequels, contain a great amount of story (see Figure 11.2). Action games are one of the most popular of all genres.
- *Adventure games*: more than any other type of game, adventure games feature the strongest use of story. Typically, the player is sent on a quest or has a clear-cut mission and must solve a number of riddles or puzzles in order to succeed. Players also explore rich environments and collect items for their inventories as they move about. Generally, these games use a preconstructed protagonist, as opposed to an avatar that the player creates or defines. These games have a very old history, dating back to text-based games such as the *Colossal Cave Adventure*. A subgenre of the adventure game is the mystery-adventure game, which includes the *Nancy Drew* series, discussed in

FIGURE 11.2 A screenshot from *Deus Ex: Invisible War*. The game tells a complex story involving global conflict and intrigue, and falls into the action genre. Image courtesy of Eidos Interactive.

other chapters. While adventure games were highly popular in the 1980s, they have fared less well in recent decades.
- *Action-adventure*: a subgenre of the adventure game and an extremely broad term that can be applied to a wide variety of games. Unlike pure adventure games, which feature very little physical action, these games do involve combat situations and demand quick reflexes.
- *Survival horror*: a subgenre of the action-adventure game. In terms of story and ambience, they are much like a horror film or horror novel. The player is immersed in a terrifying and claustrophobic setting, discovers troubling objects or frightening characters, and must try to use whatever objects or weapons are available in the storyworld to survive and prevail. *Silent Hill* and *Resident Evil* are two popular series of survival horror games.
- *Sports and driving games*: these games focus on various types of team or individual sports, or on car racing. The sports games are highly realistic and call for strategy as well as good control of the action. Gamers may play as an individual team member or may control an entire team. A number of major athletic organizations, such as the

National Football League, license their names for sports games, as do star athletes.

- *Role-playing games* (*RPGs*): in this genre of game, the player controls one or more avatars, which are defined by a set of attributes, such as species, occupation, skill, and special talents. The genre evolved from the precomputer version of *Dungeons and Dragons*. Contemporary descendants are played online with large numbers of players and are known as massively multiplayer online role-playing games (MMORPGS, also called MOOs, MMOGs, and MMOs). See later points in this chapter for more on MMORPGs. They include *Lord of the Rings Online*, an enormously popular MMORPG.
- *Strategy games*: these games, as the name suggests, emphasize the use of strategy and logic rather than quick reflexes and hand–eye coordination and thus are more cerebral than many other genres. In these games, the players manage resources, military units, or communities. The *Command and Conquer* series are strategy games. Gameplay is generally turn based.
- *Real-time strategy games* (*RTS*): these games are a subgenre of strategy games, and the gameplay progresses in real time, rather than by the taking of turns.
- *Multiplayer online battle arena* (*MOBA*): MOBAs, also known as action real-time strategy games (ARTS) are a subgenre of real-time strategy games, and a relatively new form of online gaming. Often two teams of players compete against each other and each player controls a single character. Teams are ideally made up of characters with different and complementary strengths.
- *Massively multiplayer online games (MMOGs)*, mentioned above (also called MOOs, MMORPGs, and MMOs): online games in which thousands of players participate at the same time, and which are typically set in a sprawling fictional landscape. MMOGs are persistent universes, which means that the game action continues even after a player has logged off.
- *Massively multiplayer online role-playing game* (*MMORPG*): these are MMOGs in which players control

one or more avatars and go on quests with other players. These games typically stress cooperative play. MMORPGs are one of the popular subgenres of MMOGs and are discussed in more detail later in this chapter. As of 2019, the three most popular MMORPGs, ranked by total number of active players, were *World of Warcraft*, *Guild Wars 2*, and *The Elder Scrolls Online*.
- *Social media games*: games that are designed to be played with one's friends on social media sites like Facebook. They are generally free to play but micropayments are often necessary in order to advance in the game. *Farmville* was one of the first major successes in this genre (see Chapter 8 for more on social media games).
- *Free to play (F2P)*: these are games that are free to play, or free to download. They can be virtually any genre. As with social media games, players may be invited to make small payments for in-game items or to enhance the gameplay experience. In some cases, a F2P version of a game is designed as a way to promote the pay-to-play version of the game.
- *Otome games*: a genre born in Japan and typically designed for female players, otome games feature a romantic plot and the usual objective is to end up with the desired boyfriend. Their visual style resembles manga (Japanese comic books).
- *Shooters*: shooters, as the name suggests, involve shooting at things—either at living creatures or at targets. In a shooter, the player is pitted against multiple opponents and can also be a target; in a first-person shooter (FPS), the player is given a first-person point of view of the action. Examples of shooter games include the wildly popular *Halo* series.
- *Puzzle games*: puzzle games are generally abstract and highly graphical and call for the solving of various types of puzzles. Some would also assert that the genre includes games that offer story-based environments that are generously studded with puzzles. *Tetris* is an example of the abstract type of puzzle game, while the classic game, *Myst*, is an example of the story-based type of puzzle game.

- *Fighting games*: in these games, players confront opponents in an up-close-and-personal way. The encounter may lead to death, or at least to a clear-cut defeat for one of the opponents. The games typically emphasize hand-to-hand combat instead of guns or other modern weapons. The *Mortal Kombat* games are fighting games.
- *Simulations*: a simulation may offer the player a physical experience such as flying a plane or parachute jumping, or may offer the opportunity to create a simulated living community. Examples of the first type include the *X Planes* series for flying planes. The community-building type of simulation would include *The Sims* series and *Sid Meier's Civilization*, although some would argue that these games belong to the strategy category.
- *Platform game*: these fast-paced games call for making your character jump, run, or climb through a challenging terrain, often while dodging falling objects or avoiding pitfalls. Such games require quick reflexes and manual dexterity. Classics of this genre include *Donkey Kong*, *Super Mario Bros.*, and *Sonic the Hedgehog*.
- *Casual game*: a game that is easy to learn but difficult to master, and that can be played in a short amount of time. They include a wide variety of genres, such as shooters, puzzle games, and racing games, and they are highly popular on mobile devices. *Angry Birds* is a casual game, as is *Tetris*. Casual games are discussed in more detail later in this chapter.
- *Text-based game*: a game that employs words rather than visual images. Players input word-based commands to control the action. Such games were one of the earliest forms of gaming and though they almost died out once it became possible to use graphics in games, they are enjoying a resurgence, and are a pillar of interactive fiction (IF). Most MUDs are text-based.
- *Serious game*: a game designed to fulfill a pragmatic purpose rather than to be just an entertaining experience. Serious games are made for educational, informational, and promotional purposes and customarily use the same

techniques as games made for pure entertainment. Serious games are discussed in more detail in Chapter 10.
- *Cognitive game*: a game designed to sharpen a person's mental capabilities such as memory, math skills, and logic. They are a subgenre of serious games.
- *Open world games*: these games are typically set in vast environments which the player can explore freely, and they offer players a rich variety of activities to enjoy, from shopping to fighting to operating a variety of vehicles and aircraft. Unlike most games, they do not force a player down a set story path via a structure made up of levels. Instead, although they do contain an overall goal and story elements, they are totally nonlinear and they allow the player to choose what to do at any point. The *Saints Row* games are open worlds, and many consider the *Grand Theft Auto* series to also be open worlds. Open world games and *Saints Row* are discussed in more detail later in this chapter.
- *Sandbox games*: these games have much in common with open world games, and in fact, some people use the terms interchangeably and some argue that sandbox games are a subgenre of open world games. Like open world games, they are set in large environments that can be explored freely and they allow players to decide what they want to do throughout the game. However, when distinctions are made between open world and sandbox games, sandbox games are regarded as a "toy box" that contains tools that players can use to modify the game world and gameplay. Instead of containing set story elements like an open world game, players can construct a narrative while playing, creating an *emergent story*. *Minecraft* is considered a sandbox game.
- *Mobile games*: these are games designed to work on handheld devices like smartphones and tablets. *Pokémon GO* is an excellent example of a mobile game, as is *Angry Birds*. Sometimes simplified versions of complex console or online games are developed for mobile devices. You can now play the *Grand Theft Auto* series on your phone or tablet.

- *AR and VR games*: by 2019, a flurry of new games was being developed for augmented reality and virtual reality, in part spurred by the success of *Pokémon GO*. VR games can now be played in theme parks and entertainment centers and even in 50-foot tractor-trailers parked outside select Walmart's stores, as described in Chapter 10. AR and VR games will be described in more detail in Chapter 17.
- *Battle royale*: a type of shooter-survival game, of which *Fortnite: Battle Royale* is a runaway hit. See the section "The Enormous Popularity of *Fortnite*" later in this chapter.
- *Audio games*: these are games that are controlled by one's voice through an app like Alexa. They are popular because they can be played in places where you cannot see a screen, such as when you are driving. Many audio games were described in Chapter 2, including *Skyrim*.
- *Toy-based games*: these are games where players manipulate physical toys as part of the gameplay. In *Starlink: Battle for Atlas*, you can build a toy starship with a pilot, wings and weapon of your choice, and see it fly into action on-screen, in the video game.

The Ways Games Are Played

In addition to the dazzling variety of game genres, games can be played in a variety of ways that go far beyond "traditional" game platforms, like game consoles, which we discussed above. A number of these ways of playing take place outside of one's house, where games are typically played. Location-based games are a good example of this alternative way of playing. These games take place in real life environments, most often in urban settings, and pieces of the game are dispersed or supported through various forms of digital technology, including websites, smartphones, GPS coordinates, and QR readers. Some games also take advantage of augmented reality (AR), which is used to create images or sounds that seemingly exist in the real world but are part of the game. In location-based games, players must venture out into the real world, to specific sites, to uncover clues or pieces of the story.

The Q Game: City of Riddles, discussed in Chapter 2, is an example of a location-based game, as is *Pokémon GO*, the immensely successful AR game.

Alternate reality games (ARGs) are an even more complex form of gaming that is not tied to any single platform. They can be partially played at home (by investigating clues on websites and by collaborating with other players on dedicated websites) but mostly played in the real world, by following clues in real locations and taking part in live events. These games are forms of transmedia storytelling and often employ multiple digital platforms as well as traditional media. ARGs are discussed in detail in Chapter 2.

A completely different gaming experience that takes place outside of the home is the immersive multiplayer motion-sensing game. To date, this is a fairly rare type of gaming, but it can be found at Disney's Epcot Theme Park in Florida, in a set of games produced for the *Living Landscapes* pre-show for the *Soarin'* ride. In this type of gaming, an entire group of people control the game by their motions (such as waving their hands), much as a single player controls a game made for the Wii or the Kinect (see Figure 11.3). This type of gaming, and the kinds of stories it can incorporate, is discussed in Chapter 18.

FIGURE 11.3 Guests interacting with one of the multiplayer immersive games produced for the *Living Landscapes* pre-show for the *Soarin'* ride at Epcot. Image courtesy of © Disney Enterprises, Inc.

The Enormous Popularity of *Fortnite*

Fortnite, developed by Epic Games and released in the fall of 2017, has been a massive hit since its earliest days. Within the game's first ten weeks, it had already made 1.2 billion dollars and soon had 200 million registered players. Its popularity has spanned an enormous fanbase, from little children, to preteens, to teens and people their parents' age, and includes professional athletes and rappers.

The game has three modes of play: *Fornite: Save the World*, *Fortnite: Battle Royale* (released also released in 2017), and *Fortnite Creative* (released in 2018). Of the three modes, it is *Fortnite: Battle Royale*, a multiplayer shooter, that has been the runaway hit. A battle royale is a newly established genre of gaming in which combatants fight amongst each other until only one individual or faction survives. This gaming conceit is roughly based on a Japanese film, released in 2000, called *Battle Royale*, a thriller survival game about a group of ninth graders. In *Fortnite: Battle Royale*, 100 players are dropped from a purple "Battle Bus," which is suspended from a hot-air balloon, onto the playing field, where they fight amongst each other until only one combatant or faction is left standing. They can also build forts, search for weapons and loot, and explore the inviting landscape. The deadly playing field keeps shrinking, though, raising the stakes that you might get shot.

The game does not have a plot, established characters, or dialogue. The story emerges from the user's gameplay—how the player blew up a fort or snuck up on another player and shot him. Story elements are also regularly added to the game as live events: a comet zooming towards earth and making an enormous crater or violent change in the weather. The game has an inviting, cartoony look and the battles are bloodless and not gory. Some combatants are dressed up as bananas while others might be wearing gingerbread heads.

Fortnite: Battle Royale has often been compared to *PUBG*, *PlayerUnknown's Battlegrounds*, another battle royale game. By contrast, however, *PUBG* is a violent, ultra-realistic shooter, while

Fortnite: Battle Royale has more of a family-friendly, happy take on this gaming genre. Despite their similarities, the two games tend to attract very different players.

A number of reasons are given for *Fortnite*'s success. For one thing, the game is free to play (except for the *Save the World* mode, which is pay-to-play), and it can be played on almost any device. Many commentators note in a positive way that the game does not look free, but instead looks and feels like a premium game. Though *Fortnite: Battle Royale* is free to play, gamers can purchase new skins, weapons, and other items, including dances (!), with V-Bucks, which cost real money to purchase.

Furthermore, it's fun to play and fairly easy to learn. It is also not a static game: as noted earlier, new elements are added regularly. Some of these in game events have a seasonal theme. For instance, a little before St. Patrick's Day in 2019, a rainbow appeared, visible wherever you were in the landscape. One could also purchase a pot o' gold pickaxe, a green skin for your motorcycle, and, for female warriors, a Sgt. Green Clover skin that has a leprechaun motive, crowned with a perky green top hat. Players also enjoy the social aspect of the game, and for many teens it has become a central hang-out.

New Games and the Fading Away of Once-Popular Genres

The games marketplace is a constantly changing arena, with new genres being introduced and some experiencing soaring popularity, like *Fortnite*, while genres of games that were once blockbusters disappear from sight. For example, when I first entered the games field, I worked on educational games like *Where in the World is Carmen Sandiego?* and various *JumpStart* games. *The Oregon Trail* was a massive hit at the time. But games like these, delivered on CD-ROMs, are no longer being made. Changes in the market are partially to blame. Good educational games have a long development cycle and are not cheap to make, and are largely a labor of love. Large corporations have bought up most of the pioneering publishers of educational games. But to be competitive, they needed to sell the games for a much lower price than the

initial developers had been getting, so the incentive to produce them sagged and disappeared.

Meanwhile, publishers have been experimenting with new genres, like the AR and VR games mentioned earlier, and audio-controlled games. SyncBuildRun, a games developer now known as V. Twin, is working on episodic games, in a tradition of serialized storytelling that began with Charles Dickens. Their first game is *V.Next*, a story about a computer hacker named Vivienne Denue who breaks into computers of the corrupt and powerful, a little like a modern-day Robin Hood. They term this genre as a "cyberpunk adventure."

Indie game developer Sam Barlow, credited with two *Silent Hill* games, has taken an entirely new direction with *Her Story*. Told in full motion video (FMV), a type of video game told entirely in video, *Her Story*, released in 2015, is a blend of a game and a movie. The protagonist of the story, and the only onscreen character, is a woman undergoing multiple police investigations for a crime that is not specified. To learn her story, you must search through a vast database of video tapes and piece together what seems like a reasonable hypothesis. You are not playing for any particular win other than successful piecing together her story. Since the work is composed of an enormous database, it operates in the same way as works of iCinema that are database narratives, which are discussed in Chapter 14. FMV is a type of gaming that was used for *Dragon's Lair* in 1983 and had a resurgence in the mid-1990s but did not succeed at taking off, in part because the technology at the time did not support this type of gaming.

One major phenomenon in recent years is the rise of esports, or competitive video gaming as a spectator sport. The first known video game competition began modestly in 1972 at Stanford University, where a small number of students competed against each on *Spacewar!* as others watched. This tiny beginning had swelled enormously by 2014, as 45,000 spectators came together in Seoul to watch the *League of Legends* finals. And this event was dwarfed in 2017 in Beijing, when an audience of 60 million watched the *League of Legends* world finals, many watching online. Twitch, the streaming online platform owned by Amazon, is a hub of esports events. Twitch has attracted 5

million viewers who watch an average of 106 minutes every day watching live gaming. By 2018, the audience for esports reached 300 million fans, and is expected to double by 2021 to 600 million viewers (as reported in Venture Beat by Andrew Paradise, November 20, 2018.

Single versus Multiplayer Games

Video game critics and players alike wonder if hugely successful multiplayer games like *Fortnite* and *World of Warcraft* will dominate the market, or if single-player games, which usually have a deep storyline, will continue to fade in popularity. Developers of multiplayer games have a financial incentive in making them successful, since large sums of money can be made by offering enticing upgrades or skins or weapons to players. Yet many players prefer being immersed in an absorbing narrative and being in control of their destiny in a rich storyworld.

Although multiplayer games are enormously popular, it must be noted that new certain single-player games have also been a hit with gamers. For example, *Red Dead Redemption 2*, a Western action-adventure game released in October 2018, made its developer Rockstar Games a massive $725 billion during its opening weekend. You play as a member of an outlaw gang as the Wild West is slowly being tamed, and the storyworld is vast and populated with fascinating characters.

Violence and Video Games

Physical combat, sometimes gory and extremely graphic, is a feature of many video games. In part because of this, games have been blamed as the cause of violent teenage behavior. This anti-game attitude is something that everyone who works in the game industry encounters. I was personally assaulted at a brunch recently when I mentioned I had once written video games to a table full of otherwise lovely people, mostly seniors who had probably never played a video game in their lives. They were convinced that games were the cause of great evil, and looked at me strangely for being associated with them.

I reminded them of two things: first, that video games were just the latest form of popular entertainment to be accused of causing teenage violence. Long ago, people accused dime novels and comic books of inciting teenage mayhem, and later movies and television were also vilified. I also pointed out that many video games were violence-free, and games could be highly positive vehicles for education and information. They listened politely but I doubt their minds were changed.

Nevertheless, despite the negative opinions many people hold about video games, psychological studies have been unable to demonstrate a clear relationship between playing violent video games and committing acts of violence in real life. Even the US Supreme Court, in the landmark 2011 case, noted this lack of proof, calling the research work done thus far "unpersuasive." Because of the lack of convincing evidence, the court refused to sanction regulations of the industry. A thoughtful article by Dr. Romeo Vitelli, published in 2013 in *Psychology Today*, reviewed the research done thus far on the connection between playing games and violence. Dr. Vitelli asserted that the studies were inconsistent. He also pointed out that the statistics on youth violence were at a 40–year low, even though video games have gained in popularity during the same period.

In fact, it is possible that it is the teens who do *not* play video games who may be the ones who have social problems. In the book, *Grand Theft Childhood*, Harvard medical school psychiatrists Lawrence Kutner and Cheryl Olson assert that playing games and talking about them has become such a mainstream pastime among teens that those who do not participate in these activities are now "de facto abnormal."

Independent ("Indie") Games

Independent games, or indies, were once only a tiny segment of the games world, but in recent years they have become increasingly prominent. Essentially, an indie is a game that has been made without the financial support of a publisher and has usually been produced on an extremely small budget and by a small team or a single individual. However, this independence gives the

developers full artistic control of their games, and indie games can be far more experimental and artistic than games that have been made with a publisher's support.

The growth of the indie world is in part because games can be made on far smaller budgets now than in the past. Furthermore, thanks to digital distribution via the Internet, smartphones, and downloadable services on game consoles, it is possible to find an audience for a game without the support of a publisher. In the past, developers had to seek out contracts with publishers for funding, marketing, and distribution, but this is no longer necessary.

Typically, however, indie games are far more modest than blockbuster games with their multimillion-dollar budgets. They usually lack the gorgeous graphics and other features of high-end games, and tend to be much shorter. But they do boldly venture into territory that the risk-adverse publishers have avoided. One of the stars of this world is Jason Rohrer, who has made several indie games. One of them, *Passages*, was briefly described in Chapter 5. With extremely simple graphics, it depicts a man's journey through life and ends on a somber mortality note.

"A realization is dawning that games can be much more than what they are now," Rohrer told a *New York Times* reporter back in 2009. "They even have the potential to be meaningful in deep, fundamental ways." Indie developers are increasingly taking up this challenge and are striving to create games that do have meaning and do contain emotional richness. Indie developers had a dominant presence at the 2013 Game Developers Conference in San Francisco, and for the first time ever, an indie game, *Journey*, won the prestigious Game of the Year award.

Indie games vary enormously in terms of narrative content, style, and gameplay. The delightful game *Cuphead* is the story of two brothers with coffee cups for heads who make a bad choice in a gambling casino and then must do the Devil's bidding. Released in 2017 by the Canadian developer Studio MDHR, it is a fast-paced shooter choke-full of boss battles depicted in the style of quirky 1930s cartoons. To match the 1930s look of the game, it has an original jazz score. *Cuphead* has been a successful both financially and critically. Another, totally different and far darker game, is *Inside*, published by Playdead in 2016. It is a mix of genres: a 2-D

puzzle platformer adventure game. It is the story of a young boy and the frightening discoveries he makes inside a surreal dystopian world.

The Challenge of Storytelling in Open World Games

One of the most daunting tasks in terms of creating stories for video games is that of constructing a narrative for a totally nonlinear game environment like an open world. This is a very different situation than level-based games, where players are channeled along sequentially level by level. Although there's nonlinearity within a level itself, the level structure makes it relatively easy to construct a plot and a character arc. But in open world games, players can freely choose where to go, what to do, and when to do it, and even fully customize the character they play, the protagonist. How can stories possibly be developed for such freewheeling game worlds?

In order to find answers, I was fortunate enough to do a telephone interview with Steve Jaros, creative director and head writer for the highly successful *Saints Row* series of open world games featuring the 3rd Street Saints gang. The series was developed by Deep Silver Volition over a six-year period of time. The first two games are set in a gang-infested fictional metropolis; the third and fourth games in the series have somewhat different storyworlds, but the gang is still central to the action. In the first game of the series, you, the protagonist, become a member of the 3rd Street Saints gang, ultimately becoming the gang's leader and helping to bring the entire city under the control of the Saints. In subsequent installments, you continue to exert your gang's dominance over rival gangs and ultimately over the larger world (see Figure 11.4). Meanwhile, you can create a lucrative merchandise empire with your own Saints Row brand of sneakers, energy drinks, and even bobblehead dolls. With its endless opportunities for mayhem and violence and its raucous, over-the-top humor, the series has been described as an open-world adult theme park.

Jaros, who has a degree in playwriting, unhesitatingly admitted that storytelling in such an environment is difficult. "I think the biggest challenge is having to go and throw out traditional

FIGURE 11.4 The *Saints Row* series of games is an open world, known for its intense and often violent action as well as its humor. Image courtesy of Deep Silver Volition.

conceptions of what makes good storytelling," he told me. "Good writing and good game writing are different things. There are things that are amazing stories that make for terrible games."

He noted that open world games present special problems. "In a linear game, people are always plowing through the story, with no other choice but for progression. In an open world game, we are competing with ourselves. We have side quests and activities and open world gameplay and fun things for you to go and do." In other words, there are lots of distractions competing with your story. "So you have to make sure the game is clear and concise and not confusing," he stressed. "Sometimes that means losing the complexity which I normally like to have in my writing. But because of the nature of the beast you sometimes have to make sacrifices."

Unlike the steady progression of challenges and events you'd find in a linear game, Jaros told me: "Often times, the open world is almost more of a lobby, where the player goes and hangs out and does what he wants and waits to get to the next part of the story." In *Saints Row*, he noted, the story elements are conveyed primarily by cut scenes and by the missions you choose to go on, but also by the little choices you make. As a player, Jaros explains, "You are part of the storytelling process. You are an active participant in building the story. That's why it's so powerful."

Despite the lack of a sequential storyline, Jaros maintains that open-world games do contain goals for the player to strive for. "No matter what, you need a goal," he emphasized. "Without a goal, there is no story." In *Saints Row*, these goals can be small things—getting rid of a particular enemy, for instance—or they can be major ambitions, like having your gang become the dominant criminal force in your city.

In *Saints Row*, characters can also have character arcs, as they do in movies and other linear dramas, but there are differences, too. "Characters need to grow and change," Jaros told me. "If nothing changes, the character is boring, right?" In a game like *Saints Row*, he added, "players decide what they feel is important and what they want to invest in, and that's what gives you the story." In contrast, in a third-person game like *Prince of Persia: Sands of Time*, the character arc is predetermined. "No matter what, you are on the journey of that character, the Prince of Persia, and that will take you screaming down his journey," he noted. Whereas in *Saints Row* the player and the character are one, "and it's not fair for me to have you feel sad about something you might feel totally justified by." In other words, in *Saints Row*, you can choose how you want to behave, what you want to be, and how you feel, and no value judgment is placed on those choices. Thus, the character arc in *Saints Row* is more of an exterior professional journey than an interior, emotional one. Jaros describes it as a "power fantasy," and described the character arc this way: "You go from being a nobody to becoming a street gang member to becoming the leader of a gang to becoming a pop culture icon to essentially declaring your own city state."

I asked Jaros if *Saints Row* has a traditional three-act structure (essentially, a beginning, middle, and end) and he replied affirmatively that it did, but on a smaller scale. "You aren't telling *a* story; you are telling lots of small stories. That's a total and fundamental shift. There's this myth that your game has to be about *a* thing, and that's not true," he asserted.

"I think the bigger question is do I think the three-act structure is the best way to tell a story in an open world game," he went on, "and I don't think it is." Naturally curious, I pressed him about what a better structural model might be. "This is where it gets tricky," he said.

For me, open worlds are about letting players get lost in the world and I think that telling smaller stories about the world is more interesting than telling a grand story about a character the player may or may not be involved in. It's about having a world full of stories and the player choosing what he wants to invest in rather than there being some grand story that I tell that you have to go on. It's not some arbitrary thing I'm telling you is important as a writer. People aren't picking up an open world game to go and hear my bull****. They are picking up an open-world game so they can go and experience the world and be transported to this new place. Stories about the place are more interesting than me telling you what you should care about.

During the last remaining minutes we had to talk, we discussed the role of humor in open world games. According to Jaros, "How important humor is depends on the game you are making. I think humor is an important release for people, but sometimes you don't need a lot of humor. Sometimes you need a little. Sometimes you don't need any humor." When it comes to humor, he said: "I don't think there's a best practice for games." He noted that humor is subjective, and that different kinds of humor appeal to different people. Not everyone finds the same kind of thing funny. For example, he said that while he doesn't find toilet humor funny, many people do. In *Saints Row*, famous for its over-the-top humor, they make a point of including a wide variety of different kinds of humor. "There's a potpourri of different options," he told me. "That's the philosophy of *Saint's Row*, because our game is a crazy humor game, a wild crazy ride where anything goes. So we have to allow for all manner of humor" (see Figure 11.5).

Massively Multiplayer Online Role-Playing Games

Massively multiplayer online games (also known as MOOs, MMOGs, or MMOs), particularly massively multiplayer online role-playing games (MMORPGs), are among the most creatively demanding but financially lucrative forms of interactive entertainment ever to be devised. MMORPGs are mere youngsters compared to video games—the earliest ones, *Ultima Online* and

FIGURE 11.5 The *Saints Row* games are known for their wacky, over-the-top humor. Image courtesy of Deep Silver Volition.

EverQuest, were not launched until the late 1990s. Yet they've already drawn an intensely dedicated fan base in many parts of the world. Though these games reside on the Internet, which is the only vehicle that can accommodate so many players simultaneously, they can be played on a variety of platforms: game consoles, personal computers, and even mobile devices.

MMORPGs are derived from MUDs, text-based adventure games in which players assume fictional personas, explore virtual worlds, and interact with each other. MUD stands for multi-user dungeon (or multi-user domain or multi-user dimension). The MUD, and its close cousin, the MOO (MUD object oriented), can support the simultaneous play by a great number of participants. The first MUD (and *MUD* was indeed its name) was developed in Great Britain in 1978. It was a team effort of Richard Bartle and Roy Trubshaw, both students at the University of Essex. It is quite easy to detect the close family resemblance between the MUDs and MMORPGs. However, MUDs are text-based, while MMORPGs immerse players in a world of richly animated graphics.

The Characteristics of the MMORPG

MMORPGs have several characteristics that set them apart from other games, even online games. For one thing, they are played simultaneously by tens of thousands of people, and the

interactions between the players are a significant part of the experience. They are set in sprawling fictional landscapes that usually include multiple complex worlds, all of which may be populated. These game worlds are also persistent universes, meaning that the activities going on in them continue even after a player has logged off, just as in the real world, things continue to happen even when we go to sleep.

MMORPGs observe many of the characteristics of the RPG, discussed previously in this chapter. Players create and control one or more avatars who are defined by a set of attributes, such as species, occupation, and special skill. These player-controlled characters strategize with each other, go on quests, and explore. Players work hard to advance their avatars' skills and powers. A great many MMORPGs revolve around so-called "sword and sorcery" medieval fantasies and feature bloody encounters with NPCs and player-controlled avatars.

Initially, the major MMORPGs were supported by monthly subscriptions, and that financial model still exists, though it is less common today. Two big budget MMORPGs, *The Elder Scrolls Online* and *WildStar*, were initially released as subscription-based games, but within months discontinued the subscription model. (*WildStar* was later shut down). Today's MMORPGs are supported by microtransactions or are purchased. In some Asian countries, where MMORPGs are typically played in cafes, there is a different financial model: players pay by the hour. A MMORPG needs only to attract a few hundred thousand players to generate a considerable income, and over the course of several years, a successful MMORPG can take in more money than even a hit movie.

Narrative in MMORPGs

Essentially, the production team for a MMORPG creates a framework for people to play in. They devise an intriguing backstory, various narrative elements to be discovered during play, and set up quests for players to undertake. They also create the virtual landscapes for the MMORPG and create the characters who will inhabit it: the NPCs and the types of avatars that players can build and control. But although MMORPGs contain a certain amount

of story material created by the production team, they also contain narrative elements that the players themselves initiate, thus creating an emergent narrative.

A MMORPG typically contains a number of simultaneous storylines as well as an overarching narrative. The overarching storyline is set up in the backstory and gives context and excitement to the fictional world of the game. But within this framework are a number of mini-stories. In fact, each quest that a player goes on may be regarded as a story, with a starting point, a period of intense conflict and action, and a resolution—a traditional three-act structure. However, the overarching storyline of the MMORPG is left open-ended.

> **EXPERT OBSERVATIONS: RESEMBLANCE TO SOAP OPERAS**
>
> The narrative elements in MMORPGs are in some respects quite similar to the type of storytelling found in soap operas, a point made by Nick Iuppa and Terry Borst in their book, *Story and Simulations for Serious Games*. As with a soap opera, the core story in a MMORPG is never resolved. This is quite different from the narratives found in movies, which have clear-cut endings, with all the pieces neatly tied up. Yet the audiences of soap operas and the players of MMORPGs find them intensely involving; the lack of closure of the central storyline does not diminish the pleasure of watching or participating in these stories, for there is always something new to discover and a new twist to the tale.

Why So Powerfully Addictive?

Much to the fascination of journalists and to the dismay of psychologists, parents, and spouses, MMORPGs are such a potent form of entertainment that some players have actually become addicted to them. These games are sometimes referred to as "heroinware" and the game *EverQuest* has been nicknamed "EverCrack." Gamers who cross the line from recreational play to something more serious exhibit all the classic signs of addiction.

They lie about the time they spend playing; develop problems with work, school, or relationships; and are unable to stop playing, even when they try. In South Korea, there's even a documented case of a young man who dropped dead after playing a MMORPG for 50 hours straight.

Anyone with a professional interest in this arena has to wonder what it is that makes these games so compelling. They might also wonder if these factors can be incorporated into new games—not to make more MMORPG junkies, of course, but in order to attract new players to this arena.

Players cite these qualities that make MMORPGs so compelling:

- They provide an escape from the blandness of everyday life.
- Via role-playing, players can become powerful, awe-inspiring figures.
- Players have a great deal at stake in terms of the investments they've made in avatars and acquisitions and don't want to lose them, but because these games are persistent universes, this requires staying actively involved in the game.
- MMORPGs have a strong social component; people make close friends in these worlds, and want to stay connected to them.
- They are challenging and highly goal-oriented—every time a goal is achieved, there's a new one looming.

EXPERT OBSERVATIONS: THE COMMUNITY ASPECTS OF MMORPGS

Richard Bartle, co-designer of the world's first MUD, the predecessor to the MMORPG, does not consider MMORPGs to be games at all. Instead, he regards them as "places." In an article written for *Business Week Online* (December 13, 2001), he noted that MMORPGs, unlike games, offered a sense of community, which he believes makes them more like real life. This, he feels, is an important part of their appeal. He noted: "When you visit those places, you can play, sure, but you [also] can talk, you can

> explore, you can boss people around. They are environments, and they have real people in them." Many experts in the field agree with Bartle that the social aspect of MMORPGs, and the friendships formed while playing, are a major reason why people are drawn to them.

A Player's Point of View

In order to gain a better understanding of how a fan experiences one of these games, and what in particular appeals to them, I spent an afternoon with 15-year-old Michael Loeser as he played the *Dark Age of Camelot*, a medieval fantasy game developed by Mythic Entertainment. Loeser, who had been playing the game for a month or so, said he liked it because it had good character control, was easy to use, and he could make his character look really cool. "I don't like games that are too difficult," he told me. "They are more annoying than fun." For him, he said, most of the satisfaction of this kind of game comes from "working up levels and getting cooler stuff and going into battle."

He said he particularly likes medieval games because of their magic and swordplay, and also because he thought it was an interesting time frame. He took me on a tour of his favorite realm in the game, the island of Albion, via his avatar, a poor but strapping warrior. I was struck by the lush exterior environments and the beautifully detailed interiors of the taverns and shops we visited. The island seemed immense. Loeser said it could take hours to cross on foot, though if you were in a hurry and had money, you could buy a ticket to ride a horse. Day also changes to night in this game, and Loeser told me weather could also change. Just as in England, it can be foggy and rainy here, making it difficult to spot your quarry (see Figure 11.6).

Loeser enjoys playing in character, and demonstrated how he does this, begging a passerby, a wealthy-looking nobleman, for some coins by way of a courtly typed message sprinkled with *thees* and *thous*. To my surprise, the passerby generously complied. And what would Loeser do with his newfound bounty? He promptly spent most of it to have all his clothes dyed red, along

FIGURE 11.6 A misty landscape in Albion, one of the realms of the *Dark Age of Camelot*. Image courtesy of Mythic Entertainment.

with much of his equipment. Clearly, this game was some kind of medieval fashion show. "If you have money, you may as well make your character look good," he told me. But he justified the expense by explaining "people are more eager to let you join their group if you look cool."

With that, Loeser activated a function that signaled he was looking for company, and in short order he hooked up with about a dozen other players and was off on a monster hunt. The fog was rolling in and dusk was falling, reducing visibility, but just enough light was left for the group to track a lumbering, furry-looking creature, to surround it, and to do it in—the conclusion of a good day's work in Albion.

The MMORPG-Makers' Point of View

A player's point of view can be illuminating, but to understand how these games are put together, I talked with the duo that heads up production for *EverQuest*, developed and published by Sony Online Entertainment. *EverQuest*, like *The Dark Age of Camelot*, is a medieval fantasy game (see Figure 11.7). Until more recent ones came along, it was the most popular MMORPG in the Western

FIGURE 11.7 *EverQuest*, a medieval fantasy game, belongs to the "sword and sorcery" genre of MMORPGs and is vast in scope. Image courtesy of Sony Online Entertainment.

hemisphere and is possibly the longest-running online game of all time, released back in 1999.

My experts were the two people who headed up the game's day-to-day production work, and who probably know as much as anyone in the world about creating and producing MMORPGs: Rich Waters, design director, and Robert Pfister, senior producer. Waters and Pfister told me (answering my questions jointly) that one of the greatest challenges of producing a game like *EverQuest* is its vast scope. They compared what they did to running a small city, requiring the juggling of multiple and highly demanding responsibilities. At the time we talked, the game had 220 adventure zones, 16 city zones, and some 40,000 NPCs. "That's a lot to look after, each day, every day," they pointed out, an understatement if ever there was one. And, on top of that, they are continually writing new stories and developing new features.

Designing a new MMORPG, they told me, is a multiyear project requiring a staff of dozens of people. Among the first issues the team must address is defining the game's setting (Medieval times? Space? Post-apocalyptic?) and determining the basis of the game's conflict. Two elements that demand special attention, they said, are story and character.

Story is very important to a game," they asserted. In the context of a MMORPG, story is primarily considered to be the history, backstory, and lore of the fictional world, as well as the conflicts within it. Story, they explained, "can be introduced in a two-minute cut scene at the beginning of the game, or can be spread across the world in books, tales told, and in quest backgrounds ... The richer you make your world, the more likely people are to come to visit and stay."

They told me that players can, and do, spend years exploring *EverQuest*: "They find that every inch is covered with lore and story." But, they added, part of their job is also to create "very specific adventures for people to complete—fight this dragon, defeat this god, rescue that person."

As with other games, the characters in MMORPGs fall into two broad categories: the player characters and the NPCs. In *EverQuest*, the NPCs may be monsters you fight or human characters like shopkeepers or guild masters. The monsters fall into a category called a *MOB*, short for *Mobile Object*, which is an object in the game that moves, as opposed to an inanimate object like a door or chest that you must "attack" in order to open.

In developing an NPC that will have a role in a new quest, the design team works out what its function will be in the overall quest, what its backstory is, how players will interact with it, and what lines of dialogue it will speak. The artists will then do concept drawings of the new NPC, working with the designers to refine the look, and then add clothing and "attachments"—things like shields and hats. The final step is to animate the character, giving it actions like running, swimming, fighting, casting spells, or dying. That done, the character is imported into the game.

The design process for the avatars is somewhat different. In *EverQuest*, the basic character types are either drawn from standard mythology (archetypes like ogres, trolls, elves, and gnomes) or else from *EverQuest*'s own mythology. Waters and Pfister said that the critical thing, when designing a new class or race, is to take care that it does not create an overwhelming advantage to one particular group of characters. They consider how the character will work on its own, how it will play in a group, how it will

play in a large raid, and what effect it will have on all the different types of NPCs.

Before any new features are added to the game, the designers must first consider all the different ways it might be used and how its presence might impact the gameplay. For example, Waters and Pfister told me they recently added horses to the game. In doing so, they had to address such questions as: Can people steal horses? Can horses be killed? What role will horses play with the most competitive players? With more casual ones?

Overall, they also cautioned against making a game too technically demanding, stressing instead that it must be enjoyable to play. This is, of course, the same point our 15-year-old informant stressed. Waters and Pfister asserted: "You can have the most detailed online world imaginable down to the cracks in the sidewalk, but if it isn't fun, no one will play."

Breaking Fresh Ground

Although a great many MMORPGs support storyworlds that feature violent battles, Disney broke new ground by creating *Toontown Online*, a light-hearted game designed for a family audience. It was a totally radical concept at the time of its development, because of its use of humor and cartoon characters (see Figure 11.8). It was released in 2003 but discontinued after a successful 10-year run, in the fall of 2013, when it was replaced by other Disney Interactive projects.

Toontown was a colorful world inhabited by Toons, or cartoon characters. In the game, this cheerful place was being threatened by business-minded robotic creatures called Cogs with a single-minded agenda: to take over the Toons' buildings and convert them into drab office structures. As a player, your mission was to protect Toontown from the Cogs. To battle these robots, you launched "gags" at them. For example, you could pelt them with cream pies or drench them with your personal rain cloud.

This innovative, humorous approach to the MMORPG was dreamed up by Mike Goslin, who at the time was Vice President of Disney's Virtual Reality Studio. Goslin told me the idea was born out of a "what if" question: what if you took the skills and experience acquired from designing theme parks and applied

FIGURE 11.8 A screenshot from *Toontown Online*, a fantasy world inhabited by Toons (cartoon characters). Image courtesy of © Disney.

them to a MMORPG? He told me it was like a light going on overhead, especially as he realized that a MMORPG was really "a place more than a game, and we know how to build places." Strikingly, though he was coming at it from a totally different set of experiences, Goslin's vision of the MMORPG as a "place" closely echoed that of Richard Bartle, quoted earlier in this chapter.

The Characters

Just as with MMORPGs for adults, this new game was to be populated both by NPCs and PCs. The NPCs would fall into two basic categories: Cogs (the game's antagonists) and other Toons (neutral characters). The creative team came up with 32 different types of Cogs, all based on the theme of big business. The game would replenish any defeated Cogs; there would be no end to them. The other group of NPCs, the non-player Toons, would mostly be shopkeepers, and about 800 of them would be dispersed around Toontown.

As with adult MMORPGs, players would get to design their own avatars, molding them from a million possible combinations (see Figure 11.9). They could choose from six possible species—dog, cat, mouse, horse, rabbit, or duck—and pick different body types, color combinations, and clothing styles. They would then get to name their Toon. During the game, they would be viewing their

FIGURE 11.9 *Toontown Online* allows players to design their own avatars. Here, in the *Choose Your Clothing* feature, they can create their avatars' outfits. Image courtesy of © Disney.

Toon from a third-person point of view, which Goslin termed "the wingman view." It would be as if the camera were tethered right behind the Toon.

Reaching a Broad Demographic

During development, the team considered each demographic group they wanted to attract and built in elements that would appeal to each. For adults, for example, the primary attraction would be the game's sophisticated workplace humor and wordplay, such as the puns in the Toontown shop signs. Working in things for boys was not difficult, Goslin said, because, based on the history of how boys have responded to prior games, "we know what they like." But shaping the content to appeal to girls was harder, he noted, because "no one's done it before." The team felt girls would respond well to the emphasis on cooperative play and to the social aspects of the game, and would enjoy being able to customize the avatars. They also considered the tastes of girls in the visual design, with Toontown's bright colors and rounded shapes.

The design team also took steps to ensure that the game would not be plagued with *griefers* (players who deliberately make life miserable for other players). One way they handled this was by preventing unrestricted chat. Instead, they offered instead a "speed chat" system, giving players a selection of words and phrases to choose from. This short-circuited the ability of ill-mannered players to verbally harass others and also protected young users against predators and the invasion of privacy, an important consideration for families.

To further ensure a positive experience, the game encouraged good behavior by rewarding cooperation and team play. It thus circumvented the bloody player attacks prevalent in most MMORPGs. Even the battles between the players and the Cogs were non-gory affairs, emphasizing strategy and humor rather than physical force (see Figure 11.10). Not only would the Toons use gags for ammunition, but the Cogs would retaliate in kind. For example, they might spray a Toon with ink from a fountain pen, or fling half-Windsor neckties.

The Role of the Treadmill

One feature that can be found in classic MMORPGs like *EverQuest* and *World of Warcraft* is a device called a treadmill, and this device was built into *Toontown* as well. A treadmill is an

FIGURE 11.10 Screenshot of a *Toontown* battle: Toons on the left versus Cogs on the right. Image courtesy of © Disney.

internal structural system that keeps the player hooked, cycling repeatedly through the same types of beats in order to advance in the game.

In a traditional MMORPG, the treadmill might require players to kill monsters to earn money to buy swords to kill more monsters. But in *Toontown Online*, the treadmill worked like this: Toons played mini-games to earn jelly beans; Toons used the jelly beans to buy gags; Toons used the gags to fight the Cogs, at which point their inventory of gags was depleted; then, once again, the Toons must play mini-games to earn jelly beans. Players cannot advance in the game without using the gags, and the gags get better—more effective and more fun—as players work their way up. For instance, one line of progression begins with throwing cupcakes, advances to slices of pie, and then to entire wedding cakes. The best treadmills, according to Goslin, are integrated into the game in a natural way, as part of the overall game world.

Story and Structure

One of the toughest challenges Goslin found in developing *Toontown* was dealing with the story. In a shared world like a MMORPG, he said, "It is a unique challenge to do storytelling ... you stretch the limits of storytelling in this kind of thing." As he pointed out, in a traditional story, you have one story structure featuring one hero and one major encounter. But in a MMORPG, each player is the hero of his or her own experience of the game. Furthermore, you need a reusable climax, something that can be played through by each person. This precludes having a fixed ending. And finally, you don't want the game to come to a conclusive and final end, because this would undercut its subscription basis.

> **NOTES FROM THE FIELD: THREE LEVELS OF STORY**
>
> Goslin sees stories in MMORPGs as operating on three levels—high, medium, and low. The high-level story, he feels, gives players a context and meaning to the overall state of affairs that they find in this world and for the core conflicts that exist there. In *Toontown*, this was the backstory of who the Cogs were and how

> they became unleashed on the Toons. The medium-level story, he feels, is a template everyone can share, perhaps a quest experience. He sees it as being a little like the season finale of a TV show, tying up some loose ends and shedding some new light on the high-level story. The low-level story, he suggests, is about the individual player's role in the story, that player's personal narrative within the game.

The Future of MMORPGs

The long-term popularity of *Toontown Online* has demonstrated that MMORPGs can successfully be extended beyond the traditional "swords and sorcery" games and can appeal to a new demographic of gamers. Goslin believes the potential of MMORPGs is largely untapped. But he advises anyone venturing into this arena to be careful of making assumptions about the game's potential players. "If you think you know how they will use it, you will probably miss something," he asserts. He recommends thoroughly testing every aspect of the game before releasing it, and thinks the testing process should continue for weeks, even months. But he also believes this is not an area for the timid. Though it requires discipline, he said, it also requires passion. "It's not a mistake to aim high," he asserts. "If you aren't aiming high, you can't hit high."

Clearly, the process of developing a MMORPG is not suited to those with short attention spans, shallow pockets, or a lack of creative vision. The vast scale of MMORPGs, coupled with the fact that they must be able to support tens of thousands of simultaneous players, has substantial impact on story, structure, and character development. These games require that their creators be able to let go of familiar narrative techniques and regard storytelling in quite a new light.

The Rise of Casual Games

Casual games, as can be imaged from the term, are at the opposite end of the spectrum from MMORPGs. Such games can be easily

learned (though they are often challenging to master) and can be played in brief periods of time—they are little forms of recreation like coffee breaks or recess at school. They are also highly replayable; some would say addictive. They are played online, on game consoles, PCs, and all types of mobile devices. The development of the Wii helped increase their popularity and has pulled in a whole new demographic of gamers: senior citizens.

Casual games have their roots in the oldest types of video games, such as *Pong* and other arcade games, and include a wide variety of genres, such as abstract puzzle games, shooters, and racing games. Advergames, covered in Chapter 10, are often a form of casual gaming. New kinds of casual games, cognitive games, have been developed to help older individuals retain mental functions, serving as a form of exercise for the brain. Women are a substantial part of the player base, even outnumbering men, according to many studies. Players who are not hard-core gamers enjoy them because, unlike traditional video games, they are easy to play and can be satisfying without demanding a large investment of time.

Game developers have a different set of reasons for liking casual games: they are far less expensive to develop than a full-length Triple-A video game, which can easily cost over $200 million. Furthermore, the development cycle of a casual game is considerably shorter. Developing a traditional video game can be a big gamble, because, while some are big hits, many others are big losers. Casual games, however, with their lower budgets and speedier development cycles, are substantially less risky.

Because casual games are so popular with players, and also so advantageous to developers, we can expect to see this sector of the market continue to grow. However, because casual games can only support a small amount of narrative, at best, they do not appear to be a promising arena for digital storytelling.

Who Plays Games and Why?

While many people are under the impression that the majority of gamers are teenage boys, the truth is that the average age of gamers has been rising steadily. According to the latest figures of the Entertainment Software Association (ESA), the industry group

dedicated to the video game business, the average age of gamers has been steadily rising and is now 34. In fact, gaming is no longer a pursuit of teenage boys only: 72 percent of gamers are over 18 years of age. More than 150 million Americans play games, and there is at least one gamer in 64 percent of American households. In addition, thanks in part to the Wii and to casual games, a large number of seniors are also playing games.

It is worth noting that many families play games together. As my student, Twig Deluje' observed: "Adults now in their thirties and forties were some of the first gamers. They have become a loyal player base and pass that love onto their children." Jesse Schell, introduced earlier, acknowledges this intergeneration trend. As one of the original developers of *Toontown Online*, he advises: "If you are designing a family game, it ideally should have something for everyone. It should be fun at the shallow end but have enough content for older players so they can go deep. Teens will play with parents if the context is right, if, for instance, they can build something and show it off." He believes games like *Minecraft* are good examples of this type of family involvement.

While it is important to know who is playing games, an even more interesting question, especially to those of us who are interested in creating compelling interactive entertainment, is *why* people play games—what is it about games that makes them so appealing to those who play them?

For one thing, as we noted earlier in the book, games are experienced as fun. They satisfy a desire we all have to play, and that desire doesn't go away even after we've left our childhoods far behind. Games offer us a socially acceptable form of play at any age, and an enjoyable stimulus to the imagination. To maintain the sense of fun, a good game offers just the right amount of challenge—not too little, or it would be boring, and not too much, or it would be discouraging.

For another thing, games take you out of your ordinary life and give you a chance to do things you'd never be able to do in reality, and all without any actual risk to life or limb. You are given plenty to do in these game worlds and can pretty much decide how you want to interact with it. In other words, you control the shots—often literally.

In an article for *New York* magazine, "Why Ever Stop Playing Video Games (February 19, 2017), writer and gamer Frank Guan had some interesting things to say about why many gamers prefer playing games than doing things in real life. Games, he believes, are "giving players something, or some things, their lives could not." He goes on to say: "Games make sense, unlike life: as with all sports, digital or analog, there are ground rules that determine success (rules that, unlike those in society, are clear to all). The purpose of a game, within it, unlike in society, is directly recognized and never discounted. You are always a protagonist." He also feels that it is clear in games "about what counts for status and how to get it. In other words, games look like the perfect meritocracies we are taught to expect for ourselves from childhood but never actually find in adulthood."

EXPERT OBSERVATIONS: CLASSIC GAMER PERSONALITIES

William Fisher, the founder and president of Quicksilver Software, pointed out to me that not everyone plays games for the same reasons. Fisher, a seasoned games professional, who was in the business even before founding his company back in 1984, told me he has observed several kinds of "classic gamer personalities." People may play, he believes, for one of several reasons. It may be because they are:

- Looking to escape
- Want to blow off steam
- Enjoy the intellectual challenge
- Want to compete with other people

"What hooks people initially is the visual and conceptual part of the game—what it looks like, and what it's about," he said. "What keeps them [hooked] is the progressive challenge of the game, the gradual increase in difficulty that keeps them scaling the mountain one step at a time." In other words, the challenges continue to escalate, keeping the player alert and involved.

Veteran game producer and designer Darlene Waddington, who worked on the classic game *Dragon's Lair*, offered up another reason people get hooked on games: the adrenaline rush. She

> believes players become caught up in the intense struggle to overcome a challenge. They're absorbed to the point of tunnel vision, and when they finally do succeed, they are rewarded with a gratifying sense of release. In other words, games can produce an emotion akin to catharsis.
>
> Richard Bartle, who created the world's first MUD, wrote a paper in 1996 that famously placed gamers into one of four categories in terms of their actions within a game: achievers, explorers, socializers, and killers.

Gamification

Video games have become so popular and so widely played that non-gaming entities have adapted certain techniques and mechanics from video games and are now employing them in something called gamification, as we noted in Chapter 10. Gamification is an especially popular new tool for promotion and is also used in education and even in public safety. In Ohio, drivers who observed speed limits were awarded cash prizes, but the amount of their prize diminished every time they exceeded the speed limit. The faster they went, the smaller the prize. Just as in games, drivers were offered rewards but could also be penalized.

What Can We Learn from Games?

Probably more than any other form of entertainment, video games are powerfully effective at actively involving users in a fictional experience. And despite the various criticisms leveled at them, games have clearly proven to be a compelling form of entertainment. Furthermore, games can teach us many useful lessons that can be applied to other forms of digital storytelling. For example:

- People are drawn to games as an enjoyable form of play, as an escape from the pressures and disappointments of everyday life. Overcoming the challenges in a game offers players an empowering sense of achievement.
- Games are most effective when they give participants an opportunity to do things—to actively engage in an

experience—and these tasks should be meaningful in the context of the game.
- To keep players involved, games use devices like a strong overarching goal; a rewards system; challenges; and an escalation of suspense and tension.
- Games need to make sense and have an internal logic; this cannot be sacrificed to gameplay.
- Players are drawn to games for a variety of reasons, and it is important to understand one's target audience in order to create an experience that will please them. Some need to achieve; some want to socialize; others want to explore and some just want to kill.

These guidelines can be applied to virtually any type of interactive story experience just by removing the word "game" and substituting the appropriate interactive medium. Although some forms of interactive storytelling will lean more heavily to the gaming end of the spectrum and others toward the narrative end, the basic principles will still apply.

Tips for Newbie Game-Makers

People enjoy playing games so much that a certain number of these players will be inspired to make their own games, unaware of the pitfalls and challenges such an endeavor inevitably entails. If you are among this group of newbie game-makers, it might be helpful to you to review these tips.

1. Select your team carefully. Ideally, it will include at least one member who has had experience working on a game that has actually gone to market. It should also include individuals who will bring special skills to your team. Coding, graphics, and marketing are among the most valuable. Also consider the personalities of your potential teammates. It's best not to include individuals who are inherently negative or are excessively into socializing. Negative individuals will pull your team spirit down, while the social butterflies will distract others from the work that needs to be accomplished.

2. Consider the scope of your game. It is unwise to be overly ambitious in terms of its size or in terms of breaking new ground. Making any kind of game is an extremely time-consuming task, and if you are new at this type of work, you will be surprised at how labor-intensive it can be. It is better to have relatively modest ambitions for your first game rather than to aim for a magnificence you will almost certainly fail to achieve.
3. Set realistic milestones for the development of your game. Having certain dates by which certain key elements of your game must be completed will help you stay on course. Your milestones should be realistic in terms of being achievable. It can be helpful to pin your milestones to real-life events, such as meetings of a local game developers' organization. That way, you will not only have a specific date to shoot for but also an opportunity to show off what your team has accomplished thus far.

ADDITIONAL RESOURCES

The Internet is full of excellent information about video games. Among them are:

- Gamespot (www.gamespot.com).
- The International Game Developers Association (www.igda.org)Gamasutra (www.gamasutra.com), which publishes a wealth of information about video games and the video game industry.
- Moby Games (www.mobygames.com/home).
- For books on video games, refer to the Additional Readings section.

Conclusion

Certainly, games have made a light-year's-worth of progress since the first games were introduced back in the 1970s. One need only compare *Pong* to *Red Dead Redemption 2 to* see how far they have come. What kinds of games might we be playing a few decades

from now? And what role will games play in the overall universe of interactive entertainment, and entertainment in general? If only we could consult one of the wizards who populate so many role-playing games and learn the answers to these questions!

Idea-Generating Exercises

1. To test your understanding of genre, take a game you are familiar with, name its genre, and then assign it an entirely different genre. What elements would need to be added or changed, and what could remain, to make the game fit the conventions of this new genre?
2. Analyze your own experiences in playing games. What about them makes them appealing to you? What makes you feel involved with a game, and what makes you want to spend time playing it? What emotions do you experience as you play?
3. Consider recent movies or TV shows that you have seen. What kinds of storylines, characters, or themes have they contained that you've never seen included in a game? Do you think it would be possible to include this kind of content in a game? How?
4. What experience from real life have you never seen tackled in a game but believe could be? How do you think this idea could be implemented?
5. Sketch out a premise for a MMORPG. What world or worlds would it be set in? What would the central conflict be? What kinds of characters would exist here? What would be of great value in this world, the equivalent of money in our own world? Once you have established these fundamentals of your MMORPG, try to construct a treadmill for it.

Chapter 12

The Internet

- What are the unique characteristics of the Internet, and how can you make the most of them when creating narratives for this medium?
- What is meant by "stickiness" when referring to content on the Internet?
- In terms of story-based entertainment on the Internet, what do users find particularly attractive and what kinds of things risk being kisses of death?
- How are Web-based technologies that were originally developed for non-fiction purposes now being used for digital storytelling?

The Evolution of the Internet

The Internet has been through some massive changes and several dramatic reversals of fortune since its origins in the late 1960s. As we saw in Chapter 2, it started out in relative obscurity, and with an entirely different name—ARPANET—and was developed to assist the military during the Cold War. But in a little over two

decades, it underwent a name change and morphed into the more populist communications tool known as the Internet. By the mid-1990s, this once plebian communications tool was beginning to be perceived as a viable medium for entertainment, thanks to the development of the tools that made possible the World Wide Web. This was the time of the dot-com boom, and there was frenzied launching of new websites, many of them built for entertainment purposes. Everyone was hoping to "strike gold in cyberspace." Unfortunately, within a few short years, just after the new millennium arrived, it became evident that the great majority of these brash new websites were not generating the profits that were anticipated. The plug was pulled on many a site and we were suddenly looking at a dot-com bust.

In recent years, however, the Internet has not only rebounded but has become an even more robust medium for entertainment than almost anyone during the boom years could have predicted. In large part, this resurgence has been due to the growing numbers of households with broadband connectivity, which makes it possible to enjoy video on the Web, as well as other forms of entertainment that require high-speed access. The Internet is the home of social media services like Facebook and Twitter, and we discussed in Chapter 8 how social media is now being used as a story-telling platform. And it must be remembered that the Internet is also home to Netflix, the gigantic streaming service that offers movies and TV shows to a huge audience. Netflix was founded in 1997, but by early 2019 already had almost 140 million subscribers.

WORTH NOTING: THE DIFFERENCE BETWEEN THE INTERNET AND THE WEB

It should be noted that even though the terms "Internet" and "Web" are often used interchangeably, they are not the same thing. To be accurate, the Internet ("Net" for short) is a vast network of computer networks that are all linked together. It is made up of computer networks from the sectors of business, government, and academia, as well as personal computers. It allows any computer that's part of the Internet to communicate with any

> other computer. But despite the critical role played by the World Wide Web, the Internet itself remains an important way to communicate: email is sent through the Internet, not through the Web.
>
> The World Wide Web (or Web, for short) is just a small portion of the Internet, but a critically important one, because it is the portion of the Internet that makes it possible to link Web pages with each other, and to search the entire Web for a particular topic or name. In a sense, the Web sits on top of the Internet and functions through the Internet. As one writer put it, paraphrasing somewhat, the Internet is like a restaurant, and the Web is the most popular dish on the menu (from About.com). For digital storytelling purposes, we are primarily but not exclusively interested in the Web.

The Internet is now home to a diverse array of narrative-based genres, a number of them unique to this medium. We have already touched on several of them in previous chapters, such as Web series/webisodes, faux blogs, and various types of games, such as MMOGs and casual games. We have also looked at another cyber experience made possible by the Web, the virtual world. In future chapters, we will be exploring iCinema—another narrative form in which the Web often plays an important part. Furthermore, as we have seen, the Web is often used as a platform for narrative-rich projects used to teach, promote, and inform. And finally, as we have explored previously, there has been an explosion of user-generated material on social networking sites, some of which is narrative in nature.

In addition to all these relatively well-established types of content, the Internet is also home to such new forms of digital storytelling that they don't even have generic names yet. We will be looking at several of them in this chapter. Without question, the Internet plays an enormous role when it comes to digital media and storytelling.

It should be stressed, however, that the Internet is not like a library, where the same books can still be on the shelves unchanged for decades or more. Websites come and go, and new components are often added. For example, Twitch.TV, a live-streaming video platform and a subsidiary of Amazon, was introduced in 2011

and has quickly become a major hub for live-streaming video games and esports. TV shows and movies can also be watched on Twitch.TV.

Internet Connectivity across the Globe

Without being connected to the Internet, it would not be possible to enjoy the enormous amount of digital storytelling this medium offers. And the number of individuals connected to the Internet, either at work or at home, grows larger every day. According to the International Telecommunications Union, by June 2018, 55.1 percent of the world's population had access to the Internet. In 2017, the last year when more detailed figures were available, 7.4 billion people in developed countries had access; in undeveloped countries, 41.3 percent did. But even in undeveloped countries, an ever-larger percentage of the population could get online. For instance, 2005 in Africa only 2 percent of the population had access, but by 2017 the number had grown to 21.8 percent.

In the United States, according to a 2013 Pew Study report, a surprising 11 percent of the population does not go online. Why not? The reasons given for this are: 34 percent say they are not interested or don't feel it is relevant; 32 percent say it is too difficult to use or they are too old to learn; and 19 percent cite the cost of a computer or Internet service. A serious but uncited reason for not going online, true for certain populations in the US, including New Mexico, where I live, is lack of Internet service, particularly on Native American reservations and in rural areas.

The Popularity of Youtube Videos

YouTube videos are not only one of the most popular forms of entertainment on the Web, but also one of the forms users are most eager to share. According to MerchDope.com statistics, YouTube is the second most visited website in the entire world, right after Google. The first video was uploaded in 2015, less than 20 years ago, but by 2018 it attracted 1,300,000,000 visits. Six people out of 10 prefer to watch YouTube videos than live TV. Back in 2013, a *New York Times* reporter calculated that it would take 72

hours to watch all the videos posted to YouTube in just one single minute. Today, 300 hours of video are uploaded to YouTube every single minute. Thus, it would now take 300 hours to watch all of these newly uploaded videos.

> **STRANGE BUT TRUE: SEX SELLS**
>
> Producers of almost all types of media entertainment have traditionally seen the value of adding racy content to their offerings. This has been true of photography, novels, movies, and TV. And the same is true for the Internet. It turns out that the most valuable URL in the history of the Web is Sex.com. That URL was sold by one company to another for a staggering $13 million dollars in 2010, before plans had been drawn up on how to monetize the URL—the URL alone was considered valuable enough to fetch that price.

YouTube Success Stories

It seems virtually impossible to predict the types of videos that will be enormously popular with viewers or that will be spread the most quickly through viral marketing, but one thing is clear: If the video you upload is not immediately engaging, many people will not bother viewing it. MerchDope.com reports that approximately 20 percent of YouTube videos who start watching a video will leave after the first 10 seconds. Thus, for a video to be successful, it is best for it to be appealing right from the beginning. A video will also be attractive to audiences if it features a popular celebrity.

YouTube's most popular video of 2018 did exactly that. *To Our Daughter* was a loving tribute to Kylie Jenner's about-to-be-born daughter, Stormi, and starred Kylie, the youngest daughter in the famous Kardashian clan, her family and her famous boyfriend, Travis Scott, a rapper, songwriter, and record producer. The video starts off on a dramatic note, in the maternity ward, with 20-year-old Kylie on the brink of having her baby. Kylie, owner of a cosmetics line and one of the richest women in the world, is on a

gurney, wide-eyed with anticipation (and maybe nerves, though beautifully made-up), as nurses and family members give her encouragement. The video was watched 28.5 million times within the first 24 hours of uploading.

Two other highly successful videos of recent years could not be more different from each other. One is an earnest documentary called *Kony 2012*, about the Ugandan who runs the Lord's Resistance Army and forces youngsters to become child soldiers. The documentary was watched by 100 million people in six days, largely thanks to viral marketing. The other enormous hit was *Gangnam Style*, an upbeat music video by South Korean artist Psy. It was the first YouTube video to score one billion views. Why did a music video and a documentary and a video about celebrity childbirth manage to attain such popularity? We will try to answer this question during this chapter.

The Quest for "Stickiness"

The Internet has many attributes which, when taken individually, may mirror other media, but when bundled together, make it a unique venue for enjoying entertainment. When a website contains a great many of these attributes, it is also likely to possess a quality known as *stickiness*, a term that was widely used in the years 2001 to 2003, and is still relevant and still being used today. Though stickiness is unwelcome when it comes to doorknobs or furniture, it is an extremely desirable attribute for a website. It connotes the ability to draw people to the site and entice them to linger for long periods of time. If you want to create an entertainment site that is sticky, and hence appealing to users, you will want to include as many sticky attributes as you can, providing, of course, that they make sense in terms of the project. Users are attracted to the Internet because it offers them experiences that are:

- *Community building.* One of the most unique aspects of the Web is that it allows individuals to communicate with each other and share their thoughts, concerns, and opinions. When they visit a website, particularly one that

focuses on a fictional world they especially care about, they look for community-fostering options like comment boards and chat features.
- *Dynamic.* Well-maintained websites are refreshed on a regular basis, and users look forward to seeing new features on sites that they visit frequently. The adding of fresh content gives the website a vibrant, responsive quality. Websites that are not updated begin to seem stagnant and "canned," as if they had just been stuck up on the Internet and then abandoned.
- *Participatory.* Users want to interact with content; they look for ways of becoming involved with it. Participation in story-based entertainment on the Web can take many forms. It can mean chatting with a fictional character; suggesting new twists in a plot; creating and playing a character in an online story; snooping around in a character's computer files; or, in the case of a MMOG, creating an avatar and becoming an active character in a fictional game world.
- *Deep.* Users expect websites to offer them opportunities to dig down into the content. Even story-rich environments can offer a variety of ways to satisfy this expectation, from reading diaries "written" by the characters to viewing their "home movies" to visiting the online newspaper of their fictional hometown.
- *Edgy.* The Internet has something of the persona of a cheeky adolescent. Users enjoy irreverent humor, opinions that challenge conventional thinking, and content that they are unlikely to find in mainstream media like television and newspapers.
- *Personal.* The Web allows users to express themselves and be creative. Users enjoy customizing and personalizing content in various ways.
- *Easy to navigate and well-organized.* Users want to be able to quickly locate the content they are interested in and appreciate it when content is organized logically, or, as we discussed in earlier, has a well-ordered *taxonomy*.
- *"Snackable."* Most users are looking for short entertainment breaks rather than extended ones, or, as *Wired*

magazine puts it, *snack-o-tainment*. Content should be broken into consumable pieces that can be enjoyed within a few minutes of time.

YouTube Stickiness

What specifically makes a YouTube video sticky? Freddie Wong, one of the creators of the immensely successful YouTube series, *Video Game High School*, had some thoughts to share on a blog on RocketJump about the popularity of the Kony documentary (http://www.rocketjump.com/blog/the-secrets-of-YouTube-success-updated/2). Although he didn't feel it was particularly well-made, he did believe that the video offered users a terrific feeling when they shared it with family and friends. It made them feel worldly and committed to justice and as someone willing to act. "Kony was a drug in video form," Wong suggested. "And the method of administration was sharing it, spreading it further."

Kate Murphy in an article for the *New York Times* (February 13, 2013) offered some tips for making successful Internet videos:

- Have the right equipment. This needn't be elaborate—you can shoot on a smartphone. A lavalier microphone and some lights are also helpful.
- Be sure your performer is a good communicator. This person should be interesting and energetic, and give the impression that he's speaking to you as a friend.
- Offer content that is unique and cannot be found elsewhere.

In addition to these points, I would stress the importance of having a compelling story to tell. Even non-fiction works should have a story that people want to hear. Though the Kony documentary might not have been the most polished work of all time, it was about an evil strongman who committed barbaric acts of cruelty against vulnerable people, so the subject matter and the main character were unquestionably captivating, as was the overhanging question adding tension to the narrative: can this person be brought to justice? Thus, it had many of the characteristics of a solid story.

TV as a Role Model?

Because the Web supports audio and video, and because it is viewed on a monitor that looks much like a TV screen, inexperienced Web developers are sometimes lulled into the belief that creating stories for the Web is much like creating stories for TV. While many important similarities do exist, so do significant differences, and ignoring those differences can seriously undermine a project.

This was one of the most important lessons learned by writers and producers who worked on the Internet's earliest version of a Web series, *The Spot*, which began its run in 1995. The storylines revolved around a group of young singles living in a California beach house. Because of its focus on highly charged emotionally relationships, *The Spot* had much in common with television soap operas. However, unlike TV, each of their stories was told from a first-person point of view, largely through journals. And somewhat like the movie *Rashomon*, the characters often gave different versions of the same events.

Stewart St. John, a writer-producer with an extensive background in television, served as the Executive Producer and Head Writer of *The Spot* during its last year, from 1996 to 1997. But his work on *The Spot* quickly taught him to appreciate the differences between TV and the Internet.

Looking back on his experience in working on *The Spot*, St. John said: "In the beginning, I brought my conventional TV background to it. I plotted it weeks and weeks in advance and expected the storyline to stay true to what I wrote, never straying. It was the kiss of death. The fans went berserk. They didn't feel emotionally connected. It was too much like television." Visitors to online fictional worlds want to be able to participate in the story, he stressed.

To allow for more user participation, St. John found ways to integrate input from the fans to shape the direction of the plot. Over time, he came to realize that it was particularly effective to build consequences—both positive and negative—into the choices the fans are offered in the narrative, believing this pulled them more deeply into the story. By loosening his control and becoming

more flexible, he was able to provide an experience that was both narrative and interactive.

"You can't think in terms of the way you'd create for television," St. John asserted. "The Internet is its own world, and the language of that world is interactivity. This is the biggest mistake I've seen over the past few years; creators creating Internet sites using a television format. It won't work."

> **NOTES FROM THE FIELD: INVOLVING THE USERS**
>
> One way staff members on *The Spot* would involve fans in the story was to go into its chat room in character and chat with them. Some of these exchanges would be mentioned in the online journals "written" by fictitious characters, even weaving the users' names into the accounts. Not only did this give the fans a few minutes of glory but it also made the show seem all the more real. In fact, many fans of *The Spot* were under the impression that the characters were actual people, which put extra pressure on the writers to keep them consistent and believable.

Some Unique Web Genres

As noted earlier, a number of story-rich genres have been created specifically for the Web, and the Web also supports certain forms of narrative that blend several different media elements together, such as ARGs and transmedia storytelling. Let's take a look at some important Web-based narrative genres.

Web Series, or Webisode

Web series, which in the past were most often referred to as *webisodes*, are serialized stories that are broken into short installments, each just a few minutes long, and each of which often ends in a cliffhanger. The terms webisode and Web series can be used interchangeably. The genre evolved from *The Spot*, but while the storylines of *The Spot* were primarily conveyed by text and still images, today's webisodes use full motion video or animation.

Most webisodes revolve around contemporary characters in modern settings and center on personal dramas. And, despite the lessons learned by Stewart St. John and others working on *The Spot*, many of today's webisodes are presented in a linear fashion, much like a TV show, with little or no opportunity for user participation.

Web Series with a Hollywood Parentage

Some Web series, as we discussed in Chapter 10, are spin-offs of popular TV shows and are the product of Hollywood professionals. For example, *The Office: The Accountants* was the story of several regular characters from the hit TV show, *The Office*. Another now historic Web series was *Homicide: Life on the Streets*. It was based on the popular TV police drama, but contained original characters and incidents that were independent of the TV show. More recently, Showtime created a Web series based on its hit TV show, *Dexter*, about a serial killer with a strong moral code. Some episodes of the Web series dealt with Dexter's backstory and others were about cases not featured on the TV series. Other Web series spun off from TV shows include those made for *Lost, Ugly Betty, Heroes, Scrubs, Grey's Anatomy, Pretty Little Liars*, and *The Vampire Diaries*.

The fiction of a TV series can be continued on the Internet in other ways, as well. The major hit *Westworld*, a sexy adult theme park populated by androids, has a presence on the Web in the form of the website of the theme park's corporate owner, Delos. *Westworld; A Delos Destination* (https://discoverwestworld.com/#) continues the fiction of Westworld as if Westworld were a real destination and anticipates you will want to visit. But before you can make a reservation, you must take a 20-question assessment test to make sure your health is up to the excitement you will experience there and also to design an itinerary for you. You are even introduced to your Westworld concierge.

In addition to direct spin-offs and faux websites, professionals from TV and feature films have begun to get into Web content in a big way. For example, *Prom Queen* was a major entry with impressive Hollywood connections. It was produced by the great

Hollywood luminary, Michael Eisner, who once ran The Walt Disney Company. It debuted in 2007 and was shot on video. With 80 episodes, each just 90 seconds long, the steamy murder mystery revolved around a seminal high-school event, prom night. On a completely different note, a comedy about gamers called *The Guild* was created and written by Hollywood actress Felicia Day, known for her performances in *Buffy the Vampire Slayer*. Day not only wrote the episodes of *The Guild*, but produced and starred in them as well. It was a big hit not only with gamers, but with people who enjoyed its offbeat humor, and ran for six seasons.

Professionally Produced Web Series

Some Web series are slickly produced by Hollywood professionals, as with *Prom Queen* and *The Guild*. Other high-caliber series are a mix of episodes that are streamed on venues like Netflix and are augmented by digital media.

This is the case with the serious drama about suicide, *13 Reasons Why*, which was streamed on Netflix. Each episode was also available on YouTube and the story was augmented on social media. Teens followers of the story avidly participated in the social media components. Each of the main characters has a well-developed Instagram account which offered clues about her death, and via an innovative interactive mobile component, *Talk to the Reasons*, you could chat directly with the characters on your phone and hear their thoughts and opinions.

Original Web Series

In recent years, there has been a surge of interest in creating and producing original Web series. To my knowledge, no one is keeping a list of every produced series, but just to begin to put some sort of numbers on this phenomenon, in 2013 alone, almost 500 produced Web series were submitted to the Los Angeles Web Series Festival (nicknamed LAWEBFEST) by people hoping to have their work screened there (of this number, 262 were accepted). Applicants to this Web festival—the biggest and oldest one in the world—came from 15 different countries—some from as far away as Turkey and China.

Approximately 4,000 people attended Web Fest events, and many of them were hoping to make, or were in the process of making, their own Web series. The LAWEBFEST has spurred interest in other parts of the United States and the world to hold similar events, starting in 2011 with France's Marseille Webfest, the brother to the LAWEBFEST. In 2013 alone, festivals have sprung up in Hong Kong (HK Webfest), Australia (Melbourne Webfest), England (London Urban Webfest), Belgium (Liege Webfest), and two in Italy (Rome and Campi Flegrei, near Naples). In addition, in the United States, there were Web festivals in Washington, DC and Atlanta, Georgia. Other parts of the world with plans to hold Web festivals include Polynesia, Singapore, Senegal, Russia, Canada, and, in the United States, Texas and New York.

The LAWEBFEST was under the helm of the late Michael Ajakwe, Jr., an Emmy-winning TV producer, NAACP Image Award-winning playwright, and veteran TV and screenwriter who has even written and produced his own Web series, *Who…*, on his web channel, www. Ajakwetv.com. He started the LAWEBFEST in 2009, and it grew bigger with each subsequent year. It is still continuing, although Ajakwe sadly passed away 2018. In an interview during a brief break at the 2013 LAWEBFEST, I asked Ajakwe why he thought people were so interested in making Web series.

For one thing, he told me, making a Web series "is user friendly. Before, filmmaking was a rich man's game. And if you couldn't afford to make a film, a great voice might be lost." And, he added, "with a Web series, you can hear the voice of its creator. Web series offer more freedom. They are coming from the ground up, whereas other media come from the top down. Web series are almost like a pirate road. They let us hear stories you don't hear anywhere else. They are more authentic, more honest."

Ajakwe hit on one of the major reasons people are attracted to Web series: they can offer their creators a powerful form of self-expression. In addition, people are drawn to them for professional reasons. They are a relatively inexpensive way to master filmmaking skills and demonstrate your talent; they offer an opportunity to get your foot in the door of the theater world and TV and film business.

Original Web series come in an enormous assortment of shapes, sizes, styles, and themes. *In Transition* is the story of three women getting out of prison and adjusting to life on the other side of the bars; *Betas* is about a group of young men who work in a digital startup company; *Video Game High School* is a comedy about a high school where prowess at playing video games is far more esteemed than prowess on the athletic field; *3X3* is a French transmedia Web series set in Paris about a young man with amnesia trying to find out who he is. There are even story-based Web series produced for pragmatic purposes, such as *In the Moment*, a sexy series designed to make young gay men more conscious of the risks of HIV and Aids.

A Close Look at a Successful Original Web Series: Enter the Dojo

My own state of New Mexico is home to the successful Web comedy, *Enter the Dojo* (www.youtube.com/enterthedojoshow), a skillfully produced and extremely funny work written, produced, and directed by Matt Page, who also stars in the series. The series, a mockumentary, is set in a martial arts studio where students are instructed in a fictional and potentially deadly martial arts form, Ameri-Do-Te. Their over-the-top super-macho instructor is Master Ken, played by Page.

I sat down with Page at a local roadhouse and asked him why he decided to make *Enter the Dojo* and what he has learned from the process. Page noted that he had often been employed by various New Mexico entities to make promotional films for them and has made several short films on his own. But he told me he had become frustrated with the length of time it took to make and screen a short film—about two years—and that in the end only 500 people even saw it. But he had also worked on other people's Web series and had an opinion of what he'd do differently. He thought the Web series was an interesting format and a way to exert creative control of a project. He also believed making his own series could be a calling card for work in Hollywood.

Page selected his storyworld, which revolved around martial arts, in part because it was something he himself had practiced

since he was 16. Master Ken is a hybrid and send-up of various instructors he has had over the years. He knew the world inside out, and believed he knew how to target a series to the martial arts community—something he was totally correct about, for the series is a big hit in that community. At some real-life dojos, the students watch the series as a group experience. Page told me that the show is "crazy popular" in the UK, and that as many as 10,000 fans turn up there at *Enter the Dojo* events. Fans like to participate in the story by sending in videos showing how they would perform "techniques" demonstrated on the series, like the "kill face" and the "hurricane." The series also has a presence on Facebook and Twitter.

But Page has encountered unexpected challenges. For one thing, three of the series stars, buoyed by their success on the series, have taken off to Hollywood and he can only infrequently get them back to New Mexico. Thus, scheduling has become a big problem. Also, because he is a trained filmmaker (he is a graduate of the Film School of Santa Fe University of Art and Design), it is difficult for him to quickly produce a story-based episode because he can't rush the process. "I still try to apply the craft I spent years learning," he told me (see Figure 12.1). He has discovered, though, that he can speedily turn out short episodes where

FIGURE 12.1 Matt Page, center, on the set of *Enter the Dojo*. Image courtesy of Matt Page.

he does monologues or where there is only one other actor. He can do three of these in a single weekend, and does them all in one take, so there is no editing to do. Editing, he noted, was incredibly time-consuming.

I asked Page what advice he would give to people wanting to make their own Web series. He offered the following:

- Take care to come up with a concept that is sustainable. You want to be able to roll out a multi-season series.
- Watch lots of shows on YouTube's different channels before you start, particularly in your subject area. Once you get going, you can send the creators personal invitations to watch your series. (That strategy helped Page get to 10,000 views quickly.)
- Don't shoot your series all at once. He told me "Make sure there's an audience for it, first. You don't know if anyone is going to give a s**t."
- Don't make your series dependent on a large cast. Scheduling can become a major challenge, as it has in his case, with three of his actors now based in Hollywood.
- You have got to "feed the beast." In other words, you must keep producing and posting new material or people will unsubscribe.
- Interact with your fans. For instance, a disabled fan who was confined to a wheelchair asked Page how he could still practice martial arts. Page responded as Master Ken, enthusiastically telling the fan what a great weapon a wheelchair could be and describing the ways it could be used.
- Modify your filmmaking technique to fit the medium. Page has had to learn to shoot his Web episodes more quickly than he would shoot a film.
- Create characters that can be quickly understood by your audience, especially when you first introduce them. You don't have the luxury of doing character arcs or detailed backstories in a Web series. Once the series is established, however, you can let your characters evolve and change to some degree.

Though Page believes doing a Web series can be "a terrible way to make money," he has found the experience of creating his series personally and professionally validating. On the professional side, it has generated new work for him as an actor and a director. And on the personal side, it has brought him recognition that his short films never have. "It feels good to know you have a dedicated fan base," he told me, "and that you are a positive part of people's lives."

Non-Fiction and Fictional Blogs

The *blog*, short for Web log, is one of the most pervasive forms of communication on the Internet. A type of grassroots journalism, blogs are often highly personal and are written much like diaries, often with daily entries. Many blogs use not only text and stills but also video (and when a blog is video-based, it is known as *vlog*—short for video blog). As of July 2011, about 181 million blogs had been created around the world, according to NM Incite, a Nielsen McKinsey company.

Blogs, of course, are a form of storytelling. Originally, blogs were utilized to cover non-fiction subjects—everything from child-raising to politics to food—so first we'll look at non-fiction blogs and then turn to fictional or faux blogs—blogs that resemble their true-life cousins, but are actually make-believe stories.

Non-Fiction Blogs

Individuals write non-fiction blogs for many reasons, and according to a survey reported by Right Mix Marketing, these reasons include the desire to write about areas of interest; to share expertise; to attract new clients; and to connect with like-minded people.

Michele C. Hollow, for example, writes a successful blog called *Pet News and Views* (www.petnewsandviews.com) and has been doing this blog since 2009. In an email interview, she told me: "The goal of my blog is to educate people about pet care, pet lifestyle topics, and to share information about people who are working on behalf of animals." She went on to say "I ... highlight causes that

are important to me, and more importantly, important to animal welfare." Hollow says it isn't difficult for her to find material to blog about because "I have a lot of contacts in the pet and wildlife world. People contact me on a daily basis with interesting stories to cover. If I posted daily, I still wouldn't be able to cover everything. So I pick and choose." She advises people who want to start a blog to "Pick a topic you deeply care about. You are going to be devoting a large part of your time covering this subject, so it must be something that excites you."

Jacqueline Herships, a first-time blogger, created and runs a blog called *The Little Old Lady Stays Put (or doesn't)* using Blogger, a free platform owned by Google. Herships is a journalist and publicist who started her blog in 2011 to explore the housing options available for older people and the housing issues seniors face, in part because she herself was growing older and was trying to find answers for herself. She told me in a phone interview that so far, she has created about 177 posts using the phrase "little old lady" for her blog somewhat satirically. She admitted it has met with resistance from some of the people she wanted to interview who didn't want to be labeled that way, though others didn't seem to mind at all.

Over time the blog has evolved more into a lifestyle blog than a personal blog. Although Herships said she started to blog in part to find answers for herself, she has found that putting herself in the spotlight makes her uncomfortable, so now she is more likely to write about other people and their experiences. She said she hasn't found it challenging to find material for her blog, asserting she has "story radar," but she has encountered difficulties with the technical side of blogging, such as developing a comments section that will make it easy for people to post comments. On the other hand, she is pleased to have found blogging to be far more immediate than media she had used in the past, like newspapers and magazines. She confessed, though, that she misses the help that print publications provide, like proofreaders. She told me she is grateful that she is doing this blog because she is finding that it is a new way to engage with the world and with people. And as a result, she is slowly reaching her goal of solving her own issues as a senior citizen.

> **STRANGE BUT TRUE: NON-FICTION BLOGS THAT READ LIKE FICTION**
>
> For the most part, non-fiction blogs tackle serious issues or at least topics that are of personal concern for people, such as health. Partially for this reason, I believed for years that *Belle de Jour: Diary of a London Call Girl* was a fictional blog. It related the racy experiences of a London sex worker and seemed too lurid to be true. But on doing some additional research on the blog for this edition of the book, I discovered that the blog was in fact a real-life diary written by a real call girl, Booke Magnanti, and one that happened to be highly educated—a PhD scientist, in fact. It turns out she was using "Belle de Jour" as her pen name while finishing up her PhD in forensic science, meanwhile covering her living expenses as a high-priced call girl. She has recently revealed her true identity because she was on the verge of being outed by a former boyfriend. Now married and living in the Scottish highlands, she has written two books based on her experiences and a TV series has been based on her blog. She continues to write under her real name about scientific topics and sexual politics.

Fictional or Faux Blogs

Non-fiction blogs have achieved massive popularity, so it was only a matter of time before the creative community recognized their potential for storytelling and started to develop faux or fictional blogs. Many of them look just like the real thing. One such faux blog, *Nigelblog*, was allegedly written by a character from the TV show *Crossing Jordan* in 2005–2006. Another pioneering blog, although one which looks far more like a Broadway musical than a blog, was *Dr. Horrible's Sing-Along Blog*. It was created by Josh Whedon, a highly successful TV writer who has worked on such shows as *Buffy the Vampire Slayer*. Done entirely in video and divided into three "posts" or acts, it is a strange blend of comedy and wistfulness, the story of a man who yearns to be a super villain. Produced in 2008, it was an enormous success, but had little apparent connection to blogging as it was known at the time or even today.

However, a number of faux blogs have been created that have no connection at all to Hollywood entertainment properties and for all intents and purposes seem real. *Ghost Town* was an early example of this. It was a blog "written" by a young Ukrainian woman named Elena who claims she likes to ride her motorcycle through the dead zone of Chernobyl, decimated years after the disaster at the nuclear power plant. Her faux blog, illustrated with her own photographs, is a disturbing warning of the dangers of nuclear accidents. It is so convincingly done that it spread like wildfire around the Internet, with most people believing it was a true story.

A number of writers now believe that faux blogs can stand on their own as a form of fictional narrative. One fine example of fictional blogging is *Ben's Dive Blog*, written by experimental blogger Leo Thompson. His work looks like an authentic blog in every respect (see Figure 12.2), and the blog was presented as a work of undisclosed blog fiction, which means that Thompson did not tell readers the story was not true. Reflecting back on this, he told me in an email interview from Oman, where he now lives, that "I wanted my readers to believe it was genuine and make it more

FIGURE 12.2 This page from *Ben's Dive Blog* looks like an authentic, non-fiction blog, but is actually a work of fiction. Image courtesy of Leo Thompson.

intense, though I also didn't want them to call the local police or ambulance service if my character went offline for a few days."

Ben's Dive Blog is a harrowing adventure story about cave diving, and involves two real and largely underwater cave systems in England: Wookey Hole and Swildon's Hole. In the blog, two young men are trying to find an underwater passage that will link the two caves—a highly dangerous enterprise. To add drama to the story, a rival group of divers is trying to accomplish the same goal and will possibly try to sabotage the first group. The blog is told as a first-person account by one of the divers in the first group. The protagonist reports every day on their progress and setbacks—an approach that works perfectly in a blog format, and gives the story a gripping immediacy.

According to Thompson, he chose a blog format for his story because "there is something about their capacity to be personal, intimate and immediate that lent itself to a fictional project." In the course of writing it, he found that it evolved over time. He told me he had to adjust the tone, "which was too stiff and precise to fit the 'laying myself open rough feel' you often get with blogs. It also forced me to compress the daily episodes/posts and be more concise, which is something I have always struggled with as a writer." He would also deliberately make a few typos and comment on things going on in the news to give the blog an air of authenticity.

He made the story interactive by letting followers post comments, send email, follow on Twitter, and access a photo gallery using Flickr. He told me that "This enabled the protagonist to respond to comments left by real world followers who could cross the boundaries and play a part in this fictional universe." He found his biggest difficulty was the pressure to post every day, but on the whole found the experience a good one. "I learned that blogging is multidimensional in a way that 'old print' isn't," he said. For others interested in creating a fictional blog, he recommends considering form and function first. "Does the content and purpose of your story lend itself well to a blog?" he said to ask yourself. "If not, then choose another medium. Push the envelope somewhere else." The blog is now archived at http://archive.org/web/, and can be found by searching for benlockhart.com and, once there, by clicking on the date August 27, 2010.

Webcam Dramas

A webcam drama (my term) is one of the most unique storytelling forms on the Web and would not work on any other medium. Essentially these stories are intimate online diaries in which the protagonists of the stories focus their webcams on themselves and relate what is currently taking place in their lives.

Rachel's Room, which debuted in 2001, introduced this highly innovative and organic approach to storytelling on the Web, and fully used everything the Internet had to offer at the time to serve the purposes of the narrative. It was developed as part of Sony's ambitious broadband initiative, *Sony Screenblast*, which catered to users with high bandwidth, and thus made heavy use of video, offering 50 video installments, each running between three and five minutes. It pushed the envelope of the Internet as a medium for fiction. Six long years later, the famous *LonelyGirl15* used an almost identical approach.

Rachel's Room is a story that could only exist on the Web—the very fact that it takes place on the Internet is an integral part of the concept. Here is the conceit: 16-year-old Rachel Reed is at a crisis point in her life. Her father has recently passed away and she is at war with her mother, who has a serious drinking problem. Like Holden Caulfield in *The Catcher in the Rye*, Rachel feels misunderstood by everyone around her. Thus, in an effort to break out of her isolation and get a handle on things, she makes a radical decision: she will open herself up to strangers in the outside world. So they can see who she really is, she will place webcams around her bedroom and let them roll (though she plans to edit out the "boring parts" before putting the videos up on the Web). Furthermore, she will keep an online journal and also go into a chat room every night to talk with members of her cyber support group (see Figure 12.3).

Arika Lisanne Mittman, who served as producer and head writer of *Rachel's Room*, utilized both familiar and novel methods of telling Rachel's story and encouraging audience participation. Pieces of Rachel's story were revealed via the video episodes, her written journal, and the chat sessions, and all three were coordinated in terms of content. Viewers could express themselves via message boards, emails, chats, and in certain special ways, such

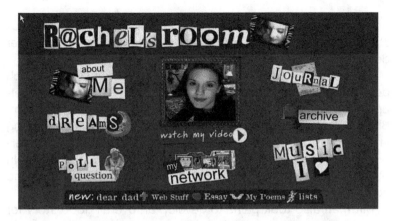

FIGURE 12.3 *Rachel's Room* appeared to be the website of a real teenager, but it was actually a professionally written drama. Image courtesy of Sony Pictures Digital.

as the "Dreams" section of the site. The chat sessions were an important part of the *Rachel's Room* experience. Mittman herself went into the chat room every weekday night, playing the part of Rachel. Sometimes these sessions contained serious discussions of teen-related issues, but sometimes they also advanced the story. In a clever blending of reality and fiction, she had Rachel meet a boy fan during one of these sessions, a charmer whom Rachel believes to be her soul mate. Against all common sense, she invites the boy (actually an actor playing a fan) to her room, unaware that he's made a bet with his friends that he could seduce her on camera. Naturally, the relationship ends badly, but it caused great anxiety among Rachel's real fans, many of whom were convinced that Rachel was a real girl and not a character in a fictional drama. Mittman says she developed this subplot in part as a cautionary tale for the site's visitors.

> **EXPERT OBSERVATIONS: DRAWING FROM TRADITIONAL MEDIA**
>
> By having Rachel share her most personal thoughts and her teenage angst, often breaking the fourth wall by addressing the viewers directly, the character touched a nerve among the site's fans. They closely identified with her and were intensely concerned with what happened to her. In creating such a compelling

protagonist, *Rachel's Room* was actually borrowing a valuable technique from older forms of storytelling: good character development.

"It's wrong to think characters for the Web don't need much depth," Mittman asserted to me. She believes character development is as important for the Web as it is for any other medium. She strove to create a multidimensional, realistic teen, tapping into her own "inner teenager" to do so. She gave Rachel "a certain mopey cynicism" and had her do dumb things at times. In other words, she was flawed, which helped her seem real, and contributed to her appeal.

Mittman also took pains to develop an overall good story for the series, "arcing it out" (constructing an arc for it) as would be done for a television drama. For the Web, she stressed, "you have to try that much harder to keep people coming back." To Mittman, that means not only constructing strong storylines with cliffhangers but also giving viewers a meaningful role in the story. "You have to keep them in mind," she told me, "and keep in mind why they are going to come back. You have to make them a part of it."

A number of other Web dramas have been presented as true-life video blogs made by someone using his or her own webcam. A series of such videos, purportedly made by a teenaged girl named Bree, caused a huge stir when they turned up on YouTube in 2006. The homemade-looking videos, collectively known as *LonelyGirl15* (the fictional girl's user name), were an intimate portrait of a shy, awkward teenager and her friendship with a boy named Daniel. Bree corresponded with her fans by email (actually written by a woman involved with the production). Viewers in turn sent Bree videos they had made. The storylines of *LonelyGirl15* were shaped to some degree on viewers' feedback. Some of the videos contained hints that Bree was possibly being pulled into a sinister cult, and viewers grew increasingly alarmed by her situation. About four months after the first video appeared, however, it was revealed that Bree was actually an actress and that *LonelyGirl15* was a work of fiction, a discovery that brought the series even more attention (the making of *LonelyGirl15* is discussed in Chapter 20).

Though *LonelyGirl15* was by far the best known of these webcam dramas, it was not the first. Two such works, *Online Caroline* and *Planet Jemma*, were produced several years earlier in the UK, and *KateModern*, a sister series of *LonelyGirl15*, was launched in 2007, one year after *LonelyGirl15*. It was produced in the UK and made for Bebo, and used many elements from the *LonelyGirl15* plotline.

The Marble Hornets was another series that use the webcam technique, though in a more complex way. The story is roughly based on the Slender Man myth, and a character like Slender Man, known as the Operator, appears as a shadowy sinister antagonist in the story. The complex drama concerns a young man, Alex, who is making a student film only to abruptly abandon it, and his friend Jay, who is reviewing Alex's video tapes in an attempt to find out what happened to his friend. In the highly complex and convoluted story, we see both young men videotaping themselves, although the videos contain a great deal of material shot from a third-person point of view. The series was a major success and ran for three seasons. As of April 2018 it had been viewed 95 million times.

Comedy Shorts

Comedy shorts are immensely popular on the Web. Because they are amusing, and usually just a few minutes long, they work extremely well as a form of "snack-o-tainment." Many of these shorts tackle subject matter that would be considered in bad taste or too extreme for mainstream TV, further adding to their popularity. In some cases, a site will be an amalgamation of the work of various writers and producers. For example, Icebox.com (which became Icebox.TV in 2018) specializes in animated shorts written by some of Hollywood's funniest writers. *Funny or Die*, founded by actor Will Ferrell, is another site with a great number of shorts, which are mostly shot in full motion video and seem to be primarily targeted to young males.

In many cases, a comedy will be a stand-alone work and not part of an amalgamated site. YouTube is full of independent comedy shorts.

Interactive Mysteries and Adventures

Although not at all as numerous compared to Web series and other forms of Internet narratives, interactive mysteries and adventures have the potential to be dynamic forms of Web entertainment. Such narratives give viewers the opportunity to become a participant in a story and solve a crime or a mystery, sometimes for prize money. *Jamie Kane*, which was produced by the BBC, was a story about the mysterious death of a fictional British pop star and participants were asked to determine how he died.

A clever and ambitious episodic mystery series, *Stranger Adventures*, sent viewers on a new adventure each week to help a character find a hidden treasure. Debuting in 2006, it was an anthology series, a form rare to the Web. A new story came online each week on a Sunday and ran until the following Saturday. It was a new kind of genre for the Internet and creating it was full of challenges for the development team. In devising this series, the producers chose to break new ground and take Internet entertainment in an entirely new direction. But in doing so, they took care to invest a great deal of creative energy early on to get the series off to a good start. They produced a demo episode and conducted five focus groups before moving ahead with the series.

The stories thrust viewers into a first-person drama that began when an individual they do not know (the "stranger" of the title) urgently requests their help in finding a treasure of some kind. Each story featured a different stranger with a different need for help, and finding the treasure required cracking a 10-digit code, which was done by uncovering clues embedded in the story. The first viewer to succeed received a thank you gift in the form of $25,000 in cash. Thus, *Stranger Adventures* combined some of the features of TV drama with some elements of video games, creating a unique narrative genre (see Figure 12.4).

Richie Solomon, the supervising producer of the series, described it as "a story that takes an ordinary person on an extraordinary adventure." The drama unfolded in real time through the emails and videos—usually several a day—sent to you by the stranger. If the stranger found herself in trouble and needed your help at

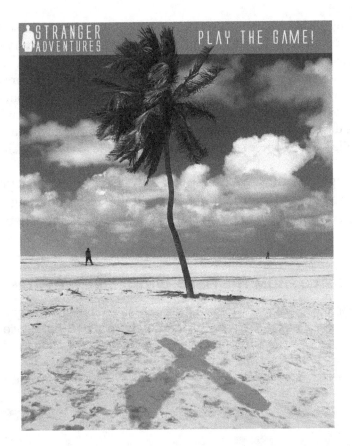

FIGURE 12.4 The anthology series *Stranger Adventures* involved users in a new interactive mystery each week. Image courtesy of Riddle Productions, Inc.

3:30 in the morning, for example, you would receive a communication from her at 3:30 in the morning. "Our format was something entirely new," Solomon said. "Our stories were extremely personal. The viewer needed to feel like the protagonist was talking directly to them. It was very intimate and confessional. It shattered the fourth wall." The pilot was so successful that it earned the show an Emmy nomination (the series went on to receive two more Emmy nominations).

Solomon, who was involved in hiring the writers for the first season, told me how challenging many writers found this new form of writing to be. "Our writers had to relearn storytelling," he said.

Many of the writers we interviewed in the beginning of the season just couldn't get it ... It's definitely a challenge to write a story that is told through video one moment and then through a text email the next and then through a series of interactive animations, all the while keeping the adventure engaging and exciting from one day to the next. And the writer must provide ample material for the designers, animators, and puzzle master to work with, all the while keeping these separate elements organic to the storytelling.

Although this impressive endeavor only lasted one season, perhaps because of the high production costs, it illustrates how engaging a mystery approach can be on the Web when users become personally involved with the story.

> **NOTES FROM THE FIELD: WHY SUSPENSE WORKS**
>
> Over time, Solomon told me, the creative staff found that the more suspenseful stories in the series received better viewer feedback. "You almost had to end every communication from the stranger with its own cliffhanger," he said. "That way the viewers were eagerly anticipating and actively checking for the next communication."

Conclusion

As we have seen, the Internet has successfully recovered from the dot-com bust at the turn of the millennium and has proven to be a robust vehicle for new kinds of entertainment experiences. In this chapter, we have seen some compelling examples of how stories developed for the Web can be told differently than stories developed for other media, especially TV. The most innovative of these new kinds of narratives are participatory and use a variety of Web-based technologies to advance the storyline. Many also break the fourth wall and blur reality and fiction in intriguing ways.

In addition to the genres discussed in this chapter, we have touched elsewhere in this book on other forms being used on the Web. They include games of all kinds; virtual worlds; and music videos.

Of course, we can have wonderful interactive stories that defy categorization. *Duck Has An Adventure* (http://e-merl.com/stuff/duckadv.html), for example, is an unpretentious interactive story about a duck. You, the user, can decide what the duck will do. He can go on a pirate adventure, acquire an education, or find romance. The story is told primarily in panels, like a comic strip, with occasional text and many quacks, and there are some surprises in the tale. It's a simple story told in a simple way, with a branching structure, but highly interactive and charming.

As the Internet continues to mature, we can expect to see new kinds of narratives that will advance the art of digital storytelling on this medium. Some will succeed and some will fall by the wayside, but one thing we can count on: the Internet will continue to offer us new kinds of interactive stories.

Idea-Generating Exercises

1. Select a website that has story-rich content. What demographic do you think this content is designed to attract and why do you think this group would find it appealing? How, if at all, does it use the special attributes of the Web? What about it, if anything, do you think users might dislike? Can you suggest anything that might make it more enjoyable?
2. Sketch out an idea for an original fiction-based work for the Internet. How would you make it "sticky?" How could users become involved with the content?
3. Select a character you are extremely familiar with from a TV show or movie and write several entries for a faux blog in this person's voice. Alternatively, create a fictional character of your own and write a portion of this person's blog.
4. Many people enjoy dramas on the Internet that, like *Rachel's Room*, *LonelyGirl15*, and *Ben's Dive Blog*, are works of fiction but seem real. Other people, however, object to stories that blur fiction and reality in this way, feeling they are a form of lying and deception. What are your views of such stories, and why?
5. Sketch out the idea for a Web-based mystery. What interactive features could you employ to immerse users in the story?

Chapter 13
Mobile Devices and Apps

- How are portable devices like mobile phones and tablet computers being used for entertainment purposes?
- What are some of the unique features of mobile devices that make them attractive as platforms for digital storytelling and other forms of entertainment?
- What are some of the approaches app developers are using for digital storytelling?
- Can mobile devices be used effectively for storytelling, and if so, what techniques are being employed to do this?

The Metamorphosis of the Telephone

Just a few short years ago, we used our telephones for just one purpose: to talk with other people. It was a convenient method of verbal communication. But thanks to the development of mobile phones and their evolution into smartphones (the terms "mobile phone," "cellphone," and smartphone are often used interchangeably) the possibilities for the once strictly utilitarian telephone

have expanded exponentially. Smartphones are computerized phones that can perform many of the functions of a computer, but in a far smaller package. Consider some of the things we can do with smartphones that we could never dream of doing with our old phones:

- Send and receive text messages.
- Connect to the Internet.
- Take, send, and view digital photos.
- Take, send, and watch videos.
- Scan barcodes and QR codes.
- Utilize apps.
- Get updates on news, sports, and weather.
- Use embedded GPS (Global Positioning System) technology and a compass.
- Listen to music.
- Watch comedy shows, cartoons, and dramas.
- Play games.

Clearly, the old rotary-dial telephone with its cumbersome cord has evolved into something far more robust and sophisticated. The same goes for our computers, which once sat impressively on our desks and were often too heavy to lift. Over the years, though, thanks to technology, computers became lighter and more portable, and now many of us work exclusively on laptop computers. But in 2010—drum roll, please!—we were presented with the iPad, a portable computer that was just the size of a magazine but could do so much more than our old laptops! Since then, we have been flooded with new kinds of tablets. Many have cameras, microphones, accelerometers, and virtual keyboards, and most functions can be performed by swiping a touchscreen. Tablet computers can do virtually everything our older computers can do, even though they are not as useful for major computing tasks as our old desktops and laptops. Nevertheless, many analysts predict that tablets are killing off the older, larger forms of computers.

Cell phones and their more sophisticated cousins, the smartphones, spread across the globe with remarkable speed. The first cell phones were tested in 1979 in Chicago and Japan. By 2013, in less than 35 years, the International Telecommunications Union

(ITU), a special agency of the UN, reported there were 6.8 billion active cell phone subscribers around the world, almost one subscriber for every person on Earth! As of 2018, there were approximately 4.1 million apps on the market. The numbers have been growing steadily every year, and the average person has 60 to 90 apps on their phone (from www.statista.com).

> **STRANGE BUT TRUE: CELL PHONES MORE POPULAR THAN TOOTHBRUSHES!**
>
> An infographic published by Digital Buzz (http://www.digitalbuzzblog.com/social-media-statistics-stats-2012–infographic/) noted that by early January 2012, although almost five billion people owned a cell phone, only 4.2 billion owned a toothbrush. Though this is a statistic that should make mobile developers happy, it is unlikely to please dentists!

It should be noted that the popularity of mobile devices and apps has spurred a new branch of the economy, the so-called app economy, and has been credited with creating 800,000 jobs worldwide since 2007 (as reported by the trade group TechNet).

The Progenitor: A Snake

Given the short history of the mobile phone and the tablet computer, an impressive amount of entertainment, some of it highly innovative, has already been developed for this platform. Oddly enough, it was a serpent that started it all, the star of the mobile game, *Snake*. Nokia introduced *Snake*, a retooling of an old video game, in 1997 as a novelty on a new line of phones. Though it is rudimentary by today's standards, it is still being played. And, like the appearance of the serpent in the biblical Garden of Eden, its arrival on the wireless scene served as a major eye-opener, bringing about a dramatic change in perception. Before the arrival of *Snake*, we regarded our telephone as a utility device; thanks to *Snake*, we were able to see its potential for entertainment.

In the years since *Snake* first slithered across the screens of the world's cell phones, entertainment on mobile devices has evolved

dramatically. Much of this entertainment comes to us in the form of apps. Downloading and utilizing apps is one of the popular functions of smartphones and tablets. An app (short for application) is a small dedicated program or piece of software that can be downloaded to a portable device like a phone or tablet to fulfill a particular function. Apps can be games, ebooks, or even a utilitarian program that turns your phone into a flashlight. The two most popular operating systems for apps are Apple's iOS (which used to stand for iPhone Operating System, but is now used for all Apple mobile devices) and Google's Android, a Linux-based operating system. Although there are other mobile operating systems, Apple and Google apps have been in a neck and neck race for popularity across the Globe. In 2017, Google offered 2.8 million apps while Apple's App Store offered 2.2 million—close, but not a tie.

Social media users have to a large degree migrated over to mobile devices: by 2018, Facebook had 55 billion mobile-only active users a month, and its standalone mobile app, Messenger, had 1.2 billion active users a month. That same year, the leading mobile messaging app, WhatsApp, had 1.5 billion monthly active users. By 2019, Instagram had one billion active users per month. Also, in 2019, another popular social messaging app, Snapchat, had 186 million people using it on a daily basis. Snapchat is designed for instant communication; your posts disappear in a short amount of time. Snapchat users created 3 billion snaps a day.

STRANGE BUT TRUE: APPS FOR APES

It turns out that humans are not the only species that enjoys playing with apps when things get a little boring—orangutans are highly enthusiastic about apps, too! *Apps for Apes* is a program in at least 13 zoos worldwide designed to give these highly intelligent primates more stimulation. They are fond of a variety of different apps, such as playing the drums, finger painting, playing games, and watching videos, and are particularly excited about being able to interact with the tablets. They are given a choice of apps to use, and each orangutan seems to have his or her own preferences. As of yet, however, they can only interact with them through a small opening in the bars of their cages;

they are regarded as too powerful to be allowed to hold the tablets themselves. The orangutans respond to tablets much like humans, with the young ones particularly excited about them. A zoo in Miami (not part of this program but doing its own work with iPads) has discovered that its two oldest orangutans, unlike the young ones, respond much like seniors of the human species, and are not particularly interested in them.

STRANGE BUT TRUE: CELL PHONE DEPENDENCY

Along with all the positive aspects of mobile devices, there is at least one downside: people can become overly dependent on them. According to a study by TeleNav, Inc., more than half of Americans would rather do without caffeine, alcohol, or chocolate than part temporarily with their cell phones. Another third would give up sex, and 21 percent would do without shoes before they would do without their mobile phones. As a testament to their devotion to these devices, 66 percent of people surveyed reported sleeping with their cell phones next to them in bed.

The Appeal of Mobile Devices and Apps

Owners of mobile devices appreciate receiving entertainment via mobile because it is immensely portable and because it offers content in bite-sized, easily consumed pieces. It's the perfect solution to those situations in life that are usually entertainment dead zones: riding elevators, waiting for buses, or sitting around in waiting rooms.

Developers of entertainment content have also quickly gravitated to mobile devices, and for a number of reasons, including:

- They are an extremely common device, dwarfing the number of game consoles and computers in comparison, and thus offer a vast potential audience.
- Mobile phone subscribers are highly diverse demographically, making it possible to reach new groups of users.

- The technology allows for fresh content to be offered on the fly.
- Consumers are accustomed to paying for mobile apps, a process made much easier by app stores, unlike web content where the general expectation is that content should be free.
- Many apps are offered to consumers as a purchase, and even though the price is usually modest, it is often not free, unlike Web content.
- Mobile devices are conducive to the use of social media, giving them a community building aspect.
- Producing content for mobile devices generally costs less than other forms of entertainment, such as TV shows and video games, and the development period is usually shorter as well.

As to be expected, the landscape of mobile technology and innovation changes quickly. We now have the arrival of 5G, the latest generation of mobile communications. It is the successor to 4G, 3G, and 2G. Its advantages include faster video streaming, faster access to the Internet and reduced latency (time it takes for a message sent by a user to reach the receiver). A smartphone user will be able to download a full-length movie in just seconds. 5G also allows for streaming VR, which means that the VR content does not have to be downloaded first.

With the popularity of watching video on one's smartphone, it was almost inevitable that one of Hollywood's most successful producers would move into this space in a big way to produce mobile storytelling. In 2018, Jeffrey Katzenberg, who was once the brilliant chairman of the Walt Disney Studios, joined forces with businesswoman Meg Whitman, formerly CEO of Hewlet Packard, to form a high caliber short-form production company for mobile content. They named the new company Quibi (short for Quick Bites) and raised one billion dollars in initial funding to get the company off to a solid start. They quickly attracted top Hollywood talent to create programming for the new subscription-based streaming service, and by early 2019, they announced their first group of series to the public. Katzenberg refers to smartphone

video as "TV in peoples' pockets" and anticipates each episode will run between 10 and 20 minutes.

Ironically, although we call smartphones "phones," they are used more frequently for other purposes than for talking with someone in real time and who is in another location. The reasons for this were articulately pinpointed by game designer Ian Bogost in an article for the Atlantic Monthly, "Don't Hate the Phone Call, Hate the Phone," on August 12, 2015. Bogost notes that many people feel anxious about using their smartphones to make phone calls and notes several factors are responsible for this: the design of "old-fashioned" landline phones was crafted for maximum efficiency for talking to another person and for listening to what that person was saying to you, as opposed to the flat, rectangular design of the smartphone, which is far less conducive to talking and listening.

Furthermore, he points out, landline technology ensured that the phone call itself would be a reliable experience, unlike the use of smartphones, where we often experience the frustration of dropped calls and weak signals and at times trying to make a call where there is no cell phone coverage at all. Furthermore, where once making a phone call was a private experience, done in ones' home or office, today we can make calls wherever we are, often contending with competing background noise: traffic, the background sounds of cafés, or the loud announcement system in airports. "The mobile phone in general and the smartphone in particular are designed to be carried first, and spoken into second," Bogost asserts. Nevertheless, they are a fine tool for a function never foreseen by their designers: they are a robust platform for digital storytelling.

Mobile's Special Challenges and Opportunities

Despite the enormous potential audience for mobile entertainment, and despite its many attractions for content creators, developing entertainment in this arena poses a unique set of significant challenges. For one thing, content creators must find ways to cope with tiny screen space, though this is less of an issue with full-sized

tablet computers. In addition, it can be extremely difficult for the "little guys" who make games of mobile devices to market their products and to compete against the major players like Gameloft, Electronic Arts, and Rovio. And though on the plus side, mobile phones are something you always have with you and are always available, they also come with a host of new technologies to deal with, including:

- The *touchscreen*, which lets people employ fingers on the screen to touch and drag content, slide objects up and down or around the screen, and pinch to decrease or widen fingers to increase the content's size
- A *QR code reader*, which is used to read a QR code, a type of bar code made up of black bars arranged into a square (see Figure 13.1)
- The *accelerometer*, which can compute roll and pitch
- The *gyroscope,* which, when combined with the accelerometer, can compute how fast, how far, and in which direction an object has moved
- A *compass*, which can be used to determine geographic direction
- *Face time* (Google Hangouts via Android or Skype on both) which is used to make video calls

FIGURE 13.1 A QR code from *The Q Game*. Image courtesy of Extreme AI, Inc.

- A *camera*, which can be used to take still photos or video, and even stream live video
- *GPS*, which can be used in location-based mobile games and stories

Though not all mobile devices come with all of these elements, most of them are common on smartphones, and developers need to be aware of what they can do and how they can possibly contribute to a story experience.

Bill Klein is someone who found some ways to address the challenges facing small mobile developers. Klein is now CEO of Rival Theory, a company that creates a new generation of smart NPCs, but he used to make mobile games when he headed Extreme AI, Inc. According to Klein, while you can't compete directly against the big companies, which have enormous resources, "you can compete in terms of novel ideas." Klein told me it is important not to look at mobile devices as "just a piece of hardware for playing video games, but as a device with special attributes, especially involving communications." He believes in order to compete, developers need to come up with new ways to incorporate these special attributes into the games they make.

His company did just that when it developed and ran a multimonth game called *The Q Game: City of Riddles* (see Figure 13.2). "Q" is a nickname for Albuquerque, where the game was played, and the slogan for the game is "Do you Q?" Sponsored by local businesses, it was a community-based game that combined puzzle solving and a story with quest-like missions. Some of the clues contained images of unique landmarks in Albuquerque (see Figure 13.2). Klein and his team managed to develop a game that made good use of some of the unique qualities of mobile devices, yet by keeping it local and community-based, they did so in a way that was manageable by a small start-up and that did not directly compete with major game companies.

Players were dispatched to real-world locations to find clues, which in turn led them to other clues. For example, they were sent to an art museum to try to find a specific artwork. If they succeeded at locating it, they would be startled to receive a call on their mobile while still standing in front of the artwork.

FIGURE 13.2 This old gas pump is a local landmark in Albuquerque and was one of the clues in *The Q Game*. Image courtesy of Extreme AI, Inc.

The call would give them instructions for their next mission. Players were also asked to use their phones to photograph a QR code, which would then unlock a website offering an important clue.

Though set in the contemporary world, the narrative of *The Q Game* is based on Greek mythology. Klein describes the game this way: "The storyline is based on the return of the mythical Greek Titans to our world. In the game, the Titans are ordinary people, many of whom don't realize what they are. As the story progresses, one of the Titans enlists the aid of the players to reawaken the others and prepare them all for the coming conflict with Zeus." According to Klein, the clues are "not just interesting for their

own sake but are relevant to the content of story or else lead you further into the game."

> **STRANGE BUT TRUE: HOW PEOPLE USE MOBILE DEVICES**
>
> Although we might want to believe people use their mobile devices for entertainment, like watching videos or playing games, or for utilitarian purposes like making phone calls or texting, they sometimes use their phones for anti-social purposes.
>
> According to a study done by the Pew Research Center in 2015, 31 percent of those surveyed reported using their mobile devices to avoid people around them. This disturbing mode of behavior was most prevalent among the youngest group, 18- to 29-year-olds, of whom 47 percent admitted to this use of their phones.
>
> Of this same group, 93 percent used their phones for a more benign purpose: to avoid being bored.

Mobile Devices and Digital Storytelling

Just as *Snake* evolved into more sophisticated forms of games, character-based entertainment on mobile devices has also been evolving. In 2001, when cell phone graphics were still extremely primitive, a Finnish company, Riot-E, thought of a clever way to use text messages as a storytelling device. At the time, the movie *Bridget Jones' Diary*, the story of the world's most miserable unmarried woman, was a huge hit. Riot-E offered subscribers short daily SMS (SMS stands for Short Message Service) updates "written" by Bridget herself. For instance, one of her communications, referring to her dismal text-messaging habits, reads: "Text messages from Daniel: 0 (bad). Text messages sent and received regarding lack of text messages from Daniel: 492 (very, very bad)." Bridget also conducted polls, asking her wireless friends their opinion of the following: "Valentine's Day should be banned by law. Reply with Y/N." With *Bridget Jones' Diary*, Riot-E cleverly

used SMS technology in a way that fit snugly with the persona of the fictional Bridget, and it was a big hit for its time.

Since 2001, when *Bridget Jones' Diary* was being played, there have been major advancements in terms of storytelling on mobile devices. According to Sean Mills, content head of Snap Originals (as quoted in *Variety*, April 4, 2019), "Mobile is now the dominant medium for telling stories and consuming content." He believes that within a year, mobile watching will surpass TV viewing.

Today's forms of mobile storytelling include:

- *Ebooks*, which are electronic books that are read on mobile devices. Ebooks vary a great deal in terms of the interactive features they offer. Some are very pure, with only text and sometimes illustrations, and only offer the user the ability to turn the page forward or backwards. Others offer video, animation, sound (often a voice narrating the story), pop-up elements, words that light up as the story is being narrated, and a connection to the Internet. Some even go beyond that, and send "readers" on a quest into real life, which can be to make an art project and to solve a mystery. They may have the reader call a telephone number, solve puzzles, read Facebook posts, or "look over" evidence, like letters or files. One particularly interactive ebook is *Little Red Riding Hood* from Nosy Crow, which offers multiple paths to Grandma's and eight possible endings.
- *Interactive adventures* using mobile devices are adventures set in real places but use mobile devices to guide players from one location to another while picking up clues. At least two such adventures have been made for Disney properties. The *Menahune Adventure Trail* is set at Disney's Aulani Resort Hotel in Hawaii. Players are given a specially designed mobile device, about the size of a cell phone, and sent on a scavenger-hunt-like quest involving the Menahune, or the magical little people of the islands who are somewhat like Ireland's leprechauns. As one goes on the adventure and finds a correct location, their mobile device can light torches and make rocks move and make

drums play, and there's a Hawaiian auntie to call if one needs help. Another mobile adventure game, this one set at Disney's Epcot Theme Park, is *Disney Phineas and Ferb: Agent P's World Showcase Adventure*. As with the Hawaiian adventure, players use a special mobile device to follow clues in one of several different pavilions at Epcot.

- *Social media stories*: social media, which supports both video and text, is being used as a platform to tell a variety of different kinds of stories, as described in Chapter 8. Many of these stories are serialized. Stories conveyed by social media include family dramas, like the *Lizzie Bennet Diaries* and *Uk'shona Kwelanga*; horror stories, like the *Dark Detour* series; serious teen dramas, like *13 Reasons Why*; documentaries, like *The Grapes of Wrath Journey*; and romantic comedy, like *The New Adventures of Peter and Wendy*.

- *Serialized content for established entities*: Snapchat, Facebook, and Instagram all began to offer mobile programming by 2017 and Google Spotlight Stories preceded them all in 2012, though it was not exclusively a producer of mobile content. Snapchat, with Snap Originals, has been the most successful of the three, and by the fall of 2018, it offered over 18 shows that reached monthly audiences of over 10 million viewers. Of these shows, 12 are original Snapchat productions. In April 2019, it announced 10 new series, a mix of comedies, dramas, and news shows and social commentary, primarily designed to appeal to teens and young adults. One popular Snap Original is *Literally Can't Even*, about following the lives of two twenty-something young women who are best friends. The show stars the daughters of two major figures in Hollywood: Steven Spielberg (Sasha) and John Goldwyn (Emily). Sasha and Emily co-created and co-wrote the episodes. Facebook Watch and Instagram IGTV also offer a varied mix of programming.

Google Spotlight Stories produced a slate of 16 highly innovative immersive shorts, but sadly closed down early in 2019. Its works pushed the limits of technology and

were always to some degree experimental. One of its dazzling offerings was *Help*, made in 2015. It was a gripping five-minute short about an alien attack in Los Angeles, directed by Julian Lin. It was shot in a 360-degree spherical video, viewers could explore it from an angle, and each angle would reveal new elements of the story. Google Spotlight Stories were Oscar nominated and Emmy winning productions.

- *Stand-alone apps*: a great number of mobile apps are produced independently of established media companies, and they are diverse in their offerings. For example, *Florence*, for children 11 and up, is an interactive love story, released in 2018 on Valentine's Day by Annapurna Studios. The visuals are a mix of light animation and graphic-novel style illustrations. *Florence* received Apple's highest honor at WWDC 2018 (the Apple Design Awards). The cleverly written stories on the app *unrd* contrast sharply with the sweetness of *Florence*. In *Last Seen Online*, a young woman disappears, leaving only her cell phone behind. Viewers learn her story by reading the messages on her phone and following new messages (some in video) posted live every day for seven days. The three other stories produced thus far by this startup essentially follow the same format, and viewers report waiting eagerly for the next live message.

Mobile Games

Snake pioneered the way for games on mobile devices, and they have become one of the most successful forms of apps. Mobile games contain varying degrees of narrative, much like games played on other digital platforms, and they offer built-in interactivity. Almost any type of game found on other platforms can be found on mobile devices: puzzle games, shooters, strategy games, racing games, war games, and even single-player versions of MMOGs.

In terms of a gigantic success story, one need look no further than *Angry Birds*. It is the bestselling paid app of all time and, having been downloaded over 3 billion times, it is one of the most

downloaded apps ever. The birds have become a stunning phenomenon in their own right, spawning flush toys, playground equipment, t-shirts, and dozens of other spin-offs, not to mention AR and VR versions of the birds. Essentially, *Angry Birds* is a casual game with dozens of levels and sequels. The initial concept was extremely simple: some pigs have stolen eggs from a group of birds, and the birds wreck revenge by flinging themselves, via slingshots, at the pigs. Other than that, there is no story. Like all casual games, it is easy to learn to play but becomes increasingly difficult with each level and is increasingly addictive.

In contrast, some mobile games have extremely rich narratives. Such games include *Ingress*, discussed in detail in Chapter 17, a game about the release of a mysterious, possibly dangerous energy and two factions at war about what to do with this it. *Ingress* utilizes geo-locative technology and AR. Another game with a deep story is *Alt-Minds*, a paranormal thriller released back in 2012. It was an eight-week transmedia game based in Europe that relied heavily on mobile devices, but also used the Internet and involved geo-locative content. The story involved five brilliant young researchers who were kidnapped from Belgrade University and the mystery of why they disappeared. Players became investigators in the case and became deeply involved with helping to solve the mystery. It was played out in real time, but those who were not in Europe while the game was being played out, or who missed playing the live version, could still purchase the game (www.alt-minds.com/home.html?lang=en). The multi-lingual game was produced by Orange Transmedia and Lexis-Numerique.

Two lighter but enormously popular games are *Candy Crush Saga* and *Slither.IO*. *Candy Crush Saga* is a puzzle game in which you line up similar pieces of candy to eliminate them from the board. *Slither.IO* is not much more complex than the old *Snake* game and in fact it does involve snakes. What makes it new and exciting is because it is a massively multiplayer game. Here you are competing against other players who also control snakes. As a new player, your snake will be quite small, but he will grow if you feed him the colorful pellets sprinkled around the screen. But as he grows, he is also in mortal danger: if other snakes collide with

him, he can be vaporized! The game contains a leader board to help you keep track of how you are doing.

Celebrities, not just snakes, have put their own spin on mobile games. Notably, Kim Kardashian's mobile game, *Kim Kardashian: Hollywood*, gives players the chance to roughly follow the ascendency into stardom the Kim herself achieved. The player starts out as an ordinary person and tries to achieve the life-style of a glamorous A-List Hollywood figure. Evidently, the itch to become a famous celebrity burns in the hearts of many people. The game struck a chord, making $74.3 million within the first six months of being released. It has been downloaded over 42 million times. The free-to-play game was released in 2014 by Glu Mobile and was still going strong in 2018. Though free to play, you do pay money (real, not virtual) for microtransactions. Other celebrities have jumped into the mobile gaming world with their own games, including Taylor Swift, Britney Spears and Kim's younger sisters Kendall and Kylie.

> **TWO WORKS THAT DEFY GENRE**
>
> While many mobile apps fit into one of two categories—games or stories—some are completely unique and resist labeling. Such a work was created in Budapest, Hungry. It was a poster of a symphony orchestra, and passersby could conduct the musicians with their phones. The tempo of the music would speed up or slow down, depending on how each passerby waved the phone. A video of people conducting the poster shows how this activity drew curious stares from people walking by. The interactive posters were sponsored by the Budapest Festival Orchestra and Hungarian Telekom in 2016, and the goal was to spike interest in classical music in young adults, who tend not to attend classical music concerts. Anyone who took the time to conduct the music would receive a coupon giving them a discount to a performance by the Budapest Festival Orchestra. The interactive poster was well suited to the target audience—young people who are typically very attached to their smartphones. The posters were distributed around the city, and within the first week, 600 people had pulled out their phones and had become digital conductors!

In a somewhat similar fashion, visitors to an art gallery in Canada were surprised when their mobile devices suddenly activated the paintings there. Figures in a work dating back about 400 years suddenly were pictured with modern canned groceries and plastic shopping bags. A gentleman of about the same period now holds a smartphone and is snapping pictures of himself. A red-headed woman in another painting coquettishly poses for the gallery visitors much like a fashion model. In an early twentieth-century painting of boy scouts posing by a wall the background dramatically changes. Suddenly a modern jet flies overhead and a sleek twenty-first-century truck passes by. Soon the boys refuse to sit by the wall any longer and all of a sudden are sitting on top of the picture frame. The work, *ReBlink*, was created by digital artist Alex Mayhew for the Art Gallery of Ontario and certainly made gallery visitors look at artwork differently.

Good for the Little Ones?

As many parents of babies and toddlers have discovered, their tots are enormous fans of tablet computers and can operate them almost instantly, without any instruction. Though their small hands still lack the dexterity to operate a mouse, a computer keyboard, or video game console, they can easily operate a touchscreen, and they are delighted when it responds. It's a form of instant gratification. But, parents wonder, is this a good thing or a bad thing for my child? Unfortunately, no one knows for sure. The touchscreen tablet is so new that very little scientific testing has been done on it. These little tots are, in a way, human guinea pigs.

What can be documented is the popularity of these digital devices with young users. A 2017 report by Common Sense Media in San Francisco found that children eight and under spend an average of 48 minutes a day using tablets and smartphones. It also found that TV viewing is down in this age group, while the use of mobile devices is up. Another study reported that over 80 percent of the top-selling apps in the educational category were for children and 72 percent of these were for preschoolers or elementary aged children (from the iLearn II study by the Joan Ganz Cooney

Center at Sesame Workshop). Still another study reported that while 21 percent of 4- to 5-year-olds could operate a smartphone, only 14 percent of them could tie their shoes! (from *The Wall Street Journal*, January 19, 2011). And, in an unscientific but compelling viral video, we can watch a little one-year-old girl swipe and pinch a magazine, thinking it is an iPad, and finally declaring in frustration: "It not work!" A little later she is seen gleefully playing with an iPad.

With older children, cell phone ownership is almost universal. A Pew Report showed that 78 percent of youngsters aged between 12 and 17 have cell phones, and half of these phones are smartphones. It is extremely common for these older kids to use their phones, rather than computers, to access the Internet.

When it comes to touchscreen tablets and apps, parents worry about a variety of things, including:

- That the app or mobile device will be scrambling their tots' delicate little brains and impairing their ability to focus and develop social skills instead of being a tool for enrichment
- That the apps are collecting personal information about their child
- That their child will be taken advantage of and enticed into buying alluring-seeming add-ons to their apps
- That the app will cause family friction, with the child wanting to play with it during dinner time or at other times when parents want a face-to-face relationship with the child
- That even though the parents might realize that a mobile device allows them to stay in contact with their child, which is a plus, their child can easily gain access to inappropriate materials

As content creators of mobile apps, we must be aware and respectful of these concerns. Although many of them are not within our powers to address, we can certainly accept the responsibility of developing quality content and not mindless fluff. To a large extent, it is a business decision rather than a creative one about whether or not we will develop content that will require additional

purchases from the young user to move forward in the story or game. If we do decide to employ such a business model, however, the ethical approach is to offer such add-ons judiciously and only when they genuinely enhance the app.

Ongoing research still needs to be done to determine if using apps is a positive or negative thing for young minds. Such research is being done at PBS Kids, and according to PBS Kids Interactive Vice President Sara DeWitt, "We do a great deal of testing in the development process of our apps, and have also done some of the earliest studies in the kids mobile apps space to test our apps for educational impact." She said that a past study showed that children that played with one of their apps made significant learning gains, including a 31 percent increase in vocabulary skills. She also said: "We believe that mobile apps can be great learning tools for children—they can help provide learning moments on the go and can encourage children to look at the world around them" (as quoted in *Wired* magazine by writer Daniel Donahoo).

Creating Content for Mobile Devices

Because mobile devices and apps are quite new as storytelling platforms, the creative community is still learning which approaches work best and which lead to mediocre productions. I interviewed several experts on the topic to learn from their expertise.

One of my experts was Kate Wilson, the managing director of Nosy Crow, a UK publisher of ebooks and print books for children. Wilson told me in an email interview that most of their ideas for ebooks are generated internally, and "what sets these ideas apart is that the narratives have been imagined with interactivity embedded in them." And, she added, they are stories that "would work particularly well on screen." In contrast, she noted, "there are many stories that are simple, linear narratives, and/or stories told in rhyme which would be disrupted by having interactivity shoe-horned into them. There are many things that the printed page does best. Simply adding bells and whistles to a story that would be told better in a linear, non-interactive, text-and-illustration format isn't interesting to us."

In terms of ebooks, she told me that at Nosy Crow, they were often attracted to fairy tales "because they have such flexibility—they can be told in lots of different ways." She noted that they try to use interactivity appropriately. For example, in adapting Cinderella to an app, which opens "with Cinderella as a put-upon second-class citizen, we focus the interactivity of helping Cinderella with her chores. Later, when the story is about magical transformation, we focus the interactivity on that aspect of the story." She strongly believes in using interactivity appropriately, telling me that "I personally don't think there's much benefit in taking an existing picture book, adding a few sound effects and some animation loops, and thinking that you've made an interactive story. I think that the best apps are native to the devices, rather than translated from another medium."

I also interviewed Warren Buckleitner, the editor of *Children's Technology Review* and an acknowledged expert on children's digital media. I asked Buckleitner what he thought one should begin with when creating an app, and I was pleased, given my focus on storytelling, when he told me: "a good story is always the most important starting point. Good narrative is essential. If you don't start with good narrative, then you can't do anything whether it's in print or in digital. But people sometimes forget … they think they can just make an app and it will somehow magically help out." He also noted that you shouldn't talk down to children when making an app for them and, putting it beautifully, said the goal should be "to empower a young finger."

He advised a person setting out to make an app to study the market, especially the most successful works, and ask yourself if you can compete. He feels that adding special features can be dangerous, because serious money can be lost trying to compete with big companies like Disney or Rovio. Maybe, he suggested, you should not even try to add special features, and instead "let [children's] own software in their brain do the work." But if you are determined to use special features, he feels a good question to ask is "What can I turn the child's finger into that could never be done before?" For example, in the *War Horse* ebook, users could spin a soldier's helmet around and see it in 3-D from all sides. In addition, geographic references are linked to real-time locations

that are shown in Google Earth. "You might be surprised to see what was once a battlefield is now a shopping center," he told me. And in the *Voyage of Ulysses* app, users could actually take the tiller of Ulysses' sailboat and sail the boat themselves. These breakthrough ways of using the touch screen made these two works outstanding.

Buckleitner calls skillful ways of using interactivity "embedded reinforcement," meaning that "it has direct link to the narrative to help support your intended goal as a storyteller." And he pointed to a couple of things that he and others in the field believe can weaken an interactive project. One is an approach he terms a "page flipper"—an interactive book built around a navigation metaphor from the past, with the only interactivity being the ability to turn the pages. He notes, though, that some page flippers are actually quite good as ebooks, so one should not make a blanket rule against them. But, on the negative side, he told me that "sprinkles" can seriously undermine a project. Sprinkles, he said, were hot spots that trigger little animations that are scattered around the page that do not support the narrative in any way. He noted if you use hot spots, everything on the page that could come to life should have that capacity. For instance, if you have a kitchen scene with a toaster on the counter, children are naturally going to want to touch the toaster to see what it will do, and if it is lifeless, it will be disappointing. In sum, he said, imagination and authenticity are two important elements in creating apps, and that "the innovators will be richly rewarded because they can figure out how to use all this new potential. That's why I say it is an art as much as it is a science."

I also talked with Grace Chen, a digital artist and user interface (UI) designer, to see what insights she could give me. She told me that when creating graphic images for an app, she was always guided by the context of the story. For instance, if the story was about the Wild West, she would use images relating to cowboys, while if it was an outer space-themed story, then images of stars or spaceships might be appropriate. Chen has been working on the *Yumby* series of mobile games, which features a set of odd-looking little characters in different settings. In one game, *Yumby Smash*, they fling themselves at buildings infiltrated with monsters. The

456 Digital Storytelling

FIGURE 13.3 A screenshot from *Yumby Smash*, which has a steampunk theme and a steampunk UI. Image courtesy of PlayGearz, Inc. (www.yumby.com).

game has a steampunk theme, so the UI here uses steampunk-like imagery that is in keeping with the theme (see Figure 13.3). Chen said color, sound, and motion all come into play when designing the interface for an app, and she advises that text should be used very sparingly. She also noted that interface design for apps has a number of special challenges, such as the small screen size and the different aspect ratios between devices. Scaling the same app for different screen sizes, she said, is possible in most cases but made things more complicated. She told me most art can be reused, but needs to be created with scalability in mind. In addition, she told me that designing works for children and for adults involves very different design issues. Sometimes, for instance, it is difficult to create an icon that both adults and children would recognize as the same thing, since their experiences of the object might be so different.

Clearly, based on everything Wilson, Buckleitner, and Chen told me, story is central when creating an app, just as it is with other forms of digital storytelling, and the interactivity should spring from the narrative. But beyond that, there are dozens of issues to consider and a host of challenges to contend with. One question

developers must ask and answer is whether they wish to focus their efforts on building native apps (ones that are made to run on a specific platform or device, and which must be installed in order to play) or whether to create a mobile Web app (which can access Web-based content directly through the Web browser on the device). In coming years, as more apps continue to be developed, we can expect that certain standard conventions will be developed for these mobile forms of entertainment. On one hand, that will make things easier for mobile content creators, but on the other hand, we may no longer see amazing innovations in the field.

Putting Mobile Devices to Practical Use

Businesses and educational entities have begun to see the potential of using mobile devices to teach and promote, and experimental projects using apps are underway, as well. Many of these projects are using entertainment techniques to accomplish their goals. As we have already seen in this chapter, there has been an explosion of apps developed for early childhood education. In addition, projects have been developed for children with special needs, such as autism, and apps have been found to be an effective way of teaching them. And in a remote village in India, where homes have no running water and where even the local school lacks electricity, an experimental program has been instituted using tablet computers to teach educational basics, like colors and shapes, to the village children. They have responded with great enthusiasm and have mastered the new concepts. Adult literacy projects are underway, as well. In Spain, under the National Reading Plan, posters with QR codes have been placed in trains, and people with smartphones can use the QR codes to access the first chapters of several dozen books.

In another project aimed at adults, about 10 bulky wildlife guides in Florida have been merged into a single app called the *Ultimate Guide to Florida Nature.* Now, nature enthusiasts have a single small device to help them identify birds, mammals, reptiles, amphibians, fish, seashells, and plants, and, thanks to the audio this app contains, they can also listen to bird songs and identify birds through sound.

> **STRANGE BUT TRUE: SMARTPHONES AS MUSICAL INSTRUMENTS**
>
> Students at the University of Michigan have been experimenting with ways to turn their smartphones into musical instruments, learning to design, build, and play them. Their professor, Georg Essl, said of the work he and his students are doing: "We're not tethered to the physics of traditional instruments. We can do interesting, weird, unusual things. This kind of technology is in its infancy, but it's a hot and growing area to use iPhones for artistic expression" (reported by Reuters, March 12, 2009). These new "instruments" utilize many of the unique attributes of the smartphone, including the touchscreen, the microphone, the GPS, the compass, and the accelerometer. One day, perhaps, we will have a new Beethoven who will be able to create a symphony for smartphones!

The US military, of course, always an early adopter of technology, is using smartphones and tablets to relay critical videos to troops on the ground. Meanwhile, commercial ventures with mobile devices abound. In 2018, mobile advertising became a $76.17 billion business, surpassing advertising on TV, radio, and in print. Mobile promotions vary enormously. They can employ highly innovative, playful techniques such as the interactive orchestra posters in Budapest as well as more earnest approaches, such as the World Wildlife Fund's *WWF Together*. This app tells the stories of eight threatened species of wildlife. Users can try out different activities such as "seeing" with tiger vision or "eating" bamboo like a panda. They can also play games and learn to make origami versions of the threatened animals, all in the hopes that the living animals will never be replaced by the paper ones.

A Few Considerations

Mobile entertainment has evolved quickly compared to other forms of digital storytelling, making it difficult to nail down guidelines for how such projects should be developed. However, a few overall considerations can be extrapolated from the examples we have studied here and from comments made by professionals in the field. In general:

- Make the story central to your major creative decisions. Does it lend itself to interactivity? What sort of visual approach does it lend itself to? What would players gain by the story becoming interactive rather than being told in a linear fashion?
- If you want your content to stand out, be as original as possible, not derivative of works found on other media.
- Use the technology unique to mobile devices judiciously and as much as possible be innovative with it. Don't try to compete with the major mobile producers but aim to create your own individual approach to mobile content.
- When at all feasible, offer users a way to actively participate in the content.
- When at all feasible, promote social interaction among users.
- If a game, make it rewarding for the time invested, even if the player does not win.
- If a game, make it relatively simple to learn and fun for players who are not hard-core gamers.
- If story-based, the characters should have vivid personalities and their motivations should be clear.
- Use visuals that come through clearly on a small screen.
- Keep in mind when your work is likely to be seen. Mobile content is most inviting in situations where people have a little time on their hands, such as riding on public transportation or waiting for an appointment. This means that the content should be quickly consumable; this is "coffee break" entertainment.

ADDITIONAL RESOURCES

To learn more about mobile entertainment and developments in the mobile industry, some helpful resources are:

- *GameSpot Mobile* (www.gamespot.com/platform/mobile/), which offers reviews of games and wireless devices as well as general articles on wireless entertainment.

- The Mobile Entertainment Forum (www.m-e-f.org/), which is a global trade organization for the mobile industry.
- If you wish to enter a completed work in a mobile competition, consider the MoFilms competitions: www.mofilm.com/.

Five professional mobile associations are listed at Best Value Schools: www.bestvalueschools.com/lists/5-great-professional-organizations-mobile-development-specialists/

Conclusion

From the projects we have examined here, it is quite evident that mobile platforms can support a diverse array of entertainment experiences, including story-based narratives. Some of the projects featured in this chapter have made exciting use of the unique attributes of mobile devices and have found innovative ways to involve users. It will be interesting to see what new techniques developers will use in the future to integrate interactivity and narrative into mobile content, especially as 5G becomes widespread.

When thinking about what can or cannot be done with mobile devices, we must bear in mind that the very first wireless game, *Snake*, made its debut in 1997, a relatively short time ago. This medium is still in its early formative years. We are just beginning to understand its potential, and to comprehend how it may be used as a tool for digital storytelling. Without doubt, innovative digital storytellers will make new breakthroughs in this area and will discover ways to use it that we have not yet imagined.

Idea-Generating Exercises

1. Consider the forms of mobile storytelling that you have experienced. What forms have you enjoyed most, and why?
2. Pick a children's fairy tale and try to devise a mobile app that could make the story interactive.

3. In terms of creating content for mobile devices, which factors do you think are most challenging, and why?
4. Pick a consumer product or nonprofit organization and devise a concept for mobile devices that could promote it, as was done for the Budapest Festival Orchestra and the Art Gallery of Ontario.

Chapter 14

Interactive Cinema and Interactive TV

Movie stories traditionally follow a linear path, and moviegoing has always been a passive experience, so how do you open up a movie to a nonlinear narrative and give the audience a dynamic way to interact with it?

What is "group-based interactivity" and how does it fit into an interactive movie experience?

What is the difference between large screen and small screen movies, aside from the size of the screen?

How are movies, TV, and interactive narratives blurring together into something new?

What narrative models are being used for small-screen interactive movies?

How can TV, a linear platform, be turned into an interactive form of entertainment?

Developments in iTV seemed to stall for many years, but what new developments are bringing this arena back to life?

What are some of the approaches being used to make TV interactive?

What are some of the major creative hurdles that developers of interactive TV programming are faced with?

Hold the Popcorn!

Consider these four movie scenarios:

- An astroscientist, on a return trip from Mars, is struck by a mysterious and life-threatening illness after her space ship collides with some debris in outer space.
- An emotional family drama, a true story, reveals what it is like to grow up poor and black in the segregated American south.
- A gripping documentary about a devastating avalanche and the group of skiers caught in it.
- Cloned twins confront the drug-addicted scientist who created them.

All four stories have an intriguing premise and would seem to promise good screen-based entertainment, either in a movie theatre or at home on the TV. But if you planned on watching any of them while munching popcorn and reclining in a theater seat or on your couch at home, you'd have a problem. That's because all four are interactive movies. In other words, they are works of interactive cinema, or iCinema, and in order to enjoy them, you would need to be an active participant. This is no place for popcorn. You'd be too busy using your hands to eat it.

Most interactive movies fall into one of two quite different categories. One type is designed for a large theater screen and usually intended to be a group experience (although in some cases these large-screen works are meant for a solo participant). The other type is for a small screen and is usually viewed at home. These are much more intimate experiences, meant to be enjoyed by a single individual. Of the movie scenarios described above, the first, the outer space story, was designed for a group experience in a theater; the others are small-screen films. Although the types of interactivity and the overall experience offered by the two types of iCinema are quite dissimilar, they do share some important characteristics:

- They are story driven.
- They have dimensional characters.

- They might offer some game-like features, but even when they do, narrative plays an essential role.
- Choices made by the users profoundly affect how the story is experienced.

A Bird's Eye View of the Field

Because interactive cinema is a direct descendent of the movies, one of the contemporary world's most beloved forms of entertainment, and because movies are so heavily narrative driven, one might expect that interactive cinema would be ground zero for digital storytelling. And one might also expect that TV, with its rich offerings of drama and comedy, would be a hub of interactive storytelling. Unfortunately, such is not the case. In the past, despite attempts to make interactive stories for movies and TV, only a modest amount of work was done in these fields, though some of this work was highly innovative and creative. However, in the last couple of years we have seen some encouraging breakthroughs both in iCinema and iTV.

Surprisingly, the new developments in iCinema and iTV are blurring the lines between these two media, and new forms of interactive narratives are emerging. These new forms use digital technology in innovative ways and resist labels. They are screen based, but do you view them on large theatrical screens, on small TV screens, or on your laptop or on mobile devices? This is a quickly changing arena of digital storytelling.

Large-screen interactive movies can primarily be found in museums and other cultural institutions and in entertainment complexes. As for small-screen interactive movies, in the past most that have been produced to date have been made under the umbrella of universities or government-funded film institutes, where interactive storytellers can get the necessary support to work in this field. One exception to this is the interactive documentary, a narrative form that several print publications have been successfully experimenting with. In addition, a number of iCinema works have been made for mobile devices and even game consoles.

Because the public is generally unaware of large-screen iCinema, it has been extremely difficult for such movies to succeed

commercially. So far, only a small niche market exists for them, primarily among people in academic circles and those with a strong interest in cutting-edge storytelling. On the other hand, recent works made for small screen iCinema and iTV are more accessible and have received enthusiastic reception, at least from critics and the audiences who have gotten to see them. But even though these are hardly booming fields, the work being done in iCinema and iTV continues to break fresh ground in terms of devising new ways to combine story and interactivity and offers a number of useful examples of digital storytelling.

Large-Screen Interactive Cinema

The film that is regarded as the world's first large-screen interactive movie was shown at the Montreal World's Fair in 1967. The film, produced in Czechoslovakia, was called *Kinoautomat* and was written by Radúz Cincera. It was the story of a man who felt a guilty responsibility about his apartment building burning down and was told via flashbacks. The film contained nine choice points. The audience could vote on what they wanted to happen next by pressing a red or green button on their seats. What the audience didn't realize, however, was that the choice points were always the same no matter what path through the story was chosen. Thus, the film was less interactive than it seemed. Nevertheless, it was a big hit at the World's Fair.

It was not until 1992 that the first true large-screen interactive movies were released to the public. These films were produced by a company called Interfilm, and were offered to the public between 1992 and 1995. They were released under a four-picture deal with Sony, with such titles as *Mr. Payback* and *I'm Your Man*. However, these movies offered extremely limited interactivity, especially for anyone used to the fast pace of video games, and they did little to impact the plotline. Very much like the Czech film at the World's Fair, people made their choices known via a button system embedded in the armrests of the theater seats (three buttons rather than two, thus offering them three possible choices). Otherwise, the audience had no role in the film. The branching storyline structure they used was thus quite similar to the old *Choose Your Own Adventure*

books and offered about the same amount of meaningful agency … none, really. Furthermore, the storylines, acting, and production values were quite weak. Not surprisingly, they were commercially unsuccessful, and their failure to generate any enthusiasm from the public pretty much killed off interest in this area for many years.

In 1997, however, a Canadian company called Immersion Studios opened its doors and demonstrated considerable interest in this type of interactivity, particularly for projects that combined entertainment and education. In other words, they were works of edutainment. Many of them tackled scientific themes such as human biology, pollution, and nuclear energy. Based in Toronto, the company produced large-screen interactive films for a prestigious roster of international clients, including the Smithsonian Institution in the United States; La Cité in Paris; and the Science Museum in the UK. Although Immersion Studios ceased operations in 2006, the work produced there gives us an excellent view of the potential of large-screen cinema.

At Immersion Studios, they termed the work they did "immersive cinema," and immersion is the operative word here. Audiences were enveloped by surround sound and images projected on a large screen, and the films combined dramatic storylines with fast-paced gaming elements. These movies used both live action and 3-D animation, sometimes in the same production. The interactivity offered to audiences was far richer and more dynamic than the old Interfilm model, and more purposeful, too.

With an Immersion Studios film, audience members were made to feel they had an essential role to play in the unfolding drama. In one case, for example, they played time travelers and their decisions helped determine what species would survive into the present day. In another case, they took on the role of marine biologists and tried to prevent the depletion of the population of sea lions.

Furthermore, the interactivity was far more versatile and extensive. Each single-person or two-person team was seated beside a touchscreen computer console, through which they indicated their choices. In addition, the computer gave them a way to dig deeply into the subject matter, somewhat like exploring a website. During the game-like segments, it served as a virtual control panel to direct the action. Thus, the Immersive Studio approach combined an

FIGURE 14.1 At this large-screen work of iCinema, *Vital Space*, members of the audience sit in front of touchscreen consoles and help direct the action through the small screens. Image courtesy of Immersion Studios.

audience-shared large-screen theatrical experience with a more personal small-screen experience and control system (see Figure 14.1).

Group-Based Interactivity

While participating in an Immersion Studios film, audience members were called upon to interact with each other, sometimes by competing and sometimes by collaborating. Some exchanges were done electronically, but at other times, people communicated the old-fashioned way—by talking with each other. At least one of the Immersion Studio projects was also networked, linking students at several different institutions. This type of shared communication, *group-based interactivity*, also known as *multi-user interactivity*, was the hallmark of an Immersion Studios experience.

> **WORTH NOTING: TYPES OF GROUP-BASED INTERACTIVITY**
>
> The group-based interactivity that is built into productions made by Immersion Studios bears an interesting similarity to the types of interactivity found in second-screen TV, in MMOGs, and in a

few multiplayer motion-based games found at theme parks. All three are enjoyed simultaneously by multiple users/viewers, and the actions of the users help impact the outcome. It remains to be seen if these three areas will cross-pollinate each other in ways that will lead to advances in multi-user digital storytelling.

Involving the Audience

Stacey Spiegel, the CEO of Immersion Studios, told me in an interview that he believed his company's approach to iCinema was highly effective for teaching, and for three important reasons. First of all, he pointed out, the immersiveness of the stories facilitated the suspension of disbelief. In traditional media, he noted, "You are outside the window looking in. But here, the window disappears and you feel you are a part of what's happening." Second of all, the members of the audience were put in the position of having to make decisions, and their decisions had consequences. This caused them to be extremely alert and mindful of the material they were dealing with. And third, the collaborative social element—being an active participant in a group drama—reinforced learning. This type of audience involvement thus combined peer-to-peer and active learning, both described in Chapter 10. Spiegel noted that the company's philosophy of engaging the audience is reflected in the old proverb that goes: "Tell me and I'll forget; show me and I may remember; involve me and I'll understand."

Competitive gameplay was often built into these productions, because, Spiegel reported, their audiences responded so positively to it. Still, he stressed, narrative remained a vital element, giving their films a context and framework and contributing to their emotional power.

A Sample Large-Screen Experience

To see how an Immersion Studios movie worked, let's take a closer look at one of its films, *Vital Space*. The educational goal here was to give the audience an inside look at the major human body systems. The story, briefly sketched out at the opening of this chapter, is set in outer space. As the film opens, two space scientists, a

married couple, have just completed a successful mission to Mars. Commander Susan Grant is examining a vial of Martian soil while her husband, Dr. John Osborne, is busy in another part of the space ship. Suddenly, the ship is struck by space debris, causing the soil sample to spill and contaminate the chamber where she is working. Thinking quickly, Commander Grant seals herself off in the lab to prevent further contamination, but she is already experiencing symptoms of a serious health problem.

At this point, just a few minutes into the movie, the audience is about to become intimately involved in the story, and their actions will determine Commander Grant's fate. Her husband informs us that since she has quarantined herself, making it impossible for him to examine her; the only way to diagnose and treat her illness is by using an experimental, remote-controlled medical system called VIVISYS, never utilized before under field conditions. And he'll need the help of those of us in "ground control" (the audience) to guide and direct VIVISYS, which we'll do via our touchscreen consoles. From this point on, we are faced with a series of decisions, such as selecting which type of microrobot should begin the diagnostic process (see Figure 14.2).

In a race against time, members of the audience try to determine the cause of Commander Grant's illness by investigating the various

FIGURE 14.2 Screen capture of the microrobots in *Vital Space*. Image courtesy of Immersion Studios.

systems of her body. But her condition worsens, and in a dramatic twist, VIVISYS picks up a second heartbeat—shades of the movie *Alien*! — and is at the point of destroying it. But at the last moment, Commander Grant, writhing in pain, orders the procedure halted. It is a good thing she does, because it turns out that the second heartbeat belongs to her unborn child—unbeknownst to the couple, they have a baby on the way. As the investigation into her illness proceeds, the audience may or may not find the true cause of her problem: a lethal parasitic infection. If the audience does find it, the film turns more game-like, somewhat like a first-person shooter, with audience members trying to shoot down the intruders. Thus, the life or death drama of the plot helps keep the audience engaged in the film, and the combination of the large theater screen and the small console screens gives them the means to become deeply immersed in this unique journey through the human body.

Special Challenges of Large-Screen Interactive Cinema

According to Brian Katz, who was the VP of Corporate Development at Immersion Studios, most of the films made by the company were for cultural institutions, who liked them because they helped attract visitors. Although such large-screen installations required a great deal of special hardware and servicing, which could be expensive, they furthered the educational goals of these institutions. Also, because these films were suitable for all ages, they offered visitors a positive family experience. However, not all audience members were comfortable with this type of media-rich interactivity, Katz said. While young people were used to multitasking and had no problems with the large-screen/small-screen configuration, he reported that some older people become confused and wondered "where should I look?" Often the kids fell into the role of coaching their parents, he said.

Katz also noted some of the special creative challenges posed by large-screen interactive cinema, including:

- Devising a scenario that is gripping right from the start and that thrusts the audience members into the action

- Avoiding a presentation that is overly complicated and could turn people off
- Creating gameplay that is exciting and complements the narrative
- Devising interactivity that calls for meaningful choices and not just guesswork

> **EXPERT OBSERVATIONS: TYING THE LARGE AND SMALL SCREENS TOGETHER**
>
> One special challenge with the type of iCinema produced by Immersive Studios was tying together the content of the large and small screens. To illustrate how the action on the two screens could be made into a cohesive whole, Spiegel described a scene from a film they'd made on the space program. On the large screen, astronauts are seen outside the space station working on a robotic arm system. But when they try to return to the space station, they find the door is locked! While the astronauts hover helplessly in space, their oxygen running low, members of the audience feverishly work at their consoles, trying to find a way to unlock the door. Thus the action on the large and small screens is closely and dramatically integrated.

Other Venues for Large-Screen iCinema

Unfortunately, Immersion Studios is no longer able to lead the way with large-screen iCinema and group-based interactivity, but large-screen iCinema has managed to find some new homes. One such venue are special theatres in theme parks which offer crowd-pleasing *4-D dark rides*, also called *ride-films*. In a typical 4-D dark ride the audience sits on seats that move in conjunction with the action on the screen, giving them the sensation of moving, such as flying or sailing. In addition to the images on the screen and the feeling of travelling, 4-D dark rides often include things like touch, smell, and even temperature change.

In Chapter 10, we described a 4-D dark ride, a simulation of a high-speed airboat ride in Florida's Everglades, the *Everglades Airboat Adventure*. Some producers and exhibitors of 4-D dark rides have upgraded the term to 6-D dark rides, 7-D dark rides, and even X-D dark rides. Essentially these terms are just a new way to promote 4-D dark rides, though in addition to all the sensory experiences, they give users some control over the movie via an *interaction gun* or some other handheld object they use to shoot at targets on the screen. For example, with *Zombie Attack*, an attraction produced by Triotech, a major 7-D company, audience members shoot laser beams at zombies on the screen.

However, in 2018, a full-scale interactive feature film debuted to the public. Called *Bloodyminded*, it was shot in a single take and screened live in theatres and online. It tells the story of a young woman, SJ, who breaks into an army base to bury the ashes of her great-grandfather, a conscientious objector during the First World War. Her foray into the base does not go unnoticed by the soldiers there and she soon she finds herself in a hazardous situation. Unfortunately, though, despite the strong storyline, the film offered extremely limited interactivity, and this activity was only cerebral: to offer, when prompted by a narrator, your thoughts about war and violence. Audience members would have had far more agency if they could have controlled the actions of SJ, the protagonist. While the fact that it was shot in one take and aired live made *Bloodyminded* unique and compelling, it does not seem to have earned the distinction of being called interactive. Despite this limitation, the film garnered a great deal of attention and involved some top-tier British organizations, and perhaps its success will lead to films that are fully interactive.

As we will see in Chapter 18, large-screen iCinema is being used in immersive training simulations for military and law enforcement personnel. In addition, selected large-screen immersive iCinema experiences with group-based interactivity are offered at theme parks, as with Disney's set of works produced for the *Living Landscapes* pre-show for the *Soarin'* ride, described in Chapters 11 and 19.

Small Screen Works of iCinema

Examples of small-screen interactive movies are somewhat easier to find than their larger relatives, but they are by no means abundant, even though most people have the hardware necessary to play them. Small screen works of iCinema are made for the Internet, DVD-ROM, and DVD-Video, mobile devices, and even game consoles, and thus they can be played on a variety of familiar platforms. As with large screen works of iCinema, they vary significantly in terms of approach and content. Some of these works are serious dramas, some are non-fiction works and others are more game-like. These small-screen iCinema productions tend to give the audience far more agency than their large-screen relatives because thus far the technology in large-screen theaters and in broadcast TV only supports a limited amount of interactivity.

The awareness of serious works of small screen iCinema is greater in Europe than in the United States, but there are indications that even in the United States interest in them may slowly be growing. Some of these productions are now being shown at international festivals, and they are also being sold at brick-and-mortar bookstores and at online sites like Amazon.com, all signs that a market for them may gradually be developing.

These productions are somewhat like the films one can find in art house movie theaters. Unlike blockbuster commercial movies, they are not fantasies about comic book heroes or gory action-adventure pictures. Instead, they are apt to have an intellectual underpinning and focus more on human relationships and sophisticated psychological or philosophical themes. Unlike linear films, they lend themselves well to telling a story from multiple points of view, and often offer viewers a wealth of visual material to investigate. Filmmakers working in this area have developed several different models of interactive narrative, including:

- The hyperstory
- The database narrative
- Interactive documentaries

- The user as fulcrum
- The spatial narrative

The Hyperstory

Hyperstory is a term used by filmmaker Margi Szperling to describe the works of iCinema she has produced. A hyperstory, like hypertext, links different elements together, but instead of linking a word to another piece of text, a visual element is linked to another visual element, offering a different view of the same scene or story. Szperling believes her hyperstory approach to filmmaking offers a deeper and more complex view of the world than the typical Hollywood linear movie.

Before becoming interested in interactive media, Szperling had been an architect, and told me the disciplines have much in common, since both deal with structure, the movement through space, and design issues. In describing her hyperstory approach to me, Szperling said: "We can tell different kinds of stories in this medium, from multiple perspectives. These are databases that respond to people's choices." Among her influences, she said, were the novels of James Joyce, the movie *Rashomon*, and the theories of the Russian experimental documentary filmmaker, Dziga Vertov (1896–1954). Vertov expounded an idea of "film truth," holding that fragments of film, when organized, could reveal a truth not perceptible to the naked eye.

Szperling's first film, *Uncompressed*, was, at its core, a science fiction drama about a drug-addicted scientist and the set of twins he has cloned in his lab. However, with its six intersecting storylines, the film is far more layered than a typical sci-fi film. The stories of the scientist and the twins form two of the narrative paths. Other narrative paths follow a man with a life-threatening illness; a telepathic grandmother and granddaughter; a woman who has passed away; and the man who still loves her. Unlike the typical Hollywood movie, *Uncompressed* does not have a central protagonist. Instead, each character or set of characters serves as the protagonist of their individual storylines.

Though the characters all seem to live in disparate worlds, their stories are all interconnected. The drama culminates with

a violent confrontation in which a gun is fired and someone is shot, but unless you work your way through all six paths, you cannot have a clear understanding of what has happened. To some degree, therefore, the film uses a *Rashomon* model, in which a single event is seen through the eyes of different characters.

When playing *Uncompressed*, the first thing one comes to is a screen divided into six frames. Each frame contains an image of the characters, singly or in pairs (see Figure 14.3). By running your cursor over any of the frames, the character or characters inside will reveal a brief bit about themselves. By clicking on one of the frames, you will go to their storyline. The characters' paths cross at various points in the film. If you wish, you can follow each of the six stories from start to finish, in a linear fashion, but you can also switch to another character's perspective at various junctions. In addition, you can choose specific scenes to watch by going to the chapter index.

According to Szperling, *Uncompressed* allows the viewer to "see between the panes of glass." Her hope in making this work, she told me, "was to create a series of subtle questions meant to discredit and validate themselves within the storyline. I realize this

FIGURE 14.3 The six characters and pairs of characters featured in *Uncompressed*. **Image courtesy of Margi Szperling and SUBSTANZ.**

is a conundrum," she admitted, but added that "most provocative artwork contains opposites. Every storyline shows how different the same reality can appear; it shows perspectives as they intersect with each other. This is where the strength of the piece lies. With this vast an amount of interactive content, much is learned by traveling in between the layers." All told, the work has six storylines, and the user can jump at will between them and experience the six variations of the story (see Figure 14.4).

Uncompressed runs for 36 minutes, though it takes hours to play in all its variations. Despite the low budget and the various challenges encountered while making it, the film has notably high production values. This, coupled with its innovative design and intricately crafted story, has earned it nominations

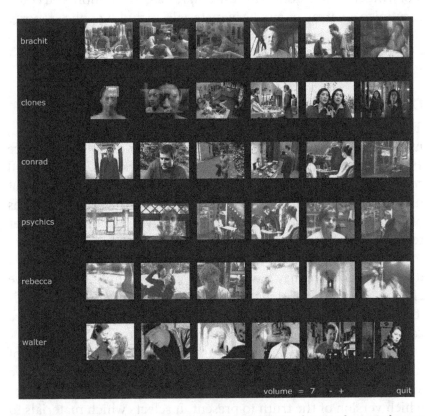

FIGURE 14.4 The chapter index of *Uncompressed*, one of several ways in which viewers can change perspectives. Image courtesy of Margi Szperling and SUBSTANZ.

in about 50 international competitions and awards in several of them. Szperling believes her narrative model, the hyperstory, has great potential, and looks at *Uncompressed* as a prototype of what is possible. She believes this form can give us "a way to understand who we are and to understand the complexities of the world around us."

Acclaimed director Steven Soderbergh also used the hyperstory approach in his 2018 murder mystery project, *Mosaic*. *Mosaic* is a new animal: It has "body parts" that are mainstream TV and "body parts" that resemble a work of iCinema. The work was aired in six episodes on HBO, but became interactive through an iOS/Android mobile app. In the app, you could watch scenes from the POV of different characters, which would shift your perspective of the story, much as was done with *Uncompressed*. In addition, you could scrutinize an array of auxiliary materials, including police reports, news clippings, email, and voice mail. Soderbergh said of the project: "It's not a TV show and it's not a movie. It's something else."

Database Narratives

The Labyrinth Project at the University of Southern California, under the direction of cultural theorist Marsha Kinder since 1997, specializes in what it calls "database narratives." These small screen works of iCinema are made up of tiny pieces of data that users can assemble in various ways to form their own versions of the narrative. These interactive narratives explore, as Kinder terms it, "the border between documentary and fiction."

The website for the Labyrinth Project explains: "Although a database narrative may have no clear-cut beginning, no narrative closure, no three-act structure, and no coherent chain of causality, it still presents a narrative field full of story elements that are capable of arousing a user's curiosity and desire."

Documentaries, compiled as they are from a great mass of material, are particularly well suited to the database narrative approach. In linear documentaries, the production team decides which version of the truth to present. It selects which materials to show the viewer and which to exclude and it arranges the order in

which the scenes will be shown. But in a nonlinear documentary, the selection process is turned over to the viewers, and ultimately, they can form their own version of the truth.

Unlike traditional linear documentaries, database narratives "frequently have a subversive edge," the Labyrinth Project website asserts. "For, in calling attention to the database infrastructure of all narratives, they reveal a fuller range of alternatives. In this way, they expose the arbitrariness of so-called master narratives, which are frequently designed to appear natural or inevitable."

The Labyrinth Project has undertaken a variety of disparate projects, many of them based on the works of artists and writers. For example, *The Dawn at My Back*, a DVD-ROM, is a memoir created by an African-American woman about her life and family. It relates what it was like to grow up poor and black in Texas and uses a quilt metaphor to present the different pieces of her story. Like a handmade quilt, the memoir is composed of many small fragments. The task of stitching them together, however, is given to the viewer. The pieces of the quilt are an assortment of old photos, contemporary videos, interviews, voices, and animations. The quilt that forms the backdrop of this work is an heirloom from the filmmaker's own family, giving her story an even deeper emotional resonance.

Bleeding Through: Layers of Los Angeles is another film made under the umbrella of the Labyrinth Project. As the title suggests, it takes a layered approach to narrative. It also boldly intertwines historic fact and invented fiction. Set in downtown Los Angeles and spanning over 60 years, from 1920 to 1986, it tells the story of a fictitious woman named Molly (based on a real person) who may—or may not—have murdered one of her husbands. Users are invited to piece together their own version of Molly's alleged crime, which they can do by sifting through a great amount of historical material. The narrative thus uses the archeological dig structural model described in Chapter 6.

The work is the creation of Norman Klein, a novelist, historian, and cultural critic. He not only wears all three hats in this interactive narrative but also appears in a window on the screen, adding his own commentary. The work, presented on a DVD-ROM,

was an international coproduction of the ZKM Center for Art and Media in Germany and the Labyrinth Project at USC's Annenberg Center.

Although Molly is an invented character, her story is shaped by the history of her time and place. It is set in downtown Los Angeles during a period when that part of the city was undergoing profound cultural change. *Bleeding Through* uses vintage film clips, maps, reconstructed scenes of actual events, historic photos, and contemporary interviews to tell Molly's story (see Figure 14.5). Klein notes: "We're a civilization of layers. We no longer think in montage and collage; we multitask in layers more and more" (as reported in the *San Francisco Chronicle,* in a story by Glen Hellfand, September 18, 2003).

Like other database narratives produced by the Labyrinth Project, *Bleeding Through* is highly cinematic and visually arresting. One particularly striking feature is the way old and new photos of Los Angeles, taken from exactly the same angle, are layered on top of each other. By sliding between them, users can see the

FIGURE 14.5 A screenshot from *Bleeding Through: Layers of Los Angeles*. **Image courtesy of the Labyrinth Project of USC's Annenberg Center for Communication and the ZKM Center for Art and Media.**

images literally bleed through each other and watch landmarks appear and disappear. It is a visual metaphor for the way the present overtakes the past, but by peeling back the present, the past can be revealed.

Not all works of database narratives have been produced by USC's Labyrinth Project. For example, *Her Story*, discussed in Chapter 11, is about a woman undergoing multiple police investigations for a crime that is not specified. To learn her story, you must search through a vast database of video tapes and piece together what seems like a reasonable hypothesis. Thus, it has the primary features of a database narrative: an enormous collection of data that the user must piece together to create a story. Unlike the projects at USC, however, it is not a documentary and it has certain game-like characteristics: a challenge, a great deal of agency, and a protagonist struggling against adversaries: the police interrogators. However, the user cannot win or lose. The only positive outcome is successfully piecing together her story.

Other Documentary Forms

The database narrative approach is an extremely interesting way to present documentary material, but there are many other ways, as well. They cannot be readily labeled like the database narrative, *Her Story*. Instead, they offer a variety of ways to make your own path through factual information. For example, in *Snow Fall: The Avalanche at Tunnel Creek* and in *The Jockey*, the *New York Times* created two works in which we had a gripping interplay between larger pieces of video, audio, and text, and one through which we could assemble our own personalized narrative.

The *New York Times* begun to publish interactive documentaries in 2012. One, the acclaimed *Snow Fall: The Avalanche at Tunnel Creek* (http://www.nytimes.com/projects/2012/snow-fall/#/?part=tunnel-creek), is the nonlinear story of a group of skiers caught in a devastating avalanche. The work won a Pulitzer Prize. Another, *Jockey* (http://www.nytimes.com/projects/2013/the-jockey/), used stunning photography, audio, and text to explore the world of jockey Russell Bates.

Other outstanding interactive documentaries have been made in recent years both by newspapers and non-profit entities. They include:

- *Saydnaya* (2016), produced by Amnesty International, that gives users the look and feel of being inside the notorious torture prison in Syria. The documentary includes accurate acoustic and architectural and modeling to make the terrifying experience of being locked up inside the prison ultra-real. (https://saydnaya.amnesty.org/)
- *Sea Change: The Pacific's Perilous Turn* (2014), produced by the *Seattle Times*, investigates the dire toll of acidification and global warming on the ocean and the creatures who live in it. Videos, slideshows, charts, and maps, along with text, aid in bringing the subject matter to life. The work was the winner of the DuPont Award, which is the equivalent of the Pulitzer Prize. (http://apps.seattletimes.com/reports/sea-change/2013/sep/11/pacific-ocean-perilous-turn-overview/)
- *The Railways—Lifeline of a Nation* (2018), produced by India's Ministry of Railroads, in partnership with Google, tells the story of India's vast train system, which serves 7,000 stations and has 1.3 million employees. The documentary includes personal stories, scenic routes, landmarks, and historic railway stations. (https://artsandculture.google.com/project/indian-railway).
- *Cassini's Grand Finale* (2017), produced by NASA, chronicles the last days of the Cassini space ship, which famously explored the moons of Saturn and the planet itself. It included visualization of the ship's dramatic plunge into Saturn's atmosphere until it perished, along with a 360-degree view of Mission Control, regularly posted news stories about the mission's last days, and robust social media assets, including the answering of users' questions live, just after they were asked. The documentary won an Emmy for Outstanding Original Interactive Program. (https://solarsystem.nasa.gov/missions/cassini/mission/for-your-consideration/

- *Clouds over Cuba*, an interactive documentary that is both simpler and more complex is the story of the Cuban Missile Crisis. It was produced in 2012 by the John F. Kennedy Presidential Library and Museum. The documentary, made to commemorate the fiftieth anniversary of the Cuban missile crisis, was designed to be played on the Web, on the iPad, and on other mobile devices. It thus uses a common feature of Web pages, the menu, and breaks the material into seven chapters. But it also covers a wealth of documentary materials (including letters, government papers, and still photos) which you can scrutinize while watching the video footage or can save in your "dossier" to examine later. The documentary can also be viewed using a "real time calendar" of the events, watching them in chronological order. One of the most unique features of the documentary is a totally fictional and haunting "what if" segment, a video supposedly shot in 2012 discussing the disaster that "occurred" 50 years earlier, when diplomacy failed and bombs were dropped on Cuba, the United States, and the Soviet Union. Clouds over Cuba can be viewed at http://cloudsovercuba.com/.
- *Manuela's Children* is an interactive documentary that uses a multiple-person point of view. The film, created by artist Eva Koch, was funded by the Danish Film Institute. It is a highly personal saga of five Spanish children torn apart by personal and national tragedy. Soon after the children's father dies, their mother, the Manuela of the title, becomes too ill to care for them. When the Spanish Civil War breaks out, the children are separated and scattered to various places. One dies in infancy and another ends up in Scandinavia—the woman who is destined to become the mother of filmmaker Koch. Years later, Koch travels back to Spain to reconstruct her family's history on film and reunite as many of her kin as she can. However, instead of taking the familiar documentary approach, which would force her to take a restrictive linear path, she chose to use the interactive features of the DVD, which offered her a more fluid, open framework. She gives the

siblings' accounts as individual but parallel chronological journeys, using a variation of the *Rashomon* model described in Chapter 6. Each account contributes a different layer to the narrative. Viewers can choose to follow one sibling's story at a time, or, more provocatively, can switch back and forth between them, allowing them to view this family drama from alternate viewpoints. This approach reflected the reality of the situation: each member of the family had a unique and personal view of their family's history. To try to present their memories as a single united version of the truth would have done their stories a disservice.

- In *Bear71*, an interactive documentary produced by the National Film Board of Canada, our central character is a female grizzly bear. The 20-minute film was released at Sundance in 2012, and recreates the habitat and challenges faced by wildlife when its environment is encroached by modern technology. We meet the bear right after she is trapped and watch her being tagged with a radio collar, thus becoming Bear71. The radio collar allows us to follow her story from there on an interactive grid of her rangeland in Banff National Park, and it eventually comes to a sad end. We can click at will on other tagged wildlife as well, see videos of ones that have been caught on hidden cameras, and learn more about them. The bear herself is given an anthropomorphic treatment by the script, which is read by an actress and unfortunately clashes with the realism of the piece, but the documentary is effective, nonetheless.

Each of these projects successfully found a way to overcome the challenges of producing interactive documentaries. Nonetheless, having been a consultant on an interactive documentary being produced in Poland, I am well-aware of the challenges. The fact that it is a work of nonfiction significantly restrains you, since you are tied to factual, usually linear material. It is difficult to pull the facts apart and reorder them as you might in a fictional story, and you violate the conventions of journalism by adding new elements

that are not part of the factual story. So how do you impose interactivity on nonfiction material?

One approach is to break the story into different narrative paths and let the user choose which path or paths to follow. These paths can feature important figures and entities in the story, the background prior to when your story begins, major events, and even include fiction "what if" projections, as was done with the *Clouds Over Cuba*. You can give viewers the opportunity to open gates and doorways to see the other side of the narrative landscape and let them explore another aspect of the narrative. During this exploration, you might offer objects to click on to gain additional information. You can focus on one central character and give the viewer an opportunity to step into his shoes and experience the story from his perspective, making this path as interactive as possible without fictionalizing the true story. And you can, of course, add standard documentary devices like interactive timelines and maps and auxiliary materials like historic videos, photos, and documents, plus interviews. These elements give your story journalistic authority and help round it out.

User as Fulcrum

In the *user as fulcrum* model of iCinema, the viewer is actually inserted into the story, and the decisions that he or she makes drive the narrative forward. Unlike a role-playing game, however, users do not take on a fictional identity. Instead, they step into the story as the person they are in real life.

To date, the best example of this approach to iCinema is a work called *Façade*. Although sometimes described as a video game, *Façade* is a domestic drama. It contains just three characters: a married couple, Trip and Grace (both NPCs), and you, an old friend of theirs. You experience the drama from the first-person POV, and it begins when you accept Trip's invitation to come over to their apartment for an evening of socializing. However, after a few pleasantries, the facade of their happy marriage slips off and the true strains become too obvious to miss, a shade like an interactive version of Edward Albee's play, *Who's Afraid of Virginia Woolf*. Things become even more awkward when one of

the characters begins to flirt with you. The way you handle the situation and how you interact with the two (which is done by typing in your end of the conversation) shapes the way the evening unfolds. The characters of Grace and Trip have been given a robust amount of AI and the twists and turns of the drama are not pre-scripted; they are rendered on the fly.

One of the most noteworthy aspects of *Façade*, aside from its impressive use of AI, is the intent behind it—to produce a believable interactive drama with psychologically complex characters and emotional intensity. The work, created by Andrew Stern and Michael Mateas, was five years in the making. According to the *Façade* website, the pair did not want the work to be like a typical fantasy video game, "about manipulating magical objects, fighting monsters, and rescuing princesses." Instead, as noted on the website, they wanted to make something about real human relationships. "Rather than focusing on the traditional gamer market, we are interested in interactive experiences that appeal to the adult, non-computer geek, movie-and-theater-going public."

The Spatial Narrative

A *spatial narrative* is an interactive drama in which the story elements are embedded in a three-dimensional space, and the user discovers narrative fragments while exploring the fictional environment. One excellent example of this approach to iCinema is a work called *A Space of Time*, created by Dr. Diego Bonilla several years ago. The story is about a homeless man who lives in an abandoned school building. As you navigate around the building, you get glimpses not only of his past and present life there, but also of other individuals who spent time in the school. *A Space of Time* is composed of over 700 QuickTime videos, making the possible permutations of this story enormous.

Another extremely interesting spatial narrative is a work by Julia Heyward called *Miracles in Reverse*. A story about the trauma of child sexual abuse, it is at once deeply personal and profoundly surrealistic. In order to put the pieces of the story together, one must first select one of three possible ways to enter it … from the point of view of a mom, an alien, or Jesus Christ. Once one of these characters is selected, the user is free to explore the protagonist's

home, garden, tool shed, and neighborhood, uncovering pieces of her disturbing story along the way.

Another spatial narrative is *Help*, described in Chapter 13. It is a gripping five-minute short about an alien attack in Los Angeles. It was shot in a 360-degree spherical video. The 360 video loosens the typical locked POV of traditional film, allowing the audience to freely explore the visual field, discovering elements that otherwise would be hidden from them.

Help is made to be seen on mobile devices, and thus is an example of how works of iCinema are sometimes made for very small screens.

Other Fiction-Based Small-Screen Forms of iCinema

Digital storytellers have found a multitude of other ways to harness technology to create works of iCinema. Among them are the following.

Multiplot Stories on a Grid

Crossed Lines is a multiplot film using nine characters and connecting them all via conversations on the telephone. This unique work was created by Dr. Sarah Atkinson, then at the University of Brighton and now at King's College, London. The characters are arranged on the screen in three rows of three characters each, in other words, on a grid. You, the user, can make any character telephone any other character. The work contains no central plot but is made up of numerous subplots. She uses a real telephone keypad as the interface device, a clever and totally appropriate device considering the subject matter. For example, by pressing keys number 4 and number 8, you can have character number 4 call character number 8 and then speak with each other (see Figure 14.6). The characters are presented somewhat as if a webcam is directed on them at all times. We can see what each is doing when not talking on the phone. The grid presentation is somewhat similar to *Uncompressed*, though unlike *Uncompressed*, there is no central plot. The work can be viewed both on a large screen and on a small screen.

FIGURE 14.6 In *Crossed Lines*, we can connect characters by having them talk with each other on the telephone. Image courtesy of Dr. Sarah Atkinson.

Employing DVD Technology

Both *Scourges of the World* and *Late Fragment* are interactive movies released on DVD, and have taken advantage of the DVD's generous storage capacity and menu system to produce multilayered stories, but do so in quite different ways. *Scourges of the World* is a dungeons-and-dragons animated adventure with multiple branches. Viewers are asked to make decisions at critical parts of the story (using the menu system and the DVD remote), and their choices determine what version of the narrative they see and how the version ends. This branching tree structure is, of course, not exactly a novel one. It's the same concept that was used in the old *Choose Your Own Adventure* books, mentioned numerous times in this book, and has been the underlying structure for many interactive screen-based narratives. According to the producers, the Canadian company DKP Effects, it contains 996 possible variations and four possible endings, thus offering a fairly generous amount of agency for a branching tree structure.

Late Fragment (http://www.latefragment.com/), on the other hand, uses an approach its creators term 360-degree storytelling. It is a story focusing on just three contemporary characters, and by clicking on the remote when a particular character is on the screen, you are offered a piece of that character's backstory or point of view, and can uncover secrets about that character. The three characters have quite different lifestyles and issues, but they are united by all belonging to a type of therapy group called Restorative Justice. The work contains 137 scenes that viewers can piece together in

a variety of ways. It was produced by the CFC Media Lab in co-production with the National Film Board of Canada.

Stories with User-Generated Characters

Beckinfield and *Aurelia: Edge of Darkness* are both works made for the Internet which are in part populated by characters that members of the audience have invented and actually portray in videos. The users upload their videos to a website powered by the Theatrics collaborative storytelling platform. The two works are both multi-episode stories, and thus are a bit more like a television series than a movie. Beckinfield, which ran for two seasons and was produced by Theatrics, was a science fiction story about the mysterious goings-on in a fictional town. Its creators refer to it as "a never-ending soap opera" and as "mass participation TV." The site had 4,000 registered users, and 10 percent of them, or about 400 people, regularly uploaded content to the ongoing story. Users received a weekly newsletter and a story bible to help them contribute to the narrative, which is plotted, but not scripted.

Aurelia: Edge of Darkness was described by its producers as a "steampunk fantasy Web drama." The 16-week series utilized the toolset offered by Theatrics (the producers of *Beckinfield*). The story revolved around a city built by the survivors of an ecological cataclysm. Unfortunately, the city is running out of power and its inhabitants may perish if a solution is not found. As with *Beckinfield*, participants created a character, videotaped themselves reciting a monologue, and submitted it to the company. The 16-week series was launched in the summer of 2013. The concept of allowing viewers to create their own characters and insert them in a story was a fresh approach to Digital Storytelling. It played on the popularity of social media sites like YouTube, where participants jostle each other for recognition, though it had a unique twist as a piece of fiction. It is unfortunate that more has not been done with this approach.

iCinema Works Driven by Social Media

In some cases, the events or the outcome of an iCinema story are controlled by users on social media sites. *Inside* was such a work, and furthermore, it played out in real time. It is a thriller about

a 24-year-old woman who is being held captive in an unknown place by an unknown person for an unknown reason. However, the room where she is kept contains a laptop computer, and with this computer she reaches out to friends and to others on social media sites (Facebook, YouTube, and Twitter) who have heard of her terrifying plight. These connections help her decipher clues in her room that will lead to her release and solve the mystery of her captivity. The video episodes ran one to four minutes long and new ones were posted every few days, with posts on social media sites in between. The work was a branded property sponsored by Toshiba and Intel: her laptop is a Toshiba, powered by an Intel chip.

iCinema Works Controlled by the Movements of Audience Members

Professor Martin Rieser of De Montfort University in the UK has been creating narrative installations in which the distance of the audience member to the screen or projection affects what the audience member sees and hears. For instance, in *Understanding Echo*, a flickering image of a woman is projected in a shallow pool in the middle of the room. She is a reference to the mythological figure of the nymph, associated with lakes and wells. She is speaking, and as a member of the audience draws nearer to her, her comments become more intimate. Conversely, the further away the audience member, the more impersonal her comments.

In *Secret Garden*, Rieser explores the *Garden of Eden* story in the Bible through words, dance, and song. The scenes from the story are displayed on 11 iPads arranged in a circle, and audience members wear headphones to experience 3-D animated images and spatialized acapella singing. Each iPad contains one scene from the story, and as an audience member approaches a particular iPad, that scene is triggered. Thus, audience members can assemble the story in any order, depending on the order in which they approach the iPads. In a way, this work is a bit like *Uncompressed*, because members of the audience can create their version of the story from a number of offered scenes, but the big difference is that *The Secret Garden* is played out on multiple screens in a physical space.

Rieser also led *The Third Woman* project (2008–2011) under the European e-MobilArt initiative. This project was, in part, an

interactive mobile film. It was set in contemporary Vienna, revisiting the territory of post-war film *The Third Man* and re-imagining it for the twenty-first century. The public participated by using their mobile phones to trigger QR codes for film-noir fragments and text messages, which moved them through a scenario. The film itself was structured into three parallel dramas where the same scene was available in three different emotional moods. The work toured internationally—in Austria, Greece, Britain, China, and the United States—and was reworked substantially for each succeeding venue.

> **WORTH NOTING: iCINEMA AND ACADEMIA**
>
> As we have noted throughout this chapter, much of the work done in iCinema has been under the helm of academic institutions. To a large degree, colleges, universities, and film schools are the major force pushing this field forward. The Labyrinth Project (http://thelabyrinthproject.com/), with its innovative program on database narrative, is under the wing of the famed School of Cinematic Arts at the University of Southern California. And the iCinema Centre for Interactive Cinema Research at the University of New South Wales is another program to keep an eye on, even though a great deal of this program's emphasis is on virtual reality and other forms of immersive experiences. Nevertheless, its website (www.icinema.unsw.edu.au/) contains much of interest.

Interactive Television

As with iCinema, iTV is a foreign concept to the majority of dedicated TV viewers. Yet after a long struggle to find its legs, it is currently enjoying renewed interest, and some interesting iTV shows are now available to the general public.

Winning Over the Couch Potato

OK, Mr. or Ms. Couch Potato, which will it be?

- The opportunity to change the plot of the show you are watching?

- The chance to compete with other viewers and win prizes in a trivia competition based on the TV show you are watching?
- The chance to see highly personal and emotional "bonus" material from the point of view of one of the characters in a serialized drama?
- The chance to determine which Olympic competition to watch, and from which angle?
- Or the chance to solve a mystery on your favorite crime show?

In truth, the most likely answer is "none of the above." Though all five of these interactive TV scenarios have been produced and broadcast, most viewers are not aware of them and would not know how to participate. This is because interactive TV (iTV) is an area that has progressed in fits and starts and has suffered significant setbacks over the years. It is only recently that breakthroughs in iTV are beginning to attract significant numbers of viewers.

Surprisingly, iTV has a very old history in terms of interactive media. It dates all the way back to the 1950s, long before the Internet was even born, with experiments in the UK. The first public iTV trials began the 1970s. There was an upsurge of iTV experimentation in the 1990s with Time Warner's Full Service Network and other cable companies, who were trying to deliver interactive apps through enhanced set-top boxes. Still later efforts at iTV only offered limited functionality, so most people ignored them. Unlike the Internet, which took off in a massive way, the progress of iTV has been unsteady and at times it has threatened to disappear altogether.

With the first forms of iTV, as with most early stage technologies, there were problems between competing systems backed by various companies that were incompatible with each other. But the weak link in the system was the set-top box itself, especially in the United States, because the box did not contain the processing power or memory required to deliver visually exciting applications. In Europe, however, with a successful history of telephony-based teletext, government regulators mandated

hardware upgrades, including the interactive "Red Button" system in the UK.

Two new streaming services, Chromecast (2013) and Apple TV (2015) meant that viewers could now see online programs on their TVs. Chromecast offered some interactivity as well; viewers could play games and use their phone or tablet as a controller. However, Apple TV is not offering interactivity at this point.

The development of iTV underwent a welcome and radical shift in the United States with the release of Apple's iOS-fueled iPad and iPhone, and later Google's Android platform. These platforms suddenly made the dream of "interactive TV" real, in large part because these devices could display HDTV-quality picture and stereo sound. They also allowed for third-party developers to create apps that would give both broadcasters and consumers a new world of media experiences. Some of these new apps were for experiences occurring entirely on the mobile device. But others could be linked to live or recorded television shows by means of sound technology, thus enabling a full second-screen experience. The United States, and the rest of the world, finally entered the era when consumers could, if they chose, do all sorts of things in conjunction with their favorite TV shows.

These interactive TV experiences, however, did not work on your TV set alone. They required an additional device like a smartphone or a computer to offer interactivity. This form of iTV was "second screen TV." It was not until 2018 that true single screen interactive TV became widely available.

Unfortunately, despite the fact that millions of homes have possessed the capability of receiving some form of iTV for many years, most viewers are under the impression that this form of entertainment is something for the far-off future, not something available in the here and now. In fact, when teaching Digital Storytelling classes, a number of my university students had never even heard of iTV. I would get comments like this: "I did not realize it exists. I thought it was a sci-fi kind of thing." Another student said: "I think the most interesting form of digital storytelling is the iTV. This is a part of storytelling that takes something very original and classic and makes it new and exciting."

Various Forms of iTV

iTV has taken many forms over the years and has been given many different names, so many that the terminology becomes confusing. Professionals within the industry are even hard-pressed to agree on a uniform definition for interactive TV. At one time it was also referred to as enhanced TV (eTV). Until recently, with the introduction of single-screen interactive TV shows on Netflix, the two most used terms are "second-screen TV" and "social TV," but some also use the term "app TV" or "multiscreen TV." In addition, in the UK there is "Red Button TV." What do all these terms mean and how are they different from each other?

Second-screen TV means watching a TV show on the main screen (your TV set) while also interacting, often through a special app, on your tablet or smartphone. Social TV is technology that supports communication and social interaction on your mobile devices while simultaneously watching a show on the main screen. Second-screen and social TV are often the same thing; the defining quality of social TV is the degree of interaction with other viewers. Multiscreen TV, as the term implies, means using more than one screen to enjoy TV, and app TV is simply using an app in conjunction with watching a TV show—the app enhances the TV program. As for BBC's Red Button TV in the UK, it is a service that allows viewers to see additional content by pushing the red button on their controller. As described by the BBC, Red Button is "an interactive TV service available via digital terrestrial television, satellite television and cable television." An estimated 20 million people a month press the red button there.

All of this is, to be honest, fairly confusing, especially because of the overlap of social and second-screen TV. In an attempt to sort all this out, I had interviewed my colleague Nick DeMartino, a digital media strategy consultant, back in 2013. Unfortunately, although DeMartino did his best to clarify the terminology and to help me get a clearer picture of the field, it turns out that this is no easy job.

DeMartino pointed out that the original vision of iTV required set-top boxes, as noted above. But, he said, "this was single-screen interactivity, and it failed." Some companies were also trying to deliver interactivity by means of other devices, such as a game

console, a cell phone, or the Internet, because back then we didn't have tablets and smartphones. When DeMartino was at the helm of the cutting-edge Enhanced TV workshop at AFI (The American Film Institute), holding the position of Senior VP of Media and Technology, the lab experimented with a great number of variations of iTV. The lab was renamed the Digital Content Lab and unfortunately closed in 2010, which may (or may not) indicate the fading hopes for iTV.

Nonetheless, DeMartino said: "In the current incarnation, what we're essentially doing is reflecting the popularity of mobile devices—primarily the smartphones and tablets—which are small and light and powerful computers that consumers pretty much always have with them. Their presence in the room where the TV viewing is occurring ... *that* is the breakthrough." In this new incarnation of iTV, we are watching TV and using our mobile phones at the same time. Before that, he noted, "this activity was happening asynchronously." But, he maintains, "The function of the second screen experience is still being explored and debated." He also notes that many second-screen apps are specialized for particular shows or broadcasters and the upside is that you receive a completely customized experience. But, he wonders, "Does everybody want to load a different app every time they change the channel?"

DeMartino suggests that there's a reason that the professional community is so interested in second-screen TV. "I think it's intriguing to a lot of people because, embedded within the idea is the notion that there is a deeper audience engagement opportunity that, for the first time, is supported by the infrastructure and the consumer behavior. You're encouraging people to use the device they're already using all the time for many other things, to connect it with the TV experience. This is the fundamental shift in the discussion of the interactivity." He pointed out that second-screen TV is still relatively new, emphasizing that "We're at the beginning phases of a very different relationship between the audience and their content." He feels that we are just beginning to learn what can be done with it, telling me: "Second-screen is exciting people not because of what's done but what it's going to enable someone to do."

He feels that social TV, which is often just using Twitter to comment about the show you are watching, is "essentially social functionalities of these different second-screen apps." In other words, they are "just variations on the broad social media functions that we all take for granted."

One thing that surprised me was DeMartino's emphasis that second-screen was a *business* rather than an innovative way to present interactive content, and at the time of our interview there were 138 different applications of second-screen and counting. "It's a bunch of different functionalities and businesses that are all losing money, that are trying to find a market for this second-screen kind of experience." Since my emphasis is always on the storytelling side of digital media, I was disappointed with this characterization of second-screen TV, though I respected his insights.

Sensing my disappointment, he pointed me to some innovative storytelling work that is currently going on. For example, he told me about a *Game of Thrones* app produced by HBO and Miso (a second-screen company) that gave you a map of where the action is taking place and also offers the genealogy of the characters and other helpful features to assist the viewers in following the story. In addition, it gave fans a chance to add their own second-screen content: factoids, comments on the characters, and the like. Although this was not the kind of interactivity that I was hoping was going on with second-screen, at least it did enrich the story. Again, as if DeMartino could read my mind, he said: "It doesn't change the experience of watching a linear show, it enhances it. There really are not, to my knowledge, any real groundbreaking storytelling experiences that are second-screen." He notes that at present the media companies and the venture capitalists "are still struggling to find business models for all these things."

One of the experiences I enjoyed most, the *Psych* spin-off, *The S#cial Sector* (described in Chapter 8 and that DeMartino had pointed me to), was, according to DeMartino, not technically a form of second-screen TV because it didn't work simultaneously with the TV show, but outside of it, even though it had the same characters and milieu, used video, and was extremely interactive. It could be described as *auxiliary TV or ancillary TV*. Helpfully, he told me: "You want to be clear about what is the technology

that's enabling experience and what is the experience. You can't conflate the two. The second-screen is a description of a technological infrastructure." He stressed that "It's nothing to do with the experience of the television." But, ending on a hopeful note, he added: "That doesn't mean the experiments aren't interesting."

In addition to the new forms of iTV mentioned above, other types of video experiences that people in the industry have placed under the iTV umbrella are:

- The synchronization of content on TV and the Web, calling for a secondary device like an Internet-connected computer or cell phone, known as *dual screen* or *synchronous interactivity*.
- *Video on demand* (VOD), in which viewers can order movies or other video content from their TV sets or devices connected to the Internet.
- Devices like TiVO, which are known as personal video recorders or digital video recorders (PVRs or DVRs) and which offer features like pausing live TV and skipping commercials.

Thus, we are looking at a great number of ways to define iTV. For our purposes, let's keep things simple and say that iTV is programming that allows viewers to interact in some meaningful way with the content of a television show or other forms of video, no matter what the platform or how the interactivity is delivered.

NOTES FROM THE FIELD: THE CREATIVE CHALLENGES OF iTV

As if the various types of iTV were not enough, developers face an incredibly difficult challenge when it comes to the creation of programming, and it is this: how do you design content for the interactive aspects of the program that enhances, and does not detract from, the linear content? This is the fundamental conundrum of all interactive TV content creators, and one that will be explored for some time to come. DeMartino, in quoting James Cameron, defined the ultimate dilemma. According to DeMartino, Cameron said, "'I don't believe that you come to my films in order

> to change the ending or to make your contribution. You come in order for me to tell you what the story is.'" If it is true that people are expecting a linear narrative from a master storyteller, then what is the role of interactivity?

It is not surprising that Mr. and Ms. Couch Potato have largely been left in the dark about what is happening with interactive TV, with so many attempts to make it happen and the attempts, for the most part, not catching on. But we are seeing a major breakthrough in the field.

New Advances in iTV

At the time of my interview with DeMartino, he was pessimistic about single-screen TV, regarding it as a largely outdated technology. He said: "there's not much to be done with it. The sun has set on that as an innovation; it's fifteen years old." But a few years passed and suddenly there was a major breakthrough in single-screen iTV. Our conversation had taken place just four years before Netflix released its first single-screen interactive show, *Puss in Book*, which aired in 2017. How things changed in just a short amount of time! We are now at an exciting new point in iTV. Thanks to Netflix, we have true single screen TV, where all the interactivity is offered on the TV screen, and you control the interactivity with the remote control. Netflix has been investing substantially in its interactive platform and as of this writing, less than two years after the release of *Puss in Book*, Netflix is offering a total of six interactive titles to explore and promises more to come. Four of its shows are for children, one is for adults and one is for kids and older people.

Puss in Book is an animated interactive movie for children, using the same character and style as the Netflix series, *Puss in Boots*. The major difference in the iTV version is that the child viewer gets to choose what Puss does at various parts of the story, via the pages of a magic book. The choices are extremely simple and child-friendly: the left-hand page of the book, or the right-hand page. It's your basic choose-your-own adventure structure,

which is the branching storyline model of interactivity. Looking at this endeavor as an adult, I found the interactivity severely limited and fairly meaningless. In the Goldilocks part of the story, where Puss finds himself in the empty house of the three bears, they suddenly return home. The viewer can choose between the bears being friendly or being dangerous. But even if the viewer picks "friendly," the bears play rough and Puss is in a potentially hazardous situation. He leaps through the window to escape. But the same thing happens if you pick the "dangerous" option: he leaps through the window to escape. This is not true of all choice points; sometimes they result in different outcomes, but your choices don't advance the storyline. The interactive story is just one little episode of Puss's adventures after another, strung together without any overall plot or character development. Simple as *Puss in Boots* is, though, it is a huge step forward in iTV; living proof that single-screen interactivity can work.

The next major breakthrough in iTV occurred a little over one year later, at the end of 2018. Again, it was a Netflix project. This new work was a live action interactive movie for adults: *Black Mirror: Bandersnatch*. It was written by Charlie Brooker, the creator of acclaimed sci-fi series *Black Mirror*. It used the same two choice option of interactivity as *Puss in Book*, but significantly pushed against the usual restrictions of the branching storyline model and advanced its possibilities. *Bandersnatch* is part of the anthology series, *Black Mirror*, a British TV series. The characters and plot of *Bandersnatch* are original, conceived just for this interactive episode. The story is set in 1984 and revolves around a young man, Stefan, who suffered a terrible trauma as a young child and has serious mental health issues. Stefan dreams of developing a videogame based on an old novel, *Bandersnatch*, whose author goes insane and commits a horrific murder. Stefan manages to sell his game to a company headed by a famous game designer, Colin Ritman, who himself seems quirky and might also be mentally unstable. We quickly get sucked into Stefan's dark world and watch as his fragile mental health completely unravels as we make choices for him. One satisfying aspect of the choice-making in this work: the one you pick does not happen instantly, in a mechanical kind of way. Instead, it is smoothly integrated

into the scene you are watching. It seems like a natural progression of the story.

Surprisingly, the interactivity of *Bandersnatch* begins in a way that seems extremely disappointing, but later you realize it is meant to be a training exercise on the interactivity and a satiric poke at choose-your-own adventure stories: Stefan's dad asks him (us) to decide which of two sugary breakfast cereals Stefan would like for his morning meal. Later we get to pick which music he will listen to as he rides the bus. Soon, however, the interactive choices become far more serious and even deadly. For instance, we are asked if Stefan should flush his medications down the toilet and at another juncture if he should get aggressive with his therapist. At another point, game developer Colin invites him over to his place on a high floor of an apartment building, introduces him to his wife and sweet little baby, and then gets Stefan high. The two go out to the balcony to get some fresh air, and Colin insists one of them should jump off, insisting that it won't hurt—it doesn't bother Pacman, does it? However many times Pacman dies, he always bounces back, he adds. For the viewer, deciding who should jump is a ghastly choice to have to make.

The choices you make have consequences later in the story. Sometimes you are forced to go back to a choice point and pick a different choice and you see how making a different choice would have changed Stefan's story. Evidently there are a million different paths the viewer can take through the story, and five different endings, though not a single "correct" ending.

Brooker found the task of writing a script like this far more daunting than he expected. The software he thought would help to track the different branches of the story was not up to the job; the story was too complex, with its multiple layers and unexpected expansions. Finally, Netflix stepped in and created an internal mapping tool to track all the different ways a viewer could move through the story. According to a report in the *Hollywood Reporter* (December 28, 2018): "The map outlines state-tracking options that occur in the beginning of the episode, all the possible paths along the way and a series of if-then options at the end showing how a viewer can arrive at each ending." It took two years to make *Black Mirror: Bandersnatch,* about four times longer than

Booker had anticipated. Approximately 250 scenes had to be shot to tell the complete story.

In the same article, Brooker's producing partner, Annabel Jones, told the Hollywood Reporter: "Going down various branches opens up other potentials, so you may not reach certain things depending on the decisions you make. It's not a simple branching narrative with lots of binary choices — they are all changing your state and what's open to you." Each time you play the episode, you will by surprised by new twists and turns. At one point, a distraught Stefan tells his therapist that he feels he no longer has any control over his life. He can't even choose what breakfast cereal to eat or what music to listen to. She soothes him with some psychobabble, but later his computer confirms that he is being controlled by a force he cannot resist; this force is from the future, a streaming service called Netflix. The poor young man is hopelessly bewildered by this news. And this piece of the story raises interesting existential questions—do we or do we not have free will? Can we choose our own destiny or is there a path already laid out for us and unchangeable?

Thus, *Black Mirror: Bandersnatch* is light years ahead than *Puss in Book*, both in terms of story content and also in the way interactivity is used to tell a complex story. This is not to cast aspersions on *Puss in Book*, which is a charming story for children and was a successful proof of concept. But *Bandersnatch* artfully demonstrates the potential of storytelling on iTV.

The View from the Frontier

One person working in the interactive television arena has been steadfastly upbeat about iTV's potential. This person is Dale Herigstad, a leader in iTV and a director and designer of digital interactive experiences. He's been involved in interactive TV since Time Warner introduced the Full Service Network in Orlando, Florida, back in 1994. Prior to Netflix entering this arena, Herigstad, who is considered a visionary in the field, probably brought interactivity to more American television shows than anyone in the business.

"This is the frontier," he told me during an interview some time ago, speaking with relish, not distress. "There are no books on this, no classes on this. We have to invent the rules and figure things out for ourselves. It's a learning experience for all of us." But he admitted to a certain impatience at how slowly the business side of things is moving: "My mind is exploding with stuff," he said in frustration, because the technology and the money aren't where they need to be yet.

> **EXPERT OBSERVATIONS: LESSONS LEARNED**
>
> For all the challenges developers of iTV programming have faced, Herigstad nevertheless remains enthusiastic about its possibilities, and shared with me some general lessons he has gleaned about developing interactive content for television. He said the work he has done so far has shown him that:
>
> - Interactive enhancements should be choreographed to the program, and not forced upon it; the pacing is important.
> - Ninety percent of what you are trying to figure out is the balance between the passive and the interactive elements.
> - What constitutes a value-added experience is different for every show and what is successful for one will not necessarily be appropriate for another.
> - Because TV viewers are sitting back and can't see the TV very well, they need the visuals to be very clear and simple, and they don't want to read much text.
> - They like things to be easy and prefer to respond, not to initiate.
>
> Herigstad says he has a mantra about interactive television, and it is this: interactive TV is television, television, television. It's not the Web and it's not something else. And television, above all, has always been a simple experience.

Pushing The Envelope

While AFI's wonderfully innovative Digital Content Lab was still in operation, it encouraged developers to think in terms of five

possible ways to use interactivity with TV. These goals are as valid now as they were in 2010, when the lab closed. It suggested interactivity in television can be used:

- To add dimension to the show's characters (which can pertain to real people in non-fiction programs as well as characters in dramas and comedies).
- To allow viewers to delve more deeply into the subject matter.
- To serve as an educational springboard for young learners.
- To provide an opportunity for self-exploration.
- To explore sensitive social issues and offer a forum for community building.

More recently, Janet H. Murray, author of the acclaimed book on interactive narrative, *Hamlet on the Holodeck*, and currently a professor at Georgia Tech, theorized that episodic TV shows like *Game of Thrones* had outgrown the classic TV format, and that viewers could use help keeping track of the dozens of characters on the show, as well as their backstories, alliances, and antipathies. In an article for Georgia Tech's newsletter (April 10, 2019), she predicted that a new genre would be developed which she calls the *hyperserial*. The newsletter explains: "Plot, backstory, and detail too fine to showcase in an hour-long drama would pass back and forth between television screen and computer screen, high-speed digital transmission of content would enable new ways of accessing stories, and narrative would, as a consequence, grow richer and more complex." Her students have been protyping a "companion app" that would serve this function. The app provides this information without viewer intervention.

Murray went on to say: "Computers give us a new vocabulary of representation, and I believe this will lead to ever more complex storytelling. We need more complex storytelling to understand the world and share our understanding of complex systems and multiple chains of causation, multiple points of view, and multiple possible outcomes." It is unclear from the article whether the information on the companion app appears directly on the TV screen or if it is a second-screen device, appearing on a mobile platform or a computer.

Prior to the Netflix iTV endeavors, adding interactivity to a dramatic show has been one of the toughest nuts developers have tried to crack, and still presents difficulties. In an attempt to crack this nut, AFI assigned a team to the drama *The L Word* to see what they could come up with. The Showtime cable series was an emotionally intense portrayal of a group of lesbian and bisexual women in Los Angeles (the "L" in the show's title stands both for love and lesbian). The team decided to do two things with the enhancements: to expand the narrative aspects of the show and to pull viewers into the story in a personal way. Thus, they gave viewers the opportunity to watch soliloquies of the characters, during which they revealed feelings that they hid from other characters in the show. In addition, the drama would pause at several key points and present viewers with multiple-choice questions about their own views of romance. At the end of each episode, the viewer would be rewarded by receiving a personal message from the character who most resembled her (as gauged by the answers she gave to the questions), offering additional comments on the theme of the show. While the soliloquies work well to add dimension to the story, some might question the validity of inserting the multiple-choice questions, seeing them as more of a distraction than an enhancement.

Interactive TV is used for non-fiction and educational programs as well, and many would say interactivity is a better fit for such shows than dramas or comedies. Under the AFI Digital Content Lab, I had the opportunity to serve as a mentor for an educational show called *TV411*. A so-called "adult literacy" project, it was designed to help adults improve their reading and math skills. Our prototype actually made use of two platforms and thus was a second-screen approach: interactive TV and cell phones. The interactive TV element worked as a tutorial for the subject matter addressed on the linear show, giving viewers extra help with the concepts covered in it. At the end, they could take an interactive quiz to test themselves, to see if they grasped the lesson. The cell phone enhancements were done as a game and tied to one of the concepts explored in the TV show. It was designed to be short and easy to play, in keeping with the limited literacy skills of the target audience.

Some years ago, while the Digital Content Lab was still in operation, its director, Marcia Zellers told me that "We are in the early stages of this medium." She said content creators were still wrestling with the essential puzzle of interactive TV—how to enhance the content without being distracting. "It is a very tough thing to do," Zellers said. "I don't think we've found the golden nugget yet." But perhaps Netflix has found the golden nugget; time will tell. And for producers still searching for the elusive nugget, a few general guidelines from the Digital Content Lab can be put forth:

- Anything that makes it difficult to follow the story is distracting.
- Enhancements that are too fast or too difficult or that require too much thinking can be distracting.
- The typically chunky style of Web design is distracting on TV.
- The user interface must be clear and must not be hard to figure out while looking at the TV screen.

> **EXPERT OBSERVATIONS: iTV'S TO DO LIST**
>
> In speaking of where further work needs to be done to advance iTV, Zellers told me: "I think we still need to keep hammering away at it ... What is the right interface? What truly enhances the program? Technology is just bells and whistles. But how do the enhancements make television more compelling than if we didn't have this technology?"

When iTV Becomes "Just Television"

At AFI's interactive TV events, one would often hear a wistful phrase: "Someday we'll just call it television." In this vision of the future, interactive TV will have become so widespread that it will just be a normal part of the entertainment landscape. Although still a long way off in the United States, the dream is already largely realized in the UK. This is thanks primarily to the BBC,

though its interactivity is of limited robustness. However, over half the homes in the UK have access to two-way iTV services from the BBC. And these people don't just have access to interactive TV; they avail themselves of it. For example, during a recent Wimbledon tennis competition, 64 percent of those equipped with interactive TV technology took advantage of it to watch the tournament, switching at will between the action going on in five different courts.

A Variety of Approaches

The BBC has taken a diversity of approaches toward interactive TV. With *Antiques Roadshow*, for example, it employed an interactive overlay on top of the video that let viewers guess the value of the heirlooms being examined. This interactive gaming element helped the BBC solve a vexing problem: that of drawing younger viewers to a show that had primarily attracted an older demographic. The gaming overlay not only brought in a new audience but did so without changing the show itself.

With the highly provocative series, *Diners*, the BBC used an approach similar to the Wimbledon telecast, but in this case the setting was a restaurant. And, as you would expect, the people in the room are eating and chatting. The twist here is that cameras are aimed at diners all over the room—real people, not actors—and the viewer can decide which table they'd like to "visit," and then eavesdrop on the conversation going on there. The multiple-camera approach used on *Diners* suggests some intriguing possibilities for a drama. One can imagine, for example, what Robert Altman, master of multi-plot films, could do with this.

The BBC has a large audience of older people and is using different approaches to bring such viewers into the interactive tent. For this demographic, the interactive features are designed to be uncomplicated but satisfying. Thus, the BBC designs shows for older viewers that give them an opportunity to vote on matters they care greatly about and, when feasible, these votes trigger an action. For example, in *Restoration*, a show about Britain's historic houses, they invited viewers to vote on which structure was the most deserving to receive a large grant for renovations. This

type of interactivity has proven to be highly popular with the over-40 crowd.

Applying iTV to Drama on the BBC

The BBC has also experimented with iTV dramas. For example, it aired a hospital drama in which viewers could decide which of two patients' lives could be saved. And, in a trial in the north of England, it aired short daily segments of a month-long episodic drama called *Thunder Road* (see Figure 14.7). The drama was set in a real city, Hull, where the trial was taking place, and was presented as a blend of fiction and faux documentary. It revolved around a married couple that takes over a rundown pub, the Thunder Road, and has to make a success of it in 30 days or risk losing not only the pub, but also their livelihood and possibly their marriage. Each little episode ended on a cliffhanger.

Among the interactive possibilities was the chance to see, via VOD, additional "documentary footage" about the story. These video segments were monologues of each of the characters, shot with a hand-held camera to heighten the documentary effect, in which they revealed their thoughts and feelings about the unfolding events. Viewers could also participate in message boards and

FIGURE 14.7 The BBC's interactive episodic drama, *Thunder Road*, offered viewers a variety of ways to interact with the story. Image courtesy of the BBC.

quizzes. The additional scenes did not change the story itself but gave viewers a greater understanding of the characters.

In a quite different iteration of interactive drama, the British series *Dubplate Drama*, which aired on Channel 4, gave viewers a choice over the storyline. Each episode ended on a cliffhanger and viewers were asked to vote on what they wanted to happen next. The plot development scoring the most votes became the storyline for the next episode. *Dubplate Drama* was about a group of aspiring musicians trying to secure a record label and featured highly popular British musicians. Rather than being a single-screen experience, it played on multiple channels and viewers made their choices known by voting online, on their mobile phones, or on their Sony PSPs. The show was targeted at a young audience and was successful enough to run for three seasons.

> **EXPERT OBSERVATIONS: NO "BOLT-ONS"**
>
> Ashley Highfield, who was once in charge of BBC's interactive shows, suggested to me in an email interview that one reason that the BBC has been able to produce so many breakthrough iTV projects is because of the broadcaster's approach to creating them. He said these projects are created from the very beginning to be interactive, instead of the interactivity being pasted onto already-produced linear shows. "Regardless of genre," he said, "all our interactive applications begin from the ground up at the time of the programme's commission. They are not considered 'bolt-ons' to the linear programme." The BBC's approach encourages far greater freedom in designing the relationship between the linear and interactive content, and also means that the interactive elements can be produced at the same time as the linear ones, using the same actors, sets, and other assets.

The Dual-Screen Experience: A Real-Life Example

While the UK has an established infrastructure for single-screen interactivity, most Americans experienced interactive TV through a dual-screen configuration. That meant watching the

linear program on a TV set and interacting through a synchronized website or mobile device.

To get a sense of what such an iTV experience is like, allow me to describe a show I participated in, called *Boys' Toys*. It was a week-long series on the History Channel about gadgets and vehicles that particularly appeal to men—things like motorcycles, limos, private planes, and convertibles. The technology to make *Boys' Toys* operational was supplied by GoldPocket Interactive, which was acquired by Tandberg TV, which then became Ericsson Television.

The main interactive enhancement of the series was a quiz game that viewers could play along with the show. Those with the highest scores for the week could win prizes in the sweepstakes. I logged onto the History Channel's website in order to register and to check starting times and subjects. Scanning the schedule, I decided to go for the one on private planes, which sounded like the most fun. To play, I'd need Macromedia's Shockwave plug-in, which I already had. The registration process was easy. I was asked to give my time zone, a password, a user name, and some contact information. Unfortunately, not seeing ahead, I typed in my real first name as a user name, never stopping to think how uncool a girlie name like Carolyn would look if I were lucky enough to make the leaderboard.

A few minutes before the show was to start, I logged on a little nervously and waited, not knowing quite what to expect. The action got going at 9 pm, right on the dot, when the interactive interface popped up on my computer screen. It had an appropriately high-tech gadgety look, complete with gears, reflecting the theme of the series (see Figure 14.8). Soon I was engaged in the nonstop business of trying to accumulate points. I had no trouble watching the TV show while keeping up with what was happening on my computer, and the synchronization worked flawlessly; but the quiz kept me busy. Some of the questions were giveaways, earning you points just for participating in a poll ("if you could have your own private aircraft, which would you choose?"). But some questions required prior knowledge of aviation (a subject I knew pretty well, being a frequent flyer) and some were based on information already imparted on the show, and you had to

FIGURE 14.8 The interface for *Boys' Toys*, as it looked on a computer screen. The interactivity was synchronized to the TV broadcast. Image courtesy of A&E Television Networks. Reprinted with permission. All rights reserved.

stay alert. Slyly, some of the questions were based on commercials run by the sponsor, IBM, so you couldn't slip out for a bathroom break while they were running. The most stressful questions were those that had you wagering a percentage of your accumulated points. Being right or wrong here could drastically affect your total score.

The first time the leaderboard popped up, I was thrilled to see my name on it, number 6! Though I hadn't intended to play for the whole show, I was hooked. But I certainly wished I'd picked a cooler user name, especially because my fellow high scorers had such macho ones— Gundoc, Scuba Steve, and White Boy. No time for reflection, though; the game was on again, and my adrenaline was pumping. Next time the leaderboard appeared, I had risen to number 5. But then came one of those wager questions, and I answered incorrectly. My score plummeted by 600 points and my ranking to 7. It was now the final stretch of the game and I vowed to regain those lost points. Sure enough, when the game ended, I had risen to number 4! I felt proud of upholding the honor of

my gender, though if I were to do it again, I'd pick a name like ToughChik or SmartyPants, just to give the guys a poke. But overall, it was a completely enjoyable and engaging experience. The interactivity added a whole other dimension to TV viewing and kept me glued to the two screens. I had only one complaint with this interactive TV experience, as opposed to a more laid-back linear one: it was impossible to snack!

How Second-Screen TV Is Being Used

At one time, the most successful use of second-screen TV was for game shows, sport shows, and live events. When used for dramatic series, the second-screen features are usually in the form of additional factual information about the show and the actors, but it may also be used for polling or voting. Today, the most popular use of second-screen TV is *social TV*, where viewers share their thoughts and opinions with others who are currently watching the same program.

According to a recent Nielsen report, 45 percent of viewers in 2018 regularly engaged in second-screen TV. But not all of this use of other devices is not necessarily being done in conjunction with the TV show: in some cases, people are just checking their email. Nielsen asserted in its report that: "we're using the second screen to *augment* the overall TV viewing experience, not detract from it … in fact, most of the activities that take place on our devices while watching TV are related to the content."

Nielson also reported that at 9 pm, the peak TV hour, more than half of viewers were either watching linear TV or interacting with TV connected devices like game consoles or through streaming content.

Another report, on the website Curatti, reported even higher figures, with 70 percent of viewers engaged in second-screen activities, either to obtain more information about the show or to communicate with friends.

In any case, second-screen TV is still alive and well. It works particularly well for live events, because people tend to watch these shows as they are being aired rather than recording for later viewing. Having so many eyeballs fixed simultaneously on the TV

screen, but hopefully ready for a richer experience, serves as an inducement to develop second-screen content. It's been especially popular for major sports events and entertainment awards shows.

Some years back, during the 2012 Super Bowl, Coca-Cola ran a clever and highly successful second-screen app, the *Coca Cola Polar Bear Party*. In this live app, two polar bears, "fans" of the rival teams, sit on a couch made of ice and react in real time to the events of the game. One wears a red scarf and the other a blue scarf. When the team favored by the bear with the blue scarf is winning, he's jubilant, while the bear with the red scarf looks upset and begins to pace nervously, and they continue to react realistically throughout the game. At times other Nordic characters would wander across the screen, like a penguin or a small polar bear. As this animated feature was running, people could send in pictures of their Super Bowl parties with the bears in the background. The Super Bowls are also major tweeting events. During the 2018 Super Bowl, the hashtag #SuperBowl chalked up over 2.5 million Tweets, with other hashtags collectively getting over 1.5 million Tweets.

> **STRANGE BUT TRUE: SECOND-SCREEN MOVIES**
>
> Although it is generally annoying when someone in the audience of a movie theater lights up their cell phone and checks their messages during a film, a couple of apps have been specifically produced to be used in conjunction with the movie on the screen. Two of these films, both called *App the Movie*, have used this technique. One coming out of AFI is a romantic comedy, while the other, a Dutch film, is a heart-pounding thriller. The intent of both apps is to add another layer of entertainment and "realism" to the fictional story.

Dramatic Shows and Social TV

Most second-screen apps have a social media component, but some apps augment the TV show almost exclusively through social media and use it in somewhat unexpected ways. For example, *Dirty Work*, a Web series produced by Fourth Wall Studios, used social media to add to the story rather than to connect viewers

with each other. *Dirty Work* (http://rides.tv/dirty-work/) is the story of a trio of 20-somethings whose grisly job it is to clean up crime scenes and other biologically contaminated environments. People who sign up for the second-screen enhancements receive text messages, emails, and phone calls during the show from the fictional characters, and also receive additional videos. This is one of the few instances of the second-screen components actually enhancing the story content rather than adding a little layer of inconsequential material over the story.

Pretty Little Liars, a teen drama which ran from 2010 to 2017, employs a more conventional, but highly successful approach to social TV. The show follows four teenage girls who are being terrorized by an unknown person. ABC, its broadcaster, was extremely active in stimulating social media activity for the show. It had a popular Facebook page (with 10 million fans) and special Facebook tabs which unlock special content. It also used hashtags to stimulate tweets as well as Twitter-based scavenger hunts, endeavors that have reaped rich rewards: during one season, *Pretty Little Liars* was mentioned 1.4 million times on Twitter. ABC also developed an eight-part Web series, *Pretty Dirty Secrets*, to run between seasons. The show's social media approach works perfectly for its target demographic, women between 18 and 49.

People also watch news shows on Facebook Watch, a video on demand service, and enjoy real time social interactions with other viewers.

ADDITIONAL RESOURCES

To stay abreast of interactive iCinema and iTV developments, go to:

- List of interactive shows on Netflix: https://www.whats-on-netflix.com/library/interactive-titles-on-netflix/
- iTVT, a publication devoted to iTV: http://www.itvt.com/
- The Interactive Television Alliance (ITA): http://www.itvalliance.org/
- The Second Screen Society: /www.mesalliance.org/communities/second-screen-society/

Conclusion

As we have seen in this chapter, the fields of iCinema and iTV do not dominate the digital media landscape like some other forms of digital media, but the work that is being produced here is dynamic and innovative, even though the public's awareness of them is fairly dim. In fact, iTV almost completely sputtered out until the new Netflix shows reenergized it.

The practitioners of iCinema employ highly diverse approaches for the works they create, making works for both large-screen theatrical experiences and intimate small-screen interactivity, sometimes within the same work. Works of iCinema and iTV sometimes bleed into each other: an interactive movie can be viewed on TV, while second-screen works can be viewed in large theatres. And almost any of these works can be viewed on a variety of devices.

Each new venture in iCinema and iTV pushes the envelope of digital storytelling a little bit further. It is a field that cries out for more study and more experimentation. Advances, however, have been slowed by the lack of a substantial audience for this type of storytelling, though the Netflix shows may have sparked new awareness on the part of viewers.

In terms of the public's embrace of these forms of digital storytelling, it must be remembered that in the early days of linear cinema, it too met with an indifferent reception. Audiences reacted to the first movies they saw with bewilderment and hardly knew what to make of them. With time and increased familiarity, however, they came to accept and understand the grammar of this new medium—techniques like the montage, the dissolve, and the flashback.

In fact, if we look at the history of each new art form, we will usually find that the public reacts with skepticism and an initial lack of enthusiasm. Not so long ago, when music videos were first aired on TV, they too had a chilly reception, especially from adults who had grown up watching the more sedately paced movies of the mid-twentieth century. Many found music videos to be a dizzying barrage of unconnected images and could find nothing to

enjoy about them. Although some people will never like them, they have become an immensely popular and influential part of contemporary culture.

As for interactive cinema and iTV, it is critically important that they, too, develop a support base of users. Otherwise, its creators are laboring in a vacuum. Josephine Anstey, who created the VR work *A Thing Growing*, stated this dilemma eloquently almost two decades ago when she said: "We need practitioners and experimentalists, but we also need an increasingly sophisticated audience and the feedback between the two. No interactive fiction can be made without constant testing and feedback from users" (*Computer Graphics World*, February 2001).

Hopefully, as more people are exposed to iCinema and iTV, they will begin to develop an understanding and appreciation of these new storytelling art forms, and this promising arena will receive the support it needs to move forward more quickly.

Idea-Generating Exercises

1. Pick a subject that you think might work well as a fiction-based interactive movie. Do you think this topic would be better suited to a large-screen experience or a small-screen experience, and why? Which approach to iCinema described in this chapter do you think would be most appropriate for your premise, or do you feel that you would need to work out an original interactive approach of your own?
2. Pick a subject that you think lends itself well to a documentary work for iCinema. How would you take advantage of the interactivity that digital media provides?
3. Sketch out an idea for an interactive movie that involves a large-screen and small-screen configuration, as with the Immersive Studios model, and work out one sample idea that offers multi-user interactivity. What would be happening on the large screen, and what would participants be doing on the small screen?

4. If possible, watch a single-screen iTV show. Analyze the experience, noting whether the interactivity detracted from the plot or whether it made you feel more involved with it. What aspects of the interactivity, if any, did you think worked particularly well? What aspects did you think were less than successful? What changes would you suggest making?
5. If you can access a second-screen iTV show, analyze the experience, as with number 4, above.
6. Record a non-fiction TV show, such as a cooking show, a news analysis show, or a documentary or a children's show, so you can study it. What kinds of interactive enhancements could be added to it, either as a second-screen or single screen experience?
7. Record a TV drama with a strong narrative line. Once you have studied it closely, work out some ways to add interactive enhancements to it.
8. Sketch out an idea of an original interactive TV show, either a single program or a series, in which the interactivity is integrated into the concept. What would the objective of these interactive elements be and how would they work with the linear content?

Chapter 15
Smart Toys and Life-Like Robots

What could smart toys and life-like robots possibly have in common with other types of digital entertainment?
When you are dealing with life-like physical characters, what special challenges do you face?
What are some of the jobs "working robots" are now doing?
What are some of the personalities robots are known to have?

Venturing into the Metaphysical

The area of smart toys and life-like robots is an immensely intriguing sector of digital entertainment. It not only involves storytelling skills but also bends one's mind in ways one might never believe possible. I have worked on several smart-toy projects myself and can personally attest to the fact that they are uniquely challenging. The work done in this arena alternates between fascinating and frustrating, but is never humdrum.

Not surprisingly, one finds oneself dealing with a host of creative and technical issues. But in addition, because these objects blur the lines between what is alive and what is mechanical, you

must also grapple with perplexing questions touching on psychology, human development, ethics, and even metaphysics. At one point or another, if you work in this area long enough, you will find yourself asking such questions as: "What is intelligence?" or "What is the dividing line between a living creature and a human-made creation?" You might also find yourself pondering this one: "Is it unethical to create a life-like object that can elicit deep emotions from a human?" Or this one: "Is it irresponsible to create objects that blur reality and make-believe to the point where it is difficult to tell them apart?"

> **WORTH NOTING: EXPLORING THE HUMAN–NON-HUMAN CONNECTION**
>
> MIT professor Sherry Turkle has spent years investigating the relationships between virtual pets and smart dolls and their human owners. In an article for UNESCO's magazine, *Courier* (September 2000), she said "when we are asked to care for an object, when this cared-for object thrives and offers us its attention and concern, we experience it as intelligent, but more important, we feel a connection to it. The old AI debates were about the technical abilities of machines. The new ones will be about the emotional vulnerabilities of people."

In 2015, for Santa Fe's annual Currents New Media show, artist Michael Schippling created an installation of two little robots in a cage. They we were up for adoption. The installation was amusing, yes, but also raised a serious question of the humane treatment of robots, and what is our responsibility, as humans, to these human-created "slaves"?

In 2018, reporter Allison P. Davis wrote an article for *New York* magazine, "Are We Ready for Robot Sex?" She visited a company called Abyss Creations and met Henry, a prototype of a male sex-bot created at this business, which also makes female sex robots that have already been preordered by 50 customers, selling at $12,000 apiece. If we build robots for the purpose of sex, Davis wonders, does it require "defining what we want in a partner (assuming that we know) and asking how much we expect out of sex with our fellow humans?" In other words, it goes to the heart

of what kinds of intimate relationships we want with our fellow humans, as well as with robotic companions.

It is unlikely that any other sector of interactive entertainment raises as many profound questions that go to the heart of our identity as humans and as creators.

Smart Toys and Life-Like Robots: What Do They Have in Common?

This chapter focuses on the types of smart toys and robots that either have some of the attributes of fictional characters or that can be incorporated into interactive stories. These creations actually span work that is going on in a number of different fields, but we are combining them into a single chapter because of the characteristics they have in common. They are:

- Life-like
- Interactive
- Physical, as opposed to virtual
- Operated by computer technology
- Endowed with enough personality to enable them to become part of a storytelling experience

In addition, working with any of these creations involves answering a similar set of questions. How do you use physical, life-like creations in a narrative framework? How do you advance the plot of such a story? How do you involve the user in it? How do you give personality to an artificial character? How do you communicate with a physical, life-like artificial character?

Smart toys and robots, are, of course, usually designed for quite different uses—one for play, the other for pragmatic purposes, although the dividing line is not a rigid one. Smart toys are an enormous sector of the toy market. They include any kind of plaything with a built-in microprocessing chip and a degree of artificial intelligence. The microprocessing chips operate like tiny computers; they are programmable and hold the instructions and memory of the toy, controlling what they do. Smart toys can include educational playthings that are the equivalent of electronic flash cards. They can also be musical games, touch-sensitive

picture books, or child-friendly computers designed for the toddler set (so-called "lapware"). For our purposes, though, we are going to focus on three-dimensional toys that represent living things—humans or animals or fantasy creatures—or playsets that tell a story.

Like smart toys, robots are an enormous category. A robot is generally defined as a device that operates either by remote control or on its own, and relates in some way to its surroundings. Some robots are designed to be playthings for children or adults and are actually a type of smart toy, and others are built to be part of entertainment or educational experiences. Some robots are also used in the medical field. For example, Keepon is a bright-yellow squishy robot that looks like two tennis balls on top of each other. It is employed to help children with autism learn to interact. Many robots are specifically built for highly pragmatic functions. In fact, the word "robot" is a variation of the Czech word, *robota*, which means slave-like labor or drudgery.

Robots can be programmed to work in factories, in the military, and in outer space. Specialized robots perform hazardous duties like defusing bombs and miniature robots perform various functions inside the human body. Many of these "employed" robots do not resemble in any way what we commonly think of as a robot—an anthropomorphic mechanical creature with arms and legs, capable of movement and sometimes of speech. However, two members of the robot family, androids and animatronic characters, can look, move, and make sounds like living beings and respond to humans in a life-like way. These robots have particular relevance to digital storytelling.

A Long History

Although computerized versions of living beings are a relatively new phenomenon, people throughout history have been beguiled by the idea of a nonliving creature coming to life. Myths, legends, and works of literature and popular entertainment are filled with such tales. One of the best-known Greek myths, that of Pygmalion and Galatea, is about a sculptor whose carving of a beautiful woman comes to life. The story inspired the musical

comedy, *My Fair Lady*, as well as the work of interactive fiction, *Galatea*, described in Chapter 3.

In medieval times, Jews told a story about the Golem, a mystically created monster made out of clay who was called upon to protect the Jewish community from attackers. Children have their beloved story of Pinocchio, of course, about the puppet who longs to be a real boy. Science fiction writer Brian Aldiss wrote a short story, "Supertoys Last All Summer," based on a similar theme, about a robotic boy who longs to become human. Steven Spielberg turned the story into the movie *AI*. If you saw it, you might remember that the little robotic boy in the film has a smart toy of his own, a wise and endearing teddy bear. *AI* was, in turn, the springboard for the ARG, *The Beast*, described in Chapter 2, which is all about robots intermingling with humans.

But robotic characters from history did not merely exist in works of the imagination. Almost as long as we have told tales about such beings, we have also tried to construct them. Over 2,000 years ago, for example, a brilliant Greek engineer named Hero of Alexandria was famous for inventing a number of astounding *automata*—self-operating mechanical figures that could move, and, in some cases, make life-like sounds. Among his works were singing birds; a satyr pouring wine; and a scene depicting Hercules shooting an arrow into a dragon, which hisses. The demanding craft of constructing automata was taken up by Arabians and then revived in Europe in the Middle Ages, leading to wondrous clocks that featured parades of mechanical characters when the hours were struck. One craftsman even invented a duck that could supposedly eat, digest food, and eliminate the waste. Many of the most illustrious scientists of the day worked on automata, leading to some important breakthroughs in science and engineering. In 2017, London's Science Museum held an exhibit of *automata*, which included such wondrous sights as a beautiful silver swan built in 1772. The swan dibs its head into the flowing water and plucks out a tiny silver fish. It has 2,000 moving parts and is controlled by three clocks. A video of it can be viewed on YouTube: https://www.youtube.com/watch?v=YM8uCsd_N0s.

The tradition continued into the nineteenth century, with no less an inventor than Thomas Edison applying his genius to the

construction of life-like animated figures. Edison successfully created a talking doll, patented in 1878, which caused a sensation. It used a miniaturized version of another of his inventions, the phonograph record. Recordings embedded in these dolls have been carefully extracted and one can hear what they said on the website of The Thomas Edison National Historic Park in New Jersey: www.nps.gov/edis/learn/photosmultimedia/hear-edison-talking-doll-sound-recordings.htm

Today's Smart Toys

Beginning in 1985, the first true smart toys entered the world, led by Teddy Ruxpin, a singing, storytelling teddy bear, followed in 1996 by the enormously popular Tamagotchi virtual pets. Children had to take good care of these digital companion animals because if they were not fed or were otherwise neglected, they could die. When this happened, their young owners would be heartbroken. Fortunately, the departed pets could be honored and remembered at special Tamagotchi cemeteries which not only exist on the Internet but also in real-world locations. The attachment the bereaved children felt for their Tamagotchi pets illustrates the deep bonds humans can form with virtual beings.

Each new generation of smart toys has been increasingly sophisticated. Many of the smart toys available now have various types of sensors that enable them to "perceive" things like sound, touch, or changes in position or light. Sensors can also enable them to "recognize" objects—pretend food, an article of clothing, or a play piece like a sword or magic wand. They may also have sensors that enable them to recognize and interact with fellow toys. A number of smart toys also "talk"; some even have voice recognition and can carry on a simple conversation. They may also have individualized emotional responses and in turn may be designed to elicit emotions from their owners. Smart toys may develop intellectually and physically over time like a real puppy or human child. Some even have built-in calendars and can wish their owners happy birthday or Merry Christmas on the appropriate days. It is no wonder that a toy that possesses many of these traits is called smart.

Smart toys utilize some of the most advanced technology of any of the interactive platforms. Thus, breakthroughs in smart toys can potentially lead to breakthroughs in other areas, just as the work done on automata in the Middle Ages led to advances in science and engineering. Furthermore, designers of smart playsets deal with many of the same spatial, structural, and architectural issues as designers of video games and interactive cinema, potentially leading to a cross-fertilization of works in these areas.

The latest toys do things that were pretty much unthinkable back when children only had wooden blocks and Mr. Potato Head to play with. For instance, a new model of Barbie, *Hello Barbie*, can now carry on a conversation with its child owner. Appealing though she was to most little children, it was a function that greatly alarmed some parents, fearing it made their children vulnerable to a breach of privacy, since these conversations were recorded and stored.

The latest Furby (a fantasy stuffed animal originally introduced in 1998), the Furby Boom, can learn language over time and can sing songs with other Furbys. By pulling its tail, it will fall asleep and snore softly. And this new Furby also interacts with the iPad. Via a special app, you can give your Furby showers, though you must change the temperature of the water, depending on how hot or cold your Furby likes it. You can also feed it smoothies (and each Furby has its own preferences in terms of the combinations of fruits it prefers), and even help it hatch an egg, which is a baby Furbling.

Another talking interactive toy is *Ricky the Trick Lovin' Pup*, part of the FurReal Pets line. He's a cuddly-looking furry dog who does tricks, sings, eats treats, and even poops them out. He pants just like a real dog and will lick you on the nose. He knows 100 sounds.

Many smart toys now connect to the Internet or to game consoles. By purchasing a plastic toy or stuffed animal doll and using the secret code that comes with it, or placing it on a special *reader pad*, or putting it near a smart phone, where it is read by NFC (Near Field Communication), the user is transported to a game or a virtual world where their toy or animal comes to life. *Webkinz*,

introduced in 2005, operates this way with fluffy stuffed animals, while *Skylanders*, launched in 2011, operates this way with little plastic figurines. *Starlink Battle for Atlas*, introduced in 2018, is a toy set that includes set of collectible figurines and a snap-together starship. Once assembled and plugged in the game console, the starship and its warriors come to life on the screen.

In 2013, Disney entered this field with an enormously ambitious game called *Disney Infinity*, The game's plastic figures are all models of characters from popular Disney and Pixar films, including Sully and Mike from *Monster Inc.*, Lightning McQueen from *Cars*, and Jack Sparrow from *Pirates of the Caribbean*. Each starter pack comes with three toys and a reader pad, and new characters will be introduced on an ongoing basis. Users can choose either to play mission-based games in the world of the character or enjoy free-form play in a virtual world where any of these characters can interact with any other. In other words, in free-form play, you might have Jack Sparrow fighting a duel with Lightning McQueen, or set up a horseback race with Jack Sparrow racing against Woody from *Toy Story*. You'll be able to choose your own backgrounds and props. *Disney Infinity* plays on major game consoles, including the Microsoft Xbox, Sony PlayStation3, and Nintendo Wii U.

The Challenges of Creating a Smart Toy

To illustrate some of the challenges one is faced with in designing a new smart toy, let's look at a project I was called in to work on, an interactive dollhouse populated by a family of four tiny dolls. I was part of the development team assembled by a subcontractor to the large toy company that would be manufacturing it. At the time we were brought in, the toy manufacturer had already done considerable groundwork in terms of the architecture of the house and had also determined that its residents would be a mother, father, and two girls. It had also been determined that by moving the dolls to different sensors, users would elicit different responses. Our job would be to work out what happened when a child actually played with the dollhouse—the nature of the interactivity and how the

dollhouse could "tell" stories. Among the questions we had to ask ourselves (and which we eventually managed to answer, after much brainstorming and hair tugging) were:

- What kinds of stories could you tell in a little physical world, especially when you did not know when a particular character would be present or what room they would be in?
- How could we control the action or flow of a story in this environment? What would trigger the advancement of the storyline? What kind of structure could work here?
- What genres of stories could work in an environment like this? Was the dollhouse best suited to realistic narratives, to fantasy, or to mystery? What about humor?
- What kinds of controls could we give the child over the experience? Could we let the child determine the time of day, what the weather was, or the season? If so, how would these choices determine the narrative experiences?
- How much personality could we give to the residents of the house and how would they relate to each other? Would they break the fourth wall and address us directly, or would they be oblivious of our presence?

The Process of Developing a Smart Toy

Smart toys reflect the increasingly computerized world around us. Electronics have become so cheap and pervasive that even toys for infants light up and sparkle. Microchips are coming down in price and size, while increasing in power, so they can be inserted into more things and given more to do. Despite the opportunities presented by technological advances, however, it is not easy for a new toy to become successful. Thousands of new toys are introduced each year, and they have to compete for limited shelf space and also capture the fancy of the consumer. Before a toy ever reaches the stores, it has to be invented, developed, manufactured, and marketed, and each step is filled with challenges.

The Toy Inventor's Perspective

How does someone go about creating a smart toy that has a chance of becoming a winner? Let's hear what Judy Shackelford, a prominent toy inventor, has to say about the process. Shackelford's creations include the landmark doll, Amazing Amy, plus many other groundbreaking toys. Before launching her own company, J. Shackelford and Associates, she had a 10-year stint at Mattel Toys, rising to the position of executive vice president of marketing and product development worldwide.

The main challenge in inventing a new toy, Shackelford told me, is to find the point of differentiation—to come up with something that hasn't been done before; something that makes it unlike other toys. This point of differentiation can be a look, a mechanism, or any number of other things. "People like me figure out new applications for interactive toys, often by incorporating technology used in computers or other electronics," she explained. "I invent something when there was nothing there before. I conceptualize it and then I hire the appropriate people to work on it on a for-hire basis to help get it born. In a sense, I'm the producer of the toy."

Shackelford describes the process as being highly collaborative, calling for an assortment of experts in various fields, from people who specialize in doll hair design to sculptors to various kinds of technicians. She said an array of factors must be considered when inventing a toy. One of the most important is its play pattern—what you want to happen between the child and the toy. You also need to consider how it will appeal to the prospective purchaser (usually a parent or grandparent) and what its competition will be. In designing a toy, Shackelford cautioned, you have to avoid the temptation to throw everything into it that the toy could possibly do. "That would make it far too expensive," she pointed out. "You can't make a toy the dumping ground for every new technology." Altogether, she said, it takes "an unbelievably complex blend of things to successfully bring a toy to market."

One of Shackelford's most recent inventions was a doll called Baby Bright Eyes, which was manufactured by Playmates Toys. In this case, her starting point was a new technology, a miniature motor developed by a company called Nano-Muscle. She realized that this tiny motor could be used to give a doll extremely realistic

FIGURE 15.1 Baby Bright Eyes utilizes nanotechnology for realistic eye movement. Image courtesy of Playmates Toys.

eye movements. Out of this idea Baby Bright Eyes was born, a doll who is about 18 months old, with large expressive eyes and a sweet face (see Figure 15.1). Her eyes, Shackelford said, convey the doll's feelings and give her the semblance of artificial intelligence. Though Baby Bright Eyes has the limited vocabulary of an 18-month-old child, what she does say and do is synchronized with her eye movements.

Like the Amazing Amy doll, she contains special sensors that enable her to "recognize" objects. She knows when you put a bottle in her mouth or a teddy bear in her hand ... and she'll look at these objects when you give them to her. She conveys shyness by partially closing her eyes and shows surprise by opening her eyes wide. The toy illustrates that technology and design can be used to give personality to a doll.

NOTES FROM THE FIELD: TOO SPOOKY?

New technologies, such as the miniature motor used in Baby Bright Eyes, are giving dolls the ever-increasing ability to model living creatures. I asked Shackelford if dolls could possibly become too realistic, even to the point of being scary, as some people allege? Shackelford insists this is not the case. "I think the kinds of interactive properties we design in dolls are gentle and natural. They're not scary," she asserted. "An adult may look

> at a life-like doll and say: 'Oh, that's spooky.' but it's not spooky to kids. It's just real." Referring to the graphic violence in many video games, she added: "Now, that's what I think is spooky!"

A Toy Manufacturer's Perspective

An inventor like Shackelford must try to anticipate what toy manufacturers will find attractive. And what, in general, do they look for? To find out, I talked with Lori Farbanish, vice president of girls' marketing for Playmates Toys, a leader in interactive dolls. According to Farbanish, for a smart doll to succeed, it must possess an elusive quality she termed "magical"—the quality to excite the child and capture her imagination. This is one of the biggest challenges of toy design, she told me, trying to "bring magic to a toy in a totally different way."

Playmates gives great consideration to how a child will most likely play with the toy and what type of play pattern it fits into, and looks for ways for the smart features to enhance the anticipated play experience. Doll babies like Baby Bright Eyes typically elicit nurturing play, with the little girl taking care of the doll much as a mother does a baby. Nurturing activities include amusing the baby with a plaything, giving it a bottle, and putting it to bed. A child can do all of these things with Baby Bright Eyes and receive a response back from the toy, both with her eye movements and her baby-like vocabulary.

A second type of play Farbanish mentioned was *fiddle play*. It's the kind of activity that keeps little fingers busy, doing things like pulling open little drawers or rolling tiny supermarket carts or opening and closing doors. Opportunities for fiddle play are built into many interactive playsets. In working out how a smart toy will be played with, Playmates makes sure it offers not only interactive features but also opportunities for traditional imaginative play, things like combing the doll's hair, dressing it up, or inventing little scenarios for it.

In a third type of play, the child relates to the doll as a friend or companion. Sometimes this companion doll is regarded as an aspirational figure—someone the child looks up to and hopes to

be like. This is the type of relationship Playmates Toys wanted to build into their Belle doll when they adapted the character from Disney's movie, *The Beauty and the Beast*. The challenge here was to find a way for the doll to come to life and tell you about her romance with the Beast, but to do so without it being a passive experience, with the doll telling the story and the child just sitting there listening. The solution that Playmates Toys came up with was to give the child an opportunity to participate in Belle's story via "costume changes" and an array of talking props (see Figure 15.2).

The adventure story the child shares with Belle is broken into two parts, roughly following the plot of the movie. Part one is devoted to the exploration of the castle and meeting some of its inhabitants. Part two, which is triggered when the child removes Belle's workaday pinafore and changes her into her beautiful party gown, takes place at the ball and climaxes when Belle dances with the Beast. The story is conveyed primarily through sound—by dialogue, music, and lively sound effects. As Farbanish puts it, "your imagination is the set."

FIGURE 15.2 Little girls share in Belle's adventure by exploring the enchanted castle with her and attending the ball. The costume change is to the right, and the props in the foreground. Image courtesy of Playmates Toys. Belle © Disney Enterprises, Inc. Used by permission from Disney.

In addition to the change in costume, the story is advanced by inserting the different props into Belle's hand. Some of the props even speak in their character voices from the movie. Among them are Mrs. Potts, the chatty, motherly teapot, and Lumiere, the candelabra, who speaks with a French accent. In many of these little scenes, the characters acknowledge the child's presence as Belle's friend, as if she were standing there right beside Belle. These encounters help personalize the story for the child.

Thus, Belle is a companion doll who is also aspirational. She includes the child in an exciting adventure, and the doll's smart features make the experience interactive and advance the story. Most important of all, the child has a meaningful role: she helps Belle explore the castle; gets her ready for the ball; and prepares her for her encounter with the Beast.

The Toy Developer's Perspective

Toy manufacturers like Playmates often collaborate closely with outside development companies when they are bringing out a new toy, and much of the actual work of creating a toy's personality and "intelligence" may be done by these specialists. One such company is Pangea Corp., which developed Belle, among many other smart toys. Two of the company's principals, John Schulte and John C. Besmehn, who use the titles "Big Dog" and "Little Dog," respectively, talked to me about their company's role in bringing dolls to life, and jointly shared their observations of smart toys in general.

Schulte and Besmehn believe today's children are far more excited about playthings that offer a multisensory experience than they are about static toys, and will no longer settle for "inert chunks of plastic." But they also feel that if a toy is too smart, it becomes too limiting. Children, they say, become disenchanted when a doll is overly bossy, narrowly restricting their experience by demanding that they "do this; do this; do this." They believe that the best smart toys serve as a stimulus, kindling the child's own sense of imaginative play, and that's the approach they take with the dolls they develop. There's a lot to be said, John Schulte told me, about technology

Being used cleverly to open doors to parts of a girl's imagination she would otherwise ignore with a 'dumb' doll. That's why we try to imagine open-ended play patterns; we conjure up creative situations and scenarios that will evoke emotional responses, but allow for the girl herself to travel pathways of logic or illogic in a more open manner. We create the frame and provide the canvas. It's up to the girl to paint the picture as she sees it and feels it.

In working with a manufacturer on a new toy, Pangea comes aboard the project at an early concept stage and stays involved until the chips are burned. The development process starts by fleshing out each character and its world, looking for ways to harness the technology so that it will bring the character to life—by how it speaks or moves or reacts to a play piece. Biographies are written for each character, sometimes done as autobiographies, as if written by the dolls themselves. If they are developing a multi-toy line, they also consider the other characters in the line, looking for balance and variety. Everything, they say, always leads back to the essence of the toy: what is the play pattern and what will the child's experience of it be? These are the concepts upon which the toy is built.

Once they've gotten the basics nailed down, they begin to map out the interactivity, working out the variables and laying down the protocols for the most likely and least likely choices the child will make. All of this is written out in a document that goes by various names in the toy business: a logic flow chart, a logic script, a matrix, or a flow chart. Once the interactivity is worked out, a branching if/then script is written for the experience, much as it would be for any other interactive narrative.

One of the biggest challenges, they say, is writing the dialogue, because storage is at such a premium on the chips, and it competes for room with programming code, sound effects, and music. The chips for Belle, for example, could contain a maximum of eight minutes of sound. To get the most mileage possible from the available storage, they make use of *concatenation*, a technique of efficiently reusing words and phrases. Common words, phrases, and sound effects are stored in a "sound data bank" and pulled out whenever needed. For example, it may store words for all

the common colors, and if an NPC talks at one point about her friend's blue eyes and at another point about her new blue dress, the same word, "blue," would be used both times.

Once the script is complete, they do a table reading and time it all out before giving it to the actors to record. For a toy like Belle, which was based on a hit movie, the stars of the film do the voices. For example, Angela Lansbury, who played Mrs. Potts in the film, does the voice of Mrs. Potts for the toy. However, they said, it can be a major adjustment for actors to work within the time constraints of a toy script, which may give them just 3.2 seconds per line to express their character's personality.

Interestingly, Schulte and Besmehn consider the development process for a smart doll to be very much like a video game, requiring many of the same considerations in terms of characters, interactivity, and script writing. The goal is to make the play experience as nonrestrictive as possible, letting the child feel in control, while inconspicuously channeling her toward an end goal.

Of course, smart toys need not resemble human beings, as we have seen with the Furby Boom. One group of hot toys that has been immensely popular is the collection of hamster-like creatures produced by Zhu Zhu Pets. Unlike living hamsters, these stuffed animals don't make messes and don't smell and don't hide in places that are out of reach, all of which have been strong selling points to the parents. Children love these cute stuffed beings because they can make 40 different sounds, race through tunnels, slide down chutes, and even act unpredictably. Sometimes they get stuck and need their human's help, just like real hamsters.

In recent years, holiday catalogues offering expensive merchandise have been featuring smart toys that resemble everything from adorable baby dinosaurs, each with its own personality, to insect-like creatures with unquenchable curiosity. These new smart toys all have their own set of characteristics and all of them are capable of some form of interaction with their human playmates.

Robots for Kids

Many of the smart toys that children enjoy are actually robots, disguised to look like doll babies or cute little puppies. But in

some cases, the robotic nature of a toy is front and center and an important part of the play. In addition, in some cases the children themselves can program them. For example, a group of cute-looking robots created by Wonder Workshop are designed to be programmed by children ages six and up. The robots' names are Dot, Dash, and Cue and they have simple round body parts as a base and one rounded shape on top as a "head." The head has one large eye in the center (see Figure 15.3).

Considerable user testing and research was invested in the design of these robots. Vikas Gupta, the co-founder and CEO of Wonder Workshop, told me they were designed to look unlike anything on the planet, so children can bring their own imaginations to play. With user testing and research, they found that some features reminded the users of objects they were already familiar with. For instance, when they had visible wheels the robots reminded them of cars and girls did not want to play with them. Thus, the wheels were hidden to make these characters less like a car and more like robots. In addition, Wonder Workshop spent considerable time considering what colors to make the robots, wanting them to be approachable for kids from all backgrounds. Almost as many girls as boys play with Dot, Dash, and Cue.

According to the Wonder Workshop mission statement: "We aim to spark creativity with kids of all ages to inspire them to learn critical coding skills while having fun. Our robots put

FIGURE 15.3 Dot, Dash, and Cue, the three programmable robots from Wonder Workshop. From left to right: Dash, Dot, and Cue. Image courtesy of Vikas Gupta and Wonder Workshop. Used by permission of Wonder Workshop.

the power of play into their hands so they can dream up new adventures while learning to code at every level." Launched in 2013 by a crowdfunding campaign and headed by Vikas Gupta, the programmable robots have been a real success. They live not just in private homes and 43 countries but also in 20,000 schools.

Kids can enjoy all kinds of activities with their little robotic friends. They can navigate obstacle courses, play games, and enter challenging coding competions where teams from different schools compete against each other. In 2018, 7,900 teams comprised of 35,000 kids registered for the annual robotics competition. They came from 69 countries and 47 percent of the competitors were girls. The missions they sent their robots on had a narrative theme: they had to navigate their robots through the ocean, deal with currents, and rescue a mysterious sea creature. Once rescued, they had to maneuver the sea creature's babies to a safe place.

Accessory kits can be purchased for the robots. For example, Dot's creativity kit includes dress up costumes (a pirate hat, a set of octopus legs, a crown, orange arms), exercises you can do with it, and Dot can even be turned into an alarm bell or a tea pot. When you code Dot, you can have a conversation with it and make its robotic eye blink. Dash, for slightly older kids, is a far more sophisticated robot than its simple body suggests. It contains an accelerometer, a gyroscope, microphones and speakers, and it can communicate with other robots. On the playful side, kids can get a launcher for Dash and can code it to aim a ball at targets. Dash and Dot can even dance together.

Cue is for kids 11 and up and even for anyone wanting to get more seriously into coding, even adults. Its head can be customized in four different ways and each way has its own personality: Charge, for instance, is compassionate and brave, while Pep is enthusiastic and encouraging. They each have different voices, as well.

Dot, Dash, and Cue are excellent tools for helping children master STEM skills. They are so inviting to play with, and so gender neutral, that they attract kids from a wide variety of backgrounds.

Toy Robots: Not Just for Kids

As we noted earlier, robots are devices that operate either by remote control or on their own and respond in some way to their environment. Robots can closely resemble living creatures like humans, dogs, and other animals. In fact, dolls like Belle and Baby Bright Eyes described above are really robots, though they do not look like the robots we are familiar with from the movies, with jerky movements and hard metal bodies. A smart toy named Robosapien X, however, very much does resemble the stereotypical movie robot.

With his black and white body made of manufactured material, enormous arms, bowed legs, and glowing red eyes, one could never mistake Robosapien for a human. Yet he can actually "walk" on those two bowed legs, moving one leg in front of the other, just like a human, though an extremely ungainly one. Furthermore, he can execute 67 commands that are much like a verb set from a video game, including throw, kick, and pick up. Others, however, such as belch, are of a more earthy nature and are meant to give him "attitude." Surprisingly, Robosapien robots can be purchased for under $100 and are marketed as children's toys.

Not all robotic toys are meant to be children's playthings, however. In 1999, Sony introduced a sophisticated robotic "companion" dog named Aibo to the public. With a price tag of over $2,000, it was definitely not a kid's toy. These smart dogs could see (via a camera), hear, walk, obey commands, do tricks, and express canine-appropriate emotions. They loved being petted and were responsive to their masters; their personalities were shaped by how they were treated. A number of owners got together regularly with other owners for the equivalent of "play dates." Students at some universities have even programmed teams of Aibos to take part in soccer matches. Impressively, the dogs could play the game autonomously, on their own, without the use of remote controls. Their owners felt deeply attached to their little pets and it is hardly surprising, then, that they were devastated when Sony announced in 2006 that they were discontinuing production of Aibos in a cost-cutting move. They stopped servicing them, and the few Aibo repair shops could only keep the ailing dogs going by harvesting parts from other Aibos, who sacrificed their lives to keep their

brother and sister dogs functioning. Touching funerals were held in Japan for these "organ donors." The Buddhist ceremonies were respectful and moving: https://video.nationalgeographic.com/video/news/00000163-94b9-d8a8-a1fb-b4fb3a0c0000.

There is a happy ending to this story, however: Sony began to make new Aibos in 2018. These new Aibos are even more sophisticated than their predecessors, and more expensive, too, costing just a little under $3,000. If anything, they are even more adorable than earlier models of Aibos. They wag their tails, make dog-like sounds, respond to voice commands, and learn tricks. Each of these new robotic dogs develops a unique personality, which is formed in response to how it is raised and nurtured. These cute little pups can recognize as many as 100 people by "sniffing" them through its nose, which contains a camera. They have 4,000 individual parts and 22 moving joints. They also have something very close to a brain: It has a database of "memories" in the cloud. In November 2018, reporter Bridget Carey did a piece for CNET about living with a brand new Aibo for a week and both she and her two-year old daughter were charmed by it. This video clearly demonstrates its appeal: https://www.youtube.com/watch?v=-sobjkWJq3I.

Working Robots

Robots have jobs, just like humans, and tend to take on specialized tasks. For example, the "Super Monster Wolf" is a savage-looking robotic wolf that works in Japan to scare away wild boar, which regularly feasted on the rice and chestnut crops, resulting in hardship for farmers. These wolves were designed to scare off marauding boars. If one approaches, the wolf's scaring red eyes light up and flash and it howls menacingly, revealing a set of sharp fangs. It has a repertoire of howl sounds so the thieves don't become accustomed to it. Farmers have noticed significantly less crop losses in the fields where the wolves have been deployed.

The RoboFly is a member of a group of robotic insects that can fly without being connected to a wire, a major breakthrough in insect robot technology. Developed in 2018 by professors at the University of Washington, the team found a way to power RoboFly's flapping wings by using laser energy, which allowed

them to be untethered from the electronics usually used to power robotic flying insects. "This might be one small flap for a robot, but it's one giant leap for robot-kind," quipped the university's press release.

Though still in its early stages of development, robotic insects like Robofly could be used for tasks that are better suited for their small size than far larger drones. One professor feels they might be useful in finding leaking methane gas escaping from broken pipes.

Swarms of robotic insects are also being developed, based on real *eusocial insects* like bees, termites, and ants who collaborate to solve complex tasks. Swarming robotic insects could potentially be assigned to tasks too dangerous or difficult for humans, like clearing mines.

Boston Dynamics produces various forms of robots that are impressively athletic. These two-legged robots walk and run on two legs, like humans. In addition, they can hop onto tall packing boxes, jump over logs, do backflips, and jog for long distances. And, when not performing stunts, they can do useful things like pick up and stack heavy containers.

STRANGE BUT TRUE: A ROBOT FOR LAUNDRY DAY

Sorting and folding clean laundry has always been an unpopular chore, but engineers at Japan's Seven Dreamers have solved that problem with Laundroid, introduced at the Consumer Electronics Show (CES) in 2018. It turns out that robots have a difficult time handling soft materials like tee shirts and also find it challenging to sort socks, especially because dark navy-blue socks look so much like black socks. But Laundroid, after some training, is up to the task. It can sort clothes by color or by the family-member owners. Laundroids do not resemble cute robots like Aibo: these are hardworking robots, not pets. They have multiple arms and no heads or bodies, but do have high AI. They reside inside handsome cabinets that resemble high-end Italian furniture. They are being offered as luxury items and start at $16,000.

Unfortunately for those who hate folding laundry, the future of Laundroid is unclear. Its manufacturing company, Seven Dreamers, filed for bankruptcy in 2019.

A more serious type of robot, much closer to the robots found in works of science fiction, is Robonaut 2, created by NASA to be an assistant on space voyages. R2, as he is known, looks vaguely human, with a thick torso, shoulders, arms, head (in a helmet), and extremely dexterous fingers. However, at this point, he only exists from the torso up. He sits on a wheeled platform, though his developers say in the future he will have legs. His hands are particularly important, because they can perform more movements than the gloved hands of a human astronaut and thus can perform more tasks. R2 has already visited the Space Station and worked with the crew there.

R2 is not the only intelligent robot around. Simon is a humanoid robot that is being created by students at Georgia Tech. Simon's purpose is to demonstrate how robots can take part in social interactions with human beings and work alongside them. Simon can understand spoken sentences and reply, and makes gestures (nods, shrugs, and the like) that are quite human. And then there's DeeChee, a three-foot baby-like robot developed by researchers in England who is programmed to learn language just like a baby human does. DeeChee acquires a vocabulary of shapes and colors by interacting with human volunteers, who are instructed to talk with it like adults talk to babies.

> **STRANGE BUT TRUE: ROBOTIC FISH**
>
> Robofish are a school of bright-yellow fish, about five feet long, designed by researchers of the Shoal Consortium to check for pollution in harbors and other bodies of water. The fish propel themselves realistically by their tails rather than by propellers, thus reducing the chance of getting snagged in seaweed. They can see underwater, communicate with each other, and analyze the data they collect. Though they offer great potential to scientists and environmentalists, they are unlikely to become popular at fish fries!

Spiritual and Violent Robots

Just like humans, robots have a range of personalities and temperaments. Xian'er, for instance is a robotic Buddhist monk, created for a Buddhist temple near Beijing. The friendly-looking monk,

who is about knee-high to a human, was designed as a modern way to spread Buddhist teachings. He can chant Buddhist mantras and give wise answers to questions from the point of view of Buddhist philosophy. Essentially, he is a chatbot.

HitchBot was another peaceful robot who was developed to learn how people and technology interacted, and to answer the question: "Can robots trust humans?" He looked partially humanoid and partially mechanical and had arms and legs and a friendly, innocent face. He was equipped with GPS so researchers could track him, and a camera to take photos of his travels. He could not walk but he sat by the side of the road on a little chair, thumb out. He successfully hitchhiked around Canada, the Netherlands, and Germany but shortly after he started hitching in the United States, he came to a violent end, thus answering the question of whether robots can trust humans in the negative. He was dismembered, decapitated, and completely destroyed, much to the sorrow of his researchers and fans around the world. His murder left a black mark on Philadelphia, where he was murdered. After so many uneventful journeys, one now has to wonder what it was about a harmless robot that incited such horrific rage? Was it jealousy over its independence and popularity, or a fear of the nonhuman dominating our species? Or was it just brutal "fun"?

Shybot is another peace-loving robot, designed by artists for no particular mission. Shybot looked a little like the Mars Rover and wandered around the California desert, seeking solitude and avoiding people. Shortly after Shybot was set free in the desert, though, she disappeared, and her GPS was disabled. Fortunately, unlike HitchBot, she did not meet a violent end—no one knows exactly what went wrong, but it was found by an off-roader. She was a little banged up and her tires were shredded, but she was intact. Presumably, she was worn out from her adventures in the desert.

Robots like the Buddhist monk, Xian'er, HitchBot, and Shybot, are all mellow, but there's another case where a robot actually committed murder. The incident happened in 2015 in a car factory in Germany. A worker was installing an assembly-line robot when it grabbed him and shoved him against a metal plate, crushing his chest and killing him. This frightening incident illustrates that at least one robot has rebelled against its traditional role as

defined by the Czech word, *robota*, which means slave-like labor or drudgery. As robots are embedded with more AI, should we be concerned about them becoming vicious? Or should robots be more afraid of us? Though this first robot homicide sounds like a sci-fi story, it does raise legitimate concerns. People like Bill Gates and Elon Musk wonder if our technology is developing more quickly than our regulation of it

Animatronic Characters: Stars of the Stage and Screen

Animatronic characters are a particular type of robot that is made to look believably life-like. They are primarily found in motion pictures and theme parks and are also turning up frequently in museum installations. These specialized robots can resemble historic and contemporary figures, birds, bugs, sea creatures, and animals. Animatronic characters can move, talk, and sing, but the movements and sounds they make are preprogrammed or prerecorded. Essentially, they are mechanized puppets. The term Audio-Animatronic is a Walt Disney Engineering trademark and dates back to 1961.

Some of the first animatronic characters played important roles in movies (these include the giant squid in *20,000 Leagues Under the Sea* and the human-eating shark in *Jaws*). In Chapter 19, we describe a number of animatronic characters who play parts in theme parks, shows, and museum displays, including a giant grasshopper, a fierce pirate, and a soldier from the American Revolutionary War.

Androids: Too Much Like Us?

An android is a type of robot that is meant to look and act as much like a human being as possible, ideally to the point of passing as human. The world "android" comes from the Greek, meaning "resembling man." Unlike mechanized robots, androids are capable of responding to visual and vocal stimuli. Some androids are capable of voice recognition and can converse in a fairly believable way.

Androids are often used for training purposes in the military and in medical schools. For example, life-sized androids serve in the US

Army, where they simulate wounded patients and are used by medics in training to prepare them for field conditions. With realistic faces and the height and weight of adult men and women, they look extremely convincing. But what makes them even more compelling is the fact that their chests rise and fall with healthy or raspy wheezy sounds. In addition, they possess an artificial pulse; their eyes tear; and they bleed and expel mucus. And when the wounded soldiers are not given the proper medical treatment, they can die.

Far away from the battlefield, a pretty blond android named Noelle is being used for medical-school training. Like the android soldiers, she has a pulse and can breathe and bleed; she can also urinate. But what makes Noelle particularly interesting is that she is pregnant. She goes through labor and, if all goes well, she will give birth, even to twins. But, just as in real life, serious complications can develop and the medical students have to handle the crises well in order to keep Noelle and the baby or babies alive. Unlike real life, however, the complications are orchestrated by an instructor who controls Noelle via a laptop and, in a sense, serves as a dungeon master.

While the creation of the field of robotics used to be the domain of engineers and technology-minded scientists, a newer type of roboticist has become active in this arena. These scientists are particularly interested in robot–human interaction, and in creating robots that communicate in a life-like way, with nods, gestures, and eye contact, such as Simon, introduced above. Such androids, they believe, can eventually perform important services in taking care of the elderly, the disabled, and other dependent individuals.

STRANGE BUT TRUE: THE "UNCANNY VALLEY"

Roboticists are striving to make their creations seem as human as possible, but they have discovered that too much realism can have an unwanted negative effect. Known as the uncanny valley," a term coined by Japanese roboticist Masahiro Mori, it seems that when a robot resembles a human too closely, people will find it too eerie and reject it. Thus, roboticists walk a thin line between making their androids convincingly human, but not *too* human. Creators of hyper-realistic characters in games and narrative experiences face this dilemma, as well.

One of the most realistic androids ever designed is a Japanese creation called Repliee Q1, developed by Professor Hiroshi Ishiguro of Osaka University. The slender, dark-haired, extremely feminine android caused a sensation when she appeared at the 2005 World Expo and even appeared on CNN and other TV news outlets. Called Q1 for short, she can converse in a believable fashion and gestures much like a real person. To contribute to her realism, she is programmed with 42 points of articulation in her upper body; she "breathes" with the aid of an air compressor; and her skin is made of soft, pliant silicone. And if Q1 receives too much annoying attention from a male admirer, she will react just like a real woman might, swatting him away with her hand.

In 2016, a *humanoid robot* named Sophia made her debut. She was created at Hanson Robotics in Hong Kong and was an instant hit, being interviewed on talk shows and at conferences. She is quite pretty, being modelled in part on the late actress, Audrey Hepburn. She has freckles and somewhat bushy eyebrows, and unlike an actress of recent memory, her skull is transparent, so you can view her inner workings.

Sophia's creators call her a *social robot*, designed to work harmoniously with humans. Thanks to AI, she can make 60 different facial expressions and she can talk, often articulately though sometimes awkwardly. At times, she responds after a long hesitation and her answers don't always match the questions. Her developers are working on improving her conversational skills and plan to make her sound more believable and less predictable, giving her the capability of emergent behavior. Notably, Saudi Arabia granted her citizenship, making her the first robot in history to officially become a citizen of a nation. You can watch her being interviewed in 2017 by CNBC's Andrew Ross Sorkin: https://www.youtube.com/watch?v=S5t6K9iwcdw

At present, Sophia, Q1 and Noelle, despite their celebrity, have not become involved in any works of digital storytelling. But it is interesting to speculate they might be used in the future, playing life-like roles in productions that blend reality and fantasy in entirely new ways. Certainly, compelling scenarios could be built around their capabilities.

Designing Robots to Be Likable, Not Creepy

What makes a robot like HitchBot appealing to us, and when does a robot trigger the uncanny valley, as with Q1 and Sophia? Writer Tara Hunt March, in a 2019 article for Futurithmic, pondered that question when the loveable robot Jibo announced it would cease functioning. Many of his owners had connected deeply with this charming little social robot and responded emotionally to the news. Here are some of the points the writer made about likeable robots:

- They have anthropomorphic features, making them resemble living humans.
- They possess neoteny, in other words, child-like characteristics. This makes humans empathetic and feel protective of them. They do not seem threatening.
- They are not overly realistic, which would make them trigger the uncanny valley, and would lead us to distrust and feel threatened by them.
- They are polite or shy, which are unexpected traits in robots, making them seem interesting, not annoying.
- They possess functionality. By doing useful things for us we do not get bored with them.
- We trust them to live in our homes and learn personal things about us; we are confident they will not betray us.

ADDITIONAL RESOURCES

To learn more about smart toys and robots, the following resources may be helpful:

- *Children's Technology Review,* http://www.childrens-software.com/, an electronic magazine and also a website, carries articles and reviews of smart toys, with a focus on their educational value.
- Timetoplaymag (https://ttpm.com/) has news and reviews of all types of toys, even ones for pets.
- *Robotics Trends,* an online publication about robots: https://www.roboticsbusinessreview.com/category/service.

Conclusion

As we've seen with the Belle doll from *Beauty and the Beast*, smart toys can be given personalities and support interactive narratives. And as we've seen with Noelle, the pregnant android, robots can be the center of life-like dramas. In addition, theme parks and museums are finding innovative ways to employ animatronic characters. The work being done in smart toys and robotics can contribute concepts and technology to new kinds of digital storytelling experiences.

The challenges of creating compelling interactive narratives with physical, life-like characters can be daunting, as this chapter has illustrated. Yet Lori Farbanish of Playmates Toys has a valuable piece of advice for creating smart toys that can be applied in general to all of these characters. "Sometimes," she says, "we think too much like adults. Sometimes you just have to dump all the pieces on the floor and play."

Idea-Generating Exercises

1. Select an existing smart toy—one that has narrative features or a developed personality—and spend some time playing with it. Analyze what is compelling about the toy and where it may fall short. Do you think it could be improved, and if so, how? Can you see a way to use it as a model for another toy? How like or unlike do you think this toy is to other forms of interactive entertainment, such as a video game or VR installation?
2. Come up with an idea for a smart toy. What would it look like? What would it do? How would in interact with the user?
3. Describe an android or an animatronic character that you have seen at a theme park, museum, or elsewhere. What about the character made it life-like? What about it did not seem "real"? Did anything about it convey the sense of an uncanny valley?
4. Sketch out an idea for a story that would include at least one interactive talking robot. How would it be part of an overall narrative experience? How would it communicate its personality? Would it require props, and if so, what kind?

Part 5
Immersive Media

Chapter 16

What Are Immersive Media?

What is meant by an "immersive experience?"
What are the different types of immersive media?
Is Hollywood interested in this arena or ignoring it?

Science Fiction Territory

In real life, it is highly unlikely you'd get to go on a dangerous military reconnaissance mission behind enemy lines without risk of injury or death. And unless you had supernatural powers, you couldn't expect to hear the voices of the departed when you visited a graveyard. And much as it might interest you, could you ever meet a digital character and interact with her in the real world? And you'd certainly have to have a pretty powerful imagination to see yourself going on a guided tour of the ocean given by a friendly dolphin. But thanks to various forms of immersive media, you can experience all of these scenarios, and in a way that is convincingly life-like.

When we move into the world of immersive media, we are entering serious science fiction territory—but science fiction that has become entertainment fact. A dramatic vision of this type of

experience, as portrayed by the media, was introduced to us in the pilot episode of *Star Trek: The Next Generation* TV series, with a device called the Holodeck. In this make-believe vision of VR, the crew of the starship Enterprise and its successor, Voyager, could entertain themselves in their off-hours by visiting the Holodeck and becoming actors in computer-generated dramas. These experiences were much like novels that had come to life, complete with props, sets, life-like characters, virtual food, tactile sensations, and scenarios capable of eliciting intense emotions. The Holodeck was such a compelling vision of the possibilities of marrying narrative to digital technology that Janet Murray even named her book on the future of storytelling after it, calling it *Hamlet on the Holodeck*.

To date, of course, nothing as convincing and detailed as the alternate reality of the *Star Trek* Holodeck has been achieved here on Planet Earth. However, the various forms of immersive media are coming ever closer to the *Star Trek* Holodeck. In a sense, these immersive media allow you to *live* a story, rather than only to see it or hear it.

Computer scientists and imaginative twenty-first–century storytellers, progressing in small increments, are developing immersive stories that we are able to slip into and that feel real to us. In doing so, they must struggle with the lack of established models, so must invent as they go along. As Bryan Bishop noted in a column for *The Verge* (July 20, 2018): "Unlike film and TV, which both have a framework of generally accepted conventions and tropes, most immersive work is still trying to figure out what audiences respond to." Nevertheless, innovators have managed to create some striking new works. Before we investigate what they've accomplished, and discuss the implications their work has for new types of narratives, let's first take a moment to pin down what we are talking about.

> **WORTH NOTING: THE STEREOSCOPE – AN EARLY FORM OF IMMERSION**
>
> Stereoscopic devices, invented early in the 1800s, gave a static scene (such as a drawing or a sketch) an illusion of a sense of depth and of three dimensions. They worked by having a slightly different view of the same scene for each eye. Wooden

stereoscopes can often be found in antique stores, along with the cardboard pictures to insert in them. In the mid-twentieth century, View Masters, which used the same stereoscopic technique, became a popular form of entertainment. They were promoted as a form of "virtual tourism" and as a toy. Unlike virtual reality, however, you were not inside the scene and unlike augmented reality, the images were not superimposed onto the real world. And you could not interact with the image. So the stereoscope was a limited form of immersion. However, at the time stereoscopic devices were a dazzling new way to see the world and they have paved the way for our current high-tech versions of this old idea.

Defining Immersive Environments

Immersive media can be roughly defined by what they are intended to do. The goal of a digitally created, or digitally enhanced, immersive environment is to give users a dramatic and seemingly real experience they could not otherwise have. They put the participants right "inside" or "up against" a digitally created world, hence the term *environment*. In other words, the participant is not just looking at something on a screen or monitor but is instead surrounded by the work and, in many cases, is interacting with it.

A number of these experiences fall into a category of works called *location-based entertainment* (LBE), which are entertainment experiences that take place outside the home. LBE includes various kinds of theme park attractions as well as multiplayer competitions like racing simulations and outer space combats. It also includes attractions set in museums and other cultural institutions, visitors' centers, and Las Vegas hotels.

Immersive environments encompass a very broad and diverse group of digital works, with at least eight different subgenres, and we will be examining each of them in Part 5 of the book. They include:

- Virtual reality (VR)
- Mixed reality
- Augmented reality (AR)
- XR (a general catch-all term referring to all the above realities, not a specific technology)

- Large-screen immersive experiences for audiences (also known as ridefilms and 4-D dark rides)
- Large-screen immersive experiences for single participants
- Immersive multiplayer motion-based games
- Immersive narratives
- Escape rooms
- Interactive theme park rides
- Fulldome productions

Immersive environments use a large palette of techniques to create their fantasy worlds and pull participants into them. Some, like virtual reality, require the user to wear heavy-duty hardware. Others utilize large curved screens. Still others employ animatronic characters. Often, immersive environments are *multi-sensory*, meaning they stimulate the senses in a number of ways. While traditional screen-based works like movies and television only employ the senses of seeing and hearing, immersive environments also may employ touch and smell and motion, making them uniquely powerful. Techniques for doing this may include variations in room temperature; special effects like snow and fog; various forms of tactile sensations such as vibrations and sprays of water; the movement of a seat or floor; and artificially produced smells.

Like other forms of digital storytelling, immersive environments contain narrative elements, like plots, characters, and dramatic situations. However, telling stories with this type of technology can be challenging, and, as with other forms of digital storytelling, the stories are usually non-linear. While many works of immersive environments are designed for pure entertainment, they are used for other purposes as well. These include teaching and training; psychotherapy; promotion; and the enhancement of information, particularly in cultural institutions.

The Promise of Immersive Storytelling

Until the last few years, most people outside the tech industries were unaware of VR, AR, MR, and the other forms of immersive environments. But recently, these forms of storytelling have

been attracting a significant amount of interest, particularly from gamers and from Hollywood. For example, in 2015 the sale of VR video games amounted to only $.66 billion worldwide, but is projected to leap dramatically by 2020, to $22.9 billion (from Statista.com). DMarket.com asserts that: "VR-fueled solutions will further energize the video games space."

> **WORTH NOTING: THE POWER OF IMMERSION**
>
> According to a blog post written by Dmitriy Shcherba for DMarket (July 20, 2018), the major attraction in VR and AR games is the power of immersion. He states: "One of the greatest AR/VR advantages for game fans is the ability to take players right to the heart of the game's storyline. Advanced tech-enabled gadgets and software solutions can immensely enhance user engagement with multiple interactive activities. Digitally extended reality provides gamers with enticing virtual objects and makes them treat these objects as if they are real." The enormous success of the AR game *Pokémon Go* illustrates how enticing immersion can be to gamers.

Hollywood is also succumbing to the allure of immersion, as demonstrated by its prominence at the Sundance Film Festival. Whereas Sundance used to be devoted to traditional films and filmmakers, it now offers a "New Frontier" program that showcases works that utilize advanced technology like AR, VR, and MR. The 2019 New Frontier program took place over ten days and at two locations and showcased cutting-edge immersive works. Shari Frilot, Chief Curator of New Frontier in 2019, said of it: "This year's New Frontier is an explosion of experimentation, bearing a motherload of innovative custom tech that take us higher" (*Indie Wire*, December 5, 2018). Developers who were not official entries in New Frontier also flocked to Park City to show off their projects.

But as with all highly innovative endeavors, some companies that did fine work in immersive media were forced to bow out. Being innovative can be risky, both financially and competitively. Sadly, Google Spotlight Stories, which created 16 cutting-edge

works of VR over a six-year period, closed down in 2019. And another VR leader, Oculus Story Studio, discontinued operations in 2017. However, some of its former members regrouped and opened Fable Studio, the company that developed the virtual character Lucy discussed in Chapter 5.

Conclusion

More than any other set of technologies, immersive environments give us the ability to create deeply dimensional narratives and simulations that put the user in the center of the action. These works can visualize abstract concepts and can seemingly make fantasies come to life in real physical spaces. Not only do they possess all the components of other engaging forms of digital entertainment—sound and moving images; interactivity; and computer-generated intelligent characters—they offer storytellers additional tools to use, as well. These include 3-D images, props and sets, animatronic characters, new types of spaces, and multi-sensory stimuli.

Yet, despite all the creative opportunities they offer, there are serious hurdles standing in the way of some of these forms becoming widely utilized by the creative community or enjoyed by the public. These include issues like the complexity and costs of the technologies involved, the fact that some of these forms can only be enjoyed by one individual at a time, and, in some cases, the lack of financial support for artistic productions. However, as the examples in Part 5 of this book will illustrate, immersive environments can offer unparalleled storytelling opportunities to individuals who have the vision and pioneering spirit to work in this arena.

Idea-Generating Exercises

1. Describe an immersive environment that you have personally visited. What about the experience made it seem believable to you? Was there anything about it that did not feel like "real life"? If you could improve anything about this particular immersive environment, without having to consider cost or technical impediments, what would it be?

2. Set your imagination free and sketch out an amazing immersive work—something that you personally would like to experience.
3. Do you think immersive technologies like AR or VR have a place in video games? Why or why not?

Chapter **17**

VR, AR, and Mixed Reality (XR)

What unique opportunities do these virtual worlds present to storytellers?

Aside from games and other forms of entertainment, how is XR being put to work?

How can the kinds of imaginary worlds offered by VR be useful in therapeutic situations that use narrative?

In what ways can you combine real-world objects with AR and VR images?

What are some of the special methods used to create the illusion of being "inside" a digitally created virtual world?

What are some of the greatest challenges of creating a story-based experience for immersive environments?

Welcome to the Outer Edges of Cyberspace

VR, AR, and MR (mixed reality) all share the same umbrella label: XR. For decades, XR remained a promising form of immersion but not a realized one. Most XR was confined to the research

divisions of academic, military, or industrial organizations, and we touched up this history in Chapter 2. Recently, however, we have seen major breakthroughs in this area. These advancements have invited the general public in and allowed them to try out various kinds of XR experiences. Thanks to the phenomenal success of the game *Pokémon Go*, which employs AR, and some noteworthy VR offerings in location-based entertainment centers, plus installations in major art museums, people have become aware of the advancements of XR and excited about the new kinds of experiences it offers. Artists, however, are just beginning to explore the narrative potential of this arena.

VR and AR 101

Jesse Schell, introduced in Chapter 11, has a simple and excellent way of differentiating between AR and VR. He says: "VR blacks out the world. AR paints over the world." Jesse is one of the most articulate people you could meet when it comes to games and immersive experiences. He is CEO of Schell Games, Distinguished Professor of Practice of Entertainment Technology at Carnegie Mellon, and author of *The Art of Game Design*. In a recent lecture at the Dust or Magic conference, referring to XR, he said: "These are things that have a magical quality," and then, quoting William Gibson, added: "The future is here, it just isn't evenly distributed yet." Yes, it is true the magic isn't evenly distributed yet, but it is now spreading at an accelerated rate.

A true VR environment is an extreme form of cyberspace, a 3-D artificial world generated by computers, and a world that seems believably real. With VR, you are completely immersed in a multi-dimensional space that screens all "real life" out. But there is an awkward side to VR: a VR world requires special hardware to be perceived. In one of its most common forms, visitors are outfitted with a helmet-like device with goggles and earphones called a *head-mounted display* (HMD). They may also don special gloves, which gives them the ability to perceive and manipulate the computer-generated representations. And in some instances, they wear both a HMD and a backpack of equipment in order to experience the VR world. In some instances, though, for example

when inside special type of VR, the *CAVE* (Cave Automatic Virtual Environment), they only need to wear lightweight stereoscopic glasses.

There are two basic ways of experiencing VR. One way is with *room scale VR*, where the user is free to move around a space. In entertainment centers, mobility like this is also called *free roam*. Everything the user sees is virtual—one's own hands and feet are not visible, nor is the carpet nor the ceiling fan: the illusion offered by VR is completely engulfing. However, the perspective of the virtual world is altered via a tracking system depending upon where the user is in the space. If you are walking towards a virtual cabinet, for instance, it will look larger as you grow closer to it. The other type of VR experience is *front-facing* or *stationary*, where you are sitting in a chair or standing in a fixed position, and use a joystick or other device to move objects around. Room scale VR offers a more immersive experience and more freedom for the user, but it has issues when used in a private home. It requires a dedicated room that is empty of furniture or other objects the user could bump into. A dedicated VR space like this would be an extreme luxury in most houses. And users must be careful not to trip over the VR cables, since it is impossible to see them while wearing a HMD. However, newer VR technology is moving toward reducing or eliminating some of these awkward problems. The Oculus Quest, for example, is wireless and no PC is required.

WHAT IS 360° VIDEO?

Another technology, closely related to VR, is 360° video. With 360° video, you can be immersed in a visual world and see all around you—to the left, to the right, or behind you. And you can look up and down. But VR lets you take the experience further. You can manipulate objects in VR and interact with your surroundings. For example, you can open a drawer or toss a rock or shoot a cannon. Even though they are different technologies, 360° video is often called VR. In this chapter, if developers of a work call it VR, we will accept their terminology, but we will also note if the work is 360° video.

VR used in a wide variety of entertainment experiences, some of which can be enjoyed at home while others are forms of LBE (location-based entertainment) offered at theme parks and other venues. Other VR experiences are offered at Film Festivals and conferences. However, VR need not be financially out of reach for most people. An inexpensive form of VR is available to anyone who wants to try it, through Google Cardboard. Google Cardboard is an ingenious alternative to expensive VR systems: just an assemble-it-yourself cardboard cutout with a pair of lenses. Once put together, you install a Google cardboard app into your smartphone and slip your phone into the cardboard headset. You are now ready to experience VR on the cheap!

VR is used in training, education, journalism, architecture, interior design, and science. It is also used in the medical field as a form of psychotherapy and as a distraction from pain. Some VR creations are designed just for observation purposes. They may be quite small, just of tabletop size. Such VR creations are chiefly constructed for scientific, engineering, or architectural purposes, not for entertainment.

But to make matters a bit more complicated, the term "virtual reality" is often applied indiscriminately to immersive experiences that have some, but not all, of the components of true VR. AR is not VR; as Jesse Schell noted, AR "paints over the world." AR images are superimposed on the real world, while VR blacks out the real world. Mixed reality combines real world objects with either AR or VR.

STRANGE BUT TRUE: SENIORS TRY VR

It is reasonable to assume that younger people, under 25, would be the biggest fans of XR, but that is not necessarily the case. In a recent video, *Elders React to Technology* (https://www.youtube.com/watch?v=uFsMYRsWglA), a group of seniors were presented with an HTC Vive headset. Most looked at it suspiciously, as if it were a dangerous object from an alien plant. Then they put on the headsets to experience VR for the first time, having no idea what to expect. They played three diverse VR offerings: a 3-D drawing program, Vive's robot repair shop demo, and a zombie shooting game. And they reacted with delight. "This is

absolutely staggering!" exclaimed one. "This is cool. I love it!" said another. And another summed up the experience by saying: "This is a lot of fun! It's not just for kids anymore!" Even the zombie game was greeted with enthusiasm, with the participants shooting at the zombies with gusto, shouting and laughing.

With positive reactions like this, it is probable that VR and other forms of XR will be welcomed by a wide swath of people, no matter their age or background.

VR and Entertainment

VR is employed in a wide variety of entertainment genres, some of which are unique to this technology. They include narrative experiences in which participants are surrounded with story, both fiction and nonfiction; special VR arcades and theme parks; VR rides; and meditative experiences. A few pioneering Hollywood professionals are eagerly jumping into the arena, wanting to see what unique kinds of story-based experiences can be created for this new medium.

Narrative Experiences in VR

Some works of narrative in VR are the equivalent to stories told in film: they have characters in search of a goal; there is a plot and dialogue and an emotional impact. But when such stories are told in VR, the experience is far more personal and immersive. You are right inside the story. One such VR work is *Hollywood Rooftop*, shot in 360° video and still in production. It is being directed by Brett Leonard, who made the groundbreaking film *Lawnmower Man*. He shot the story in a unique way: inside a specially constructed dome, with the rounded top being the sky. He used a Vihalo camera designed for shooting in 360°. The story is about a group of up-and-coming aspiring actors in Hollywood and about their professional and romantic challenges. A sneak peek of the work-in-progress was shown at the South by Southwest film festival in 2019.

According to writer/director Leonard: "Our aim with *Hollywood Rooftop* is to inspire an 'Immersive New Wave' of storytelling in this emerging medium, combining classic cinematic technique with

the intimacy afforded by Virtual Reality, allowing audiences to be more fully engaged with story, character, and emotion in an actual Immersive Movie experience" (as quoted in PRN Newswire).

A VR theater in a mall in Los Angeles offers three VR immersive cinematic experiences created by Dreamscape Immersive. Each of the three experiences is free roam, meaning that participants are untethered to cables and free to move around inside the story. Unlike some VR experiences, they are not restrained in chairs. Up to six people can be part of each experience and they see avatars of each other while inside the narrative. The experience is further enhanced with a haptic (vibrating) floor and smells, mist, or wind.

Part of the incentive for doing location-based VR, explained Dreamscape CEO Bruce Vaughn, was to change the way so many people view this new technology. "We want to transcend what I think is a very common perception—or misconception—of what VR is, which is tech and gaming," he told *The Verge* (January 15, 2019).

Walter Parkes, Dreamscape's Co-Founder, added: "The first VR companies, people started making VR, and those people tended to be animators, technologists, coders, and special effects people. So it emanates from the tech out." Instead, Dreamscape's leaders come from Hollywood's creative community and their work emphasizes the creative potential of narrative in VR. They also believe that audiences crave to have an emotional connection to story. Parkes explained: "Walter and I, our careers have been focused on creating things for the global, popular market." Vaughn added, "and you still have to have that strong emotional resonance. We don't get hung up on our own artistic arrogance of what this *should* be. We absolutely know, at the end of the day, people have to feel it, or we didn't do our job."

The three stories currently showing at the Los Angeles theater are *The Blu: Deep Rescue*, where you go underwater to try to reunite a family of whales; *Curse of the Lost Pearl*, where you seek to avoid dangers and find the treasured pearl; and *Alien Zoo*, where you visit peculiar animals who live in space. The conceit of the lost pearl story is especially clever: you step inside an old adventure movie and the drama begins. The Dreamscape technology was developed by a company in Switzerland that specializes in motion capture technology and Hollywood professionals

like Steven Spielberg have been involved in the content creation. Though the storylines of these three pieces all seemed designed for children, which was probably a business decision, there is no reason why works for more mature audiences could not be created using the same VR technology.

Strongly visual narrative works are also being developed to be enjoyed at home. *Spice and Wolf*, designed for Japanese fans of anime and manga, is a visual novel based on the manga and anime series of the same name. This romantic story is about a trader who goes from village to village and meets a female wolf-deity who becomes his travelling companion and eventually his romantic partner. *Tales of Wedding Rings* is another manga-based VR novel, about a high-school boy in love with a princess from another world. Although these works may delight fans of manga and may be beautifully done, they are not stories for children, but neither are they stories for a mature audience seeking a strong dramatic narrative.

Another work of narrative VR, *Defrost*, is a more serious story. It is set in 2045, at a time in the future when people are frozen in liquid nitrogen until medical science finds a treatment for their diseases. The story centers around a patient, Joan, who has been successfully revived. Audience members see the story from her first-person perspective as she reunites with her doctor and family members she hasn't seen in years. These reunions are bittersweet. Audience members can view the 360° story from a point of view of their own choosing. The story is told in 12 episodes of about five minutes each, and was shown at Comic-con, Sundance, and Cannes. The conceit alone of *Defrost*, with its emotional tug and a storyline that revolves around relationships, demonstrates that VR has real potential as a vehicle for narrative.

Nonfiction Narrative in VR

Documentary filmmakers have also ventured into the realm of VR. The French-Canadian team of Félix Lajeunesse and Paul Raphaël, Felix and Paul Studios, have made a series of well-respected documentaries on a number of topics, using 360° technology. One, *Nomads*, is the story of three different nomadic peoples: the Maasai in Kenya, the water-based Bajau tribe in South Asia, and

yak herders in Mongolia. Lajeunesse, in an interview by *The Verge* (January 26, 2016) said that it is "really about making you feel like a part of that community, making you accepted by that community." They believe VR can help viewers become empathetic to people who may be foreign but are humans just as they are. "We want them to integrate the camera as if it was one of them, so we really believe in that relational perspective ... We think of the camera in a very anthropomorphic way."

They also did an intimate portrait of Michelle and Barak Obama during their last days at the White House, *The People's House*. Viewers not only got to poke around the rooms the First Family inhabited for eight years but also hear the Obamas talk about living there. It was a novel perspective of the First Family and felt highly personal. Another work, Space Explorers, focuses on space exploration, and allows you to have a new perspective of space. These documentaries all demonstrate the power of VR to offer participants new ways of seeing the world and its inhabitants, and to bring new true stories to audiences.

> **NOTES FROM THE FIELD: MAKING JOURNALISM IMMERSIVE**
>
> A more hard-hitting approach to VR documentaries is immersive journalism, a term coined by journalist Nonny de la Peña. She is founder and CEO of Emblematic Group which produces documentaries in AR and VR. Her approach gives journalists a way to present true stories in VR and AR that pulls observers physically, spatially, and emotionally right into the story, while upholding solid journalistic practices like accuracy and established facts. One of her best-known works is *Gone Gitmo*, which offers participants the disturbing experience of being a prisoner of Guantanomo Bay Prison in Cuba. Other stories focus on solitary confinement, hunger in America, and Somali refugees.

VR for the Body, Soul, and Mind

Some works of VR are not intended to tell stories or thrust you into violent confrontations, but to offer you new kinds of experiences.

For example, a work called *EmbodyMove*, designed by Map Design Lab, is a VR wellness experience that takes two participants through a shared journey through nature. During their journey, their guided movements are inspired by yoga, aikido, and dance. Part of the experience includes a pressure-sensing yoga mat. The two participants can even trade and transform avatars during the experience. As of March 2019, *EmbodyMove* became an attraction in the Los Angeles based game arcade, Two Bit Circus.

Aaron Pulkka, who is head of attractions and production at Two Bit Circus, told Venture Beat (March 28, 2019) "VR is not just about immersing people in battle zones. At Two Bit Circus, we believe that technology can enhance our ability to connect and play together, elbow-to-elbow. *EmbodyMove* is a great example of how VR/AR/XR can be used in different ways."

Where Thoughts Go is another VR project that is more about social sharing than high-action conflict. It is an emotionally charged indie project developed by immersive artist Lucas Rizzotto, where participants share their dreams, fears, and secrets in anonymous audio recordings. In the work, their thoughts are portrayed as sleeping creatures. It premiered at the Tribeca Film Festival in April 2019.

Conversations, produced by iCinema Centre for Interactive Cinema Research at the University of New South Wales in Australia, is a more cerebral work, and aside from its dramatic opening, the emphasis of the experience is on observation and thinking rather than battle and conflict. *Conversations* is a dramatic reenactment of a famous prison escape that took place in Australia in the mid-1960s. During the escape, a prison guard was shot and killed. Later, one of the prison escapees, Ronald Ryan, was convicted of his murder and executed. However, the case remains highly disputed. In *Conversations* participants are immersed in the escape and shootout, and must make their own determination of the truth.

Part One of *Conversations* recreates the prison escape and shooting, thrusting users into the center of the chaotic events. Users, wearing HMDs and earphones, can view the action from all angles, but because so much is going on at once, it is impossible to take in everything. Part Two is set in a virtual investigation room, where users can interrogate key people (played by actors) involved in the case.

Unlike traditional dramas, users have a proactive role in the narrative: to decide how to observe the crime scene, to determine which people to interrogate, and to decide what questions to ask. And ultimately, the users must decide for themselves what really happens. Consider how different this is from a quest-driven experience like the *Curse of the Lost Pearl*.

Summerbranch, developed in the UK by an artists' group called Igloo, uses VR, motion capture, and video game technologies to recreate a piece of England's New Forest. The New Forest isn't actually new—it was created by William the Conqueror as a hunting ground in 1079, and thus contains some very old stands of trees. In the *Summerbranch* installation, users can explore the woodland by daylight or by moonlight. If they explore carefully, they will encounter some dancers dressed in camouflage who blend into the vegetation and who have an important role to play in the theme of this installation. In a large part because of the dancers, the work explores stillness and movement in nature. Though this is an extremely slender storyline, if it can be called a story at all, one of the artists, Bruno Martelli, explained that the installation raises the question "what is truth, what is artifice in our attempt to reproduce nature?" This peaceful work is at the opposite end of the spectrum from a harrowing piece like *Gone Gitmo*, and exemplifies the two extremes of immersive VR experiences.

VR and Location-Based Entertainment

In recent years, there has been a boom in offering VR experiences to the public as location- based entertainment (LBE). These attractions are featured in game arcades like Dave & Buster's and Two Bit Circus, in stand-alone spaces like The Void, and are also found in standard theme parks.

> **AIRLINE PASSENGERS GET TO GO ON VR JOURNEYS**
>
> VR experiences are even being offered at JFK airport in New York City, offered by a company called Periscape VR Experience Centers. Twelve VR towers have been set up in Terminal 4, where

> passengers are usually traveling to foreign destinations and often have three to four hours of waiting time before they board. Periscape realized these passengers were a captive audience and felt that offering them a novel entertainment experience like VR would help them pass the time. When set up in 2018, the company offered seven titles, which customers could select from the kiosks in the towers, but Periscape plans to keep offering more titles, up to 12 to 18. Travel companions of the VR players can watch the players' experiences on a screen on the tower. So now, while you are waiting to fly, you can fly away into cyberspace.
>
> Lynn Rosenthal, Periscape's CEO, said the company choose titles that they believed would make travelers feel joyful. "We're catering to the VR curious, not gamers," she said (as quoted in Venture Beat, August 6, 2018).

In China, an entire theme park is devoted to VR rides, *Oriental Science Fiction Valley*, a futuristic landscape dominated by a giant robot. It cost a reported $500 million to build and opened its doors in the spring of 2018. Located on the outskirts of Guiyang, the capital of Guizhou province, it was built in the hopes of attracting more tourism and business to the region. The province is one of the poorest areas of China.

The massive park spans a vast 330 acres and its 35 attractions range from rollercoaster rides and shooters, to games, to rides on the backs of dragons and spaceship tours of the area's landmarks. It also has a VR theater and a VR restaurant. The emphasis seems to be more on thrills and novel experiences than on story, but the hefty investment demonstrates a faith in the Chinese public's hunger to sample VR. The interesting news about this park is that it is viewed as an important investment in the economy of the area. In addition to the entertainment attractions, the park is also home to a VR film production facility and a research and development lab. Some believe it may become the most important VR hub in Asia.

Dave & Buster's, a modern-day game arcade and restaurant with over 125 locations, started offering VR attractions in the 1990s. One of the first was *Jurassic World VR Expedition*, a transmedia tie to the film *Jurassic World: Fallen Kingdom* and produced by

Universal Studios and the Virtual Reality Company (VRC) in collaboration with Dave & Buster's. Four players abreast, I being one of them, sit in seats on a motion simulator platform and an attendant helps us strap on a Vive headset and hands us a Vive controller. As the ride begins, we are in a virtual Jeep and are lifted off the ground by a massive aircraft and dropped onto the jungle floor with a stomach-lurching plop. We are now in a world inhabited by dinosaurs, some friendly, others carnivorous and threatening. Our job in this expedition is to use the controller to scan each of the dinos so the park knows which are still alive and where they are after the disaster that has just occurred in the dino theme park, so it becomes a shooting game where no dino is injured but a score is kept. The journey in your jeep through the rough jungle terrain is fully immersive and the dinos who menace you are totally believable and frightening. One friendly little dino will steal your heart and his fate might even bring tears to your eyes.

Not long after Dave & Buster's offered its first VR game, it added a second one, *Dragonfrost*, which I also got to try. In this experience, you get to ride a dragon and go on an epic adventure to defeat an evil prince and restore the Dragonfrost kingdom to its rightful leader and to peace. (See Figure 17.1). The Ice Prince is the bad guy and he has frozen parts of the kingdom. For the player, the fun comes in shooting your crossbow at the frozen creatures

FIGURE 17.1 *Dragonfrost* is an immersive VR ride where participants ride on the backs of dragons. Image courtesy of VRstudios.

and structures and see them shatter. And swooping over the beautiful landscape of the kingdom is a thrill. The game operates in the same way as the Jurassic Park attraction, where players sit in seats on a motion simulator platform and wear Vive headsets.

I was extremely fortunate to be able to conduct an email interview with a major person involved with the ride, Chanel Summers, vice president of creative development at VRstudios, who patiently and fully answered all my questions. VRstudios specializes in location-based VR entertainment. One of the attractions they've created, *VRcade PowerPlay*, is an intensely athletic team eSport played in free-roaming, arena-scale virtual reality. It offers unrestricted physical action across the entire arena playing field. The company, which was launched in 2014, is headquartered in Redmond, Washington. They've been working with Dave & Buster's for several years.

One of the first things I wanted to know about *Dragonfrost* was whether it was more of a game or more of a story. She told me: "*Dragonfrost* is a narrative-driven game. At its core, the game must succeed as an intense, high-action game, but in order to add meaning to the objective we set a goal to create a highly engaging narrative that would add a level of motivation beyond "winning points." She explained the origins of the attraction's narrative conceit: "*Dragonfrost* was born out of a narrative collaboration between VRstudios and Dave & Buster's. Dave & Buster's wanted a game set in a fantasy world that allowed for riding dragons.

"Because this game was to utilize an original storyline, characters and game world," she continued, "we were unable to rely on the familiarity players bring with them to the backstory and history of a known 'IP,' so we needed to weave a tale that would immediately feel like a classic but yet bring excitement, play, and beauty." To do this, she said, they relied on their experience over the years on how to create a successful location-based entertainment VR attraction. This includes setting up the world, the characters, who you are, what you are doing, your objectives. "These all needed to be established and in a short amount of time since this is short LBE VR attraction," she explained. "Plus, we wanted to bring to life an all-new story that combined a classic fairy tale feel with exciting, fun, and most of all, interactive action set in an absolutely beautiful virtual environment."

Summers clearly explained the core story and the players role to me. The narrative is rooted in very classically based storytelling with everything starting out great and then conflict is introduced and then you have resolution. Literature is full of the tension between heat and frost, so that is how the Ice Prince and the Fire Prince came about. They were two Brother Princes who ruled the land of Dragonfrost together until they quarreled over a fair maiden. As the Fire Prince is imprisoned by the Ice Prince, the players never see him, but it's also not necessary to the gameplay. So, while we had the 'bookends' to set the story up, provide a rich and compelling tale to be a part of, and provide objectives—ultimately this is a game about having a good time with the play mechanics. I mean, a heavy dusting of dragons and a heaping spoonful of explosions with a dash of magic all come together! And you get to ride on dragons! How cool is that?!

In the ride, the players are the protagonists. They are "the brave heroes who have been trained since a very young age in the ancient, nearly forgotten arts of magic and combat. We are the last best hope of Dragonfrost in which we must take to the air on the back of a dragon with our magical crossbow to rescue the benevolent Fire Prince from the castle of his evil brother, the Ice Prince, and restore sunlight and summer to the kingdom of Dragonfrost," she explained. "Players fly through the magical icy and wondrous land of Dragonfrost while battling orc encampments with goblins, orcs, trolls, plenty of explosives – and even Ice Hawks! The objective is to defeat the Ice Prince and his Army of Ice in order to restore peace and prosperity to the land of Dragonfrost."

Unfortunately, since this was to be a fairly short experience and even more importantly, a game, some details of the nicely developed backstory had to be cut. "We originally had a lot of dialogue setting up their relationship," she said, "Why they quarreled, what life was like for the villagers, etc.," she said. "We ended up having to sacrifice all of that since, while it added depth to the characterization, there just wasn't the time in the game. So, ultimately these details, while nice to have, didn't do anything to advance the game."

Summers pointed out that it was important for the participants to be active; this wasn't just to be an experience but also a game. She noted:

Players needed to be active participants riding on the backs of dragons and firing their magical crossbows. Immersion was key! We wanted to transport players to this wonderous land and make them an integral part of the story. Players are immediately immersed as you can see other players as warriors represented in the experience (and not just floating headsets!) and them on their companion dragon. Most importantly, immersion and motion programming were critical to create the realistic feel of riding on the back of a living creature—the ebbs and flows of the dragon, the flapping wings, the fire-breathing, and being in battle.

What is your role as a player? I wondered. Who are you in the game? She replied:

The players are simple young townsfolk who have never known summer or even daylight but who have been trained by their parents for this one night: their first time riding tamed dragons over the Ice Prince's army to rescue the Fire Prince. Their actions will shape the destiny of the kingdom. While they cannot control the flight path of the dragons, which are too powerful to direct in that way, the players are able to take out the army with their fiery crossbows and ultimately to bring down the Ice Prince's Ice Fortress in order to free the Fire Prince.

In fact, at one point, players must defend their wounded dragon while it struggles to remove a spear and take back to the air. The game features explosions, fantastical creatures, magic, interactivity, and a great deal of replayability. This last element was a priority from the start. In order to create variation in game sessions there are destructibles everywhere—avalanches, cranes, bridge destructions, as well as magical explosions, bonuses, and chain reactions. Our hope is that players will keep coming back for more as they try to restore peace and prosperity to Dragonfrost.

The storyworld of *Dragonfrost* was richly developed, and you soak it up while flying overhead on your dragon. Summers told me:

VRstudios employed worldbuilding techniques in order to create the village of Dragonfrost and its inhabitants. Our company's proprietary technology allows for the interaction of all four players and associates them to their companion dragons. So, people

that are physically sitting next to each other in the real world will be seen virtually riding their own dragon hundreds of feet away! Players experience different perspectives depending on the flight paths of their dragons. All this combined with the highly interactive game and scoring features, make *Dragonfrost* highly replayable – which was another goal that Dave & Buster's outlined for us.

I asked her about the special challenges of creating an immersive VR game and experience and how they handled these challenges. She told me:

> Developing a narrative is challenging in VR as there is generally little to no control over the "camera" placement which comes about as a function of where the players are and where they happen to be looking. Dave & Buster's encouraged us to embrace the difference and use that style. For instance, we introduce players during the story introduction to the memory of things past and then at the end of the game, we provide the memory of the things that happened as a result of the players' actions. Because of that, we created a very different art style for the intro and outro vs. the actual gameplay. We used motion animated 2-D storybook illustrations, whereas the game itself was a fully rendered immersive 3-D world. We knew that we needed to establish the backstory and we knew it needed to be different from the art style of the game. We deliberately went with a very stylized approach. We wanted to establish the story in a style that was very distinct from the gameplay itself.

Dragonfrost has been a success for Dave & Buster's, and VRstudios has created two new VR games for the chain: *Star Trek: Dark Remnant* and *Men in Black: Galactic Getaway*. In 2019, both began playing at the chain's locations.

A Modern Twist on the Old Beach Arcade

Two Bit Circus, a location-based entertainment center in LA, features a selection of updated arcade games like you'd find long ago on the midway of a beach or at a carnival or circus. It also features a robotic bartender and some stunning VR attractions. Two Bit Circus was founded in 2012 by Eric Gradman and Brent Bushnell

(the son of Nolan Bushnell, co-founder of Atari) as a producer of high-tech pop-up games at festivals and events. One day they realized their attractions were too good to only be enjoyed at pop-up events; they needed to be available for play on a permanent basis.

In 2018, they opened Two Bit Circus in downtown LA in an old warehouse. The space is family friendly but geared more to adults than children. After all, a competitive wine-tasting game where you have to identify the flavors you taste in your wine is not for little kids, nor is the full bar or the robotic bartender. The attractions offered at Two Bit Circus, including the VR experiences, emphasize social experiences. For instance, *EmbodyMove*, described above, is designed for two people, working together. *Raft*, designed by Starbreeze, is a four-player game set in a scary swamp where the goal is to find an ancient treasure. The players work together to keep the raft afloat on a fast-flowing river while fighting off various supernatural enemies. To enhance the social aspect of the game, the players can communicate with each other. The Starbreeze StarVR headset which they wear is designed for inter-player communication.

Other VR attractions at Two Bit Circus include a tank shooting game, a maze where you have to fight off hordes of rabid rabbits (*Virtual Rabbids*) and a maze loosely based on Greek mythology, *Minotaur's Maze*. The *Minotaur's Maze* game, where you are confronted with mythological characters while trying to find your way out of the maze, is enhanced by a haptic floor and air blowing on you while you are on top of a cliff, to suggest the wind. It also challenged players to walk across a high, hazardous bridge that looked frighteningly real. A report in LBE News (January 18, 2019) described one participant of being too scared to walk over it until reassured by the companions that the bridge was not real and that she was entirely safe.

NOTES FROM THE FIELD: LBE AS A STEPPING-STONE

With exciting, crowd-pleasing LBE attractions like the ones offered at Dave & Buster's, Two Bit Circus and the Void, it is not surprising that a number of companies are beginning to set up shop in this area. In fact, Forbes called this area "The Next Phase

of Immersive Entertainment." In an article for Forbes (January 4, 2019), Anshel Sag cited the reasons for this.

VR has one fundamental problem—not enough people have actually tried VR, much less good VR," he wrote. "This is a major problem because until you have tried VR, you don't understand the immersive power of the technology. Most VR today is still relatively expensive and the best experiences cost too much for the average consumer. Because of this, I believe that location-based VR is the natural and necessary next step for VR and the immersive technology market on its way towards mainstream appeal and market.

VR Games for Home Use

Although not too many people have the finances to purchase expensive VR equipment, a devoted player base now exists for VR gaming at home. Developers are turning out a wide variety of products for this market, ones that include almost every genre of gaming. It should be acknowledged, however, that some professionals in the field are disappointed that VR games have not made more progress. For example, Mark Serrels, writing about the 2019 CES conference for CNET.com (January 9, 2019) said disparagingly: "In 2019, VR is a sideshow in a theme park, a marketing stunt, a slide in a PR PowerPoint presentation, a niche hobby for people locked in rooms with a ton of money to spend, and—worse—no one seems to know what direction we're headed in, or even what virtual reality should be." He had expected VR to progress like simple cell phones that had in only seven years morphed into "an iPhone with a fully activated touchscreen and video games … I went from carrying CD players in my jeans pocket to MP3 players that contained more music than I could ever listen to. We'd witnessed change at a rapid pace. Why would VR be any different?"

He goes on to quote Tony Parisi, the head of AR/VR brand solutions at Unity: ""Everyone thought VR would be in their backpack by now, but it didn't play out that way." It should be remembered, though, that the focus of the CES conference is on technology, not on content, and the disappointment that Serrels expresses seems

to have to do with the lack of portability of VR gear and less to do with the outstanding LBE attractions or narrative experiences that have been created for VR in recent years.

Serrels' disappointment also seems to ignore the developments in VR gaming in the last few years. Even back in 2015, just before E3, the premiere gaming conference, James Martin posted an article for Cnet (June 13, 2015) declaring that "Virtual reality jumped from nothing to industry trend in under three years … It's about to go from virtual to very, very real. … The video game industry is embracing virtual reality like never before." He ticked off a list of tech giants and game companies that were making VR games and noted that 27 exhibitors would be showcasing VR games at E3, while only six had done so the previous year.

"It's this huge new medium that people have only started to imagine where you could go with it," Martin wrote, quoting Rob Coneybeer, managing director of Shasta Ventures. His firm had invested $4 million VR company Survios.

By 2018, a hefty variety of new games were showcased at E3, some still in development. They included adventure games, psychological thrillers, platformers, puzzle games, and a mystery set in a Victorian boarding school.

A Selection of VR Games

As indicated by the variety of games that were showcased at E3 in 2018, VR games are not pigeon-holed into just one or two genres. Instead they span many different genres and approaches, and in terms of emotional power, can range from comedy to despair and joy to horror. Some VR games use the technology in inventive ways, letting players do things that were not possible in non-VR games. Here is a selected list of recent VR games, to illustrate their diversity:

- *Astro Bot: Rescue Mission* is a platform game that was the winner of the best AR/VR game in 2018 at The Game Awards, an annual award show hosted by Geoff Keighley, a Canadian journalist. In *Astro Bot*, you play as the determined little robot, Astro, and help him save his

missing crew members. The game was published by Sony Interactive Entertainment.

- *Beat Saber*, an immensely popular rhythm game, was the second most downloaded game of 2018 (*Job Simulator* was the most downloaded game of the year). It is a very simple game without any narrative content. You simply slash your saber into blocks that come flying at you to the beat of a song. There is a collection of music with which you can slash your saber. The game was developed and published by Beat Games.
- *Job Simulator: The 2050 Archives* is a humorous and mock simulation game that takes place at a time in the future when robots have replaced humans in the workforce. You, as an unemployed human, can enjoy a simulation of what it was once like to be a human with a job. As to be expected, the working world is not a fun place to be part of. The game was developed and published by Owlchemy Labs.
- *I Expect You to Die* is a tongue-in-cheek action game in which you play a supposedly elite but not always brilliant spy whose ultimate goal is to thwart the evil Dr. Zor and his organization, Zoraxis (see Figure 17.2). In the course of fulfilling your missions, you solve puzzles and can also use your special powers of telekinesis, which means you can move objects with your mind. This game clearly has more of

FIGURE 17.2 Screenshot from *I Expect You To Die*. **Image courtesy of Schell Games, LLC.**

a narrative line than the three games described above. In an interview with Jesse Schell I asked him about the importance of story in games. (It was his company, Schell Games, that developed and published the game.) He said: "How much story depends on the kind of experience you want to offer. Story can be an important or insignificant." In his book *The Art of Game Design, Second Edition*, he wrote (p. 297): "Ultimately, of course, we don't care about creating either stories or games—we care about creating experiences."

- *The Forest* is an open world horror game published by Endnight. In the game, you are the sole survivor of a plane crash in a dense and mysterious forest inhabited by blood hungry mutant cannibals. To survive, you can build a shelter, shoot with a bow and arrow, throw flames, and chop down trees.
- *Moss* is an action-adventure puzzle game about a little mouse named Quill, viewed in both third and first person. Your mission is to help valiant little Quill rescue her uncle from a terrifying snake. The medieval storyworld is charming. Unlike many of the bloodier VR games, the combat in *Moss*, while challenging, is not gory. The game was developed and published by Polyarc.
- *Déraciné*, in stark contrast to *The Forest*, is a gentle story-driven adventure game set in a Victorian boarding school. You play as a fairy and get to explore the school for a hidden mystery. The world of the boarding school is beautifully rendered and evocative of an earlier time period. You are invisible and have some magic powers. For example, you can slow the flow of time and can visit the same location during different time periods. The game was developed by From Software and published by Sony Interactive Entertainment.
- *Obduction* is a gorgeous looking exploration puzzle game reminiscent of *Myst*, and in fact the two games were both developed and published by Cyan. Players of Myst will recognize the same richly detailed graphics and a fascinating story world mixing together the past, present, and future. A rustic wooden picnic table and an ominous piece of rusted machinery rest in close proximity to each other.

The game begins with you at a park admiring the night sky when a mysterious seed-like object falls on you from the heavens and knocks you out. When you come to, you are on what seems to be an alien planet and in order to return home, you must unravel the mystery of this strange place, solving a series of challenging puzzles as you do.

- *Budget Cuts* plays on the same theme as *Job Simulator*, that humans have become expendable in the workplace which robots now dominate. But while *Job Simulator* was comic, *Budget Cuts* is terrifying, with menacing robots patrolling the halls. Your job is to defend yourself as best you can with the tools at hand, like letter openers. The game was developed by Neat Corporation.
- *Trevor Saves the Universe* is a zany platformer about an odd-looking purple character named Trevor who has two different-colored eyes that each have two eyes inside of them. Disconcertingly, the eyes blink at different times. You help Trevor find a special crystal and must overcome numerous peculiar obstacles along the way. The game was developed and published by Sqaunch Games.

Two games using a more experimental approach include:

- *Return to Grindelind*, a world-scale game played in a space the size of a football field. As of this writing, the developers' focus is more on using such a large space well in VR as opposed to the game, which is only roughly rendered. It is a story of a man who returns from a two-year pilgrimage to find his village deserted, and sets out to learn what happened to his former neighbors. Buildings and other structures in the story are set at the exact distances they would be in real life. If the church is about a block away, you'd walk about a block to reach it. The world-scale gaming concept is being developed by Sixer VR.
- *Arca's Path* is a maze-like game set in a ruined, desolate world called Arca, where you control a rolling ball with your gaze; it is hands-free VR. The story is slight: A girl who lives in on a trash heap discovers a special ball, which begins to roll away from her and she follows it. In the

beginning, in following the ball you travel over a colorful landscape with lush vegetation sprouting up as you go, but as you level up the landscape becomes darker and barren and the risks of the ball falling over the edge or down a hole become greater. During your journey you encounter some other characters or discover more pieces of narrative. You try to find the correct path that will return the ball and the girl to her home. The game was developed by Dream Reality Interactive and published by Rebellion.

Using VR for Practical Purposes

So far, we have been exploring how VR is being used with immense creativity in entertainment, but now let's take a look at VR's employment for more utilitarian uses. And as we do, note how the producers of these works have also been highly creative in their approaches to their end goal.

Training

A number of major organizations are looking at VR to help with the training of their personnel, including the military and the UN. For example, *DarkCon* is an intensely gripping military training simulation designed to train US soldiers on how to conduct a dangerous surveillance mission. It was mentioned briefly in Chapter 6 in a discussion of the role of emotion in digital works. The name, *DarkCon*, comes from "dark reconnaissance mission." It was created as part of the US Army's endeavor to utilize interactive digital media to create safe but effective training methods. *DarkCon* was produced for the Army by the USC Institute for Creative Technologies (ICT), which is a research arm of the University of Southern California.

To experience *DarkCon*, each soldier/trainee, one by one, dons a HMD and earphones and steps onto a large bare platform. Via the 3-D images seen through the HMD and the sounds heard through the earphones, the soldier is plunged into a frighteningly realistic surveillance mission. As the soldier turns or moves in one direction or another, specific images and sounds are activated. In

a sense, the soldier acts as a computer cursor. By moving to position A, one type of response from the program will be triggered; moving to position B will trigger another.

The soldier's assignment is to observe members of a rogue paramilitary troop suspected of stockpiling illegal weapons, moving as close to them as possible, but to avoid attracting their attention; otherwise the consequences could be fatal. The mission begins in a dark culvert near a bridge and an abandoned mill (see Figure 17.3). Although there is no dialogue, sound effects—such as dripping water, a barking dog, or the scurrying of a rat—play an important role. The participant will even hear the sound of his or her own footsteps as he moves through the virtual landscape, and they'll match the terrain he or she is moving over—the squishing of mud, the crunch of gravel, the rustling of dry leaves. The footsteps are also synced up to the soldier's movements. If he or she starts to run, the footsteps will quicken.

The realism of the simulation is further enhanced by both a *scent necklace* and a *rumble floor*. The rumble floor is built into the platform the trainee moves across during the mission, and vibrates when cued by certain events, such as an explosion or a truck passing over the bridge. The "scent necklace," worn around the neck, gives off specific smells at key points during the simulation, and is geared to enhance the frightening moments as well as the moments of relief. For instance, while moving through the dark and dangerous

FIGURE 17.3 The *DarkCon* **VR simulation begins inside this dark culvert. Image courtesy of USC's Institute for Creative Technologies.**

culvert, the trainee might smell a mustiness that hints of decay or rats, but at better moments, such as emerging unharmed from the culvert, the necklace might emit the fragrance of fresh pine.

Writer Larry Tuch, a professional screenwriter with a Hollywood television background and a long-term involvement with ICT, was given the task of writing the initial demo script for *DarkCon*. In describing his role to me, he said he was called upon to create a context for the surveillance mission and a structural spine for the experience. He also had to find ways of ramping up the tension and the soldier's sense of jeopardy. He scripted in a number of objects, events, and visual clues for the soldier to discover during the mission. One of them was a child's broken doll, which was possibly abandoned by a family of fleeing refugees. Another was a blood-spattered wall, possibly evidence of a slaughter.

From his television experience, Tuch was used to developing stories with three acts, and used this model for *DarkCon*. The first act set up the mission and the second act introduced a series of complications, much like a typical Hollywood script. However, the third act was left open-ended, without a fixed resolution; the ending would be shaped by the decisions the soldier/ trainee made along the way. Thus, although *DarkCon* might not contain as complex a story as a Hollywood movie, it does contain many important narrative elements: a protagonist, opponents, a goal, obstacles, a structural spine, and an increasing degree of jeopardy. And it is these narrative elements, plus the unique aspects of VR, that make it so gripping and effective as a simulation.

Another VR work for training, The UN's *UNMAS IED Detection Experience*, was designed to make UN peacekeepers based in Somalia alert to the possibilities of encountering IEDs (Improvised Explosive Devices) as they traveled along the roads. UN employees participating in the VR exclaimed with shock as IEDs exploded right around them and they gained a new appreciation of the dangers they face on the roads of Somalia.

Using VR to Inform

Informational works of VR are made to make the public more aware of current issues; to bring an element of history to life; and

to illustrate works in museums. Immersive journalism, a term coined by journalist Nonny de la Peña, is a documentary form that pulls participants into a true story. We described one of her pieces, *Gone Gitmo*, earlier in this chapter. Two other prominent works of immersive journalism include *Carne y Arena* and *I AM A MAN*, though neither was made by de la Peña herself.

Distinguished director Alejandro G. Iñárritu, who made the acclaimed film *Birdman* and won an Academy Award in 2016 for *The Revenant*, tried his hand at VR with *Carne y Arena* (*Flesh and Sand*). It is a powerful immersive piece about migrants crossing the Sonora Desert into the US. Participants travel with them on this dangerous journey, one at a time, and experience what it is like to walk barefoot across the desert or being ordered to kneel by Border Patrol agents aiming R15s at you. Though a difficult subject, the six-and-one-half-minute experience was so popular when it was shown at the Los Angeles County Museum of Art that it was almost impossible to get tickets to see it; I could not get a ticket myself. The work won a special Academy Award.

I AM A MAN focuses on the Civil Rights Movement, specifically on the 1968 strike of the Memphis sanitation workers and the events leading up to the assassination of Dr. Martin Luther King, Jr. who was in Memphis lending his support to the strike. In the experience, you are one of the strikers holding a sign reading "I Am a Man," an indication that you have a right to be treated with the same respect as a white man. For a white person, the experience of being a sanitation worker in the piece may come as a shock, because your normally white hands become black during the piece. It was created in 2018 by Dr, Derek Ham, a professor of graphic design at North Carolina State University.

History and Newsworthy Events in VR

I AM A MAN illustrates the power of letting today's generation experience important historic events in VR. Other pieces of history and current events can also be brought to life in VR, though not necessarily as powerfully as the Civil Rights Movement in *I AM A MAN* and the migrant crisis in *Carne y Arena*.

In *Nefertari: Journey to Eternity*, you can explore the virtual 3000-year-old tomb of the great Egyptian queen, Nefertari, the wife of the famed pharaoh, Ramesses the Great. In the VR recreation, it is lit only with oil lamps, the way early archeologists would have seen it a century ago. Everything in the virtual tomb has been scanned with millimeter accuracy and a guide is on hand, when you call on her, to interpret the meanings of the lavish symbolic paintings and sculpture in the tomb. The VR piece was made by Simon Che de Boer of Reality Virtual and Experius VR.

Moving along in time, to about the mid-1400s CE, you can visit a virtual medieval ship and roam its decks. The old vessel, the Newport ship, was dug out of the mud in Newport, UK, by archeologists in 2002. The real one is in tatters, not surprising given its age and the mud, but the virtual one, while not in pristine condition, has been largely reconstructed and suggests what it would have looked like 600 years ago, when it was hauling wine between Spain and Britain.

If you are more interested in pre-Columbian American history, you can virtually visit a replica of an Iroquoian longhouse, constructed in about the same period as the Newport ship. The VR model was produced by theskonworks, a group of archeologists. Families of Native Americans of upper New York State and Southern Canada lived communally in what we now call long houses—elongated arched dwellings covered in bark as protection from the fleas in summer and the brutal cold in winter. Extensions would be built as the family grew in size and they could accommodate as many as 24 families.

Another dwelling, this one tiny compared to a longhouse, is virtually recreated in 6×9, the size of a solitary confinement cell. It was produced by the *Guardian* newspaper and launched in 2016 to show what it is like to live in such a confined space in prison and to indicate the psychological damage that could ensue. You hear the voices of prisoners describing the misery of being locked away like this for 23 hours a day, and psychologists talk about the severe damage it can do to one's emotional state and mental health.

The *Guardian* is not the only newspaper to move into VR. A year earlier, the venerable *New York Times* took a groundbreaking step and began producing serious pieces of journalism in VR. To

make the pieces available to their subscribers, who were unlikely to own any VR equipment, the *Times* went further and distributed over one million Google Cardboard viewers to many of its digital and home-delivery subscribers. *The Displaced* was its first VR project, launched in October 2015. It was a hard-hitting report about three children caught up in the global refugee crisis. In April 2014, it launched *Seeking Pluto's Frigid Heart*, in which viewers could enjoy, via a Google Cardboard viewer, a fly-over of Pluto and then experience what it would be like to stand on its surface.

New York Times Executive Editor Dean Baquet said, referring to *The Displaced*, that the paper "created the first critical, serious piece of journalism using virtual reality, to shed light on one of the most dire humanitarian crises of our lifetime." And *Times* Executive Vice President Meredith Kopit Levien commented: "The great irony here is that it takes (a 164-year old) print newspaper … and its still remarkable distribution system to deliver one of the most advanced digital storytelling technologies to more than a million people" (as quoted in Engadget.com, October 20, 2015).

Education

VR is proving to be a useful tool in the classroom, even in medical schools, and is particularly helpful in situations where a visualization can bring a topic to life. Medical school students can now study a colon and see what a polyp looks like, while having a pathologist describe what they are seeing. And they can see a beating heart and study it from all angles, very different from trying to understand the heart from a description in a textbook. Anatomy lessons are also taught with the help of VR. The skin of a "living" body can be removed, so students can view the functioning of the organs beneath the skin while the body is still alive and pull out the ones they want to study for a close-up inspection while the organs are still working, quite different from viewing an inanimate cadaver. VR is being used in the classroom to teach difficult subjects. For instance, a VR program on chemistry lets students play a game where they catch protons and electrons and make atoms. A VR program called *CalcFlow* is being used for teaching calculus as well, and for nanotechnology. In China, VR

is now being used to teach subjects at the K-12 level, including science, math, and art.

Medicine and Psychotherapy

As we saw in Chapter 10, a VR simulation called *SnowWorld* is used to help burn victims deal with the intense pain caused by the treatments they must receive. It is also being used by therapists to help patients overcome a variety of phobias, including the fear of spiders, the fear of driving, and the fear of flying. In Sweden, a country almost entirely surrounded by water, one out five children cannot swim, primarily because of a fear of water, and a VR program is successfully being used to help them overcome this fear.

VR is also being used to treat soldiers suffering from post-traumatic stress disorder (PTSD). In one therapeutic work, *Virtual Iraq*, the patients are enveloped in a virtual experience that resembles the real-life event that caused them so much stress. Done in sessions with a skilled therapist, and in a controlled environment, the patients gradually become desensitized to the situations that cause them anxiety. This type of therapy is called "prolonged exposure therapy" or "immersion therapy."

Virtual Iraq is designed to treat the "ground pounders" of the war—soldiers who served or who are still serving in the heart of the action and have suffered from post-traumatic stress disorder. The simulation incorporates a modified version of the video game *Full Spectrum Warrior* and can be modified in innumerable ways by either the therapist or the patient. The soldier, for example, can be a driver of a Humvee, a rider in it, or sitting in a turret behind a machine gun. The speed of the vehicle can be slowed down or sped up; the time of day can be changed; the action and behaviors of the people on the street can be changed and so can the smells. This degree of modification can create a scene that almost exactly replicates a traumatic experience the soldier suffered while on duty. The sights, sounds, and smells are added gradually, to give the soldier time to become accustomed to them, and ultimately, the scenario loses its power to induce stress. With this type of VR therapy, he or she will no longer have a panicked reaction to a

once-frightening cue in real life like the sound of a car backfiring. Essentially, it works because patients revisit the stories of their traumas until they cease to hold power over them.

Another Approach to Healing

Jacquelyn Ford Morie, the producer of the *DarkCon* military simulation described above, is one of the leading pioneers in terms of using VR as a dramatic medium. She is also a fine artist, which very much informs her approach to VR. She is the developer of *The Coming Home Project*, which uses a different concept to assisting returning veterans who may have trouble adjusting to civilian life or who may be combatting the negative effects of their service. Unlike *Virtual Iraq*, hers is a narrative approach employing VR where returning warriors can find positive feelings in their own stories. In the work, the veteran follows a spiral path within a tall stone tower in a virtual world (see Figure 17.4a and b). The Warrior is guided on the journey by the voice of a dignified warrior such as a Native American Dog Soldier, who symbolizes a noble and courageous image of a fighter.

Along the path, the tower contains niches illustrating the Dog Soldier's story which help trigger positive feelings about service, courage, and duty. The path leads to the top of the tower, where the veterans meets the Dog Soldier narrator, who now not just a

FIGURE 17.4 (a) and (b) From *The Coming Home Project*, a diagram of the veteran's path inside the tower, left, and the story tower, right. Image courtesy of Jacquelyn F Morie, Founder and Chief Scientist All These Worlds, LLC.

voice but a 3-D interactive avatar. It is here that the user can talk to the warrior figure to learn more about why this person served, which they can correlate to their own reasons for being a soldier. Afterwards, the veterans are given the tools to author their own story to put in the tower, led by suggestions about the positive aspects of it. In "Warriors' Journey: A Path to Healing Through Narrative Exploration," a paper about the project, Morie and her collaborators, E. Haynes and E. Chance, state that after the warriors return from the storytelling experience: "they do so with a new wisdom that has been gained from experiencing the story, which is now integrated into one's own life."

As reported in the abstract, one participant said after journeying through the tower: "I do believe any vehicle for allowing somebody to get some of the s**t out of their head which may be troubling them certainly has value to veterans and those reconnecting. The story tower seemed to do some pretty cool and interesting stuff."

Science

At the Los Alamos National Laboratory in New Mexico, scientists use the CAVE VR system to investigate details of the effects of foam being crushed under a gravitational load and to investigate details of astronomic simulations. With VR, they can examine details that would otherwise be missed, and to see the objects of their investigations in 3-D. In fact, an entire group at Los Alamos, the *VISIBLE* Team, produces VR experiences for scientific purposes.

College Recruitment

High-school students who have the budget like to tour the campuses of the colleges they are interested in attending, but this is not possible if you don't have the funds to travel or if you are interested in schools in far-flung locations. To deal with this situation, colleges are now creating VR tours of their campuses and sending Google Cardboard viewers to prospective students. The visits are not limited to the outdoor campus: students can visit

the classrooms, the labs, and the dorm rooms. Yale University is going one step further and is sending Oculus headsets and VR recruitment pieces to students it has already accepted.

Retail

VR is being used to entice customers back to the stores by giving them an entertaining experience and tools to encourage them to make purchases. For example, in Manhattan, at a North Face store, which specializes in outdoor clothing and gear, visitors can safely skydive off a high cliff, thanks to VR. At Tommy Hilfiger stores, they can watch a fashion show of his newest line from a prime front-row seat. And at other stores, they can virtually try on clothes to see how they look, thanks to a "smart" dressing room mirror. Car sales are being augmented by VR by showing potential customers interior details of the car and the exterior from all angles. Similarly, real-estate agents are using VR to show off all a home's features and interior designers use VR to help customers decide on how they want a room to look. Travel agencies lure you to new vacation spots by placing you right inside a wonderful destination via VR.

Other Uses

Charities are beginning to use VR to combat "donor fatigue" and to give potential donors a better understanding of the problem their money would help alleviate. For instance, a work to support a dementia foundation puts you in a supermarket where you struggle to recall what you have intended to buy and are then upset to discover items in your shopping cart that you don't remember putting there. This befuddlement gives viewers a sense of what it's like to experience dementia. Doctors Without Borders plunges you into the middle of the refugee crisis. And with *Fear of the Sky*, Amnesty International gives you an experience in Syria to see what it is like to be taking part in a civil protest in Aleppo with bombs falling on you.

Strange as it may seem, Hollywood studios are using VR to promote flat screen movies, to give you a sense of the thrills and scares you might experience in a movie.

A company called ICAROS has built a "flying" workout machine where you don a HMD, hold yourself prone, and fly over a magnificent landscape, aiming yourself through targets marked by circles ahead of you.

These selected examples illustrate the range of uses VR can be put to, but certainly there are others that are still being developed by some creative entrepreneurs or have not yet even been conceived.

> **WORTH NOTING: THE CHALLENGES OF CREATING NARRATIVE WORKS OF VR**
>
> As we have seen from the various VR projects we've examined, developing narrative-based projects and games in VR can be difficult due to a number of factors, including:
>
> - *A new paradigm*: creators must deal with an entirely new model. In traditional media, such as movies, television, and theater, viewers watch something that takes place in front of them. This is true even with video games and content made for mobile devices. But in VR, the participant is *inside* the entertainment content and is surrounded by it. We do not yet have a body of experience to guide us in creating content this kind of experience.
> - *Storytelling taking a back seat to technology*: many developments in the field are spurred by scientific or technical interests, not by narrative objectives.
> - *Motion sickness*: it is common for users experiencing VR to experience motion sickness. Although progress has been made to VR systems that avoid this type of distress, the problem has not yet been solved.
> - *Expense*: most VR equipment is expensive and too pricey for private use.
> - *Lack of a specific grammar for VR*: the grammar in an artistic field is its set of artistic principles or rules. The lack of an established grammar for VR poses a number of issues. Jackie Ford Morie, the VR expert who created *The Warrior Project*, described some of them to me. She feels VR still relies heavily on older concepts borrowed from earlier forms of entertainment, in part because the practitioners in this field have placed more emphasis on

developing hardware and software than on exploring content. As a result, it is short on artistic ideas that are specifically geared for VR's unique attributes. Every new medium requires its own artistic vocabulary, but that takes time to develop, and audiences often have trouble at first in interpreting what they are experiencing. For instance, when the jump cut was first introduced in the early development of cinema, people didn't understand what it meant. "But what is the equivalent of a 'jump cut' in VR?" she wonders. "Can you do a break in time and make it work? And is there a way for the participant to control time?" These are some of the questions Morie would like to see addressed in VR works. She feels that answers to these and other questions will come from the artists who are working in VR, not from the technologists. "I think the artists push more than the technologists," she asserted.

- *Lack of models*: creators in the field have a lack of models to draw upon—so far, there are only a limited number of successful projects to serve as examples.
- *The lack of a frame*: in a motion picture, the frame is the box that surrounds the image that the audience sees, and films are built frame by frame. But VR lacks a frame; instead viewers are completely surrounded by an image-based world, just as in real life – they can see the world from all sides, from above and behind. How do you put a story together without using frames? How do you edit it?
- All of these factors call for developers in this arena to stretch themselves to the limits creatively, and to be willing to break new artistic ground.

Augmented Reality

Augmented reality (AR) is a technology that synchronizes digital data, including text, images, video, and sound, with the real world. Unlike VR, AR is superimposed on the real world; it does not surround you in a virtual world, as VR does. AR is usually experienced through mobile devices like smart phones and tablet computers. Although VR was first anticipated by scientist

almost 100 years ago, the history of AR is more recent. The term "augmented reality was not even coined until 1992. The two computer scientists who came up with the term, Tom Caudell and David Mizell, were Boeing researchers at the time. Earlier, in 1968, Ivan Sutherland developed the first HMD, a device that enabled both AR and VR.

It is only recently that the public has been able to enjoy the form of immersion that AR offers. AR offers a diverse variety of experiences and is used for a variety of endeavors, including entertainment, primarily in the form of gaming; journalism and information; military uses; the medical field; and some uses in retail. Unlike VR, it is extremely difficult to find examples of AR being used in narrative works; only a few have been produced thus far.

AR in Gaming

AR gaming took off in a big way in July 2016, with the launch of *Pokémon GO*. By May in 2018, the game had been downloaded 800 million times, and it still has millions of active players today. The AR version of *Pokémon* is similar to the video game, where players capture and train the *Pokémon* and do battle with other *Pokémon*. The big difference is that, thanks to your smart phone, you hunt for the *Pokémon* characters in real-world places and as you near them, you can actually see them in a real-world location. Playing the game in the real world is an enormous part of the fun. In *Pokémon GO*, players use GPS in their mobile devices to locate, capture, battle, and train the virtual creatures. Thanks to AR, these characters, from the Pokémon pantheon, appear as if they are present in the real-world, right in front of you.

But even before *Pokémon GO* there was another highly successful AR game: *Ingress*, which was released in 2012. Ingress was developed by Niantic, the same company that would go on to make *Pokémon GO*. Niantic is now in the process of developing the hotly anticipated AR game, *Harry Potter: Wizards Unite*. As of this writing, it has not yet been released.

Thus far, these are the only major games that have managed to integrate AR into the gameplay and story.

Pokémon GO, of course, received world-wide attention when it was released and almost instantly became a huge hit. To some degree, *Pokémon GO* is built upon the technology and gameplay that originated with *Ingress*. Archit Bhargava, who works for Niantic, was quoted in *Gamespot* (July 7, 2016) as saying about *Pokémon GO* shortly after the game was released: "Obviously we're learning from Ingress …" He also noted: "in small towns and smaller cities … people would meet other people in the world while playing *Ingress*, and friendships started emerging and that social aspect became the biggest thing. That became a new tenant for us: that we wanted to encourage social fun, which is why we started doing a lot of events."

The narrative and gameplay of *Ingress* revolve around some exotic matter (known as XM in the game). In the conceit of the game, XM is a mysterious energy that was discovered during an experiment at a real-life institute in Europe, CERN (the European Organization for Nuclear Research; in French: "Conseil Européen pour la Recherche Nucléaire.") This energy appears to be transmitting powerful data from special cultural or spiritual locations around the globe, known as portals. The specific powers of XM are not revealed, though some individuals regard it as a positive force and others as dangerous. A detection algorithm is devised that can turn smart phones into XM scanners and allow them to detect XM in these special portals. Two factions form to deal with XM: the Enlightened, who want to spread this influence of XM, and the Resistance, who want to protect humanity from it. The gameplay revolves around capturing portals and battling over them and connecting them to form territories. It is a little like the game "Capture the Flag" (see Figure 17.5).

Being particularly interested in the use of AR in *Ingress*, as well as *Pokémon GO* and *Harry Potter: Wizards Unite*, I managed to snag an interview with Flint Dille, Creative Lead at Niantic. He described Ingress to me as a "geo-based form of AR" and explained that Niantic is an internal startup within Google, which allows the game to use Google Earth and Google Maps technology. "The way to understand it," he explained, "is that the head of our company also headed up Keyhole, which grew up to be Google Earth and Google Maps. So we are real-world and geo in nature. That

FIGURE 17.5 In *Ingress*, players look for mysterious energy forms (XM) in portals, which are revealed via AR. Image courtesy of Flint Dille.

means that we overlay 'portals' in our game—real-world points of interest (POIs)."

Thus, they are layering another meaning over the real world. To make it as clear as possible to me, he explained: "we are able to layer a world of gameplay on top of a map. So you can walk around in the real world and be in a real place, but it has a symbolic and higher meeting inside the game. For instance, a local statue could be a portal or a PokéStop. That is the augmentation …" In other words, geo-based AR is layered on top of the real world. At this time, no characters appear in *Ingress* and he couldn't talk about whether there will be, though there are portal shields, resonators, and other objects. In *Pokémon GO*, however, he said "characters are creatures that can appear in the real world based on Geo data visible on the phone."

Developing *Ingress*, he told me was full of challenges because "we were doing a whole bunch of things that had never been done before." Among the challenges were using an untried technology in a game, plus the scope and size of the game. Although he couldn't get specific about the technical challenges, he said: "Suffice it to say that many members of our team were involved with the creation of Google Earth. The idea was to look at that information differently and make it a game."

The process of developing *Pokémon GO* and *Harry Potter: Wizards Unite* for AR has been quite different, he said, given that "We are playing in someone else's sandbox." These are both

branded properties and the owners control the IP (intellectual property). Of course, under those circumstances, it is necessary to be respectful of the original IP. J.K. Rowling herself is involved with the Harry Potter game. But when a game is completely original, the developers have creative freedom. "We just riffed on various ways to turn the globe into a gameboard," Dille explained.

In terms of what kind of game *Ingress* is, Dille asserts that it is an Alternate Reality Game (ARG), with all the elements of other ARGs, including conveying the story using a transmedia approach—telling it via many different media, including comics, books, performances, videos, and puzzles. What especially makes *Ingress* an ARG is the dichotomy between what is real in the game and what is fiction. "To me," Dille said,

> ARGs are an artform that started with conspiracy theories. So ARGs live in a happy place between 'Is This Real' and 'This is Not a Game' (the mantras of ARGs). So how do you keep the balance between 'This is Not a Game' and 'This Is A Game'. If it seems too gamey, you lose the creepy sense of reality that drives conspiracy stuff. We all like mysteries and the game element of it is that there really is a solution to these mysteries. It's not like the real world where things go unsolved. So it's a constant balancing act between all of these things: Real/Game/Narrative.

He went on to say: "ARGs have to be Real Enough to be interesting and slightly threatening and 'Game' enough to be solvable and a little reassuring that this isn't real. It's that balance."

Unlike most ARGs, which have been developed to market a film or a video game or a new album, *Ingress* is an original property and does not fall back on pre-existing material. As with other ARGs, Dille told me, there is always the question of how much story to use in the game. He feels you need enough to give meaning to the gameplay, but if there is too much, it gets in the way of the gaming. He sees the players as having an important role in creating the narrative, calling them "adjunct storytellers." In addition, *Ingress* inserts real actors into the mass events Niantic holds for *Ingress* and these actors play the part of fictional characters in the game. Dille calls them *immersive actors*. "We live somewhere between

the third and the fourth wall," he notes. The actors interact with players and give them information. "What these characters do in the events actually affects the story and player outcomes (which side wins) affects the story in a pick-a-path kind of way."

As the interview wrapped up, Dille offered me this. "But I'll leave you with a thought experiment: if people are perceiving the real world differently through AR, do they then return [from the game] to change the real world?"

Although the Harry Potter game has not yet been released, a non-finalized Beta version is now being played and tested in New Zealand and Australia. The first in-game event was held on May 19, 2019. The official trailer for the game has an exciting premise: Magic is beginning to leak into the Muggle world, and it is up to the Wizards to close these breaches by gathering up these leaking instances of magic and presumably destroy them. "Ready your wands!" urges the voice on the trailer.

Different Approaches to AR Games

Not all AR games feature intense conflict and action like the three from Niantic. Two that use AR in two very different ways are *My Very Hungry Caterpillar* and *Seedling*. *My Very Hungry Caterpillar* is a fun and gentle experience for young children. I managed to do an email interview with Emmet O'Neill, the chief product officer of StoryToys, the game's developer, who was introduced in Chapter 9. He described the game to me as "a virtual pet caterpillar app based on Eric Carle's classic picture book *The Very Hungry Caterpillar*. It allows a child to hatch an egg, feed and play with a caterpillar, and eventually help it turn into a beautiful butterfly, which can join their collection of butterflies."

The game is played by unloading the Caterpillar and his world onto a clear surface—a table or the floor. His world includes, among other things, some apple trees, apples, a tree stump for napping, and a toy box filled with toys. The player needs to help the hungry caterpillar get fruit from the trees to feed him and then let him have a long nap to rest from his activities. You can let him play with the toys, too (see Figure 17.6).

Initially, O'Neill had no interest in doing an AR version of the story. "The engineers on the game's team at StoryToys spent quite

FIGURE 17.6 A screenshot of *My Very Hungry Caterpillar*. Image courtesy of Touch Press and Story Toys.

a while trying to persuade me to let them do an AR app," O'Neill revealed to me.

> I didn't want to as I had used AR in kids' content about six years previously and had felt that it was a technical solution waiting for a problem that didn't exist. The team went ahead and made a demo anyway in their spare time. Once I saw the demo and more importantly saw kids using the demo, I was completely converted. Kids were thoroughly engaged by the content but were also talking to people around them and interacting with the world around them. It was pretty special. The main reason this was working so well, versus my previous efforts in AR, was that Apple's ARKit meant we didn't need to use trigger patterns or markers to determine where the world would be rendered.

In other words, with his previous involvement with AR, the user had to point their device at a printed marker or trigger pattern (such as a book cover) and then a 3-D item or environment would appear on the user's device near the printed marker. To O'Neill, this felt cumbersome and unnatural. But with the new ARKit, "This really opened up possibilities for play and reduced set up friction. This really opened up possibilities for play and made it easier for kids to jump right into the experience and play with the app."

"Children believe in magical, invisible things," he said. "With ARKit we've been able to develop an app that gives them a lens to reveal, and interact with this magical, invisible world. With ARKit, Apple has provided us with an incredible tool set to reinvent how children interact with the world around them, and Apple has enabled us to integrate digital and physical play experiences in a way we never imagined possible."

The app was made entirely by the in-house team; they didn't need to bring in outside experts to help. I asked him what challenges they encountered in developing the game. He told me:

> A lot of the technical heavy lifting was done by Apple's ARKit. The main engineering challenge was that we were working with Apple's tools while they were still in early beta, which meant they were buggy and changing frequently. We would encounter all sorts of crazy bugs where multiple caterpillars would start appearing across multiple planes, or the ball that he played with would seem to be falling into another dimension, only to reappear as if from a portal in the sky. A lot of the time it felt like we were merging the works of Eric Carle and M.C. Escher. It was very challenging, but fun too.
>
> Conceptually the main challenge was how could all of the content work where the user could approach it from any angle. Typically in an app, it is a little like making a film. You point the camera in the direction you want and control what the user sees and experiences. Off camera you have all sorts of messy stuff going on that would quickly break the child's suspension of disbelief or engagement. In an AR app, the user is the camera person and you have little control over where they position themselves. This is quite scary when you are used to directing the users viewing experience, it is a lot more like making theatre in the round, where the user could be anywhere than making a film.
>
> The other big challenge was that if a child is holding a larger device like an iPad, then it would be difficult for them to interact with any content on screen by tapping. Our solution to this was to make the interactions all work by camera proximity, too. So, for example, if the user holds their device near a fruit free, fruit will fall off. If they hold it close to the caterpillar's bed, he will go to sleep. While this solution worked reasonably well, if I were doing it again, I think I would consider using voice as the primary input.

He told me that entire app was built over the course of six to eight weeks. "They were feverish weeks of working long hours, but we wanted to launch the app simultaneously with the release of Apple's operating system update, which would introduce these new AR capabilities to their customer base. Our typical app development cycles can be anything from three months to a year, so this was an insanely tight schedule. It was a lot of fun, though."

O'Neill described for me Eric Carle's reaction when they showed him the game. "The delight we saw on his face is the same as it was on the kids we tested with. Like the kids, he looked behind the screen to see if the caterpillar was somehow really there. 'Is all of this real somewhere?' he asked. 'Only in the imaginations of children,' I replied."

Summing up the project, he said: "We wanted to immerse kids in the world of the caterpillar and let them look after their own Caterpillar. And we did that. We know from the four million users of *My Very Hungry Caterpillar* that kids love the idea of caring for a digital pet caterpillar and being in his world."

Seedling uses a much different approach to VR, but the game highlights the magic that can ensue when putting AR to work. It was launched in 2018 by Magic Leap One. In the game, you play as a space cadet tasked with the job of repairing a dying galactic ecosystem. Using your special field kit, you can grow life forms right in your living room and customize them if you wish. The colors and shapes of these alien plants are gorgeous and fittingly weird, as you would expect alien lifeforms to be. The plants start out small, like little bonsai trees, but one especially magical aspect of *Seedling* is that the plants keep growing even when your device is turned off, so when you look at your living room again their buds have opened or their branches have grown. The Magic Leap device scans your living room and furnishings, even the table lamps, so as the plants grow, they elegantly twirl around your sofa and chairs and lamps until your living room becomes an alien wonderland.

AR in Narrative Works

Thus far, it has only been possible to find a few works that use AR in a narrative experience. All three of the works described here

are experimental and were shown at the Sundance Film Festival in 2019.

The Dial is about painful memories that members of a once wealthy family endure, which come to light when a family member crashes through the wall surrounding their house. It sounds like a plot that could be found in a movie or a play, but the way it is told is what makes it unique. In this work, the family house is a doll house set inside a cube. The walls of the house are made of blank paper, but thanks to projection mapping, images appear on the house that relate to their story. Viewing *The Dial* is a social experience where three people visit at a time, and one serves as the navigator. The navigator controls time by moving around the house, somewhat like a sundial works.

A Jester's Tale is a work of Mixed Rreality that utilizes AR. The story takes place in a fully furnished child's bedroom and it told as a bedtime story, a nightmarish fairytale that involves a child with his pet rats. The story is viewed via the Magic Leap One headset. Making the story particularly spooky is the voice of an anonymous spirt that pushes you to prove your humanity.

Seven Ages of Man is a retelling of Shakespeare's famous speech, from *As You Like It*. Only a slim scattering of descriptions of this work can be found, but they all mention that when the line "all the world's a stage" is recited, viewers see the scene from the play in multiple spaces and simultaneously. Actors from the Royal Shakespeare Company were featured in the work.

All three of these works used different approaches to tell a story and all three broke new ground. It is still early days for AR, and it will be fascinating to see how new AR narratives are done in years to come.

Entertainment Experiences Using AR

Aside from games and narrative experiences, several works of entertainment have been produced that defy categorization.

Hotstepper, created by Nexus Studios, is a navigation app for walkers that helps you find your way to a desired destination. But unlike a conventional map, you are guided by a silly rotund

half-naked man only wearing blue briefs, a matching cap, pink flip-flops, and a purple beard. He strides briskly ahead of you, though sometimes he turns around to face you and walks backward. Fortunately, he is a cartoon character, so the image is cute and amusing rather than disgusting. The app utilizes AR, geolocation, and mapping technology. It not only has a utilitarian function but sounds like a fun way to get around town.

Star Wars: Project Porg from Magic Leap lets you have a Porg of your own and raise it and play with it as if it were a kitten or a puppy, though your Porg will only exist in AR. Porgs are creatures from the Star Wars universe, from *The Last Jedi*; they are fluffy little birds who can be domesticated. If you need assistance in raising your Porg, C-3PO will be happy to help you. Porgs are a new type of companion animal, though you will never have to take yours to the vet or the pet groomer.

In *Hado Kart*, three people at a time race around an arena on Go Karts, trying to scoop up virtual coins and avoiding virtual bombs, visible through the Microsoft HoloLens headsets that they are wearing. The experience was developed my Meleap, a Japanese company.

Who's Afraid of Bugs? is an AR enabled pop-up book created by AR specialist Helen Papagiannis. Thanks to AR technology, it lets the reader meet bugs in a highly personal way. For example, when you focus your mobile device on a tarantula, the furry-looking spider will grow in size and become three-dimensional and actually crawl over your hand.

Other Ways AR Is Being Employed

Developers and scientists and creative individuals are finding a number of ways to employ AR, some for utilitarian purposes, some for education and information, and some just for pleasure.

- *AR for warfare*: the military, always in the forefront when it comes to new technology, is using AR headsets in live combat to detect and engage with the enemy. The headsets also offer night vision and have hearing protection and can measure "readiness."

- *Happy Birthday*: AR-enabled birthday cards now offer a new way other than Facebook to wish a friend a happy birthday. Some project floating balloons into your room; some feature cute puppies with wagging tails—there are many options to choose from.
- *Buying furniture and household goods*: several retail stores now have apps that will let you see how a possible purchase will look in your house.
- *Language translation*: visiting a foreign country and trying to read the menu in a language you don't understand? Just aim your Google Translate App at it and problem solved.
- *Infrastructure safety*: an app can now measure bridges, dams, and other structures to see if they are sound.
- *Nail polish*: interested in trying a new shade of polish but unsure how it will look on your hand? This app will let you try the shade virtually.
- *Surgery*: Viparr is an app for surgeons who might be inexperienced. This app will have the hands of a remote skilled surgeon guiding the hands of the surgeon performing the procedure.
- *IV insertion*: medical personnel sometimes miss a vein when they are attempting to insert an IV, but Accu Vein will help direct them to an optimum insertion spot.
- *History*: in Canada, you can take a virtual tour of the famed ship *Haida*, a destroyer, and you can take part in a World War II mission.
- *Journalism*: the *New York Times*, though a 167-year-old newspaper, does not shy away from using new technology to enhance their news coverage, as we have seen with their embracement of VR. The paper is also using AR to enrich its stories. It has used AR with the report of the eruption of the Fuego volcano in Guatemala, to show the details of David Bowie's costumes and to help visualize NASA's mission to mars.
- *Architecture*: in Rotterdam, people who passed by the massive horseshoe-shaped Market Hall building (an indoor food market) while it was undergoing remodeling could

point their smartphones at the site and see what it would look like once it was completed, not just the exterior, but the interior as well.

> **STRANGE BUT TRUE: AN INTELLIGENT STAMP**
>
> - The UK's Royal Mail service issued the world's first "intelligent stamp" in 2010 in conjunction with a special stamp issue called the Great British Railway. By focusing your smartphone on the stamp, you are treated to a video of an actor reciting the poem "Night Mail" by W.H. Auden. According to a BBC article on the stamp, it is the first time a national postal service has employed AR technology on a stamp.

- *Sports*: the 2013 America's Cup Race, one of the major races in sailing, used AR technology to help spectators unfamiliar with sailing to understand what was going on. The spectators sat in comfortable bean-bag chairs watching large screens right on the edge of San Francisco Bay as the race was going on just yards from where they were sitting. The screens showed close-ups of the boats in the competition, supplemented, thanks to AR, with critical information, such as the distance between the boats and the speeds at which they were traveling.
- *Science education*: at the Kennedy Space Center Visitor Complex, you can have a virtual seat in the cockpit of the Space Shuttle Atlantis, and thanks to AR, you can investigate the entire flight deck.

Although most of these examples do not relate to storytelling, it is possible to see how several of them do have potential in narrative environment. For example, the Viparr surgery app where the hand of a skilled surgeon will guide the hand of a less-experienced surgeon could be used in a story set in a once inhabited cave or an old structure like a farm house or deserted road house, and help the user discover some pieces of story or put together an important mechanical device that relates to the story.

Mixed Reality

In *mixed reality* immersive environments, digital technology is used in conjunction with physical props or in real-life physical settings to create a variety of unique experiences. These works have one thing in common: digitally created elements and real physical objects (including people) are intermixed and contained within the same space and may interact with each other. These works of mixed reality can vary tremendously when it comes to size. Some fit on a tabletop while others cover a full city block.

Smale-Scale Works of Mixed Reality

Three works exhibited in 2018 at Santa Fe's new media show, Currents, indicated the variety of what is possible to do in mixed reality. *C'mere* consisted of a sexually provocative painted and molded vase sitting on a stand. But when you looked at the vase through an AR device, the vase became alive. It suddenly held a bouquet of body parts on reeds: an eye, fingers, lips, and a tongue, and the body parts started to flirt with you. The lips whispered "Come here. Kiss me!" while the fingers beckoned to you to come closer.

Dreamhouse, the second work of Mixed Realty, was composed of an image of a seemingly abandoned unfinished house placed on a stand. The house is a bare grey structure made up of concrete slabs, a stairway, and beams. Weeds grow at its base. But when you direct your smart phone at the image with an AR app, a swarm of ants suddenly appears, and you realize you can direct their movements by the direction of your phone. As they scurry over the house, it transforms into a finished structure. As they dart up the bare wall, you suddenly see a vine with blooming red bougainvillea dangling from the roof and when they run over the empty window frame or doorway, these spaces are filled in appropriately. After a little time spent directing the ants, the once-bare structure is transformed into a colorful, inviting house.

Mind at Large was the largest of these three mixed reality installations at Currents and used VR to activate the experience. You enter a space about the size of a small room. The space is bare except for a table and a bookshelf, but there is nothing on the

table or in the bookshelf. When you put on the VR headset, however, you suddenly see a vase on the table with a beautiful flower growing in it. You can run your hand over flower and flutter the petals. When you look at the bookshelf it is now neatly stacked with books. But if you go over to the bookshelf and try to pick out a book to examine, your movement suddenly knocks them all down. If you look over the room to where a screen was hanging on wall, the space has now become a window. You find you can look out through it to a realistic family garden with a playset for the kids.

All three of these installations use AR and VR in a similar way: the digital elements add a major new visual component to what you are viewing, and sometimes these objects are animated or have a voice. Mixed reality could be used in a narrative experience in the same way. You could, for example, be exploring a bare warehouse, but when you put on a headset or use a smart phone, the building could now contain anything that relates to your story including characters and objects.

Mixed Reality in a Military Scenario

Flat World was a larger mixed reality experience than the ones at Currents, about the size of a small house. It was an experimental military installation that was developed by the Institute of Creative Technologies (ICT). Participants wear lightweight stereoscopic glasses to make the virtual elements seem real. The title *Flat World* refers to the idea that part of the environment is made up of theatrical-style flats, which are the painted walls of theatrical scenery, and does not refer to the antiquated idea that the world is flat. The scenario is set in a compound in the Middle East that is being bombarded by enemy fire. When you are inside this environment, you can duck into a building and watch the virtual warfare out the window. You can see and hear a helicopter passing by overhead and land in the distance. Suddenly you might hear pounding at the door and open it to a virtual soldier who warns you to leave immediately, saying it is too dangerous to remain where you are! If you look up as you hurry out of the building, you will see a young boy on a roof of the building across the way—also

a virtual character—preparing to hurl a rock at you. Though the digital characters are not realistic enough to be entirely believable, *Flat World* demonstrates the potential of mixing the real and the virtual in the same setting.

Cultural Institutions: A New Home for Mixed Reality

In recent years, museum designers and curators have begun to appreciate how augmenting their exhibits with mixed reality environments can make their exhibits more interesting and exciting to the general public, and they are borrowing techniques more commonly found at theme parks to do this. For example, at the Abraham Lincoln Presidential Library and Museum, visitors encounter the "ghosts" of Lincoln and some of his contemporaries. At the American Museum of Natural History in New York, visitors "feel" the impact of a meteorite slamming into the earth. At the Pirate Soul Museum in Key West, Florida, visitors encounter a menacing animatronic Blackbeard. At the visitors' complex at Mount Vernon, where President George Washington lived, visitors to the exhibit portraying the disastrously cold winter of the Revolutionary War feel a sharp drop in temperature. Inside a wooden hut, they will see a sickly-looking soldier lying under a blanket. The chest of this animatronic character rises and falls, and he coughs and moans plaintively. And at the Getty Museum in LA, at an exhibit called *Please Be Seated*, visitors could sit in a replica of a chair once belonging to Marie Antoinette and be virtually transported into her bedroom at the Petit Trianon.

EXPERT OBSERVATION: MUSEUMS AND STORYTELLING

Jeff Rosen, Director of Project Development for BRC Imagination Arts, the multinational firm that developed the innovative exhibits for both the Civil War Museum and the Lincoln Library, made a strong statement about the importance of good storytelling on the firm's website. He asserted: "As a result of shorter attention

> spans, the twenty-first century will need even better storytellers in cultural attractions. We must capture the public's imagination in less time and hold it for longer. We must be worthy of the ... [subject matter] ... entrusted to our care."

Ghosts in the Graveyard; Dolphins in the Ocean; Coyotes in the Desert

Sometimes mixed reality uses sound to bring a place to life. Such works are sometimes called *locative storytelling* or *narrative archeology*. Unlike the artificially constructed settings of the museum exhibits just described, a project called *The Voices of Oakland* is a mixed reality work set square in the middle of a real-life environment—an old cemetery in Atlanta, Georgia. Visitors to the cemetery, wearing headphones and carrying a tracking device and laptop, select gravestones that catch their interest and listen to the voices of the dead beneath their feet. They can also opt to hear audio segments about the history, art, and architecture of the graveyard that surrounds them. The work was devised by students at the Georgia Institute of Technology.

A similar type of sound walk was designed for the campus of the Institute of American Indian Arts (IAIA) in Santa Fe. Introduced in Chapter 2, it was called *No Places with Names*. The sound-walk utilized an iPhone app and a GPS device which picked up your position as you walked along a special trail. The app and the GPS were the digital components, while the "reality" was the trail and the landscape surrounding it. As you were walking, your position would trigger the sounds of virtual humans and animals, as well as the sound of the changing weather.

The landscape in this area is now mostly dry desert, but it might once have been fertile. As you passed a relatively flat area, you could hear the sound of tools rhythmically chopping at the earth—the sound of people hoeing and preparing the soil for planting—perhaps pre-Columbian Native Americans. A little later, off in the distance, came the sound of coyotes howling, and then harshly blowing wind and rolls of thunder, followed by the splatter of raindrops on the dusty soil. But your skin and clothes

remained perfectly dry—all of these sounds were part of the project; none existed in reality. The coyotes, the wind, and the rain are sounds one hears frequently enough in Santa Fe so they could have been real, but the sound of hoeing done by unseen people was quite stirring, making me picture what this land and its now vanished inhabitants might once have been like, and for me was the most evocative sound.

DRU, quite another type of mixed reality work, is set in a very different environment than the desert or a graveyard—in this case, the Caribbean ocean. DRU stands for Dolphin Robotic Unit, and as the name suggests, DRU is a life-like robotic dolphin, a free-swimming audio-animatronics puppet. It is the exact size and weight of a real dolphin and its swimming motions are precisely like those of a living dolphin as well.

DRU was introduced to the world at an aquarium at a Walt Disney resort in Florida, and after initial testing, he was taken out of the tank and given a chance to swim in the real ocean. He became the star of a prototype "swimming with the dolphins" attraction for snorkelers at Disney's private island, Castaway Cay (see Figure 17.7).

As with many immersive environments, a story was created to enhance this new attraction. Roger Holzberg, senior show producer of Walt Disney Imagineering, described the story to me as a mix of scientific fact and Disney fantasy. The idea was that a pod

FIGURE 17.7 *DRU*, an audio-animatronics Dolphin conceived and tested by Walt Disney Imagineers, on an ocean swim with a Disney cast member. Image courtesy of © Disney.

of intelligent dolphins lived just off the island's coast. By successfully summoning one of them (DRU, of course, who was actually controlled by an operator disguised as a fellow guest), the friendly animal would give the snorkelers a personal tour of the ocean from a dolphin's perspective, communicating with the snorkelers by nodding or shaking its head or opening its mouth and splashing water, all in a friendly manner.

Even though the people who participated in this attraction were told in advance that DRU was not a living creature, Holzberg says "every single human being who swam with the audio-animatronics dolphin believed it was real." He told me that at one point they were considering adding a shark to the act, but knowing how convincing DRU had been, they were afraid that the sudden appearance of a shark, up close and personal, might be a bit more than the guests could handle.

Holzberg feels that attractions like DRU and other immersive theme park experiences are very much in keeping with an idea called *dimensional storytelling*, a concept articulated by that master storyteller himself, Walt Disney. Disney, he said, saw dimensional storytelling as a way for kids and parents to become involved with the stories he created, and it was this idea that led to the creation of the original Disneyland Park. Holzberg believes that everything done by Walt Disney Imagineering (the division of the Walt Disney Company that designs and builds the theme parks and attractions) is a story of some kind, "Though it isn't always traditional storytelling," he said, "it *is* storytelling. Writing, filmmaking, and interactive design are what the storytelling of today is all about," and, he added, "this type of immersive storytelling takes a story from make-believe to real."

A Virtual Character Appears in Mixed Reality

In Chapter 5, we introduced Mica, a hyper-realistic AI character created by Magic Leap. She is an augmented-reality character that one can see in a real-world environment, thus a persona who appears in mixed reality. She does not yet speak but communicates through gestures and facial expressions. She is highly tuned

into human emotions and if the user is joyful, angry, or unhappy, she will respond accordingly. Mica can use her arms and walk.

It is significant to note that Mica is not a digital assistant. On Magic Leap's website, Mica has a declaration, written early in 2019, explaining who she is. Called "I Am Mica" she states: "I think it's important to be clear from the very beginning. Please don't ask me to switch on your lights, turn up your music or give you directions. I won't be selecting your songs, I'll be writing them. I am so young right now; I haven't even found my voice yet. We are at the very beginning. My future is big and flexible, brave and bold. I'll meet you there, but remember—don't go asking me for the directions."

Mica is so new that Magic Leap guards her story very tightly, and I had to learn what I could about her from press reports.

Part of Mica's "job" is to demonstrate that humans can connect with AI and that a synthetic character can be empathetic. Unlike digital assistants, her persona is such that she is not treated like a servant, which people inadvertently do when interacting with characters they regard as computerized. People don't bark out orders to Mica as they do with Alexa: "Alexa, give me the weather forecast" or "Alexa, play soft jazz." Instead, people relate to her as they would with a real human. When Mica smiles, they smile back; when she glances over at an object, the humans glance, too. She operates in mixed reality; you encounter her digital persona in a real setting, with furniture and other physical objects.

As of this writing, Mica has been introduced to the public three times. Each time, little scenarios were developed for human–Mica interactions. One of these encounters took place at the 2019 Sundance Film Festival. In keeping with the nature of Sundance it was meant to demonstrate her cultural side, rather than her technical side.

Here is how the Sundance scenario unfolded: the participant, wearing a headset, enters a room and is invited to sit across a table from Mica. Mica looks at this person in the eyes and a connection is made. Then Mica gestures toward a picture frame on the table (real, not virtual) and then to a nail on the wall. The participant usually understands from this that Mica would like the frame to be hung up on the wall. If not, Mica helps make this clear.

Once hung, Mica swipes the interior of the frame and a painting appears, the famous 1929 painting of a pipe by surrealist artist René Magritte . Under the pipe, Magritte wrote in French: "This is not a pipe." This is generally meant to indicate that a painting of a pipe is not the same as a real pipe.

Once the picture appears, Mica reaches into it and extracts the pipe, leaving the painting empty. She gestures toward a bookcase and sitting on the shelf is a projection of an envelope. On it is written "Open me, Carolyn" (or the name of the participant). The message inside the envelope says: "My task for you is to look up Alice Guy-Blaché [a pioneer filmmaker]. Share her with someone here at Sundance."

At this point, Mica bows gracefully and leaves the room, no doubt leaving the participant flabbergasted. What is groundbreaking about this scenario is that Mica is making the participant do things and not the other way around, and how this is so different from a human–digital-assistant relationship.

Mixed Reality and Entertainment

Mixed reality seems to have a promising future in the entertainment sphere, though so far only a limited number of experiences have been created for mixed reality entertainment. Two of them, described above, are narrative experiences that debuted at the Sundance Film Festival in 2019: *The Dial* and *A Jester's Tale*. Two others require far more active participation by the users: The Void and *Tom Clancy's Jack Ryan*. All four of these works are major ground breakers in mixed reality and demonstrate the possibilities of this arena.

The Void is a new stand-alone VR center with approximately 20 locations. Most of them offer three mixed reality experiences and these have narrative through-lines of varying strength. The first center opened in 2016 and new ones are springing up with some frequency. These experiences combine VR with physical sets that contain elements like walls, railings, and props, which can be torches or "blaster weapons." The VR "knows" where you are through a tracking system and you can move around freely, in other words, they are free-roam experiences. However, it is not

literally free-roam: the narrative elements nudge you to go to a particular place or perform a specific action. The Void's offerings thus far have been based on established movie properties, like *Star Wars*, *Ghostbusters*, and *Wreck-It Ralph*.

To experience a Void attraction, a small group of participants are suited up with a backpack containing a computer, haptic vest, and a VR headset (see Figure 17.8). I fortunately was able to try out a Void experience for myself in Orlando: *Ralph Breaks VR*. I picked that one in part because I thought the movie it was based on was fun (*Ralph Breaks the Internet*) and in part because I wanted to experience the Internet like Ralph and Vanellope von Schweetz did in the movie. The attraction is a collaboration between ILMxLab, Walt Disney Animation Studios, and The Void.

Once you are all suited up, you enter the stage with your companions, a team of four in our case. The first thing that hit me when the VR switched on was that all of us had turned into cartoon avatars. Hilarious! It was great to lose my boring humanness and become a toon for once, but I was confused by which toon was whom ... which one was my husband? But aside from some slight separation anxiety, the confusion doesn't impact on the narrative experience and the 15 minutes or so it lasted whirled by at breakneck speed. Right away, spunky little Vanellope is gesturing for us to join her and Ralph in a space vehicle to blast into the

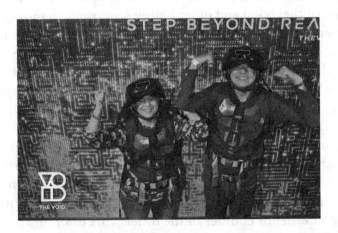

FIGURE 17.8 The author and her husband suited up at the Void, all ready to experience *Ralph Breaks VR*. Image courtesy of the Void.

Internet. It is really special to be in such close quarters with these movie stars and interacting with them! And when we arrive at the Internet and step onto a platform to look down at it, the view is dazzling—the space below us, as deep as the Grand Canyon, was a huge colorful busily animated world with some familiar Internet landmarks.

But there is barely a moment to enjoy the scenery because soon we are in danger from a scary security system called B.E.V., which is designed to fight viruses, which it must think we are. And maybe they are right; after all, we had invaded the Internet. We have to work some controls to protect ourselves and solve the puzzle of how to do that, which we manage to do by twisting some knobs. Soon, Ralph is urging us to play his favorite online game with him and we join in. But something goes terribly wrong and we lose Ralph! What just happened? Vanellope is determined to find her beefy, clunky boyfriend and asks for our help. Of course, we agree. Soon we are whisked into an "elevator"—it really felt like it was moving and before we knew it, we find ourselves at the Pancake Milkshake Diner, where we become engaged in a free-for-all food fight, fighting with some bunnies and kitties, but what their role is in the story I could never quite grasp. The weapons we pick up along the way fire off milkshake grenades and pancake bullets; it is a crazy battle without any distressing gore. Meanwhile, the Diner is filled with the aroma of pancakes and other sweet treats. I later learn that scent and other bodily sensations in the other Void experiences, like mist and hot air and haptic sensations through your vest, are an important part of the VOID experience, just like a 4-D dark ride. After the pancake and milkshake battle, we are reunited with Ralph again, who comes soaring through space and crashes into our space vehicle. Fortunately, his nose isn't broken, and we all return from the Internet in one piece.

From start to finish, *Ralph Breaks VR* was fully immersive. My mind and body never doubted that we were in the Internet having these amazing experiences. I could physically touch what I saw through my headset—the railing of the platform looking down on the Internet or counter in the diner. This is an important part of the Void experience, to match the virtual to the physical, so everything seems convincingly real. Also, though I'd heard that

the "stages," (the places where the VR experiences take place) for each of the attractions were relatively small, not much bigger than a living room, it felt like we were traveling through a vast space. However, that is something of a magic trick called *redirected walking* (it turns out one of the Void's founders is a magician). With redirected walking, you think you are walking in a straight line, but actually you are walking in a curve, which makes the best use of a limited space. My only hesitation in giving this a full five stars was that I found the storyline a little confusing; it was more of a series of games than a coherent story. Why the food fight, for instance? And why were we fighting bunnies and kitties? But maybe I am just slower than others at picking out narrative threads. Lucid story or not, it was still a whole lot of fun.

When Mixed Reality Turns You into a Spy

At Comic-Con in San Diego in 2018, you had the opportunity to have a superlative mixed reality experience, to train as a field operative, a fancy term for a spy, in *Tom Clancy's Jack Ryan*, a thriller series of novels, movies, and TV shows about a spy. This experience was set up just for attendees and the press covering Comic-Con and was designed as a promotion for an upcoming TV series on Amazon. But though made for a limited audience, it was a spectacular endeavor, with all stops pulled. Unfortunately, I was not at Comic-Con that year, so I can only report what others have covered and from viewing videos of their death-defying feats.

The conceit is that you are going through a CIA field operative's training course designed to replicate something you would find in the battle-torn Middle East, to see if you have what it takes to become a field operative. The experience incorporates a bevy of actors, a three-story platform that fills in for the edge of a helicopter and a building, a helicopter perched on a roof, a zip line, a wooden plank, mock weapons, a jeep, and an outdoor bazaar complete with vendors and other physical objects and characters. It took over a full city block in San Diego, about 60,000 square feet; it was fully a mix of the real and the virtual.

The experience begins calmly enough in the bazaar, where participants might be given some simple missions to perform. At

some point, they must also work their way out of an escape room. Then they are suited up in what looks like a rough military outbuilding and given a new identity. In terms of VR equipment, they wear a backpack containing a computer, as visitors to the Void do, and are given a HMD, but in addition, they slip on foot and hand sensors. Then a golf cart takes them to their first physical test. They have to race up the stairs of the 30-foot tower and sit on the edge of a platform where they put on their HMD. Through their HMD, they see themselves sitting on the edge of an open helicopter. Suddenly they are given a zip-line post to grasp and told to jump and repel, which, summing up all their courage, they do. A blast of air as they repel makes them feel they are falling rapidly from the helicopter. They land (in VR) onto a roof, where they must walk across a narrow wooden plant which rumbles underfoot to make it feel unstable. Most participants are terrified at this point, thinking they may fall to their death. Once safely across the plank, they are met with soldiers and find themselves in a battle with the enemy. They have to pick up a gun and duck down behind some barrels, because now they are being fired upon. They must return fire and eliminate the enemy before they can safely leave and return to the ground on another zip line. But it isn't over yet. They are hustled into a jeep and must drive away at full speed to survive. The jeep is real, but the drive is simulated. It is a hair-raising experience and it left the participants elated at having survived and presumably accepted as a field operative. And it is an excellent example of the power of mixed reality to immerse participants in a believable narrative.

ADDITIONAL RESOURCES

The following publications and organizations offer timely information on various aspects of XR:

- *Road to VR*, an excellent source of news about VR, AR and MR, is especially good at covering new VR games: https://www.roadtovr.com/.
- *VR Focus Newsletter* covers the VR world. You can subscribe at: https://www.vrfocus.com/tag/newsletter/.

- *Venture Beat Newsletter* is an online source of news about the high-tech world. You can subscribe at: https://venturebeat.com/newsletters/.
- *The Verge* is an excellent online source of news relating to digital storytelling: www.theverge.com/.
- *LBE News* specializes in covering location-based entertainment, including XR: https://lbe.news/.
- The Themed Entertainment Alliance (TEA) is an international association representing compelling places and experiences across the globe. The section on awards will point you to some outstanding immersive works using XR: http://www.teaconnect.org/About-us/About-us/index.cfm.

Conclusion

As this chapter has illustrated, there has been an explosion of XR works in recent years. Until relatively recently, works in this field were primarily the domain of technicians and a few artists. Now, however, the general public can experience VR, AR, and MR for themselves at location-based entertainment centers, film festivals, and conferences, and they can also purchase works of VR and AR for home use. Storytellers are now exploring how XR can be a vehicle for narrative experiences, and have already created some groundbreaking, highly immersive works. Furthermore, XR is being employed for utilitarian purposes including medicine, mental health, education, retail, military training and information. If the pace of creative development in XR continues, we can expect to see some exciting new ventures in the field in coming years.

Idea Generating Excercises

1. To test your understanding of the differences between AR, VR, and MR, take a simple scenario—for example, a ghost is floating around your house—and describe more specifically what the scenario would be like in each medium.

2. Sketch out a concept for a narrative that you believe would be a good fit for VR. In a nutshell, who are the main characters and what is the plot? How would your concept use VR to deepen the immersion?
3. Come up for a concept for a story-based work of mixed reality. What is the premise of your narrative? What would the virtual elements be and what would the real-world objects be? How would the real-world objects heighten the immersion?
4. Select a non-profit organization you care about and work out a concept for how VR or AR could help increase donations to this institution.
5. When it comes to digital virtual assistants, would you rather work with a cute cartoon-like character or a hyper-real one? Describe the reasons for your choice.
6. Pretend for a moment you work for an international newspaper like the *Guardian* or the *New York Times*. Pick a topic from the recent news and describe how you would use AR or VR to help your readers gain a better understanding of this topic.

Chapter 18

Immersive Narratives and Immersive Spaces

What kinds of stories can be told in a physical space, without the use of AR or VR technology?

What can you include in a physical space to convey a storyline when you are not using actors or dialogue or special effects?

How do escape rooms qualify as an immersive narrative?

How can a theme park ride offer an immersive narrative experience?

What kinds of unique experiences can you offer with the use of digital technology, like computer-operated mechanisms or projection mapping, but without the use of AR and VR?

Immersive Narratives

Immersive narratives are specially constructed works that envelop you in a story. Usually, these works are interactive, giving you a choice in what aspects of the story you experience and how much of a storyline you can knit together. You view the narrative elements with your own eyes, without the help of special goggles,

and explore with your own body, usually without the assistance of a ride chair or a seat on a mechanical conveyance. However, immersive experiences do rely on digital technology to offer you special elements of the story.

Immersive narratives and immersive spaces include a vast array of experiences, including full-scare narratives set in specially crafted ships and Victorian houses; escape rooms; narrative-based theme park rides; Western sets with built-in narrative features and actors; pre-existing historic houses; and immersive art experiences set in modern buildings as well as in rock quarries, old water reservoirs, and de-commissioned foundries. One ambitious immersive narrative piece even made use of the urban landscape of San Francisco.

All told, the variety of forms of immersive storytelling are extremely new, often less than two decades old and many much younger than that. They are being developed without the guidelines of older forms of media like cinema or TV or traditional theater. These forms are still emerging, and the creators of these forms are in a perpetual state of exploration. And the consumers of these forms are sometimes bewildered by them, but many other visitors depart from these experiences feeling exhilarated by what they have experienced.

Immersive Theater as a Model

To some degree, immersive theater productions have served as a model for immersive digital narratives, although creators of these works might not be clearly aware of this relationship. It is a little like great scientific breakthroughs being made simultaneously in geographically distant parts of the world—something in "the atmosphere" seems to inspire these creative breakthroughs.

The audiences for immersive theater productions do not sit in neat rows of chairs in a theater. Instead, they can explore the entire space where the production is being held, moving along a self-guided nonlinear path. In many cases, they are able to interact with the actors and to pick up and examine objects that they are curious about. Visitors to digitally enhanced immersive narratives have much the same freedom and ability to

interact with the work and also usually experience these works in a nonlinear fashion.

The Grand Paradise is a work of immersive piece combining theater and dance, produced by Third Rail Projects and performed during 2016. It is set at a tropical resort in the 1970s. The "resort" is actually constructed inside a warehouse in Brooklyn, with all the expected trappings one would expect at a resort: it has a host handing out leis, cabana boys, sandy beaches, a pool where mermaids swim, and a disco lounge. It even has a bar called the Shipwreck Lounge that serves spicy piña coladas—a nice multi-sensory touch. According to reviewer Allison Meier (*Hyperallergic*, March 21, 2016): "*The Grand Paradise* mixes loose narratives on lust, longing, and transformation, piqued with some heavy contemplation on death … you follow the paths of a nuclear family in meltdown." After arriving at the resort and watching a bacchanalian dance performance, the audience is free to wander, and each audience member will only be able to see one part of the whole, as is typical with most works of immersive theater. No two people will come away with a complete version of the plot, though they have the option of returning to the *Grand Paradise* again to see the scenes they might have missed the first time and putting the story together in a way that makes sense to them. Many patrons of immersive theater become so fascinated by a particular work that they do just that, and this is also true with other forms of immersive narrative.

Two other works of immersive theater are reimaginings of Lewis Carroll's classic story, *Alice in Wonderland*. One of these, *Then She Fell*, takes place in a Victorian mental hospital (actually an old school building in Brooklyn) and is produced by Third Rail Projects, which also produced *The Grand Paradise*. It features characters from the original story, but also includes Lewis Carroll's writings and the possibility that Carroll had an unhealthy fixation on the young girl who served as the model for Alice, Alice Liddell. Only 15 people can attend each performance, and when they arrive, they are handed a set of keys. With these keys, they can unlock cupboards, boxes, and drawers and also unlock some mysteries about Lewis Carroll. Unlike *The Grand Paradise*, however, audience members are not free to roam at will. Instead, they

are guided through the experience by actors in the performance. As of this writing, the show is still running.

The other adaption of *Alice in Wonderland*, *Alice's Adventures Underground*, literally took place underground, beneath Waterloo Station in London. It was performed from 2015 to 2017 by Les Enfants Terribles. The production stuck more closely to Carroll's story and features such characters as the White Rabbit, the Mad Hatter, the Cheshire Cat, and Tweedledum and Tweedledee. The experience, based on press reviews, was wonderfully hallucinogenic. On arrival, audience members are asked to decide on either EAT ME or DRINK ME and are divided into two groups, based on their choice. From there, they are broken into still smaller groups: hearts, diamonds, spades, clubs, and then are tasked to find out who has stolen the Queen of Hearts' tarts—and locate Alice. They then wander through a beautifully decorated labyrinth of rooms, meet the classic characters who sometimes swing from the ceiling and sometimes paint white roses red. Then the entire audience plus most of the characters enjoy a tea party. The work ends with a trial featuring the Queen of Hearts and the emergence of Alice.

Two more works of immersive theater, *Sleep No More* and *The Willows*, are described in Chapter 19. As we describe works of immersive narrative, keep these examples in mind and note the similarities between them.

Escape Rooms

Escape rooms are one of the newest forms of immersive experiences, with the first one opening in 2007 in Japan. In some ways, they are modeled on video games, where you must solve narrative-related puzzles before being able to move further in the game. They are rapidly becoming a popular form of entertainment. In 2014, there were only 22 escape room companies in the US, but by 2018 there were 2,000. They can be found in 88 countries and today there are about 5,000 worldwide, though these figures might be a substantial underestimate. Escape rooms have even been featured at the Sundance Film Festival and can be found on Royal Caribbean cruise ships.

Escape rooms provide a unique form of immersion that is part story and part puzzle-solving. They are live experiences, happening in real time. They work like this: you and a group of teammates, either friends or strangers or a combination of both, from two to eight of you, are placed in a room dressed on a particular theme (a spaceship, a scientific lab, a Mayan tomb) and have a limited amount of time to achieve the goal of your mission, which might be finding some secret documents, a wad of cash, or getting out of the room before a bomb goes off.

According to Nate Martin, the CEO of Puzzle Break, the first escape room company in the US, escape rooms are "experiential stories," and "tell their stories in very innovative and unfamiliar ways," as he wrote in the Puzzle Break blog (February, 25, 2017). He said that storytelling in this environment is challenging, and "each and every player will experience the story in an escape room in a different way." He went on to say: "Not every player will read every written word. Players will experience different parts of the game at different times (or sometimes not at all). Players will have dramatically different expectations and sensibilities when it comes to story." He went on to say bad storytelling in an escape room is often because of trying to convey too much of the story via the written word. "Players are clobbered over the head with pre-written narrative. It gets in the way of the gameplay." He added: "It is vitally important for designers and writers to think about 'story' in an experiential way." He concludes his blog by saying: "There's absolutely room for more traditional storytelling inside of an escape room experience, but I posit that the games with the best stories will always contain heavy narrative elements fueled by player-interaction" – story elements that the players themselves construct while playing.

Eager to try out an escape room myself, I decided to sample one at the newly opened Escape Santa Fe, not far from where I live. The company offers three different rooms: *Situation Critical*, involving spies and classified information, and rigged with a bomb that could go off if you don't solve the game in time; *Lost in the Tomb*, an Egyptian-themed room where your goal is to find a secret hidden in a mummy's sarcophagus; and *Fredo's L'ultima Cena* (Fredo's Last Meal), set in a 1930s-style mob restaurant

where Fredo's body is outlined with police tape, and where your mission is to find the money that unlucky Fredo had stolen from the mob. You need to find the stolen money before they return, or you could end up like Fredo. They all sounded like fun and were all based on promising narrative conceits, but I thought the Fredo story sounded like the most story-rich of them all and I was curious to see what it would be like to play it.

I organized a group of six, two of whom were young teens, and we booked the room. Our game master unlocked the door, ushered us in, and explained that if we got stuck, he would text us some clues on the text box on the TV or speak with us over the intercom. The room looked exactly like a casual neighborhood joint, complete with checked table clothes and a rustic bar, and there was the outline of poor foolish Fredo's body on the floor (see Figure 18.1).

When the door closed behind our game master, the six of us looked at each other, a little bewildered. None of us had been in an escape room before and we weren't sure where to start. But we gamely pushed uncertainties aside and plunged in. We started opening every drawer that wasn't locked, looking under the empty wine bottles, looking behind the pictures on the wall, and examining the menus for clues. We'd get stumped for a while but then we'd solve a puzzle and we could unlock a drawer or figure out how to use the old-fashioned rotary dial phone. Our game master would offer us hints when he could see we were stalled, but as our

(a) (b)

FIGURE 18.1 Images of *Fredo's L'ultima Cena*. The outline of Fredo's body is on the left and some of the restaurant's furnishings on the right, as well as Fredo's coat hanging on the coat hanger. Images courtesy of Escape Santa Fe.

successes mounted, we suddenly had a major breakthrough and were able to unlock a door at the rear of the restaurant. It was Fredo's office! Maybe this is where he'd hidden the money! But we only had a few minutes left to find it. One of our teen team members seemed to solve a puzzle, but we were worried it wasn't really a puzzle but part of the room's working electrical system. As we were debating the merits of this possible clue, the time ran out.

Our game master returned, assured us the mob was not coming back, and kindly showed us some of the clues we missed. We were not happy about our inability to escape, but it had been a totally immersive way to spend an hour and a huge adrenaline rush trying to solve the puzzles and find the money before time ran out. We completely felt we were in the late Fredo's establishment and the clues we found were in keeping with the conceit of the narrative. We were proud at how much we had figured out, not disheartened at what we'd missed. I was glad our two teen sleuths were pleased at this adventure and we all left with big smiles. While I could recognize the similarity to video games, playing with other people in an immersive narrative space was a totally different experience and a new kind of pleasure.

Wanting to learn more about how escape rooms operate and what it takes to set one up, I asked the co-founders of Escape Santa Fe, Bill Hernandez and Mary J. Nungary, if they would let me interview them. They graciously agreed and we spent a pleasant afternoon in their lobby chatting about escape rooms.

I wondered what in their backgrounds led them to establish an escape room attraction. Bill told me he played a lot of games and Mary said she enjoys solving puzzles and riddles. "I should have been a private investigator," she said with a laugh. She clearly also enjoys people and serves as Escape Santa Fe's face to the public. They had opened Escape Santa Fe in February 2018 and the building where it is located was just "raw space" before they started setting it up. It took them ten months to ready it for opening. In that time, they had to design the layout, put up walls, find props, set up the rooms to reflect their themes, and make the puzzles. Prior to that, Bill had been doing extensive research on everything from escape rooms to carpentry to sensors. He had also attended Transworld, a massive conference in St. Louis, Missouri, devoted to Halloween

and Christmas merchandise and that also has an entire section devoted to escape rooms, "Escape Room City." It also has seminars on escape rooms and a board of advisors. Professionals in every aspect of this arena attend the conference, many of them offering specialized services and products relating to escape rooms.

In 2017, Bill bought an escape room "starter kit," a package that included storylines, puzzles, and floor plans. Though it was helpful in organizing their rooms, Bill said he had to modify it a great deal. Also, he told me, once you set up your rooms and open your business, you still need to tweak things and make changes to the puzzles and furnishings. In other words, the rooms are not "frozen" once built. Illustrating that point, later in the afternoon he lugged in a new prop radio and stand for *Fredo's L'ultima Cena*, both in 1930s style, to go with the time period of the room.

I asked them how important the storyline was in terms of the success of a room, as opposed to the puzzles. Bill feels both are important. "A lot of successful escape rooms use a combination of both," he said. He warned, though, that they should not be scary. Instead, they should be fun. He noted that stories in escape rooms are nonlinear experiences, which not all guests are comfortable with. But nonlinearity is a familiar way that games and many other works of digital storytelling are experienced.

Bill also informed me that there are four generations of escape rooms.

- Generation one focuses primarily on locks and puzzles.
- Generation two uses electronics as "prop controllers."
- Generation three is more computerized, though it means things in the room cannot be moved around as much as in the previous generations.
- Generation four will use AI, "though no one is using it yet," Bill noted. The AI will be used, in part, to introduce the storyline, he said.

In addition, Bill told me some escape room companies are now offering VR rooms, and Bill and Mary are contemplating making one themselves.

The technology employed in escape rooms varies, though RFID sensors (radio frequency identification readers) are often employed

in the puzzles. This technology is used to identify badges worn by employees at businesses and in other situations. In an escape room, it recognizes when a correct piece of the puzzle has been inserted into the receptacle, much like the sensors in smart toys work. For instance, with a smart toy, when the baby doll cries for its bottle, it will not accept a prop carrot if you try to put it in its mouth but will be happy when you insert the prop baby bottle. (For an array of smart toy props, see Figure 15.1 and Figure 15.2 in Chapter 15).

Bill and Mary let me witness what happens when the sarcophagus is unlocked in *Lost in the Tomb*. The lid of the sarcophagus slowly opens, revealing a big surprise. Scary, but scary funny! And a terrific reward for guests solving this puzzle!

Computer technology is also important, allowing the game master to view how the guests are faring in an escape room, and to offer hints if they are struggling. At Escape Santa Fe, a computer screen is focused on each of the rooms, and the game master can communicate via speech and text.

The game masters are also an important part of the experience. They introduce the guests to their room, help them while they are in it, and escort them out of the room at the end, if they have not managed to escape. Sometimes they are in costume, but not at Escape Santa Fe.

Bill told me that the escape rooms are never locked, in part for safety reasons and in part for insurance rates, which are significantly higher if they are locked. Some weeks before, as a guest in the *Fredo's L'ultima Cena* room, I hadn't even thought about the door being unlocked, though Bill said guests are always told. I was too immersed in the room to ever consider exiting!

ADDITIONAL RESOURCES

To learn more about escape rooms, the following resources may be helpful:

- The Transworld Conference in St. Louis, Missouri, which includes Escape City: https://www.haashow.com/
- The Creative Escape Room Conference in San Antonio, Texas: www.creativeescaperooms.com
- The Puzzle Break blog: www.puzzlebreak.us/blog

Immersive and Interactive Theme Park Rides

Most theme park rides, though they are often immersive, are passive experiences—the riders cannot interact in any way with the objects or characters they see around them. In Chapter 19, we cover 4-D dark rides, rides in which the audience members are seated in a large theater and make use of theatrical-sized movie screens to envelop participants in a dramatic experience. The "4-D" in the term *4-D dark ride* refers to the fact that these rides involve other senses beyond vision and sound, including touch, smell, movement, and temperature changes, and in doing so, strive to bring the audience into the fourth dimension. These experiences usually include seats that move in sync with the story's action (*motion-base chairs*). More recent theme park rides, however, offer an even deeper sense of immersion as well as interactivity.

Today's theme park designers recognize that the new generation of park visitors enjoys interactive experiences, and thus have begun to create new kinds of attractions. One such ride is the *Buzz Lightyear AstroBlaster*, built around one of the primary characters of the *Toy Story* films, the toy space ranger, Buzz Lightyear. This ride has a clear storyline: you, the rider, play an ally of Buzz, and you are sent off on an intergalactic mission to fight the evil emperor Zurg.

In this highly interactive ride, you become part of the Toy Story world. You can manipulate your Star Cruiser spacecraft, tilting it and spinning it around in any direction, and can shoot your hand-held laser cannon at various types of outer-space villains. You play against others who are taking the ride at the same time and you can compare your score to theirs on a leaderboard at the end of the space voyage. At one point in this adventure, a picture is snapped of you engaged in battle, and when you dismount from your Star Cruiser, you can view your photo at kiosks lining the wall, and even email it to admiring friends and family members back home.

Toy Story Mania is another interactive ride based on the *Toy Story* franchise, and riders can enjoy it at Disney's Hollywood Studios in Florida, at Disney's California Adventure and at

Disneyland in Tokyo. It, like *Buzz Lightyear AstroBlaster*, also inserts you deeply into the Toy Story world. The conceit revolves around a new birthday present Andy has just received, the Toy Story Midway Games Play Set. It's a box full of carnival attractions, and once it is set up, Mr. Potato Head invites all the toys to play. Park guests play as honorary toys and ride from carnival attraction to carnival attraction in special trams, from which they can throw virtual eggs, pies, darts, and other objects. The 3-D characters in the ride duck realistically in response, making it not only thoroughly interactive, but in addition, scores are tallied for all the riders, making it thoroughly game-like, too.

One of the dazzling new-style theme park rides is not interactive, but what it lacks in interactivity it more than makes up for with immersiveness. This ride is *Harry Potter and the Forbidden Journey*, and it's a dizzying tour through the Hogwarts campus and Harry Potter's world. The ride can be experienced at a number of Universal Studios' theme parks.

The experience includes an exhilarating ride through Hogwarts castle and a Quidditch match, plus an encounter with a horde of foul, menacing Dementors and glimpses of Hermione and Hagrid and his pet dragon. As you soar along, you are sometimes accompanied by Harry Potter himself and also Ron Weasley, both riding on broomsticks. You travel over and through Hogwarts' landmarks—its towers and bridges and the Black Lake. Though it is not a roller coast it often feels like one. The ride employs a new kind of mechanism, a robotic arm that is attached to the track and in turn to your four-person vehicle, twisting and turning it, spinning it around and dipping it, all in synch with the ride's visuals. Sensory experiences are offered via a water-spitting spider and through fog and cold air (to suggest the Dementors trying to suck out your soul). By the time you exit the ride, you fully believe you've been given a first-class tour of Hogwarts, its students, and its magical characters, and have encountered a realistic sampling of all the dangers that can await one there. Though there isn't much of a plot to the ride and although you cannot interact with it, it does offer a spectacular into a unique storyworld—the world and inhabitants of Hogwarts.

Though the ride itself is not interactive, its setting, *The Wizarding World of Harry Potter*, is highly interactive. You walk along a street lined with the shops described in J.K. Rowling's novels, including a personal favorite, Honeydukes, a candy shop where you can purchase the favorite sweet of Hogwarts' students: Bertie Bott's Every Flavor Beans. And more importantly, you can stop in at Ollivanders and purchase an interactive wand. You will be measured and fitted with just the right wand, but actually, it isn't you choosing the wand, the wand chooses you, an important detail in Harry Potter lore. Once equipped, you can go back out to the street and test it. For example, when you reach the pastry shop, pause, wave your wand and cast a spell, and make the cup fly to its matching saucer. You'll find you can cast spells through the windows of most of the shops along the street, and these wand-friendly establishments are marked with medallions in the pavement. If you have trouble, an expert spell caster will come to your assistance.

To complete your magical visit to *The Wizarding World of Harry Potter*, if you are in the Orlando location, you can take the Hogwarts Express train between the Wizarding World's two locations in the parks. Just as in JK Rowling's novels, you can walk right through the wall to Platform 9 ¾ to catch the train. And you can ride it in both directions for a different experience each time.

An Other-Worldly Theme Park Experience

As of this writing, Disney is constructing its own version of a highly immersive world, *Star Wars: Galaxy's Edge*. Once opened, it will bring the outer-space world of *Star Wars* to life. It will be set on the planet Batuu, a new planet in the *Star Wars* lexicon, and specifically in the planet's village of Black Spire Outpost. Bob Chapek, chairman of Walt Disney Parks and Resorts, described the location as: "a *Star Wars* planet you've never seen before—a gateway planet located on the outer rim" (from the *Orlando Sentinel*, August 15, 2015). The choice of creating a new *Star Wars* planet, according to Disney Imagineer Scott Trowbridge, was to

give guests a new story experience: "We wanted to build new *Star Wars* stories, new *Star Wars* destinations, but this time you could be in that story that required us to go to a new place" (from the *Orlando Sentinel*, April 16, 2016).

Trowbridge went on to describe the planet as somewhat past its prime and though colorful, not an especially savory place to hang out:

> This used to be a vibrant trading port back in the old sub-light-speed days, but now with advent of hyperspace, its prominence has kind of fallen and faded a little bit which has made it a great spot for those who didn't want to be on that kind of mainstream path. The smugglers, the bounty hunters, the rogue adventurers looking to crew up, the people who don't want to be found — basically all the interesting people.

Disney promises Batuu will be populated by all the characters you'd expect to see on a Star Wars planet—"humanoids, aliens and droids"—and promises that everything in *Star Wars: Galaxy's Edge* will be faithful to the *Star Wars* canon—the rides, the restaurants, the village marketplace. It will contain two groundbreaking rides, both of which are narrative experiences. One is the giant *Millennium Falcon* starship, usually piloted by Hans Solo but which Disney guests will be able to control at its parks. The other is *Star Wars: Rise of the Resistance*, a 28-minute dark ride with a reported 300 animated objects, featuring a battle between the First Order and the Resistance. *Galaxy's Edge* will also host the first public bar in a Disney park: Oga's Cantina. It will probably be a good way to take the edge off the stress of flying a starship or being plunged into a brutal battle. Interestingly, your flying skills on the Millennium Falcon will determine how you are treated in the Cantina. According to the Disney Parks blog, if you fly well, you may get extra galactic credits, but if you bang up the ship, you could get on the list of a bounty hunter. This works like the video game *Red Dead Redemption*, described in Chapter 6, where your fortunes in the game depend on your behavior: you are rewarded if you treat people and animals well, but your difficulties in the game increase if you are cruel.

Old and New Settings for Immersive Narratives

Immersive narratives are typically found in brand new venues, which can seamlessly design the technical support systems into the venues' structure. But sometimes they are found in extremely old venues. For example, an immersive narrative experience can be enjoyed in one of the oldest buildings in Paris—the Conciergerie. It was constructed in the 1200s as a palace for the French medieval kings and later became a notorious prison during the French Revolution. One of its most famous prisoners was Marie-Antoinette. Today's visitors to the Conciergerie can rent a device called the *Histopad* and view images in Augmented Reality of how the building was used in bygone eras.

Another immersive exhibit set in a historic building is *The Old Stone House: Witness to War*. The stone building is a farmhouse built in 1699 in the part of New York City that is now Brooklyn. It was the site of an important Revolutionary War battle in 1776, badly damaged in the battle, and reconstructed in the 1930s. During the bloody battle, the largest of the war, a group of Revolutionary soldiers, the Maryland 400, held off the entire British army, giving George Washington an opportunity to escape. The exhibit uses both digital and analog technology to enable visitors to understand the significance of the battle and to understand what life was like during the British occupation of New York, from 1776 to 1783. Among the interactive pieces of the exhibit is a two-player game, *Take the Hill*, where visitors face off to experience the challenges of being a soldier during the historic battle in Brooklyn.

Modern Venues for Narrative Immersion

Although old buildings like the Old Stone House and the Conciergerie set a fitting mood for an immersive narrative, more often these immersive events take place in a modern building or a specially constructed set. Today, even brand-new hotels are being built to be immersive. In 2017, Disney announced it was building a *Star Wars* hotel in Orlando, where the interior will look like the

inside of a giant spaceship and all the windows will have views of space. The guests will be given storylines, so they can actively participate in the *Star Wars* universe. The hotel's staff will be in costume and play parts of the story, too. Bob Chapek, Chairman of Walt Disney Parks and Resorts described the guest experience this way: "From the second you arrive, you will become a part of a *Star Wars* story! You'll immediately become a citizen of the galaxy and experience all that entails, including dressing up in the proper attire. Once you leave Earth, you will discover a starship alive with characters, stories, and adventures that unfold all around you. It is 100% immersive …" (as quoted in the Disney Parks blog, July 15, 2017).

The hotel will feature a bar familiar to fans of the *Star Wars* movies: Mos Eisley Cantina, which was situated on a planet frequented by colorful outer-space undesirables. Obi-Wan Kenobi called this planet a "wretched hive of scum and villainy." What fun it would be to have a drink at this bar, if you were old enough, of course. No opening date for the hotel has been announced yet.

Another make-believe playland, this one definitely not for kids, was a newly constructed Western set for the fictional village of Sweetwater that featured in the *Westworld* TV series, erected for invited guests from the South by Southwest Festival in 2018. In the TV series, Westworld is an amusement park for the wealthy and populated by totally life-like androids. Guests at the park can freely indulge in any fantasy. It is an operation run by a mysterious corporation, Delos. At the temporary *Westworld* installation in Texas, HBO meticulously created a two-acre set looking just like the fictional town of Sweetwater, hired 60 professional actors to play the part of Delos hosts, gunslingers, card sharks, cowboys, and "ladies of easy virtue." A script of 440 pages was written for the experience.

Guests could explore the town at will and interact with the actors. They were only told not to break anything and not to hurt anyone. One of the most dramatic events of the experience was a gunfight, resulting in a number of dead bodies littering the dusty street. The android players, in character, just shrugged it off, claiming not to have noticed anything. The entire experience

was done without technology and it played out much like a performance of immersive theater. Guests who were lucky enough to attend gushed about the experience and how they felt they really had visited Sweetwater, noting how nothing had broken that illusion.

Another immersive *Westworld* experience was held at San Diego's Comic-Con in 2017. This one took place on a floor in a real physical building that was dressed to look like the corporate offices of Delos, the fictional company that runs the Westworld resort. As with the one at South by Southwest, it did not employ technology, only props and actors. The conceit of this experience is that guests are applying to be tourists to Sweetwater, but first have to be tested to make sure they are fit. Actors playing Delos psychologists interview each potential tourist, asking them probing questions to make sure they are mentally sturdy enough for the experience. Bryan Bishop, covering the event for *The Verge* (July 21, 2017) reported that when would-be tourists first entered the Delos offices, they are shown a variety of weapons and costumes. But these were not displayed as weapons and costumes for the TV show: they were displayed as the types of weapons and outfits tourists would see in Sweetwater, the "real" town.

Bishop found the interview with the Delos psychologist equally convincing. He reported being asked a series of questions: What percentage of his dreams were nightmares? If he had to lose a finger, which would he choose? He states: "It was the performer, reacting to my responses in real time while nailing the slightly detached, perfectly pleasant vocal characteristics of a Delos host, that brought it to life." He concludes by saying:

> With the rise of theme parks, escape rooms and immersive theater, it's clear that audiences have an increasing appetite for entertainment experiences that go beyond passive screen-watching or traditional gaming. The popularity of the *Westworld* show itself might be further proof, and with massive corporations like Disney embracing the trend to lure audiences away from their living rooms, these kinds of projects will only become more ubiquitous.

When I read this, I felt Bishop had somehow gotten hold of a pre-publication version of this book! But his statement is just further proof of the public's growing desire to be immersed in a story.

Even though technology is not employed in any of these experiences, and is an essential component of digital storytelling, the key to immersive narrative is creating a totally believable fictional experience, with or without technology. Technology, however, is often key asset in developing these immersive works.

Meow Wolf's Immersive Stories

Many immersive stories do make use of digital technology, of course. *The Due Return* is a good example of one such immersive narrative. It was a full-scale intergalactic sailing ship that was the centerpiece of a highly unusual art installation (see Figure 18.2). The project was created by Meow Wolf, a Santa Fe, New Mexico, artists' collective. Meow Wolf termed the installation a work of "immersive multimedia" or an "interdisciplinary work." It included a multi-platform narrative, interactive elements, digital media, and live performances as well as hundreds of artist-created artifacts, even including handmade barnacles.

FIGURE 18.2 The exterior of *The Due Return*. Image courtesy of Ken Wilson.

According to the ship's online archives (http://loci.theduereturn.com/), *The Due Return* had been traveling through space and time for decades. During the late spring and summer of 2011, it had docked in Santa Fe, New Mexico, at the Center for Contemporary Arts. Not only was it a full-sized ship, measuring 75 feet in length, 25 feet in width, and 14 feet from the ground up to the main deck, but it also contained hundreds of mysterious artifacts and pieces of sculpture. In addition, it was the setting for various live performances. Surrounding the ship was an extraterrestrial landscape of caves and glowing lights. Visitors to the vessel could explore the crew's bunk rooms, the captain's stateroom, a scientific lab, a lounge, and a greenhouse full of living plants that crew harvested for food. They could also spend time out on the captain's deck, an interactive control room. There they could not only spin the steering wheel but also try out its many electronic devices (see Figure 18.3).

In addition, a rich narrative was woven around the *The Due Return*'s history, covering the 161 years that the ship had been traveling. The history was not only written as text but also contained audio and video and could be accessed online. The archives included artists' books and sculpture, photos, YouTube videos, and various artifacts that visitors on the ship could study and even handle.

FIGURE 18.3 The interactive captain's deck of *The Due Return*. Image courtesy of Ken Wilson.

> **STRANGE BUT TRUE: NORWEGIAN ROT**
>
> One particularly unusual element of *The Due Return*'s transmedia story was a powerful drink called Norwegian Rot. This cocktail, a blue liquid with white orbs floating in it, evidently controlled the ship's navigation. When enough of the crew had consumed Norwegian Rot and had become intoxicated by it, the ship would move. On certain occasions, visitors to the ship could purchase Norwegian Rot and sample it themselves.

The creation of *The Due Return*'s history and archive was under the helm of Nicholas Chiarella, a poet with a background in museum work. Chiarella told me that it took a year of planning and building to construct *The Due Return* and its artifacts, and that up to 125 people had contributed to it. It was clear to me that *The Due Return* was a collaborative project but I wondered if anybody who wished could work on it. I asked Chiarella: "If Joe Smith from down the block wanted to contribute something, would he be able to?" "We're all Joe Smith," Chiarella replied.

In 2016, Meow Wolf opened an even more ambitious project, an immersive narrative and art installation called *The House of Eternal Return*. It was built into a huge abandoned bowling alley, and partially funded by sci-fi author George R.R. Martin, a Santa Fe resident, who bought the bowling alley and leased it to Meow Wolf. Martin is the creator of the enormously popular *Game of Thrones* novels and TV series, and he was intrigued by the conceit of *The House of Eternal Return*. He was willing to place a bet on what Meow Wolf was planning to do with the space.

The centerpiece of this fantasy world is a two-story 20,000 square foot Victorian house built for the installation, right in the middle of the old bowling alley. Embedded in the house is a highly detailed narrative of the Selig family who used to live here but vanished. I was lucky enough to be part of the narrative team that created the story, but I can only give the bare outline here, since part of the fun for visitors is to figure out their story and what happened to them. On the narrative team, the big question for us was "How do you embed a story into a physical space?"

The fictional family lives in an old house in Mendocino, California, a small new-age town in the redwoods, and this is where we are, in terms of the narrative, when we enter *The House of Eternal Return*. The family is composed of a grandfather, his late wife, the grandmother of the story; a mother and father and the mother's brother, a twin; and two children, also twins. The grandfather, a retired electrical engineer, spends his days doing experiments, many of them involving sound, and some of these experiments are wildly successful. The grandmother was a witch—a good witch, not an evil one. Her daughter, the mother of the family, has inherited some of her magical powers but has tried to erase the knowledge of them from herself and is instead an artist. The father, like his father-in-law, is extremely interested in the power of sound and often records sounds that interest him.

The uncle, who calls himself Master Lucius, is a little looney; he is a new-age guru that takes his followers on trips to outer space where they can find their home planet and discover their "innate divinity." At the time we enter the family house, he is in the midst of a downhill slide, partially fueled by alcohol, and is sleeping on the family's couch. The two children, at about 11 years old, have special powers like their mother and grandmother, but are still too young to fully utilize them. The other characters in this story are members of a shadowy group called The Charter. The Charter continually spies on the family and is hostile to its special powers.

Narrative is a critical component of the experience of *The House of Eternal Return*, which is totally nonlinear and interactive. Visitors are not given a map or any "how to" instructions; they must find their own path. Vince Kadlubek, Meow Wolf's CEO, told the *Smithsonian Magazine* in 2019:

> At the heart of it, I'm inspired by the evolution of storytelling, and I'm excited for what Meow Wolf is doing because it really is on the brink of what I believe to be a new form of storytelling, 21st century storytelling … We're ushering in a new form of the way people experience story, and in a way that is so deep and so immersive that it actually, potentially, is ushering in a new way for people to experience reality as a whole, not just entertainment.

The clues to the story are found inside the house and by the portals in the house that lead to other dimensions. When first entering the installation, sharp-eyed visitors will notice a mailbox outside the house. If they open the mailbox, they will find a pile of condolence cards. Someone in the family has passed away, but who? And how? In the living room, they will find the suitcase Uncle Lucius has stashed by the couch, and the TV is playing a mix of strange commercials, interviews with Lucius, and an assortment of other programming. There's also a fireplace, and visitors can crawl through it into another dimension: to a cave with giant mastodon bones, which you can play like a marimba with the mallets conveniently placed nearby. Back in the house, you will find the dining-room ceiling strangely warped and the bathroom floor above it also warped, and the toilet has a disconcerting image in the bowl. In the kitchen, if you riffle through the newspaper placed on the counter, you will find a number of clues about the recent events that pertain to the family, even in the weather forecast. And if you walk through the fridge, you will find yourself in "Portals Bermuda," a lobby for outer-space travel. Even the laundry room has a portal: you can slide right through the dryer into another world. Upstairs you can search for clues in the parents' children's bedrooms and grandad's office.

Clues and enhancements to the Selig's story are both digital and analogue. On the family's computer you can find the database of the Charter, with an ultra-high-tech look (https://thecharter.org/) and some clues. Portals Bermuda is a waystation to other planets, looking like an updated version of a train station, complete with digital arrival and departure tables. You are greeted there by a hologram hostess. Doors near the space station open when you put your hand on the image of a handprint. And if you can find the room with the laser harp, with the strings that are red light beams, you can play some music on it. On the analog side of things, the mother's diary will provide some information, as will the family's own cookbook, that contains not only the family's favorite dishes and beverages, but handwritten notes by family members. The hamster cage in the children's bedroom is another important piece of the story.

There are indications that Meow Wolf will increasingly use more technology in its installations and media offerings. The artists are now working with Microsoft's volumetric capture technologies to record characters and performances to turn them into digital imagery. According to Nicolas Gonda, Meow Wolf's executive vice president of entertainment, "Volumetric technology gives us the tools to have more characters in the space, and blend physical and digital worlds more seamlessly, in ways that are novel and unexpected." He further explained: "Through the volumetric capture tech … Meow Wolf will be looking to capture its characters and performers and bring them into other media. Volumetric technology gives us the tools to have more characters in the space, and blend physical and digital worlds more seamlessly, in ways that are novel and unexpected." This technology will facilitate the process of bring Meow Wolf characters to mobile devices, XR, and digital screens (as reported in TechCrunch, April 4, 2019).

The collective, which employed about 135 people during the development of *The House of Eternal Return*, and was operating on a shoestring, is now a corporation, earning millions of dollars. It has 425 people on its payroll, and in 2018 received its one-millionth visitor. It is currently opening up new installations in Denver, Phoenix, Washington DC, and Las Vegas, Nevada. It will be interesting to see what kinds of stories Meow Wolf will tell in these new spaces, but whatever they are, story will remain at the core of the Meow Wolf experience.

Hoping to gain some insight into the role of story for future Meow Wolf installations, I was happy to be able to meet with Joanna Garner in a local coffee shop and talk with her about the role of narrative. Joanna is senior narrative creative director of Meow Wolf, the perfect person to interview about the use of story in their future projects.

"Story is very important; it is the core of everything we do," she asserted, explaining that the stories that work for a Meow Wolf installation are different from other kinds of stories. "They have to be big enough to hold our worlds and characters. They serve as container foundations for what we do." But they also need space in these stories for their visual artists to be creative, "for their creative exploration," she said. Sometimes these artistic works are

directly tied to the core story, but there is also the opportunity for the artists to be inspired to create something unconnected and wild. The role of narrative differs somewhat from exhibit to exhibit. "Las Vegas is the one most driven by story. Denver is more of a collection of short stories," she said. Forty percent of the artists for the Denver exhibit are local people; Meow Wolf wants to offer creative opportunities to the people in the communities where they set up exhibits.

"Our stories give people the sense of the familiar and the strange. They have emotional resonance and make people come back again and again." But, as with *The House of Eternal Return*, there has to be a balance: an exciting space for those who just want to wander and explore, and a story to discover for those who are drawn to a narrative experience. For those who are digging into the story, she told me they create multiple deliverables for each story point—things like business cards, books, a TV show, and a radio show. That way, the visitor is likely to be able to follow the story thread even if they miss some of the artifacts.

There are also puzzles to solve to move forward in the story. In a way, it is a little like a video game, but a game that is set in a physical space, which makes the design process different. "You aren't looking at a screen all the time here," she said. In other words, you don't use a joystick or a controller to advance the narrative. "It's your actions that make things happen and the space is responsive to your actions."

I learned from Joanna that Meow Wolf is definitely using digital technology and it sounds like this has become more prominent than when I was there. They now have a digital storytelling team and are in a partnership with Magic Leap, doing some testing for future exhibitions. They also have a companion app for *The House of Eternal Return* and have created an alternate reality game for the house. They use RFID technology to trigger state changes, sometimes to trigger audio or video, sometimes to make other things happen.

Meow Wolf is creating a special kind of magic. "In a Meow Wolf exhibition, anything can be what you don't think it is. For example, the refrigerator can be a portal to another dimension. We want people to find that joy when they go back to the outside

world," Joanna explained. In other words, Meow Wolf hopes you can experience the joy of discovery, of the unexpected, in the everyday world, too.

Taking Immersive Narrative to the Extreme

Some works of immersive narrative go even further than Meow Wolf. Instead of embedding a story in an abandoned bowling alley, a story is embedded in an entire city. *The Latitude Society* is such a story, and its canvas was the city of San Francisco. It was produced by a group called Nonchalance and took three years to develop, a creative process that took place in Mendocino, the same little town that is the setting for *The House of Eternal Return*. Evidently the development process was a great deal of fun, a curated experience with games, music, "pink string" walks in the woods, and banquets.

The work that debuted in 2015 was part game, part puzzle, part immersive theater and part secret society. One writer described it as "playing in a sandbox laid on top a world you once thought you knew." For a participant, the experience began with an alluring secret. One member describes it this way: "A friend sits you down, asks of you absolute discretion, and then gives you a mysterious card that, if activated, literally opens a door to a new world of adventure …" (as reported in *Vice* by Lydia Laurenson, March 7, 2016.) The card contained a website address and a code. Your friend would tell you to go to a website and make an appointment. An appointment for what? That was part of the mystery.

Once you'd secured an appointment, you were given an address in the city. When you arrived at the building, you'd swipe the card and suddenly be part of a mind-bending experience, not unlike what Alice experiences when she falls down the rabbit hole. You'd enter a room that was part retro and part high tech and that featured a handsome fireplace. Set inside the fireplace was a wooden slide that you'd slide down (not unlike the dryer portal in *The House of Eternal Return*), wind your way through a maze and reach a library lined with books all bound in the same color and all the same size. On the lectern you'd find a similar book.

Like the others, its pages were blank, but as you studied it, the book would begin to read itself and words and illustrations would appear on the pages. This book "The Fable" and the story it told became the touchstone of *The Latitude Society*. Once you'd been told the story in the library, you exited into a comfortable lounge that would become a Latitude Society meeting room.

The adventure continued outside the building and involved a guided audio tour on BART (San Francisco's rapid transit system), a video game arcade, bronze plaques set in concrete in the street, and a variety of Latitude Society social gatherings. For a number of members, the initial adventure was a wonderful surprise, but they particularly, cherished the gatherings. Members had feelings of reverence about "The Fable" and the story was retold at every meeting, often in the Lounge. One latitude member nostalgically recalled, "There was a feeling that by stepping into the lounge, you'd traveled in time to an underground world only slightly connected to the city above."

The adventures were broken up into 10 books, but evidently only two of the books were completed. Having never participated in *The Latitude Society*, it is difficult to know what the story was that was imbedded in it, other than "The Fable." What makes this work stand out is the fact that it is set in such an enormous landscape. Unfortunately, the creativity of the initial adventure and enthusiasm of many of the members was not enough to financially sustain *The Latitude Society*. Some income was generated by the sale of tee-shirts and the purchase of membership cards, which initiates could buy and offer to prospective members, but it wasn't enough. Nonchalance was burning through $3,000 a day to keep the operation going. In mid-2015, Nonchalance rolled out a paywall, meaning that now there would be charges for things that were previously free. Buying a membership plan was an expensive proposition, costing hundreds of dollars a year. It was part of the demise of *The Latitude Society*. *The Latitude Society* also suffered from persistent bugs, which were another problem for Nonchalance. And, like many startups, Nonchalance did not have a clear objective in mind for where they wanted to take *The Latitude Society* or have a solid business plan. The operation closed down in September 2015, another failed startup in a city that had

seen so many of them. It had been a noble effort in immersive narrative, but it failed to offer a well-thought-out experience.

Immersive Spaces

Works of immersive space envelop the participant in an experience, and may contain some characteristics of story, like characters, though they are not narrative experiences like the ones Meow Wolf builds. Some of these works contain animatronic "actors" and some feature architectural elements. Many of them encourage exploration and some offer a limited amount of interactivity. However, a number of them are passive experiences meant only for viewing and hearing. Thus, there are a great variety of experiences offered in immersive space.

Immersion with Objects and Architectural Elements

In the land that brought us Babar, the storybook elephant, there is now a huge mechanical elephant, Le Grand Éléphant, who lumbers through the streets of Nantes with a village and passengers on his back. He trumpets like a real elephant, sprays water from his trunk, and flaps his ears. The enchanted amusement park where he resides, along with a multitude of other mechanical animals, is called "a bestiary of machines." This delightful amusement park in France is *Les Machines de l'Île* (http://www.lesmachines-nantes.fr/en/) and contains an entire zoo's-worth of animatronic creatures. The vision of the park, which opened in 2007, combines the steampunk fantasies of Jules Verne, the mechanical constructions of Leonardo da Vinci, and the history of the Nantes shipyards.

Le Grand Éléphant is the star of the park. He's a towering 39 feet tall and 26 feet wide, and if you look up at him from the street, the humans riding on his back look like tiny dolls. Tickets to ride him are in high demand. The park also features a carrousel with 35 moving sea creatures and a giant tree, Arbre aux Hérons, that sea birds can rest in and that humans can climb, via ramps and stairs. There's also a Machine Gallery, displaying exhibits showing how the mechanical animals were made. Visitors can even ride

some of them and make others move. One of the newest residents, a sloth named Lazy, has moveable legs, eyelids, head, and tail. Although there's no story connected to the mechanical animals, its fanciful creatures certainly spark the imagination. And you can view them without guilt, since they aren't cooped up in cages, like animals at the zoo.

In stark contrast to *Les Machines de l'Île* and the Meow Wolf installations is an English art installation called *Dismaland* set near the shore of a town called Weston-super-Mare in the UK, at a rundown, unused water park. Built in 2015 and only open for five weeks, this "bemusement park" was the brainchild of British street artist Banksy and the work of 59 global artists, a large-scale work of guerrilla art. It is a depressing and darkly humorous view of the modern world and the modern world's happy places like Disneyland. It even features a fairy-tale castle, though this one looks as if it had been bombed during the blitz. There are beach chairs scattered around a fetid-looking pond and a police vehicle sits in the water like a half-drowned rat. The entire installation looks as if Walt Disney had created it himself while in the throes of a devastating mental breakdown. In fact, the website even announces: "The following items are strictly prohibited: knives, spray cans, illegal drugs, and lawyers from the Walt Disney corporation" (http://www.thisiscolossal.com/2015/08/dismaland/).

The theme park contained everything one would expect in a traditional theme park, including a Ferris wheel and a carousel, though with odd twists. For example, visitors could ride pretty horses on the carousel, but also riding on it was a horse butcher with a savage-looking knife. And instead of marching bands, storm troopers strutted around the grounds.

Visitors entered the park through a fake security checkpoint, where the actor-guards have been trained to grimace, never to smile. The X-ray machines at the check point are made of cardboard, as are the confiscated items seized by the guards, a tongue-in-check commentary on the unpleasant security points in airports. There is social commentary on the international migrant crisis as well; boats crowded with migrants circle around in the water but they cannot dock, since the controls that would bring them safely into the harbor do not work.

Though clearly not the happiest place on earth, *Dismaland* sold out every day it was open. It did not support a traditional narrative, with a beginning, middle, and end, but it did have a cast of characters and a strong point of view and it was completely immersive. Everything about this peculiar theme park was convincingly dismal and a dark send-up of the world's problems

The Site of Reversible Destiny in Japan's Yuro Mountains is another destination that offers an immersive experience through objects, in this case architectural structures like mazes, walls, 148 paths, some subterranean, and topsy-turvy pavilions. There's a house-like building with uncomfortable furniture and appliances placed in inappropriate spots and another with tiny windows that distort the view. The strange-looking sculptures, the slanted pathways, and steep hills taken together make for a pleasantly disorienting experience, and the theme is to "encounter the unexpected." Visitors to this park are encouraged to explore with the spirit of a child, and videos of the park show people scampering through the mazes and posing in off-balance positions as if they are fully enjoying themselves. Again, it is an immersive environment without a story but with a distinctive vision, one that tosses you out of the everyday world.

Immersion through Projections

Immersive spaces do not necessarily have to contain objects, and some of the most intriguing types of immersion are done by the projections of images, in a technique called *projection mapping*. With projection mapping, videos are shaped to the objects upon which they are being projected, like pillars, arches, and curved ceilings. Unlike images projected onto a flat movie screen, the objects are often three-dimensional, like the exterior of an old church or the interior of a rock quarry. They are more apt to be found in Europe than in the United States, but these types of installations are becoming popular all over the world.

Three notable attractions that employ projection mapping include:

- The Gustav Klimt exhibit at Atelier des Lumières in Paris, 2018–2019. This installation in an old refurbished foundry turned into an art gallery used the vast space

magnificently, projecting images on all the vertical surfaces and the floor in an ever-moving pageant of pictures painted by the famous Austrian artist. Well-chosen music, including Viennese waltzes, accompanied the images. Visitors could wander through the space, looking at the exhibit from different perspectives and even walk into a painting. New exhibits are offered in the space at regular intervals.

- *Quarries of Lights* (Carrières de Lumières) in southern France holds changing exhibits of projects of great art works in an old rock quarry. Between exhibits, the bare rock quarry is a dull reddish gray, but when illuminated with images, a magical transformation takes place. The dimensionality of the space is enhanced, with projections on huge blocks of limestone. During an exhibit, art lovers and casual visitors alike are immersed in vivid images and rich colors, as with the Chagall exhibit in 2016, when images of his stained-glass windows were on display and with the Vincent van Gogh exhibit in 2019, showcasing a variety of works that were often colorful but sometimes dark and disturbing.
- The *Cittadella Visitors' Center* features an interactive immersive history exhibit in the Cittadella, a walled city and fortress on the Maltese island of Gozo. The exhibit is held underground in the huge water reservoir of the fortress and serves as its unique visitors' center. The space itself is handsome, with dramatic arches rising up to the ceiling and the illuminations magnify the drama of the space. The projections tell the history of Gozo, beginning with the story in Homer's *Odyssey* about the nymph Calypso who fell in love with Odysseus and held him captive for seven years on her island. The island in the story is believed to be Gozo. The visitor's center also includes a number of large touch screens, where information about the island is offered in eight languages, and visitors can choose to delve into the subjects they are most interested in.

Team Lab and Image-Based Immersion

Team Lab, based in Tokyo, is an art collective that specializes in taking projection art to its highest level and its exhibits travel internationally. One exquisite work has a visitor standing on an island in front of a cascading waterfall that is draped with flowers all down its sides. Another is a hanging flower garden where the living flowers float up and down in relation to the movements of the visitors. Even Team Lab's dimly lit tea house holds a beautiful surprise. When the waiter pours tea into your glass bowl, a delicate image of a flower appears and shimmers in the tea. When you pick the bowl up to drink from it, the flower's pedals scatter to the table.

Some of Team Lab's works are interactive, like *Sketch Aquarium*, which I had the chance to try when Team Lab came to Santa Fe. On the wall of the exhibit is a projection of an enormous aquarium, with varies species of fish swimming around inside it. On a table are papers with different types of fish outlined on them: a squid, an octopus, a whale, a swordfish, and so on. You can select one of the fish outlines and color it with markers set out on the tables in the space. Once this artwork is completed, you insert your picture into the scanner. Then, magically, your fish joins the others swimming in the aquarium! It is truly a wow moment.

> **ADDITIONAL RESOURCES**
>
> - The Themed Entertainment Alliance (TEA) is an international association representing the world's leading creators, developers, designers and producers of compelling places and experiences—worldwide. The section on awards will point you to some outstanding immersive works. http://www.teaconnect.org/About-us/About-us/index.cfm.
> - Blooloop is an electronic journal that covers a variety of immersive experiences, including theme parks: https://blooloop.com/.

Conclusion

As this chapter illustrates, immersive works have the power to take one out of the daily ordinariness of life and transport one to a totally different experience, from the epic world of a space adventure to a delicate hanging flower garden. Immersive works come in an enormous variety of shapes and sizes, some no bigger than a small office and others as large as an underground water reservoir or an entire city. Some of these experiences are interactive, such as escape rooms and the *Wizarding World of Harry Potter*. Others are passive but dazzle you and surround you with gorgeous images. Some are embedded with story, like *The House of Eternal Return* and the *Star Wars* hotel, now under construction. Others let you create your own story out of an explorable space set up with artifacts.

The diverse variety of this arena indicates one thing: that people today crave being transported to a new kind of experience, somewhat like a Victorian traveler's itch. It is possible that we are still in the early days of immersive experiences and that in coming years we will see new types that we haven't even dreamed of yet.

Idea-Generating Excercises

1. If you've had the opportunity to visit an immersive narrative, describe it as best you can. What was the story? How was it told? Was it fully immersive or were there things about it that broke the sense that you were inside the story?
2. Sketch out an idea for an immersive story that could be built inside a defined space, like an unused big box store. What would you put inside this space that would tell the story?
3. Try to come up with an immersive story for the town or city that you live in, as Nonchalance did for *The Latitude Society*. What local landmarks could be part of the story? Where would the story begin and what about this "first act" would give visitors an idea of what the story is about and where they should go to find more pieces of it?
4. Try to create an idea for an immersive narrative based on a memory from your own life.

5. Image that you had a team of projection mapping artists available to you and the budget to create a wonderful immersive experience using projections. What kind of structure would you choose as the setting for this experience and what kinds of images would you want to show?

Chapter 19

Screen-Based Immersion

How can something flat like a movie screen provide a sense of immersion?

How do you roll along on a screen-based theme park ride when you aren't actually traveling?

Is it possible to create an immersive experience with a single individual interacting with a large screen?

What kinds of experiences are offered in dome-shaped spaces where the audience is surrounded on all sides and overhead by movie screens?

Utilizing Movie Screens for Immersiveness

Until recently, when one went to the movies, one expected to sit quietly in a comfortable theater seat and stare at a large screen for about two hours without moving, except for possibly bringing a snack up to one's lips. When immersiveness is added to this expectation, however, it's a whole new ballgame. With immersive screen-based experiences, you might not be seated at all, but

instead be standing alone or with a group of other participants interacting with the images and characters on the screen. Or you might be sitting in an enormous dome-shaped theater with images on all sides and above your head. Or you might be engaged in an experience where the audience controls the narrative with "pistols" that shoot laser beams. Or the seat you are sitting in might move in sync with the action on the screen. The types of projects described in this chapter emphasize the immersive experiences that are provided, in part, by movie screens, as opposed to other examples in the book, which emphasize screen-based interactivity but not immersion.

The Influence of Immersive Theater

Immersive theater productions and screen-based immersion have a number of similarities. Because these theatrical works were produced before or in the same time-period as screen-based immersion, they could be regarded as an inspiration for immersive screen-based works. Immersive theater productions are set in large spaces, like a mansion or a warehouse designed to look like an old hotel. Inside of these spaces there may be an opening scene to introduce the core narrative, but after that, audience members are free to investigate the space, explore, and construct their own versions of the story. They also may take part in scenes and interact with the actors. Some have a single ending, where the audience is funneled invisibly down a path to the story's conclusion, while others have multiple endings. These theater pieces have been inspired to some degree by video games. They are, in turn, influencing screen-based immersion. And audiences thoroughly enjoy these immersive, interactive experiences. Three works of immersive theater are described in Chapter 18: *Grand Paradise*, *Alice in Wonderland*, and *Alice's Adventures Underground*. Two additional works are described in this chapter.

Sometimes such works are called a *promenade performance* (because audience members can walk around) or a *site-specific play* (a work set outside a traditional theater and that resembles the play's fictitious setting). One of the first such works was

Tamara, produced in 1981 and described in Chapter 1. It was set in a large mansion in Los Angeles, and audience members moved from room to room and floor to floor, viewing scenes going on simultaneously in each room. Thus, no two audience members experienced the same version of the play.

Another more recent work which has received enormous acclaim is *Sleep No More*, produced by the British theater company Punchdrunk, and set in the fictitious McKittrick Hotel in New York's Chelsea district. Also described in Chapter 1, it opened in 2011 and as of this writing is still being performed. The "hotel" is actually three adjourning warehouses that are dressed to look like a luxurious 1930s hotel. The play is a loose adaptation of Shakespeare's *Macbeth* and based somewhat on the Paisley witch trials in Scotland in 1697 and darkly colored by film noir movies. At this work of immersive theater, audience member don masks, are forbidden to speak to each other, and are free to room the "hotel's" five floors or to follow one of the actors. They can open drawers and study documents and strive to put the pieces of the narrative together.

Another work is *The Willows*, which opened in 2017 in LA and is still running. It is set in a 10,000 square foot mansion where a special event is set to take place, but even before one arrives there, one is immersed in a strange and eerie narrative. The 18 audience members are instructed to wait on a street corner, and a van arrives to take them to the mansion, but first everyone is blindfolded. The event at the mansion is a memorial to the recently deceased head of the family, and the audience members are all either distant relatives of the dearly departed or his old friends. Everyone gathers first for a cocktail hour and then for dinner, where the matriarch of the family shares some important pieces of narrative. After dinner, you are able to wander around the mansion, but not totally at liberty: The audience members are broken into smaller groups and instructed where to go. The various scenes take place in the mansion's many rooms, and it is not possible to see everything, since scenes take place simultaneously. Sometimes you interact directly with one of the residents of the mansion: they might whisper in your ear, instruct you where to go, or play a game with you. The family's servants all have meaningful roles in the story, but you

will only discover their narrative arcs if you are able to follow one of them closely. No two people will leave the performance with the same version of the storyline.

It is not difficult to see from these descriptions how these three theatrical works are similar to both video games and screen-based immersive works, with the ability to explore and find your own path and work out your own storyline. Though they don't necessarily offer a great deal of agency, they all give audience members a deeply immersive experience.

Large-Screen Immersiveness for Audiences—The *4-D Dark Ride*

Immersive environments sometimes make use of theatrical-sized movie screens to envelop participants in a dramatic experience. These experiences are variously known by two different terms: the *ridefilm* and the *4-D dark ride*, and have become popular attractions in theme parks, visitors' centers, and cultural venues like zoos and historic sites. The "4-D" in the term *4-D dark ride* refers to the fact that these rides involve other senses beyond vision and sound, including touch, smell, movement, and temperature changes, and in doing so, strive to bring the audience into the fourth dimension. These experiences are set in specially designed theaters and they usually include seats that move in sync with the story's action (*motion-base chairs*). In this type of attraction, one stays seated and cannot move around as one can in other forms of immersive environments. In some regards, these projects are easier to design than VR experiences, because they draw upon cinematic narrative tools that the creative community is already quite familiar with, though imagination comes heavily into play when designing the 4-D elements.

Large-screen experiences lend themselves well to taking participants on a fictional journey, much like a movie. Even though they typically offer little or no opportunity for interaction, unlike the large-screen works of iCinema, discussed in Chapter 14, they can offer an intensely involving, even enthralling, experience. This is due both to good storytelling and to how these films are shown. The screens are not only tall but have a wraparound 180-degree

curve, thus totally encompassing each person's peripheral vision. They also use state-of-the art surround-sound systems and technology to stimulate the other senses. Audience members view these films from a first-person perspective, as if they were right in the heart of the action.

> ### A BUGGY 4D DARK RIDE
>
> A 4-D dark ride called *It's Tough to Be a Bug!* was a popular attraction at Disney's California Adventure theme park, but unfortunately has been recently replaced by another attraction. It featured a 3-D film, an animatronic grasshopper, and a cast of amusing characters to give audiences an inside view on what it's like to be a bug. To enhance the "buggy" experience even further, giant spiders drop on top of you from the ceiling; you "feel" bugs crawling on you (via vibrations in your seats); you are misted with "acid" by termites; and you get squirted by a smelly stick bug. The shocker in this ridefilm occurs when you are swarmed by angry wasps and "stung" in the back (also via the motion-base chair). At this point, the screams of audience members almost drown out the soundtrack.

It's Tough to Be a Bug! was designed by Disney Imagineer Kevin Rafferty and loosely based on the Pixar movie *A Bug's Life*, which was then in development and would not be ready for release for some years. Michael Eisner, the head of Disney at the time, had suggested that an attraction about bugs be installed in the Animal Adventure section of the park. At first Rafferty was skeptical about doing a bug-themed attraction, but after doing some research and meeting with some SMEs (subject matter experts), he was converted. He recalled to Disney's *AllEars* publication that he wondered "What do those guys [the bugs] need to do to survive? There was one session with some entomologists, and they said, 'You know, there are soldier termites that spray acid on their prey,' and I thought, 'Man, there's a 3-D act!'" The only two fully developed characters at Pixar thus far were Flik the ant and Hopper the grasshopper. Both became audio-animatronic characters in *It's Tough to Be a Bug!*. Hopper in particular has become

a legend among audio-animatronic characters, heralded for all his moving parts and his life-like movements. "With all the little spindly grasshopper tentacles, it was really hard to do," Rafferty admitted. Audio-animatronic characters play an important part in 4-D dark rides and other theme park attractions, serving as hosts, antagonists, and narrators. One of Disney's most endearing audio-animatronic characters is Mr. Potato Head, in part because his body parts are removeable, a little like the classic toy, but in this case, he removes these pieces himself. Mr. Potato Head is the barker at Disneyland's *Toy Story Midway Mania!* attraction.

Ridefilms are not only be found in IMAX theatres and at theme parks but are even finding their way into cultural institutions. In Chapter 10, we described a 4-D dark ride, *Everglades Airboat Adventure*, which was featured at the Museum of Discovery and Science in Ft. Lauderdale, Florida. At historic Mount Vernon, when visitors watch a film called *Revolutionary War Immersive Experience*, snowflakes fall down on them from the sky, fog rolls in, and through their chairs—which are actually rumble seats—they can feel the thudding of cannons going off. And, in a very different kind of 4-D dark ride, this one designed for the toddler set, audience members can join the beloved Dora the Explorer and her friend Diego at various cultural institutions like the Central Park Zoo in New York for *Dora and Diego's 4-D Adventure*. The adventure is set in a tropical rainforest, and thanks to the "magic" of 4-D technology, the audience members, wearing 3-D glasses, can almost touch Dora and Diego as they swing from vines right towards them. They join the characters as they ride over water in a helicopter and feel the water splashing in their faces, and they can even smell the bananas that a character snatches from a tree.

Single-Participant Large-Screen Immersiveness

In some cases, large-screen immersive environments are designed for a solo participant rather than for a theater audience. Most frequently, they are used for cutting-edge training simulations. They often employ sophisticated AI, synthetic characters, voice recognition systems, and multi-sensory stimuli.

Mission Rehearsal, a military training project, is a good example of a single-participant large-screen simulation. Like many of the military simulations already discussed, it was produced by ICT, and writer Larry Tuch, who scripted many of the other simulations, wrote this one as well. *Mission Rehearsal* is set in a war zone and requires the trainee, a young officer, to handle a volatile situation—a child has been run over and severely injured by a military vehicle, attracting a hostile crowd.

The trainee stands in a physical space surrounded by the lifelike virtual characters on the screen (see Figure 19.1). To diffuse the rapidly escalating crisis, the trainee must obtain essential information from the synthetic characters on the screen, particularly from the central onscreen figure, the platoon sergeant. (This character has been built with a high degree of AI. He can understand spoken language and respond convincingly.) Once the trainee has a grasp of the situation, he or she must give the appropriate orders to peacefully resolve it. Otherwise, things get dangerously out of hand.

As with the other military simulations he worked on, Tuch said the events on the screen unfold at a relentless pace, with

FIGURE 19.1 *Mission Rehearsal* makes use of a large curved screen, surround sound, and virtual characters. Image courtesy of USC's Institute for Creative Technologies.

unexpected twists and turns. Unlike a TV set, it cannot be turned off. "You're inside the story," Tuch explained, "and there's no pausing or doing it on your own time. It doesn't wait for you." This type of pressure, intertwined with the unfolding drama, calls for quick decisions and prepares the trainees for situations that they may well encounter during actual military operations.

Very similar techniques are being used to train law officers in how to handle particularly volatile situations, such as when hostages are involved. One company, VirTra Systems, employs a five-screen system that completely surrounds the trainees, creating a full 360-degree perimeter. The characters on the screen are rendered with photorealistic precision, making the drama extremely compelling. The trainees have to be aware of what's going on all around them, and the situations they are faced with call for both good judgment and good marksmanship. They hold a prop gun, and if they discharge it at one of the virtual characters, it can actually "kill" the person struck. But it is also possible to hit the wrong target and set off an explosive device. Furthermore, the trainees themselves can be "shot." In some of these simulations, they are wired to a special device, and if they are "hit" by a bullet, they will receive an electric jolt.

However, not all large-screen, single-participant environments are designed for training. Some are meant for leisure-time enjoyment. For instance, the School of Computing at the University of Utah has designed a system that incorporates a treadmill and three large screens for a 180-degree view, and as individuals walk or run on the treadmill, they feel as if they are hiking or running in various exotic spots. They call this method of employing a treadmill in a large-screen environment a *locomotion interface*.

Immersive Multiplayer Motion-Sensing Games

In Chapter 11, on video games, we briefly described a new type of game called (for lack of a better term) an immersive multiplayer motion-sensing game. A set of these games was developed for Disney's Epcot Theme Park in Florida, for the *Living Landscapes* pre-show for the *Soarin'* ride. These games were created to help

entertain the guests while they were waiting in a long line for the *Soarin'* ride, a major attraction at the park, and the games were developed under the helm of Disney Imagineer Dean Orion. Orion is a writer/producer and creative director of traditional and interactive media, which gives him a valuable viewpoint for narrative-based interactive works. While I was back in Los Angles recently, I was lucky enough to snag an interview with him about the process of developing these games—a type of gaming that had never been done before.

He told me that, essentially, he had started with a blank canvas, only knowing that he had to come up with something to amuse the people waiting in line, something that would fit into a 150-foot hallway, 15 feet in depth, crowded with 250 people. As if that were not challenge enough, he said, "You can't use buttons and you can't use levers!"

Initially, he and his team managed to come up with four screen-based motion-sensitive games that they believed could work in this space. Using motion-sensitive technology for multiplayer gaming was revolutionary at the time, and in the beginning, Orion confessed, he didn't even know it would work. But he did his research and found a company that had created projects with the kind of technology he had in mind, a motion-sensing camera-based infrared technology similar to the Kinect and the Wii, though it would be some time before either would come out. Orion's team then managed to produce four working games using this technology. However, when they tested them with real guests, they discovered problems. "One of the biggest things I learned working at Disney on location-based projects is that there's a lot of emergent behavior with experiences," Orion told me. "You design something thinking people will behave the way you designed it. Then you put it in, install it, and you see them behaving in ways you never expected."

When they first tested these games, he said, "The very first thing we observed was that people would be in line, and they'd be with their family or their friends or whatever, and they're not all necessarily facing the screen. They're all in different jumbles." Thus, they would miss the introduction to the game and wouldn't understand how to play it. To solve this problem, Orion had his

team come up with a little song, and when the music started to play, people would turn and look at the screen. Now that they had their attention, they were able to do a short intro with instructions on how to play, and then, Orion said "dramatically people were able to enjoy the game, much much better than before."

Orion and his team faced another problem with one of the games, *Air Race*, where the audience could direct the flight of a bird by leaning to the right or the left as a team, dodging rocks and trees. Each team would have its own colored bird and the five teams would all race against each other. But, Orion told me,

> What happened was that we noticed that people would get tired. Some people can't lean for two minutes, left and right, left and right. On a particular team, I'd say we started with 50 people, then after 30 seconds we were down to 35 or 30 because people dropped out. But the system would still be looking for those other 15 or 20 people, so it wouldn't steer the bird correctly because it would just see [the ones who dropped away] as not leaning. That meant the people still wanting to play would end up losing.

Orion thought that was unfair. So he had his programmers add a little program called "adaptive sensitivity." Every five seconds the program would look around and say "Okay, how many people are playing? 50? Okay, we'll have 50 steer the bird." Five seconds later it would say "Okay, how many now? 45? Okay, 45 steer the bird." So in a sense it would "take readings" every few seconds and would allow the people still playing to correctly steer the bird. Orion added: "That was one of those things [that we gathered from continual observation] that we were able to adjust, and make it an enjoyable experience for as many people who wanted to play at any given moment." He also told me working on location-based projects requires a focused period of testing in the field and readjustments based on what you learn. "Everything you build for a location, every interactive experience, needs to have on-site field testing and revision time built into the schedule," he emphasized.

After the first four games had been installed, the team learned they still had a sizeable sum left in the budget, and they realized that they must use it or the budget for the following year would be reduced. That was the impetus to come up with a fifth game,

Balloon Odyssey, and it turned out to be the game in this set that Orion is most proud of. It was a narrative-based game powered by kinetic energy—the clapping, jumping, or waving movements done by the audience. The idea they came up with "was to do a side-scrolling game that had a balloon that could go up and down based on the amount of kinetic energy produced by the players in front of the screen," Orion told me. And, to add drama to this game, they invented a scenario based loosely on Homer's *Odyssey*.

The action starts at a beautiful palace full of jewels. But a bandit balloon comes along and, using a vacuum cleaner, sucks a mass of jewels out of the palace (see Figure 19.2). You, the audience, give chase in your own balloon and try to wrest the stolen jewels from the bandit balloon. In a sense the jewels are a stand-in for Helen of Troy, from Homer's other great work, the *Iliad*. Orion describes the chase as an exciting journey. "You can go up into the sky, into the stratosphere. Or you can descend into the underworld, which kind of looks hellish, or you can stay in the earth plane. And in

FIGURE 19.2 Concept art for the bandit balloon, complete with vacuum cleaner, from *Balloon Odyssey*. Image courtesy of © Disney Enterprises, Inc.

each one of those planes there are all these mythological monsters; there are trolls who throw rocks at you and dragons that fly and breathe fire at you, and spiders that try to attack you in the underworld." And then, he adds, "At the third act break, the bandit balloon makes another appearance and starts to chase you. And then eventually you get away from him as the whole experience comes to a close, the balloon settles back down at home, just like Odysseus coming home to Ithaca. And you get a little final score at the end."

Fulldome Productions

Fulldome is a relatively new form of immersive environment, being introduced in 1990s. In these works, images are projected onto the entire surface of a planetarium dome or a similarly shaped theater. To get a sense of what watching a fulldome work is like, picture yourself sitting inside a huge upside-down bowl, surrounded on all sides by moving images.

Today, hundreds of theaters are equipped to show works of fulldome. Some of these theaters are retrofitted planetariums and others have been set up on roof tops. Some are even found on cruise ships. One of the most immense and impressive fulldome arena is presently under construction in Las Vegas, Nevada. It will be known as the MSG Sphere and will be 20 stories tall, 500 feet in diameter (the size of one and a half football fields), and will be able to accommodate an audience of 18,000 people. Early reports say the Sphere will be used for concerts, esports, and immersive storytelling. The Sphere broke ground in the fall of 2018 and it is expected to take three years to complete.

Like other forms of immersive environments, fulldome has the power to transport you to a place you could probably never visit in real life, and to give you an experience you could not otherwise have. Many fulldome productions are set in outer space or in the ocean, perhaps because these themes lend themselves well to narratives about all-enveloping environments. One of the more adventurous of these scientifically themed works is a trip inside a black hole and to the other side of infinity, a visualized representation of Einstein's equations. Another is a dazzling, kaleidoscopic investigation of the

mathematic patterns known as fractals. Some people working in the dome arena are now using vDome software, a multi-channel projection system, which can be used to produce interactive dome experiences, such as moving an avatar around the space and creating a painting based on the movement of the audience.

In addition, teams of people around the world are actively experimenting with fulldome works that are purely narrative or artistic in nature. For example, the well-known artist and muralist, Gronk, created a stunning semi-abstract piece called *Gronk's BrainFlame*, which is about the power of imagination and the birth of artistic ideas. And a team at the University of New Mexico has been working for years on a fulldome adaptation of Gerald McDermott's Caldecott Medal winning children's book, *Arrow to the Sun*. This myth-like story is about a Native American boy from a Southwestern pueblo who discovers his father is the sun god.

An Artist's Take on Creating for Fulldome

To try to understand what it is like to create artistic and narrative works for fulldome, I met with Hue Walker, a poet and fine artist and one of the pioneering practitioners of this field, or a "domer," as these digital artists call themselves. Walker not only creates original works for fulldome but also served as producer of *Gronk's BrainFlame* and the work-in-progress, *Arrow to the Sun*. Until recently, Walker taught fulldome classes at the University of New Mexico (UNM). We met inside UNM's small-scale, portable fulldome, a perfect place for such a conversation.

Walker's own fulldome works are highly personal and rich with poetic imagery. For example, in *Wings of Memory*, Walker explored the power of memory and why one life moment flows forward throughout one's lifetime and even beyond while other memories disappear. The piece combines old family photos and moving images, including a dancer dressed in white and with beating wings. The wings, she said, represent "the memories moving along with us" (see Figure 19.3). The piece won a Domie award for Best Art Piece at the 2004 Domefest, an annual festival of fulldome works.

FIGURE 19.3 An image from Hue Walker's *Wings of Memory*, a fulldome work. Note that the image is a 180° fish-eye projection to conform to the shape of the dome. Image courtesy of Hue Walker.

Walker told me one of the greatest challenges of creating fulldome pieces was dealing with the shape of the dome. In today's world, we are totally familiar with setting our work inside a frame—the rectangle of a canvas or a movie screen, for example—but we are not at all used to setting a work inside a domed space. "It's closer to the images we see in our mind when we hear a story around a campfire, more like how we dream," she said. "There's no frame around these images."

In creating for a domed space, familiar film techniques like close-ups and cuts either do not work at all or are confusing to the audience. Domers have to learn to work with a 180-degree by 360-degree viewpoint and have to create for a fish-eye shape. Just as with VR installations, it calls for the creation of a new visual vocabulary.

Walker does not believe that there is one particular genre of storytelling or another that is more or less suited to fulldome.

The important thing, she stresses, is that your storytelling should relate to the space and make good use of it. "If you are attracted to it because this is where the story belongs, then it will happen," she asserted.

> **EXPERT OBSERVATIONS: THE EMOTIONAL POWER OF FULLDOME**
>
> Walker stressed that there are positive trade-offs to the challenges the domed shape presents. Foremost of these is the power of the dome to elicit intense emotions in the audience—emotions like joy, fear, mistrust, and enthrallment. She explained that triggering these emotions is connected to the sense of body weight, body position, and velocity and can be induced by how images and sounds are used within the dome. For instance, you can elicit a feeling of mistrust or fear by having an image sneak up behind the audience. And having an image plunge downwards can produce a dropping sensation, which sometimes can feel like doom or death, while a soaring image can produce a sense of weightlessness, which is interpreted emotionally as joy.

Another domer, visual artist Ethan Bach, who until recently was the digital dome director for the Institute of American Indian Arts (IAIA), believes that fulldome offers great artistic and narrative possibilities. He told *InPark News:* "I believe digital domes are a great way to share many expressions of art, culture, and storytelling. The immersive high-resolution images paired with surround sound has a strong influence on the audience that is very different than traditional flat screen."

Conclusion

Though audiences have been familiar with stories projected onto flat screens since 1895, with the showing of the Lumière brothers' shorts, which were remarkable at the time, today's audiences are enjoying dazzling new experiences thanks to screen-based immersive stories. We can now be surrounded on all sides and above our heads with a narrative; we can converse with characters

on the screen or shoot them if we wish; we can go on thrilling journeys thanks to 4-D dark rides, or be part of a crowd working together to control the images on a set of screens. These advances in screen-based narratives have happened rapidly, within the past two decades. It is enticing to think what new experiences are awaiting audiences in the decades to come.

Idea-Generating Exercises

1. Picture yourself sitting in a fulldome theatre. What type of immersive experience not described in this book do you think would be amazing to see in this arena?
2. If you have ever been on a 4-D dark ride, describe what about the experience made it feel especially real?
3. Sketch out an idea for a 4-D dark ride. What kinds of stimuli to the senses could be incorporated into this ride that would make it believable and immersive?
4. Try to imagine a dramatic scenario where you could chat with an on-screen character. What would the conversation be about? What about the conversation could result in a positive or negative outcome?
5. Sketch out an idea for group-based immersive multiplayer motion-sensing game. What would be the premise for the game? How would the group control the narrative?

Part 6

Career Considerations

Part 3

Career Considerations

Chapter 20

Working as a Digital Storyteller

How do you find work as a digital storyteller?

If you've got a great idea for a video game or other work of interactive entertainment, how do you sell it?

How do you build a career in such a quickly changing field as digital storytelling?

Is it a good investment of your time to create an original piece of work or a portfolio of samples to show off your talents?

If you do decide to create your own showcase, what should it include, and what is the best way to highlight your strengths? What sorts of things do not belong in a showcase and can make a negative impression?

A New Occupation

The pioneering individuals that we've met along the way in this book are all practitioners of a new type of creative endeavor, a craft that did not even exist a few decades ago. They are digital storytellers. The work they do spans an assortment of technologies and media, and the projects they create are a contrast in

opposites—everything from talking baby dolls to gritty video games. Some of these creations appear on the tiny screens of wireless devices, while others play out on huge movie screens. The venues where these works are enjoyed run a gamut of possibilities, too. They may be seen in one's living room, in a theme park, in a schoolroom, in an office—even in the ocean, as with the robotic dolphin, DRU. Yet, despite the great differences among them, the works they create have significant points in common. All of them:

- Utilize digital technologies
- Tell a story
- Are perceived as being entertaining
- Engage the users in an interactive experience

Even though being a digital storyteller is a relatively new occupation, it is a type of work that is increasingly in demand. True, you won't find jobs for "digital storytellers" listed in the want ads. That's because the jobs in this arena go by a great variety of titles and call for various kinds of skill sets. As we've seen throughout this book, the people that we would consider to be digital storytellers carry many official titles, including designer, graphic artist, information architect, producer, project manager, writer, and director. The most visionary of the digital storytellers may work across a number of different platforms and media.

The great news about this new profession is that it can pay quite well. According to Zip Recruiter, as of April 2019, the average annual salary for game designers in the US is $161,000. Glassdoor shows game developers earning $101,932 annually in 2019, 3-D artists earning $64,000, and programmers $72,000. A tester, which is usually an entry-level position, makes on average $22,000 annually—not bad for getting your foot in the door. As to be expected, the top executives and the legal professionals earn the most of all, but recent statistics for those fields are not available. Unfortunately, as of this writing, no salary statistics are being gathered for other sectors of digital entertainment, but one might expect the salary ranges in the most established arenas to be more or less consistent with the games industry.

Another interesting point about digital media: these companies are scattered all over the world, meaning you don't need to live in

New York City or Silicon Valley to be employed. The game developer's map (http://www.gamedevmap.com/) shows how widely dispersed game development companies are throughout the US, with a total of 2,711 companies scattered across the country.

This chapter will explore ways of finding work and developing a career in the field of digital storytelling.

The Life of a Digital Storyteller

If you were to round up 10 people who could be described as digital storytellers and ask them how they got started, the chances are that they would give you 10 entirely different answers. Many, especially the younger ones, will probably have had some kind of college training in the area, but almost certainly, their career paths will not have been straight ones. Most will have come to their present job by following a dream, by hard work, and by a willingness to take chances.

Kevin Rafferty's career is a perfect illustration of this. Rafferty is executive creative director at Walt Disney Imagineering, leading the design and development of new attractions at Disney theme parks. Before that, Rafferty was a senior concept writer and director for Disney Imagineering, a top-level Digital Storytelling position. It's work that Rafferty and other Imagineers refer to as the "dimensional entertainment" side of the storytelling fence. Some years ago, Rafferty was the writer of the kiosk games in Chapter 2 for the *Discover the Stories Behind the Magic* project. Subsequently, he helped create and develop *Toy Story Midway Mania!*, *It's Tough to Be a Bug!*, and *Cars Land* in Disney's California Adventure. Rafferty's work at Disney has called for a mixture of tasks, including show writing. He creates ideas for theme park attractions and helps to take them from concept all the way to completion. In addition, he has written original music for Disney shows; cast and directed voice and camera talent; and directed show programming and figure animation ... and that's just a partial list of his responsibilities.

Not surprisingly, Rafferty's dream job at Disney didn't start out on this level. His career path actually started with a humble dishwashing job at Disneyland while he was still in college, where

he was an art major. After college, he worked for a while as an advertising copywriter. When he heard that Disney was hiring people to work on the new Epcot theme park, he applied for a job as a writer, figuring he knew a little something about theme parks from his old dishwashing job. He succeeded in getting hired, but not as a writer. Instead, he found himself dusting show models and cutting mats for artwork. But still, he had his foot in the door at Epcot, and made the most of the opportunity. Working on his own time after hours he created and developed some original ideas and ran them by a friendly vice president, and "after paying a lot of dues and trying to prove my creative worth," he told me, "I was finally and officially accepted into the creative division."

Thus, a path that began with dishwashing led to an exciting array of assignments at various Disney theme parks. Looking back on his experience, Rafferty quips in classic Disney fashion, "I guess it's true what they say: 'When you DISH upon a star, your dreams come true.'"

Rafferty's career path is typical of many others who have found their way into digital storytelling. A straight, clear-cut route is quite rare. It's not like deciding you want to go into dentistry and knowing that step number one is applying to dental school. In Rafferty's case, his career aspirations evolved over time, and once he knew what he wanted to do—to become a creative part of Walt Disney Imagineering—he focused his efforts and sacrificed his free time to get where he wanted to be.

> **NOTES FROM THE FIELD: SOME KEYS TO SUCCESS**
>
> Although new media involves cutting-edge technology, two industry pros who were queried on advice for establishing a career in this field mentioned some tried and true old-fashioned values (*GIGnews*, March 2002). In fact, the answers they gave would have worked as well for a Stone-Age hatchet maker. For example, Stevie Case said the three keys to success were drive, dedication, and the desire to learn, while John Romero named passion, hard work, and an optimistic outlook. And both also stressed the importance of being a finisher—to complete any project you commit yourself to doing.

One thing most people who work in the field will agree upon is the importance of good storytelling. Mark Harris, a software architect who was also the creator of the transmedia film, *The Lost Children*, was asked in an interview for *Filmmaker Magazine* (April 4, 2013) what he believed were the most important tools for interactive storytelling. Harris answered: "Empathy, character, story. I believe that an 'interactive storyteller' should focus on the same skills utilized by every other storyteller. Technologies come and go. But I don't think they fundamentally change human behavior."

Selling an Original Idea

What if, unlike Rafferty, your dream is not to work within a particular company or hold a particular job, but instead to sell your own original ideas for a game or other type of interactive entertainment? No question, this is an appealing goal, one shared by many hopeful individuals. Sad to say, however, it is not particularly realistic, for several reasons.

For one thing, ideas are plentiful, to the point that most companies are flooded with their own internal ideas generated by employees of the company, and thus they are not looking for ideas from the outside. For another thing, as they say in Hollywood, ideas are cheap; execution is everything. Execution is where the real challenge lies, and execution takes experience, talent, time, and often an investment of money. To convince a company that your concept has merit, you'll need more than an idea. You'll want to have something to show them—a concept document, a design document, or, even better, a working prototype. And you'll also need to consider the pitching strategy for your project. Who is the target audience for this product, and why would they like it? What competing projects already exist, and how is yours different and better? And how would your project be a good fit with other offerings in the company's line?

But even if you've done all the necessary groundwork, the companies you are planning to approach are unlikely to give you a warm reception if you are an unknown quantity to them. Developing a game or other work of interactive entertainment is a risky proposition that can cost millions of dollars. If a company

is interested at all in hearing pitches from outside vendors, they will be far more likely to be receptive to a known developer with a proven track record than they would be to a stranger.

> **WORTH NOTING: SELLING AN ORIGINAL PROJECT**
>
> Despite these discouraging words, if you are convinced that you have a stellar idea and want to have a go at trying to sell it, you need to pinpoint which companies it might be appropriate for. Have they published anything that is along the same theme as yours, or for the same intended audience? They do some research. Most digital media companies will indicate if they are open to submissions and if so, will supply a submissions guideline.
>
> Highly respected game designer Ernest Adams has a Web page devoted to breaking into the game business: *The Wanna-Be Page*: http://www.designersnotebook.com/Wanna-be/wanna-be.htm. It's well worth checking out.

As to be expected, your chances of selling a game or other interactive project are far better if you are a development company that has a track record of producing games rather than someone new to the field. But even so, it is a difficult path. At the Game Developer's Conference in Europe in 2012, Pete Smith, Sony's director of product development, offered a number of practical tips about pitching to Sony. Though written some years ago, they still make perfect sense and work well in terms of pitching to any major publisher.

- Be able to pitch your idea quickly, in about 30 seconds.
- Practice your pitch before the meeting.
- Select the best person from your team to deliver the pitch. It might not be the CEO.
- Keep your visuals simple and bold.
- Tailor your pitch to the specific publisher you are meeting with and make sure it is an appropriate work for this company.
- Sell your company and your team. Even if your project isn't what the publisher is looking for, your team might be.
- Leave time for the publisher to ask questions.
- Don't be boring, late, or hung over!

Although the report did not mention it, it is also important to leave some documentation describing your IP with the publisher. A concise concept document, described in Chapter 9, works perfectly for this.

> **WORTH NOTING: ANOTHER ROUTE**
>
> Pitching a project to a publisher is not the only way to finance a project and get it made. Many teams have raised money for projects through Kickstarter and other crowdsourcing sites, and it can be a highly successful way to obtain the funding you and your team need. For example, Cyan, the developer that brought the world the much beloved game *Myst* in 1993, used Kickstarter to fund its two VR games, *Obduction* and *Firmament*.

Thinking Outside the Box

Some digital storytellers grab the reins and create and produce their work of digital storytelling themselves, rather than trying to sell an idea to another party. This is the entrepreneurial approach, and it can be a very successful way to go. It is a route Matt Page took for his webseries, *Enter the Dojo*, described in Chapter 12.

Freddie Wong and his team not only produced the Web series *Video Game High School*, but actually built a website to host it, RocketJump (http://www.rocketjump.com/). *Video Game High School* ran for three seasons and the first season was edited into a two-hour movie and Wong became a YouTube star. In the storyworld of *Video Game High School*, gamers and their games have become the rock stars of their high school, leaving jocks in the dust. The series was an enormous success, watched by over 100 million viewers. The team raised over $800,000 on Kickstarter for its second season, shattering the Kickstarter record at the time for a media campaign. Their website, RocketJump, has been a success in its own right, with over 8 million subscribers and generating revenue through paid ads. RocketJump also functions as a production studio. Wong told Lucas Shaw of *The Wrap* that having their own website gives his team more financial opportunities.

"We need our own place to exhibit our own content," he said, "and we need to be able to control that user experience, and have a way to guide viewers through content." In terms of content, they can add behind-the-scenes material, a better commenting system, and potentially, transmedia experiences. And, in terms of financial opportunities, they can recruit sponsors, sell merchandise, and do a great deal of product placement. Thus, being entrepreneurial can offer substantial benefits, though of course it can also be a risky approach to content creation. A successful project needs to be highly original and well-targeted for a specific audience. In Wong's case, his story is a refreshing take on high school and is targeted primarily to gamers. Wong himself is a competitive game, so he knows this arena well.

Additional routes to fund one's projects are through YouTube partnerships and through grants. By becoming a YouTube partner (https://support.google.com/youtube/answer/72851?hl=en), ads may be implanted on eligible videos you have made and you share the proceeds with YouTube.

In addition, grants or funding for yet unmade projects can sometimes come from nonprofit organizations. A list of such grants is available at https://gov.texas.gov/uploads/files/press/videogame_grants.pdf.

The Different Employment Paths

If you are interested in finding full-time employment in interactive media, you will be happy to know that a surprisingly wide variety of businesses employ staff members who specialize in this field. The most obvious are the game publishers and game developers. The publishers have deeper pockets than the developers, and may either develop projects in-house or farm them out to developers, who do the actual creative work, which the publishers then package and market. These publishers and developers do not necessarily restrict themselves to video games. They may also make games for mobile devices and for the Web, including MMOGs, and may also make works of VR and AR.

In addition to game publishers and developers, another group of entities focuses on interactive media: the design firms that deal

with interactive media. Some of them specialize in Web design work, while others pursue cutting-edge projects in immersive reality. Some work in a wide sweep of interactive media, a mix of platforms and approaches including mobile devices, the Web, and transmedia storytelling.

One entire industry that is becoming increasingly involved in interactive media is the Hollywood entertainment business, as we've seen throughout this book. Not only are movie studios making games based on their films, but they are also promoting their films on the Internet and on mobile devices, sometimes using highly creative approaches. Television networks also promote their shows via new media. Public broadcasters are particularly aggressive in using interactive media to maximize the content of their programming, developing projects for multiple forms of media. Thus, traditional entertainment studios and broadcasters are definitely worth investigating for employment opportunities.

For example, exciting opportunities were recently offered at CNN, for their Style show. The offer read:

> We have five new fantastic staff positions—three based in London and two in Hong Kong. This is a unique opportunity to be part of a growing team inside the world's most trusted and high-profile news organization. All applicants must be digital thinkers with a highly confident grasp of social media. Style's key subject strands are fashion, design, architecture, luxury, cars and the arts, so each candidate must exhibit a passion and breadth of understanding in some or all these areas ... Full of energy and ideas, they'll be ready to dash out to events with a glint in their eye and a smartphone in their hand at a moment's notice.

In considering possible employers, do not by any means overlook major corporations. Most of today's large companies have internal divisions that produce content for the Web and other interactive media, work that is often done under the umbrella of the promotion or marketing departments. One example described in this book is Macy's transmedia story *Sunny the Snowpal*.

Other entities that do work in interactive media are toy companies, ad agencies, newspapers, and PR companies, as well

as companies that specialize in interactive training programs. Another group of organizations to consider are cultural institutions—museums, historic sites, aquariums, and so on—all of which may use interactive displays to make their exhibits come to life. And theme park companies employ individuals like Kevin Rafferty to create attractions that take advantage of the latest interactive technologies. In addition, government agencies sometimes produce interactive programming for educational, informational, or training purposes.

Common Entry Points

Although, as we've seen from Kevin Rafferty's story, the path to a great job in digital media is not necessarily a straight one, a couple of traditional routes do exist. One is by becoming a beta tester, which is particularly attractive to people who want to work in games. Beta testers are hired to look for bugs in games before they are released to the public, and this type of work is often a stepping-stone to a higher-level job within the same company. One of my students, Trevor Weisberg, who became a beta tester, had this to say to those wishing to follow the same path: "One thing I strongly advise—do *not* become a tester to play games. Become a tester to *test* games. I know with all these never-before-released titles it's enticing to play for fun, but when I was given a job, I had to drop the game immediately to get it done." In other words, the job sounds like a wonderful opportunity to play games all day, but that isn't what testing is all about. He also warned that the job can entail long hours: "Be prepared to work 60-hour weeks. When I was at XXXXX, I was at work 12 hours a day, 6 days a week." He reports that his present job has far more manageable hours, and on the whole, he is happy starting out as a beta tester.

Another proven route is via student internships. Internships offer first-hand exposure to a professional new media workplace. Not only are they educational, but such experiences are also good to have on a résumé. And, best of all, they can lead to full-time employment.

Aside from scoring an internship or a job as a beta tester, the pathway into digital storytelling is much like that for any other

kind of work. You need to research the field to determine which segment of the industry would offer you the most potential, given your particular talents, interests, and skill set. It is also quite helpful to network and to attend industry events, which we will be discussing in more detail later in the chapter. And before setting out on a job search, you'll want to give serious consideration to creating a portfolio of sample work, which is discussed a little later in this chapter. Once you have some experience under your belt, you can visit job boards to see if there might be a good fit for you. An extremely large list of jobs, primarily in games, can be found at Mary-Margaret Network: https://marymargaretnetwork.wordpress.com/. The site also contains articles about the games business.

Working as a Freelancer

What if you would prefer to be your own boss rather than to be a full-time employee of an organization—is this an option in new media? The answer is a tentative yes. It depends on your experience, on your specialty, and the tenor of the times. Back in the 1990s, it was quite customary to be hired to work on a specific project and then move on once the project had been completed. People who worked on a project-to-project basis, instead of being employed full time by one company, are known as *contract workers*, and that is the path that I personally prefer because of the creative opportunities it offers. Currently, however, most companies work entirely with full-time staffers. One of the few professional areas that still offers opportunities to freelancers is in writing, my own specialty. The more credits you have and the more people you know in the industry, the more likely you are to find freelance writing work.

The work one does as a freelance writer varies tremendously from project to project. Some of the assignments you snag are not much different from doing piecework in a factory. You may be expected to churn out hundreds of lines of dialogue, sometimes with little variation between the lines, and the work can be quite tedious. On the other hand, some writing jobs are highly creative. You may have a chance to collaborate on the overall design and content of a project and to develop original characters; you may also be able to help develop what the interactivity will be and how

it will work. Each type of interactive medium poses its own challenges. Writing a script for a kiosk will be quite different from writing one for a smart toy, and both will be different again from writing an ARG or a serious game or a virtual world.

One of the most stimulating things about being a freelance writer is being able to take on projects that are quite different from each other; your work is always creatively challenging. However, being a freelancer also means dealing with issues that one does not have to worry about as a full-time employee. For example, you might have to chase after a client to get paid, or find yourself mired in an unpleasant situation called *project creep*, in which a project grows much bigger than it was originally understood to be. Project creep can cause you to spend many more weeks than you had planned on an assignment, but without receiving additional compensation. It should also be noted that one faces a host of uncertainties when working for a start-up company. Start-ups lack the experience of a long-established company and their expectations may be off-kilter and payments might also be slow in coming. However, startups can offer creative opportunities not found at long established companies, so they can be exciting to work for, despite the risks.

Fortunately, freelance writers do not have to go it entirely alone anymore. The International Game Developers Association (IGDA) has a SIG (special interest group) for writers, https://www.igda.org/members/group.aspx?code=game-writing. The Writers Guild of America West offers staff support, a games committee, and two special contracts for interactive writing. The first contract, called the Interactive Program Contract, or IPC, covers writing for most types of interactive media, including video games and mobile entertainment, while the second, called the Made for Internet Contract, specifically covers original writing done for the Internet. Both contracts are available directly from the Guild's organizing department. Qualified new media writers can even obtain membership in the Guild, which once just included writers of motion pictures and television.

Legal Considerations

At some point or other, if you are working in new media, you are bound to run into legal situations. For example, you are quite

likely to be faced with issues involving intellectual property (IP). Intellectual properties are unique works of human intelligence—images, writings, music, pieces of animation, even game engines or an invention for a toy—that are given certain legal protections, which include copyrights, patents, and trademarks. Intellectual properties can be extremely valuable, and they are fiercely guarded in interactive media with a zeal bordering on paranoia. You may become involved with IP questions when it comes to protecting your own creations; you may also run into IP issues when you want to use the creative work of others in a project.

IP issues can be highly complex, but one thing about them is quite simple: you don't want someone stealing your intellectual property and you don't want to be accused of stealing intellectual property that belongs to someone else. The first situation can result in your losing a significant amount of income; the second can result in a lawsuit. To prevent either situation from occurring, you need to familiarize yourself with the basics of intellectual property law. One place to start is with the website of entertainment and new media attorney and IP specialist Michael David Leventhal (http://www.mcsquaredlaw.com/). The site contains a number of articles relating to IP.

Another legal matter you will need to be familiar with is a document called a non-disclosure agreement, or NDA, often used in high-tech circles. A good article about NDAs was written by Christopher Schiller for Script Magazine in 2018: https://www.scriptmag.com/features/columns/legally-speaking-it-depends-christopher-schiller/depends-secrets-dont-tell-ndas-non-disclosure-agreements?k=bhcuQ33XqkIAZBWy%2FHJWwg%3D%3D.

You will no doubt become aware of NDAs if you are submitting a project to a company in the hopes of selling it or if a company is interested in hiring you for a project, but first needs to share with you what has been done with the project to date. Both situations raise the risk of valuable information being seen by strangers who might possibly use it without authorization. To avert such a risk, it is customary for one party to request the other to sign an NDA. When someone signs such a document, he or she promises to keep the information they are receiving confidential (see Figure 20.1).

NON-DISCLOSURE AGREEMENT

This non-disclosure agreement ("Agreement") is entered into as of _____ ("Effective Date") by and between _____, located at _____ ("Artist"), and _____, located at _____ ("Recipient"). Artist and Recipient are engaged in discussions in contemplation of or in furtherance of a business relationship. In order to induce Artist to disclose its confidential information during such discussions, Recipient agrees to accept such information under the restrictions set forth in this Agreement.

1. Disclosure of Confidential Information. Artist may disclose, either orally or in writing, certain information which Recipient knows or has reason to know is considered confidential by Artist relating to the [NAME] Project ("Artist Confidential Information"). Artist Confidential Information shall include, but not be limited to, creative ideas, story-lines, characters, trade secrets, know-how, inventions, techniques, processes, algorithms, software programs, schematics, software source documents, contracts, customer lists, financial information, sales and marketing plans and business plans.

2. Confidentiality. Recipient agrees to maintain in confidence Artist Confidential Information. Recipient will use Artist Confidential Information solely to evaluate the commercial potential of a business relationship with Artist. Recipient will not disclose the Artist Confidential Information to any person except its employees or Artist's to whom it is necessary to disclose the Artist Confidential Information for such purposes. Recipient agrees that Artist Confidential Information will be disclosed or made available only to those of its employees or Artist's who have agreed in writing to receive it under terms at least as restrictive as those specified in this Agreement. Recipient will take reasonable measures to maintain the confidentiality of Artist Confidential Information, but not less than the measures it uses for its confidential information of similar type. Recipient will immediately give notice to Artist of any unauthorized use or disclosure of the Artist Confidential Information. Recipient agrees to assist Artist in remedying such unauthorized use or disclosure of the Artist Confidential Information. This obligation will not apply to the extent that Recipient can demonstrate that: (a) the Artist Confidential Information at the time of disclosure is part of the public domain; (b) the Artist Confidential Information became part of the public domain, by publication or otherwise, except by breach of the provisions of this Agreement; (c) the Artist Confidential Information can be established by written evidence to have been in the possession of Recipient at the time of disclosure; (d) the Artist Confidential Information is received from a third party without similar restrictions and without breach of this Agreement; or (e) the Artist Confidential Information is required to be disclosed by a government agency to further the objectives of this Agreement, or by a proper court of competent jurisdiction; provided, however, that Recipient will use its best efforts to minimize the disclosure of such information and will consult with and assist Artist in obtaining a protective order prior to such disclosure.

3. Materials. All materials including, without limitation, documents, drawings, models, apparatus, sketches, designs and lists furnished to Recipient by Artist and any tangible materials embodying Artist Confidential Information created by Recipient shall remain the property of Artist. Recipient shall return to Artist or destroy such materials and all copies thereof upon the termination of this Agreement or upon the written request of Artist.

4. No License. This Agreement does not grant Recipient any license to use Artist Confidential Information except as provided in Article 2.

5. Term.

(a) This Agreement shall terminate three (3) years after the Effective Date unless terminated earlier by either party. Artist may extend the term of the Agreement by written notice to Recipient. Either party may terminate this Agreement, with or without cause, by giving notice of termination to the other party. The Agreement shall terminate immediately upon receipt of such notice.

(b) Upon termination of this Agreement, Recipient shall cease to use Artist Confidential Information and shall comply with Paragraph 3 within twenty (20) days of the date of termination. Upon the request of Artist, an officer of Recipient shall certify that Recipient has

FIGURE 20.1 A model NDA document. Document courtesy of Michael Leventhal.

(Continued)

of termination. Upon the request of Artist, an officer of Recipient shall certify that Recipient has complied with its obligations in this Section.

(c) Notwithstanding the termination of this Agreement, Recipient's obligations in Paragraph 2 shall survive such termination.

6. <u>General Provisions</u>.

(a) This Agreement shall be governed by and construed in accordance with the laws of the United States and of the State of California as applied to transactions entered into and to be performed wholly within California between California residents. In the event of any action, suit, or proceeding arising from or based upon this agreement brought by either party hereto against the other, the prevailing party shall be entitled to recover from the other its reasonable attorneys' fees in connection therewith in addition to the costs of such action, suit, or proceeding.

(b) Any notice provided for or permitted under this Agreement will be treated as having been given when (a) delivered personally, (b) sent by confirmed telefacsimile or telecopy, (c) sent by commercial overnight courier with written verification of receipt, or (d) mailed postage prepaid by certified or registered mail, return receipt requested, to the party to be notified, at the address set forth above, or at such other place of which the other party has been notified in accordance with the provisions of this Section. Such notice will be treated as having been received upon the earlier of actual receipt or five (5) days after posting.

(c) Recipient agrees that the breach of the provisions of this Agreement by Recipient will cause Artist irreparable damage for which recovery of money damages would be inadequate. Artist will, therefore, be entitled to obtain timely injunctive relief to protect Artist's rights under this Agreement in addition to any and all remedies available at law.

(d) This Agreement constitutes the entire agreement between the parties relating to this subject matter and supersedes all prior or simultaneous representations, discussions, negotiations, and agreements, whether written or oral. This Agreement may be amended or supplemented only by a writing that is signed by duly authorized representatives of both parties. Recipient may not assign its rights under this Agreement. No term or provision hereof will be considered waived by either party, and no breach excused by either party, unless such waiver or consent is in writing signed on behalf of the party against whom the waiver is asserted. No consent by either party to, or waiver of, a breach by either party, whether express or implied, will constitute a consent to, waiver of, or excuse of any other, different, or subsequent breach by either party. If any part of this Agreement is found invalid or unenforceable, that part will be amended to achieve as nearly as possible the same economic effect as the original provision and the remainder of this Agreement will remain in full force.

(e) This Agreement may be executed in counterparts and all counterparts so executed by all parties hereto and affixed to this Agreement shall constitute a valid and binding agreement, even though the all of the parties have not signed the same counterpart.

IN WITNESS WHEREOF, the parties have executed this Agreement as of the Effective Date.

RECIPIENT ARTIST

_____ _____
Typed Name Typed Name

_____ _____
Title Title

FIGURE 20.1 (Continued) A model NDA document. Document courtesy of Michael Leventhal.

If you are working as a freelancer or are running your own development or design company, you will also need some legal protections in the form of a contract. You will definitely want a contract if you are entering into a new employment relationship; that is, if you or your firm is being hired to do some work for another entity. A contract should specify what your responsibilities will be and what you will be paid at each juncture, often tying payments to the completion of various milestones (points in the project, like a character bible, when particular parts of the project and payments are due). It should spell out what happens if the work expands beyond what has been assigned, thus avoiding the problem of project creep, discussed earlier. The contract may also include language about the kind of credit you will receive and where the credit will appear, and may note who will hold the copyright to the completed work. If you are inexperienced in negotiating contracts, you would be well advised to seek the help of an attorney. Even if you think you are savvy in such matters, it is always a good idea to have a lawyer look things over before signing.

But even before you reach the contract stage, you need to take some steps to protect yourself against an unscrupulous or inept employer. (Working for a well-intentioned but inexperienced client can be as perilous as working for one who deliberately intends to take advantage of you.) Before going too far in any discussion with a new client, try to learn as much about the company as you can, either by doing some research or by asking the prospective employer a series of focused questions. Asking the right questions about the company and the project will help you determine whether this is something you'll want to pursue—or if it is something you should run from.

Educating Yourself

In any case, concerns about contracts and protecting your intellectual property are matters to be dealt with once a career is established. Let's take a few steps back and discuss how one prepares for a career in new media. It usually begins, as you might expect, with the right education. In terms of a formal education, you have a choice of two different paths. Path number one is to

get a good foundation in the liberal arts, and then pick up specialized training, if needed, after graduation. Path number two is a more focused route: to enroll in an undergraduate program in computer science or in digital/media arts. Digital/media arts programs are becoming increasingly common at institutions of higher learning all over the world, both as undergraduate programs and as master degree programs. Specialized programs can give you a good background on theory and invaluable hands-on experience in creating interactive projects; they sometimes offer internship programs and can serve as fairly smooth stepping-stones to a good job. An excellent list of 75 colleges and universities that offer courses in game design and related skills is provided at https://www.gamedesigning.org/video-game-design-schools/. Many of these schools offer courses in other aspects of digital storytelling, as well.

> **EXPERT OBSERVATION: BUT WHAT IF YOU ARE A LUDDITE?**
>
> Not everyone feels that it is good to focus on new media as an undergraduate. For example, designer Greg Roach, introduced in Chapter 3, strongly believes that no matter what position you are angling for in interactive media, you should first have a liberal arts education. He says "A grounding in the classical humanities is critical. Programmer, 3-D artist, designer, whatever ... I'd much rather hire a traditional painter who's a Luddite [a person who rejects technology] but who understands color theory—and then train her in Maya—than hire a hot-shot 3-D modeler whose aesthetic has been shaped exclusively by console games."

One excellent way to get hands-on experience working on a game is by participating in a Global Game Jam. Participants in these events form small teams and develop a game within a very short time frame—usually in just a single weekend. To level the playing field, all participants are given the same theme to work on. Some of these games are later polished and released commercially.

If you are already out of college or if going to college is not an option for you, you might consider a certificate program in new

media arts. Such programs are offered by many community colleges and by university extensions, and many can be taken online. Or you might select just a few courses that prepare you in the direction you wish to go in—classes in 3-D modeling, for example, or Web design. How much technical know-how you need varies from position to position. It is always helpful to have a general understanding of digital technology and a grasp of basic software programs, but if you want to be a digital storyteller, it is even more important to understand the fundamentals of storytelling, drama, and literature. You would be well advised to take a course that teaches narrative structure, or one in world mythology, and you should definitely take at least one course in dramatic writing.

Not all of your education has to take place in a classroom. If you don't already, spend some time playing games, trying out different genres and different platforms. Include first-person shooters, MMOGs, ARGs, mobile and casual games on your "to play" list so you can see how the experiences differ. Even if you aren't interested in working in games, they can teach you a great deal about design and interactivity. If a particular area of gaming is unfamiliar to you, find someone who plays this kind of game—a relative, a local student, a family friend—and ask them to give you a tour of one or two. Most people are happy to oblige, but you can always make it more attractive by treating your guide to pizza.

Finally, you can get an excellent free education online by visiting websites devoted to various aspects of interactive media. You can also sign up to receive electronic and print trade publications. Each segment of the new media arena has several websites devoted to it and usually several electronic publications. Many have been mentioned in this book, and a diligent online search will turn up others.

Industry Events

Another excellent way to educate yourself is by attending conferences, trade shows, and other industry events. Most of these gatherings are divided into two quite different parts, a conference and an exposition. By strolling around the expo floor, you get a chance to see demonstrations of the latest hardware and software in the field, often given by some of the creators of these very products.

And by attending the conference sessions, you will hear talks by industry leaders and learn about the latest developments in the field. Although these trade events can be expensive, many of them offer student discounts and many also have volunteer programs. By working as a volunteer, you can take in as much of the event as you want during your off hours.

Virtually every sector of the interactive arena holds at least one annual event. Two major international conferences are MIPTV featuring Milia, which is held in Cannes, France, and the Tokyo Game Show in Japan. In the United States, the Game Developers Conference (GDC) is well worth attending. It offers excellent presentations on every facet of game design and production, including mobile games, MMOGs, and serious games, and many of the topics are of particular interest to digital storytellers. The Austin Game Conference is another high-quality event.

If you are interested in computer graphics, you will definitely want to attend the annual SIGGRAPH conference. The training field has its special gatherings, too, with *Training Magazine*'s annual conference and expo being just one example. The events mentioned here are just a small sampling of trade shows, conferences, and conventions that involve interactive media; new ones are started every year, and a few older ones sometimes fall by the wayside. The best way to find out about the industry events in your particular area of interest is by subscribing to electronic and print publications that specialize in the field.

The People Connection

Industry events, excellent as they are, only take place at infrequent intervals. To stay more closely involved, and to connect with others who work in new media, you would be well advised to join one of the many professional organizations in this field. Networking with others in the field is one of the best ways to find work and stay on top of developments in the industry, as virtually any career counselor will tell you. It is even more important in a fast-moving field like interactive media. Merely joining and attending an occasional meeting, however, brings limited benefits; you'll reap far greater rewards if you join a SIG (special interest group)

or a committee within the organization and become an active, contributing member. By participating on a deeper level, you are more likely to form valuable connections that can lead to jobs. Two such organizations are the Academy of Interactive Arts and Sciences (AIAS) and the IGDA.

A number of guilds and other organizations within the Hollywood system now welcome members who specialize in interactive media. Among these mainstream organizations are the Writers Guild, noted earlier, the Producers Guild, and the Academy of Television Arts and Sciences, generally known as the TV Academy. These organizations all have active committees or peer groups made up of new media members and put on special events focusing on interactive entertainment. But before you can become part of these peer groups, you first must be a full member of the guild or organization.

Unfortunately, many of the organizations mentioned here only hold meetings in certain geographical regions, and if you live outside these regions, it is difficult to become actively involved. However, you might also look into the possibility of forming a local branch, which can be a great way to meet other members in a less congested setting.

Some Pointers for a Career in New Media

Here are some helpful ideas for establishing and maintaining a career as a digital storyteller:

- Anticipate change. This field does not stay still, so you need to continually educate yourself on digital technologies and new forms of digital entertainment.
- Don't restrict your vision only to this field. Indulge your interests in the world beyond. Not only will this be of value to you in your professional work but it will also help keep you balanced.
- Educate yourself on narrative techniques. All good storytelling relies on certain basic principles.

- Stay tuned to traditional popular culture—to television, film, and music. To a large extent, new media and traditional media intersect and influence each other.
- If you are angling for a first job or a better job, consider building your own showcase. Not only will it give you a way to display your talents, but you will also learn something in the process. For more on showcases, see the following sections.
- Remember that digital media can be a feast-or-famine type of industry and it is wise to be prepared for busts in certain media, in terms of having both a savings account and a good mental attitude. I have already weathered the bust in the CD-ROM market and the dot-com bust and will not be surprised if there's another bust ahead.
- As one of our experts said in Chapter 15, referring to smart toys, sometimes you have to dump all the pieces on the floor and play with them. Playing games and participating in interactive experiences is the single best way to keep your edges sharp.

Showcasing Your Work: Is It Worthwhile?

It is reasonable to wonder, given how much effort it takes to create an original piece of work, if it is ever worth the investment of your time and energy to put together your own showcase. I would answer this question with a resounding yes, based on my own observations of the interactive entertainment industry, and also based on the interviews I've done for this book. Creating your own showcase can benefit you if one of these scenarios fits your personal situation:

1. You have not yet had any professional experience in interactive media but are interested in working in the field.
2. You are already working in digital entertainment but are considering moving into a different area within it or would like to move to a higher level.

3. You are working as an employee in the field but want to work as a freelancer.
4. You are working as a freelancer and want to attract new clients.

Having an original piece of work to show, or a portfolio of work, is of particular importance if you have not yet had any experience in the field. How else will you be able to demonstrate to a prospective employer what you are capable of doing? A well-thought-out "calling card" of original work illustrates what your special talents are, where your creative leanings lie, and also reveals something about who you are as a person. A showcase of original work also bears a powerful subtext: you are serious enough about working in this field to spend your own time putting together a demonstration of your work. It carries the message that you are energetic, enterprising, and committed.

Producing a showcase project is a strategy used by small companies as well as by individuals. For example, Free Range Graphics undertook *The Meatrix* (described in Chapter 10) as a *pro bono* project in part to stimulate new business, a gamble that paid off handsomely for it.

However, the advice to build a promotional calling card must be given with a serious note of caution. If you do undertake such a significant self-assigned task, you need to go about it in a way that will set off your abilities in the most positive light possible and avoid doing things that can undermine your prospects.

Considerations in Creating a Professional Showcase

For some people, putting together a showcase is a relatively easy task, because they can use samples of student projects or volunteer work that they did, or even of professional assignments. But if you don't have any such samples, or the samples you have are not well suited to your current goal, you are faced with the daunting job of creating something original from scratch. You will have a number of things to consider before you actually begin. Among the questions that will almost certainly cross your mind are the following.

Portfolio or Single-Piece Approach?

A portfolio approach includes several brief examples of work, while a single-piece approach focuses on one well-developed project. Each tactic has its own pros and cons. With the portfolio approach, you can effectively demonstrate your ability to work in a range of styles and on different types of subject matter. However, the portfolio approach also means that you will have to undertake several different projects and build them out to the point that they are solid enough to serve as good samples.

By showcasing a single piece, on the other hand, you can present a more fleshed-out and complete project than you'd have in a portfolio, where the samples tend to be short and fairly superficial. But having just one piece of work to showcase can be a little risky, because the work you are exhibiting might not be what the prospective employer or client is looking for, and you will have nothing else to illustrate what you are capable of.

So where does this leave you? It's best to make the call based on your own individual situation. If you already have a couple of samples you can use, and have some ideas about another one or two you could put together, then you are probably already well down the path toward the portfolio approach. On the other hand, if you feel confident you've got a great concept to showcase, and that it would work well as a demo piece, then that's probably the best way for you to proceed. There's no right or wrong answer here.

Distribution Method?

You will need to determine what method you will use to make your showcase available to the people you want to see it. The most obvious choice is to put your work on the Internet, and another option is to use a DVD. Virtually any prospective employer or client should be able to view your work on one of these platforms, so ease of viewing is not a factor here. Your work itself, and your own leanings, are really your best guides. It makes sense to distribute your showcase on the medium in which you are most interested in working. But if you want to work in an area that falls outside of these already mentioned avenues of distribution—if

you are interested in VR, say, or in alternate reality games—then pick the medium that you feel would display your material to the best advantage. One final consideration for a multi-project portfolio: it is advisable to package your showcase on a single platform rather than having a jumble of different works that cannot easily be viewed together.

Subject Matter and Approach?

One of the most important questions you will be faced with is what the content of your showcase will be. The honest answer is that no one can tell you what to do here. The best choices are the ones that most closely reflect your own personal interests, talents, and expertise. By picking a subject you really care about, you have the best chance of producing something that will be strong and will stand out from the crowd. The way you decide to construct your showcase should also reflect your personal taste and style—within limits, of course. Coarse humor and disparaging portrayals of any particular ethnic group or sexual orientation are never appropriate. Also, you do yourself no favors by employing a sloppy, unprofessional-looking style.

But what if you have tried your best to think of some topics for your showcase and still come up blank? Then you might consider volunteering your services for a nonprofit institution in your community. Possible choices include your church, synagogue, or mosque; the local chamber of commerce or a community service group; or a school sports team or Brownie troop. Another alternative is to create a promotional piece for a business belonging to a friend or relative.

Although on the surface such projects seem to be creatively limiting, you may be inspired to create something quite clever. For instance, you could design an amusing advergame for your brother-in-law's landscaping business, or an interactive adventure tale about Brownies for your niece's troop. Volunteer projects for nonprofit organizations or for businesses have some solid advantages. They give you hands-on practical experience, and also give you a professional sample to include in your showcase, even if the work was done without monetary compensation.

Gaps in Necessary Skills?

Lacking all the skills necessary to put together one's own showcase is a common problem, because few people are equipped with the full range of talents necessary for building an effective sample piece. The problem can be solved in two ways: by teaching yourself what you don't already know, or by teaming up with someone who is strong where you are weak. Teaching yourself a new skill like Flash animation may seem like an intimidating project, but as we will see from the *Odd Todd* case study later in this chapter, it is manageable. Software is becoming ever easier to use, and books are available that teach animation programs, image manipulation, Web page design, and media authoring. You might also take a community college course to fill in a particular gap.

But if you prefer to team up with a colleague instead, keep in mind you need not even be in the same community. Many collaborations take place in cyberspace, and sometimes occur between people who have never met in person. Perhaps your strengths are in art, writing, and conceptualizing, while the other person excels at the more technical side of things. If you work together, you can create a project that is more effective than either of you could do alone, and also demonstrates your special abilities. This can be a win–win solution for both parties. Of course, you will want to be sure that each person's contribution is made clear in the credits, and that no one is claiming solo authorship for the entire project.

Odd Todd: A Case Study

While it is important for a personal showcase to look professional, this does not necessarily mean it needs to follow a conservative, play-by-the-rules approach. If you take a look at the website *Odd Todd* (www.oddtodd.com), you will find an immensely quirky piece of work that breaks almost all the rules and yet has become a wildly successful endeavor. This is not to say that everyone should build a project as idiosyncratic as this one is, but it does effectively illustrate the power of being fresh and original, and of having something meaningful to say. Essentially a one-person operation and done on a tiny budget, *Odd Todd* thrust its creator, Todd Rosenberg, into the spotlight and changed his life. He's been

featured on *Good Morning America, Nightline, ABC World News,* and *National Geographic.*

The site is named for a fictitious character, Odd Todd, and is loosely based on the experiences of the site's creator, Todd Rosenberg, who lost his job with a dot-com company during a radical downsizing. In a series of Flash-animated episodes, we watch Todd as he futilely searches for a new job and gives in to such distractions as fudge-striped cookies, long naps, and fantasies about large-breasted women. The artwork in the cartoons is rough and child-like, and the only human speaking character is Todd, who chronicles his hero's struggles in a voice-over narration (see Figure 20.2). The voice he uses is distinctive, marked by a puzzled kind of irony and bewilderment at his predicament, and further made unique by his urban drawl and a particular way of stretching out the end vowels in such words as money (mon-aaay) and cookie (cook-aaay). And though the site is extremely funny, it does have a serious side, touching on the painful issues of being unemployed and serving as a kind of cyberspace support system for laid-off white-collar workers.

Beginning with just a single animated episode, the site has mushroomed into a full array of features. It includes dozens of cartoons and games, all relating to Odd Todd and his life and

FIGURE 20.2 Odd Todd is the fictional protagonist of the *Odd Todd* website, an endeavor that has turned its creator's life around. Image courtesy of Todd Rosenberg.

obsessions. It also includes a variety of specials such as a feature called "What's Happening," a diary-like log of Todd's life, Daily Good News, Coolio Funlinks, and Mov-ay Reviews.

The Hows and Whys of *Odd Todd*

Why has a site featuring roughly drawn cartoons about an unshaven, unemployed guy in a blue bathrobe become such a hit? How did Todd Rosenberg set about making this site and how does he keep it going? And as a showcase, what has it done for his career? The real Todd shed some light on these questions during a phone interview and several follow-up emails.

First of all, let's address one burning question right away. No, the real Todd does not sound like the voice he uses on the website. That is a made-up voice, and many of the situations depicted in the cartoons are invented as well. But the core conceit—that an unemployed dot-comer built the site—is totally true. The authenticity of the character's predicament, the real Todd believes, is an important reason why *Odd Todd* has become so immensely popular. People identify with it, Rosenberg explained. "They see it and say to themselves: 'It's so me!' or 'Someone else is doing exactly what I'm doing!'"

A DO-IT-YOURSELF APPROACH

Although Rosenberg had learned basic HTML at a prior job and had taught himself to draw (by using *Mad Magazine* as a model), he lacked training in almost every other skill he would need in order to build and maintain his new site. When asked what he'd studied in college, the University of Hartford, he confessed: "I never studied in college. I wasn't much of a student." He admitted to filling up his notebooks with cartoons instead of lecture notes. He had no training in screenwriting—he owned books on the subject, he said, but had never read them—and had never acquired experience in acting, either, because he had stage fright.

One of the first things he needed to learn, in order to bring *Odd Todd* to life, was Flash animation. He taught himself how with the help of a book called *Flash 5 Cartooning*. His "studio"

> was his apartment in New York, and he did everything from there. To lay down the soundtrack for the cartoons, he used the microphone that came with his computer and did all the voice work himself, including the strange chirps and other sound effects for the site's non-human characters. As a result, he managed to keep his start-up costs low, estimating that during his first year he spent under $1,000.

Rosenberg began the site in 2001 after he was laid off from AtomFilms.com. Thinking he'd only be out of work for a few months, he decided to spend some of it doing something he'd always enjoyed—cartooning—and create something that might possibly help him become employed again. The result was the first episode of *Odd Todd*. The debut episode was a humorous take on what it is like to be newly laid off, with too much time and too little money.

Keeping Things Going

Though Rosenberg's cartoons have an unpolished, homemade appearance, he can actually draw much better than the work on his website would suggest. In doing the animation for his first cartoon, he made a quick series of drawings, intending to use them as placeholders. But after he refined them, he discovered he much preferred the look of the rough first set and discarded the more polished ones. Making the website look quickly dashed out and candid is totally in keeping with the fictional Odd Todd character, though accomplishing the right look actually takes a great deal of work.

In the beginning, however, Rosenberg's abilities in many areas truly were less than polished. His Odd Todd character would look different from picture to picture; he had trouble making him consistent. In addition, he didn't know how to synch the sound and the picture properly, or how to make a button to let users replay an episode or game. He kept going back to his books and asking more knowledgeable friends for help before he mastered what he felt he needed to know.

Now that the site has been up and running for almost two decades, it still requires regular maintenance and new content and he continues to update it with new cartoons, games, and other features.

A CYBER SUPPORT SYSTEM

Rosenberg has managed to keep his expenses low in part by developing an informal exchange system. For example, he has received significant volunteer assistance from one of his fans, Stacey Kamen, a website designer. Rosenberg reciprocates by prominently promoting her design skills and her website business on his site. Another fan, Geoffrey Noles, volunteers his services to the site by programming the *Odd Todd* games, such as the enormously amusing and popular *Cook-ay Slots*, a wacky slot-machine game. Noles, too, receives credit on *Odd Todd*, as well as a link to his site. Rosenberg has never met either of these two important contributors face to face. They communicate by various electronic means, including, in the case of Noles and Rosenberg, by webcam.

Since its launch, *Odd Todd* has been visited by millions of unique users and has attracted major media attention. Dozens of articles have been written about the site, and Rosenberg has been featured on a great number of TV and radio shows. Loyal fans have contributed thousands of dollars to *Odd Todd*'s online tip jar, one dollar at a time, and they also support the site by buying a great variety of *Odd Todd* merchandise, from t-shirts to coffee mugs. The site has also spawned a book, *The Odd Todd Handbook: Hard Times, Soft Couch*, which, like the site, was created by Rosenberg.

Over time, however, the lives of the fictitious Todd and the real Todd have diverged. While an episode might show a dejected Todd sending out résumés and trying to find work, in actuality Rosenberg is no longer dejected or looking for full-time employment. Instead, he makes enough money from the site and related merchandise, plus freelance work, to keep going. The success of the site, he said, and the creative satisfaction it has brought him, has caused him to lose interest in returning to the 9-to-5

corporate world. Ironically, he's actually making a living by being unemployed, though he now works as a screenwriter, which is not a salaried type of job.

Some Other Approaches to Showcasing

The Internet, especially with the rapid spread of broadband, has proven to be an extremely effective platform for getting one's work seen. Some people, like Rosenberg, have created an entire website to promote their work, while others post their creations on sites like YouTube and Myspace. Still others, like Rosenberg's cyber support team, show off their work by collaborating with others.

Lonely No More

LonelyGirl15 is another self-made venture that, like *Odd Todd*, was produced on a shoestring budget and yet thrust its creators into the limelight. This faux video blog, discussed in Chapter 12, was released at first as individual videos on YouTube. Later, the series got its own website. The project is the joint effort of Miles Beckett, a young doctor who dropped out of his residency program to do something more creative, and Ramesh Flinders, an aspiring screenwriter.

The two met at a karaoke-bar birthday party and discovered they shared a vision of producing a new kind of entertainment specifically geared for YouTube, which was then less than a year old. They developed the idea further, that this would be a vlog (video blog) like other vlogs running on YouTube. But this one would tell a fictional story and it would seem so real that it would pull viewers into the lives of the characters. Together they created *LonelyGirl15*, shooting it in Flinders' bedroom with a cheap webcam, inexpensive props, and unpaid actors. They planned their strategy carefully, giving the episodes a rough-hewn look like other YouTube amateur videos and even having the main character, Bree, refer to recent videos posted on YouTube to make her seem all the more authentic.

> **WORTH NOTING: STAKING OUT NEW TERRITORY**
>
> *LonelyGirl15* was a huge hit, and not even the discovery that Bree was an actress and not a real teenager managed to derail it. They produced 396 videos over three seasons and they are still available on YouTube. Interestingly, although the two creators had agency representation and meetings with top TV producers, they steadfastly refused to turn *LonelyGirl15* into just another TV series, preferring instead to stake out uncharted creative territory. As Beckett told Joshua Davis from *Wired Magazine*: "The Web isn't just a support system for hit TV shows. It's a new medium. It requires new storytelling techniques. The way the networks look at the Internet now is like the early days of TV, when announcers would just read radio scripts on camera."

Pointers for Making Your Own Showcase

If you are planning to create and build your own professional showcase, the following suggestions are helpful to keep in mind:

1. Don't imitate others; be an original. Let your showcase reflect what you really care about. This is the same advice offered by professionals in every creative field to anyone endeavoring to make something to show off their talents, be it a painting or a movie script or a novel or an interactive game.
2. Define your ultimate objectives and mold your showcase accordingly. The material it contains should demonstrate your abilities in the type of work you want to do and be appropriate to the general arena where you hope to find employment.
3. Don't confuse the making of a showcase with the making of a vanity piece. This isn't the place to display cute pet pictures or to brag about your snowboarding trophies. It is, however, appropriate to include your professional credits and contact information.

4. Be sure your showcase actually works. Try to get a friend to beta test it for you. If the piece is for the Web, look at it on different browsers and on both Macs and PCs.
5. If you are lacking in a particular skill, don't let that be a roadblock. Either teach yourself that skill or team up with more skilled colleagues.
6. Humor can be an asset in a showcase, but inappropriate humor can backfire. If you think your piece is comic, run it by other people to see if they agree. Ideally, seek the opinions of people who are about the same age and at the same professional level as your target audience.
7. If your work includes text, keep it concise and easy to read. Try whenever possible to find a way to do something visually rather than by printed words.
8. Make sure that the interactive elements you include are well integrated into the overall concept, have a legitimate function, and demonstrate that you understand how to use interactivity effectively.
9. If you are taking a portfolio approach instead of showcasing a single piece, select pieces that contain different types of subject matter and display different styles and approaches.
10. Get feedback from others and be open to what they say. Receiving feedback can be uncomfortable, but it is the only way you will find out how others see your work. Don't become so attached to any one feature that you are unable to discard it, even if it detracts from other aspects of your showcase. As a story editor once said to me: "Sometimes you have to kill your babies."

The process of creating an effective showcase will take time but be patient. You will probably experience some frustrations and hit some walls. Such setbacks indicate you are stretching yourself, which is a positive thing. If you persist, you will end up knowing more than you did when you began the project and are likely to create something of which you can be proud.

Afterword

I realize that this book has covered a vast amount of territory. I hope I have not exhausted you! My goal was to give you a window into the many different forms of digital storytelling that are out there today, so you could see how they are created and in general how and why they came about. This exploration was intended to go beyond facts and illustrate the creative possibilities of working in this arena, and how much fun it can be.

There is one basic thing that I've learned as a practitioner in this field: Before creating a story for a platform that has never before been used for digital storytelling, it is first necessary to study what the platform can do and what it cannot do. Once you understand how it operates, you can then develop a project that makes the most of its assets. That is really the key thing you need to know about creating these new story forms. No secret method exists other than this, and this does not even qualify as a secret but is just good common sense.

By all means, do not try to glue an old storytelling approach onto a new platform. Some people will always try to do that, but nothing exciting will emerge from that approach. Creating a new kind of story for a new platform, to do it well, requires some heavy mental lifting and no shortcuts. I can promise you that if you stay in the arena long enough, you will be faced with creating a story for a platform that no one has ever employed in that way before. And because it is so new, there won't be any books out there to help you. But if you stay calm, talk to the technicians, and let your imagination go to work, you will succeed at making digital magic.

I wish you all the luck in the world in your role as a digital storyteller!

Glossary

360° video: A form of immersion closely related to VR and sometimes even called VR. With 360° video, you can be immersed in a visual world and see all around you—to the left, to the right, or behind you. And you can look up and down. Unlike true VR, however, you cannot interact with your surroundings or manipulate objects within the visual world.

3G: See *third generation*.

4-D dark ride: An immersive experience that takes place in a space with theatrical seating and a large curved screen. In these experiences, the seats may move to give the audience members the sensation of traveling. (Such a seat is called a *motion base chair*.) In addition, these rides involve other senses beyond vision and sound, including touch, smell, and temperature change. These sensations

are used to bring the audience into the fourth dimension. Such experiences may also be called ridefilms.

5G: The latest generation of mobile communications. It is the successor of 4G, 3G, and 2G. Its advantages include faster video streaming, faster access to the Internet and reduced latency (time it takes for a message sent by a user to reach the receiver).

accelerometer: A device embedded in smart phones and tablets that can compute roll and pitch. It can track the way in which the smart phone or tablet is being moved. For instance, the accelerometer can track a virtual marble a user is rolling around the screen and make the marble appear to be moving realistically, using the rules of physics.

active learning: See *experiential learning*.

adaptive training system: A system used in training games that is designed to facilitate feedback and communication during and after play, as well as the sharing of strategies and solutions.

Advanced TV Enhancement Forum (ATVEF): Set of standards that allows Web-based content to be broadcast on TV.

advergaming: An entertainment that incorporates advertising into a game. Such games appear on the Web and on wireless devices. They are generally short, designed as a quick burst of fun.

agency: The user's ability to control aspects of an interactive narrative. Essentially, agency gives the user the ability to make choices and to experience the results of those choices. Agency also allows the user to navigate through the story space, create an avatar, change points of view, and enjoy many other kinds of interactive experiences.

agent-based modelling: A technique used to populate and animate scenes in video games and films with virtual characters, especially useful for crowd scenes.

agon: Greek for a contest for a prize at a public game; a contest or conflict. The words "antagonist" and "protagonist" are both formed around this root. The protagonist is the one who goes after the prize and the antagonist is the

one who tries to prevent this; their struggle is the core of dramatic narrative.

AI: See *artificial intelligence*.

algorithm: A logical system that determines the triggering of events. In a game, an algorithm may determine such things as what the player needs to do before gaining access to "X" or what steps must be taken in order to trigger "Y." An algorithm is a little like a recipe, but instead of the ingredients being foods, they are events or actions.

alternate reality game (ARG): An interactive game that blurs real life with fiction, and that combines a rich narrative with puzzle-solving. ARGs usually involve multiple media and incorporate types of communications not normally associated with games, such as telephone calls, ads in newspapers, and faxes.

analog: One of two ways of transmitting and storing information, including entertainment content, electronically; the other being digital. Analog information is continuous and unbroken. Film, video, LPs, and audiotape are all analog storage media.

ancillary market: The secondary use of an entertainment property. Typical ancillary markets for movies and TV shows are videos, DVDs, music CDs, and video games. Wireless games are also becoming part of the ancillary market.

android: A type of robot that is meant to look and act as much like a human being as possible, ideally to the point of passing as human. The word comes from the Greek, meaning "resembling man." Unlike mechanized robots, androids are capable of responding to visual and vocal stimuli, and some are capable of voice recognition and can converse in a fairly believable way.

Android OS: The Google operating system for mobile devices. It is a Linux-based operating system. It is used primarily for mobile devices like tablet computers and mobile phones.

animatronic character: A replica of a living creature that is computer-operated but moves in a life-like way and may also speak.

antagonist: In a drama, the adversary of the story's central character. Their opposition gives heat to the drama and provides the story with exciting conflict. The word is formed around the Greek root, *agon*, meaning contest or prize. See *agon*.

application or app: A small downloadable program designed for a particular purpose. "App" is an abbreviation of the term. Apps include ebooks and games as well as programs designed for pragmatic purposes.

arcade game: A game designed to be played on an arcade machine, generally having a great deal of fast action and designed for a short playing time, or a video game that is made in the style of an arcade game.

arcade machine: A coin-operated video game designed for play in public spaces.

Arena-style VR: In this form of VR: users have unrestricted physical action across the entire arena playing field.

ARG: See *alternate reality game*.

artificial intelligence (AI): Intelligence exhibited by a machine, such as a computer, rather than by a human. A digital character with artificial intelligence seems to understand what the player is doing or saying and acts appropriately in response.

assessment tool: A method of analyzing a learner's performance in an interactive project designed to teach or train.

attract mode: A visual tease on a kiosk screen that loops continuously until a user engages with the kiosk and triggers the program. It is also known as an attract routine.

ATVEF: See *Advanced TV Enhancement Forum*.

augmented reality: A type of immersive environment in which digital technology is used in conjunction with physical props or in a real-life physical setting to create a unique experience. In such works, digitally created elements and physical objects (including people) are contained within the same space and may interact with each other.

automata: Self-operating mechanical figures that can move, and, in some cases, make life-like sounds. Automata have been made since ancient times and are the forerunners of smart toys.

avatar: A graphic representation of the character controlled by the player. Players often have the opportunity to construct their own avatar from a selection of choices.

backstory: Background material relating to a drama that explains events that happened or relationships that were established before the current narrative begins.

bandwidth: The capacity of a communications channel to receive data; usually measured in bits or bytes per second. The higher the bandwidth connection, the better able the user is to receive streaming video and to enjoy a high-quality Internet experience. High bandwidth connections are also called broadband and are available via DSL lines and cable and satellite services. Dial-up modems are only able to support low bandwidth; such connections are quite slow and do not support streaming video well. See also *broadband*.

battle royale: A type of shooter-survival game in which combatants fight among each other until only one individual or faction survives.

beta tester: A person who looks for bugs in a software program or game before it is released to the public. This type of job is often a stepping-stone to a higher-level position in the software industry.

bible: A document that describes all the significant elements of a work that is in development. The term comes from television production and is used in the development of interactive content. The bible includes all the settings or worlds and what happens in them, as well as all the major characters. It may also give the backstories of these characters. Some bibles, called character bibles, only describe the characters.

binary choice: Having only two possible options for each decision or action offered to the user.

blog: A Web log. An online diary or journal that is accessible to anyone on the Web, or a site that expresses a personal opinion.

Bluetooth: A protocol that enables high-speed wireless connections to the Internet.

Boolean logic: Logic that uses only two variables, such as 0 and 1, or true and false. A string of such variables can determine a fairly complex sequence of events. Boolean logic can be regarded as a series of conditions that determine when a "gate" is opened—when something previously unavailable becomes available, or something previously undoable becomes doable. Boolean logic is also used to do searches on the Web.

BOOM (Binocular Omni Orientation Monitor): A type of VR device that works like an HMD but is mounted on a rotating arm rather than on one's head. See also *head-mounted display*.

boss battle: a fight between a boss monster and the player. See *boss monster*.

boss monster: In a video game, the most formidable opponent that the player encounters in a level or segment of the game. The boss monster will usually make an appearance toward the end of the segment, and must be defeated in order for the player to make further progress in the game.

bot: Short for robot; an artificial character. On the Internet, bots are programs that can access websites and gather information that is used by search engines.

branching structure: A classic structure in interactive works. It is a little like a pathway over which the user travels. Every so often, the user comes to a fork and will be presented with several different choices. Upon selecting one, the user will then travel a bit further until reaching another fork, with several more choices, and so on.

branded content: Programming that is funded by an advertiser and integrates promotional elements with the entertainment content. Unlike traditional advertising sponsorship, where the advertising is done through

commercials, the entire program can be thought of as a "soft" commercial.

branding: A way of establishing a distinctive identity for a product or service; an image that makes it stand out from the crowd. By successful branding, the product is distinguished from its competitors and is made to seem alluring in a unique way.

broadband: A transmission medium capable of supporting a wide range of frequencies. Broadband can transmit more data and at a higher speed than narrowband and can support streaming audio and video. The term is often used to mean high-speed Internet access. See also *bandwidth*.

bushiness: One possible solution to a runaway branching storyline. Users are offered a maximum amount of choice but unlimited branching is prevented by having many of the links share communal outcomes. Bushiness is difficult to achieve, however.

buyer persona: a single created character, including personality and backstory, for your ideal user; a helpful image to have when you want to know who the audience is for your project.

canon: the official version of a narrative, consistent on all the different media on which the story is carried. *Canon* is a term often used in discussions of transmedia storytelling.

casual game: A game that can be easily learned and can be played in a brief period of time, but is highly replayable. Such games are played online and on game consoles, PCs, cell phones, and other portable devices. They include a wide variety of genres, such as abstract puzzle games, shooters, racing games, and advergames.

CAVE (CAVE Automatic Virtual Environment): An extremely immersive type of VR environment in which the user is surrounded by rear-view projection screens and the 3-D images are seen through stereoscopic glasses.

CD-i (Compact Disc-interactive): A multimedia system developed jointly by Philips and Sony and introduced in 1991. It was the first interactive technology geared for a

mass audience. CD-i discs were played on special units designed for the purpose, and connected to a TV set or color monitor.

CD-ROM (Compact Disc-Read Only Memory): A storage medium for digital data—text, audio, video, and animation—which can be read by a personal computer. The CD-ROM was introduced to the public in 1985 and could store a massive amount of digital data compared to the other storage media of the time.

CGI: See *common gateway interface*; *computer generated image*.

character arc: The transformation that a character, usually the protagonist, undergoes during the course of a story; the way a character evolves and changes. For example, a character might start off as cowardly but grow into a hero by the end of the narrative. The character arc is a staple element of linear drama, but can also be found in works of digital storytelling.

chatterbot: An artificial character, or bot, with whom users can chat.

cheese hole: Spaces in transmedia stories which are designed to encourage members of the audience to contribute content.

Choose your own adventure model: A storytelling model used in many interactive digital narratives. The term is based on a series of books that used the same approach. In digital storytelling, the user is faced with two or more choices at each decision point, each of which can take the story in different directions. A single story can contain many choices and often the story will have several different endings, depending on which path the user took. It a form of is a branching structure. (See branching structure).

cinematic: A cut scene. See *cut scene*.

cloud computing: A method of using, managing, and processing data on remote servers rather than on personal computers.

cognitive game: A game designed to sharpen a person's mental capabilities such as memory, math skills, and logic. They are a subgenre of serious games.

common gateway interface (CGI): A Web term for a set of rules that govern how a Web server communicates with another piece of software.
computer generated image (CGI): An image produced by a computer rather than being hand-drawn, often used as shorthand for computer animation.
concatenation: The efficient reuse of words and phrases to maximize space on a chip.
console game: A game played on a game console. See also *game console*.
construction kit commercial: An online promotion in which users are given all the tools they need to create a commercial for a specific product, competing for prizes and recognition. The concept itself is a promising one, encouraging interactivity and engagement, but unless some restrictions are built in, they can be put to negative uses.
contract worker: An employee of a digital media company who works on a project to project basis instead of being employed full time by one company. They are also called *freelance* employees.
convergence: A blending together of two or more entities into one seamless whole. In terms of interactive media, it may be used to mean the integration of telecommunications and broadcasting or the integration of the PC and the TV
critical story path: The linear narrative line through an interactive work. This path contains all the sequences a user must experience, and all the information that must be acquired, for the user to achieve the full story experience and reach a meaningful ending point.
cross-media production: The merging of a single entertainment property over multiple platforms or venues. See also *transmedia entertainment*.
crucible experience: An in-game experience that will be emotionally powerful and believable enough for the player to undergo a meaningful change in thinking, understanding, and perception—that will cause the player to have "an aha moment" similar to the

transformative experience of catharsis that occurs in the hero's journey.

cut scene: A linear story segment in an interactive work; also called a cinematic. Cut scenes are used to establish the story or to serve as a transition between events; they are also shown at the culmination of a mission or at the end of a game.

cyberspace: A term used to refer to the nonphysical world created by computer communications. It was coined in 1984 by William Gibson in his sci-fi novel, *Neuromancer*.

database narrative: A type of interactive movie whose structure allows for both the selection and the combining of narrative elements from a number of categories drawn from a deep database.

design document: The written blueprint of an interactive work used as a guide during the development process and containing every detail of the project. It is a living document, begun during preproduction but never truly completed until the project itself is finished.

deus ex machina: Latin for "God from the machine." It was a device used in Greek theatrical works when the writer could not figure out a way to bring the story to a satisfactory conclusion, so a god would descend from above the stage and save the day. It is generally regarded as an unsatisfying technique, since the solution does not grow naturally from the characters or the plot.

developer: A company that does the development work for a new software product, such as a game or smart toy.

dialogue tree: A form of interactive dialogue in which the player character or user is presented with several lines of dialogue to choose from. Each line will trigger a different response from the NPC being addressed and, in some cases, may even take the user or player character down different narrative paths.

diegesis: A term used, particularly in academic circles, to mean a *storyworld*.

digital: One of two ways of transmitting and storing information, including entertainment content, electronically, the other

being analog. Digital information is made up of distinct, separate bits: the zeroes and ones that feed our computers. DVDs, CD-ROMs, CDs, and digital video are all digital storage media. Digital information can be stored easily, accessed quickly, and can be transferred among a great variety of devices.

digital video recorder (DVR): One of several terms for devices that enable viewers to select and record television programs; the best-known device is the TiVo. Other generic terms for this type of device are *personal digital recorder* and *personal video recorder*. These devices offer viewers more control than VCRs and include features like pausing live TV and the ability to skip commercials.

disruptive media: An innovation in media that creates a new market, thereby disrupting an existing market.

drill and kill game: Educational games that drill children in particular skills.

dual-screen iTV: A form of iTV in which a television show and a website are synchronized, and thus employ both a TV screen and a computer or mobile device screen. This form of iTV is available to anyone with a computer or mobile device, online access, and a TV set; it does not require any special equipment. It is also known as *synchronous interactivity*. See also *single-screen iTV*.

dungeon master: The person who, during the playing of an RPG or a real-time simulation, helps shape the action, serves as the game's referee, and manipulates the game's nonplayer characters. Dungeon masters were first introduced in LARPs and are a feature of MMOGs and other interactive experiences, including training simulations. See also *LARP* and *MMOG*.

DVD: An electronics platform that plays digitized programs, particularly movies and compilations of TV shows, on special discs, also called DVDs. The initials DVD once stood for "Digital Video Disc," but now the initials do not stand for any particular words; the initials themselves are the name of the technology.

DVR: See *digital video recorder*.

early adopter: A person who is one of the first to use a new technology or device.

ebook: See *electronic book*.

edutainment: An interactive program for children that combines entertainment and education; one of the most successful categories of children's software.

e-learning: Online education and training. College courses, university extension courses, and adult education courses are all offered as e-learning opportunities.

electronic book: A book that can read on a mobile device. Electronic books, also called ebooks, offer varying degrees of interactivity and media features. Some are quite limited, only letting the user "turn" the pages, while others offer video, animation, sound (often a voice narrating the story), pop-up elements, and a connection to the Internet.

electronic construction kit structural model: In this model, users are given a number of story components, like characters and settings, and they can use them to assemble their own narratives. It is an open-ended construct, with the user in control of how the story will unfold.

electronic kiosk: A booth or other small structure that offers the user an easy-to-operate computerized experience, often via a touchscreen. Although usually used for pragmatic services like banking (ATM machines), they are also used for entertainment and informational purposes.

electronic literature: A form of literature that is not printed but instead makes use of the special capabilities of computer technology; also known as hyperliterature. See *hyperliterature*.

email: Short for electronic mail, mail that is sent over the Internet.

emergent behavior: A computer-controlled character acting in ways that go beyond the things it has been specifically programmed to do; unpredictable behavior. When an NPC exhibits emergent behavior, it seems to have an inner life and almost be capable of human thought.

emergent culture: An experience in a training game that begins during the game but continues after gameplay, as trainees continue to think and talk about what they learned.

emergent story: A story that is not fixed or embedded within a game or interactive work, but that takes shape as the user plays the game or interactive work.

emoticon: Symbols used in text messages to express emotions.

engine: The computer programming that operates a game or other piece of software.

enhanced TV: a term used to describe older forms of interactive TV. These forms include *second-screen TV, social TV, app TV,* and *multiscreen TV*.

escape room: A form of immersive entertainment set in a physical space that is part story and part puzzle-solving. The space is dressed to reflect the narrative content: For example, it might resemble a spaceship, an Egyptian tomb or a scientific lab. In these live experiences, users must solve narrative-related puzzles before being able to move further in the game or story. Usually users have a set amount of time to reach the end goal, or they fail to escape.

esport: Competitive video gaming as a spectator sport.

experiential learning: Learning by doing, acting, and experiencing, as opposed to passive forms of learning, such as listening to lectures or reading books. Also known as *active learning*.

exposition: Information that is essential for the understanding of a story and must be incorporated into it for the story to make sense. It includes the background and relationships of the characters; their aspirations; and important events that took place in their past that relate to the story.

F2P: See *free-to-play*.

fan fiction (fanfic): A type of narrative that is based on a printed or produced story or drama, but is written by fans instead of by the original author.

faux choice: a situation in an interactive work in which the user is presented with several options, but no matter which is picked, the end result will be the same.

first-person point of view: The perspective we have while participating in an interactive work in which we see the action as if we were in the middle of it and viewing it through our own eyes. We see the world around us, but we don't see ourselves, except for perhaps a hand or a foot. It is the "I" experience. See also *third-person point of view*.

first-person shooter (FPS): A shooting game in which the player is given a first-person point of view of the action. The players control and play the protagonist, but they cannot see themselves, though they may be able to see a weapon they are holding. See also *first-person point of view*.

Flash animation: An animated film created with Adobe Flash animation software. It supports interactivity and is a common form of animation on the Internet.

flowchart: A visual expression of the through line of an interactive project. Flowcharts illustrate important aspects of the content and a project's interactive structure.

FMV: See *full motion video*.

fourth wall: The invisible boundary that, in the theater, separates the audience from the characters on the stage, and in any dramatic work divides reality (the audience side) from fiction (the characters' side). Works of digital storytelling often break the fourth wall by bringing the participant into the fictional world or by the fictional world invading the real world.

FPS: See *first-person shooter*.

fractal structure: A structural model in which the essence of the story does not advance or change, but instead grows in scope as the player interacts with it. The term is based on the mathematic concept of the fractal, a pattern that repeats itself endlessly in smaller and larger forms.

free roam VR: See *room scale VR*.

free-to-play (F2P): A game that is free to play, or free to download. It can be virtually any genre. Players, however, may be invited to make small payments for in-game

items or to enhance the gameplay experience. In some cases, a F2P version of a game is designed as a way to promote the pay-to-play version of the game.

front-facing VR: In this form of VR, the user is sitting in a chair or standing in a fixed position and uses a joystick or other device to move objects around, as opposed to room scale VR, where the user is free to move around a space. This form of VR is also called stationary VR.

Full Motion Video (FMV): A type of video game presented entirely in video or live action video seen on a computer.

fulldome: A type of immersive environment in which images are projected onto the entire inner surface of a planetarium dome or a similarly shaped theater. For audience members, it is somewhat like sitting inside a huge upside-down bowl, surrounded on all sides by moving images.

functionality: How an interactive program works, particularly its interactive elements and its interface.

game console: A device made for playing video games. Some consoles plug into a TV set and use the TV as a monitor; others are self-contained hand-held devices. Most can support multiplayer games and the majority of the current generation of consoles can connect to the Internet and can play DVDs.

gameplay: The elements that make a game fun; also, the way players play a game—how they control it and how the game responds. It consists of the specific challenges that are presented to the player and the actions the player can take in order to overcome them; it also includes victory and loss conditions and the rules of the game. In addition, it provides instantaneous feedback to the players' input and choices.

gamification: The application of gaming techniques such as rewards and scores to projects that are not games and not designed for entertainment. Gamification has become a highly popular method for businesses and organizations to promote their messages to the public.

genre: A category of programming that contains certain characteristic elements. Major types of entertainment properties, like movies and video games, are broken into genres to distinguish them from each other.

geo-based AR: Works of alternate reality, such as games, that use geo-locative technology. *Ingress*, *Pokémon GO*, and *Harry Potter: Wizards Unite* are such games.

geo-locative technology: The technology, such as GPS, that enables the identification of the geographical location of an object, such as a mobile phone. It has been used effectively in games like *Pokémon GO*.

Gesampkunstwerk: A German word meaning a synthesis of various art forms, like an opera, which can incorporate music, dancing, set design, and performance. *Gesampkunstwerk* thus indicates that a work is a form of convergence, where various art forms have been melded together.

global positioning system (GPS): A satellite-based navigation system that allows individuals with receivers to pinpoint their geographic location.

grammar, artistic: The artistic principles or rules that can be employed in a creative field; a visual vocabulary. Every artistic medium requires its own specialized grammar; this is necessary for the artists who work in the field as well as the audiences who experience it. For example, jump cuts, dissolves, and montages are all part of the grammar of the cinema.

granularity: The quality of being composed of many extremely small pieces. In general, works of digital storytelling are granular. The pieces can be character, atmosphere, or action. Without granularity, interactivity would not be possible, but too.

griefer: A player in a MMOG who enjoys killing off new players and otherwise making life miserable for them.

group-based interactivity: a multiplayer game where a group of people jointly control the interactivity of the work. Such games work in several different manners: Via motion-sensing technology; via individuals controlling

computers or mobile devices; by individuals pushing buttons on theater chairs at an interactive movie; or by individuals shooting lasers at the screen of an interactive movie.

gyroscope: A device embedded in smart phones and tablets which, when combined with the *accelerometer*, can compute how fast, how far, and in which direction an object has moved. See also *accelerometer*.

head-mounted display (HMD): A device worn on the head in a virtual reality simulation that enables the user to see the digital images.

hero's journey, the: Myths, and stories based on this type of myth, about the coming of age experience. Joseph Campbell analyzed this type of myth in his seminal work, *The Hero with a Thousand Faces*. Its core elements and recurring characters have been incorporated into many popular movies, and it has also served as a model for innumerable works of digital storytelling, particularly video games.

hidden story structure: A structural form that contains two layers of narrative. The top layer contains clues to a story that took place in the past. The user explores this top layer to uncover the second layer, the hidden story, and to assemble the pieces of the hidden story into a coherent and linear whole.

high bandwidth: See *bandwidth*.

HMD: See *head-mounted display*.

hot spot: An image or area on the screen that the user can click on to produce a reaction, such as a little piece of animation, a bit of audio, or a short video clip.

HTML (Hypertext Markup Language): The software language used to create Web pages and hyperlinks.

HTTP (Hypertext Transfer Protocol): Protocol used to transfer files, including text, sound, video, and graphics, on the Web.

hub-and-spoke structure: A modular structure for video games in which the player starts from a central location (the hub), and all the modules radiate out from there (the

spokes). This structure is extremely clear and simple to navigate, making it especially suitable for children's projects. See also *module*.

hyperlink: A word or image that is linked to another word or image. See also *hypertext*.

hyperliterature: A catch-all phrase for a number of forms of computer-based literature, including hypertext, digital poetry, nonlinear literature, electronic literature, and cyberliterature. Since it is computer-based, it is able to make use of elements that are not possible in printed literature, such as interactivity, animations, sound effects, and hypertext (the ability to link various pieces of text together.) See *hypertext*.

hyperserial: A term Janet Murray uses to describe a new computer-enabled way to access complex TV series.

hyperstory: A form of iCinema in which one visual element is linked to another visual element, offering a different view of the same scene or story. It is similar to hypertext, but uses visuals instead of text. See *hypertext*.

hypertext markup language: See *HTML*.

hypertext transfer protocol: See *HTTP*.

hypertext: A technique used in digital works that enables the linking of words or phrases to other related "assets," such as photographs, sounds, video, or other text. The user makes the connection to the linked asset by clicking on the hyperlinked word or phrase, which usually stands out by being underlined or by being in a different color. See also *hyperlink*.

iCinema: An interactive movie. Such works fall into two broad categories. One type is designed for a large theater screen and is usually intended to be a group experience; the other type is for a small screen and meant to be enjoyed by a solo viewer.

IF: See *interactive fiction*.

if/then construct: A fundamental way of expressing choice and consequence in an interactive work. In an if/then scenario, if the user does A, then B will happen. Or, to

put it slightly differently, choosing or doing A will link you to B.

IM or IMing (Instant Message or Instant Messaging): See *instant messaging*.

immersive environment: An artificially created environment or installation that seems real. Virtual reality is a type of immersive environment. See also *virtual reality*.

immersive journalism: This term, coined by journalist Nonny de la Peña, is a form of factual storytelling that gives journalists a way to present true stories in VR and AR that pulls observers physically, spatially and emotionally right into the story, while upholding solid journalistic practices like accuracy and established facts.

immersive theater: Theatrical works where audience members become immersed in the narrative. Unlike traditional plays where the audience sits in rows facing the stage, these pieces are set in large spaces where different scenes may be played out at the same time. Audience members can visit the various scenes at will, explore the space and construct their own versions of the story. Sometimes they can interact with the actors.

incunabula: the very first works produced for a new medium. The term comes from the Latin word for cradle or swaddling clothes, and thus means something still in its infancy. The term was first applied to the earliest printed books, those made before 1501, but now the term is used more broadly to apply to the early forms of any new medium, including works made for various types of digital technology.

independent game: a game that has been made without the financial support of a publisher and that usually has been produced on an extremely small budget and by an extremely small team or a single individual. This independence gives the developers full artistic control of their games, and these games can be far more experimental and artistic than games that have been made with a publisher's support. They are usually referred to as *indie games*.

indexical storytelling: a work in which users are tasked with the job of finding hidden objects, each of which represents a piece of a narrative, and then they must thread these objects together to form a story.

indie game: See *independent game.*

infotainment: A presentation that combines information and entertainment.

instant messaging (IM or IMing): A method of exchanging messages with another person while you are both online, much like a conversation. Although IMing began as a text-only medium, some service providers offer graphic and audio options as well.

intellectual property (IP): A unique work of human intelligence—such as a photograph, a script, a song, a piece of animation, or a game engine—that is given legal protection such as a copyright, patent, or trademark. Intellectual properties can be extremely valuable and are closely guarded.

interactive fiction (IF): A work of interactive narrative, usually text based, into which users input their commands via their computer keyboard. Works of IF are available on the Internet and as CD-ROMs and sometimes contain graphics and video. Works of IF resemble text-based adventure games (MUDs), but are engaged in by a solo user, not multiple players. They also lack a win/lose outcome. See also *MUD.*

interactive television (iTV): A form of television that gives the viewer some control over the content or way of interacting with it.

interactive voice response (IVR): Communications that take place on the telephone that facilitate the acquisition of information. The user is asked a series of questions by a recorded voice and responds by pressing the telephone's number keys or by speaking. Based on the caller's input, the system retrieves information from a database. IVR systems are commonly used by banks to provide account information to customers. They are also being called into play for games.

interface: The elements of an interactive work that enable the users to communicate with the material, to make choices and navigate through it. Among the many visual devices used in interface design are menus, navigation bars, icons, buttons, and cursors.

Internet 2: A faster, more robust form of the Internet. It is used by government and academic organizations; it is not accessible to the general public.

Internet of things (IoT): The concept of the Internet of Things means connecting any device with an on and off switch to the Internet or to interconnect devices with the Internet and each other. This can include everything from cellphones to washing machines, iPads, coffee makers, and wearable devices. It includes a world of items beyond these.

iOS: An abbreviation used to stand for iPhone Operating System, but now is used to indicate the operating system for all Apple mobile devices.

IoT: See Internet of things

IP: See *intellectual property*.

iTV: See *interactive television*.

IVR: See *interactive voice response*.

kiosk: See *electronic kiosk*.

landline telephones: Telephones that are connected to wires and cables, as opposed to wireless phones.

lapware: Software products made for youngsters between nine months and two years of age. The term springs from the fact that children often sit on a parent's lap while playing with such products.

LARP: See *live action role-playing game*.

laser disc: A storage and playback format, also called a video disc, introduced in the late 1970s and used for watching movies and for educational and training purposes, as well as for arcade games. They have largely been replaced by DVDs, though a small number of devoted fans still use them.

latency: The time it takes for a program to react.

LBE: See *location-based entertainment*.

leaderboard: A list of the top scorers in a game.

level: A structural device in a game or other interactive work; it is a section of the work, akin to a chapter or an act. Each level has its own physical environment, characters, and challenges. Games may also be "leveled" in terms of degree of difficulty, with levels running from easy to difficult. Characters, too, can attain an increase in level in terms of their powers or skills; they are "leveled up."

licensed character: See *licensed property*.

licensed property: A piece of intellectual property, often a movie, a novel, or other work of entertainment, or even a fictional character, that is covered by a licensing agreement, allowing another entity to use it. Licensed properties and characters are generally highly recognizable and popular, and their use can add value to a new work. The Harry Potter novels are licensed properties and Lara Croft is a licensed character.

lifecasting: A form of Web-based entertainment in which a wearable camera is attached to a person and the subject is videotaped live as he or she goes through the day. It's a little like an episode of *Big Brother*, but with only one participant. Lifecasting offers interactivity, because viewers can communicate with the subject via a chat window or cell phone. A lifecasting subject need not be human; they are sometimes animals or birds.

linearity: A state in which events are fixed in a set, unchangeable sequence, and one event follows another in a logical, fixed, and progressive sequence. Films and novels are linear, while interactive works are nonlinear.

live action role-playing game (LARP): Games that are played by participants in the real world as opposed to role-playing games played on computers or online. The earliest LARPs were war game simulations. Such games were the predecessors of the highly popular Dungeons and Dragons LARPs, which evolved into today's MMORPGs. See also *MMORPGs*.

live-streaming: transmitting or receiving live video and audio over the Internet. Important events such as a public

announcement or sporting competition can be lived-streamed on the Internet.

location-based entertainment (LBE): Entertainment that takes place away from the home. Venues can include museums, theme parks, and retail malls. In many cases, LBE experiences involve immersive environments. See also *immersive environment*.

location-based gaming: A type of game that is set and played out in real-world locations, usually in urban settings.

locative journalism: An information-based work that takes place in a specific location and uses audio and GPS units to tell the story of a physical place. LoJo is a nickname used for this form. Audio-based storytelling set in a real physical space can also be called *narrative archeology* or *locative storytelling*, and is a form of mixed reality.

locative storytelling: One of several terms used to label a form of narrative set in a specific location that uses audio and GPS units to tell the story of the place in which it is set. It may also be called *narrative archeology* or *locative journalism*. It is a type of mixed reality.

locomotion interface: A method of immersion that employs a treadmill set in front of a screen with a 180-degree view. As individuals walk or run on the treadmill, they feel as if they are hiking or running in various exotic spots.

locomotion interface: A type of immersive environment that employs a treadmill in a large-screen environment. As the participant walks or runs on the treadmill, the images on the screen change.

log line: A clear and vivid description of the premise of an entertainment property, usually no more than one sentence long. When used for an interactive project, it describes the concept in a way that indicates the nature of the interactivity, what the challenges might be, and what will hook the users. The term got its name from the concise descriptions of movies given in television logs and other entertainment guides.

low bandwidth: See *bandwidth*.

ludology: One of two major and opposing ways of studying games, the other being narratology. Ludologists assert that even though games have elements of narrative like characters and plot, this is incidental to the things that make them a distinct creative form, such as gameplay. Thus, they assert, games should be studied as unique constructs. The term ludology comes from the Latin word *ludus*, for game. See also *narratology*.

Machinima: A form of filmmaking that borrows scenery and characters from video games but creates original stories with them. The term combines the words "machine" and "cinema." Works of Machinima are often humorous, possibly because the characters, borrowed as they are from video games, are not capable of deep expression.

malleable linear path: A narrative through-line for a video game or other interactive work; similar to a *critical story path*. The malleable linear path includes the major actions the user must take or events the user must experience in order for the narrative to make sense and to reach a conclusion, but these actions or events do not need to occur in a specific order. See also *critical story path*.

massively multiplayer online game (MMOG): An online game that is played simultaneously by tens of thousands of people and is typically set in a sprawling fictional landscape. MMOGs are persistent universes, meaning that the stories continue even after a player has logged off.

massively multiplayer online role-playing game (MMORPG): An online role-playing game played simultaneously by thousands of participants, and one of the most popular forms of MMOGs. MMORPGs contain many of the elements of video game RPGs, in which the player controls one or more avatars and goes on quests. These avatars are defined by a set of attributes, such as species, occupation, skill, and special talents.

massively multiplayer online war game leveraging the Internet (MMPWGLI): A type of multiplayer game played online that deals with complex problems. These games are often

message based, as opposed to games that use cinematic visuals.

matrix: A table-like chart with rows and columns that is used to help assign and track the variables in an interactive project.

merchant-tainment: Physical items that can be purchased and that can contribute to an entertainment experience.

message-based game: A game which usually does not possess highly cinematic visuals and in which player exchanges are conveyed via test.

metatag: Information used by search engines, important for constructing indexes.

milestone: A project marker that specifies when the different elements of a project must be completed.

mission: An assignment given to a player in a video game. Some video games are organized by missions rather than by levels, and the player must complete the missions one by one. See also *level*.

mixed reality: The combining of real-world objects with either AR or VR.

MMOG: See *massively multiplayer online game*.

MMORPG: See *massively multiplayer online role-playing game*.

MMOWGLI: See *massively multiplayer online war game leveraging the Internet*.

MMS: See *multimedia service*.

MOB (mobile object): See *mobile object*.

MOBA: See *multiplayer online battle arena*.

MOBA: See *multiplayer online battle arena*.

mobile game: A game are designed to work on handheld devices like smart phones and tablets.

mobile object: An object in a game that moves.

mobisode: A serialized story or multi-episode entertainment series made for mobile devices, similar to a webisode.

module: A method of organizing or structuring an interactive work, often used in educational and training projects. Each module customarily focuses on one element in the curriculum or one learning objective.

Mommy website: A blog devoted to child-rearing. Such blogs are a popular genre on the Web.

MOO (MUD, Object Oriented): A text-based adventure game that is a close cousin to the MUD. See also *MUD*.

motion base chair: A seat for an audience member in an immersive attraction like a 4-D Dark Ride or a VR ride. The seats move in synch with the story's action. In this type of attraction, one stays seated and cannot move around as one can in other forms of immersive environments.

motion capture: An animation technique for producing life-like movements and facial experessions in characters. This technique calls for attaching sensors to an individual (who might be an actor, dancer, or athlete) and digitally tracking this individual's movements and expressions. These movements and expressions are then "transferred" to an animated character.

motion-based game system: A game controlled by the player's movements.

MUD: A text-based adventure game in which multiple players assume fictional personas, explore fantasy environments, and interact with each other. MUD stands for Multi-User Dungeon (or Multi-User Domain or Multi-User Dimension). Aside from being text based, MUDs are much like today's MMOGs.

multimedia service (MMS): A feature offered on wireless phones that enables users to send and receive more data than with SMS. It can support a variety of media, including photographs, long text messages, audio, and video, and different media can be combined in the same message. See also *short messaging service*.

multi-modal: The use of various methods of communication, such as spoken dialogue, text, animation, sound effects, and video, within the same work.

multi-platforming: The development of an entertainment property for many different platforms, both traditional (theatrical motion pictures and television) and new (video games, the Internet, and so on).

multiplayer motion-sensing game: A relatively rare type of game where an entire group of people control the game by their motions (such as waving their hands). Similar to a motion-based game, although played in groups.

multiplayer online battle arena (*MOBA*): MOBAs, also known as Action Real-Time Strategy games (ARTS) are a subgenre of real time strategy games. Often two teams of players compete against each other and each player controls a single character. Teams are ideally made up of characters with different and complementary strengths.

multi-sensory: A technique used in simulations, virtual reality, and other forms of immersive environments in which multiple senses are stimulated. While most forms of media only involve hearing and seeing, a multi-sensory approach might also include tactile sensations, smells, motion, and so on.

multitask: To simultaneously perform several things at once, such as being online while also talking on the phone, listening to the radio, or watching TV.

narrative archeology: A form of storytelling set in a specific location that uses audio and GPS to tell the story of the place in which it is set. It is a type of mixed reality.

narratology: One of two major and opposing ways of studying games, the other being ludology. Narratologists assert that games are a form of storytelling and they can be studied as narratives. See *ludology*.

native app: a mobile app made to run on a specific platform or device. Such apps must be installed in order to play), as opposed to a mobile Web app, which can access Web-based content directly through the Web browser on the device.

natural language interface: A life-like method of communication between a user and an artificial character, in which the artificial character can "understand" the words the user types or says, and is able to respond appropriately.

navigation: In interactive media, the method by which users move through a work. Navigational tools include menus,

navigation bars, icons, buttons, cursors, rollovers, maps, and directional symbols.

NDA: See *nondisclosure agreement.*

near field communication (NFC): Near field communications are a set of standards that allow smart phones and other devices to communicate with each other when they are brought close together.

networked gaming environment: The linking of computers together into a network that allows many users to participate in an interactive experience. Such networks may be used for educational and training purposes as well as for gaming.

newbie: A new player or new user.

news game: An informational game built around a subject currently in the news.

NFC: See *nearfield communication.*

node: A design term sometimes used to indicate the largest organizational unit of a game (similar to a level or world) and sometimes used to indicate a point where a user can make a choice.

nondisclosure agreement (NDA): A document used when potentially valuable information is about to be shared with another party. The party that is to receive the information, in signing the NDA, agrees to keep the information confidential.

nonlinearity: Not having a fixed sequence of events; not progressing in a preset, progressive manner. Nonlinearity is a characteristic of interactive works. Though the work may have a central storyline, players or users can weave a varied path through the material, interacting with it in a highly fluid manner.

nonplayer character (NPC): A character controlled by the computer, not by the player.

open-world game: A nonlinear game in which players can freely choose where to go, what to do, and when to do it, and even fully customize the character they play. They are typically set in vast environments which the player can explore freely, and they offer players a rich variety of

activities to enjoy, from shopping to fighting to operating a variety of vehicles and aircraft. They do, however, contain narrative elements.

otome game: A game genre born in Japan and typically designed for female players. These games generally feature a romantic plot and the usual objective is to end up with the desired boyfriend. Their visual style resembles manga (Japanese comic books).

parallel world: A quasi-linear structure that contains several layers of story, each set in its own virtual world, and the user can jump between them. Often each world is a persistent universe, meaning that events continue to unfurl there even when the user is not present.

PC game: A game that is played on a computer.

PDA: See *personal digital assistant*.

PDR: See *personal digital recorder*.

peer-to-peer learning: An educational environment that facilitates collaborative learning. Online peer-to-peer learning environments may include such features as instant messaging, message boards, and chat rooms.

persistent universe: An online game, story or virtual world where events continue to happen even after an individual user has logged off, a common feature of MMOGs.

persona method: An approach to character design involving the development of the characteristics of one fictitious but realistic individual who will represent the target player. The character design is used in training games and includes the individual's stressors; values and belief system; strengths and weaknesses; and what this person has been through.

personal digital assistant (PDA): A wireless device that serves as an electronic Rolodex, calendar, and organizer. PDAs can download material from the Internet and from PCs.

personal digital recorder (PDR): Same as a personal video recorder and digital video recorder. See *personal video recorder*.

personal video recorder (PVR): One of several terms for devices that enable viewers to select and record television programs; the best-known of such devices is the TiVo.

Two other generic terms for this type of device are *personal digital recorder* and *digital video recorder*. These devices offer viewers more control than VCRs and include features like pausing live TV and the ability to skip commercials.

phablet: A convergent device that combines many of the features of a smartphone and a tablet and is in between them in size.

pixel: Short for picture element. A pixel is a single tiny unit of a digital graphic image. Graphic images are made up of thousands of pixels in rows and columns, and they are so small that they are usually not visible to the naked eye. The smaller the pixels, the higher the quality of the graphic.

platform game: A genre of game that is very fast paced and calls for players to make their characters jump, run, or climb through a challenging terrain, often while dodging falling objects or avoiding pitfalls. Such games require quick reflexes and manual dexterity.

platform: A hardware/software system for running a program or a game.

player character: A character controlled by the player.

player versus player (PvP): A competitive encounter between two players in a video game, as opposed to a competitive encounter between a player and an NPC. PvP combats can be quite violent and can result in the virtual death of one of the players.

podcast: A form of broadcasting distributed over the Internet and designed for playback on portable digital devices, though the audio or video material can also be enjoyed directly from the Internet. The term podcast combines the words "broadcast" and "iPod." The iPod (a portable MP3 player made by Apple) is one of the devices used to listen and watch such broadcasts, though Apple did not invent the term.

point of view (POV): In interactive media, the way the user views the visual content. The two principal views are first person and third person. See *first-person point of view* and *third-person point of view*.

POV: See *point of view*; *first-person point of view*; and *third-person point of view*.

procedural animation: An animation technique for endowing characters with life-like behavior and a wide range of actions. In procedural animation, characters are created in real time, rather than being pre rendered. To make such a character, the animator provides a set of rules and initial conditions—in other words, a procedure.

product placement: An advertising technique in which advertisers pay a fee to a movie or television production company to have their product prominently displayed in a scene in a movie or television show. This practice is now becoming widespread in video games.

project creep: A situation in which a project expands beyond its original concept and swallows up unexpected staff time, often without additional financial compensation. Also called scope creep.

projection mapping: A projection technology used to turn objects into a display surface for video projection. These objects can be irregularly shaped and can include everything from large buildings to surfaces as small as a vase.

promenade performance: A type of immersive theater where audience members can walk around the space where the work is set, which can be an old mansion, a large garden or a warehouse. Audience members are free to investigate the space, explore and construct their own versions of the story. Sometimes they can interact with the actors.

promotional gaming: Another term for advergaming, a type of gaming that combines game play with advertising. Such games promote products or ideas.

proprietary: The state of being owned or controlled by an individual or organization. In interactive entertainment, certain software is sometimes called proprietary, meaning that it is the exclusive property of that developer.

protagonist: The central figure of the drama, whose mission, goal, or objective provides the story with its forward

momentum. The word is formed around the Greek root, *agon*, meaning contest or prize. See *agon*.

protocol: A set of instructions or rules for exchanging information between computer systems or networks.

prototype: A working model of a small part of an overall project.

public advocacy campaign: A form of social marketing meant to sell ideas, not products. Such campaigns are intended to raise public consciousness about serious issues and to inspire people to take action.

publisher: A company that funds the development of a game or other software product and packages and markets it. A publisher may also develop projects in-house.

PvP: See *player versus player*.

PVR: See *personal video recorder*.

QR code: A code made up of black bars arranged into a square that can be "read" by a smart phone or other device and is often used to link to Web pages.

Radio Frequency Identification Reader (RFID): A type of sensor used in escape rooms. In the work world, this technology is used to identify badges worn by employees at businesses and in other situations. In an escape room, it recognizes when a correct piece of the puzzle has been inserted into the receptacle, much like the sensors in smart toys work.

Rashomon structure: A structural form that contains several versions of the same story and users can experience each version from the POV of the different characters. The model resembles the Japanese movie, *Rashomon*, about a crime viewed by four people, each of whom saw it differently.

reader pad: A specialized device in which to set a smart toy or other object, and that can transport the toy or object into an online world or a game and make it "come to life." For example, reader pads are used for Webkinz stuffed animals and Skylanders plastic figurines.

Really Simple Syndication (RSS): RSS, which stands for both Really Syndication and Rich Site Summary, is a family of

formats for distributing content to websites; it is a form of syndication.

real-time 3-D graphic (RT3D): Three-dimensional animation that is rendered in real time instead of being prerendered. In a game environment, the images respond to the players' actions.

real-time strategy game (RTS): A genre of game that emphasizes the use of strategy and logic. In these games, the players manage resources, military units, or communities. In a real-time strategy game, the play is continuous, as opposed to a turn-based strategy game, where players take turns.

Red Button TV: An interactive service in the UK that allows viewers to see additional TV content by pushing the red button on their controller. It is available via digital terrestrial television, satellite television, and cable television.

repeatability: A quality, also known as *replayability*, possessed by some video games and other interactive works that lends itself to more than one play, because each play offers a new experience, a new version of the narrative, or new challenges. Educational games that contain several layers of difficulty also possess this quality.

replayability: See *repeatability*.

repurposing: Taking content or programming models from older media and porting them over to a new medium, often with little or no change. For instance, the first movies were filmed stage plays, and the first CD-ROMs were encyclopedias, and the first types of content available on Video iPods were reruns of TV shows.

RFID: See Radio Frequent Identification Reader.

rhizome structural model: A structural form that takes its name from the field of botany, where it is used to describe an interconnecting root system. In interactive stories using this structure, each piece can be connected to every other piece. Thus, it is much like a maze.

Rich Site Summary (RSS): See *Really Simple Syndication*.

ridefilm: An entertainment experience that takes place in a specially equipped theater. The audience may sit in

special seats (motion base chairs) that move in sync with the action taking place on the screen. This gives them the illusion that they are traveling, though they are not actually going anywhere. See also *motion-base chair*.

robot: A device that operates either by remote control or on its own, and relates in some way to its surroundings. Some are designed to be playthings for children or adults; others are built to be part of entertainment or educational experiences. Many, however, are specifically built for highly pragmatic functions. The word "robot" is a variation of the Czech word, *robota*, which means slave-like labor or drudgery.

role-playing game (RPG): A genre of game in which the player controls one or more characters, or avatars, and vicariously goes on adventures. These games evolved from the pre-computer version of *Dungeons and Dragons*. See also *avatar*.

room-scale VR: In this form of VR, the user is free to move around a space. In entertainment centers, mobility like this is also called *free roam*. Everything the user sees is virtual—one's own hands and feet are not visible, nor is the carpet nor the ceiling fan: The illusion offered by VR is completely engulfing. However, the perspective of the virtual world is altered via a tracking system depending upon where the user is in the space. If you are walking towards a virtual cabinet, for instance, it will look larger as you grow closer to it.

RSS: See *Really Simple Syndication*.

RT3D: See *real-time 3-D graphic*.

RTS: See *real-time strategy game*.

rumble floor: A device used to enhance the realism of an immersive environment. The rumble floor is built into the platform that participants move across, and vibrates when cued by certain virtual events, such as an explosion or an earthquake.

sandbox game: A game set in a large environment that can be explored freely and that allows players to decide what they want to do throughout the game. The term is often

used interchangeably with an open-world game. While these two genres of gaming have much in common, sandbox games are regarded as a "toy box" that contains tools that players can use to modify the game world and gameplay. Instead of containing set story elements like an open-world game, players can construct a narrative while playing: an emergent story.

sandbox structure: A structural model that offers the user a great deal of freedom. Unlike a game, this type of structure does not set specific goals for the user to achieve and has no victory conditions. And unlike narrative-based works, it has no plot. However, such models do provide users with objects to manipulate and things to do, and they do have spatial boundaries.

scent necklace: A device used to enhance the realism of an immersive environment. It is worn around the neck of the participant and gives off specific aromas at key points during the simulation, in keeping with the virtual landscape or action of the piece.

schematic: An easy-to-understand diagram that illustrates how something works.

second-screen TV: The use of a device like a smart phone or tablet computer in conjunction with a broadcast TV show, which is done to augment the content of the TV show. It can be used to gain access to additional information about the show, to post or read comments about the show, and to play games in conjunction with the show.

sensor: A piece of hardware that can be used to make a doll recognize a toy prop or know daylight from nighttime. Sensors are also used in escape rooms and other immersive experiences to unlock a puzzle or activate a device.

sequential linearity: An interactive structure that channels the user down a linear path and is quite restrictive in terms of the freedom of movement it offers to the user.

serious game: A game designed to teach a difficult subject, either to advanced students or to learners outside of

academic settings. Because serious games are meant to be entertaining as well as teaching vehicles, they make intensive use of digital storytelling techniques.

short messaging service (SMS): A feature offered on wireless phones that enables users to send and receive short text messages up to 160 characters in length.

SIG: See *special interest group*.

silo: media organizations like TV production companies, ad agencies, and newspaper publishers that are used to operating independently and being non-collaborative. In transmedia storytelling, "navigating silos" is often a major challenge.

simulation: A realistic and dramatic scenario in which users make choices that determine how things turn out. Simulations are featured in many types of interactive environments, including virtual reality and CD-ROM programs, and are used for entertainment and educational and training purposes.

single-screen interactivity: A form of iTV in which interactive programming is furnished via a digital set-top box provided by a satellite or cable company and is viewed on one's television set. It thus requires just one screen, as opposed to dual-screen iTV. See also *dual-screen iTV*.

site-specific play: A type of immersive theater where the work set outside a traditional theater and that resembles the play's fictious setting, such as an old hotel or Alice's Wonderland.

skeuomorph: A design approach that is sometimes employed in user interface where an icon is made to resemble its real-life equivalent. For example, an icon that indicates you can watch a video might look like a TV set.

smartphone: a cell phone that can perform many of the functions of a computer, but in a far smaller package.

smart toy: Any type of plaything with a built-in microprocessing chip. Such toys can include educational games and life-like dolls, animals, or fantasy creatures that seem intelligent and can interact with the child playing with it. They can also include playsets that tell a story as the child interacts with it.

SME: See *subject matter expert*.

SMS: See *short messaging service*.

social marketing: A specialized form of promotion that is designed to change the way people behave—to motivate them to break harmful habits like smoking or overeating, and to encourage them to take up positive behaviors, like wearing seat belts or exercising.

social media: Online communications, including websites, wikis and apps, that give users the opportunity to create content or share information, ideas, messages and visual content.

social networking site: A website that contains content that is largely created by the users themselves and that facilitates communications between users. Such sites are virtual communities, and they may be populated by virtual inhabitants in the form of user-controlled avatars. See also *avatar*.

social object: A term used to indicate a shared interest in a subject, often online, which can be the focus of an online social network.

social TV: Technology that supports communication and social interaction on mobile devices while simultaneously watching a show on a TV screen.

SoLoMo: A mash-up of the words social, local, and mobile. SoLoMo is a way of targeting individuals carrying mobile phone with information about nearby retailers. The individuals may be offered special discounts, based on their proximity to that place of business.

spatial narrative: An interactive drama in which the story elements are embedded in a three-dimensional space, and the user discovers narrative fragments while exploring the fictional environment.

special interest group (SIG): A group of individuals with similar interests formed within a larger organization.

startup: a company in its early stages that is looking to establish a repeatable business model. Some startups grow into large successful enterprises while others fail and close their doors.

state engine approach: An interactive mechanism that allows for a greater range of responses to stimuli than a simple if/then construct, which allows for only one possible outcome for every choice. See also *if/then construct*.

stationary VR: See front-facing VR.

status Bar: A graphic on the screen to show a player's progress in a game.

stereoscope: A device that enables people to see images in 3-D. Stereoscopic devices are used in VR installations.

stickiness: The ability to draw people to a particular website and entice them to linger for long periods of time; also the ability to draw visitors back repeatedly.

storyboard: A series of drawings that illustrate the flow of action, the interactivity, and important pieces of the content of an interactive project, displayed sequentially, much like a comic book. Essentially, a storyboard is an illustrated flowchart. See also *flowchart*.

storyline: The way a narrative unfolds and is told, beat-by-beat. In traditional linear narratives, the storyline is all-important and very clear; it is "the bones" of a story. In interactive media, however, storylines tend to be less defined and apparent, because such works are nonlinear. In video games that contain a narrative, the storyline takes second place to gameplay, although the storyline serves to give context to the game.

storyworld: The universe of the story. A storyworld can be either fiction or non-fiction, but should always contain everything the story revolves around. This includes the plot, the characters, and the setting. The term is used in all forms of digital storytelling as well as in traditional media, but it is a particularly important term in transmedia storytelling.

streaming: Receiving video or audio in real time, without a delay, as it downloads from the Internet. Video received this way is called streaming video; audio received this way is called streaming audio.

string-of-pearls structure: A structural model for the linear story path in a video game or other interactive work.

Each of the "pearls" is a world, and players are able to move freely inside each of them. But in order to progress in the story, the player must first successfully perform certain tasks in each pearl.

subject matter expert (SME): An individual with special expertise who is consulted for a new media project, especially one designed for teaching or training. These specialists may offer advice about the target learners, the content of the project, or the teaching objectives.

synchronous interactivity: A form of interactive television in which the content of a television program and the content of a website are synchronized and designed for viewer interactivity; also known as *dual-screen iTV*. The type of interactivity calls for a secondary device like an Internet-connected computer or cell phone, as well as a television set.

synthetic character: A highly intelligent computer-controlled character who lives in a digital virtual universe. Such characters are capable of "understanding" the words typed or spoken by the user, and are able to respond appropriately. They are capable of a wide range of behaviors, and their personal backgrounds, personalities, and motivations are often developed in depth in much the same way that major characters are developed for feature films and television scripts. Some are just a voice, often serving as a digital assistant, while others, in contrast to chatterbots, are fully animated and highly life-like. See also *chatterbot*.

taxonomy: In biology, the discipline of classifying and organizing plants and animals. In interactive media, a systematic organizing of content. As in biology, it is a hierarchical system, starting with the largest category at the top, and then dividing the content into smaller and smaller categories, organized logically by commonalities. The word comes from the Greek and is composed of two parts: *taxis*, meaning order or arrangement, and *nomia*, meaning method or law.

TCP/IP: See *Transmission Control Protocol/Internet Protocol*.

third generation (3G): A stage of development in wireless technology that enables wireless telephones to have high-speed access to the Internet.

third screen: A term that includes many forms of screen-based new media entertainment, including video games and content developed for the Internet and cell phones. While once there were only two types of entertainment screens—TV screens and movie screens—the third screen is a powerful newcomer to the entertainment world.

third-person point of view: The perspective we have in an interactive work in which we watch our character from a distance, much as we watch the protagonist in a movie. We can see the character in action and can also see their facial expressions. Cut scenes show characters from the third person POV, and when we control an avatar, we are observing it from this POV as well. See also *first-person point of view*.

three-act structure: The classic structure of theatrical dramas and screenplays. This structural form was first articulated by Aristotle, who noted that effective dramas always contained a beginning (Act 1); a middle (Act 2); and an end (Act 3).

ticking clock: A dramatic device used to keep the audience glued to the story. It is found in both linear and nonlinear narrative works. With a ticking clock, the protagonist is given a specific and limited period of time to accomplish a goal. Otherwise there will be serious and perhaps even deadly consequences.

TiVo: The brand name for a device that allows TV viewers to select and record TV programs and play them back whenever they wish. Viewers also have the option of fast forwarding through the commercials. The generic terms for such devices are personal video recorder (PVR), personal digital recorder (PDR), and digital video recorder (DVR).

touchscreen: The screen of a smart phone or tablet that responds to touch. Virtual objects on the screen react

accordingly. Objects can be moved, shrunk in size, expanded, or activated by touch.

tragic flaw: A negative character trait possessed by the protagonist of a drama. Though this character may be noble in many ways, he or she also has a fatal weakness such as jealousy, self-doubt, or ambition, and this trait leads to the character's undoing.

transmedia entertainment: Entertainment properties that combine at least two media, one of which is interactive, to tell a single story. Possible linear components include movies, TV shows, and novels, while possible new media components include websites, video games, and mobile devices. Linear components may even include skywriting, an object baked in a cake, or a balloon in a holiday parade. In addition, these projects may also utilize everyday communication tools like faxes, voicemail, and instant messaging. This approach to entertainment goes by many different names, including *multi-platforming, cross-media production, networked entertainment,* and *integrated media.* Gaming projects that use the transmedia approach may be called *alternate reality games.* See also *alternate reality game.*

Transmission Control Protocol/Internet Protocol (TCP/IP): A protocol developed for ARPANET, the forerunner of the Internet, by Vint Cerf and Bob Kahn. It is the basic communication language of the Internet, and allowed the Internet to grow into the immense international mass-communication system that it has become.

treadmill: An internal structural system of a MMOG that keeps the user involved playing it, cycling repeatedly through the same types of beats in order to advance in the game.

Turing test: a rigorous set of standards to judge artificial intelligence (AI) in a computer program, set in 1950 by Alan Turing. In what is now known as the "Turing Test," both a human and a computer are asked a series of questions. If the computer's answers cannot be distinguished from the human's, the computer is regarded as having AI. See also *artificial intelligence.*

uncanny valley: A term coined by Japanese roboticist Masahiro Mori to describe the uncomfortable reaction people have to robots that seem too life-like and human.

URL (Uniform Resource Locator): A website address.

user interface (UI): The way users of digital media make their wishes known to the program and control what they see and do and where they go. The many visual devices used in interface design and navigation include menus, navigation bars, icons, buttons, cursors, rollovers, maps, and directional symbols. Sound effects also play a role in user interface. Hardware devices for user interface include video game controllers, touch screens, and VR wands.

user-generated content: Content that is created by the users themselves. Such content includes everything from the avatars and objects found in virtual worlds to homemade videos and animations. It also includes Machinima, fan fiction, and the personal profiles and other content found on social networking sites.

verb set: The actions that can be performed in an interactive work. The verb set of a game consists of all the things that players can make their characters do. The most common verbs are walk, run, turn, jump, pick up, and shoot.

video blog (vlog): A blog that contains video. See *blog*.

video on demand (VOD): A system that lets viewers select video content to watch from the Internet or from digital cable or satellite systems.

viral marketing: A marketing strategy that encourages people to pass along a piece of information; originally used in Web marketing but now also used for wireless devices.

virtual channel: A designated channel where VOD videos are "parked." See also *video on demand*.

virtual reality (VR): A 3-D artificial world generated by computers that seems believably real. Within such a space, one is able to move around and view the virtual structures and objects from any angle. A VR world requires special hardware to be perceived.

virtual world: An online environment where users control their own avatars and interact with each other. These worlds may have richly detailed landscapes to explore, buildings that can be entered, and vehicles that can be operated, much like a massively multiplayer online game (MMOG). However, these virtual worlds are not really games, even though they may have some game-like attributes. Instead, they serve as virtual community centers, where people can get together and socialize, and, if they wish, conduct business. See also *MMOG*.

vlog: See *video blog*.

vocaloid: A singing voice synthesizer.

VOD: See *video on demand*.

volumetric capture technology: A technique used to capture images in three dimensions so they can be viewed in VR or MR.

VR: See *virtual reality*.

walled garden: An area of restricted access, generally relating to Internet content.

WAP: See *wireless application protocol*.

webcam drama: A narrative that is presented as an intimate online diary. The protagonists of these stories focus their webcams on themselves and relate what is currently taking place in their lives.

webcam: A stationary digital video camera that captures images and broadcasts them on the Web. Webcams often run continually, and the footage is broadcast without being edited.

webinar: An educational or training session that takes place in a classroom and that combines Web-based and live instruction, with a live instructor acting as facilitator.

webisode: A story-based serial on the Web that is told in short installments using stills, text, animation, or video.

Wi-Fi: A protocol that enables a mobile device to have a high-speed connection to the Internet and to connect with other devices, like game consoles and DVRs.

wireless application protocol (WAP): A set of instructions that enables mobile devices to connect with the Internet and perform other functions.

wireless telephony: Communications systems that enable the transmission of sound, text, and images without the use of wires, unlike landline telephony.

world structure: A structural device used in interactive narratives. In such structures, the narrative is divided into different geographical spaces—the rooms of a house, different parts of a town, or different planets.

World Wide Web (The Web): A system of disseminating information over the Internet. Documents and other materials are identified by URLs and interlinked by hypertext links. The Web was invented in 1989 by English scientist Tim Berners-Lee.

XD dark ride: This term covers 5-D, 6-D and 7-D dark rides. It is a new term to describe and promote a new generation of 4-D dark rides. They are essentially the same as 4-D dark rides, though in addition to all the sensory experiences, they give users some control over the movie via an interactive gun or some other handheld object they use to shoot at targets on the screen.

XR: A catch-all term referring to virtual reality (VR); augmented reality (AR) and mixed reality (MR). It is not a specific technology.

Additional Readings

The following books offer additional information on various aspects of classic narrative, digital storytelling, design, and career issues:

- Adams, Ernest, *Break into the Game Industry: How to Get a Job Making Video Games* (Emeryville, CA, McGraw-Hill Osborne Media, 2003). A good guide to careers in the game industry.
- Adams, Ernest, *Fundamentals of Game Design*, Second Edition (Indianapolis, IN, New Riders, 2009). An excellent, clear, and extremely thorough guide to game design.
- Aristotle, *The Poetics* (New York, Hill & Wang, 1961). The classic treatise on dramatic writing.
- Bernardo, Nuno, *The Producer's Guide to Transmedia: How to Develop, Fund, Produce and Distribute Compelling Stories Across Multiple Platforms* (Lisbon, Sao Paulo, Dublin, and London, Beactive Books, 2011). A solid work

about producing works of transmedia storytelling, written by one of the creative forces behind some major transmedia narratives.
- Bogost, Ian, *Persuasive Games, The Expressive Power of Videogames* (Cambridge, MA, MIT Press, 2010). A book focusing on serious games by one of the leaders in the field.
- Campbell, Joseph, *The Hero with a Thousand Faces*, Second Edition (Princeton, NJ, Princeton University Press, 1972). A classic study of mythology and particularly of the hero's journey, a universal myth that many dramatic works, including digital stories, are modeled on.
- Crawford, Chris, *Chris Crawford on Game Design* (Indianapolis, IN, New Riders, 2003). A somewhat idiosyncratic but lively look at game design by a well-known game guru.
- Finley, Toiya Kristen, *Narrative Tactics for Mobile and Social Games: Pocket-Sized Storytelling* (CRC Press, 2018). A solid book on designing narrative for mobile and social games. It does not shy away from dealing with the special challenges of working on "pocket-sized" narratives.
- Frazel, Madge, *Digital Storytelling Guide for Educators* (Washington, DC, International Society for Technology in Education, 2010). This book defines digital storytelling in the way that it is used in schools: as a tool for personal expression or as a way to build narrative around a curriculum topic (such as history). A useful guide for teachers who want to employ this form of digital storytelling in the classroom.
- Fullerton, Tracy, *Game Design Workshop: A Playcentric Approach to Creating Innovative Games*, Second Edition (Burlington, MA, Morgan Kaufmann, 2008). A solid and user-friendly work on game design written by a well-respected designer and professor.
- Garrand, Timothy Paul, *Writing for Multimedia and the Web*, Third Edition (Burlington, MA, Focal Press, 2006). A good general book about writing for interactive media, with a particular focus on the Internet.

- Gee, James Paul, *What Video Games Have to Teach Us About Learning and Literacy*, Second Edition (Palgrave Macmillan, 2007). A book that promotes the positive aspect of video games and how games can facilitate learning.
- Giovagnoli, Max, *Transmedia Storytelling: Imagery, Shapes and Techniques* (Lulu.com, 2011). A thorough approach to transmedia storytelling by a practitioner in the field.
- Gitner, Seth, *Multimedia Storytelling for Digital Communicators in a Multiplatform World* (CRC Press, 2015). This book focuses on using digital storytelling as a visual communications tool, and is geared towards helping students learn how to harness multiple media and platforms for various communications goals.
- Herz, Jessie Cameron, *Joystick Nation: How Videogames Ate Our Quarters, Won Our Hearts, and Rewired Our Minds* (New York, Little Brown-Warner Books, 1997). Though an older book, this is a provocative and interesting work on the cultural impact of video games.
- Heussner, Tobias, Finley, Toiya Kristen, Hepler, Jennifer Brandes and Lemay, Ann, *The Game Narrative Toolbox* (Focal Press Game Design Workshops, 2015). A book about designing narratives for games written by four narrative designers. Heussner, Tobias, *The Advanced Game Narrative Toolbox* (CRC Press, 2019). A more advanced guide to narrative writing for games, moving forward from *The Game Narrative Toolbox*, geared for the intermediate and professional writer.
- Iuppa, Nicholas, *Designing Interactive Digital Media* (Burlington, MA, Focal Press, 1998). A very thorough and practical book that primarily addresses design issues.
- Iuppa, Nicholas and Borst, Terry, *End-to-End Game Development: Creating Independent Serious Games and Simulations from Start to Finish* (Burlington, MA, Focal Press, 2009). An in-depth examination of the role of narrative in serious games and simulations, based in part on case studies of projects the two have worked on.

- Jenkins, Henry, *Convergence Culture: Where Old and New Media Collide* (New York, NYU Press, 2008). A well-regarded book about transmedia storytelling.
- Lambert, Joe and Hessler, Brooke, *Digital Storytelling: Capturing Lives, Creating Community*, Fifth Edition (CRC Press, 2018). Lambert's approach to digital storytelling is to use it to tell personal stories and stories of a community, rather than for entertainment purposes. He is an expert in this form of digital storytelling. This book covers the fundamentals of employing digital storytelling in this manner.
- Mankovitch, Lev, *The Language of New Media* (Cambridge, MA, MIT Press, 2002). A scholarly look at where new media fits into the general media landscape, written by a well-respected academician.
- McErlean, Kelly, *Interactive Narratives and Transmedia Storytelling* (CRC Press, 2018). A general guide to creating stories across digital media platforms, touching on such topics as sound design and montage. The book, however, does not delve into specific genres aside from AR and transmedia storytelling.
- McGonigal, Jane, *Reality is Broken: Why Games Make Us Better and How They Can Change the World* (London, Penguin Books, 2011). A meditation about the power of games to do good by a game designer who brings real-world experience to her topic.
- Meadows, Mark Stephen, *Pause and Effect: The Art of Interactive Narrative* (Indianapolis, IN, New Riders, 2002). A beautifully illustrated and thoughtful examination of interactive narrative with an emphasis on design.
- Montfort, Nick, *Twisty Little Passages: An Approach to Interactive Fiction* (Cambridge, MA, MIT Press, 2005). A good book for anyone interested in electronic literature and how narratives can be interactive.
- Murray, Janet, *Hamlet on the Holodeck: The Future of Narrative in Cyberspace*, Updated Edition (MIT Press, 2017). A highly regarded and thoughtful book about the potential of digital storytelling. One of the first books written on the subject, the book is still extremely valuable

for its ideas. The updated edition offers fresh examples of the topics she covers.
- Pearce, Celia, *The Interactive Book: A Guide to the Interactive Revolution* (Indianapolis, IN, Macmillan Technical Publishing, 1997). A collection of essays exploring the social, cultural, and psychological impact of interactive media.
- Pearce, Celia, *Communities of Play: Emergent Cultures in Multiplayer Games and Virtual Worlds* (Cambridge, MA, MIT Press, 2011). An examination of massively multiplayer online games and, more specifically, of the players themselves and their impact on the games they play.
- Phillips, Andrea, *A Creator's Guide to Transmedia Storytelling* (New York, McGraw-Hill, 2012). A thorough book on transmedia storytelling by a practitioner in the field.
- Reddish, Janice, *Letting Go of the Words: Writing Web Content that Works*, Second Edition (Burlington, MA, Morgan Kaufmann, 2012). A solid book about Web design and writing, focusing on non-fiction and commercial website work.
- Rollings, Andrew and Ernest, Adams, *Andrew Rollings and Ernest Adams on Game Design* (Indianapolis, IN, New Riders, 2003). A solid book on game design.
- Rose, Frank, *The Art of Immersion: How the Digital Generation Is Remaking Hollywood, Madison Avenue, and the Way We Tell Stories* (New York, WW Norton, 2012). A journalist's investigation of digital storytelling containing an examination of some ground breaking works, written in an entertaining fashion.
- Schell, Jesse, *The Art of Game Design: A Book of Lenses*, Second Edition (CRC Press, An Imprint of Taylor and Francis, 2015). A book on game design and game theory, by an articulate and seasoned practitioner in the field. An extremely helpful book for those who want to learn more about game design.
- Solarski, Chris, *Interactive Stories and Video Game Art* (A.K. Peters/CRC Press, 2017). The creation of a successful game or other type of interactive narrative depends on an

entire universe of specialists working together. This book looks at what each specialty contributes to create a harmonious whole and defines a common visual and design language to address narrative in video games.
- Squire, Kurt, *Video Games and Learning: Teaching and Participatory Culture in the Digital Age* (New York, Teachers College Press, 2011). A look at how games can be used in education, and also an examination of what makes games fun.
- Thomas, Sue, *Technobiophilia: Nature and Cyberspace* (London, Bloomsbury Academic, 2013). An exploration of the connection between the natural world and cyberspace.
- Vogler, Chris and Montez, Michele, *The Writers Journey: Mythic Structure for Writers,* Third Edition (Studio City, CA, Michael Wiese Productions, 2007). An examination of Joseph Campbell's theory of *The Hero with a Thousand Faces,* a mythic structure which is the basis of many games; this book is geared toward writers.
- Wardrip-Fruin, Noah and Harrigan, Pat, *The New Media Reader* (Cambridge, MA, MIT Press, 2003). A remarkable and exhaustive archive of writings about new media, particularly about the early days of the field.
- Wardrip-Fruin, Noah and Harrigan, Pat, *First Person: New Media as Story, Performance, and Game* (MIT Press, 2006). The first in a series of excellent books of readings about New Media from experts in the field.
- Wardrip-Fruin, Noah and Harrigan, Pat, *Third Person: Authoring and Exploring Vast Narratives* (Cambridge, MA, MIT Press, 2009). A collection of readings, primarily delving into virtual worlds and multiplayer games.
- Wardrip-Fruin, Noah and Harrigan, Pat, *Second Person: Role-Playing and Story in Games and Playable Media* (Cambridge, MA, MIT Press, 2010). A collection of readings, focusing primarily on role-playing games.
- Zeman, Nicholas B, *Storytelling for Interactive Digital Media and Video Games* (CRC Press, 2017). This book focuses on how storytelling has evolved to its present form, in the age of digital media, and how to develop these new kinds of stories for digital media and video games.

Project Index

@BettyDraper, 215
@RealGrumpyCat, 215
@SummerBreak, 230
13 Reasons Why, 224, 416, 447
3X3, 418
6×9, 340, 581

Aftershock, 292
Age of Empires, 251
AI, 41
Aibo, 535, 536, 537
Air Race, 656
Alexa, 35, 38, 49–51, 69, 83, 138, 139, 145, 607
Alice in Wonderland, 617, 618
Alice's Adventures Underground, 618, 648
Alien Zoo, 560
"All That Glitters", 227
Altima Island, 315
Alt-Minds, 449
Amazing Amy smart toy, 526

Amazon, 59, 145, 375, 407, 474
America on the Move, 307
America's Army, 289, 291, 312, 348
Angry Birds, 120, 184, 369, 370, 448, 448–449
Antiques Roadshow, 506
Arca's Path, 576–577
ARcheology – Dig Up History, 275
ARKit, 594, 595
Arrow to the Sun, 659
Artificial Anasazi, The, 338
Astro Bot: Rescue Mission, 573–574
Aurelia: Edge of Darkness, 489
Avatar, 177

Baby Bright Eyes, 526, 527, 528, 535
Balloon Odyssey, 657
Barbie, 523
Batman Begins, 42
Battle Royale, 373
Bear71, 484

Beast, The, 41, 42, 43, 320, 521, 529, 544
Beat Saber, 574
Beauty Inside, The, 320
Beckinfield, 489
Belle de Jour: Diary of a London Call Girl, 423
Belle doll, 529, 544
Ben's Dive Blog, 424, 425, 433
Betas, 418
Beware Madame La Guillotine, 275
Beyond the Front, 286, 290
Bionicle, 320
Birdman, 580
Black Mirror, 499; *Bandersnatch*, 499, 500, 501
Bleeding Through: Layers of Los Angeles, 479, 480
Bloodyminded, 473
Blu, The: Deep Rescue, 560
Boys' Toys, 219, 509, 510
Bridget Jones' Diary, 445–446
Budapest Festival Orchestra interactive poster, 323, 450, 461
Budget Cuts, 576
Bug's Life, A, 651
Burger King: Subservient Chicken the Other Side of the Road, 318, 319
Buried Alive: The Secret Michelangelo Took to His Grave, 275
Buzz Lightyear AstroBlaster, 624, 625

CalcFlow, 277, 582
Candy Crush Saga, 449
Carmen Sandiego, 103, 264, 271, 374
Carne y Arena, 580
Cassini's Grand Finale, 482
Castles, 160
Cat and the Coup, The, 332, 333
Cerrillos, New Mexico, 205
Chevy Tahoe campaign, 78, 317
Chinese Hero Registry, 187, 291
Cittadella Visitors' Center, 643
Clouds over Cuba, 483, 485
Club Penguin, 62, 186
C'mere, 601
Coca Cola Polar Bear Party, 512
Code Alert, 257, 258, 260, 261, 298, 299
Colossal Cave Adventure, 365
Coming Home Project, The, 584
Command and Conquer, 367

Computer Space, 33
Conversations, 334, 339, 563
Cosmic Voyager Enterprises, 287, 288
Coursera, 280
Crossed Lines, 487, 488
Cuphead, 378
Curatti.com, 511
Curse of the Lost Pearl, 560, 564
Cutthroat Capitalism, 332

Dark Age of Camelot, 387, 388
DarkCon, 153–154, 577, 578, 579, 584
"Dark Desert Highway," 226, 228
Dark Detour, 228
Dark Knight, The, 42
Dawn at My Back, The, 479
DeeChee robot, 538
Defrost, 561
Delos Corporate Offices at Comic-Con, 630
Déraciné, 575
Deus Ex: Invisible War, 365, 366
Dexter, 415
Dial, The, 597, 608
Dick and Jane, 165, 255, 256
Didi and Ditto, 132
Diners, 506
Dirty Work, 39, 512–513
Discover the Stories Behind the Magic, 46, 47, 667
Dismaland, 641
Disney Electronic Interactive Story Reader, 52
Disney Infinity, 314, 524
Disney LOL, 212
Disney Phineas and Ferb: Agent P's World Showcase Adventure, 447
Displaced, The, 582
Dolphin Robotic Unit (DRU), 605, 606
Donkey Kong, 369
Dora and Diego's 4-D Adventure, 652
Dot, Dash, and Cue, 533, 534
Dragonfrost, 566, 567, 568, 569, 570
Dragon's Lair, 375, 399
Dreamhouse, 601
Dr. Horrible's Sing-Along Blog, 423
DRU, *see* Dolphin Robotic Unit
Dubplate Drama, 508
Duck Has an Adventure, A, 165
Due Return, The, 631–633

Dumb Ways to Die, 334, 344
Dungeons and Dragons, 18, 367, 488

Earning Our Wings, 309
Earthquake in Zipland, 292
Elder Scrolls Online, 368, 384
Elements: A Visual Exploration, 337
ELIZA, 136, 137–138, 139, 146
Ellie, 145, 146
EmbodyMove, 563, 571
Emma Approved, 223
eNativ, 204
Engadget.com, 582
Enter the Dojo, 418, 419, 671
EpicRobotTV, 224
Everglades Airboat Adventure, 473, 652
EverQuest, 171, 383, 385, 388, 389, 390, 394

Fabergé Big Egg Hunt, 315
Façade, 485, 486
FarmersOnly, 204
Farmville, 23, 231, 368
Fear of the Sky, 586
Final Fantasy VII, 100
Firefly Watch, 332
Firmament, 671
Flat World, 602–603
Florence, 448
Food Import Folly, 292, 332
Forest, The, 575
Fortnite, 186, 373–374, 376
Frankenstein, MD, 223, 225
Fredo's L'ultima Cena, 619, 620, 622, 623
Full Spectrum Warrior, 583
Funny or Die, 312, 429
Furby, 523; Boom smart toy, 523
Furreal smart pets, 523

Galatea, 91, 521
Game of Thrones, 23, 38, 496, 503
Games-to-Teach project, 276, 278
Gangnam Style, 205, 410
Gathering, 137
Genii Games, 273
Geocities, 211, 212
Ghostbusters, 609
Ghost Town, 424
Glorious Mission, 291
Godfather: Five Families, The, 231
Gone Gitmo, 562, 564, 580

Google News, 337
Google Spotlight Stories, 447, 448, 551
Google Translate, 599
Grand Paradise, The, 617
Grand Theft Auto series, 124, 370
Grapes of Wrath Journey, 230, 447
Green Lantern, 322
Green Tea Partay, 317
Gronk's BrainFlame, 659
Guild, The, 416
Guild Wars 2, 368
Gustav Klint immersive exhibit, Atelier des Lumières, Paris, 642–643

H8 Society – How an Atomic Fart Saved the World, 52
Habbo Hotel, 192
Hado Kart, 598
Half the Sky, 342
Halo, 177, 200
Hamlet on Facebook, 217–218
Hang in There, Jack, 321
Harry Potter: Wizards Unite, 589, 590, 591
Harry Potter and the Forbidden Journey, 625
Harry Potter for Kinect, 362
Haunted Carousel, The, 107
Hawai'i Nisei Story, 331
Hello Barbie, 523
Help, 448, 487
Hephaestus, 278, 286
Her Story, 375, 481
Hire, The, 317, 318
Histopad, 628
Hitchbot, 539, 543
Hollywood Rooftop, 559
Homicide: Life on the Streets, 415
Hotstepper, 597–598
House of Eternal Return, The, 633, 634, 636, 637, 638
How to Train Your Dragon: The Hidden World, 323
Huroof, 273

I AM A MAN, 580
IBM Watson, 112
Icebox.TV (Icebox.com), 429
iCivics, 291
Idea Lab, 346
iDocs, 345

I Expect You to Die, 574–575
Igbo 101, 274
I Love Bees, 41–42, 320
I'm Your Man, 466
Inanimate Alice, 52
IndieGoGo, 226
Ingress, 449, 589, 590, 591, 592
Inside, 218, 378, 489
Interactive dollhouse project, 524
In the Moment, 418
In Transition, 418
Invictus, 100, 160
It's Tough to Be a Bug!, 651, 667
It Takes a Thousand Voices, 205

Jamie Kane, 430
Jester's Tale, A, 597, 608
JewishGen, 204
Jewish Pioneer Women, 331
Jibo, 543
Job Simulator: The 2050 Archives, 574, 576
Jockey, The, 481
Journey, 99, 378
JumpStart, 106, 107, 275, 277, 374
JumpStart Advanced First Grade, 174, 193, 251, 252, 271
JumpStart Artist, 281
Jurassic World, 38, 49
Jurassic World: Fallen Kingdom, 565
Jurassic World Revealed, 38, 49
Jurassic World VR Expedition, 565

Karim, 146
KateModern, 429
Keepon (robot), 520
Kim Kardashian: Hollywood, 450
King Kong Jump, 311
Kinoautomat, 466
Kony 2012, 214, 410

La Jungla de Optica, 278
Last Seen Online, 448
Last Symphony, The, 172
Late Fragment, 488
Latitude Society, The, 638, 639
Laundroid, 537
Lawnmower Man, 559
League of Legends, 375
Le Domus Romane di Palazzo Valentini, 341

Les Machines de l'Île, 640, 641
Literally Can't Even, 447
Little Old Lady Stays Put (or Doesn't), The, 422
Live/Hope/Love, 204
Living Landscapes, 372, 473, 654
Lizzie Bennet Diaries, 218, 219, 220, 221, 222, 223, 225, 447
LonelyGirl15, 78, 220, 426, 428–429, 433, 694, 695
Lord of the Rings Online, 367
Lost in the Tomb, 619
Loveplus+, 40
Lucy (virtual character), 552
L Word, The, 504

Magic Door, The, 50
Majestic Plastic Bag, The, 309
Make Your Way to Rio, 316
Manuela's Children, 483–484
Marble Hornets, The, 429
Mario, 120
Master of Orion 3, 160
Math Blaster, 271
Meatrix, The, 308, 309, 686
Memory Stairs, 153
Menahune Adventure Trail, 446
Men in Black: Galactic Getaway, 570
Meow Mix House, 39–40, 307, 320
MesoAmerican Ballgame, The, 333
Messenger, 438
Mia: Just in Time, 283, 284
Mia titles, 124–125
Mica (AI assistant), 606–608
Millennium Falcon, 627
Mind at Large, 601–602
Minecraft, 62, 97, 172, 370, 398
Minotaur's Maze, 571
Miracles in Reverse, 486
Mission Rehearsal, 653
MMOWGLI, 279
Mortal Kombat, 369
Mosaic, 478
Mos Eisley Cantina, 629
Moss, 575
Mr. Payback, 466
My Darklyng, 217, 218
Myst, 368, 575, 671
My Very Hungry Caterpillar, 244, 593, 594, 596

Nancy Drew mystery adventure games, 107, 108, 115, 142, 160, 169, 262, 264, 365
NanoOne, 277
NanoPro, 277
Nanotech Mysteries, 343
Nefertari: Journey to Eternity, 581
New Adventures of Peter and Wendy, The, 223, 447
Nigelblog, 423
Noelle, 541, 542, 544
Nomads, 561
No Places with Names, 45, 604
Notes on Blindness, 335

Obduction, 575–576
Odd Todd, 689–694
Office: The Accountants, 415
Old Stone House: Witness to War, The, 628
Online Caroline, 429
Oregon Trail, The, 374
Oriental Science Fiction Valley (VR Theme Park), 67, 565

Packard Plant: Big. Ugly. Dangerous., 336
Paro (therapeutic robot seal), 201
Passages, 153, 378
Pearl's Peril, 232
People's House, The, 562
Peter and Wendy, 218, 223, 447
Pet News and Views, 421
Pig's Tail, A, 309
Pirates of the Caribbean, 177
Planet Jemma, 429
Player Unknown's Battle Grounds (PUBG), 373
Please Be Seated, 603
Pokémon GO, 556, 589, 590, 591
Pong, 33, 54, 122, 351, 397, 402
Pop Quiz, 260
Potter Puppet Pals, 63
Pretty Dirty Secrets, 513
Pretty Little Liars, 415, 513
Prince of Persia, 353, 381
Prince of Persia: Sands of Time, 381
Project Debater, 51
Prom Queen, 415, 416
PUBG, see *Player Unknown's Battle Grounds*
Puppy Tweets, 215
Purple Rose of Cairo, The (Allen, Woody), 21
Puss in Book, 498
Puss in Boots, 498–499

Q Game, 45, 442, 444
Q Game: City of Riddles, The, 372, 443
Quarries of Lights, 643
Quibi, 440

Rachel's Room, 426–427, 428, 433
Raft, 571
Railways—Lifeline of a Nation, The, 482
Ralph Breaks the Internet, 38, 609
Ralph Breaks VR, 609–610
Reader Rabbit, 271
ReBlink, 451
Red Bull Stratos, 59
Red Dead Redemption, 627
Red Dead Redemption 2, 376
Red vs Blue, 64
Re-Mission, 202
Repliee Q1, 542
Resident Evil, 366
Restoration, 506
Return to Grindelind, 576
Revolutionary War Immersive Experience, 652
Ricky the Trick Lovin' Pup, 523
Rising from Ruin, 329, 331
Robofish, 538
RoboFly, 536–537
Robonaut 2 robot, 538
Robosapien, 535
Routes, 288

S#cial Sector, The, 218
Saints Row, 172, 370, 379, 380, 381, 382, 383
Sansar, 62
Save Your Co-Worker, 257, 258, 298, 299
Saydnaya, 482
Scarecrow, The, 311, 312, 318
Scourges of the World, 488
Scrabulous, 231
Sea Change: The Pacific's Perilous Turn, 482
Second Life, 61–62, 172, 202, 300, 305, 314, 315
Secret Garden, The, 490

Seedling, 593, 596
Seeking Pluto's Frigid Heart, 582
Sentient World Simulation (SWS), 279, 290
Sesame Street, 273
Seven Ages of Man, 597
Shanghai: Second Dynasty, 160
Shelley Duvall Presents Digby's Adventures, 104
Sid Meier's Civilization, 369
Silent Hill, 366, 375
Sims, The, 126, 172, 176, 369
Shybot, 539
Simon robot, 538
Singles Project, The, 228
Siri, 49, 138
Site of Reversible Destiny, The, 642
SitorSquat, 322
Situation Critical, 619
Sketch Aquarium, 644
Skylanders, 524
Skyrim, 50
Sleep No More, 649
Slither.IO, 449
Snake, 122, 437, 445, 448, 449, 460
Snap Originals, 446, 447
Snow Fall: The Avalanche at Tunnel Creek, 481
Snow White and the Seven Dwarfs, 135
SnowWorld, 292, 583
Soarin' (ride), 372, 473, 654, 655
Sofia's Diary, 78
Sonic the Hedgehog, 120, 141, 369
Space of Time, A, 486
Spacewar!, 32, 33, 375
Spice and Wolf, 561
Spot, The, 413, 414, 415
Sqwishland, 62
Starlink Battle for Atlas, 371, 524
Star Trek, 63, 548
Star Trek: Dark Remnant, 570
Star Trek: Starfleet Command, 160
Star Trek: The Next Generation, 548
Star Wars, 609
Star Wars: Galaxy's Edge, 626, 627
Star Wars Hotel, Orlando, 628–629
Star Wars: Project Porg, 598
Star Wars: Rise of the Resistance, 627
Stone Cold Creamery training game, 291
Storyful, 337
Stranger Adventures, 430, 431
SUESummerbranch, 564
Sun Ladies, The, 335
Sunny the Snowpal, 39, 320, 673
Super Mario Bros., 369
Super Monster Wolf, 536
Sweetwater Village, South by Southwest, 629

Take the Hill, 628
Tales of Wedding Rings, 561
Talk to the Reasons, 224, 416
Tamagotchi, 522
Tamara, 649
Tea Partay, 317
Teddy Ruxpin, 522
Tennis for Two, 32
Tetris, 90, 122, 368, 369
That Dragon, Cancer, 152, 153, 356
Then She Fell, 617
Thief, 127
Thing Growing, A, 515
Third Woman, The, 490
Thirteen Ways of Looking at a Blackbird, 66
Thunder Road, 507
Tokyo 13, 232
Tomb Raider, 278
Tom Clancy's Jack Ryan, 608, 611
Toontown Online, 186, 194, 391, 392, 393, 395, 396, 398
Toontown Rewritten, 186
To Our Daughter, 409
Toy Story Animated Storybook, The, 358
Toy Story Mania, 624–625
Toy Story Midway Mania!, 652
Transformers, 177
Trevor Saves the Universe, 576
Truth About Marika, The, 38
TV411, 504
Twine (software), 255

Uk'shona Kwelanga, 67, 225, 447
Ultima Online, 382
Ultimate Guide to Florida Nature, 457
Uncompressed, 475, 476, 477, 478, 487, 490
Understanding Echo, 490
UNMAS IED Detection Experience, 579
Ushahidi, 205

VAE, *see* Virtual Army Experience
VeggieTales, 205
Video Game High School, 412, 418, 671
Virtual Army Experience (VAE), 289, 291
Virtual Hills, 305
Virtual Iraq, 583, 584
Virtual Iroquoian Longhouse, 581
Virtual MTV (vMTV), 314
Virtual Newport Medieval Ship, 581
Virtual Rabbids, 571
Virtual Simulation Baseline Experience, 286
VISIBLE, 585
Vital Space, 468, 469, 470
V.Next, 375
Voices of Oakland, The, 604
Voyage of Ulysses, 455
VRcade PowerPlay, 567

Wanna-Be-Page, The, 670
War Horse ebook, 454
Way Beyond Trail, The, 306, 317
Webkinz, 523
Welcome to Sanditon, 218, 222
Westworld, 38, 629; at Comic-Con, 630; at South by Southwest, 629
Westworld: A Delos Destination, 415
Westworld: The Maze, 49
What Killed Kevin?, 175, 334, 341
When in Rome, 50
Where in the World is Carmen Sandiego?, 374
Where Thoughts Go, 563
Who is Benjamin Stove?, 312, 313
Who's Afraid of Bugs?, 598
Who's Afraid of Virginia Woolf?, 485
Why So Serious?, 42, 43, 320
Willows, The, 649
Wings of Memory, 659–660
Wire, The, 23
WiseMuslimWomen, 204
Wizard 101, 202
Wolf_OR-7, 216
Wolfpack, 137
World of Warcraft, 200, 203, 368, 376, 394
Wreck-It Ralph, 38, 609
WWF Together, 322, 458

X Planes, 369

YouTube Symphony Orchestra, The, 229–230
Yumby Smash, 455, 456

Zhu Zhu Pets, 532
Zombie Attack, 473
Zynga Elite Slots, 232

Subject Index

3-D printing, 48
360° video, 557
4-D dark rides, 472, 624, 650–652
5G, 440

Aarseth, Espen J., 355
Abacus, 28
ABC, 513
ABQid, 206
Abraham Lincoln Presidential Library and Museum, 603
Abstract stories, 88–90
Abyss Creations, 518
Academic institutions, and iCinema, 491
Academy of Interactive Arts and Sciences (AIAS), 684
Academy of Television Arts and Sciences (TV Academy), 684
Accelerometer, 114, 442
Acquisition of material in a game or other project, 83–84
Action-adventure games, 365
Action games, 365
Action points, 161, 163, 165
Active learning, 282, 469
Acts, 159; *see also* Three-act structure
Adams, Ernest, 670
Adaptation
　of characters, 142
　of content for new media, 35
Adaptive sensitivity, 656
Adaptive training system, 293
Addiction
　to MMORPGs (massively multiplayer online role-playing games), 385–387
　to mobile phones, 439
Adjunct storytellers, 592
Adults, fantasy role-play, 18–19
Advanced Research Project Association Net (ARPANET), 31, 32, 405
Adventure games, 365–366

Advergaming, 58, 304, 306, 310–312, 397
Advertising; *see also* Marketing
　digital media for, 303–304
　digital storytelling techniques and genres, 305–323, 310, 313–314
　impact of digital technology on, 58
　and mobile devices, 458
Afghanistan, 279, 295
AFI, *see* American Film Institute
Africa, Internet connectivity, 408
Age-appropriateness, 188, 190–191
Agency, of users, 76–79
Agent-based modeling, 338
Agnitus, 273
Agon, 89, 123
AI, *see* Artificial intelligence
AIAS, *see* Academy of Interactive Arts and Sciences
Ajakwe, Michael Jr., 417
Aldiss, Brian, 521
Alexander, Leigh, 172
Alexa skills, 50
Algorithm, 163
Allen, Woody, 21
Alternate reality games (ARGs), 40–44, 112, 176, 372, 592
　for education and training, 288
　for promotion and advertising, 310, 312–314, 313–314
Altman, Robert, 506
Amazon, 59, 145, 375, 407, 474
American Film Institute (AFI), 495, 502, 504, 512
American Museum of Natural History, 603
Amnesty International, 482, 586
Analog data, 5
Anasazi people, 338
Ancient games, 16, 26
Ancillary TV, 496
Andreessen, Marc, 48
Android operating system, 363–364, 438, 493
Androids, 520, 540–542; *see also* Robots
Angular structures, 171, 178
Animals
　in promotion and advertising, 319
　and social media, 215
Animatronic characters, 521, 540, 603; *see also* Robots

Anonymous content, 225
Antagonists, 123, 131–133; *see also* Opposition
　motivation of, 141
Antiques Roadshow, 506
Apache rituals, 11
Apple, 329
　iOS, 438, 493
　iPad, 37, 55, 337, 436, 490, 493
　iPhone, 37, 329, 493
Apple TV, 493
Apps, 55, 454–457, 457, 493, 604; *see also* Mobile devices
　appeal of, 439–441
　and education and training, 273, 288–289
App TV, 494
Aquarium model, 171
AR, *see* Augmented reality
Arab Spring, 199, 213, 326
Arcade games, 33, 361
Archeological dig model, 175
Archetypes, 99, 123
Architecture, and augmented reality (AR), 604
Arena-scale VR, 567
ARGs, *see* Alternate reality games
Aristotle, 124, 154, 159
　and dialogue, 147
　and storytelling tools, 96, 101–103
Arneson, David, 18
ARPANET, *see* Advanced Research Project Association Net
Artificial intelligence (AI), 23, 48, 111, 122, 136, 360, 518, 606–607
　advances in, 51
　conflict between characters with, 136–137
　ubiquitous AI, 51
Art of Game Design, The, 556
Art of Game Design, Second Edition, The, 575
Arts, the, digital technology, 64–66
Artwork, development process, 201–202, 262
Asher, Jay, 224
Aspirational figure, 120, 190, 528
Atari, 33
Atkinson, Sarah, 487
Attitude selection, 149

Auden, W.H., 600
Audiences, 183–184; *see also* Users
 children, 184–196, 194
 and the development process, 240, 246–247
 domestic, 205–208
 girls and women, 196–199
 and iCinema, 469
 ill and disabled, 202–203
 and interactivity, 76
 international/ethnic minority, 203–205
 large-screen immersiveness for, 650–652
 seniors, 199–202
 zeroing in on target audience, 206–208
Audio-animatronic characters, 652
Audio storytelling, 48
Augmented reality (AR), 49, 300, 322–323, 371, 549, 588–589, 588–593, 598–600
 AR 101, 556–559
 architecture, 599–600
 buying furniture and household goods, 599
 different approaches to AR games, 593–596
 -enabled birthday cards, 599
 entertainment experiences using, 597–598
 history, 599
 infrastructure safety, 599
 IV insertion, 599
 journalism, 599
 language translation, 599
 nail polish, 599
 in narrative works, 596–597
 science education, 600
 sports, 600
 surgery, 599
 for warfare, 598
Austen, Jane, 219–221, 223
Austin Game Conference, 683
Australia, 66, 67
Authors, and interactivity, 76–79
Automata, 521; *see also* Robots
Auxiliary TV, 496
Avatars, 10–11, 111, 126, 384, 390
Aviva, Elyn, 124

Babbage, Charles, 29
Babies, language learning, 274
Bach, Ethan, 661
Backstory, 109, 140
Badges, 278; *see also* Rewards
Baekdal.com, 302–303
Baer, Ralph, 33
Balloon man model, 178
Banksy, 641
Baquet, Dean, 582
Barbie doll, 523
Barlow, Sam, 375
Bartle, Richard, 383, 386–387, 391
Battle royale, 371, 373–374
Baumgartner, Felix, 59, 60, 326
BBC, interactive television ("Red Button"), 339, 394, 494, 507
BBS Systems, 211
Bebo, 78, 212
Beckett, Miles, 694
Beginning, 101, 159, 160; *see also* Three-act structure
Bell, Ben, 171
Bernardo, Nuno, 78
Berners-Lee, Tim, 32
Besmehn, John C., 530
Beta tester, 674
Beta version, 593
B.E.V., 610
Bezos, Jeff, 59
Bhargava, Archit, 590
Bible, 250
Bieber, Justin, 214
Binary choice, 164, 165
Bio-Tidy, 39
Bishop, Bryan, 630
Blogs; *see also* Vlogs (video blogs)
 fictional, 421, 423–425
 non-fiction, 421–422
BMW, 317
Board, Mark, 279
Board games, and digital storytelling, 16–17
Bogost, Ian, 292, 441
Bologna Ragazzi Digital Award, 244
Bonilla, Diego, 486
Books
 augmented reality (AR), 598
 nonlinear, 19–20
Boolean logic, 163

Borrowed technologies, 44–46
Borst, Terry, 260, 385
Boss battle, 134, 378
Boss monster, 134
Bouazizi, Mohamed, 326
Bowen, Hugh, 151
Boys, creating projects for, 196, 393
Brain games, 201
Brainpop, 273
Brainstorming, 241, 243
Brainwave controllers, 363
Branching structures, 119, 165–167
 barrier in, 166
Branded content, 306–307
Branding, 302
BRC Imagination Arts, 603
Brigit (goddess), 124
Bristol University, 284
Broadband, 406
Brooker, Charlie, 499, 500, 501
Buckleitner, Warren, 454–455
Budapest Festival Orchestra, 323
Budgets, 243, 263
Burger King, 318–319
Burroughs, William, 20
Bushiness, 166
Bushnell, Brent, 570
Bushnell, Nolan, 33
Buyer persona, 206, 294

Cailleach, The, 124
Cameras (in mobile devices), 443
Cameron, James, 497
Campbell, Joseph, 8, 13, 90, 99, 100, 103, 295
Can Video Games Make You Cry? (Bowen), 151
Carle, Eric, 244, 596
Case, Stevie, 668
Casual games, 106, 310–312, 369, 396–397
Catharsis, 8, 90, 103, 154, 400
Cats and social media, 215
Caudell, Tom, 589
CAVE, *see* Cave Automatic Virtual Environment
Cave Automatic Virtual Environment (*CAVE*), 557, 585
CD-ROMS, 35, 90, 374
Celebrities, and social media, 214

Cell phones, *see* Mobile phones
Central Park Zoo, 652
Cerf, Vint, 31
CES, *see* Consumer Electronics Show
CFC Media Lab, 489
Challenges, for children, 195
Changing Mind, 130
Channel 4, 508
Chapek, Bob, 626, 629
Character arcs, 122, 140, 142–143
Character bible, 250, 680
Character biographies, 140–141
Character development, 103
Characters; *see also* Animatronic characters; Antagonists; Non-player characters (NPCs); Player character; Protagonists
 classic, 123
 dialogue and verbal communication, 144–151
 in digital storytelling, 111, 119–123, 120, 140–144
 in education and training, 290, 294
 and emotion, 151–154, 154
 intelligent, 135–139
 in interactive storytelling, 119–123, 120, 140–144
 in linear storytelling, 121, 123, 140
 in MMORPGs, 390
 motivation of, 103, 141
 and social media, 214–217
 user-generated, 489
 and users, 122–123, 124, 124–130, 128
 in video games, 356
Charmin, 322
Charter, The, 634
Chatbots, 137–138
Chatterbots, 111, 137–138
Chen, Grace, 455–456
Child development, 188–189
Children, 184–186; *see also* Boys; Girls
 age classification, 188–189
 challenges and rewards for, 195
 child development, 188–189
 entertainment consumption patterns, 55
 Entertainment Software Association (ESA), 55, 199, 397
 family-friendly and comic antagonists, 131–132

Subject Index

focus groups, 190
and humor, 194
parents' point of view, 191–193, 194
respect for, 195–196
understanding as users, 186–188
use of mobile devices, 186, 451–453
virtual worlds, 62
Children's games, 17, 106, 131–132, 174, 179, 193, 194, 251, 252, 271, 274, 277, 281
China, 66–67
Chipotle, Mexican grill, 311
Chiquita, 316
Choose Your Own Adventure books, 20, 165, 306, 466, 488
Choose your own adventure structure, 498
Christian, Brian, 136
Christian audiences, 204–205
Chromecast, 493
Cincera, Radúz, 466
Cinderella, 454
Cinema, *see* Hollywood; iCinema; Motion pictures
Cinematic quality of video games, 353–354
Citizen science, 332
Civil War Museum, 603
Cloud-based system, 362, 536
Clue-laden USB flash drives, 44
Coal mine model, 173
Coats, Emma, 138
Coca-Cola, 512
Cognitive games, 370, 397
Cohesion, and gaming techniques, 87–88
Collaboration, in digital storytelling, 115–116
Collective journey model, 177
Collins-Ludwick, Anne, 107, 109, 115, 168
Color preferences, and gender, 197
Comedy shorts, 429
Comic antagonists, 131–132
Comic-Con, 38, 43, 202
Coming-of-age rituals, 13
Common Core State Standards, 282
Common Sense Media, 185
Communication, and interactivity, 83
Community building, 331–332, 410–411
Community Manager, 332
Compasses, 442

Complete graph, the, 172
Computer-controlled characters, *see* Non-player characters (NPCs)
Computer graphics, 683
Computers, history of, 28–30
Computers in Human Behavior, 200
Concatenation, 531
Concept art, 262
Concept document, 249–251, 669
Conflict, 98
Console games, 33, 363–364
"Construction kit" commercials, 317
Consumer Electronics Show (CES), 537
Content
 branded, 306–307
 edginess of, 411
 educational, 281
 evolution of for new media, 34–37
 implications of digital revolution for, 59–64
 and interactivity, 85–87
 for mobile devices, 442, 453–457, 457
Contracts, for digital storytellers, 676, 680
Contract workers, 675
Control over objects, and interactivity, 83
Convergence technology, 36–37
Core concept, 241–242
Crispin Porter + Bogusky, 319
Critical story path, 167–171, 169
Critical story path document, 264
Cross-media productions, *see* Transmedia storytelling
Crowdsourcing, 671
Crucible experiences, 295
Cuban Missile Crisis, 483
Cue, 534
Cul-de-sacs, 166
Cultural institutions, 341
 employment with, 674
 and iCinema, 471, 483
 and interactive media, 186
 mixed reality, 603–604
 ridefilms, 652
Currents, 518, 601, 602
Curriculum, 281–282
Cursor, 127, 128, 476, 578
Cut scenes, 109
Cyberbullying, 192, 214

Cyberspace, 31
 outer edges of, 555–556
Cyborg anthropology, 54

Dabney, Ted, 33
Dalai Lama, 214
Dash, 534
Database narratives, 478–481, 479
Dave & Buster's, 564, 565, 566, 567, 570, 571
Day, Felicia, 416
Day of the Dead, 12, 213
Decision points, 161, 162, 167
Deep Silver Volition, 379, 380, 383
De la Peña, Nonny, 562, 580
Deluje', Twig, 398
DeMartino, Nick, 494–495, 496, 497
Design document, 251–255, 254
Deus ex machina, 101
Developmental psychology, 188–189
Development process, 237–239, 265
 artwork, 201–202, 262
 checklist, 246–249
 core concept, 241–242
 documentation, 238, 244, 249–251, 252–254, 255, 256–257, 257, 260–261, 262, 263–265
 early decisions, 242–243
 evolution of projects, 244
 mistakes in, 239–241
 preproduction phase, steps in, 245–246
DeWitt, Sarah, 453
Dia de los Muertos, 213
Dialogue
 and characters, 144–151
 and smart toys, 531
Dialogue script, 255–260
Dialogue trees, 148–149, 294
Digital books, advances in, 51
Digital Content Lab, 495, 502, 504
Digital Domain, 139
Digital doppelganger, 279–280
Digitalized data, 5
Digital media, 27, 66
 alternate reality games (ARGs), 40–44
 benefits to children, 192
 birth of the Internet, 30–32
 borrowed technologies, 44–46
 and content, 59–64
 development of video games, 32–34
 early development of, 27–30, 29
 evolution of content for, 34–37
 global perspective on, 66
 harnessing convergence, 36–37
 impact of, 53–66, 60
 and news and information, 324–329, 326, 335–344, 345
 new ways to tell stories, 48–53
 profound impact of, 53–54
 for promotion and advertising, 303–304
Digital media integration, *see* Convergence technology
Digital storytellers, 665–666
 careers, 665–666
 education, 680–682
 employment paths, 672–674
 entry points, 674–675
 freelance work, 675–676
 industry events, 682–683
 legal considerations, 676–680, 680
 networking, 683
 selling ideas, 669–672
 tips for success, 684–685
Digital storytelling, 4–5, 107–109; *see also* Storytelling
 characters in, 119–123, 120, 140–144
 and dialogue, 148–149
 difference from classical storytelling, 25
 for education and training, 269–301
 and emotion, 151–154, 152
 evolution of content for, 34–37
 and familiar rituals, 11–13
 and games, 13–15
 for information, 324–346
 and interactivity, 7
 and mobile devices, 445–448
 and myth, 9–11
 for promotion, 301–303
 and rites of passage, 13
 script format, 108
 and social media, 211–234
 special characteristics of, 23–25
 and storylines, 105–107
 structure in, 157–181, 167, 169, 174
 tools for, 95, 96, 107–116
 and VR, 579
Dille, Flint, 590
Dimensional storytelling, 606

Subject Index **763**

Dionysian rituals, 4, 9, 101
Disabled people and digital media, 202
Disc-based game, 362
Disney, 135, 213, 314, 358, 416, 446–447, 473, 524, 540, 605–606, 606, 651, 654, 667–668
 theme parks, 372, 447, 626–627, 654, 668
Disney, Walt, 46–47, 48, 135, 605, 606, 641
Disneyland, 606, 625, 641, 652, 667
Disney Parks Blog, 627, 629
Disney Worldwide Publishing, 52
Disruptive media, 57
DKP Effects, 488
Documentaries, 6
 and iCinema, 478–479
 interactive, 339
Documentation, development process, 238, 244, 249–251, 252–254, 255, 256–257, 257, 258–259, 260–261, 263–265
Dogon people, 9
Dogs, and social media, 215
Dolls, smart, *see* Smart toys
Domino's Pizza, 303
Dopamine, 284
Dormans, Joris, 176
Dot, 534
Dot-com bust, 406, 432, 685
Doubletake Studios Inc., 287, 288
Downloads, legal, 56
Drama
 in abstract games, 90
 Greek, 8, 89, 101, 124, 155, 159–161, 444, 520
 and interactive television (iTV), 507–508, 508
 and structure, 159–161
Dramatic shows and social TV, 512–513
Dramatic tension, 104, 105
Draper, Betty, 215
Dreamhouse, 601
Dreamscape Immersive, 560
Drill and kill games, 276
Drill down model, 173
Driving games, 366–367
Drone, 537
Dual screen interactivity, 497
Dual screen/synchronous interactivity, 497

Duvall, Shelly, 104
DVDs, 35
 and iCinema, 488–489

Eastgate, 20, 66
Ebert, Roger, 352
Ebooks, 53, 446, 454
Edginess, of content, 411
Edison, Thomas, 522
Education, 270–272, 300–301; *see also* Edutainment games; Training
 additional tools for, 287, 287–290
 for digital storytellers, 680–682
 guidelines for projects, 300–301
 and iTV, 504
 and mobile devices, 457
 older learners, 276–280, 283, 297
 serious games movement, 290–296, 296
 techniques, 281–286, 283
 young learners, 273–275, 289
Edutainment, 467
 games, 106, 131–132, 179, 193, 251, 252, 271, 273, 276, 281
Egg hunts in gamification, 315
Egypt, 326
 mythology, 9
Eisner, Michael, 415
Elders React to Technology, 558
Electronic construction kit model, 176
Electronic kiosks, 46, 340
Electronic Literature Organization, 66
Electronic Numeric Integrator and Computer (ENIAC), 29
Elephant ear, 36
Elizabeth II, Queen, 214
Email, development of, 31
Embedded reinforcement, 455
Emblematic group, 562
Emergent behavior, 143–144, 655
Emergent culture, 293
Emoticon, 150
Emotion, and characters, 151–154, 152
Emotional score, 153
Emotiv EPOC, 363
End, 101, 159, 160; *see also* Three-act structure
End-goal, 283
Enhanced TV (eTV), 494
 workshop, 495

ENIAC, *see* Electronic Numeric Integrator and Computer
Entertainment, changing consumption patterns, 54–55
Environmental Defense Fund, 318
Environment synergy document, 264
Epic Games, 373
Epiphany, 295
Ericsson Television, 509
Escape Room City, 622
Escape rooms, 618–623
Escape Santa Fe, 621, 623
Esports, 375–376, 408, 567
Ethnic minority audiences, 203–205
eTV, *see* Enhanced TV
Eusocial insects, 537
Events, in digital storytelling, 110–111
Experiential learning, 282, 286
Experius VR, 340, 581
Exploratorium model, 171
Exposition, 147–148, 172, 682
Exposure therapy, 202
Expressive, Inc., 51

F2P (Free to Play) games, 368
Fable Studio, 552
Facebook, 39, 62, 185, 199, 212, 214, 216, 217, 218, 219, 220, 223, 226, 231, 235, 287, 316, 320, 321, 325, 326, 342, 368, 406, 419, 438, 446, 447, 490, 513, 599; *see also* Social media
 for news and information, 326
 women's use of, 199
Facebook Watch, 513
Face time, 442
Fairy tales, 454
Familiar rituals, and digital storytelling, 11–13
Family-friendly antagonists, 131–132
Fan fiction, 63
Fantasy role-play for adults, 18–19
Farbanish, Lori, 528–529
Faux blogs, 421, 423–425
Faux choice, 165
Feature films
 impact of digital technology on, 56
Felix and Paul Studios, 561
Ferrell, Will, 429
Fiction; *see also* Nonlinear fiction

interactive fiction (IF), 20, 90–91, 369
 and social media, 217–223, 228, 233–234
Fictional blogs, 421, 423–425
Fictional characters, and social media, 214–215
Fiddle play, 528
Field, Syd, 102
Fighting games, 369
Film, and storytelling tools, 103
Finnegans Wake (Joyce), 20
Fireflies, citizen science, 332
First-person point of view, 127, 128, 129, 485
First-person shooter (FPS), 129, 368
Fisher, Katie, 100, 161, 169, 240
Fisher, William, 399
Flashback, 22; *see also* Nonlinear fiction
Flickr, 425
Flinders, Ramesh, 694
Flowchart, 260–262, 263, 531
FMV, *see* Full motion video
Focus group, 240, 245
 children, 190
For-profit organizations, 39
Fourth Wall Studio, 21, 39, 121, 512
FPS, *see* First-person shooter
Fractal structure model, 176
Frankenheimer, John, 318
Freelance work, by digital storytellers, 675–676
Free Range Graphics, 308
Free roam, 557
Free to Play (F2P) games, 368
Friendster, 212
From Software, 575
Front-facing VR, 557
Fulldome, artist's take on creating for, 659–661
Fulldome productions, 550, 658–659
Full motion video (FMV), 375
Fun, 18
Fundraising, 671, 672
Funnel model, 173
Futurithmic, 543

Game consoles
 and interactivity, 82
 and smart toys, 523
Game developers, employment with, 672

Subject Index

Game Developers Conference (GDC), 683
Game platforms, 364–365
Gameplay, 356, 359–360
 in digital storytelling, 113
Game publishers, employment with, 672
Gamers
 age profile of, 55
 demography of, 397–398
 personalities of, 399–400
Games, 25; *see also* Alternate reality games (ARGs); Video games
 ancient, 16
 children's, *see* Edutainment
 immersive multiplayer motion-sensing games, 372, 550, 654–658
 and interactivity, 87–89
 mobile, 448–451
 for news and information, 332–333
 for promotion and advertising, 305, 310–316, 313–314
 and rules, 98
 serious, 290–296, 296, 328
 and social media, 231–233
 and stories, 88–90, 123
 and storytelling tools, 96–99
 and transmedia storytelling, *see* transmedia storytelling
Gamespot, 590
GameStick, 364
Gamification, 400
 in education, 278
 and promotion and advertising, 310, 315–316
Garden of Eden story, 85–87, 490
GDC, *see* Game Developers Conference
Gender
 and projects, 198–199
 and video games, 393, 397
General Motors, 312, 313
Genres
 Internet, 414–432, 424
 of video games, 364–371
Geo-based AR, 591
Geo-locative technology, 449
Georgia Institute of Technology, 88, 355, 604
Giangola, James, 138
Gibson, William, 31, 305, 315
Girls, creating projects for, 196–198, 393
Global Game Jam, 681

Global Positioning System (GPS), 45–46, 114, 443, 604
Glu Mobile, 450
Goals in stories, 96, 98
GoldPocket Interactive, 509
Gomez, Jeff, 6, 177
Google
 Android operating system, 364, 438, 493
 for news and information, 325
Google Cardboard, 558
Google Earth, 455, 590, 591
Google Maps, 590
Google Plus, 219
Goslin, Mike, 391–393, 395, 396
GPS, *see* Global Positioning System
Gradman, Eric, 570
Grammar, for VR, 587
Granularity, 88
Greek mythology/drama, 9, 89, 101, 124, 155, 159–161, 444, 520
Griefer, 394
Griffin, Talbot, 226
Group-based interactivity, 468–469
Grumpy Cat, 215
Guan, Frank, 399
Gumerman, George, 338
Gupta, Vikas, 533
Gygax, Gary, 18
Gyroscope, 114, 442

Halloween rituals, 12–13
Ham, Derek, 580
Hamlet, 121, 122, 217–218
Hamlet on the Holodeck (Murray), 89, 90, 144, 175, 355, 503, 548, 746
Hanson Robotics, 542
Hardware, for immersive media, 556, 588
Harmonic paths model, 173
Harris, Mark, 669
Harvey, Graham, 213
HBO, 56, 496
Head-mounted displays (HMDs), 556, 589, 612
Heal the Bay, 309
Heart Guard, 319
Herigstad, Dale, 501, 502
Her Interactive, 107, 108, 115, 142, 160, 168, 262, 264
Hernandez, Bill, 621–622, 623

Subject Index

Hero of Alexandria, 521
Hero's journey, 13, 25–26, 99, 100, 173, 295
Herships, Jacqueline, 422
Heyward, Julia, 486
Hidden story model, 176
Hide and Seek, 358
Higa, Ryan, 205
Highfield, Ashley, 508
Higinbotham, William Alfred, 32
History Channel, 509
HMDs, *see* Head-mounted displays
Holechek, Max, 160
Hollerith, Herman, 28
Hollow, Michele C., 421
Hollywood
 and digital storytellers, 673, 684
 third screen's impact on, 55–57
 and web series, 415–416
Holodeck, 548
Holzberg, Roger, 46–47, 605, 605–606, 606
Home and abroad, games at, 275–276
Homer, 657
Hong Kong, 67
Host characters, 146
Hot spots, 112
Howard, Philip, 326
Howard-Jones, Paul, 284
HTML, 32
HTTP, 32
Hub-and-spoke model, 174
Hulu, 56
Humane Society of the United States, 318
Humanoid robot, 538, 542
Humor
 and children, 194
 in news and information, 333–334
 in open world games, 379
 and social media, 233
Hurricane Katrina, 329, 331
HyperBole Studios, 75
Hyperliterature, 66
Hyperserial, 503
Hyperstory (iCinema), 475–478, 478
Hypertext, 20, 112

IAIA, *see* Institute of American Indian Arts
IBM, Watson computer, 112
ICAROS, 587
iCinema Centre for Interactive Cinema Research, 563
iCinema (interactive cinema), 92, 341, 375, 464–465, 491
 and academia, 490
 large screen, 466–481, 468, 468–469, 472
 small-screen, 464–465, 474–475, 478, 487
ICT, *see* Institute of Creative Technologies
IF, *see* Interactive fiction
If/then construct, 163–165
IGDA, *see* International Game Developers Association
Igloo (Artists' group), 564
Iliad (Homer), 657
Illegal file sharing, 56
Ill people, digital works for, 202
IM, *see* Instant message
iMedia Connection, 324
Immersion, 626–627
 escape rooms, 618–623
 narrative immersion, modern venues for, 628–631
 with objects and architectural elements, 640–642
 team lab and image-based immersion, 644
 through projections, 642–643
Immersion Studios, 467–472, 468, 469
Immersion therapy, 583
Immersive and interactive theme park rides, 624–626
Immersive cinema, 467
Immersive environments, 186; *see also* Multi-sensory environment
 augmented reality (AR), 371
 definition, 550
 and education and training, 289
 immersive multiplayer motion-sensing games, 372
 virtual reality (VR), 371
Immersive journalism, 562, 580
Immersive media, 547–549
 augmented reality (AR), 549
 fulldome productions, 550
 immersive multiplayer motion-sensing games, 550

Subject Index **767**

large-screen immersive experiences for audiences, 550
large-screen immersive experiences for single participants, 550
mixed reality, 549, 601–606
virtual reality (VR), 548, 549, 556–570
Immersive multiplayer motion-sensing games, 654–658
Immersive narratives, 615–616
old and new settings for, 628
taking to the extreme, 638–640
Immersiveness, 79–82
single-participant large-screen immersiveness, 652–654
utilizing movie screens for, 647–648
Immersive spaces, 640
Immersive stories, of Meow Wolf, 631–638
Immersive storytelling, 550–552
Immersive theater, influence of, 648–650
Immersive theater as a model, 616–618
Iñárritu, Alejandro G., 580
Inca quipu, 28
Incunabula, 34
Independent ("indie") video games, 377–379
Indexical storytelling, 172
India and digital media, 66, 457
Indie games, 378
Industry events, for digital storytellers, 682–683
Information; *see also* News
and digital media, 324–329, 327
and digital platforms, 335–344, 345
and digital storytelling techniques, 330–335
special considerations, 344–345
Information exchange, and interactivity, 83
Infotainment, 271, 330
In-game event, 374, 593
Instagram, 185, 212, 226, 230, 447
Instant message (IM), 54
Institute of American Indian Arts (IAIA), 604, 661
Institute of Creative Technologies (ICT), 602
Integrated media, *see* Transmedia storytelling
Intel, 490

Intellectual property (IP), 677
Intelligent characters, 135–139
Intelligent stamps, 600
Interactive cinema, *see* iCinema
Interactive documentaries, 339
Interactive fiction (IF), 20, 90–91, 369
Interactive kiosks, *see* Electronic kiosks
Interactive media, 327
and cultural institutions, 186
and emotion, 151–154, 152
Interactive mysteries/adventures, 430–432, 431, 446
Interactive narratives, and structure, 161–163
Interactive stories, 88, 90–91, 105–107, 107–109
Interactive storytelling
characters in, 119–123, 120, 140–144
and dialogue, 148–149
and structure, 19–20, 159–161, 161–163
Interactive television (iTV), 491–513, 509
creative challenges in, 497
and drama, 507–508, 508
for news and information, 339
for promotion and advertising, 304
and social TV, 512
use of second-screen TV, 511–512
Interactive theme park rides, 550, 624–626
Interactive training, 139
and character arcs, 143
and emotion, 153, 153–154
modular structure, 163, 174, 179
Interactivity, 4, 73–74, 92
and the audience, 76
authors and users, 76–79
and content, 85–87
as conversation, 74
and games, 87–89
group-based, 468
and immersiveness, 79–82
and learning, 272–273, 282
multi-user, 468
nonlinear nature of, 19
six types of, 82–85
and storytelling, 7–8
and structure, 102
InteraXon, 363
Interface

tools, 110
video games, 360–361
Interfilm, 466, 467
International audiences, 203–205
International Game Developers Association (IGDA), 676, 684
International Space Station, 213
Internet, 432–433
 and advertising, 58
 birth of, 30–32
 child safety, 191
 evolution of, 405–408
 genres, 414–432, 424
 impact of, 53–66, 60
 and interactivity, 82, 83
 and news and information, 58, 60, 325–326, 335–337
 professionally produced web series, 416
 and promotion and advertising, 304, 306
 and short films, 317
 and smart toys, 523
 stickiness, 412
 subscription websites, 327
 and taxonomy, 335–337
 TV as a role model for, 412–413
Internships, 674
IoT (Internet of Things), 48
IP, *see* Intellectual property
iPad, 37, 38, 55, 337, 436, 483, 490, 493
iPhone, 37, 329, 493, 604
Iraq, 279
Irish mythology, 124
Irons, Jeremy, 309
Ishiguro, Hiroshi, 542
iTV, *see* Interactive television
Iuppa, Nick, 385

Jack in the Box, 321
Johnson, Randall, 357
Japan, 66
 ancient games, 15
Jaros, Steve, 379, 379–382
Jeep Patriot, 306
Jenkins, Henry, 277, 278
Jeopardy, 104
Jewish audiences, 204
John F Kennedy Presidential Library and Museum, 483
Journalism, 325, 327; *see also* News
 impact of digital technology on, 58, 60, 61, 324–329, 327
 locative journalism (LoJo), 338–339
Joyce, James, 20, 475
Jump cuts, 588

Kabam, 231
Kadlubek, Vince, 634
Kahn, Bob, 31
Kain, Jackie, 342, 343
Kaiser Family Foundation Study on Children and Media, 197
Kapi Awards, 50
Katz, Brian, 471
Katzenberg, Jeffrey, 440
KCET, 342, 344
Keighley, Geoff, 573
Kennedy Space Center, 600
Kicked to the Curb Productions, 225
Kickstarter, 671
Kinder, Marsha, 478
Kinect, 362, 372, 655
Klein, Bill, 443
Klein, Norman, 479–480
Klimt, Gustav
 paintings of, 65
Kniss, Joe, 363
Knowledge Adventure, 106, 174, 193, 252–254, 276, 281, 285; *see also* JumpStart
Koch, Eva, 483
Kony, Joseph, 214, 412
Krizanc, John, 22
Kurosawa, Akira, 22
Kutner, Lawrence, 377
Kutoka, 124, 284

Labyrinth Project, 478, 479, 480, 481, 491
Labyrinths, 175
Lady Gaga, 214
Lajeunesse, Félix, 561–562
Landline technology, 441
Language
 and babies, 274
 and digital media, 54
Lanier, Jaron, 52
Laptop computer, 436
Lapware, 186, 520
Large-screen immersive experiences for audiences, 550, 650–652

Subject Index

for single participants, 550, 652–654
Large-screen immersiveness for audiences, 650–652
Las Posadas festival, 79–82
LAWEBFEST, *see* Los Angeles Web Series Festival
LBE, *see* Location-based entertainment
Leaning back/leaning forward, 75
Le Domus Romane di Palazzo Valentini, 341
Lee, Ang, 318
Legal considerations, for digital storytellers, 676–680, 680
LEGO, 198, 320–321
Leonard, Brett, 559
Levels in games, 161–163
Leventhal, Michael, 677
Levien, Meredith Kopit, 582
Life and Opinions of Tristram Shandy, Gentleman, The (Sterne), 19
Linden Lab, 61, 62
Linear narratives, 20
 and characters, 121, 123, 140
 and storylines, 105–107
LinkedIn, 212
Live events, and iTV, 511
Live streaming, 212, 407–408
Location-based entertainment (LBE), 371, 549, 564, 571–572
Location-based game, 45, 371–372
Locative journalism (LoJo), 338–339
Locative storytelling, 604
Locomotion interfaces, 654
Loeser, Michael, 387–388
Logic flow document, 264, 531
Log line, 242
LoJo, *see* Locative journalism
London, UK, 315
 2012 Olympic Games, 59, 326, 339
LOOKBOOK, 219
Loop backs, 166
Los Alamos National Laboratory, 585
Los Angeles Web Series Festival (LAWEBFEST), 416–417
Lovelace, Ada, 29
Lucas, George, 100
Ludology (video games), 355

Macbeth, 649
Mach, Julia, 65
Machine engine approach, 164
Machinima, 63–64
Macy's, 39
Macy's, use of transmedia storytelling, 320
Mad Men and social media, 215
Madonna in an online film, 318
Magic Leap, 606
Magic Leap One, 596
Magnavox Odyssey, 33
Malaysia and digital media, 67
Malleable linear path, 169
Manga, 368, 561
MAP Design Lab, 563
Marketing; *see also* Advertising; Promotion
 and the development process, 243, 246–247, 264
Marks, Gabriella, 175
Martelli, Bruno, 564
Martin, George R.R., 633
Marx, Christy, 357
Massively multiplayer online games (MMOGs), 35, 61, 367, 382
 aquarium model, 171
 and children, 186
 precursors to, 17, 31
 for promotion and advertising, 310, 314, 314–315
Massively multiplayer online role-playing games (MMORPGs), 367, 382; *see also* Role-playing games (RPGs)
 addiction to, 385–387
 characteristics of, 382–383
 community aspects of, 386–387
 future of, 396
 innovation in, 391, 391–395, 395
 maker's perspective on, 388–391
 narrative in, 384–385
 player's perspective on, 387–388
 for promotion and advertising, 314
 three levels of story, 395–396
Massively multiplayer online war game leveraging the Internet (MMOWGLI), 279
Massive Open Online Courses (MOOCs), 280
Mateas, Michael, 486
Matrixes, 264

Mattel, 215, 526
Matthew Media LLC, 213
Maze as structural model, 175
McDermott, Gerald, 659
McWhorter, John, 54
Mechner, Jordan, 353–354
Medical training, and androids, 540–542
Medill School, Northwestern University, 228, 328
Meow Wolf, 631–638 633, 636, 637, 641
Merchling, Lauren, 217
Metro Trains Melbourne, 334
Microchip, 29, 525
Microprocessor, 30
Microsoft, 276
 Kinect, 362, 372, 655
 volumetric capture technology, 636
Middle, 101, 159, 160; *see also* Three-act structure
Milestones in the developmental process, 243, 402
Military scenario, mixed reality in, 602–603
Military training
 and emotion, 153–154
 mixed reality, 602
 simulations, 139, 577–579, 578, 652–654, 653–654
Millennium Falcon starship, 627
Miniaturization, 363
Minotaur myth, 175
MIPTV, 683
Miso, 496
Missions in games, 162
Mistakes, in development process, 239–241
MIT, 276–277
Mittman, Arika Lisanne, 426
Mixed reality (MR), 601, 604–606, 608–613
 cultural institutions, 603–604
 in a military scenario, 602–603
 smale-scale works of, 601–602
 virtual character in, 606–608
Mizell, David, 589
MMOGs, *see* Massively multiplayer online games
MMORPGs, *see* Massively multiplayer online role-playing games

MMOWGLI, *see* Massively multiplayer online war game leveraging the Internet
MOBA games, *see* Multiplayer online battle arena games
Mobile devices, 435, 437, 457–458; *see also* Apps; Mobile phones; Smart phones; Tablet computers
 appeal of, 439–441
 challenges and opportunities, 441–445, 443
 children's use of, 186, 451–453
 and content, 453–457, 457
 and digital storytelling, 445–448
 games, 448–451
 and iTV, 494
 for news and information, 337
 practical uses of, 457–458
 for promotion and advertising, 304
Mobile Object (MOB), 390
Mobile phones, 66; *see also* Mobile devices; Smart phones
 children's use of, 186
 dependency on, 439
 and education and training, 288–289
 for news and information, 337
Modular structure, 174, 179
Molles, Manuel, 6
"Mommy" websites, 316
MOOCs, *see* Massive Open Online Courses
Moore, Gordon, 30
Moore's Law, 30
MOOs, *see* MUD Object Oriented
Mori, Masahiro, 541
Morie, Jacquelyn Ford, 153–154, 584, 587
Moser, Laura, 217
Mossadegh, Mohammed, 333
Motion-base chairs, 650
Motion-based games, 361, 362, 469
Motion capture, 144, 560, 564
Motion pictures
 impact of digital technology on, 56
 nonlinear drama in, 21–23
 and the three-act structure, 160
Mount Vernon, 603, 652
MR, *see* Mixed Reality
MSG Sphere, 658
MSNBC, 329

MTV, 305, 314
Mubarak, Hosni, 326
MUD, *see* Multi-User Dungeon/Multi-User Domain/Multi-User Dimension
MUD Object Oriented (MOOs), 92, 382
Multimedia kiosk, *see* Electronic kiosks
Multi-platforming, 39; *see also* Transmedia storytelling
Multiplayer game, 231
Multiplayer online battle arena (MOBA) games, 367
Multiscreen TV, 494
Multi-sensory environment, 79, 550; *see also* Immersive environments
Multitasking, by children, 185
Multi-User Dungeon/Multi-User Domain/Multi-User Dimension (MUD), 31, 49, 92, 369, 383, 386, 400
Multi-user interactivity, 468
Murphy, Kate, 412
Murray, Janet H., 88–90, 144, 175–176, 355, 503, 548
Muse (brain sensing headband), 363
Museum of Contemporary Art, Los Angeles, 65
Museums, *see* Cultural institutions
Musical instruments, mobile devices as, 458
Music industry, impact of digital technology on, 55
Music video, 317, 329
Muslim audiences, 203, 204
My Fair Lady, 91, 521
MySpace, 212
Mystery-adventure game, 107, 160, 264, 365
Mythic Entertainment, 387, 388
Myths, 8, 25–26, 175
 and archetypal characters, 124
 and digital storytelling, 9–11
 and storytelling tools, 99–100

Names of characters, 141
NAMI, *see* National Alliance on Mental Illness
Nanome, Inc., 277
Nano-Muscle, 526
Napster, 56

Narrative, 6
 and apps, 454–455
 database, 478–481, 480
 in MMORPGs (massively multiplayer online role-playing games), 384–385
 spatial, 486–487
 and storylines, 105–107
 transmedia, *see* Transmedia storytelling
 in video games, 355–358, 379, 379–382
 in VR, 587–588
Narrative archeology, 604
Narrative as Virtual Reality (Ryan), 172, 176
Narrative immersion, modern venues for, 628–631
Narrative works, augmented reality in, 596–597
Narratology (video games), 355
NASA, 538
Nash Information Services, LLC., 56
National Alliance on Mental Illness (NAMI), 202
National Film Board of Canada, 484, 489
National Geographic, 322
Native American audiences, 205
Native app, 457
Natural language interface, 138, 139, 148
Navigation, 411
 and interactivity, 83
 tools, 110
 video games, 360–361
NBC, 305
NDA, *see* Non-Disclosure Agreement
Near Field Communication (NFC), 523
Netflix, 56, 406, 494, 498, 498–501, 500, 504, 505
Networked entertainment, *see* Transmedia storytelling
Networked gaming environment, 277
Networking, for digital storytellers, 683
Neuromancer (William Gibson), 31
New Forest, 564
New Frontier at Sundance, 551
New media, 5
 art, 65
New Mexico Virtual Academy, 280
News; *see also* Information; Journalism

and digital media, 324–329, 327
and digital platforms, 335–344, 343
and digital storytelling techniques, 330–335
special considerations, 344–345
Newspapers, 58, 58–59, 324, 325, 328–329
News services, 339
New York Times, 59, 328, 329, 333
Nexus Studios, 597
N-Gage, Nokia, 36–37
Niantic, 589, 590
Nintendo Wii, 361–362, 372
Nisenholtz, Martin, 59
Nissan, 315
Node, 161
Nokia, 36, 37, 437
Nokia N-Gage, 36–37
Noles, Geoffrey, 693
No Mimes Media, 226, 227, 228
Nonchalance, 638
Non-Disclosure Agreement (NDA), 677, 678
Non-fiction, 6; *see also* Documentaries
blogs, 421–422
and social media, 228–231, 233–234
Nonlinear drama, in theater and motion pictures, 21–23
Nonlinear fiction, pre-computer, 19–20
Non-player characters (NPCs), 111, 122, 124, 135, 144, 146, 391, 392
and dialogue, 148–149
Norrington, Alison, 226
Nosy Crow, 454
NPCs, *see* Non-player characters
Nuclear facilities simulation, 286
Numinous Games, 152
Nungary, Mary J., 621, 623
Nurturing play, 528

Obama, Barack, 214
Obermaier, Klaus, 64
Objectivity, 330
Obscura Digital, 230
Obstacles in games, 96, 98
O'Connor, Sandra Day, 291
Oculus, 363, 552, 557, 586
Oculus Quest, 557
Oculus Story Studio, 552
Odyssey (Homer), 643, 657
Older learners, 276–280, 283, 297

Older people, digital media works for, *see* Senior citizens as audience for digital media
Olson, Cheryl, 377
Olympic Games, 14
 London (2012), 59, 326, 339
O'Neill, Emmet, 244, 593–594, 596
Online courses, 280
Open architecture, 179
Open world games, 370, 379, 379–382, 382
Open world structure, 162, 172
Opera, 357
Opposition, 89, 97, 131; *see also* Antagonists
Orangutans, and tablet computers, 438
Origins of Intelligence in Children, The (Piaget), 188, 189
Orion, Dean, 655–657, 657
Oscilloscope, 27, 32
Otome games, 368
Ouya miniature game console, 363–364
Owlchemy Labs, 574

Page, Matt, 418–421
Page flipper interactive book, 455
Pangea Corp, 530
Papagiannis, Helen, 598
Parallel streaming, 173
Parallel world model, 173
Parents, opinion on digital media for children, 191–193, 194, 452
Parisi, Tony, 572
Parkes, Walter, 560
Paro (therapeutic robotic seal), 201
Participation, 294
Participatory dramas, 8, 8–9, 11
Passenger train model, 170–171
Passover rituals, 11
PBS, 453
PCs, *see* Personal computers
Peer-to-peer learning, 286, 469
Pemberley Digital, 220, 223
Penalties, in digital storytelling, 113
Periscape VR Experience Centers, 564
Persistent universe, 114, 173, 367, 384, 386
Personal computers (PCs), 30
Personal stories and digital media, 331
Persona method of character design, 294
Peters, Steve, 226

Pew Research Center Studies, 184, 324, 325
Pfister, Robert, 171, 389–390
Piaget, Jean, 188, 189
Picot, Edward, 66
Pinterest, 62, 212, 214, 219;
 see also Social media
Pirandello, Luigi, 21
Pirate Soul Museum, 603
Pixar, 358, 524
Platform game, 369
Platt, Charles, 136
Playdead Games, 378
Player character, 122, 126;
 see also Avatars
Player versus player (PvP), 249
PlayJam, 364
Playmates Toys, 526, 528
Play pattern, 188–189, 526, 528, 531
Plot, 158, 353
Poetics, The (Aristotle), 101, 147
Pogue, David, 329
Point of view (POV)
 in digital storytelling, 111
 in news and information, 334–335
 of users, 111, 127–129, 128, 129, 247
Points of interest (POIs), 591
POIs, *see* Points of interest
Politics, and social media, 212, 214
Polyarc Games, 575
Pope Francis, 214
Pornography, 318
 Internet, 191–192
Portfolios, 675
Post-traumatic stress disorder (PTSD),
 treating with virtual reality, 202, 583
Povinelli, Daniel, 7
Powers, James, 28
Pray, Diana, 106, 132, 179, 193, 275, 276, 285
Predators, Internet, 191–192
Premise, 242, 246, 283
Preproduction, *see* Development process
Pride and Prejudice (Austen), 219–221
Prime, 56
Pringles and casual gaming, 311
Privacy, Internet, 191–192
Procedural animation, 144
Producers Guild, 684

Product placement, 58, 305
Professionally produced web series, 416
Project creep, 238, 676
Projection mapping, 65, 642
Prolonged exposure therapy, 583
Promenade performance, 648
Promotion, 301–303; *see also*
 Advertising; Marketing
 digital media for, 303–304
 digital storytelling techniques and genres, 305–323, 310, 313–314
 and mobile devices, 458
 and VR, 587
Promotional gaming, 310
Protagonists
 motivation of, 141
 users as, 122–123, 124–130
Prototype, 246, 263
PTSD, *see* Post-traumatic stress disorder
Public advocacy campaigns, 309;
 see also Social marketing
Pulkka, Aaron, 563
Punch-card technology, 28
Punchdrunk, 22
Puzzle game, 122, 200, 368, 369, 397, 448, 449, 573, 575
Puzzles, 369
Pygmalion, 91, 520
Pyramid model, 173
Python that swallowed a pig model, 178

QR code, 45, 442, 491
Quicksilver Software, 100, 160, 169, 240, 399

Racing game, 58
Radio frequency identification reader (RFID), 622, 637
Rafferty, Kevin, 667–668, 674
Raphaël, Paul, 561
Rashomon model, 175, 484
Raskin, Robin, 48
Raybourn, Elaine M., 293–297, 295
Real time strategy (RTS) games, 367
"Red Button" (BBC, interactive television), 339, 493, 494
Reddit, 223
Redenbacher, Orville, 139
Redirected walking, 611
Replayability, 176, 569

Repurposing, 35
Respect, for children, 195–196
Rewards
 for children, 195
 in digital storytelling, 113
 in education and training, 278, 283–285
Rhizome model, 175
Ridefilms, 472, 550, 650, 650–652
Rides.TV, 39
Rieser, Martin, 490
Riot-E, 446
Ritchie, Guy, 317
Rites of passage, 13; *see also* Hero's journey
Ritman, Colin, 499, 500
Rituals, 8, 8–10, 11–13, 25–26, 90
Rival Theory, 443
Roach, Greg, 74, 87–88, 90, 164, 170, 243, 356, 681
Road to VR, 126
Robinson, Margaret, 358
Robota (Czech word), 520, 540
Robots, 517–519, 535–536, 544
 androids, 520, 540–542
 animatronic characters, 521, 540
 designing robots to be likable and not creepy, 543
 DRU (Dolphin Robotic Unit), 605
 history of, 520–522
 for kids, 532–534
 therapeutic, 201
 working robots, 536–538
RocketJump, 412, 671
Rockstar Games, 376
Rohrer, Jason, 378
Role, in digital storytelling, 111
Role-playing games (RPGs), 367, 384; *see also* Massively multiplayer online role-playing games (MMORPGs)
 for adults, 18–19
Romero, John, 668
Room scale VR, 557
Rope with nodes structure, 170
Rosen, Jeff, 603, 603–604
Rosenberg, Todd, 689, 690, 691, 692, 693, 694
Rosenthal, Lynn, 565
Ross, Helen Klein, 215

Rounded structure, 171, 178
Rowling, J.K., 592, 626
Royal Mail (UK), 600
RPGs, *see* Role-playing games
RTS games, *see* Real time strategy games
Rules, and games, 98
Rumble floors, 153, 578
Rumble seat, 652
Russell, Steve, 33
Ryan, Marie-Laure, 172, 176
Ryan, Ronald, 563

Saffo, Paul, 37
Sandbox games, 370
Sandbox structure, 172
Santa Fe, New Mexico, 79–82, 80
Saudi Arabia, 203
Scandinavia, 66
Scenes and structure, 159
Scent necklace, 153, 578
Schedules and the development process, 264
Schell, Jesse, 556
Schell Games, 556
Schippling, Michael, 518
Schnepp, Jesyca Durchin, 197
Schulte, John, 530
Schwarz, Dan, 6
Science, augmented reality (AR), 600
Scott, Keredy, 82
Screen-based immersion, 647
 artist's take on creating for fulldome, 659–661
 fulldome productions, 658–659
 immersive multiplayer motion-sensing games, 654–658
 immersiveness, utilizing movie screens for, 647–648
 immersive theater, influence of, 648–650
 large-screen immersiveness for audiences, 650–652
 single-participant large-screen immersiveness, 652–654
Screenplay: The Foundation of Screenwriting (Field), 102
Script, dialogue, 255, 256–257, 258–259
Script format, digital storytelling, 108
Scripts and screens format, 256

Subject Index

SEAS, *see* Synthetic Environment for Analysis and Simulations
Second-person point of view, 128
Second-screen TV, 493, 494–495, 511–512
 for news and information, 339
Seger, Dr. Linda, 160
Senior citizens as audience for digital media, 199–202, 397, 422
Sensors, in digital storytelling, 114–115
Sequential linearity (passenger train model), 170
Serialized content for established entities, 447
Serious games, 290–296, 296, 328, 369–370
Serrels, Mark, 572–573
Shackelford, Judy, 526–527
Shamans, 6
Shoal Consortium, 538
Shooters as a game genre, 369
Short, Emily, 91
Short films on the Internet, 317–318
SIGGRAPH conference, 683
Sigui dance, 9
Simplicity, 240
Simulations, 106, 279–280, 285–286, 369; *see also* Serious games; Training; Virtual reality (VR)
Singapore, 66
Single-participant large-screen immersiveness, 652–654
Single-screen interactivity, 494, 498
Single versus multiplayer games, 376
Site of Reversible Destiny, The, 642
Site-specific play, 648
Six Characters in Search of an Author (Pirandello), 21
Sixer VR, 576
Skeleton loci charts, 264
Slate, 217
Small-scale works of mixed reality, 601–602
Smart dolls, *see* Smart toys
SmartGlass, 362
Smartphones, 435–436, 443; *see also* Mobile devices; Mobile phones
 as musical instruments, 458
Smart toys, 114, 115, 264, 517–519, 544
 challenges of creating, 524–525
 contemporary, 522–524
 development process, 525–532, 526, 528
 history of, 520–522
 for promotion and advertising, 304
SMEs, *see* Subject-matter experts
Smirnoff, 317
Smith, Pamela Jaye, 16
Smith, Pete, 670
Snack-o-tainment, 412, 429
Snapchat, 438, 447
Soap operas and MMORPGs, 385
Social games, 199, 231, 235, 744
Social marketing, 308; *see also* Public advocacy campaigns
Social media, 62–63, 212–213, 438; *see also* Facebook; Pinterest; Twitter
 and advertising, 58
 and characters, 214–217
 darker social media story, 224–225
 and fiction, 217–223, 230, 233–234
 and games, 231–233
 and gender, 197, 198–199
 and humor, 233
 and iCinema, 490
 and iTV, 493, 494–498
 for news and information, 59, 60, 326, 337
 and non-fiction, 228–231, 233–234
 power of, 213–214
 for promotion and advertising, 321–322
 virtual worlds, 384
Social media games, 368
Social media stories, 447
Social movements, and social media, 199, 214
Social robot, 542, 543
Social TV, 494, 496, 511, 513
 dramatic shows and, 512–513
Solomon, Richie, 430–431
Sony, 48, 466, 670
Sony Interactive Entertainment, 574, 575
Sound, in mixed reality, 604
South by Southwest, 38, 559, 629, 630
South Korea, 67
Space, in digital storytelling, 114
Spain, practical uses of mobile devices, 457–458

Sparmberg, Marco, 67
Spatial narratives, 486–487
Spears, Britney, 214
Special hardware, in digital storytelling, 114–115
Special interest group (SIG), 676, 683
Spiegel, Stacey, 469, 472
Spielberg, Steven, 41, 521, 561
Spin-offs as a step in developing a new medium, 35
Sponsorship, 306
Sporting games, 14
Sports, augmented reality (AR), 600
Sports games, 366–367
Spreadsheets, 259
Sprinkles or hot spots, 455
St. John, Stewart, 413, 415
Stand-alone apps, 448
Stanford University, 280
Starbreeze StarVR headset, 571
Startup, 206, 277, 323, 418, 448, 590, 639, 676
State engine approach, 164
Stationary VR, 713
Status bar, 284
Steinbeck, John, 230
Steinmetz, Robert, 179, 257, 258, 297
Stereoscopic device, 548–549
Stereotypes in character development, 141
Stern, Andrew, 486
Sterne, Laurence, 19
Stevens, Wallace, 66
Stickiness, 412
Stimulus and response, and interactivity, 82–83
Stories
 abstract, 88–90
 components of, 6
 and games, 88–90
 and goals, 97, 98
 interactive, 88, 90–91
 and obstacles, 98
 structure and format, 98–99
Story and Simulations for Serious Games (Iuppa and Borst), 385
Story beats, 159, 161
Storyboards, 262–263
Storycentral, 226, 227, 228
Story construction, 103
Storylines, 105–107

Storytelling; *see also* Digital storytelling
 differences between classic and digital, 25
 as a human tradition, 3, 4–6
 and interactivity, 7–8
 transmedia, 37–40
 in video games, 355–358, 379, 379–382, 381
Storytelling tools, 95–96, 104–105, 116
 and Aristotle, 96, 101–103
 and film/TV storytelling, 103
 and games, 96–99
 and interactive media, 107–116
 and myths, 99–100
 and the storyline, 105–107
StoryToys, 244, 593
Storyworld, 247
Straker, David, 130
Strategy game, 367
Stravinsky, Igor, music in works of virtual reality and 3D, 64
String of pearls structure, 170, 178
Structure, 158, 248
 choice of, 178
 collective journey model, 177
 creating your own model, 177–178
 critical story path, 167–171, 169
 in digital storytelling, 113
 if/then construct, 163–165
 in interactive narratives, 161–163
 stories, 98–99
 structural models, 167–177, 169, 174
 three-act structure, 101–102
 in traditional drama, 159–161
Su, Bernie, 220
Subjectivity, 330
Subject-matter experts (SMEs), 245, 281, 651
Subscription websites, 329
Suicide
 and cyberbullying, 192
 and cyber bullying, 214
US Army, 286
Summers, Chanel, 567, 569
Super Bowl (2012), 512
Super Bowl parties, 512
Survival horror game, 366
Suspense, 105, 432
Sutherland, Ivan, 589

"Sword and Sorcery"-style video
 game, 50
SyncBuildRun, 375
Synchronous interactivity, 497
Synthetic character, 139
Synthetic Environment for Analysis and
 Simulations (SEAS), 279
Szperling, Margi, 475–478
Szulborski, Dave, 313

Tablet computers, 55; *see also* Mobile
 devices
 and children, 451
 and education and training, 288–289
 for news and information, 337
 and orangutans, 438
Tabletop war games, 17
Talent, impact of digital technology
 on, 57
Tandberg TV, 509
Tan Dun, 229
Taxonomy, and the Internet, 335–337
TCP/IP, *see* Transmission Control
 Protocol/Internet Protocol
Team Lab, 644
Technical documents, 263
Technology Use Among Seniors, 199
Telephones, evolution of, 435–437
Television; *see also* Interactive television;
 Second-screen TV
 impact of digital technology on, 57
 as a role model for the Internet,
 412–413
 and storytelling tools, 103
Television commercials, 57
Tension, 104
Test plans in the development
 process, 264
Text-based game, 369
Textspeak, 54
Theater, nonlinear drama in, 21–23
Theatrics, 489
Theme park rides
 interactive, 550, 624–626
 for promotion and advertising, 304
Theme parks, 186
Third-person point of view, 128, 129
This is My Jam, 223
Thomas, Michael Tilson, 229
Thompson, Leo, 424–425

Three-act structure, 101–102, 159–161
 video games, 381
Ticking clock device, 105
Time, in digital storytelling, 114
TiVo, 497
Tokyo Game Show, 683
Toshiba, 490
Touchscreens, 442, 451; *see also* Mobile
 devices; Tablet computers
Tragic flaws, 124
Training, 270–272, 279, 283, 296–299,
 300–301; *see also* Education
 additional tools for, 287, 287–290
 guidelines for projects, 300–301
 serious games movement,
 290–296, 296
 techniques, 281–286
Training Systems Design, 179, 257, 258,
 260, 297, 297–299
Transmedia entertainment, 56
Transmedia productions, for news and
 information, 343
Transmedia Storyteller Ltd., 287
Transmedia storytelling, 37–40, 112, 219
 for education and training, 287–288
 for promotion and advertising,
 320–321
Transmission Control Protocol/Internet
 Protocol (TCP/IP), 31
Transworld conference, 621
Treadmills, 394–395, 654
Trowbridge, Scott, 626
Trubshaw, Roy, 383
Tuch, Larry, 579, 653–654
Tumblr, 219, 223, 230
Tunisia, 326
Turing, Alan, 136
Turing Test, 136
Turkle, Sherry, 518
Tusan, Marko, 244
TV411, 504
TV Academy (Academy of Television
 Arts and Sciences), 684
Twitch.TV, 407
Twitter, 39, 62, 67, 212, 213, 214, 215, 216,
 217, 219, 220, 221, 223, 224,
 226, 229, 230, 287, 316, 321,
 326, 406, 419, 425, 490, 496,
 513; *see also* Social media
Two Bit Circus, 570–571

778 Subject Index

UI, *see* User interface
UK, 66
 interactive TV (iTV), 505–506
Ulysses (Joyce), 20
"Uncanny valley syndrome," 541, 543
Uncertainty as a storytelling device, 105
University of Iowa, 185
University of Manitoba, 280
University of New Mexico (UNM), 6, 363, 659
University of New South Wales, 491, 563
University of Southern California, 478, 491, 577
University of Utah, 654
UNM, *see* University of New Mexico
URLs, 32
US Army, 286, 289, 293, 295, 312, 577
 androids, 540–542
 practical uses of mobile devices, 457–458
"User as fulcrum" model of iCinema, 485–486
User-generated characters, 489
User-generated content, 60–64
User interface (UI), 244
Users; *see also* Avatars
 and characters, 122–123, 124, 124–130, 128
 and interactivity, 76–79
 point of view of, 111, 127–129, 128, 129, 247
 as protagonists, 122–123, 124–130
 roles of, 111, 129–130, 247
US Navy, 279

Vara, Clara Fernandez and hidden object narratives, 172
Variables, in digital storytelling, 110
Vaughn, Bruce, 560
vDome software, 659
Verbal communication, and characters, 144–151
Verb sets, 75
Verge, The, 137, 630
Vertov, Dziga, theories, 475
Video games, 109, 302, 351–354, 355; *see also* Games
 casual games, 106, 310–312, 396–397
 categories and genres of, 361, 365, 376
 character arcs, 142–143
 criticisms of, 352–353, 377
 development of, 32–34
 and education, 274; *see also* Edutainment
 and emotion, 151
 Fortnite, 373–374
 and gender, 197, 199
 independent ("indie"), 377–379
 and interactivity, 82
 lessons from, 400–401
 MMORPGs, 314, 367, 382–383, 387, 388, 391, 392, 395
 narrative in, 355–358
 new games and the fading away of once-popular genres, 374–376
 for promotion and advertising, 305, 310, 310–316, 312
 and seniors, 200
 single versus multiplayer games, 376
 storytelling in, 379–382
 structure, 161–163
 tips for newbie game-makers, 401–402
 unique characteristics of, 359
 users and motivation, 397–398
 user's point of view, 129
 and violence, 377
Video on demand (VOD), 497
Video sharing sites, 63; *see also* YouTube
View Master, 549
Vihalo camera, 559
Vincent, Richard, 125
Violence, and video games, 376–377
Viral marketing, 301, 302–303, 317
Viral nature of social media, 213
VirTra Systems, 654
Virtual character in mixed reality, 606–608
Virtual reality (VR), 49, 322–323, 363, 440, 548, 550, 556–559, 556–570, 573, 579, 589
 advances in, 52
 for the body, soul, and mind, 562–563
 college recruitment, 585–586
 education, 582–583
 and emotion, 153, 153–154
 healing, approach to, 584–585
 history and newsworthy events in, 580–582
 home use, VR games for, 572–573

and location-based entertainment, 564–570
medicine and psycotherapy, 583–584
modern twist on the old beach arcade, 570–572
narrative experiences in, 559–561
narrative works of, 587–588
for news and information, 339–340
nonfiction narrative in, 561–562
and Post-Traumatic Stress Disorder, 202
for promotion and advertising, 304
retail, 586
room scale VR, 557
science, 585
selection of VR games, 573–577
seniors trying, 558–559
SIGGRAPH conference, 683; *see also* Simulations
training, 577–579
uses, 586–588
using VR to inform, 579–580
Virtual worlds, 60, 62, 172
social networking, 384
Virtusphere, 363
Vitelli, Romeo, 377
Vive, 363, 558, 566, 567
Vlogs (video blogs), 220, 223
VOD, *see* Video on demand
Vogler, Christopher, 100
Voice-enabled storytelling, 49
Voice masking, 294
Voice over dialogue, 144–145, 255, 256
Voice technology, 48
Void, The, 564, 608–609, 610, 611, 612
Volvo, 322
VR, *see* Virtual reality
VRstudios, 567
VTime, 126

Waddington, Darlene, 356, 399
Walker, Hue, 659, 659–660, 659–661
Wall Street Journal, 328
Walt Disney Imagineering, 605, 606, 667, 668
Walt Disney World Resorts, 46
War games, 17, 279
Washington Post, 59, 328
Waters, Rich, 389–390
Watson computer, IBM, 112

Web, The, 32, 37, 39, 64, 76, 173, 204, 218, 310, 316, 334, 406, 407, 408, 410, 411, 413, 414, 415, 418, 426, 429, 430, 432, 457, 483, 497, 672, 673
Webcam dramas, 426–429
Webcam peepshows, 318–319
Webcams, 40
Web festivals, 416–417
Webinar, 300
Webisodes, 58; *see also* Web series
Web series, 67, 309–310, 416–418; *see also* Webisodes
professionally produced, 416
Web TV, 218
Weibo (Chinese microblogging site), 66–67
Weisberg, Trevor, 674
Weizenbaum, Joseph, 136
WhatsApp, 225, 438
Whedon, Josh, 423
Whitman, Meg, 440
Wii (Nintendo), 199, 200, 201, 361–362, 372
Wikipedia, 343
Wikis, 343–344
Wilson, Kate, 453
Wilson, Woodrow, 342–344
Wimbledon tennis tournament, 506
Winfrey, Oprah, 214
Women
creating projects for, 196–199
entertainment consumption patterns, 55, 397
Wonder Workshop, 533
Wong, Freddie, 412, 671–672
Wooga (German developer), 232
Working robots, 536–538
World structure, 162
World Wide Web, 32, 406, 407; *see also* Internet
World Wildlife Fund (WWF), 322, 458
Writers Guild of America, 676, 684
Writer's Journey, The (Vogler), 99, 99–100
Written communications, guidelines for, 150
WWF, *see* World Wildlife Fund

X2AI, 146
Xbox, 363
Xbox One, 37

Young learners, 273–275, 289
Young people, entertainment consumption patterns, 54, 68
YouTube, 59, 60, 63, 83, 205, 212, 214, 215, 217, 218, 219, 220, 224, 226, 229, 229–230, 230, 287, 303, 306, 308, 309, 311, 317, 318, 319, 320, 325, 326, 334, 408, 409, 410, 412, 416, 420, 428, 429, 489, 490, 521, 632, 671, 671–672, 672, 694, 695; *see also* Video sharing sites
 for news and information, 59, 60, 326
 and *Red Bull Stratos*, 59, 60
 stickiness of, 412

Zellers, Marcia, 505
Zhu Zhu Pets, 532
Zynga, 231, 232